Hogarth's Harlot

PUBLISHING FOR THE WORLD
125 Years
THE JOHNS HOPKINS UNIVERSITY PRESS

Hogarth's Harlot

Sacred Parody in
Enlightenment England

Ronald Paulson

The Johns Hopkins University Press
Baltimore and London

© 2003 The Johns Hopkins University Press
All rights reserved. Published 2003
Printed in the United States of America on acid-free paper
9 8 7 6 5 4 3 2 1

The Johns Hopkins University Press
2715 North Charles Street
Baltimore, Maryland 21218-4363
www.press.jhu.edu

Library of Congress Cataloging-in-Publication Data
Paulson, Ronald.
 Hogarth's harlot: sacred parody in Enlightenment England /
Ronald Paulson.
 p. cm.
Includes bibliographical references and index.
 ISBN 0-8018-7391-6 (hardcover : alk. paper)
 1. England — Church history — 18th century. 2. Religious satire,
English — History and criticism. 3. Christianity and the arts —
England — History — 18th century. I. Title.
 BR758 .P38 2003
 700'.4823 — dc21
 2002154082

A catalog record for this book is available from the British Library.

Blest be the wisdom and the power,
 The justice and the grace,
That join'd in counsel to restore
 And save our ruin'd race!

Our father ate forbidden fruit,
 And from his glory fell;
And we, his children, thus were brought
 To death, and near to hell.

Blest be the lord, that sent his Son
 To take on flesh and blood.
He for our lives gave up his own,
 To make our peace with God.

He honour'd all his father's laws,
 Which we have disobey'd;
He bore our sins upon the cross,
 And our full ransom paid.

Behold him rising from the grave;
 Behold him raised on high;
He pleads his merits there, to save
 Transgressors doom'd to die.

There, on a glorious throne, he reigns;
 And by his power divine
Redeems us from the slavish chains
 Of Satan and of sin.

Thence shall the Lord to judgment come;
 And, with a sovereign voice,

Shall call and break up every tomb,
 While waking saints rejoice.

O may I then with joy appear
 Before the Judge's face;
And, with the blest assembly there,
 Sing his redeeming grace.

ISAAC WATTS, *Divine and Moral Songs for Children* (1715), No. 3, "Praise to God for our Redemption"

Contents

Illustrations

Preface

Sacred Parody recalls *parodia sacra*, a term referring to the medieval carnival and holiday practice of inventing parodic equivalents of liturgies, prayers, and hymns — of the Paternoster, the Credo, and the Ave Maria. I use the words in a general sense, focusing on the more complex case of the eighteenth century in England. And yet Mikhail Bakhtin's well-known definition fits the scope of my enterprise: "parodying, travestying, reinterpreting and re-accentuating" the sacred Latin texts, translating them into the vulgar national language, producing a sort of macaronic text; or, again in Bakhtin's words, contrasting "a dismal sacred word and a cheerful folk word."[1] This took the form, for example, of the Credo of a drunkard or the Ave Maria of a prostitute. *Pater Noster* became *Potus Noster:*

> Our drink, which art in a goblet, let your renown be increased. May your power come in a goblet as in court. Give us this day and forever well-cooked white bread and good wine. And (for)give us our cups as we forgive our drinkers. And lead us not into drunkenness, but deliver us from an empty goblet . . . Hail, color of bright wine, sweet taste without equal. May your clemency intoxicate us.[2]

In England as the Protestant clergy had replaced Latin with a vernacular liturgy, an artist replaced New Testament images with contemporary ones, or a musician replaced Italian arias with English; a poet reinterpreted the Son of God as a poet by way of the metaphor of redemption, or a painter associated a Pietà with the death of General Wolfe at the Battle of Quebec — or a libertine wit replaced Christ on the cross with a beautiful young woman. Parody in my title means both a parody of Redemption and parody as a form of redemption. Isaac Watts's poem, which I have used as epigraph, is in this sense a sacred parody of the Atonement for the ears of children.

A major theme of religion in eighteenth-century England was the search for substitutes. The spectrum was from faith to belief to blasphemy. After the Glorious Revolution John Locke, in his *Essay Concerning Human Understanding* (1690),

essentially substituted belief for faith (he regarded it as a supplement): Belief "is the admitting or receiving any proposition for true, upon arguments or proofs that are found to persuade us to receive it as true, without certain knowledge that it is so." Whereas faith "is the assent to any proposition, not thus made out by the deductions of reason, but upon the credit of the proposer, as coming from God, in some extraordinary way of communication" — such as revelation or church doctrine.[3] Locke did not contest the role of faith in salvation, for the present and not the hereafter was his primary concern. In relation to rules of conduct (i.e., works), "Faith must be regulated by Reason." Belief involved strong assent to opinions that were of the moment. The most generally accepted belief, as opposed to faith, was in the teachings of Jesus as a moral rather than soteriological agenda.

Doctrines of faith were blasphemed by libertines, diluted by Latitude Men, demystified by critical deists, historicized by historians and novelists, aestheticized by philosophers and politicians, and reclaimed, in an attempt at recovery, by Evangelical enthusiasts. The questioning of doctrines of faith can be traced back to Bacon, Hobbes, and Locke — to British empiricism, the test of reason, and the withdrawing tide of religious authority. The process had begun, however, with the official (national) substitution of Calvinist Protestantism for the Church of Rome, and the demonizing of popery spread to include all priestcraft and even the Protestant stronghold of the Scriptures. Yet the same old "problem of evil" (why death, pain, war, disease, the suffering of the innocent? — the question of how a good and omnipotent god can permit this) remained, and there was no way of saying much without recourse to the vocabulary of religion. Although the most significant developments in the century were heterodox, and it is a commonplace to see the main drive as one toward secularization, the Christian religion remained the base from which politics and art carried on their revisions. As the atheist Pierre Proudhon referred to religion in the nineteenth century, "Our monuments, our traditions, our laws, our ideas, our languages, and our sciences — all are infected with this indelible superstition, outside of which we are not able either to speak or act, and without which we simply do not think."[4] The Redemption, whether in belief or parody or blasphemy, represented to eighteenth-century English men and women a story or set of images and symbols that enabled them to cope with fears and anxieties concerning death and what might follow — salvation or damnation or nothing.

Redemption remained the center of attention. Isaac Watts was a Calvinist, but his Eucharistic hymns reflected the beliefs and fears of most religious English

men and women in the early years of the century. As the prominence of spiritual autobiography attests (from *Grace Abounding* and *Pilgrim's Progress* to *Robinson Crusoe* and *Pamela*), salvation was the issue. Salvation was celebrated in the Sacrament of the Eucharist, commemorating Christ's Atonement and Redemption: The former, associated with the harsh eye-for-an-eye vengeance of a god who is willing to sacrifice his own son in satisfaction for an act of disobedience, was in the process of being replaced by the latter. This book reflects the translating of atonement into redemption and, in some cases, redemption into mediation. The final term of the Eucharist mystery was Incarnation. In the nineteenth century scholars have noted "a radical and permanent change in the 'orthodox' theology, — viz., a shifting of its centre of gravity from the Atonement to the Incarnation."[5] The reference is to the reaction against Methodism and the evangelical movement with their emphasis on the Atonement — the particular fetish of the Cross, which at the end of the eighteenth century William Blake branded as the church's appropriation of Jesus' message of forgiveness for its own ends. By the end of the nineteenth century, as Vernon F. Storr commented, "In all schools of theological thought, Christology rather than Soteriology, the Incarnation rather than the Atonement, now occupies the central position. In place of the *Christus Redemptor* stands the *Christus Consummator.*"[6]

The story a hundred years earlier is about artists who reflect signs of this change, specifically from atonement to redemption, blood sacrifice to a sort of ransom, and the sacrificial lamb to Jesus; from an emphasis on personal salvation (or damnation) to acts of charity and love; from religion as all about everlasting felicity in paradise (or everlasting torment) to concern with living in this world. And this involves the shift Storr defined — toward the incarnation theory that seeks truth in terms of the whole of Jesus' incarnated life, birth, miracles, teachings, and resurrection as well as death on the cross. The focus is more on the here and now — and therefore not so much on atonement-redemption as on mediation — and less on Jesus' mediation at the Redemption between God and the wicked heirs of Adam than on Jesus' day-to-day mediation between God and striving, troubled humans.

David Newsome, on the other hand, has more realistically suggested that there is a repeated "pendulum swing" in theology,[7] in the eighteenth century from Calvinism to Arminianism, corrected in the second half of the century by the Methodist return to Calvinism, and so on. It is arguable that the artists with whom we deal merely participate in this pendulum swing. They represent, in a larger perspective, the advent of one strand of what has been called sentimental-

ism, where the "means of grace" is replaced by the "pleasures of the imagination" and aesthetics provides for "beatitude in this life and in this world" ("pleasure," "delight," and "joy") as opposed to the future life.[8] I do not, however, mean to add to the books on sentimentalism and sensibility. What might be related to the school of feeling is here the result of casting a cold eye—of parody and satire, blasphemy and doubt—and is seldom soft and tearful, even when the central figure is female. (The female is either inefficacious or carries a strongly subversive sexual charge.)

It was an aim of the Enlightenment to recover moral teachings from the doctrine of salvation. I should justify the words of the subtitle, "English Enlightenment," in relation to J. G. A. Pocock's view, set forth in a series of essays, that the Enlightenment in England was in fact a "conservative Enlightenment," providing protection against enthusiasm, whether the fanaticism of radical Protestant sects or the superstition of Counter-Reformation Catholicism.[9] In his more recent work, Pocock has admitted that the Enlightenment consisted of "a series of programs for reducing the power of either churches or congregations to disturb the peace of civil society by challenging its authority." But the key phrase is "civil society," which absorbs transgressive forces into itself, domesticating them. This process led, in Pocock's view, to a surprising unity of purpose between Church and Enlightenment, in effect a "clerical" Enlightenment: "In short," as Knud Haakonssen concludes in his useful survey *Enlightenment and Religion: Rational Dissent in Eighteenth-Century Britain,* "the peculiarity of England was that the strong modernizing drive that we identify with the Enlightenment was integral to the preservation of the establishment in state and church."[10]

There were, Pocock admits, two Enlightenments: "There was an Enlightenment of and by the increasingly rationalist sects, as well as an Enlightenment directed against the enthusiasm of the sects." It is even possible, he suggests, "that the Dissenting Enlightenment rose against the conservative Enlightenment, and particularly against the latter's aristocratic and clerical components (which did not cease to be enlightened in their own way)."[11] This Enlightenment, he goes on, was "capable of leading to a general assault on the central traditions of Christian theology as conveying the notion that divine spirit was present in the world and exercising authority in it."[12]

Thus, at the time of the French Revolution, Edmund Burke represented the conservative Enlightenment, excoriating the French for their subsidence into a barbaric neoreligious enthusiasm, while Blake and Thomas Paine represented the Revolution (for a time at least) as the answer to Antinomian prayers in the

Apocalypse that radical Protestants and democrats had been waiting for. Blake and Paine came from the group excluded as Dissenters from the Anglican Church-state. The question, as Haakonssen puts it, "is whether their Enlightenment had more in common with the conservative one from whose clerical establishment they dissented or with the radical one that eventually emerged on the Continent" (4).

Pocock's formulation points to some facts: William Hogarth stood most firmly on the ground of his Englishness (signing paintings "W. Hogarth Anglus pinxit"), as did Blake and even, to the extent that he was projecting a reformed Church of England, Christopher Smart. Pope and Swift (and Dryden before them), fitted Pocock's model in the sense that England "had only just escaped the barbarism of religious wars, especially civil wars, and the task of enlightened minds was to preserve modern society from the confessional backwoodsmen of all creeds."[13] This would place them in Pocock's "Enlightenment," defending English culture by way of Milton and Virgil against the Goths of *Dunciad* II.[14] But the cases I examine would seem to be primarily Dissenter, indeed Antinomian, in that they defend the individual against the law in its various forms, including a strong monarchy and a visible church. (At their extreme they call for the abolition of the Sabbath, tithes, the clergy, and magistrates.) They ask whether the law, if not religion itself, is part of the eternal structure of the universe or an arbitrary set of impositions for the purposes of power. Hogarth's "dissent" points toward the American Revolution and the radicalism that eventuates not only in Blake but in Paine, Price, Wollstonecraft, and Godwin.

My first example is Hogarth, who posed the problem of "sacred parody" in its most glaring form. He was also the most original and daring "author" of the earlier part of the century—"author," though he employed graphic images as well as words and verbal projections. What this book demonstrates, if it needs demonstration, is the centrality of Hogarth within English culture of the eighteenth century. My point of departure is the paradox that the scandal of Hogarth's New Testament parody in *A Harlot's Progress* (1732) has met with silence, from both Hogarth's contemporaries and modern art historians. One English art historian, David Bindman, finally, in 1997, the tercentenary of Hogarth's birth, acknowledged the possibility but only to comment, in an endnote, that he is "not persuaded"—showing that the determination to deny these images their full, subversive force is as strong as ever.[15]

An occasional biblical echo in Hogarth's works has been acknowledged. As part of London's tercentenary celebration, an art historian writing in *Apollo* no-

ticed that Hogarth had "borrowed," perhaps from Annibale Carracci, a Pietà in the last plate of *A Rake's Progress* (see fig. 34). Hardly news, it was as if he had just come upon Frederick Antal's "Hogarth's Borrowings" (1947), but he put a new twist on Antal's "borrowing" by commenting that Hogarth "was a lifelong plagiarist" of the foreign old masters he denigrated.[16]

What was new among art historians of the 1990s was the image of the pragmatic, expedient, self-serving Hogarth who would *steal* from, exploit for profit, the same old master paintings he attacked in print as "dead *Christs, Holy Families, Madona's*, and other dismal Dark subjects, neither entertaining nor Ornamental."[17] The rise of material culture ideology and method has drawn attention to the making, marketing, and distribution of Hogarth's prints, but some art historians have permitted this useful approach to jaundice their view of the artist, whom they reduce to purely economic terms: making a living, how much he made, and therefore his opportunism, as if he did not also have beliefs, in particular religious beliefs.

My first assumption about Hogarth's art, forty years ago, was that Antal's identifications were not "borrowings" but allusions and parodies, not decorative but substantive, and my chief example was the *Harlot's Progress*.[18] As a literary historian of the eighteenth century, I argued that these *quotations* (a more felicitous term, used by Edgar Wind) were part of a satiric strategy common among writers and poets of using the past to comment on the present (the "mock-heroic" satires of Dryden, Swift, Pope, Gay, Fielding).[19] Of course, images can go into the making of a work without influencing its meaning, without being alluded to. But the allusion sets off the work from that of the mere borrower or the plagiarist who does not want you to recognize the source of his borrowing. In Johnson's *Dictionary, allusion* is "that which is spoken with reference to something supposed to be already known, and therefore not expressed." "Allusion then," as Michael Leddy has put it, "is predicated upon the possibility that some will catch the point while others will (or would) miss it; even when an allusion seems obvious, the fact that there is pleasure in recognition presupposes that an allusion is not all that obvious, not to everyone."[20]

I have wondered whether the denial of the English art historians was simply their reticence about looking at a picture rather than studying the history of taste or contemporary documents that supposedly limit the range of our understanding of a picture. The answer is probably that Hogarth has not been given sufficient credit. To these scholars he is still a "cartoonist" whose graphic images do not deserve the sort of attention given by critics to major painters and poets.[21]

His contemporaries called him the Shakespeare of art, referring to the abundance and variety of the characters he created. I am convinced that he is the only graphic artist, in England at least, whose expression is as rich, as polysemous, as worthy of analysis (and of the same sort), as Shakespeare's.

True, we have to balance the overwhelming visual evidence of the engravings against the absence of written support. The German scholar Bernd Krysmanski, for example, accepts my identification of the *Harlot* parodies and adds some of his own but detects no pattern in them, regarding them as only mnemonic supports for the artist. He argues that Hogarth used his "borrowings" as inspiration, as a way to get his ideas moving along. He seems to go along with the material culture view of Hogarth: his borrowings are pragmatic shortcuts.[22] So, even if we accept the evidence of the burlesque, there may be legitimate disagreement on how to interpret it. My interpretation in the following pages is based on two contexts — the whole body of Hogarth's work and the relevant literary and religiopolitical texts of his time. The latter suggests, for example, that in Hogarth's case the burlesque, given its roots in Protestant antipopery, may not have been as shocking as at first appears. Much can be explained about the great popularity of this apparently blasphemous work by the fact that Hogarth was at bottom an English Protestant-Whig, not just a deist infidel (as he also was). In particular, these diverging beliefs shared with a large part of the public the two-sided Antinomianism of *against* the law, in all its forms, and *for* the worth (if not divinity) of the "common sort," the lower orders of society.[23]

At the far end of this study is the other most original and daring artist of the English eighteenth century, Blake. The trajectory of atonement that begins with Hogarth's *Harlot* ends with Blake's "London" and his "Bible of Hell" and "Everlasting Gospel." Between are versions of redemption (the poet redeems, the beautiful woman mediates), but the tendency is to see these in terms of the time between the act of redemption and its fulfillment (between the Redemption and the Last Judgment), a time that Hogarth places in the here and now and Blake pushes very close to the Apocalypse — the time of Antichrist. That Smart's *Jubilate Agno* would have been regarded in the eighteenth century as parody or blasphemy is suggested by the fact that it was not published until 1939 and, if published earlier, would have been covered by the screen of Smart's "madness."

The poetic texts of Smart and Blake were, unlike Hogarth's, virtually private — in Smart's case written with obviously pious intentions — and the only issue is whether or not they can be linked to the Hogarthian parody. In both cases there is strong evidence to support the hypothesis. My argument presupposes the

recognition of Hogarth's general argument by Smart and Blake (as it was, more obviously, utilized by novelists like Fielding and Sterne), but I want to demonstrate (as E. P. Thompson draws a line connecting Blake—and Clement Hawes draws a line connecting Smart—with the radical sects of the seventeenth century)[24] that at the least all three shared enough common ground to carry out a similar transformation of Christian Atonement/Redemption. The end results, of course, were very different: While Hogarth demystified and aestheticized religion, Smart returned aesthetics to the service of religion and Blake created out of religion *and* aesthetics a counter-religion or a mythology. These writers (with a few other poets and artists) make what we might call a *tradition*—not necessarily a Hogarth tradition but one in which he and they equally participate.

My interest in the process of sacred parody began with work in the 1970s on the French Revolution, which carried out in a more violent and decisive way the "transfer of sanctity" from the old order to the new, from heaven to earth, that these English artists attempted when they encoded older meanings and fused older cultural elements in new patterns.[25] In some ways this book is a rethinking, clarifying, and narrowing of the argument of *Breaking and Remaking,* where I wrote of iconoclasm.[26] It rounds off the argument of *The Beautiful, Novel, and Strange: Aesthetics and Heterodoxy* and *Don Quixote in England: The Aesthetics of Laughter.*[27] Primarily it seeks to demonstrate a continuity and some common denominators among artists for whom the Christian religion (or "religion") was a subject of particular concern.

To make my point about Hogarth clear, I have had to recall a few examples from my earlier books: Wright of Derby's candlelight paintings, a Gainsborough landscape that parodies a Rubens Deposition, and Zoffany's study of Christian and pagan art in *The Tribuna of the Uffizi.* I don't believe I can assume the reader's knowledge of these passages; I request the indulgence of those who do remember them.

My personal thanks, for favors great and small, to Brian Allen, Joan Dayan, DeAnn DeLuna, Linda Forlifer, Allen Grossman, Robert Hume, John Irwin, Paul Korshin, Trevor Lipscombe, Richard Macksey, Catherine Molineux, Annabel Patterson, Claude Rawson, Ruth Smith, and Ann Stiller.

I dedicate this book to Leslie Moore, a sometime student and colleague and friend, who taught me what was important about atonement in *Paradise Lost* and, deserting us to go into the law (in her case, not the Law), left an empty space I have tried to fill with this book.

Hogarth's Harlot

Introduction

The Sacrament of the Eucharist

Redemption/Atonement

The Eucharist is the central sacrament of the Christian religion. Its purpose is to reassure the descendants of the fallen Adam that their sins can be forgiven and their deaths salvaged by the hope of an everlasting afterlife. The Eucharist, the sacrificial meal by which, *offering* bread and wine to God, Christians *receive* the Body and Blood of Christ, celebrates the story that was the most compelling and persuasive aspect of the Christian religion. Jesus' moral teachings (Do unto others as you would they do unto you, Love thy neighbor) were secondary to the story of his Redemption of our sins by his death. The power of the body and blood of Christ and the preoccupation with thoughts of saving Grace found vent in everything from the plots of novels to everyday asseverations, swearing by God's blood, body, wounds, or death (*Od's Blood* or *Sblood, Od's Body, Zounds, Od's death,* even the adjective *bloody*).[1]

The story began in the first century of the Common Era with the crucifixion of a Jewish sect leader, a prophet identified by his followers with the "Messiah." The original message of the Jesus sect was presumably eschatological, about their

imminent triumph over the enemies of Judaism, the Romans. Faced with the fact of this Messiah's failure — the circumstance that, far from triumphing, he was crucified as a common criminal — Saint Paul, a convert to the sect, in his Epistles to the fledgling Christian communities of Greece and Asia Minor, created the essential etiological fiction, preaching salvation in Christ's death.[2] He returned to the sacred text that came to be called the Old Testament ("preparation" for the New Covenant or Testament). Given all the OT stories of sacrifice, redemption, and atonement, he connected these as foreshadowings (what came to be called *types*) of the death of Jesus.[3] Saint Paul went to the anonymous prophet known as Second Isaiah (Isa. 40–55), whose subject was the destruction of Jerusalem by Nebuchadnezzar, the Babylonian exile, and the servitude of the Jews. Isaiah explained how this shocking event could have happened, much as Paul explains how the crucifixion could have happened. Isaiah's answer was the Jews' sins against Yahweh (i.e., disobedience and the worship of other gods); to this he added the hope of liberation and a return to Jerusalem, which he refers to as "redemption" (49:7, 26), a word Paul adopts and applies to Jesus.

The economic metaphor of redemption (from Latin *emo, emere*, to buy; i.e., to buy again, to recover — or exchange *this* for *that*) evoked a commercial transaction, as of a slave or captive who could be "redeemed" or ransomed, or land or a house that could be bought back (Lev. 25:23–26), or the sin against God that could be redeemed in order to deliver the exiled of Jerusalem from servitude in Babylon. In Paul's Epistle to the Galatians, the economic sense of redemption specifically recalls Isaiah's manumission of a slave or servant in the context of Cyrus's freeing the Israelites to return to Jerusalem (Isa. 11:11, and 48–53; Gal. 1:10, 2:4, 3:19, 4:5, and 5:1). But in Exodus a son must be redeemed, possibly from sacrifice (as in the case of Isaac in Genesis), by a ram or lamb or goat, as the land or house must be redeemed by money (Exod. 22:28–29). A third party is called for. At the first Passover a lamb was killed to mark with its blood the houses of the Israelites to be spared by the avenging angel, the result being "redemption" in the Levitical sense from their bondage in Egypt. Mark, Matthew, and Luke developed the metaphor of redemption as ransom, as in the lamb who redeems sinners with his own life: Jesus says he came to "give his life a ransom for many" (Matt. 20:28, Mark 10:45).[4]

Atonement, as opposed to redemption, is at-onement or reconciliation between estranged parties — bringing together God and man after a break or a sin (the OT backsliding into idolatry). In Leviticus, on the Day of Atonement a goat was slain (Lev. 16:9), and so in the NT a similar breach requires the death of a

sacrificial victim. Blood, Leviticus 17:11–14 tells us, is to be shed "upon the altar to make an atonement for your souls: for it is the blood that maketh an atonement for the soul" (not to be eaten but used for sacrifice), and blood marked the doors of the saved in Exodus. In Judaism the sinner atoned by sacrificing a lamb and saying penitential prayers — and, with the memory of Abraham's binding of Isaac, this was often interpreted as a substitution of a lamb for the father's best-beloved son.[5] The death of a Messiah could then be interpreted as being that of a sacrificial victim to heal the breach with God.

Messiah in the OT was God's anointed, which became in the NT the Greek *Christ*, with Paul's added denotation of savior. The Messiah's "sonship" derived from the general OT term "son of God," applied to the people of God or someone especially close to God (and Daniel's "Son of Man," who would soon come on the clouds to rescue the redeemed of Israel); the term *son* was taken literally — raising, in the sequel, the threat of dualism or polytheism, of an OT Father and a NT Son, countered by the doctrine of the Trinity.

In his description of Israel in exile, the Second Isaiah applies the metaphor of atonement to a servant of God (52:13–53:12), one who suffers for the community as a whole: He is "brought as a lamb to the slaughter, and as a sheep before her shearers" (53:7); this is repeated verbatim in Acts 8:32–33 and becomes, in 1 Peter 1:19, "But with the precious blood of Christ, as of a lamb without blemish and without spot." The sacrifice of Christ, which took place at the Jewish Passover, was associated with the sacrifice by priests of the paschal lamb for every family to eat roasted with unleavened bread. The lamb has become the Lamb, the unleavened bread the Host, and the OT sacrifice Christ's Atonement. As the Book of Common Prayer puts it, "Christ our Lord . . . is the very Paschal Lamb, which was offered for us," praying, "O Lord God, Lamb of God, Son of the Father, that takest away the sins of the world, have mercy on us."[6] In whatever text we encounter a lamb/Lamb, it will be a sign of both the Nativity and the Crucifixion, with the OT association of impending slaughter and/or ritual sacrifice (as in Renaissance paintings of the Madonna holding the Child in a pose prefigurative of the Pietà).[7]

Isaiah's servant, as servant (vs. lamb), is "taken from prison and from judgment, . . . cut out of the land of the living: for the transgression of my people was he stricken." In his Epistles Paul made the servant the Messiah, a new "man of sorrows," and called upon the remarkably exact precedent of the crucifixion. When Jesus says he came to "give his life a ransom for many," he is echoing Isaiah 53.

In Romans 5 Paul wrote that "Christ died for the ungodly" and "God com-

mendeth his love toward us, in that, while we were yet sinners, Christ died for us. Much more then, being now justified by his blood, we shall be saved from wrath through him" (Rom. 5:6–11). But it appears that atonement is still for breaking God's First Commandment ("Thou shalt have no other gods before me"). Finally, picking up the story in Genesis of Adam's Fall, Paul attaches the Atonement to Adam and his original transgression: "Wherefore, as by *one man* [Adam] sin entered into the world, and death by sin; and so death passed upon *all men*, for that all have sinned: . . . for if through the offense of one many be dead, much more the grace of God, and the gift by grace, which is by *one man, Jesus Christ*, hath abounded unto many" (5:12, 15, emphasis added).[8]

Christological Typology

Luke tells the story of the Evangelist Philip, who is asked to interpret the Book of Isaiah, whereupon "Philip opened his mouth . . . and preached unto him Jesus" (Acts 8:26–39). This is typology in practice. The Gospels adapt the story of the substituting servant, even down to the "stripes" of the Flagellation (recalling also 50:6, "I gave my back to the smiters, and my cheeks to them that plucked off the hair: I hid not my face from shame and spitting"). Jesus is crucified, and then Paul and the authors of the Gospels take off, and all the details of the mockers, the piercing wounds, the vinegar, Christ's crying out to God who has forsaken him, and even the dividing of the garments follow. Typology in its determinist aspect was stressed by Matthew: Mary and Joseph must carry Jesus to Egypt, not just to save him from Herod but "that it might be fulfilled which was spoken of the lord by the prophet, saying, Out of Egypt have I called my son" — so that Jesus can *return* from Egypt. And they have to live in Nazareth: "that it might be fulfilled which was spoken by the prophets, He shall be called a Nazarene" (Matt. 2:15, 23). Even the Wise Men were foreshadowed — by the Queen of Sheba and her retinue, who brought identical gifts to another son of the house of David. There were twelve tribes of Israel; therefore, there are twelve disciples.

Typology, as developed by Paul in his Epistles, is centered on Christ. One half of the relationship is Christ, the other pre- or postfigurative: An OT figure prefigures Christ, or Christ prefigures a person of later times, even of the historical present. God's miraculous intervention in human history in the OT prefigures Christ's incarnation and redemption of man in the NT — which serves to perfect the OT paradigm. In the procedure of Pauline typology, the NT (in the words of Leslie Tannenbaum) "adopts the most significant symbols from the Old

Testament in order to *interpret, criticize, and transform* the form and content of the earlier text—at the same time that it claims both to *fulfill and supplant* that text" (emphasis added).[9] The principle is not that of metaphor and simile, allegory and personification: rather, the old dispensation is followed, criticized, and both fulfilled and supplanted by the new. The NT reaffirms the pattern of God's salvific plan in history; it revises the terms in which that plan was first set forth, replacing the dispensation of the law with the dispensation of grace. The paschal lamb that commemorates God's delivery of Israel out of Egypt in Exodus 12 is reprised by Christ, the true Lamb of the NT (1 Cor. 5:7), "whose sacrifice enacts God's delivery of the new Israel and abolishes the Mosaic law that prescribes the yearly ritual sacrifice of the paschal lamb."[10]

Paul specifies that "Christ hath redeemed us from the curse of the law" (Gal. 3:13, again, 4:5, 21–31)—that is, from the OT law by the New Covenant. Paul's aim, in his struggle with the Judeo-Christians, was to deny the normative character of the OT and show the Old Law as only figure, shadow, a type of the New. In fact, when he wrote "For until the law sin was in the world; but sin is not imputed when there is no law" (Rom. 5:13), Paul opened the door to what came to be known as Antinomianism, literally "against the law" (Greek *anti* and *nomos*), in its most pervasive form shared by Milton, Hogarth, and Blake. In its most extreme form, with the English Ranters and Levelers, it was interpreted as not only *against* the law but *above* the laws that bind others.

Paul's story of redemption answered the problem of evil with the promise of a future state, which was one of the chief enticements offered by the new religion —the most significant sense in which the New Covenant replaced the old, flawed one. The obverse of Pauline typology was the determinism of the precedent, especially of the Mosaic law, which, unless controlled, will exert an oppressive weight on the present: the type being merely repeated, and the human misshapen in its image.[11]

Incarnation

With Second Isaiah's servant still in mind, Paul introduced the Incarnation and so the Son of God, who "made himself of no reputation, and took upon himself the form of a servant, and was made in the likeness of men. And being found in fashion as a man, he humbled himself" (Phil. 2:7–8).[12] "And," Mark writes, "the Scripture was fulfilled, which saith, And he was numbered with the transgressors" (or "he let himself be taken for a criminal"—Mark 15:28). God

humbles himself, not just taking on weak human flesh but being treated as a criminal, having the flesh humiliated, lacerated, and pierced. The Incarnation (also referred to as the humanation) of God was very different from the embodiment of the classical deities: Jupiter inhabits Amphitrion's body in order to seduce his wife, but producing, with Jupiter's terrific power and potency, Hercules. In the Christian story God becomes man in all aspects (including, as Leo Steinberg has shown, his sexuality) *except* for man's sin, and some theologians included even sin.[13]

The Incarnation elicited two interpretations, stressing either God's divinity or his humanity: In one, God has chosen to humble himself, enfleshing himself in weakness — thereby showing his love; in the other, he has chosen to sacralize that weak flesh. If in the first God condescends into flesh, in the second he ennobles (or *re*ennobles, since before the Fall, man had been created in God's image [Gen. 1:26]) the human and corporeal, giving a sacramental value to fallen man, who was commonly referred to in the devotional works, sermons, and hymns as a worm. He shows by Jesus' incarnation the grace (or the divinity) in earthly things. The first was the emphasis of the Protestant sects as they tended toward Calvinism, the second was the emphasis of the Church of England in its Arminian and latitudinarian aspects: The Incarnation proved that each of us is worth the blood of our Lord. God's becoming flesh and redeeming man could even be construed as preferable to his original act of Creation, as the new dispensation was to the old. The Creation had proved corruptible through Adam's Fall and Satan's seduction; the Incarnation redeemed this corruption and so was superior and everlasting.

There were various moments of incarnation. From the First Isaiah (Isa. 7:14) came the type of the Incarnation and the virgin birth: "Behold, a virgin [a maiden] shall conceive, and bear a son, and shall call his name Immanuel" (God with us). Luke, telling the story of the virgin birth, conflates it with Isaiah's lowly servant ("marred more than any man" who "shall be exalted and extolled, and be very high," "his form more than the sons of men" [52:13–14]), and creates the fiction of Incarnation as elevation of the lowly. This takes the form of the Magnificat, Mary's song of praise when she has heard the Annunciation and compared stories with her cousin Elizabeth (who, nearly as old as Abraham's Sarah, is surprisingly pregnant with the future John the Baptist): "And Mary said, My soul doth magnify the Lord, ... For he hath regarded the low estate of his handmaiden: for, behold, from henceforth all generations shall call me blessed. For he that is mighty hath done to me great things; and holy is his name. ... He hath put down the mighty from their seats, and exalted them of low degree" (Luke 1:46–52).

Although the Incarnation was revealed in Matthew and Luke in the Annunciation and Nativity, the usual event referred to was the Crucifixion (the torture and death of Isaiah's servant), and Paul, in the First Epistle to the Corinthians (chap. 10), places the incarnational moment in the Last Supper: "The cup of blessing which we bless, is it not the communion of the blood of Christ? The bread which we break, is it not the communion of the body of Christ? For we being many are one bread, and one body; for we are all partakers of that one bread" (10:16–17). In chapter 11, he elaborates:

> For I have received of the Lord that which also I delivered unto you, That the Lord Jesus, the same night in which he was betrayed, took bread; And when he had given thanks, he brake it, and said, Take, eat; this is my body, which is broken for you: this do in remembrance of me. After the same manner also he took the cup, when he had supped, saying, This cup is the new testament in my blood: this do ye, as oft as ye drink it, in remembrance of me. For as often as ye eat this bread, and drink this cup, ye do show the Lord's death till he come. (11:23–26)[14]

The passages in Mark, Matthew, and Luke may be based on Paul's, or there may have been a common source; they are conflated in the text of the Communion Service in the English *Book of Common Prayer.*

Transubstantiation, the crucially controversial term of the Eucharist and of the Protestant Reformation, designates the mystery of the Incarnation: Christ's body and blood in heaven, and the bread and wine on the altar of the church, become with the priest's blessing a physical identity. The Protestant reformers argued that Christ in heaven could not also be at the same time the bread and wine of the Eucharist on the altar. The difference between the Catholic and Protestant Eucharist is summed up in the words uttered at the moment of the Elevation of the Mass: *Hoc est corpus meum*, spoken by the Catholic priest, which in Protestant usage becomes *Hoc significat corpus meum.* The sacraments are not *signa exhibitiva* that exhibit what is present but *signa representativa*, signs that represent what is absent—that is, a way of representing both what is present *and* what is absent. The Protestant distrust of the Mass focused on Transubstantiation, not only because of its "mystery" but because it depended on the function of the priest, as did salvation—on confession, penance, and the indulgences for relatives in Purgatory that set Luther on the path to Reformation.[15]

The Reformation replaced the Catholic Mass with the Lutheran or Anglican Holy Communion and the Reformed Church's Lord's Supper, and Communion was commemoration ("in remembrance of me"; "Take and eat this in remembrance that Christ died for thee"), not the repetition, the Transubstantiation, of

Christ's sacrifice.[16] There was no need for the action of the priest making God's body and blood manifest (the wafer and wine) for more than a remembrance of the miracle of God's Grace by "the priesthood of all believers." Thus, in Charles Wesley's "Eucharistic Hymns": "Jesus, suffering Deity, / Come help remembering Thee . . . Gladly now we call to mind . . . ," and so on. Wesley refers to the "sad memorable night," the Last Supper, and quotes Jesus: "And thus, my friends remember Me."[17]

Bishop John Jewel, of the generation after Archbishop Cranmer, explained that "three things herein we must consider; first, that we put a difference between the sign and the thing itself that is signified. Secondly, that we seek Christ above in heaven [i.e., not on the altar] . . . Thirdly, that the Body of Christ is to be eaten by faith only, and none otherwise." That is, the papist worships the sign in place of what is signified (idolatry). Christ's presence is not in the sacrament but in the soul of the communicant who has received the sacrament worthily; it is therefore a subjective phenomenon, conceived in terms of the psychological being of the recipient, the sinner whose faith alone assures him of his salvation and not the work of the priest or his own work in taking the communion (preceded by confession and absolution of his sins by a priest and supplemented by works of charity outside the church). The common-sense Church of England view was expressed by Bishop Jewel when he wrote that we eat the sacrament "with the mouth of faith":

> the sacrament-bread is bread, it is not the body of Christ: the body of Christ is flesh, it is not bread. The bread is beneath: the body is above. The bread is on the table: the body is in heaven. The bread is in the mouth: the body in the heart. The bread feedeth the outward man: the body feedeth the inward man. . . . Such a difference is there between the bread, which is a sacrament of the body, and the body of Christ itself.[18]

In our own time, Malcolm Ross's discussion of poetic imagery in Renaissance England assumed the ideal of Transubstantiation. Writing in the context of T. S. Eliot's "dissociation of sensibility," he celebrated the poetic identity of divine essence and historic thing (the unity of the idea and the scent of a rose), deploring the "dissociation" that came with the Protestant Communion, which reduced this reality to a memory, this unity to a metaphorical relationship (the bread and wine are merely *like* Christ's body and blood) and ultimately a cliché. The spirit of Protestantism, he argued, leads to the "separation of the sign from the thing signified, of the sacrament from the Body and Blood, . . . in effect separating heaven and earth, past and present, spirit and flesh, and leaving to the ancient

symbolic words a purely psychological function," that is, the function of "Faith" in the mind of the celebrants.[19]

The point of invoking Malcolm Ross is to note his identification of Incarnation with Transubstantiation as the basis for great art:

> Though the flesh is frail, and though nature herself has suffered the wound of sin, the Incarnation redeems the flesh and the world, laying nature and the reasonable faculty open once more to the operation of the supernatural. In other words, the Incarnation makes possible, indeed demands, the sacramental vision of reality. The flesh, the world, things, are restored to dignity because they are made valid again. Existence becomes a drama which, no matter how painful it may be, is nevertheless meaningful. And no detail in the drama is without its utterly unique reality. No thing is insignificant (10).

"No thing is insignificant" means in a particular sense of religious belief. (There are obviously other ways in which "no thing is insignificant," say, in Virgil's *Georgics*.) But similar words have been applied by Perry Miller, William Haller, and others to the belief of the Puritans in the importance of the most commonplace everyday objects.[20]

The assumption of Eliot and Ross was that belief in Transubstantiation gave the poet a "special, anti-intellectual way of knowing truth," and this required "an age in which the Image was more readily accessible and acceptable"[21] — that is, an age of belief in a central religious image or symbol accepted by all. Transubstantiation represented the unity of the divine and such fallen everyday objects as bread and wine: what Ross calls "the sacramental vision of reality." But, of course, Eliot was only making a case for a sort of modernist poetry that, like some seventeenth-century poetry (as he and Samuel Johnson saw in their different ways), yoked together such incongruities as body and spirit or sexual and spiritual love, even while doing so was a hopelessly nostalgic effort. Eliot's critique was of the age-old temptation "to glide off into abstractions" — for which he cited the poetry of Collins, Gray, and Johnson, suggesting why personifications (concepts and qualities, virtues and vices, personalized, materialized) became so popular in eighteenth-century England.[22] In one story of eighteenth-century poetry, there are, first, abstractions such as Faith, still an aspect of deity, and then Morality. The latter, to Bunyan at least, was a false replacement for Faith, therefore for deity. Virtue and Vice substituted moral abstractions for the deity, and finally Pity and Terror substituted aesthetic or psychological qualities for moral abstractions.

There was another story, the one referred to by Miller and Haller. Paul in 1 Corinthians read the Lord's Supper as a symbol, and therefore the emphasis fell

on bread and wine *as* bread and wine, that is, as food, a meal shared by Christ and his disciples, and all Christian communities ("The cup of blessing which we bless, is it not the communion of the blood of Christ? The bread which we break, is it not the communion of the body of Christ?").[23] It was Christ who made these symbols of community into metonymy or metaphor ("this is my body"): metonymy by his body's proximity to them, objects on the table; metaphor by telling his disciples that they are his body and blood, by comparison or analogy between the shape of his body and the loaf of bread (and the breaking of both) as between his blood and the wine, as to liquidity and color — all of which signified not communion but sacrifice (the continuum being nourishment).

The metonymic reading, which was Calvin's (and therefore influential among English Protestants), places the emphasis on body, blood, and sacrifice — and so on Atonement. Calvin introduces the term *metonymy*, "a figure of speech commonly used in Scripture when mysteries are under discussion": "our souls are fed by the flesh and blood of Christ in the same way that bread and wine keep and sustain physical life." This suggests metaphor but in fact is Calvin's particular sense of sacramental metonymy: "Not only is the name transferred from something higher to something lower [i.e., from Christ to bread], but, on the other hand, the name of the visible sign [the bread and wine] is also given to the thing signified [Christ's flesh and blood]: as when God is said to have appeared to Moses in the bush, . . . and the dove, [in] the Holy Spirit."[24] Ann Kibbey, in an important analysis, comments that Calvin's "metonymy locates the invisible but 'true' presence of Christ in the material world. . . . The conflict of meaning in sacramental metonymy grants an intrinsic power, however subordinate, to material shapes" — to the lower half of the equation, the bread and wine.[25]

Calvin's sacramental metonymy is based on his belief that the bread of Communion remains bread, as the water of Baptism remains water. At bottom is the principle of Christ's Incarnation, that when God was incarnated as Jesus of Nazareth — or carried out the Redemption on men and women — he left his imprint on everything: the bread was not the same after Christ accepted incarnation and carried out redemption. He left something of himself behind, which made it possible to think of the bread as being Christ or (as the Ranters believed) that Christ is in us.

Reformation/Iconoclasm

The first step taken by the Protestant reformers was to demystify the Roman sacraments. In England they were reduced to two, the Eucharist and Baptism, the

only sacraments traceable back to the Gospels. The sacraments were conducted not in Latin but in the vernacular (as in the Bible and *Book of Common Prayer*). Distinctions between priests and laymen such as celibacy/marriage were eliminated. In the architecture of the new church, chancel and nave were joined, side chapels and chancel screens eliminated, bringing together the whole body of the faithful at worship. The altar, now a simple table, was moved down toward, often into, the body of the church, among the congregation. The Romish priest drinking alone from a chalice was replaced by all communicants sharing a large cup, the officiant now speaking and the congregation listening and responding in the same vernacular. The supper/communion of believers drew attention away from the sacrament and so from the priest who consecrates the wafer and administers the sacrament. The communion concept underlined the social importance of the Eucharist in England. As J. A. I. Champion has noted of the church service: "The sermon confirmed both the injunctions of Christ and the political order in the minds of the congregation. The distribution of the Eucharist was symbolic of the moral, social and political status of the individuals in a community."[26] This was, first and foremost, a nationalizing Reformation.

Roman Catholicism was called (rather than "Catholic" or universal) "Papist" or "Popish" or "Romish," pointing to its tyrant and its foreignness.[27] The danger was first political, in the time of Philip II's Spain and in the time of Louis XIV's France: Popery, as Richard Baxter put it in the 1660s, "destroyeth our government," leading men "rather [to] obey a foreign power, than submit to our lawes."[28] The related danger was popery's unreasonableness — its prejudice, superstition, and obscurantism; again politically, this meant papal authority or "idolatry" as opposed to the English claims for the "liberty" of Protestant reason.

The conflicting strains of Protestantism were distinguished by an alleged inclination toward or away from popery and priestcraft. Priestcraft in English politics was taken to mean that (as in Roman Catholicism) the priests' "chief business is to give a helping hand towards making Princes Arbitrary." "All the radical objections against Christianity came to a head in their hostility to the role of the Church in politics."[29] The danger the Puritans saw in the Church of England was the return to popish sacerdotalism and ritualism. And from the political perspective, liturgical worship had the effect of establishing uniformity in religion.

The Anglicans retained the roles of bishop, priest, and deacon; the Presbyterians had pastors, teachers, elders, and deacons. Anglicans, especially of the Laudian persuasion, retained the symbolic architecture of the cross-shaped church with nave and transept, while Puritan meeting houses were square, with the

communion table placed in the center so that the congregation would seem to be sitting around it. The focal emphasis was shifted from the altar or table to the pulpit and, secondarily, to the baptismal font. In Protestant worship one experienced primarily prayer, praise, and the reading and preaching of the Word.[30] It was the sermon that usurped the central role of Holy Communion. Wren's first principle in planning the churches he built for London after the Great Fire of 1666 was to make sure every auditor could hear the Word of God. The Word of God was, nevertheless, very much concerned with the doctrine of Atonement.

The Church of England retained some of the vestments and ceremonies rejected by the Puritans as polluted by Romish use and association. The High Church officiant knelt for reception of Holy Communion ("One kneels before an altar, but one sits at a table"; "the use of an altar is to sacrifice upon, and the use of a table is to eate upon").[31] In Baptism the Anglican retained the sign of the Cross, which the Puritans regarded as a remnant of popish superstition. By the 1640s this had come, with the work of Archbishop Laud, to a bitter conflict between the Church of England and dissenting sects: by the end of the century, Independents (in later usage, Congregationalists), Baptists, Presbyterians, not to mention splinter sects of radical Dissent (Ranters, Quakers, Philadelphians, Muggletonians, and in the second half of the eighteenth century, Methodists and Unitarians).

When Laud moved the altar back to the east wall and made recipients of Communion kneel at the rail, he subordinated the pulpit to the altar. The issue at stake was whether, as argued by the papists, it is God's body (how can his body be both on the altar and in heaven?) or whether, with Calvin, it is God's bread (the *result* of the Incarnation). Laud came close to expressing the former position when he described the altar as "the greatest place of God's residence upon earth," that is, his body is present in the wafer — "greater," he adds, "than the pulpit; for there 'tis *Hoc est corpus meum*, 'This is my body'; but in the pulpit 'tis at most but *Hoc est verbum meum*, 'This is my word' "[32] — a position the Puritans had reversed. Thus the sermon was drowned out in Laud's church by the sound of contrapuntal and orchestral music, as attention was diverted by the colorful baroque painting and stained glass. From the Puritan's perspective, Laud's scenographic high-church liturgy was the same as Charles I's court masques, in which the myth of kingship, founded upon more visual than verbal expression, became manifest idolatry.

Calvin's principle of iconoclasm was based on his sacramental metonymy (the spiritual signified attached to a material signifier): In Transubstantiation there

was the popish icon of the body-bread (in the form of a wafer) as opposed to the plain bread on the table. Nothing needed to be done to it because it *was* the bread invested by Christ's Incarnation. Transubstantiation elided the truth of Incarnation, and so, in the iconoclasm of a church, as Ann Kibbey has written, the Puritan's intention was to "destroy fully a threat of power inhering in the *figura*" of, for example, the altar: "Altar stones became 'paving stones, bridges, fireplaces, or even kitchen sinks,' basins for holy water were used to salt beef, and a triptych was used as a pig trough."[33] She cites the example of Emmanuel College, Cambridge, where the Puritans "convert[ed] the old Dominican church into the buttery, hall, and fellows' parlor for the new college" (49–50). Thus the Mass became a communal dinner, the Host real, nourishing bread.

The symbolic principle of the Reformation, especially potent in England, where from the advent of the Henrician Reformation it carried the authority of the monarch, was iconoclasm. The Twenty-eighth Article of the Royal Injunctions of 1547 reads:

> Also, that they shall take away utterly extinct and destroy all shrines, covering of shrines, all tables, candlesticks, trindles or rolls of wax, pictures, paintings, and all other monuments of feigned miracles, pilgrimages, idolatry, and superstition: so that there remain no memory of the same in walls, glass-windows, or elsewhere within their churches or houses.[34]

Since the danger of the Eucharist, as the reformers saw it, was idolatry, they first destroyed the images, then replaced the Eucharist with a supper: the chalice with a cup, wafers with plain bread, the altar with a table placed not altar-wise but on an east-west axis, with chairs on at least two sides; the priestly vestments they remade and used as seat cushions. The windows were cleared of stained glass, and, as a Protestant architecture developed, especially after the Great Fire destroyed the old parish churches of London, the Gothic style of popery was replaced by simple barnlike structures, monochrome with only clean white walls and sober woodwork. In the wake of Protestant iconoclasm, English artists and poets destroyed the idol and made it over into something useful, everyday, and quintessentially English, in effect, nationalizing as well as naturalizing it.

Politically, the English iconoclasts replaced God (symbolically God but in fact the pope) with the English king. The incarnation as the embodiment of God in Christ was transferred one step downward, or to the side, to Henry VIII and then to his daughter Elizabeth, with a further shift from male to female and a conflation of Christ and Mary the Virgin Mother. With Charles I, the "martyr king,"

whose martyrdom was the result at least in part of Archbishop Laud's attempt to return the table to an altar, the remainder of the Sacrament was fulfilled. The parallels drawn between Charles I's martyrdom and the passion and death of Christ began with the lesson read Charles I on the scaffold by Bishop Juxon (Matt. 27).[35] The Charles of *Icon Basilike* takes the place of the Body and Blood, adding Passion and Atonement to royal Incarnation. On the frontispiece of *Icon Basilike*, Charles is taking up Christ's crown of thorns in place of his royal crown, his eyes raised to a heavenly crown: "With joie I take this Crown of thorn / Though sharp, yet easie to be born." But from the iconoclast's point of view, the king himself, like those statues of saints in the churches whose heads only were smashed, was beheaded.[36] In the 1700s a Whig group calling itself the Calf's Head Club celebrated the anniversary of Charles I's beheading with a parody Eucharist.[37]

Restoration

In Leviticus chapter 25 the terms *redemption* and *restoration* appear in tandem, applied to the loss of land or a house: "And if the man have none [money] to *redeem* it, . . . Then let him count the years of the sale thereof, and *restore* the overplus unto the man to whom he sold it; that he may return unto his possession. But if he be not able to *restore* it to him, then that which is sold shall remain in the hand of him that hath bought it until the year of jubilee" (25:26–28, emphasis added). By *jubilee* the NT commentators meant the Second Coming.[38] When Charles II returned to England in 1660, the poets celebrating his return relied heavily on a mixture of biblical and classical analogies, based on the terms *redemption* and *restoration*. Edmund Waller in "To the King, upon His Majesty's happy Return," refers to "Our guilt," "our crime": The English have killed Charles, their king, and Charles, his son, returns to redeem them. Abraham Cowley's "Ode upon his Majesties Restoration and Return" mingles imagery of the Stuart exiles as the chosen people returning from Egypt to the "promis'd land" (line 169) with Christ's redemption of Englishmen for the people's sin of regicide (placing Cromwell in the role of "that great *Serpent,*" line 67). Charles I and II are therefore two sides of a coin, the sinned-against father and the redeeming son:

> *As a choise* Medal *for* Heaven's Treasury
> God *did* stamp *first upon one side of* Thee
> *The* Image *of his* suffering humanity:

On th' other side, turn'd now to sight, does shine
The glorious image of his Power Divine.
(lines 270–74)

The figure of Christ becomes Virgil's Aeneas, who "long troubles *and* long wars *sustain*," restoring ("You restore") Troy with Rome (lines 292–97). With Aeneas comes the metaphor of rebuilding and Virgil's georgic ethos of labor and reconstruction. (In English lore one of Aeneas's followers made the further journey to found England.)

Dryden, in *Astrea Redux: A Poem on the Restoration of Charles the Second*, places Charles in the story of Christ, "forc'd to suffer for Himself and us!" The son is "Heir to his Father's Sorrows, with his Crown," and his return permits us to "Work out and expiate our former guilt," those "Crimes" that his "Just Cause betray[ed]." "Wise by our suff'rings learn to prize our bliss."[39] Dryden's emphasis is on penitence and repentance rather than redemption—on the active role (the guilt) of the English people, a high-church position and, incidentally, that of a satirist. But his discourse shifts, like Cowley's, from Christian sins and redemption to Roman restoration and recovery, pivoting on the metaphor of redemption and legal ransom:

Of those your Edicts some reclaim for sins,
But most your Life and Blest Example wins.
Oh happy Prince whom Heav'n hath taught the way
By paying Vowes, to have more Vowes to pay!
Oh Happy Age! Oh times like those alone
By Fate reserv'd for Great *Augustus* Throne!
When the joint growth of Armes and Arts foreshew
The World a Monarch, and that Monarch *You*.[40]

Six years later, in *Annus Mirabilis* (1667), Dryden shows how the English "from th'Injurious *Dutch* redeem the Seas" and how the Great Fire, the king's "sorrows," and his "pious tears" all atone for Cromwell's sin of rebellion (but "We have all sinn'd"). *Annus Mirabilis* in its second half, about the Fire of London, operates as typology, with the Fire of 1666 recalling the Civil War of 1642–49. The sin of rebellion and regicide, fulfilled in the Great Fire, is "redeemed" by Charles II, who is associated with Isaiah's suffering servant and his redemption of the many: "On me alone thy just displeasure lay, / But take thy judgments from this mourning Land," he tells God the Father. "But, since it was profan'd by Civil

War, / Heav'n thought it fit to have it purged by fire"; and so Charles "To the All-good his lifted hands he folds, / And thanks him low on his redeemed ground."[41]

Alan Roper, discussing *Annus Mirabilis*, has called this strategy analogy.[42] In the eighteenth century Dr. George Cheyne subsumed typology under this general term: "Analogy and its Appendages, Type, Allusion, Similitude, Parable, Hieroglyphic and Allegory (all more remote or nearer Approaches to Analogy) is the only natural Language the Deity can speak to us at present, under our Degeneracy and Lapse." Divine analogy was hierarchal, relating microcosm and macrocosm, God and king, the spirit and body — or religion, politics, and art; and scholars have regretted the sundering of these unities as an aspect of Eliot's "dissociation of sensibility." Typology, however, as in *Annus Mirabilis*, was analogy based on history.[43]

In *Annus Mirabilis*, again, Dryden imbricates Christological with Roman typology by invoking the discourse of Virgilian georgic:

> But, since [London] was prophan'd by Civil War,
> Heav'n thought it fit to have it purg'd by fire.

> Now down the narrow streets it swiftly came,
> And, widely opening, did on both sides prey.
> This benefit we sadly owe the flame,
> If onely ruine must enlarge our way.

"Redeem" is now followed by "renew": "She shakes the rubbish from her mounting brow, / and seems to have renew'd her Charters date, / Which Heav'n will to the death of time allow." Out of the desolation of civil war comes renewal, recovery, and improvement: a new city with wide and spacious streets. We see the rise of "a City of more precious mold," though, still recalling the Resurrection, London "New deifi'd . . . from her fires does rise: / Her widening streets on new foundations trust, / And, opening, into larger parts she flies."[44]

It is important to see that the Redemption — indeed, reference to Christ, the Lamb of God, and the Eucharist — indicates a stage in human history that follows the Fall and is postpastoral and so essentially georgic. In the Jesus story all the lambs, sheep, trees, and plants suggest pastoral, but the sowing, reaping, and harvesting in largely rural settings — employed in Jesus' parables — present an analogue to Virgil's georgic world.

At this time it seemed prudent, talking about Caroline London, to replace as far as possible the NT story and the Eucharist with a classical, a Roman equivalent: not the Redemption but the recovery of Roman *pax* following the Civil

Wars with an Augustus. The *Aeneid* was only a larger version of *Georgic* IV: there the bee hive, destroyed and recovered; in the *Aeneid*, Troy burnt and restored in the greater form of Rome. Destruction was due to an original sin, the Trojan Paris's rape of Helen, like Aristaeus's attempted rape of Eurydice. As Paul constructed the story of Christ's Redemption out of the OT, Virgil constructed the story of Rome out of his own literary-religious equivalents, the *Iliad* and *Odyssey*. Nevius's *Punic Wars* gave him Dido's Carthage, but he brought her together with Aeneas, recovering Homer's story of Odysseus's dalliances with Calypso and Circe. He turned Aeneas into the second Odysseus and Augustus into the second Aeneas, genealogically and by a sort of typology (Christ the Redeemer was the Second Adam).[45] Charles II returned to the strains of "Astrea Redux" and died to a "Threnodia Augustalis."

Broadly speaking, this kind of writing offered a model developed by Dryden from *Astrea Redux* to his translation of Virgil's *Aeneid*, which was indirect, allusive, and based on an extended parallel of Christian, Roman, and English history.[46] The mode was carried on by Pope, Swift, and Gay, all expressing the need to invent new ways in which the political, religious, and literary issues of the day could be mythologized by translating the religious and classical texts into the idiom of the present.

Paradise Lost

Milton opened *Paradise Lost* (1667, 1673) by redefining restoration/recovery as redemption. This poem, he says, is "an example set, the first in *English*, of ancient Liberty recover'd to Heroic Poem from the troublesome and modern bondage of Riming" (the royalist Dryden's, primarily on the stage). His poem is an act of true restoration. It tells how "a greater Man [will] restore us" through an act of true restoration, or redemption. In the invocation to book 1, the words *restore*, *regain*, and *soar*, *raise*, and *support*, conflating the stylistic, mythical, and historical, lay claim to territories that *are* in fact redeemed. The opening of book 2 continues the analogy between political and spiritual restoration/redemption in the description of Satan's monarchical splendor, and book 3 then, moving up to heaven, replaces the false Stuart "restoration" with the true Christian Redemption. By reliance on the divine analogy, Milton extends redemption from the macrocosm to the microcosm, from the universe to his poem. He can therefore associate the poet with the Son and with his type Moses, and so the redemption of both man and poetry after the Restoration of the Stuart monarchy.

When we speak of Incarnation, Atonement, and Redemption in eighteenth-

century English literature, we are speaking less of theological debate and church practice than of the representation of the mystery in *Paradise Lost*, which inaugurated, with the Restoration it in many ways encapsulates, the Long Eighteenth Century. Milton's version of the story was the one Dryden, Pope, and Addison transmit, parody, and aestheticize.

Initially *Paradise Lost* was read by its commentators as simply the Genesis story of Satan, Adam and Eve, and the Fall—especially the temptation ("who first seduc'd them to that foul revolt?"). This "paradise lost" was the reading of Puritans, whose main concern was with Original Sin, but also of the High Churchman Dryden, whose rhymed rewriting of *Paradise Lost*, his opera *State of Innocence, and Fall of Man* (1673, publ. 1677), omitted book 3 and the subject of redemption, proceeding straight from Satan to Adam and Eve.[47] It was the temptation and the Fall that Dryden parodied in *Absalom and Achitophel*, and later he remarked that Milton's "design is the losing of our happiness . . . and his human persons are but two."[48] John Dennis, the first of Milton's major critics, argued that the most sublime poetry is religious, and therefore *Paradise Lost*, because it focuses on the most terrible of sublime ideas, the anger of God, is the most sublime epic. Dennis was thinking, however, less of the Father's anger at Adam for his disobedience than of his response to the rebellion of the angels and the plots of Satan.[49]

Patrick Hume, in his *Annotations on Milton's Paradise Lost*, attached to the sixth edition of the poem (1695), was the first commentator to pass beyond "Man's First Disobedience" and his Fall to identify the action of *Paradise Lost* in the next lines: "till one greater Man / Restore us, and regain the blissful seat"—of *this*, Milton continues, "Sing Heav'nly Muse." Hume draws attention to the subject of incarnation and redemption and the role of the Son. Of course, the Redemption takes place largely in prophecy—as if the *Iliad* were said to be about the Trojan War instead of the anger of Achilles. If the focus is moved from book 9 to book 3 and to the Pisgah vision of books 11 and 12, the action of *Paradise Lost* becomes the Redemption. At the bottom of Hume's interpretation, however, remained the angry God. Hume's reading of the Redemption ends where Milton's begins, with the "Satisfaction" theory of vicarious atonement.

Atonement could be interpreted either as the wonderful love, sacrifice, and condescension of God or as the Son's placating the wrath of the Father—a father who is willing to sacrifice even his beloved son. The latter is the interpretation Milton examines in *Paradise Lost*, which separated Father from Son and opened the door to awkward questions elided by the orthodox Trinitarian doctrine. The

contradiction between Old Testament justice and New Testament mercy remained unexamined, especially in hymns like those of Isaac Watts, who writes not only of God's amazing love for the "worm" man but of the justified wrath that must be satisfied. With the debate in heaven in book 3, however, Milton draws the reader's attention to issues of belief that were more skeptically and ironically raised by Hobbes, Locke, and Shaftesbury.

Travesty/Burlesque

Before turning to heaven, Milton presents first a false or parodic action (royalist restoration, not redemption). Recalling the *Aeneid*, Satan, like Aeneas, goes on a journey to restore his empire in the new world — a mock action followed by the true action, the Son redeeming fallen man. In the same way, Satan, Sin, and Death build their bridge to earth, parodying the Trinity's creation of that earth. The parody practiced by Dryden in *MacFlecknoe* (1676) and by Pope in *The Dunciad* (1728) took its resonance from Milton: The egregious Shadwell becomes a mock Messiah, preceded by Flecknoe as John the Baptist (as well as the Roman analogues of Tiberius and Augustus, Ascanius and Aeneas); the dunce Theobald and his mother Dulness make a parody Pietà, and Theobald is in effect the "Antichrist of Wit."

In *Paradise Lost* and its successors, parody is called for because the evil represented accords with the Christian definition — an absence or denial or perversion of the good, which is everything created. There can be no evil in a world created by God (i.e., not a Manichean world of equal powers of good and evil), and so the evil here is *not*-Augustus, *not*-Virgil, and *not*-Christ, not sense but only nonsense. Among other things, it is Satan's parody of God, or, as in Dryden's "But S — 's genuine night admits no ray," it is darkness, night, the absence of light, implicitly opposed to the Light of John 1:5 ff. and the First Epistle 1:5–7.

The vocabulary and practice of parody in England, however, also absorbed the fashionable neoclassical theory imported from France with the Restoration. The term *parody* itself was limited to poetry, defined by Antoine Furetière, in his *Dictionnaire universel* (1690), as "Poetic pleasantry which consists of turning some serious works into burlesque."[50] *Burlesque* he defined as "pleasant, licentious, tending toward the ridiculous" ("plaisant, gaillard, tirant sur le ridicule"), adding that burlesque was no longer popular among the French because of its indecorum, "because too much license was introduced, both in the subject and in the verse, and too much ridiculous pleasantry."[51] The sense of travesty, which we

think of as the high reduced to its lowest equivalent, was based on the titles of such works as Jean Baptiste Lalli's *Eneide travestita* (1634) and Paul Scarron's *Virgile travesty* (1648), the latter Englished by Charles Cotton as *Scarronides* (1664–65). But the word derived from the French *travestir,* literally *reclothe,* from the root *vestir,* as in "Un homme se travestit. Il change de caractère" ("A man 'se travestit.' He changes character"). This is from the *Dictionnaire de l'Académie françoise* of 1694; by the middle of the next century, using the *Virgile travesty* as example, the *Dictionnaire* of 1776 wrote: "One says 'to travesty' an author, meaning to make a sort of free translation of a serious work, to make it comic, burlesque" (*"Travestir* un auteur, pour dire, faire une sorte de traduction libre d'un ouvrage sérieux, pour le rendre comique, burlesque").[52]

It is worth noting that the terms were generally those of entertainment rather than moral judgment; that they depended on a binary of old and new, one that tended toward a redefinition of the old in terms of the new. Travesty and burlesque in particular were regarded as new (as opposed to parody, with its Greek origin, as old); in some cases their treatment of the travestied text was considered praise, translating a classical text into the vernacular, nationalizing or popularizing it. Thus Lalli wrote on his *Eneide travestita:* "It seemed to me that it would be a crime against such an eminent poem not to translate it into a delightful, jocose style, so that the savor would be more universal, and everyone, when resting from serious occupation, could take opportune relief."[53]

Part of Dryden's running argument in the 1660s–70s (as in Neander's speeches in the *Essay of Dramatic Poesie*) was that contemporary poets improved on the works of the giants of the Elizabethan-Jacobean age. The present "has the advantage of knowing more, and better than the former" age.[54] In the "Battle of the Ancients and Moderns," the present improved on the past because it benefited from the past's mistakes as well as its discoveries. In the art of translation into English (one of Dryden's greatest accomplishments), the poet absorbed the classic into the national culture, and the original object from the past was revalidated if not superseded by its new Englishness.

If Virgil used the past to glorify the present — connecting Augustus with Aeneas, imperial Rome with its humble origins — Christian typology offered the present (the antitype) as a corrective of the past, freeing man from the OT law, indicating his redemption or "restoration." The old was the negative pole, the new the positive; this as opposed to the structure of Juvenalian satire in which value was embodied in a past now lost and subverted. Juvenal wrote a satire of the out-of-office. With the fall of James II and the "usurpation" of William III, in the 1690s

Dryden became Juvenalian, and so also his followers Swift and Pope in the 1700s. These satirists still based their work on the binary oppositions of ancient versus modern, high versus low, and good versus bad, but ordinarily with the first term (the parodied text) valued and the second, modern equivalent denigrated by the contrast. Boileau's best-known formulation was in a note to his mock-epic poem *Le Lutrin* (1674, 1683): "Instead of, as in burlesque, having Dido and Aeneas speak like fishwives and porters," he writes, "here watchmakers speak like Dido and Aeneas" ("au lieu que dans l'autre Burlesque Didon et Enée parloient comme des Harengères et des Crocheteurs, dans celui-ci une Horlogère et un Horloger parlent comme Didon et Enée").[55] In his terms, "éviter la bassesse" ("avoid baseness"): do not have the Parnassians speak the language of the streets.[56] Thus Johnson defined "burlesque. (Fr. from *burlare*, Ital. to jest)" as "Jocular, tending to raise laughter, by unnatural or unsuitable language or images." He cites Addison, who believes Homer's description of Vulcan or Thersites "to have lapsed into the *burlesque* character, and to have departed from that serious air, which seems essential to the magnificence of an epick poem" (*Spectator* no. 279).

Boileau is, of course, using literary parody to make a statement about social distinctions "between the official social status of a character and the language in which he speaks": In the mock heroic, "the parodic characters thus speak a socially pretentious language"; or, in travesty such as Scarron's *Virgile travesty*, they are "debased by their language."[57]

The ridicule can therefore be addressed to (1) the text that is parodied or (2) the other, the new, local, and ordinary as opposed to the ideal world of the parodied text, but it can also — as in the pre-Boileau sense — (3) simply celebrate the new, local, and immediate in contrast to the old and literary text. Pope's *Dunciad*, like *Le Lutrin*, shows up the dunces who speak as if they were Aeneas, who try to pass for Aeneas (or Virgil), but in Gay's *Trivia*, the classical text is no longer adequate to the needs of eighteenth-century London, and the bias shifts toward the new and untidy. There is no evidence that in England such a device was used against the Bible until the advent of the deists and, in particular, Thomas Woolston in the 1720s.

Parody, at least as the critical definitions suggest (an old text reinterpreted or reaccentuated into a new), had something in common with the figure of typology — not allegory or personification (based on supplementing an abstraction with a particular) but typology's principle of recurrence. In Joseph Mazzeo's words: "The archetypal story [of the Old Testament or, in the New, of Christ] is the pattern for events of permanent significance repeated now in the life of everyman

in an individual mode," that is, in our perspective, in England in the eighteenth century.[58]

Recall Furetière's "One says 'to travesty' an author, meaning to make a sort of free translation of a serious work, to make it comic, burlesque"; the treatment of the travestied text could be considered praise, going from classical to local, from (in common with the Protestant Reformation) Latin to vernacular. Indeed, Furetière and the other seventeenth-century theorists meant by travesty/burlesque something very like what Calvin meant by sacramental metonymy — making the incomprehensible comprehensible. Parodying Homer or Virgil, translating them into down-to-earth speech is producing what Calvin would call "a visible sign," a bush, a dove, or a piece of bread that represents God. Iconoclasm, then, was also an artistic image of the spiritual that is reduced to its material truth.

Deism and Aesthetics

By the beginning of the eighteenth century, there were in England, besides a few atheists and agnostics, a number of deists, who accepted God but moved him up into transcendence, denying him immanence (interference in our current affairs, or "miracles"), and even questioned his presence in the words of the Bible. Once set running, in the old clock metaphor, God's creation followed his plan without further interference. The deist called him the First Mover or embodied him in his works, calling him Nature. By limiting their attention and belief to this, deists effectually ruled out miracles, the whole of the NT as both text and story, and in particular the greatest of all miracles, Christ's Incarnation, Redemption, and Resurrection. They rejected the Eucharist quite emphatically, along with all the sacraments, priestcraft, church, and religion.

The diverging beliefs of radical Calvinist and deist, libertine, or freethinker agreed in the attack on rewards and punishments, which was the basis for the doctrines of Original Sin and Redemption. They recognized that the link joining church and state was obedience. Religion binds obedience by the hope and fear of rewards and punishments in the afterlife. For Calvinists, works were inefficacious if based on belief in rewards and punishments, which was mere legalism (or mere moral principle). An incomprehensible god, arbitrarily electing and distributing grace — a cruel or pragmatic god of rewards and punishments or overseer of a "chosen people" — was a concept shared by the Calvinists and the third earl of Shaftesbury (whose background was, after all, Puritan). Shaftesbury demonized this deity, arguing that virtue cannot be interested, cannot depend on promised

rewards and punishments. The political Shaftesburian merely secularized and rationalized the elect into men of property, who are not constrained by physical needs; a Whig oligarchy should (according to Shaftesbury, senior and junior) *replace* the tyrant god-king. Neither creed, Calvinist nor Whig, was based on reason but on a form of inner light or conscience, one religious and the other social.[59]

Both were constructed in opposition to the Law, and in that sense were extreme forms of antipopery, taking their animus out on the OT: The English distrust of the OT law led all the way to the Antinomian belief that Christ's crucifixion abolished the Mosaic law once and for all, at least for Christians (the elect). A consequence for the orthodox Anglican, especially the latitudinarian, was to prefer, in theory at least, mercy to justice; for the orthodox Calvinist, faith and grace over the OT legalism of eye for an eye; for the unorthodox or libertine, the possibility that if the Law no longer applies, we can do whatever we wish. All sins are forgiven, or there *are* no sins, since these as well as the original one were atoned for by Christ's sacrifice.

Shaftesbury's version of deism specifically replaced the God of rewards and punishments (in Shaftesbury's view, a monster) with a "Divine Example," a Platonic idea or form, based on balance and harmony: one might say he goes, with the Freemasons (some of whom were deists), from the Trinity to the triangle. Shaftesbury replaced God with beauty, religion with aesthetics, and this was one of the most significant features of culture (art and literature) in eighteenth-century England. He showed, followed by Addison, that one way of dealing with the God of rewards and punishments was an evacuation of religion and a reconstitution of it as art and, covertly, politics. A consequence was the rise of the new philosophy of aesthetics, which replaced worship of the deity with appreciation of beauty. Even, or especially, *Paradise Lost* was transformed by Addison from a religious to an aesthetic experience as he described in several *Spectator* papers the "beauties" of each book. But every time religion was aestheticized it was by an act of politicization: Addison, among other things, sanitized the strong political strain of Milton's poem in the name of eighteenth-century Whiggery. In its shift of authority from the poet-maker to the critic and connoisseur (the experiencer of art), aesthetics reflected the Whig shift of authority from the monarch to the oligarchy of property-owning, therefore disinterested, aristocrats. As our story opens, the two aesthetic models available were Shaftesbury's Platonic aesthetics of beauty/virtue versus the ugly and Addison's revision or recovery of the ugly as the novel (new, uncommon, strange) and the great (later called by Burke the

sublime), with the nod given to the middle area, the novelty of Mr. Spectator and *The Spectator.*[60]

We can summarize thus far: The doctrine of Atonement/Redemption as worked out by Paul and the church fathers was revised, starting with the Protestant Reformation, in a series of parallel modes of expression: typology, sacramental metonymy, iconoclasm, "restoration," georgic recovery, travesty, deist deconstruction, and (in a way, a summation of all these) aesthetics. They have in common the taking of an old text (OT, Latin, Greek), in particular a doctrine such as atonement, and demystifying, secularizing, demonizing, but also in the process making it new, nationalizing it, and "redeeming" or recovering it for the contemporary world.

Spiritual Pilgrimage

There are two aspects of the Eucharistic Sacrament: the Incarnation-Redemption-Atonement by God through Jesus Christ and the salvation of sinners. There are two subject positions: that of the deity, or rather the Son aspect of the Trinity, and that of the sinner. From mankind's point of view, Christ's Atonement for Adam's sin brings the hope of immortality and happiness in the afterlife and a great deal of anxiety in this life. What gripped the Protestant imagination was not so much the prospective pleasures of paradise or the pains of punishment as the question of which was it to be. The most pressing question for these "sinners" was: For how many, for whom, and by what means or standard of judgment? Did God's Grace (as a result of the crucifixion, through Christ's blood) extend to everyone? Or only to a few? The Calvinists, at any rate, believed that the nature of Adam's Fall was such that no act, however apparently virtuous, could be remotely acceptable to God — no act was not unalterably stained by Original Sin.

The perspective of the sinner (totally corrupt, dependent only on faith in God's Grace) produced in the seventeenth century a great deal of major devotional poetry. The poets of the early, pre-Laudian and pre–Civil War Reformation (Donne, Herbert, and Vaughan) wrote poems either of self-flagellation or of praise, adulation, and worship — about the man who does or does not (cannot) merit salvation; this as opposed to the subject of the Incarnation that brings it about. Out of love poetry Donne created a new Protestant/divine poetry about the experience of the sinner seeking union with God through conversion, irrational seizure, and conflict resolved in love over reason (in faith over works). When this was labeled enthusiasm in the Restoration (as in Dryden's *Religio Laici*), its corrective was a poetry of morality.

The major prose form was the spiritual autobiography, epitomized by Bunyan's *Grace Abounding* in the first person singular and his *Pilgrim's Progress* in the third person (1666, 1678); thus, the story of Adam, Eve, and Satan, the focus taken from early readings of Milton's *Paradise Lost* on the Fall rather than the Redemption. In the eighteenth century the spiritual autobiography helped to produce the English novel. In popular fiction there were stories that combined the plots of the spiritual pilgrimage and conversion with the old romance plot of lovers, separation, pursuit, attempted seductions, and final reunion. *Pamela* and *Clarissa* (1740, 1747–48) were based on Satanic seduction and rape — perhaps a Christianizing of the libertine novel of amorous intrigue, told as the story of the person who actively seeks his or her own redemption, but also a rewriting of the Christian pilgrimage in the terms of socioeconomic politics. If we can say that Redemption was rewritten as Restoration by the Stuart court, then perhaps we can add that a spiritual autobiography was rewritten as *Pamela*, and *Pamela* then was rewritten — or rather travestied — as *Shamela* (1741).

One consequence of the deist repudiation of an immanent deity was an anti-providential history, and deist practices of reading and demystifying texts had, by the 1730s, rendered the reading of a providential narrative like *Robinson Crusoe* (1719) or *Pamela* difficult as anything but existential experience recalled and reconstructed as providential design.[61] The spiritual pilgrimage retained "spiritual" only as a delusive discourse against which to describe the real. A manifestation of this demystification was the plot of Adam's descendant trying to reconstruct, or in a metaphorical sense "redeem," his lost Eden, compensating for the Fall by the active remaking. The conversion and salvation narratives become, even in Defoe and certainly in Fielding, narratives more in the classic georgic mode of recovery and rebuilding, or from the history of the 1660s Restoration, secular versions of theological redemption. The protagonist rebuilds a human simulacrum of the lost paradise, which is not recoverable and not about redemption in the theological sense — closer indeed to Locke's definition of "property" in his *Two Treatises on Government* (1690). This is the pilgrimage of a Tom Jones, even a Crusoe or Pamela when seen from the novel-reader's perspective. Agency is important, as it is in the other narrative in which the protagonist seeks conversion and salvation.

We are principally concerned in this book with redeemers — with stories where the agency lies with the redeemer, not with the sinner, and with the redeemed from the perspective of the redeemer. Thus, in *Paradise Lost*, the Son, not Adam or Eve; the presence of God, not the worries of the sinners except as their anxieties are reflected in the image of deity. The story of Hogarth's Harlot,

which he called a "progress," a parody pilgrimage like Christian's in *Pilgrim's Progress*, is in fact a parody of incarnation and redemption. We are concerned, then, not with the sinner (or only incidentally with the sinner) but with the savior in his various forms: who in the case of the poet Milton, living in the "middle world" of fallen and not yet redeemed life, replicates the Son's Redemption with his own redemption of fallen experience with his poetry; or, in the case of Pope, redeems bad (transgressive) poetry. In the case of Blake, the imaginative principle (the "human form divine") "resides in the human breast" and "only Acts & Is, in existing beings or Men."

Blasphemy and Belief

The Case of *A Harlot's Progress*

The Case

A Harlot's Progress (1732, figs. 1–6) was Hogarth's first great popular success, the first of what he called his "modern moral subjects."[1] The popularity of the six plates was at least in part due to the symbol of the Harlot: a woman who is both criminal and victim, commodity and trophy, beautiful and diseased, summing up the pleasures, fears, and sentiments of 1730s Londoners. The story was of a young woman from the country who comes to London, is picked up by a bawd for the pleasure of a rake, passes into the hands of a rich Jew but betrays him with a younger man, is banished, becomes a common prostitute, is arrested for practicing her trade, is beaten in Bridewell Prison, dies of syphilis, and is last glimpsed lying in her coffin. At its most popular level, it was a simple story of crime and punishment, though the punishment could be interpreted (especially in the light of the sentimentalizing of prostitutes by Addison, Steele, and others) as greatly exceeding the crime.

One reason for thinking that the Harlot is less guilty than the people around her is that the rake in the doorway was a recognizable likeness of the notorious

Colonel Francis Charteris, recently pardoned for a rape conviction by the influence of his political patron, the king's chief minister Sir Robert Walpole, and the magistrate who arrests her was recognized as Sir John Gonson, notorious for his overzealous pursuit of prostitutes and another Walpole supporter.[2] These "great men" (to use the term frequently applied to Walpole) — representatives of church and state — were, to some viewers, the real subject of *A Harlot's Progress*. In the first plate, the clergyman turns his back on the girl, alone and unprotected, his attention focused on a paper bearing the address of the Bishop of London, Walpole's dispenser of ecclesiastical preferment. He evokes Ezekiel 34:2: "Thus saith the Lord God unto the shepherds: Woe be to the shepherds of Israel that do feed themselves! Should not the shepherds feed the flocks?" and Jesus' compassion for the people "because they were as sheep not having a shepherd" (Mark 6:34).

Hogarth called his heroine a harlot — neither prostitute nor whore. *Prostitute* appears in the Bible only as a verb, *whore* as a noun ("do not prostitute thy daughter to be a whore" [Lev. 19:29]), but *harlot* carries more weight. In the Old Testament the term designates someone who forsakes the true God and follows idols and false gods (Isa. 1:21), that is, breaks the first Commandments. Leviticus also warns that "The adulterer and the adulteress shall surely be put to death" (Lev. 20:10). In the New Testament, however, Christ refuses to condemn the woman taken in adultery, and he tells the priests of the temple that "the publicans and harlots will go into the kingdom of heaven before you" (Matt. 21:31).

But there was more. If we compare the six plates of *A Harlot's Progress* with well-known illustrations of the NT, Dürer's woodcuts and engravings of "The Life of the Virgin" and "Life of Christ" (figs. 7–16), we see that plate 1, the young M[oll? Mary?]. Hackabout's arrival in London and encounter with the bawd Mother Elizabeth Needham (and her master Colonel Charteris standing in the doorway) is a parody of the Visitation: The Virgin Mary, aware of her bizarre pregnancy, seeks the reassurance of her cousin Elizabeth, whose husband, Zacharias, stands in the doorway.[3] (The rose the Harlot wears in her bosom, though not present in Dürer's print, was an emblem of the Virgin Mary, "the rose without thorns," i.e., sinless.)[4] Plate 3, her arrest by Justice Gonson, is an Annunciation, the magistrate entering to arrest Hackabout replacing the Angel Gabriel entering to announce the divine birth. The Virgin in Annunciations holds a book on her lap — the word designating the Word, her Son; Hackabout, seated on the same tester bed as the Virgin, has before her the Bishop of London's "Pastoral Letter." In plate 4, in Bridewell beating hemp, she appears in a Flagellation

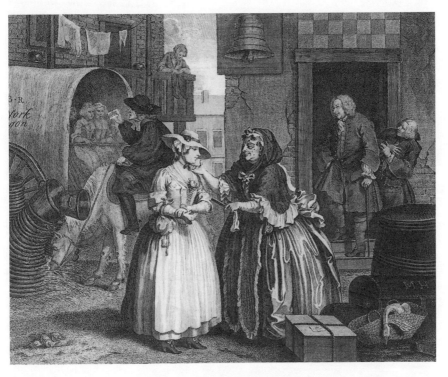

Fig. 1. Hogarth, *A Harlot's Progress* (1732), plate 1;
etching and engraving; first state. Reproduced by courtesy
of the Trustees of the British Museum.

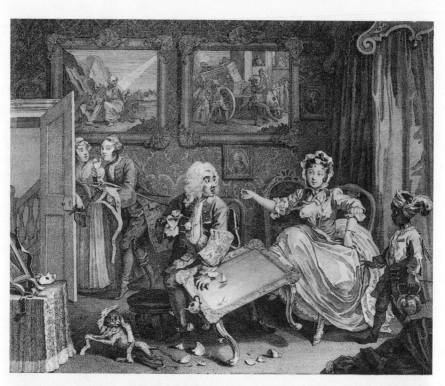

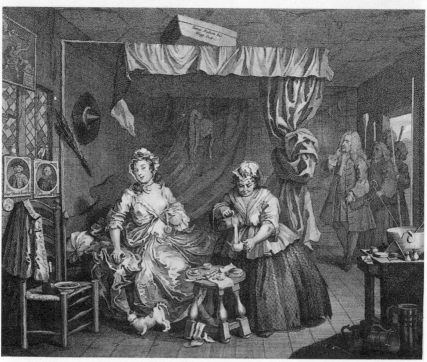

Fig. 2. Hogarth, *A Harlot's Progress*, plate 2; etching and engraving; first state. Reproduced by courtesy of the Trustees of the British Museum.

Fig. 3. Hogarth, *A Harlot's Progress*, plate 3; etching and engraving; first state. Reproduced by courtesy of the Trustees of the British Museum.

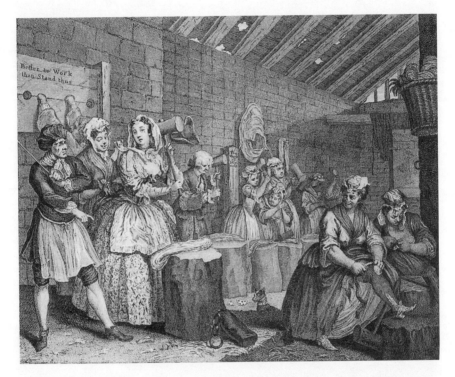

Fig. 4. Hogarth, *A Harlot's Progress*, plate 4; etching and engraving; second state. Reproduced by courtesy of the Trustees of the British Museum.

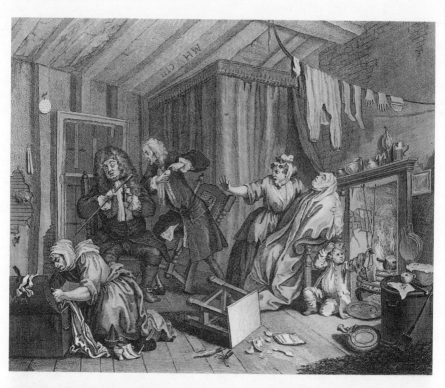

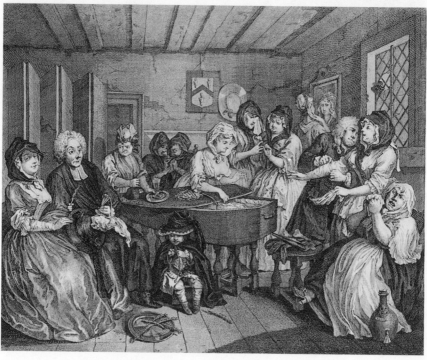

Fig. 5. Hogarth, *A Harlot's Progress*, plate 5; etching and engraving; first state. Reproduced by courtesy of the Trustees of the British Museum.

Fig. 6. Hogarth, *A Harlot's Progress*, plate 6; etching and engraving; first state. Reproduced by courtesy of the Trustees of the British Museum.

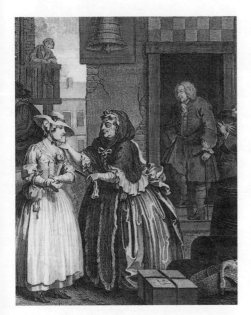 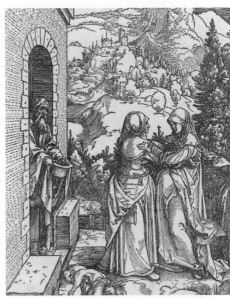

Fig. 7. Hogarth, *A Harlot's Progress* (1732), plate 1 (detail). Reproduced by courtesy of the Trustees of the British Museum.

Fig. 8. Albrecht Dürer, *The Visitation* (detail); woodcut; from *The Life of the Virgin* (1511). (Woodcuts by Dürer are reproduced from *The Complete Woodcuts of Albrecht Dürer*, ed. Willi Kurth [New York: Crown, 1946].)

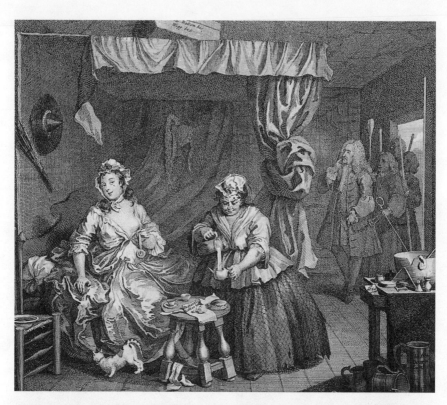

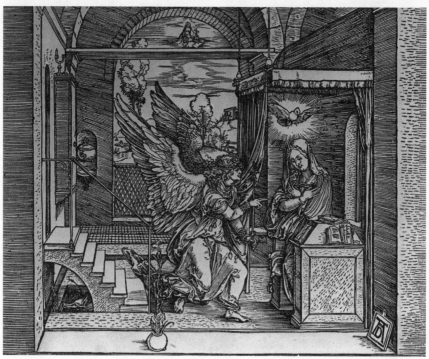

Fig. 9. Hogarth, *A Harlot's Progress*, plate 3 (detail). Reproduced by courtesy of the Trustees of the British Museum.

Fig. 10. Dürer, *The Annunciation* (detail); woodcut; from *The Life of the Virgin* (1511).

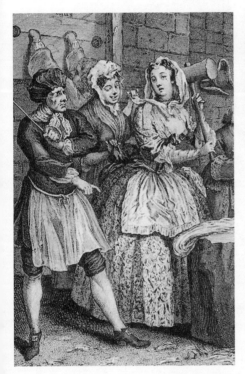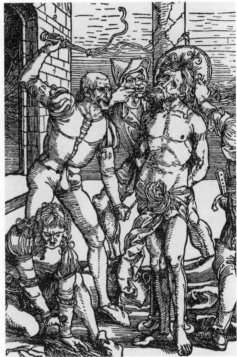

Fig. 11. Hogarth, *A Harlot's Progress*, plate 4 (detail). Reproduced by courtesy of the Trustees of the British Museum.

Fig. 12. Dürer, *The Flagellation* (detail); woodcut; from *The Albertina Passion* (ca. 1500).

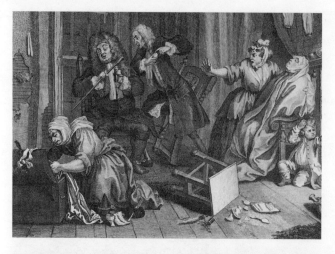

Fig. 13. Hogarth, *A Harlot's Progress*, plate 5 (detail). Reproduced by courtesy of the Trustees of the British Museum.

Fig. 14. Dürer, *The Crucifixion* (detail); woodcut; from *Pictures of Saints* (1500–1504).

Fig. 15. Hogarth, *A Harlot's Progress*, plate 6. Reproduced by courtesy of the Trustees of the British Museum.

Fig. 16. Dürer, *The Last Supper*; woodcut (1523).

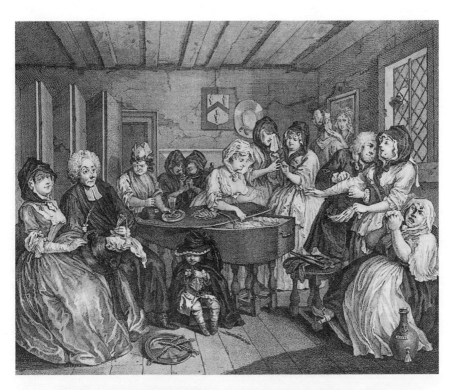

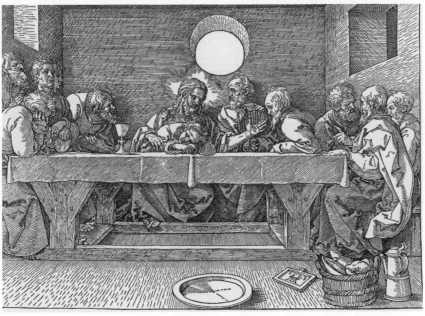

Antiquam exquirite Matrem &

 necesse est
Indiciis monstrare recentibus abdita rerum,
 dabiturque Licentia Sumpta pudenter. *Hor:*

Fig. 17. Hogarth, *Boys Peeping at Nature* (1731), etching; subscription ticket for *A Harlot's Progress*. Reproduced by courtesy of the Trustees of the British Museum.

Fig. 18. Hogarth, *A Harlot's Progress*, plate 2 (detail). Reproduced by courtesy of the Trustees of the British Museum.

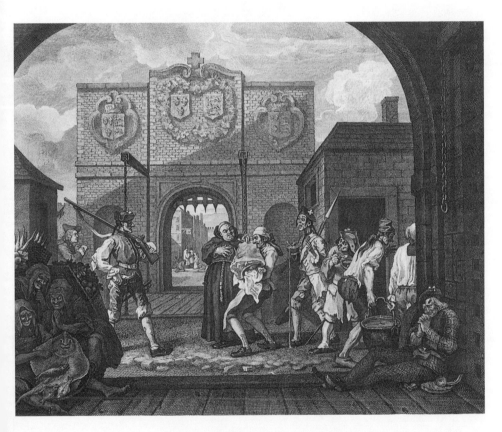

Fig. 19. Hogarth, *The Gate of Calais* (1749), etching and engraving. Reproduced by courtesy of the Trustees of the British Museum.

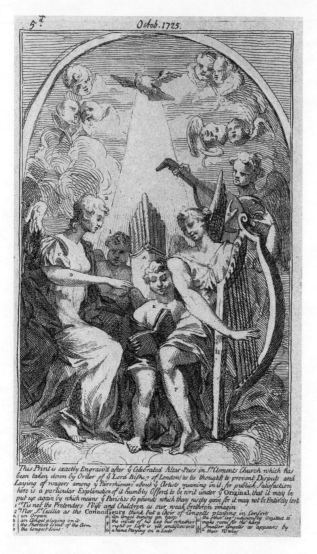

Fig. 20. Hogarth, *A Burlesque on Kent's Altarpiece* (1725),
etching. Reproduced by courtesy of the Trustees of the
British Museum.

Fig. 21. Hogarth, *The Battle of the Pictures* (1745), etching.
Reproduced by courtesy of the Trustees of the British
Museum.

Fig. 22. Hogarth, *Royalty, Episcopacy, and Law* (1725),
etching. Reproduced by courtesy of the Trustees of the British
Museum.

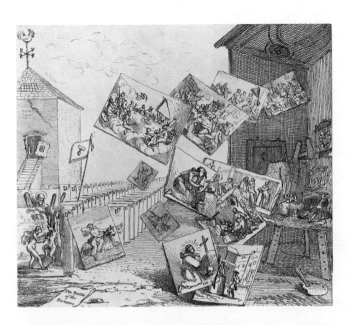

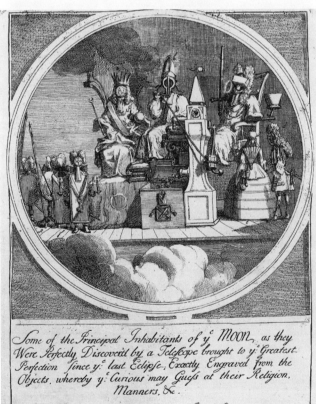

Some of the Principal Inhabitants of y̓ MOON, as they
Were Perfectly Discovered by a Telescope brought to y̓ Greatest
Perfection since y̓ last Eclipse. Exactly Engraved from the
Objects, whereby y̓ Curious may Guess at their Religion,
Manners, &c.

1725. Price Six Pence

41

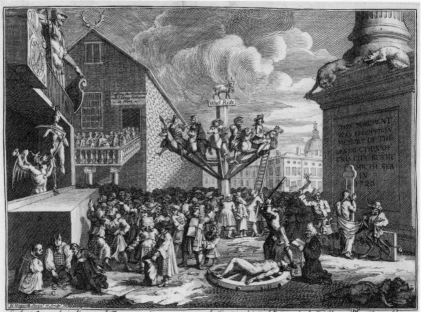

See here ẙ Causes why in London,— | Trapping their Souls with Lotts & Chances | Leaving their strife Religious bustle, | B Honour, & honesty, are Crimes
So many Men are made & undone, | Shareingos from Blue Garters down | Ringed down to play & preach & Hustle (C) | That publickly are punish'd by
That Arts, & honest Trading drop, | To all Blue Aprons in the Town,— | Thus when the Shepherds are at play | (G Self Interest and W Villany,—
To Swarm about ẙ Devils Shop, A | Here all Religions flock together— | Their flocks must surely go Astray, | So much for Mony's magick powers
Who cuts out B Fortunes Golden Haunches | Like Tame & Wild Fowl of a Feather. | The woeful cause ẙ in these Times. | Guess at the Rest, you find out now.
| | | price 1 Shilling

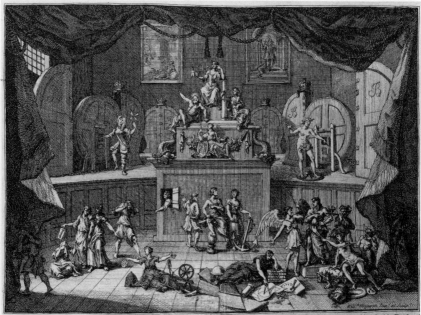

The Explanation. 1. Upon the Pedestal National Credit leaning | The
on a Pillar supported by Justice. 2 Apollo shewing Britannia a | LOTTERY
Picture representing the Earth receiving enriching Showers |
drawn from her self (an Emblem of State Lottery) 3 Fortune |
Drawing the Blanks and Prizes. 4 Wantonness Drawing ẙ Numbrs. |
5 Before the Pedestal Suspence turn'd to & fro by Hope & Fear. |

6. On one hand, Good Luck being Elevated is seized by Pleasure &
Folly; Fame persading him to raise sinking Virtue, Arts &c. 7 On ẙ
other hand Misfortune oprest by Grief, Minerva supporting him
points to the Sweets of Industry. 8. Sloth hiding his head in ẙ
Curtain. 9. On ẙ other side. Avarice hugging his Mony, 10 Fraud
tempting Despair wth Mony at a Trap-door in the Pedestal.
Price one Shilling.

42

Fig. 23. Hogarth, *The South Sea Scheme* (1724), etching. Reproduced by courtesy of the Trustees of the British Museum.

Fig. 24. Hogarth, *The Lottery* (1724), etching and engraving. Reproduced by courtesy of the Trustees of the British Museum.

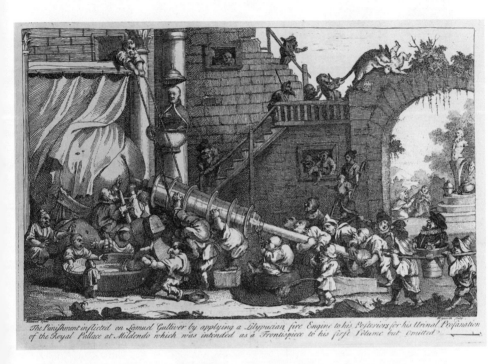

Fig. 25. Hogarth, *The Punishment of Lemuel Gulliver* (1726), etching and engraving, first state. Reproduced by courtesy of the Trustees of the British Museum.

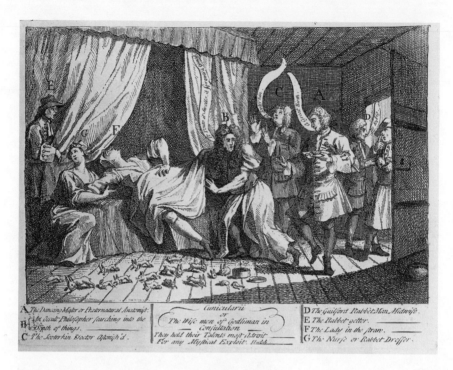

Fig. 26. Hogarth, *Cunicularii* (1726), etching. Reproduced by courtesy of the Trustees of the British Museum.

Fig. 27. Dürer, *The Adoration of the Magi;* woodcut (1511).

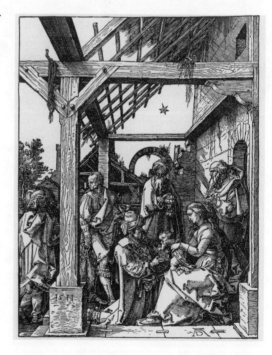

scene, flanked by scourger and mocker. The crosslike shape of the mallet she holds for beating hemp also recalls the Passion. In plate 5 the dying Harlot is in the pose of a mourning Mary at the foot of the cross, while the doctors who contest her cure and the landlady who pilfers her clothes recall the trio of soldiers casting lots for Christ's robe as He suffered on the cross. Finally, plate 6, the Harlot's wake, is a Last Supper with precisely its thirteen participants. The parallels with Dürer's *Last Supper* extend to the plate in the foreground and the rondel window, which is echoed in the displaced "halo" of the Harlot's sunhat on the wall. The dead Harlot's coffin has replaced the table, and her body (her face is just visible) has taken the place of the Host. Her body, and the wine in the beaker nearby, placed on a paten, parody the Body and Blood of the Eucharist.

The most famous Last Supper was, of course, Leonardo's. The image was well known — engraved copies were made within a year or so of the mural's completion (a remarkable phenomenon in itself), and there were numerous copies and adaptations based on the composition. Dürer's woodcut was one of these (fig. 16). Like Leonardo's *Last Supper* it refers not to the moment when Christ says "This is my body" but to the moment when He exposes Judas. The earliest engraved copy of Leonardo's *Last Supper* added a Latin inscription, translated: "I say unto you, one of you shall betray me" (Matt. 26:21). Dürer goes further than Leonardo, having Jesus point at Judas. Insofar as Hogarth alludes to this specific image, he indicates the "betrayal" of the Harlot, but the Dürer version, unlike Leonardo's, offered him the sacrificial chalice (the bread is not on the table but in a nearby basket) and could be said to conflate the moment of the Sacrament with the betrayal.[5]

Hogarth's plate 2 is the exception, the one scene that is *not* formally a parody of the NT story (see fig. 2). Plate 2 reveals the truth beneath the mystery of the Nativity, announced in plates 1 and 3: the human lover. One function of the rich Jew who is keeping her, evident in the optical illusion and graphic puns of the antlered wallpaper behind his head and the departing lover's "stabbing [him] in the back," is to evoke a cuckolded Joseph who is being diverted by M[ary]. Hackabout from seeing her lover, who was one skeptical explanation for the "miracle" of the Virgin conception.

In *Boys Peeping at Nature* (fig. 17), Hogarth's subscription ticket that announced and accompanied the prints, a faun lifts Nature's skirt, a bawdy gesture announcing the low subject matter. But educated readers would have recognized the emblem of truth unveiled. As Addison memorably put it, describing the "veil of allegory": "The Story should be such as an ordinary Reader may acquiesce in,

whatever Natural, Moral or Political Truth may be discovered in it by Men of greater Penetration."[6] Under the veil of allegory, a more profound truth is to be uncovered: first, that the *Harlot's Progress* is not a story of simple crime and punishment but of exploitation by the "respectable" figures of clergymen, gentlemen, merchants, constables, jail warders, and physicians; second, that this woman is being compared to Mary, the Mother of Jesus.

The Nature being unveiled is Diana of the Ephesians (Diana Multimammia), supplemented by the Virgilian inscription behind her, *Antiquam exquirite matrem*. In the *Aeneid* "Seek out your ancient mother" refers to Aeneas's homeland, the place of his birth, where he came from, punningly (in terms of the visual image, the lifting of the skirt) his mother's womb. And *matrem* is not only the Mother goddess, Nature, and Virgil's Mother Rome, but, as Richard Steele tells us in *The Conscious Lovers* (1722), "a mother! . . . that's the old phrase for one of those commode ladies who lend out beauty for hire to young gentlemen" (in short, "Mother" Needham, the bawd of plate 1, whom Hackabout "seeks out").[7] As Hogarth was probably aware, the Diana of the Ephesians had been turned into Mary the Mother when the Ephesians adopted Christianity. Stories were told of Mary escorted by Saint John or Luke from Jerusalem to Ephesus, where a basilica was constructed in the fifth century in her honor.[8]

If we look again at the six plates, we see that in plate 2 the mystery of the conception is revealed, followed in plate 3 by the Annunciation. So far, we have the story of Mary the Mother. Plate 4 shows the Flagellation, but it is *hers*; the Son is present only in her belly. In plate 5 the soldiers are casting dice for Christ's robe at the foot of the cross, but it is *hers* (the doctors contest her cure, the landlady rifles through her clothes) — though she is in the pose of the grieving Mary the Mother, and the Son now appears, off to the side, picking lice out of his hair, unconnected with the sacrifice that is unfolding. Finally, in plate 6 the Mother's body is congruent with the table, the Body next to the Blood (the chalice); she has *become* the Christ figure — Mary the Mother substituting, in Hogarth's version of the Incarnation, for the Son. The son is present, a mute witness (in fact, his back is turned, he is seated on the wrong side of the table), but it is the *mother* whose body and blood figure the Eucharist.

The *Harlot's Progress* starts as a "Life of the Virgin" but takes Hackabout into a "Passion" at just the point where she is carrying the Child.[9] In all the orthodox theology of the Virgin, her role depended on her subordination to her Son. But Hogarth's series of echoes reverses this as he inserts her as a mother, but primarily and scandalously a harlot (an adulteress), into the story of the Incarnation, Passion, and Atonement as its protagonist.

Lifting the veil in *Boys Peeping at Nature*, among other things, reveals the fact that something untoward is going on. A chief principle of Hogarth's aesthetics (later developed in *The Analysis of Beauty* of 1753) will be surprise, curiosity, and the "pleasure [*or* love] of pursuit."[10] There are questions, of course, such as how many of Hogarth's audience were able to make the connection between the *Harlot* plates and the parody? I cite the woodcuts of Dürer (many other prints and paintings employed the same iconography), but few if any of these compositions were available to the semiliterate and illiterate parts of Hogarth's audience.[11] A corollary is the question why Hogarth did not bother, when he engraved the Dürer scenes, to correct for reversal? If the parody were to be obvious, Hogarth should have engraved so that the two graphic images, parody and parodied, would be parallel. In fact, prints and copies of prints of Old Master paintings sometimes corrected for reversal but often did not. The elements (doorway, emerging man, two women meeting) were probably more easily identified than the order of their appearance from left to right. Hogarth follows his usual procedure with these images, giving priority to the reading structure of the engraving. Thus, in plate 1 the reader's eye, moving from left to right, must terminate in Needham and Charteris in the doorway (Elizabeth and Zacharias); in plate 3, in the stealthily intruding Justice Gonson (the angel of the Annunciation); in plate 5, in the shrouded figure of Hackabout.

Blasphemy

Blasphemy was an extreme form of disbelief — irreverence ranging from ridicule to the curse directed against God (or the monarch — legally they amounted to the same thing). Etymologically the word *blasphemy*, of Greek origin, refers to the damaging of a person's reputation, but it came to refer to the attempt to damage God's. In his *Commentaries on the Laws of England* (1769), William Blackstone makes the distinction between swearing and holding up the Bible to ridicule: cursing and swearing are profanity, but ridiculing the Word of God is blasphemy; the one is mere vulgarity, the other theological dissent, extending from church to state.[12] The biblical precedent for punishing blasphemy was Leviticus 24:16, significantly perhaps the same punishment as for adultery ("he that blasphemeth the name of the Lord shall surely be put to death, and all the congregation shall certainly stone him"), and in the Bible the term invariably refers to verbal abuse of God. With Christianity it became the mocking, rejecting, or denying of Christ.[13]

Initially, punishment for blasphemy was by Act of Parliament. As late as 1648

Parliament passed an act making heresy and blasphemy capital offenses. James Nayler (see p. 135) was punished by the House of Commons in 1656, but not under the act, and from the Restoration "the expression of unorthodox religious opinion was generally recognized as an offence at common law."[14] A notorious case of 1663 involved the court rake Sir Charles Sedley. Sedley, with some of his friends on a balcony, stripped naked and addressed the plebeians below (according to Samuel Pepys), "acting all the postures of lust and buggery that could be imagined, and abusing of scripture, as it were, from thence preaching a Montebank sermon from that pulpit, saying that he hath to sell such a pouder as shoud make all the cunts in town run after him—a thousand people standing underneath to see and hear him." He then, in an obscene parody of the Eucharist, linking allegiance to church and state, "took a glass of wine and washed his prick in it and then drank it off; and then took another and drank the King's health." He was tried for blasphemy before the Court of King's Bench in 1663. According to the court, Sedley did "such things, and spoke such words" as broke the public peace "to the great scandal of Christianity."[15]

The pivotal case was John Taylor's in 1675, based on words spoken in public: "Christ is a whore-master, and religion is a cheat." Lord Chief Justice Matthew Hale of King's Bench decreed in 1676 that "such kind of wicked blasphemous words were not only an offence to God and religion, but a crime against the laws, State and Government, and therefore punishable in this Court. For to say, religion is a cheat, is to dissolve all those obligations whereby the civil societies are preserved, and that Christianity is parcel of the laws of England; and therefore to reproach the Christian religion is to speak in subversion of the law."[16] Taylor was fined a thousand marks, imprisoned until he "found sureties for his good behaviour for life," and condemned to stand in the pillory wearing a paper, "For Blasphemious Words and tending to the subversion of all government."[17] This was the first case that established blasphemy as an action punishable in the criminal courts. Christianity was, of course, part of the law of the land, as was Church of England doctrine and observance.

In Scotland, dominated by the Calvinist Kerk, an act against blasphemy was passed in 1695, and in January 1697 one Thomas Aikenhead, an eighteen-year-old student, was hanged for blasphemy. Though he recanted, the sentence was upheld by the clergy, apparently as a useful legal precedent during the Trinitarian controversy then raging (retained in the reference to Clarke in *Harlot* 2). Aikenhead had read some deist tracts and, besides denying the Trinity and the authority of the Bible, declared Moses and Christ impostors. The idea of Jesus as

God-man, he was accused of having said, is "as great a contradictione as Hircus Cervus," the mythical goat-stag, and "as to the doctrine of redemption by Jesus [said his accusers], you say it is a proud and presumptuous devyce, and that the inventars thereof are damned, if after this life ther be either rewaird or punishment."[18] Patrick Kinnymount, another Scotsman, was tried in 1697 for, among other blasphemies, calling Christ a bastard — essentially what Hogarth was suggesting in graphic images in the *Harlot*. Unlike Aikenhead, he was given a light sentence.[19]

The Toleration Act of 1689, which made it possible for Dissenters to worship in their meeting houses, had excluded from the term *blasphemy* denial of doctrines that were specific to the Church of England. The Act for the More Effectual Suppressing of Blasphemy and Profaneness of 1697 (9 Will. 3, c. 35), however, extended the term — in effect contradicting the Toleration Act — to any denial or ridicule of the basic tenets of Christianity and the authority of the Bible. The crime, given the heat of the current Trinitarian controversy, was to "deny any one of the Persons in the Holy Trinity to be God or [to] assert or maintain that there are more Gods than One or [to] deny the Christian Religion to be true or the Holy Scriptures of the Old and New Testament to be of Divine Authority."[20] This act, essentially concerned with heresy and in particular anti-Trinitarianism, as Leonard W. Levy has noted, was aimed at suppressing "criticism that reached the level of an explicit denial of anything Anglican"; that is, the Church of England, with its secular head, was the only religion that could be blasphemed; and therefore it could be interpreted as serving as "a weapon for subverting the Toleration Act as well as intellectual and religious liberty of opinion."[21] In short, it would have appeared to Dissenters of all stripes a reassertion of authority by the popish Church of England under a government of Tories. Nevertheless, although it was included by Bishop Gibson, who brought the charges against Woolston, in his notorious *Codex Juris Ecclesiastici Anglicani* (3.373–74), the act was never used to prosecute anyone.[22] Blasphemy was dealt with by the common law, essentially as an attack on the state (Woolston v. R.), as seditious libel rather than heresy. The terms applied were, variously, *blasphemous*, *obscene*, *impious*, and *seditious*.[23]

Between 1727 and 1729 the Reverend Thomas Woolston published six *Discourses on the Miracles of our Saviour*, in which he burlesqued the story of Jesus from Nativity to Resurrection. As he put it, the stories of the miracles "imply Improbabilities and Incredulities, and the grossest Absurdities, very dishonourable to the Name of Christ," and therefore they were never intended as truth but

as allegories—"as prophetical and parabolical Narratives of what would be mysteriously and more wonderfully done by him." That is, one must "lift the veil of allegory" to see the truth of the Gospels (the verbalization implied by *Boys Peeping at Nature*).[24]

The indictment charged Woolston with "intending to vilify and subvert the Christian religion . . . to represent [Christ] as an impostor and false prophet . . . to turn into contempt and ridicule his holy life and miracles, also to cause the truth of the Holy Scriptures to be denied and to weaken their authority, and thereupon to spread among the king's subjects irreligious and diabolical opinions."[25] Proof of blasphemy depended not on intent but on the presumed effect—"the actual or potential effect . . . perceptible to the general public," as determined by the judges.[26] While this put excessive power in the hands of the judges (reflected perhaps in Hogarth's frequent attacks on judges),[27] the important issue was the general public's need to comprehend the blasphemy: Whether in the case of Woolston or later Wilkes or Paine, the ferocity of the prosecution corresponded to the popularity and sales of the book.

In 1729 Woolston was found guilty of blasphemous libel and was fined and imprisoned, dying in prison four years later. In 1730 Hogarth was working on his paintings of *A Harlot's Progress*, which he published as engravings in 1732, including a reference to the Woolston case. In plate 2 the portrait next to the Jewish keeper's head was labeled, in a prepublication state (recalled by John Nichols), "Mr. Woolston." Hogarth removed this inscription before publication but returned it to the cheap authorized copy by Giles King, adding, under the second portrait, the name of Samuel Clarke.[28] Woolston was regarded as a deist, Clarke as an anti-Trinitarian.[29]

In plate 2 there are two OT scenes hanging on the wall, presumably collected by the rich Jew. Adjacent to Woolston's portrait, as if to comment on it, is the painting of Uzzah (fig. 18), whose well-intentioned steadying of the Ark of the Covenant to prevent it from falling caused God to strike him dead. (He was not a priest.) In the context of Uzzah, Woolston is being rewarded for writing his *Discourses on the Miracles of our Saviour*—which he regarded as an attempt to correct the corruptions of contemporary religion—by a stab in the back, not by God but by an Anglican bishop.[30] Bishop Gibson, the Bishop of London whose address the clergyman is perusing in plate 1 instead of protecting Hackabout (she shows her regard for his *Pastoral Letter* by using it as a butter dish in plate 3), was the clergyman who set in motion the prosecution of Woolston.

In the ironic interplay of NT and contemporary London, Hogarth goes far

beyond any of his literary contemporaries — with the exception of poor Woolston — in the direction of blasphemy. The example of *A Harlot's Progress* raises the issue of the relationship between graphic and written blasphemy. The case for written wit as blasphemy had been judged proven in the Woolston trial. There was no precedent for blasphemous references in graphic images, unless we go back to the Sacheverell trial.[31] There was nothing in the Blasphemy Act about images — only words, writings, printing, and teaching ("by writing printing teaching or advised speaking"). One possible explanation is that the *Harlot* was Hogarth's gesture of a defiance beyond the reach of writers. Indeed, Sir John Gonson (whom Hogarth includes in plate 3) demanded in one of his "Charges to the Grand Jury" that graphic material be equally prosecuted, being "Dumb Scandal" or "Scandal by Pictures or by Signs."[32] But one writer noted, explaining why such prosecution was impossible, "tho' I were infallibly certain that I hit right in explaining the Design and Meaning of the Contrivers . . . still, it were impossible to prove to others that I had at all hit their Meaning, in case Men of their Kidney had a mind to controvert it."[33]

What Hogarth demonstrates in terms of censorship is that images are more indeterminate than words — they invite multiple readings, a fact that he exploits outrageously and successfully. As Freud recognized, the meanings of images are always multivalent and therefore in dreams serve as a censoring mechanism, which seeks to conceal the motivating desires behind the dream. Where the possibilities for meaning are many, a forbidden one can easily be hidden and overlooked. Thus the need for verbalizing — or, in Freud's terms, following the dream-content must be their verbalization in the dream thoughts.[34]

An analogy may be helpful. The Hebrew language prints consonants without vowels, leaving the vowels to be filled in by the reader. So *'dny*, according to the vowels added, can mean: *'adōnī* ("my lord"), *'adōnay* ("my lords"), or *'adōnāy* ("my Lord"), that is, God. Given the inherent polysemy of the graphic medium, the reader will try out the different possibilities within the verbal context. The knowledgeable reader will know at once what is intended. On the model of censorship, with the invitation to double reading, one chooses the reading that fits one's needs.

We can imagine Hogarth testing the unconsolidated boundaries of print propriety — announcing in the *Harlot's Progress* (especially in its subscription ticket, in the unveiling of Nature): Woolston proved that literary burlesque of the sacred was prosecutable as blasphemy; let's see whether anyone can prosecute graphic blasphemy. But then, when publication day approached, he removed the red flag

of Woolston's name from plate 2 (though retaining it in the authorized copies by Giles King).

In the following sections I attempt to show the development of Hogarth's thinking as he conceived the *Harlot*, at the same time defining an interpretive community for readers (Addison's "readers of greater penetration") of the *Harlot*, or rather a group of communities — radical Protestant, Old Whig, Walpole opposition, deist, even libertine, but with a basic Protestant antipopery and anti-priestcraft at its center.

Burlesque

No contemporary commented on Hogarth's NT burlesque (or travesty). Signs of recognition appeared only after he became a subject of controversy in the 1750s, when his public stand against a state academy of art in his *Analysis of Beauty* made him unpopular among the younger artists. Some of these attacks included allusions to the way he "copied" from foreign models, using scatology and even impiety for his own ends (as in Paul Sandby's caricatures of 1753–54).[35] The one exception of which I am aware was the immediate imitation of the *Harlot* by his friend Henry Fielding in his burlesque farces, performed at Drury Lane Theatre.[36]

On 2 June 1732, less than a month after *A Harlot's Progress* was delivered to its subscribers, Fielding presented a double bill, *The Old Debauchees* and, as afterpiece, *The Covent-Garden Tragedy*, one "a Farce" and the other "a Tragedy." Though not produced until June, Fielding's play may have been ready as early as 4 April, but in any case Fielding would have seen the paintings as early as the subscription in March 1731, by which time Hogarth had made a frontispiece for his *Tragedy of Tragedies; or the Life and Death of Tom Thumb the Great*. The *Covent-Garden Tragedy* was a burlesque taking place in a brothel run by Mother Punchbowl and contains many allusions to the *Harlot*.[37] In *The Old Debauchees*, the mainpiece of the evening, however, Fielding touches upon Hogarth's more scandalous materials. The wicked priest, Father Martin, poses as a heavenly spirit (like the Angel Gabriel) in order to enjoy the beautiful Isabel; he promises her that "Great things are design'd for you, very great things are designed for you . . . such Promotion, such Happiness as will attend you" — to which she replies with her own fiction: "I dreamt I was brought to bed of the Pope" (9:300). Isabel: "for none but the Church can contradict our Senses." Old Laroon: "Nothing's impossible to the Church you know." And Father Martin himself: "You are to believe

what the Church tells you, and no more."[38] Fielding presents this as an antipapist satire, based on the scandalous story of Catherine Cadière and Father Girard, safely distanced in France. But the satire on priestcraft extends far enough to follow Hogarth and Woolston into the realm of miracles and the hint of a Virgin Birth for Isabel.

In the context of the mainpiece's fantasy about divine birth, *The Covent-Garden Tragedy* offered its own suspicious play on "Mother," in the *Prolegomenon* as well as the play proper, both as bawd and as nurturing mother to her "sons" and "daughters." Mother Punchbowl is Fielding's burlesque of Andromache, the mother in Ambrose Philips's *The Distrest Mother* (1712), but she more immediately evokes Hogarth's Mother Needham, another "Mother" implicitly included in the *magna mater* of *Boys Peeping at Nature*, and therefore a memory of M[ary] Hackabout the "Mother."[39] The denouement is Bilkum's death in a duel and Stormandra's suicide, followed by what, in Woolston's terms, would have been her "Resurrection," though in Fielding's the stage convention of a "happy ending."

"Miso-Cleros" (Richard Russel) in *The Grub-Street Journal* recognized Fielding's attack on the popish clergy as an attack on "priests and priestcraft in general": "since he makes so free with the Bible," he wrote of Fielding, "no wonder if the Priests are splashed with his mud."[40] Fielding's comedies were not prosecuted, but in 1737 Walpole and Parliament brought the axe down on the Opposition satires (including Fielding's) that were then playing on the stage. The particular piece of evidence that was used to justify the Licensing Act was a play called *The Golden Rump*, built around graphic worship addressed to the governmental backside (see below, p. 73). In the 1740s a Walpole supporter, Corbyn Morris, made a strong case against the dangerous power of the theater, much greater because more immediate (he claimed) than that of the printed word, as a way of stirring up popular discontent. He made no mention of graphic images such as engravings.[41]

The stage still suffered from Jeremy Collier's attack in *A Short View of the Immorality and Profaneness of the English Stage* (1698) and the controversy it aroused. Collier's chief concern, based on Aristotle's principle that the subject of comedy is the low (tragedy, the high), was the indecorum of comic laughter directed at the high. The inference Collier draws (and the principle of the Blasphemy Act) is that "stage portrayal of elite immorality weakens the social fabric": theatrical immorality puts at risk social order. If one writes comedy or satire, the subject matter should therefore be restricted to the low.[42] Collier's most effective

critic, Elkanah Settle, pointed out that the order he promised following censorship of the stage was in fact the return of Stuart and papist tyranny. The Jacobite issue arose because the attack on the stage was made by the nonjuring Collier. Settle reminded his readers that the source of the "Immorality and Profaneness" of the stage castigated by Collier (and satirized by the comedies he attacks) was in fact the court of the Stuart brothers, Charles II and James II, and that "the *Effeminacy* of the two last Reigns has both furnish'd the Stage with so many *Libertine Pictures*, and indulg'd their Reception."[43]

While agreeing that the stage should represent less flagitious characters, Settle doubts that *all* the characters should be virtuous or that the virtuous characters should necessarily be nuns or hermits or anchorites: "No, his [Collier's] Characters of Virtue must come forth into the gay World, with Levity, Vanity, nay, Temptation it self, all round them. They must go to the Court, the Ball, the Masque, the Musick-Houses, the Dancing-Schools, nay, to the very Prophane Play-Houses themselves, (to speak in Mr *Collier's* Dialect;) and yet come off unconquered."[44] They must, in short, be like Hogarth's Harlot entering the corrupt London of Charteris and Needham but able to "come off unconquered."

Collier was particularly upset by comedy at the expense of women of the higher orders, who, he said, are treated as if they were "Whores." (Hogarth presents a whore who wants to pass for a woman of the higher orders.) The tendency of the Restoration comic dramatists, Collier believed, was "to outrage *Quality* and Virtue" (Collier's italics). He advocated, therefore, the rigid dichotomy of women of good family and whores, respectable and immodest, chaste and sexually profligate — a dichotomy related to the high-low relationship of the mock-heroic satire, of Dido acting and speaking as if she were a whore, or what Hogarth demonstrates in the *Harlot* and what bothered some of Fielding's audience in the genteel diction used by his brothel characters in *The Covent-Garden Tragedy*.

Besides the satire on women of quality, Settle notes, for Collier the "greatest Transgression of the Stage, is, the abuse of the Clergy" (60). Collier, himself a clergyman, drew on criticisms of irreligion in the theater that went back to Elizabethan times. Writing of the early seventeenth century, Jonathan Dollimore cites Philip Stubbes's opinion that in the theater "you will learn to contemn God and all His laws, to care neither for Heaven nor Hell" and William Prynne's that "there is nothing more dangerous in a state than for the stage and Poet to describe sin . . . because it causeth magistrates, ministers and statesmen to lose their reputation, and sin to be less feared."[45] These were precisely the effects that

Collier feared, with which Hogarth and Fielding associated themselves in the 1730s. When Hogarth points the finger of guilt away from the Harlot and toward "magistrates, ministers and statesmen," it is almost as if he were answering Collier.

Finally, the issue of censorship with Collier was specifically about the stage. In Hogarth's practice in the 1730s, he associated his graphic images with scenes on a stage in a theater, and in the words of his *Autobiographical Notes* written in the 1760s, the stage was the model for his "scenes": "my Picture was my stage and men and women my actors who were by Means of certain Actions and expressions to Exhibit a dumb shew."[46]

Hogarth's prints were public images, with greater impact than that of the stage because they were fixed before the eye and did not immediately pass into the next scene, but without the spoken words that were heard and the written text that could be checked by the censor. Like signboards, they used words but also images that could be silently verbalized by the spectator. The sign of a headless woman was labeled "The Silent Woman," and in Hogarth's engraved representations, the sign of the King's Head (Charles II) was used for a brothel, the sign of a bell and clapper for a bawd, or the sign of the Scissors (a seamstress) doubled as the sign of a cuckold, his horns on the top, his wife's legs spread on the bottom.[47]

Popular burlesque was part of Hogarth's childhood experience at Bartholomew Fair, which held forth every summer a block from where he was born. Settle's famous *Siege of Troy* juxtaposed a heroic scene involving Menelaus, Ulysses, and Sinon with a comic scene between Bristle a Cobbler and his wife who wants to go out of Troy to see the great horse and he won't let her. The same was true of biblical stories. In *The Creation of the World*, a puppet show at Mr. Miller's booth, Noah and his wife squabble between the spectacular scenes of the Flood. One of the most popular plays at the fair was *Jephtha's Rash Vow*, which characteristically intermingled the serious scenes concerning Jephtha's sacrifice of his daughter (recalling Abraham and Isaac) and burlesque scenes.

Collier believed (on Aristotle's authority) that the distress of the poor and mean is the proper subject of comedy — that is, regarded as comedy by the great — and the calamities of the great are then tragedy. But to the mean we can presume the latter will be comedy. From their perspective the hamartaia and peripeteia suffered by the great bring them inescapably down to the level of the comic, a travesty of tragedy (of the sort Fielding wrote in *The Covent-Garden Tragedy* and *Tom Thumb*). This is comedy that laughs at tragedy — that weighs life in the balance with death, the great with the small. The most elevated of subjects, life and death, monarch and deity, state and religion, and the greatest of distresses

(Christ's sacrifice and Atonement) are, of course, the most plebeian and dangerous subjects of jokes.[48]

The Joseph-Mary Joke

"Great things are design'd for you, very great things are designed for you": Father Martin's speech to Isabel in *The Old Debauchees* shows the direction mockheroic satire was being carried by Hogarth, toward the high-low of the Magnificat: "For he that is mighty hath done to me great things; and holy is his name. . . . He hath put down the mighty from their seats, and exalted them of low degree." Suppose Gabriel's Annunciation or Mary's Magnificat as a joke: It is at the Visitation when Mary utters the Magnificat—the scene in which Hogarth places M[ary]. Hackabout—and this follows the Gospel text: "Then Joseph her husband, being a just man, and not willing to make her a public example, was minded to put her away privily. . . . But while he thought on these things, behold, the angel of the Lord appeared unto him in a dream, saying, Joseph, thou son of David, fear not to take unto thee Mary thy wife: for that which is conceived in her is of the Holy Ghost" (Matt. 1:19, 21). Mary: "How shall this be, seeing I know not a man?" Angel: "The Holy Ghost shall come upon thee" (Luke 1:34–35).

The Mary-Joseph jests derive from the plebeian common sense that says the Virgin Mary only appears to be the consort of God but in fact is using this story as an excuse to beguile her aged husband Joseph faced with her pregnancy. The story goes back into oral tradition (it appears in no jest book, presumably censored) but was elaborated into the story that named a Roman soldier, Panthera, the guilty party.[49] The deist Charles Blount retold the joke under the disguise of the heathen gods: "Reason would tell us that *Romulus* and *Rhemus* were bastards, and that their Mother *Rhea's* pretence of being layn with by the God *Mars*, was only a sham upon the credulous multitude, hoping thereby to save both her Credit and her life."[50] In the 1740s the deist Peter Annet examined *The Miraculous Conception* and concluded that we "will never be able to make anything of the story than that a poor, ignorant, credulous man, dreamed in his sleep that an angel had been talking nonsense to him."[51]

In the 1731 *Tragedy of Tragedies: The History of Tom Thumb*, which sported Hogarth's frontispiece just as the subscription for the *Harlot* was being launched, Fielding added to Doodle's speech on the birth of Tom Thumb in the 1730 text: "Some God, my *Noodle*, stept into the Place / Of Gaffer *Thumb*, and more than half begot, / This mighty *Tom*." To which Noodle adds, "Sure he was sent Express / From Heav'n, to be the Pillar of our State." The story of Amphitrion

could be cited as the reference, but so — in the context of the *Harlot* — could the Joseph-Mary joke. The subject is cuckoldry or simple incongruity or even Fielding's "affectation," "the only true source of the ridiculous":[52] Mary claims to be a Virgin, yet has a baby. One could say that the single relentless joke of the mock heroic, the bathetic juxtaposition of the superior world of gods and heroes with the domesticity of everyday life, was summed up in the story of Joseph, Mary, and the Angel.

Such ambivalent laughter draws upon *parodia sacra* — carnival, the subculture's Saturnalia, which Bakhtin described as a "folkloric dialogue," including sequences concerning the Virgin.[53] Hogarth's aim then would be to depict not the Ave Maria but the Magnificat of a prostitute. The Mary-Joseph cuckoldry, in its different manifestations, had appeared in the japes performed on the fringes of the Nativity in mystery plays where Joseph's unenlightened and uninspired neighbors respond to Mary's pregnancy; they make cuckold horns behind old Joseph's head (as in *Harlot* 2).

Hogarth's relieving himself on a church porch after the publication of the *Harlot* would in terms of *parodia sacra* amount to the subculture's discourse of the lower body vis-à-vis the sacred.[54] But as is the case with so many of Bakhtin's examples, this explanation proves to be ahistorical: *could* anything in the deist-haunted 1720–30s be read as "parodia sacra"? Moreover, the iconoclastic soldiers of Cromwell's Model Army — forerunners of the Old Whigs — were said to have relieved themselves in baptismal fonts and on altars as they destroyed the church's holy images. High churchmen such as Henry Sacheverell made a direct identification between the Dissenters and Cromwell's Puritans.[55]

Protestant Antipopery

Popery and Jacobitism were safe subjects of attack, even if the attack was more probably, as in Fielding's plays of 1732, on Walpole's politicized Church of England. Fielding's use of the French Father Girard and popish superstition was the easiest justification for impiety and the one he and Hogarth would have invoked. When Russel, a nonjuror, attacked Fielding's comedies as blasphemous, he made the mistake of referring to slighting remarks about Purgatory, and Fielding (replying as "Philalethes"), deflected the criticism by reminding him that no one *"but a Nonjuring Parson, would be asham'd* to represent a Ridicule on Purgatory as a Ridicule on the Bible, or the Abuse of *Bigotted Fools* and *Roguish Jesuits* as an Abuse on Religion and the English Clergy."[56]

Hogarth's Eucharist parody was most clearly an expression of antipopery,

anti-Jacobitism, and Francophobia in *The Gate of Calais* of 1748 (fig. 19). Like Tobias Smollett and others, he equates the French with their food: fancy ragouts with no nourishment for the rich and for the poor starvation, frogs, and only spiritual nourishment. The conceit lies in the analogy between substantial and transubstantial meat. In the distance the Mass is being celebrated by priests worshiping at a cross and under an inn sign of the Dove (the Holy Spirit). Both are aligned under the cross atop the gate of Calais in the foreground, and perched on the cross is Hogarth's version of the popish Dove, a crow, a carrion bird (the bird appears in the painting only). The gate framing the priests celebrating Mass resembles an open mouth, with the portcullis providing the teeth and two escutcheons serving as eyes and the whole as a face.

On this side of the open mouth, behind the skeletal Frenchman is a fat priest, savoring the huge side of beef a poor Frenchman is carrying to the local English tavern, celebrated in the subtitle, "O The Roast Beef of Old England."[57] In the left foreground fishmongers are worshiping the apparent face (parallel to the face of the gate) of a ray fish, another sign of superstition and a memory of the ancient symbol of Christ, the fish.[58] This group is balanced by the Irish Jacobite at the right who has gone over to the French (a remnant of the War of the Austrian Succession, recently ended). The skeletal figures recall Andrew Marvell's Irish priest Flecknoe, who is

> so thin
> He stands, as if he only fed had been
> With consecrated Wafers: and the *Host*
> Hath sure more flesh and blood than he can boast.
> (lines 59–62)

Hogarth's print of 1749 was used again as anti-French propaganda in the Seven Years' War and again in the wars of the 1790s. Hogarth's *Invasion* prints of 1756 focus again on hunger, with priests accompanying the invading French.

Antipopery pervades Hogarth's graphic works. In plate 8 of *A Rake's Progress* (1735, see fig. 34), Hogarth's next "progress" after the *Harlot*, madness takes the form of believing you are the pope—wearing a papal tiara and nailing three crosspieces to a stick to simulate a papal cross.[59] Opposite this madman, paired in adjacent cells, are two others: One thinks he is king, while the other has a cross and pinup pictures on his wall of popish fanatics—Clement, Lawrence, and Athanasius, the last responsible for the doctrine of the Trinity. The Trinity, neutralized by the association with popery, was nevertheless an Anglican dogma

as well, central to the Blasphemy Act, the one doctrine singled out since burlesque of it would blaspheme three different aspects of godhead.

The *Harlot*, in terms of antipopery, refers primarily to the cult of the Virgin, a prominent aspect of the Counter Reformation. Mariolatry was one of the chief tenets espoused by the Council of Trent, along with the Sacrament of the Mass and worship of the saints, the elevation of the priesthood, and the sanctity of martyrs.[60] I cite the lines of John Oldham in his *Satyrs upon the Jesuits*, one of the prominent texts of the Popish Plot (1681), partly because Hogarth owned a copy of Oldham's collected poems.[61] Loyola is predicting the horrors to follow the fiendish plot:

> Tell how blest *Virgin* to come down was seen,
> Like Play-House Punk descending in Machine:
> How she writ Billet Doux, and love-Discourse,
> Made Assignations, Visits, and Amours. . . .
> (III.301–4)

Not only would such satire have offered Hogarth a way into the subject; it would also have provided an excuse for introducing the parody of plates 1 and 3.

There may also have been an anti-Jacobite, antipapist subtext in the story of the Virgin Mary's all too human conception of her child. The notorious warming-pan baby, Mary of Modena's surprise delivery of an heir when it was assumed that James II could not produce one, was still a potent piece of political propaganda. The queen had been depicted as "a pseudo-Virgin, miraculously begetting heirs without the aid of a husband," and analogies were noted "between Mary of Modena and the Church of Rome as apparent 'mothers' who are really whores."[62] As late as the general election of 1747, Hogarth introduced the image of a baby labeled "No Old Baby." In the 1730s, with the Pretender still a threat in France, with his support from the French king (and given the French association Fielding gave the story of Father Girard in the month following the *Harlot*'s publication), Hackabout's case could still be counted on to carry echoes of anti-Jacobitism, here linked to Walpolean rule in England.

In 1725 Hogarth had published a burlesque etching of an altarpiece painted by William Kent for the church of Saint Clement Danes (fig. 20). He exaggerates Kent's inept painting and gives one of the angels what is clearly (to judge by contemporary portraits) the likeness of Clementina, Princess Sobieski, the wife of James III, the Jacobite Pretender. What Hogarth knew about Kent was that he had studied in Rome, was influenced by Catholic painting, and had even been awarded

the Pope's Prize for one of his paintings.[63] It is also possible that the clergy of Saint Clement Danes, which had Jacobite leanings, had paid Kent to include the portrait of Clementina (appropriate for St. Clement's). In any case, outraged contemporaries had made this claim, and the painting was ordered removed by, coincidentally, Bishop Gibson. Hogarth confirmed the likeness in his burlesque, thereby drawing attention to the popery of Kent's painting (whether or not, as has recently been argued, Kent and his patron the earl of Burlington were in fact crypto-Jacobites).[64]

The issue here was not blasphemy but Jacobitism and gives a good idea of what most offended Londoners. Still in people's minds was the case of Saint Mary's Whitechapel in 1714. The nonjuror (and probable Jacobite) Dr. Richard Welton had commissioned a Last Supper that caused great scandal because the artist, supposedly at his instructions, gave Judas the face of White Kennett, the Whig dean of Peterborough, and Saint John the face of James Francis Edward Stuart, the Young Pretender. There was such a fuss that the then Bishop of London, John Robinson, ordered the painting removed "since the said Picture, by SOME of the figures there represented, will give an Occasion of Scandal and Offence, if continu'd there."[65] Among other things, this case — as well as that of William Kent's altarpiece in Saint Clement Danes — demonstrates that papist-Jacobite references in a church could elicit angry responses. The *Letter from a Parishioner*, which satirized Kent's altarpiece, refers to the earlier scandal as if it were still well known.[66]

English Antipopish Art

A year after he published *A Harlot's Progress*, Hogarth was working on *A Rake's Progress* (publ. 1735). In an oil sketch for one scene, known as *The Marriage Contract* (ca. 1733, see figs. 60 and 61), Tom Rakewell has on his wall a painting of a Eucharist machine, which shows the Virgin Mary dropping the Christ Child into a hopper, out the other end of which drops the Host (specifically wafers) into the waiting hands of priests, who distribute the wafers to the crowd.[67] In *The Battle of the Pictures* (1745, fig. 21), Hogarth paired the painting of *Harlot* 3, the Annunciation, with a Penitent Magdalen, a safe equivalent of the other Mary, the Mother. He shows the *Magdalen* of a "Dark Master" attacking his own painting, tearing a hole in the canvas. The *Battle of the Pictures* is the emblematic and polite retrospect on what he had intended in the *Harlot*, drawing attention to his parody of Counter-Reformation art.

In these works Hogarth has introduced the discourse of Old Masters and dark masters, the painters of the continental Renaissance. The term *esteemed masters* ("les plus grands maîtres") had been applied to Leonardo, Michelangelo, and Raphael at the end of the sixteenth century and thereafter to their heirs, the Carracci and their followers.[68] Their paintings, which dominated art theory and the London art market to the detriment of Hogarth and other English artists, served as a code for continental despotism. Worse were the excesses of the baroque Counter-Reformation paintings (or at least prints) that were sought by English connoisseurs. The paintings that were flooding the market, which Hogarth regarded as bad copies of bad copies, were an example of "Popish Forgeries and Impostures."[69]

Allusion is the calling into play of the words or images of earlier (Old Master) artists. Besides the indeterminacy of the visual image and the fact that there was nothing in the Blasphemy Act about images, there was the further circumstance that the burlesque could be construed as merely aesthetic — satire on Old Master paintings of Annunciations, Flagellations, and Last Suppers, with the associations of continental papist (French and Italian) art Hogarth is travestying in the name of a native English art. The Diana Multimammia of the subscription ticket was cited as the emblem of Nature in the art manuals, where artists were urged to copy it.[70] The witty similitudes, with the conventional art figures of putti and faun, say: Seek out (or unveil) the hidden truth, and in terms of the NT parodies, the true reality beneath the popish paintings that mystify the NT by focusing on Mariolatry, miracles, and priestcraft. Embodied in a national English art, the *Harlot* is Hogarth's suggestion for a way to improve upon those "dead *Christs, Holy Families, Madona's,* and other dismal Dark subjects" he referred to in his "Britophil" essay and parodied in his prints.

In short, the real subject of attack in Hogarth's work, it could be argued, was not religious belief, papist or other, but papist, foreign, hierocratic art. Bernd Krysmanski has argued that Hogarth was addressing himself, when he made NT allusions in his prints, to the connoisseurs, who could be expected to recognize them.[71] Dürer prints, while available in London printshops, would have been primarily known to collectors. Knowledgeable art lovers could be expected to take the reference to be art (implied by the baroque subscription ticket) and a parody of papist art as seen by an iconoclastic Protestant Englishman. On the other hand, Hogarth's point could be that collectors and connoisseurs *should* recognize the content of the allusion, but being students of taste rather than art, they will not. He may be betting that they will not — defying them to violate their

own rules of connoisseurship and recognize the cognitive dimension of a work of art, or what Leo Steinberg has called "the authority of the picture."[72]

In Hogarth's later campaigns (from the "Britophil" essay to his "Apology for Painters"), a chief aim was to nationalize the traditional cultural representations of continental art. As formulated during the Reformation by Richard Bale and Matthew Parker, John Foxe's *Book of Martyrs* and Sir Richard Baker's *Chronicle*, and, after the triumph of the Whigs, Gilbert Burnet's *History of His Own Times*, the myth was of England as an elect nation free of popish absolutism, based on an ancient Church of England founded by Joseph of Arimethea, independent of Rome in both ecclesiastical and royal pedigrees.[73] This was the fiction of a Whig England and the model Hogarth offered for painting (and later Fielding for writing) in a distinctively English way in an English nation. He was asserting ethnicity and the claim of an indigenous tradition against the classical and the Judeo-Christian traditions of art that had dominated Europe since the Renaissance.

The Leonardo *Last Supper* itself — to which Dürer's print alludes — was one of the most renowned paintings in the world, praised especially for what the art treatises ranked highest in the criteria of history painting: the representation of "the passions of the souls of the Apostles, in [their] faces and in the rest of the body," "the varied expressions and diverse emotions of the soul."[74] This would have been reason enough for Hogarth's finding a way to include a Last Supper of a harlot, with its spectrum of passions, as a challenge to high art.

A further, more private allusion is also possible. Hogarth, as he scrabbled his way up from engraver to painter in the 1720s, modeled himself on Sir James Thornhill, later his father-in-law. Thornhill (who, incidentally, had a score of his own to settle with William Kent, with which Hogarth may have assisted him) was the first native-born English painter to achieve success as a history painter on a large scale (the *Acts of St. Paul* in St. Paul's cupola and the allegory of the Protestant succession in the Great Hall of Greenwich Hospital), the first to be knighted. Another occasion for Hogarth's NT parody may have been Thornhill's ambitious religious paintings: he had painted altarpieces of *The Adoration of the Magi* (chapel of Wimpole Hall) and *The Last Supper* (St. Mary's Church, Weymouth), both completed in 1724. There are no direct echoes,[75] but these could have served as a stimulus for Hogarth to correct, to modernize, or merely supplement his father-in-law's religious paintings.

Given Thornhill's interest in the demotic in art (his drolls, his portrait of Jack Sheppard, and his arguments pro and contra contemporary dress for the landing

of George I in his Greenwich Hospital painting), Hogarth may have thought he was fulfilling a desideratum of his father-in-law or even improving upon his work. Thornhill objected to his daughter Jane's romance with her déclassé lover, and in 1729 William and Jane Thornhill eloped. There is a story that it was the *Harlot's Progress* that reconciled the irate father-in-law.[76] In print Hogarth consistently defended Thornhill's reputation and praised his paintings.

Thornhill could have introduced Hogarth to (or, through his contacts, facilitated his introduction to) the work of Antoine Watteau. Hogarth is projecting in the *Harlot* a new kind of art in England comparable to Watteau's in France — summed up in *L'Enseigne de Gersaint* (Berlin), in which Watteau shows the old style being packed away and the new exhibited on the walls of Gersaint's shop. Watteau had visited England in 1719–20, and his paintings could be seen in English collections and, by the 1730s, were available in prints. Hogarth began his painting career with Watteauesque conversation pieces, and one painting in particular made an impression on him. Watteau's *Comédiens Italiens*, painted while he was in England for Dr. Richard Mead (1719–20, now in the National Gallery, Washington), showed a commedia dell'arte company centered on the simpleton Pierrot, all in white, being displayed in an *Ecce Homo* scene. This scene, which verbalizes the clown as something like "Holy Fool," could have given Hogarth the idea for a painting of a harlot in an Annunciation, which was the first thought for *A Harlot's Progress*.[77] He would have seen the painting in Dr. Mead's collection, which was open to artists, and in particular through the good graces of Thornhill.[78] The painting may have directly inspired Hogarth's *Beggar's Opera* paintings of 1728–29, which show actors presenting themselves on a stage — Macheath in that case in the Pierrot position (see fig. 54).

It was Roman Catholic belief, as well as its expression in Counter-Reformation painting, that Hogarth attacked in the *Analysis of Beauty* when he insisted on the reader's seeing for himself. He would have been familiar with such antipapist polemics as Charles Leslie's *The Case stated between the Church of Rome and the Church of England* (1714), which contrasts the Catholic with the Protestant who has been raised "to *Seeing* with his own *Eyes*, instead of being led by others *Implicitly* in the *Dark*." "The Bigot [in] his *Blindness*" has been "Persuaded [that] there is less Danger of *Stumbling*, than if his *Eyes* were open."[79] More generally, when Hogarth wrote on art, he used the vocabulary of religious bigotry, hoping that he could lead his readers to "believe their own eyes" and ignore those who (in Hogarth's holograph spelling), "imbibing false oppinions, in favour of pictures, and statues, and thus by losing sight of nature, . . . blindly descend, by such kind of

prejudices, into the coal pit of conoiseiurship; where the cunning dealers in obscure works lie in wait." In his *Autobiographical Notes* he argues that those who "have been brought up to the old *religion* of pictures love to deceive and delight in antiquity and the marvelous and what they do not understand, but I own I have hope of succeeding a little with such as dare think for themselves and can believe their own Eyes." In his own case, he writes, "I grew so *profane* as to admire Nature beyond the finest pictures and I confess sometimes objected to the *devinity* of even Raphael Urbin Corregio and Michael Angelo . . . I could not help uttering *Blasphemous* expressin[s]. . . . I fear *Persecution*" (emphasis added). Passages like these show how Hogarth joined religion and aesthetics in his thinking.[80]

Dissenter Anticlericalism/Old Whig Politics

In the late 1680s, Hogarth's father Richard came down to London from the north, probably Westmoreland (the Harlot arrives on the York Wagon, which he would have ridden). The name was Scottish; at least some branches of the family were Scottish Presbyterian, and Richard registered his son William's birth (10 November 1697) in a separate Nonconformist register in the church of Saint Bartholomew the Great.[81]

On 5 November 1688 William III had landed at Torbay and, after a conference at the beginning of 1689, he was proclaimed joint-sovereign. One of the first things he did was pass an Act of Toleration that gave Nonconformists the right to worship in their own "meeting houses." Richard Hogarth's appearance in London coincided with William's repeal of James II's reinstatement of absolute monarchy and the Roman Catholic Church in England. Richard may have named his son, born at just the time of the celebrations for the Peace of Ryswick and the king's triumphal return from the Continent, for William III.[82]

In the year of Hogarth's birth, a tract called *A Letter to a Convocation Man* criticized the Whig government of William III for presiding over a virulent attack on the established Church of England and its clergymen by dissenters, deists, and even atheists. As J. G. A. Pocock has pointed out, "the First [or Old] Whigs were a faction of former Presbyterians" whose aim at the Restoration was "the institutionalization of dissent."[83] Led by the first earl of Shaftesbury, they found their cause in abhorrence of France, Rome, popery, and priestcraft. The high-flying Tory Sacheverell believed that "Presbytery and republicanism go hand in hand; they are but the same, disorderly, levelling principle in the two branches of our state, equally implacable enemies to monarchy and episcopacy."

And, he added, "It may be remembered that they were the same hands that were guilty both of regicide and sacrilege, that at once divided the king's head and crown, and made our churches stables, and dens of beasts, as well as thieves."[84]

In *Harlot* 3 Hogarth presents Sacheverell as a Roman Catholic icon, hung on the Harlot's wall alongside a holy medal and a portrait of the highwayman Macheath and beneath a print of Isaac saved from Abraham's knife by the intervention of the angel. Hackabout's holy medal verbalizes her displaying of Macheath, Sacheverell, and Isaac as "idolatry."[85] All four came to miraculous ends, Jesus by his Resurrection and Ascension, Macheath and Sacheverell by reprieves after convictions — in Sacheverell's case by lucrative church preferment — and Isaac by Jehovah's changing his mind.

Sacheverell gives some idea of the world of nonconformity and dissent in which Richard Hogarth lived and William was brought up. In politics it was always the religious dimension that guided Hogarth, and even his xenophobia can more precisely be described as a distrust of things Roman Catholic, which for Dissenters included the Church of England. The Anglican priests he represented wear surplice and cope.

There is a story that Richard Hogarth traveled south with none other than Edmund Gibson.[86] Gibson studied in the free grammar school of Bampton, which, if the story is true, would probably have been Richard's school as well. Both were Latin scholars. Richard published Latin textbooks, and his great work was a dictionary; Gibson published an edition of Quintillian. Gibson took holy orders and distinguished himself as a conservative Anglican clergyman, swiftly rising in the church hierarchy. For Richard, as a Dissenter, the possibilities of his teaching were severely limited;[87] around 1700, he opened a Latin-speaking coffee house, which failed; he spent several years in debtors' prison and died in 1718. His Latin dictionary survived only in a manuscript preserved by his son but now lost. Gibson's major work, the *Codex Juris Ecclesiastici Anglicani*, the Bible of the most extensive claims for Church powers (for which he was known as "Dr. Codex"), was published in 1713.[88] By 1726 Gibson was Bishop of London and Sir Robert Walpole's chief ecclesiastical advisor (called by Walpole "my Pope"), responsible for dispensing ecclesiastical preferment and so control of the House of Lords — a point that was dwelt upon by opposition propaganda, which was essentially Old Whig.[89]

In plate 1 of the *Harlot*, the clergyman who ignores Hackabout's plight has turned his attention instead to the address of Walpole's Bishop of London, that is, to his own preferment (the shepherd ignoring his flock); the association of Gib-

son and Walpole is repeated in plate 3, which refers to one of his *Pastoral Letters*, better known for their support of Walpole than their piety. In plate 2 it is a bishop who, taking the place of the deity, stabs Uzzah in the back when he prevents the fall of the Ark of the Covenant — just above what was in the first state labeled a portrait of the deist Woolston, whom Gibson had prosecuted. Plate 6 shows the conventional anticlerical image of the priest who, while he should be officiating at the Harlot's wake, is groping one of the whores under her dress (the cause of his wine's spilling).[90]

It seems that Hogarth's mother Anne Gibbons, before she married Richard Hogarth, was brought up in an orthodox Anglican family. The Bible Hogarth kept was his mother's, the Gibbons family Bible, which included the *Book of Common Prayer* (dated 1622), the very symbol of tyranny for a Nonconformist.[91] This can only mean that the Gibbons family was Anglican, while the baptismal register records that Richard, the husband and father, regarded himself as a Nonconformist.[92] So Richard was known as a Nonconformist but was willing to marry an Anglican (though absence of any record of the service suggests that it may have been a Nonconformist one) and have his child baptized, though in a Nonconformist register, in Saint Bartholomew's.

One wonders whether the peculiarly verbal quality of Hogarth's engravings (with their use of inscriptions, words, emblems, verbalizations of visual images, and so on) does not reflect the Puritan belief in the precedence of the preached word, the priority of the art of words, and poetry's precedence over the other arts — as well as the Calvinist belief that the subject of art, never the deity or the sacred, should be limited to contemporary history and portraits.

On the other hand, the sort of wordplay Hogarth used in *Boys Peeping at Nature* he would have learned from Richard Hogarth the Latin scholar, author of learned works, teacher, and proprietor of a Latin-speaking coffee house in which such punning would have been an everyday affair. (Richard's Latin-English text-books are notable for their little jokes and attempts at verbal wit.) "The Master of the House," one of his advertisements announced, was anxious to converse with his learned clientele, "being always ready to entertain Gentlemen in the Latin Tongue."[93] Spoken Latin, the discourse of his father's learning and of his coffee house, one nexus for Hogarth's verbal wit, indicated a social and educational level (at such public schools as Eton all instruction and conversation were carried on in Latin) and, of course, a level of pretension as a come-on to prospective clients, whether for Richard's coffee or William's prints. The wit of the *Harlot* (recall the graphic puns of the antlered wallpaper behind the Jew's head and the departing

lover's "stabbing [him] in the back," the monkey "making a monkey" of him, and so on) functions not just to assert his own control but to establish the level of his readership and his own social superiority. The operation of his engravings depends upon the sort of pedantry as well as pedagogy he would have lived with for his first fifteen years, and his audience included at one end the public school–educated Englishman, like his friend the Etonian Henry Fielding, who was inordinately proud of his classical learning.

Coffee houses had the further reputation of being "republics of Freethought" counter to the Church, a public sphere that carried secular, even freethinking, associations.[94] Wit was first associated with the Cavalier rakes of the Restoration (by the Old Whigs), summed up in Shadwell's *Libertine* (1675), which presented a Cavalier and libertine Don Juan who rapes and murders as an attack by the higher orders on the lower. By the 1670s, however, wit was being used by the Old Whig opposition in the subversive anticourt satire of Rochester and the comedies of Etherege and Wycherley. This was a discourse flourishing, until condemned by Jeremy Collier and his followers, in the London theater of the 1690s and 1700s when Richard Hogarth was trying to make his way. With its libertine sense of disinterestedness, "wit" was adapted by freethinkers and deists at the end of the century (ethical, perhaps, as well as critical deists) and was the literary mode of Woolston's accounts of the miracles of Christ.

The *Harlot* was, among other things, a test of how far Hogarth could carry graphic-verbal wit but also a sign that he wished to attract an elite audience like the clientele of his father's Latin-speaking coffee house. Wit draws attention to artifice, as sheer virtuosity or self-presentation — the virtuosity of his performance, echoing and mimicking the Old Masters he seeks to replace. Wit represents — or presents — Hogarth the innovating, shocking "artist" but also Hogarth the learned, the gentlemanly, libertine wit.

Opposition Politics: Swift, Nicholas Amhurst, and Bishop Hoadly

As early as 1725 Hogarth's print, *Royalty, Episcopacy, and Law* (fig. 22), showed a machine, like the Eucharist machine in *The Marriage Contract*, from which an Anglican bishop cranks out not babies or Hosts but money. The reference is not to Roman Catholic Transubstantiation but to the alliance of church and state in England. In the words of the radical Puritan Gerard Winstanley: "Kingly power depends upon the Law, and upon buying and selling; and these three depend

upon the Clergy, to bewitch the people to conform; and all of them depend upon Kingly power by his force, to compel subjection from those that will not be bewitched." Episcopacy was central in keeping the people under control: "The former hell of prisons, whips and gallows they preached to keep the people in subjection to the King: but this divined Hell after death, they preach to keep both King and people in awe to them, to uphold their trade of tithes and new-raised maintenance."[95]

Earlier Hogarth had published a pair of satires, *The South Sea Scheme* and *The Lottery* (1724), which directly anticipate the *Harlot* in their anticlerical imagery.[96] The first (fig. 23) shows the destruction of London by stockjobbers and speculators: While this is taking place, and "Virtue" figures in a Flagellation, in the lower left corner three clergymen—a bishop (identified by the cross on his cope as a popish priest), a rabbi, and a Dissenter—parody the three soldiers casting dice for Christ's robe at the foot of the cross. But the second, *The Lottery* (fig. 24), parodies Raphael's Vatican *Dispute on the Blessed Sacrament of the Eucharist*, replacing the Host with a lottery wheel. These images could, of course, be regarded as a depiction of a contemporary England that has degenerated from the ideals of Christianity.

If questioned about the *Harlot*'s parody, Hogarth might have cited a precedent in the mock-heroic "Augustan" satire of Dryden, Swift, and Pope. Dryden's significant invocations of the Incarnation (and allusions to *Paradise Lost*) were parodies dealing with the issue of the succession and the Exclusion Bill. In *Mac-Flecknoe*, Flecknoe and Shadwell comprised a Satanic parody of John the Baptist and Christ and of their classical analogues, Aeneas and Ascanius. In this sense, we could see Hogarth's NT burlesques as the Juvenalian fiction of a glorious past and a degenerate present: The Virgin Mary has *declined* into a harlot.[97] The deletion of God throughout Hogarth's work could mean that He *should* be there —that the state has secularized God out of existence. I do not want to rule out this reading, though all the supporting evidence tends against it, because it could well have been the contemporary reading that got the prints past the censor in the wake of the Woolston trial—a Scriblerian (a Popean, a Swiftean) reading of the *Harlot*. In the years leading up to the publication of the *Harlot*, the Scriblerians were focusing their satire on the Walpole administration.

Swift's *Gulliver's Travels* was published on 28 October 1726.[98] Hogarth's engraving, *The Punishment of Lemuel Gulliver* (fig. 25), was announced as "speedily to be published" in the *Daily Post* of 3 December and as published in the *Daily Post* of the 27th. It is the first clear interpretation of *Gulliver's Travels* as an attack on the Walpole ministry.

The earliest indications of an organized campaign of opposition to Walpole were during the summer of 1726 in the meeting at Bolingbroke's country estate of Dawley—and the earliest unmistakable sign was on 5 December, when the first issue of Nicholas Amhurst's journal, *The Craftsman*, was published. Hogarth's print was announced on the 3rd of December, two days before the first issue of the *Craftsman*. Hogarth's print refers to a scene that does not appear in *Gulliver's Travels* and is not mentioned in Curll's *Key* or any of the other pamphlets published in December as responses to *Gulliver's Travels*.[99] It claims to "illustrate" *Gulliver*, but it shows a hypothetical scene, one very different from the actual punishments projected and the one decided upon—the blinding of Gulliver and his slow starvation. The punishment Hogarth envisages—an enema—refers not to Gulliver's refusal to lay waste Blefuscu/France but to his magnanimous attempt to put out the fire in the Empress of Lilliput's apartment in the Lilliputian palace. Hogarth is explicit in his caption beneath the print: "The Punishment inflicted on Lemuel Gulliver by applying a Lilypucian fire Engine to his Posteriors for his Urinal Profanation of the Royal Pallace at Mildendo." He imagines a homeopathic punishment, water corrected by more water.

If the first crime, refusal to lay waste the neighboring country Blefuscu, obviously applied to Oxford, Bolingbroke, and the Treaty of Utrecht, the second—the crime for which Hogarth has Gulliver punished—evokes Swift's own crime, the impiety of publishing *A Tale of a Tub*, which had been construed by Queen Anne as the profanation of her beloved Church of England and which Swift himself, in the "Author's Apology" (added in 1710), defended in similar terms. What some saw as blasphemy, he argued, was the only way to extirpate not religion but "Corruptions in Religion" (Woolston's defense)—that is, to put out the conflagration of radical religious sects—but its ambivalence, its relentless materializing of the spiritual, cost him the advancement he felt he deserved in the Church of England.

Within the text Hogarth could have taken the idea for the purge from Gulliver's emphasis on the excretory function, especially his insistence on withdrawing for this purpose as far away as his chain will permit from the "temple" in which he is housed—because he is cleanly, but also perhaps because he wishes to avoid the profanation of a church (Queen Anne's Church of England), though it has been abandoned by the Lilliputians/Whigs themselves. The abandoned, ruined church could be taken as an ideal in the past on the model of Swift's own *Argument against Abolishing Christianity*, where it is the faint memory of apostolic Christianity. But in Hogarth's *Punishment* the satire is not (as in Swift's *Argument*) on the secularizing latitudinarians but on the Church of England itself—its

bishops, its clergy—whose focus on the punishment of a supposed blasphemer permits their parishioners to turn to the worship of Pan. One consequence is that their children are carried off unopposed by Gulliver-scaled rats.

The focus on the church was timely. By 1726 Walpole's chief assistant in matters of religion was Bishop Gibson. Earlier, in his *Codex Juris Ecclesiasticae* Gibson had taken the position that ecclesiastical authority should extend into civil affairs; primarily, as it developed in his practice in the later 1720s, in the case of prosecutions of vice and heterodoxy. The *Harlot* was followed directly, in both its title and its focus on Bishop Gibson and a corrupt clergy, by Richard Savage's *Progress of a Divine* (1735). And at this time the *Old Whig*, another antiministerial journal, was still equating "Dr. C-d-x" with monks, popes, and popish bishops (8 May 1735).

Swift was a major influence on Hogarth, and the influence was reciprocated. It is likely that Swift himself, through his Dublin publisher George Faulkner who (by the 1730s, at least) imported Hogarth's prints from London, saw *The Punishment of Lemuel Gulliver*.[100] As Hogarth reinterpreted *Gulliver* in *The Punishment*, so a decade later Swift in "The Legion Club" reinterpreted Hogarth's *Rake's Progress*, plate 8 (see fig. 34)—but in *Rake* 8 Hogarth had himself reinterpreted Swift's own vision of Bedlam in "A Digression on Madness" in *A Tale of a Tub*, the work to which Swift was alluding in the palace-burning episode of *Gulliver* and which Hogarth reinterpreted in *The Punishment of Lemuel Gulliver*.[101]

There was, however, a third party without whom it is difficult to imagine the publication of Hogarth's *Punishment* at just this moment. Hogarth and Amhurst, young men of the same age and background, lived near each other and were acquainted. In June 1726 Amhurst had published a collected edition of his satiric periodical *Terrae-Filius*, to which Hogarth contributed a frontispiece.[102] The significance of Amhurst's career lies in its spanning the ministries of Stanhope and Walpole, explaining both his admiration for Bishop Hoadly and his distrust of Bishop Gibson.

Benjamin Hoadly, a friend of Samuel Clark, was accused of anti-Trinitarianism during the Bangorian controversy.[103] His sermon before George I in 1717 on the text "My kingdom is not of this world" (John 18:36) argued that Christ had "left behind him no visible, human authority; no vicegerents who can be said properly to supply his place; no interpreters, upon whom his subjects are absolutely to depend; no judges over the consciences or religion of his people"[104]— which Hoadly understood to mean that Christ had made no grant of temporal "dominion" to his disciples "over the faith and religious conduct of others of his

subjects." From this Hoadly concluded that the church possessed no divine mandate to support establishments or to impose on people's consciences. Such a mandate was a perversion of Christ's true spiritual legacy. The purpose of the Bangorian Controversy, which resulted in the suppression of Convocation, was from the Stanhope ministry's point of view "to silence an institution deemed threatening to the government." The upper clergy in Hoadly's case was "a bulwark of opposition to the regime" and, from his and Amhurst's perspective, Jacobite.[105] From one perspective (that of Hogarth's *Royalty, Episcopacy, and Law*), the state was a theocracy. Bishops sat in Parliament, made civil laws, and presided over courts that governed not only moral offenses but many civil affairs. The king was ex officio head of the church, and the whole population were members of it. The church parish was the unit of local government.

As a "respectable" and successful clergyman, Hoadly was praised by deists, in order to attack Bishop Gibson and other orthodox Church of England clergymen, and was accused by High Church clerics of deism.[106] Among his clerical brethren Hoadly was heartily disliked for what J. P. Kenyon has called his "militant unorthodoxy" and resolute insubordinacy to the ecclesiastical hierarchy.[107] Hoadly, the central spokesman of the anti-Gibson position in the church, was the "latitudinarian" ecclesiastic invoked later by Hogarth and Fielding as the embodiment of true (for which read *liberal*) Christianity in England, as opposed to priestcraft. Hogarth's portrait of Hoadly (engraved by Bernard Baron after Hogarth's painting in 1743) was the only portrait of an ecclesiastic, the only portrait not engraved by himself, that Hogarth included in the folios of his prints.[108] The Hoadly admired by Hogarth and Fielding was not the supporter of Walpole but the Erastian Old Whig who called for a radical disempowering of the clergy. Hoadly's extremely successful career in the church was due to the support his Erastianism gave the ministry and to his latitudinarianism, which supported the rights of Dissenters, a position applauded by George I himself.

Amhurst introduces a new strand in the 1720s, that of the "Commonwealthmen," Whig extremists whose origins were in religious skepticism and heterodoxy.[109] In *The Independent Whig* and *Cato's Letters* (1720–23) — the latter characterized as "a handbook of early eighteenth-century extreme Whiggery" — Thomas Gordon and John Trenchard joined Commonwealth and deist doctrines to attack priestcraft and defend "the Bishop of Bangor's scheme."[110] They had ties with both Hoadly and the Stanhope-Sunderland ministry, which in December 1718 had introduced "the widest conceivable measure aimed against Anglican hegemony: a Bill repealing the Occasional Conformity and Schism

Acts, and providing a way of avoiding the reception of the sacrament required by the Test and Corporation Acts."[111]

For Amhurst the two most significant facts were the Bangorian Controversy of 1717 and his expulsion from Oxford in 1719, evidently for his part in defending Hoadly's position and attacking English "Papism" in a series of poems published in quick succession, collected and reprinted in 1719 and again in 1720 (all published by Curll). What Amhurst maintains directly and indirectly is Bishop Hoadly's denial, which was supported by Stanhope's ministry in its war against the nonjurors, that there is a visible church of Christ, that is, that the church and its clergy carry any authority whatever. The enemy was the absolutist and hierocratic regime supported by the nonjurors of Oxford—which came down to the slavish theory of passive obedience to a divinely instituted (papist) monarch. Thus, when the government changed, Amhurst used the same line of attack on the Walpole Whigs, now in alliance with Bishop Gibson.

The Oxford story, as Amhurst formulated it and reformulated it in works between 1719 and 1726, was the persecution of a young man for his Protestant Whig principles in a seat of nonjuring Jacobitism and Laudian priestcraft. This expulsion was the story by which Amhurst came to identify himself and be identified.[112] In his *Poems on Several Occasions* (1720), which retains the portrait of Hoadly for its frontispiece, Amhurst makes the fact of central importance his expulsion by the Laudean ecclesiastics, and he presents it as a "punishment" (a word he emphasizes throughout). In the preface he acknowledges that he was called by the Oxford authorities atheist, libertine, and freethinker and an enemy to religion and revelation. The result, in this ironic redaction of the story, is his submission: "therefore, like other polite Malefactors, I heartily forgive my Accusers, and confess that I deserv'd the punishment I suffer'd," and he proceeds, with a humble, lengthy, and hyperbolic recantation: "I can scarce forgive my self for my childish Behaviour," "My Eyes are now open," "I hope all young Men will take warning from me," and "I have indeed been a very naughty Boy" (xiii–xiv, xxi). With heavy irony he apologizes and accepts his "punishment" "for *thinking* like one *in his Senses*," which means, he makes abundantly clear in the following sentences, "Freethinking."[113]

Thus Amhurst suffers a "punishment" that, though it would hardly have found a sympathetic audience in Swift, was as misguided, Amhurst would like to think, as the attacks on Swift's "irreligion" and "blasphemy" in *A Tale of a Tub*— and later, Hogarth would have thought, as the punishment inflicted on Woolston.[114] The *Craftsman* picks up the emphasis of Amhurst's dedication to the

Poems on Several Occasions and the word *punishment*. Caleb D'Anvers (Amhurst's persona) starts off with an epigraph from Seneca which he translates as: "The Punishment of learned Men . . . was a new and unusual thing" (31). He concludes the paper with Seneca's observation that tyrants gained only "*Infamy* to *themselves*, and *Glory* to *those* whom they have *punished*" (38). The "punishers" here are the Stuart monarchs (whom Caleb D'Anvers compares by analogy to Augustus and Tiberius) and the royalists of church and state of the 1640s. Again, no. 4 (16 December), on liberty of the press and speech, uses the word *punishment*. We should note the emphasis on "punishment," which seems to anticipate the excessive punishment embodied in the *Harlot*.

Hogarth's was a perceptive illustration of Gulliver's sacrilege, dictated by one whose own case would have made him susceptible to this reading. Amhurst's reference to his "childish Behaviour," his apology for having been "a very naughty Boy," may have inspired Hogarth to bare Gulliver's bottom as for a juvenile flogging. Amhurst's citation of the "many strenuous Pulpit-Attacks" upon such "Heresiarchs" (xxvi) may reappear in the pulpit adjacent to Gulliver's bottom.

Given the coincidence of the first issue of the *Craftsman* and the announcement of Hogarth's print and of Amhurst's and Hogarth's views of religion, the paranoid scenario would seem to be Amhurst's, and so the association of his personal trauma with England's and, specifically under the aegis of church *and* state, with the church clearly predominating. While in the "Voyage to Lilliput" the only allusion to the church is the ruined temple in which Gulliver is lodged, in Hogarth's print the temple is centered, adjacent to the bishop in his teapot pulpit; the Walpole figure, carried in a thimble, is marginalized.[115] Liberty of the press, however, is applied to government *and* religion, state *and* church, and is specified as the right to criticize their corruptions (no. 2, 9 December).

The central image of *The Punishment of Lemuel Gulliver*, Gulliver's bottom, returned in later anti-Walpole satire, but by then identified as Walpole's own or as George II's, an object not of punishment but of worship. The most scandalous case was the play of 1737 called *The Golden Rump*, which survives only in a satiric print titled *The Festival of the Golden Rump* published in *Common Sense* and accompanied by an explanatory "Vision."[116] George II is a satyr mounted on a pedestal, whose rump is being worshiped; the figure recalls the Pan-satyr figure in Hogarth's *Punishment* and indeed conflates this figure as object of worship with Gulliver's rump. The priest officiating at the ceremony is Walpole. *Idol-Worship or The Way to Preferment* (1740) showed Walpole himself as "pagod," bottom

facing out, filling the gateway of Saint James's Palace, very much as Gulliver was positioned in the doorway of the church.

Hogarth's position was more radical. The locus for the appearance and representation of God was notoriously, in the OT, his backside: "Thou shalt see my back-parts, but my Face cannot be seen" (Exod. 33:23). In Hogarth's print the deity has been replaced by Gulliver's backside, and the "sacrificial figure" — the "body and blood" — is Gulliver's: He saved Lilliput from the Blefuscudian invasion, and he is rewarded with a Christological Passion. In short, Hogarth turns Gulliver into a sort of parodic redeemer destroyed, as Christ was (or Swift or Amhurst), by the combined forces of state and church (Pilate and Caiaphas).[117]

Amhurst and Hogarth held a set of beliefs that were not easily accommodated to those of their colleagues in the Walpole opposition, such as Arbuthnot, Swift, Gay, and Pope.[118] Of course, the opposition to Walpole was by no means of a piece, by no means limited to, or distinguished by, the Jacobite-Tory nostalgia of Swift himself (or Bolingbroke or Pope).[119] The first-mover of the *Craftsman*, the first person to reinterpret *Gulliver's Travels* as an anti-Walpole satire, was a free-thinker and Hanoverian Whig, and certainly no "Ancient." Bolingbroke, also a freethinker, was otherwise temperamentally one with the exiled Swift and the Roman Catholic outsider Pope. For Amhurst and Hogarth the past was not a Golden Age, a country-house idyll, but Jacobite, tyrannical, priest-ridden, and (in Hogarth's case) dominated by academic and continental (Roman Catholic) models of painting. Hatred of ecclesiastical tyranny was the element shared by Amhurst, Bolingbroke, and Hogarth. Bolingbroke, the figure who bridged the two groups, kept his deism to himself, and both Amhurst and Hogarth kept theirs under the umbrella of Hoadlian latitudinarianism and Erastianism.

The opposition cry of "liberty" referred not only to freedom of property but also to freedom of thought, conscience, and speech, particularly in religious matters. This was a rhetoric that began in the Restoration but by the end of the century, in certain of its forms, had accrued traces of deism along the way. In the context of the "Voyage to Lilliput," *liberty* means the liberty of the subject, specifically (given the Lilliputians' confiscation of Gulliver's possessions) of property, but in Hogarth's print, in the context of the church in which Gulliver huddles, it is liberty of conscience and religious expression.

Both Amhurst and Hogarth would have been associated with the anticlerical wing of the opposition Whigs. The question is: At what point did Hogarth cross the line into critical deism? There is no proving whether Amhurst crossed the line; certainly his assertion and reassertion was that he stood for a Protestant

monarch and an Erastian church, and no more.[120] The *Craftsman* itself, ironically conciliatory along the lines of Amhurst's *Poems on Several Occasions* with its apology for his heterodoxy, avoided religious issues.

Cunicularii: The Nativity Parodied

Whether or not at the suggestion of Amhurst, Hogarth carried the same witty strategy into a print that he advertised as published in tandem with *The Punishment of Lemuel Gulliver* — a topical, ostensibly reportorial depiction of the scandalous hoax of Mary Toft, the "Rabbit Woman" of Godalming. Word of her extraordinary delivery of seventeen rabbits began to appear in the newspapers of the second week in November. The *Weekly Journal* published an account in the issue immediately preceding the one of 26 November with a letter from Ephraim Gulliver (Lemuel's brother) and again in the issue of 3 December. The exposure of the hoax was reported on 10 December, and there was a front page essay on the 17th (also in the *London Journal*). Hogarth's print, *Cunicularii, or the Wise Men of Godliman in Consultation* (fig. 26), was announced as published in the *Post-Boy* of 22–24 December, just two days before *The Punishment of Lemuel Gulliver*.[121]

Amhurst launched his satire in the first issues of the *Craftsman* with a sort of coding that represents one thing (a safe social situation) but refers to another (an incendiary political situation). Caleb D'Anvers, his spokesman, talks about a bad servant (named Robin), and the readers see that he is talking about political "servants," specifically about the king's chief minister Sir Robert Walpole. The "craft" of the *Craftsman* itself is, of course, "state-craft" and "political craft" (nos. 1 and 15). When Caleb introduces the theater and (with it) the fall of princes, and so the example of Shakespeare's Cardinal Wolsey, the readers see Walpole (nos. 8, 72). Whenever he mentions "Great Men," they again see Walpole. And so when he discusses quackery in medicine, they see that he is talking about "quackery" in politics (no. 3).

London physicians, conspicuously including court physicians, had been taken in by the Toft hoax. A print on this subject, appearing as Amhurst was writing about quackery in medicine and in politics, about "hoaxes" on the stage and in politics, would have been read the same way one read the *Craftsman*. *Cunicularii* shows courtiers and quack physicians worshiping Mary Toft, whose miraculous birth of seventeen rabbits was a hoax (a Walpolian "hoax," analogous to his cover-up of the guilty parties in the South Sea scandal). This is, exclaims one of the doctors, "A great birth," and the composition resembles a traditional scene of

Wise Men bearing gifts to the Christ Child; Mary Toft's husband stands at the left, gaping at the miracle, in the position of Joseph (fig. 27).[122] But in the Toft case, the Wise Men arrive fortuitously at the moment of birth: They are there to witness a "Nativity" like the one in which the birth, as the deists complained, had precisely gone *un*witnessed. The wit lies in combining the "Miracle" of the Birth of Christ with the "hoax" of Toft's litter of rabbits; in replacing the three Wise Men with the three "Wise Men of Godlimen," who are quacks (according to Hogarth's epigraph from *Hudibras,* "They held their Talents most Adroit / For any Mystical Exploit"); and in replacing Mary the Mother with *Mary* Toft and Christ with the rabbits.[123] The rabbit birth is, of course (like, it is implied, the Virgin Birth), fraudulent: Yet another rabbit carcass ("too big") is being offered for sale at the door.

To be sure, ridiculing the superstition with which such trumpery as the Toft hoax was received by the credulous does not necessarily question revealed religion. It *need not,* Hogarth would have added; in the manner of Caleb D'Anvers in the *Craftsman,* his audience was invited to have it either way. When the clergymen Humphrey Prideaux and Isaac Barrow attacked Mohammed as an imposter guilty of frauds, they intended no disrespect to Christ and his authentic miracles.[124] But Prideaux and Barrow attacking Mohammed as an imposter, not meaning any disrespect to Christ's miracles, is at some distance from Hogarth's presenting Mary Toft and her rabbit hoax in a composition that does on the face of it invoke the other Mary and the Wise Men — with, Hogarth's explicit addition, the Virgin in the act of giving birth.

Cunicularii asked to be read as a bold extension of the Protestant attack on the particular emphases of Counter-Reformation popery, and, in its context of Whig opposition anticlericalism, on the supposed acceptance of these by High Church Anglican prelates: the role of priests and their spiritual primacy, the nature of the Holy Sacrament as the Body of Christ, and the worship of the Virgin as Mother of Christ.

Deism: Thomas Woolston

In 1725 Thomas Woolston (like Amhurst, dismissed from his university for impiety [from Cambridge, in 1721]) had published his *Moderator between an Infidel and an Apostate,* which debunked the literal meaning of the Virgin Birth and the Resurrection. Woolston's intention was, following Origin and other church fathers, "to expose the Absurdities of the Letter, as much as may be, to

turn Men's Heads to the mystical and true Meaning"; thus he demystifies in order to allegorize.[125] On the suspicious "miracle" of the Virgin Birth, Woolston comments:

> Was the most modest young Lady of the City to be found pregnant, and even so solemnly profess ignorance of Man, her nearest Relation would not only disbelieve her, but the whole Town would make sport with it. And were some Women now disposed to give their Wit a *Loose* to Infidelity, they would say such Things in Railery upon the Virgin *Mary*, and upon feminine Arts, to sooth up a weak and jealous Husband into a good Humour; and upon that Masterpiece of a pretended Ghost and Apparition, like an angel, saying, *Fear not Joseph, &c.* as I care not to think of.

Woolston refers to the Jewish slander that Jesus "might be *Panthera's*, a common Soldier's Son." In fact, the Gospels, Woolston believes, must be referring to a spiritual birth, of a Virgin Church.[126] For this he was charged by Bishop Gibson with blasphemy and arrested in the autumn of 1725, though the charges were finally dropped. The publicity surrounding Woolston's theories, his prosecution, and the stories of his sincerity (he thought of himself as a defender of true Christianity) and his reputed madness (he had suffered a breakdown and two or three years in confinement)[127] could explain why a year later Hogarth applied Woolston's hermeneutics to Mary Toft, the woman who claimed to have given birth to seventeen rabbits. He appears to have picked up on Woolston's message that the miracles of Jesus are in fact parabolic prophecies of mysterious future events — such as Mary Toft's parturition.

Woolston was a clergyman who regarded himself as a theologian and reformer, not a deist, but whose signature was anticlericalism. Like Swift in the *Tale of a Tub*, he claimed to be correcting the corruptions of the church.[128] Though it has been argued by Roger Lund that he shared Swift's claim,[129] it is difficult to say how much is sincere religious belief and how much deist irony and satire. It does not sound as if Woolston was part of the Amhurst circle but a serious religious thinker. Whatever the depth of Woolston's sincerity, his method was ridicule, and he is often very funny. Hogarth would have appreciated the comical common sense of Woolston's "literal" readings "that call the Truth of the whole into question."[130]

Besides being on a wavelength with the *Craftsman* satire of Walpole, suggesting that Toft is a Mary of our time, corrupted and Walpolean, *Cunicularii* is a parody, in the manner of Woolston and Anthony Collins, which "historicizes" the NT story in order to demystify it. In 1724 Collins, in his *Discourse of the*

Grounds and Reasons of the Christian Religion, had started his demystification of Scripture with the example of the Virgin Birth — always, among freethinkers, the miracle that evoked the most mirth (common sense said the story of Mary's virgin conception was a hoax and the aged Joseph a cuckold). He had sought to uncover "the plain drift and design" of the story, "literally, obviously, and primarily understood," which he therefore was forced to interpret in "a secondary or typical, or mythical, or allegorical sense."[131]

Between May 1727 and March 1729, Woolston published his most inflammatory work, six *Discourses on the Miracles of our Saviour*, in which he demystified and then allegorized one miracle after another. In his *First Discourse* (1727), he satirized "the Journey of the Wisemen out of the East," remarking that, had they acted "as wise as well as good Men," they would have brought gifts of not gold, frankincense, and myrrh but soap, candles, and sugar (55–56). In the same passage he referred to Mary as Jesus' "Mother in the Straw" (Hogarth's inscription in *Cunicularii* called *his* Mary "The Lady in the straw").[132]

The blasphemy and, not least, the ridicule Woolston employed caused Gibson to renew civil charges. The attention, prosecution, and extraordinary sales of the *Discourses* were mutually reinforcing and, along with Woolston's refusal to stop publishing the *Discourses*, led to his arrest, trial, conviction, and fine and imprisonment in March 1729. He refused to pay the fine on principle and remained in prison, continuing to publish *Defenses*, until his death in January 1732/3. In June 1730 he even published and sold a portrait of himself engraved by Hogarth's friend Gerard Vandergucht — the model for the one on the wall of plate 2.[133] During this period Hogarth was producing and in June 1732 published and distributed *A Harlot's Progress*, some eight months before Woolston's death. Thus Woolston could have enjoyed Hogarth's *Harlot*. In fact, he was in and out of prison, sometimes in a cell and sometimes living within the Rules, and not so badly treated.[134] The law was comparatively lenient on blasphemy, and Woolston simply could not find a way to pay his fine. Nevertheless, a conviction for blasphemy would very likely have ruined Hogarth, as it did Woolston.

The *Harlot* picks up where *Cunicularii* left off. The first scene Hogarth painted of the *Harlot* was the third, the parody Annunciation.[135] The nucleus, at least of its subscription ticket, *Boys Peeping at Nature* (see fig. 17), may have been the physician's searching under Toft's dress. The foremost Wise Man was labeled "An Occult Philosopher searching into the Depth of Things," and the Latin title of *Cunicularii* played on the pun of *cuniculus* (rabbit) and *cunnus* (vulva). Thus Hogarth's faun searches under Mother Nature's shift — which in turn looks forward to the priest's hand groping under the whore's dress in plate 6.

In his "Verses on the Death of Dr. Swift," in late 1731 (lines 281–98), Swift wrote ironically about the notoriety and fashionableness of Woolston's *Discourses*, noting that he was so esteemed by the court that he might well be elevated to a bishopric. Swift's note adds: "He is much caressed by many great Courtiers, and by all the Infidels, and his Books read generally by the Court Ladies." Only published in 1739 (by which time the subject was long out of date), Swift's "Verses" could not have been seen by Hogarth when he composed the *Harlot*, but they indicate an orthodox response as well as the immense sales of Woolston's *Discourses* in 1729 as his trial for blasphemy proceeded (well over 20,000 copies were sold).[136] The NT allusions could, partly at least, be Hogarth's poking fun at a madman who, with his mad theory, was in the news.

But Hogarth retains the primary Woolstonian contempt of the clergy. Woolston interpreted the allegorical sense of the NT "miracles" to be Jesus' attack on priestcraft. (Indeed, he thought his confinement for madness was due to the clergy's effort to silence his radical ideas of the NT.) The dedication of the first *Discourse* to Gibson and the subsequent prosecution and severe treatment, which Woolston, at least, blamed on Gibson,[137] laid the groundwork for the satire of the *Harlot's Progress.*

Gibson, in a pastoral letter of 1728 (to which the Harlot draws attention in plate 3 by using it as a butter dish), attacked Woolston and threatened prosecution. His major points were the danger of ridicule and the effect Woolston's sort of writing had on a popular audience: "There is no subject how grave and serious in itself, but may be turn'd into jest and ridicule; and by being so turn'd, may be made to appear mean and dispicable"; further, "once a subject has been defined as ridiculous, it can be treated with greater freedom than would ordinarily be allowed."[138] And by such methods as ridicule, "the Minds of the people are easily carried into a disregard of it and an indifference about it" (8). We cannot overemphasize the importance of the fact that Woolston's writings reached so wide a popular audience — which Hogarth was also to reach with his *Harlot* (this also explains the violence of the attacks on Paine's *Age of Reason* in the 1790s). Such a threat is only controlled by "a constant and serious Regard to every Thing that bears a Relation to God, and to consider it as *Sacred* on that account."[139] Gibson defends the clerical instigation of civil prosecution for blasphemy, accusing Woolston of exhibiting a "*Licentiousness*, in treating the serious and important Concerns of Religion in a *ludicrous* and reproachful manner." He says it is the duty of the civil magistrate to protect the national religion from "such Books as turn Religion into jest and mirth," books that "strike equally at the foundation of all religion . . . and, by consequence, at the foundation of civil society." This

pastoral letter makes the points that to treat religion in a ludicrous manner implies "an irreligious design" that is dangerous to church *and* state.[140] Thus, it is an Anglican bishop who, instead of the deity, stabs Uzzah in the back when he saves the Ark of the Covenant.

Woolston's *Discourses* elicited more than sixty responses, one of which was Hogarth's. Hogarth is, like the deists, defending an interpretation of the true and basic teachings of Jesus against the clergy who tried and imprisoned Woolston. The deists and radical dissent shared the belief in the teachings of Jesus and the "Everlasting Gospel," equalitarianism or the rights and responsibilities of the laity (the common man), and distrust of religious institutions.

Samuel Clarke's name was attached to the second portrait in plate 2 of the *Harlot*. Clarke, who, though deeply opposed to deists (whom he lumped with atheists in his Boyle Lectures of 1704–5), had supported Woolston while in prison, was the author of *The Scripture Doctrine of the Trinity* (1712), which under-mined orthodox Trinitarianism by a careful exegesis of the Bible itself.[141] Clarke gathered every text in the Bible that might touch on the Trinity, demonstrating that there was no scriptural support for Athanasius's doctrine. What he demon-strated was that the Son was in effect a mere creature, no different (Hogarth could have inferred) from a harlot.[142] Woolston would have regarded this as support of his historicizing of the Scriptures. Clarke, though not approving of Woolston's radicalism, had attempted to secure his release but died in May 1729 before it could be accomplished.

The other side of the Woolston blasphemy trial was the plea for freedom of speech. The essence of deism was the belief in free rational inquiry and the free expression of this inquiry. In *A Discourse of Free Thinking* (1713), Collins had argued that "the design of the gospel was by preaching to set all men upon Free Thinking, that they might *think themselves out* of those notions of God and reli-gion which were every where established *by law.*"[143] My emphases indicate the sense in which Collins was describing the freeing of oneself from the "law." In his *Discourse of the Grounds and Reasons of the Christian Religion* (1724), he argued that, "in matters of opinion, it is every man's mutual right and duty to think for himself," adding that he "should be allowed *freely* to *profess* his opinions, and to endeavor when he judges proper, to convince others also of their truth, provided those opinions do not tend to the disturbance of society."[144] Priestcraft and repression — "*authority* and *force*" — do not "put an end to error, or make men wiser"; rather they have ever "contributed to encrease the errors and follies of men." The only way to truth is through "*free inquiry, profession,* and *debate,* which

cannot make men more erroneous and foolish than they are" (xx–xxi). As James A. Herrick sums up the deist position, "Religious ideas are foundational to societies and must for that reason be tested more rigorously than other ideas. Freedom of thought and expression are religious duties, almost acts of worship."[145]

At the time of the Woolston case, Herbert Randolph, rector of Deal in Kent, preached a sermon, *Legal Punishments Consider'd*, arguing for prosecution of blasphemy: "It is no longer a secret that a design has been carrying on by various Arts and under different Disguises, to subvert the whole of Christianity." Such writers used "prophane Raillery" and "an unworthy Treatment of every thing that is sacred abounds in their Writings"; "Banter weighs more than Argument," and these deists know "that the most important truths may be ridiculed tho' they cannot be confuted."[146] Woolston's writings were "light, empty, frothy, foul, insolent, impious, and infamous," and prosecuting him demonstrated "the High Wisdom and Justice of our laws." To some worried clerics these writers employed *"the language of the Fiends."*[147]

Jonathan Jones, on the other hand, referring to Gibson's hounding of Woolston, wrote in *Liberty Vindicated* (1730) that it is "an Insult upon the *British* Nation, that any Bishop or Churchman Whatsoever, should *dare* to *prescribe us laws*, or *limit our liberties*. . . . A proceeding like this would have procured an *Impeachment* in former times, and Arch-Bishop *Laud* was brought to the Scaffold, for Offenses much less injurious to his Country."[148] Matthew Tindal, responding to Gibson's *Pastoral Letter* of 1728 in *An Address to the Inhabitants of the Two Great Cities of London and Westminster in Relation to a Pastoral Letter, Said to be Written by the Bishop of London* (1729), characterized Gibson's attacks on blasphemy as "the wicked methods taken to hinder men from thinking freely themselves, and as freely communicating their thoughts." What Gibson calls blasphemy, Tindal argues, is only the expression of another religious discourse, another set of theological beliefs, which happen to be that of groups out of power, offensive to those holding power, who persecute them.[149]

We can see the *Harlot* as also, in this sense, a test of freedom of speech, a part of the deist rhetoric that was spectacularly attacked and defended during the Woolston affair. Woolston himself, in his final statement to the court, said: "If I survive this prosecution (persecution, I mean), I shall . . . write a book [on] blasphemy," which has never been defined, especially given the different views of the different churches and sects.[150] Hogarth may be thought to have accepted Woolston's challenge. Given the law's principle, plain in the Woolston case, that

the general public must be cognizant of (affected by) the blasphemy, we may assume that Hogarth regarded his allusions as esoteric versus exoteric, in either the deist or Masonic sense, a stratagem of protection against the censor. Detailed instructions for how blasphemous or controversial arguments were to be encoded so as to convey a secret or hermetic message to the initiated, while frustrating the interpretive hostility of the pious, were to be found in Shaftesbury's *Sensis Communis* (1708) and Toland's essay, "Clidophorus; or The Exoteric and Esoteric Philosophy," in *Tedradymus* (1720).[151]

The presence of encoded messages required an interpretive community to decode them. They were intended to be understood. In the artists and connoisseurs, presumably of the Saint Martin's Lane Academy and Slaughter's Coffee House, in which Hogarth played a large part in the 1730s, he had such a community, a club of the sort addressed by Shaftesbury, who could be depended upon to recognize his encoded meanings. If so, reversal, for example, may have helped to veil the meaning, picking up the emphasis in the subscription ticket on the skirt as the "veil of allegory," half revealed and half concealed. (Some believed that the veil assured us of the truth underneath.)

Deists, with their distinction between esoteric and exoteric readings, were presumably Hogarth's designated interpretive community when he undertook the *Harlot's Progress*. But there may have been a discrepancy between the interpretive capabilities of those who were able to recognize the graphic allusions (who, whatever their views of continental Counter-Reformation art, may have been orthodox Church of England men) and the community of deist, Antinomian, and skeptical radical Whigs from which Hogarth drew his basic assumptions. There may, nevertheless, have been a substantial overlay between what the exoteric and the esoteric reader saw.

Antisemitism

David Solkin has drawn attention to the figure of the Harlot's Jewish keeper in plate 2 (see fig. 2) in the context of some contemporary antisemitic tracts. He has argued that Hogarth introduced the Jew only to pander to the feelings of antisemitism in prospective buyers. Through the eyes of contemporary antisemitic tracts, Hogarth's Jew appears to be a representation of bestiality, lechery, and (beneath his clothes) a hairy body. The Jew's "goggle" eyes are staring lecherously at the Harlot's bosom, while the sword and cane of her young lover, who is sneaking out the door, make a scissors that threatens to punish the Jew with "circumcision" or "castration."[152]

To begin, the Jew's prominent eyes are directed not by lust for Hackabout's bosom but by surprise at her kicking over the tea table to divert his attention from her young lover. Second, Solkin's identification of the sword and cane as scissors forgets the more obvious fact that the sword, by an optical illusion, activates for the reader the words "stab in the back" (by the young lover), which relate to the painting above the Jew of Uzzah being literally stabbed in the back by the bishop as well as to the cuckold horns in the wallpaper that appear to sprout from his head. There is no evidence that Hogarth or his readers would have associated scissors with circumcision, which was traditionally carried out with a knife.[153] In plate 1 the scissors hanging at Hackabout's waist are evidence that she plans to work in London as a seamstress (as Moll Flanders had done to prepare for the life of a "gentlewoman"). A milliner's shop was regarded as often serving as front for a brothel. Elsewhere in Hogarth's works scissors signify a woman with either closed or open legs; open, they become the sign of cuckold horns (as in *Hudibras and the Skimmington*).[154]

Solkin's reading supposes an aberration in the spectator (antisemitism) *and* the exploitation of this aberration by the wily, unscrupulous Hogarth, who preferred sales to the integrity of the artist's work of imagination. It presupposes a viewer of the 1730s who would misread the six plates in order to conform to his hatred and fear of Jews. Jenny Uglow, a literary historian who does accept the reference to Woolston in plate 2, nevertheless reads the image as no more than evidence of Hogarth's opportunism, noting of the portraits of Woolston and Clarke that "these might not demonstrate *allegiances* [to their *beliefs*], but rather Hogarth's *shrewd awareness* that Tory Londoners would be happy to identify Woolston and Clarke with 'enemies of Christ'" such as the Jewish keeper of the Harlot (my emphasis).[155]

The Jew in plate 2 does, as Uglow implied, owe something to the persona of a rabbi through which Woolston ridiculed the "miracle" of the Resurrection in his final *Discourse*,[156] but only to emphasize Hogarth's "allegiance" established in the graphic parallels in each plate to stages in a "Life of Christ." In the context I have sketched, the Jew functions not only as a parody of Joseph but also as a part of the discourse of anticlericalism.[157] That the Jew served Hogarth as a symbol of priestcraft finds substantiation in *The South Sea Scheme* of the early 1720s (see fig. 23), an emblematic foreshadowing of the *Harlot's Progress*, in which the three soldiers casting dice for Christ's robe are replaced by Anglican and Dissenter clergymen joined by a Jewish rabbi. The deist equation of Judaism, priestcraft, and the cruel reward-punishment ethos of the Judeo-Christian God is Hogarth's point in *Harlot*, plate 2.[158] It is the Jew who has punished Hackabout by plate 3,

where she receives her Annunciation, which is arrest by the prostitute-hunting magistrate Sir John Gonson.

In effect, Hogarth associates Christian divine "justice" (of the priest in 1 and 6, of the bishop in 1, 2, and 3) with the vengeful deity of the OT — in which deist discourse the Jews were characterized as "wild, brutish, ungovernable, drenched in their own and other nations' blood."[159] But deism was hardly necessary as an explanation for the Jew: Paul's attack on the OT law, focused on the law of circumcision, was a cornerstone of Protestantism. Both anticlericalism and Antinomianism were epitomized in the figure of the Jew.[160]

If Hogarth did not exploit the crude antisemitism Solkin finds in *Harlot*, plate 2, he did employ Jewish stereotypes. What Hogarth associates with his Jew is, first, the ethos of *lex talionis* and a god of vengeance and law, rewarding worship and punishing those who did not, and, second, the social stereotypes, often contradictory, of the Jew as unassimilable foreigner, grasping usurer, and hair-splitting talmudic scholar, as one of the "chosen people" but also as assimilating *arriviste*. Social climbing included the fashionable collecting of Old Master paintings of the sort he wished to discredit and supplant with English art. For Hogarth the Jew's bloody-mindedness is embodied in the OT paintings he collects and hangs as models on his walls. Directly above the escaping young man's head is a *Jonah Cursing Ninevah*, in which God is replaced by a surrogate. Jonah is sent to Ninevah, as God's "priest," to inform the Ninevites of their fate, and when they repent God forgives them, but not Jonah, who would then (he surmises) be proved a false prophet. Jonah wants to and does (parallel to the bishop in the other picture) replace the deity. And, of course, in plate 3 the Jew *has* carried out the OT law, "thou shalt have no other God before me," and cast out Hackabout. In the context of the story of Mary and Joseph, the OT paintings indicate the presence of Christian typology: they foreshadow the events taking place beneath.

Solkin believes that the pictures were chosen by Hackabout to ridicule her keeper. The hat under the Jew's arm indicates that he has just arrived, surprising Hackabout, and that this is Hackabout's, not his own, residence. But the Jew has set her up here, decorating her flat in his own style, with other objects (like her) of his choice and reflecting his taste and ethnic assumptions. She is another "furnishing" like the paintings, as she is, given the black boy, another "possession" and "slave."[161]

Obviously, lechery plays a part in the Jew's desire for Hackabout, but what is stressed in plate 2 is his need for her as a "trophy" like his paintings, another

beautiful object — the Ark of the Covenant in the picture above his head. The Jew is being ridiculed because he aspires, like the Harlot, to a higher social order. He rhymes with the monkey, an emblem of *imitatio*, "aping" his betters (another Hogarthian verbalization), because the wealthy Jew was the prototype for imitation and upward mobility. The Jew's attempt at assimilation — he has cut off his beard and replaced his yarmulke with a wig — is successful, while the Harlot's effort (she is also related to the monkey, sharing his headdress) leads her to disaster.

Hackabout has taken the young lover because this is what London "ladies" do.[162] In the third plate, having been cast out, she has imitated the imitator and hung her own pathetic equivalent of the Jew's picture collection — a print of "Abraham's Sacrifice of Isaac" and penny portraits of Macheath and Dr. Sacheverell, all objects of veneration (idolatry) but, in this context, also of imitation. Collecting, a subject that will dominate the *Rake's Progress*, is associated in the *Harlot* with Jews and whores, strange intermediate figures who collect to raise their status.[163]

The paintings may also serve as her keeper's admonitions, warning her what dire consequences will follow if she strays. They are hardly (as Solkin supposes) works chosen by her as mockery of the Jew; as his possessions, they characterize *him*. Implicitly, his paintings also show that his being "made a monkey of" by the Harlot is parallel to his duping at the hands of the connoisseurs and picture dealers.

The primary stereotype, in terms of Hogarth's total oeuvre, is that of the Jew as nonartist, forbidden by the Second Commandment to make images of God and pictures of any kind. As with his beard, he has defied the laws, but he remains the prototype of a race without its own art but collectors and, by implication, traders in art. He represents the antithesis of a national art, since Jews have no "homeland" or unified community for which a national art can be constructed.[164]

Hogarth's trade was in stereotypes, of a Harlot, a Rake, a distressed Poet, and an Enraged Musician. But the Jew deviates from the stereotype in one important particular. Like Colonel Charteris, Justice Gonson, the warder of Bridewell, the doctors, and the clergymen in the other plates, the Jew exploits the girl, but, unlike them, he has been "made a monkey of" and turned into a poor cuckolded "Joseph." He is the social climber who *will* be successful, and yet the Harlot can play tricks on him — and part of the joke is that in plate 2 he is actually the NT Joseph rather than the OT King David, the dupe Uzzah rather than the vengeful Jonah (though between plates 2 and 3 he demonstrates the *lex talionis*). In plate 2

Hogarth works against the stereotype by making the Jew a dupe, as (following Steele and others) he worked against the stereotype of the Harlot by making her a victim. As he defined the human, contemporary Harlot through a template of NT Incarnation, Sacrifice, and Redemption, Hogarth uses the OT stereotypes of the Jew as both revenger and victim to humanize his Jew. The Jew's face expresses not lechery or beastliness but unease and insecurity. In this respect, as in their aping of fashion, the Jew and the Harlot are parallel types.

There is, in fact, a third: Woolston, his portrait on the wall above the Jew's head, the Jew, and the Harlot are all in the Uzzah position, touching the untouchable and for this transgression being stabbed by society's priests. Uzzah-Woolston in the painting is in a situation parallel to that of the Jew in the scene below — suggesting the sympathy Hogarth feels for both.

The painting of the Ark was keyed into the larger scene, rhymed by the common shape of the rectangular frame, one within the other, and by the forms within the painting: the tea table and the Ark; the Jewish keeper and Uzzah; the young lover and the bishop, both with swords, one stabbing the Jew, the other Uzzah. There are, however, two figures unaccounted for: David himself, dancing before the Ark, and above, in a window, his wife Michal.[165] The biblical commentaries stress the distinction between the two moments: the first "attempt" to bring in the Ark, "which failed and miscarried. The design was well laid (*v.* 1, 2). But, 1. They were guilty of an error in carrying it in a cart (*v.* 3–5). 2. They were punished for that error by the sudden death of Uzzah (*v.* 8, 9) and put a stop to his proceedings (*v.* 10, 11)."[166] Hogarth has conflated the two attempts and the two scenes: on the second, successful attempt to bring in the Ark, David leaps and dances, exposes himself (wearing only an ephod, a very scant garment), and Michal looks down from the window, sees him "leaping and dancing before the Lord; and she despised him in her heart" (6:16), addressing him with heavy irony: "How glorious [or honored] was the king of Israel to-day, who uncovered himself to-day in the eyes of the handmaids of his servants, as one of the vain fellows shamelessly uncovereth himself!" (6:20).

Presumably, the way Michal treats her "husband" David is echoed by the Harlot's treatment of the Jew. But the figures of David and Michal may also allude to the artist and his wife, and beyond to her father (Saul, or Sir James Thornhill) and his disapproval of his son-in-law — and perhaps her own impatience with her husband's disreputable, embarrassing project of painting the life of a prostitute — possibly offense at his blasphemous intent.[167] Michal's words to David, which connect David's raised ephod with Nature's raised skirt in *Boys*

Peeping at Nature, could allude also to Jane's doubts about the undertaking. The reference to David and Michal, and their alienation from her father, would have been rendered more poignant by the fact that Hogarth is asking for a comparison between his NT scenes and Thornhill's — in particular plate 6, the Last Supper. If the Jew's "Ark" is his trophy Hackabout, Hogarth's is the *Harlot's Progress* itself, being conducted into London by David, with memories of little David (Hogarth's short stature was noted by contemporaries) having defeated the giant Goliath. On the deepest level of significance, addressed to an esoteric audience of three or four only, social instability and social ambition connect the Harlot, the Jew, and Hogarth.

Atonement

The Problem of Vicarious Atonement

The Reverend Jacob Duché, a radical clergyman, wrote to Thomas Paine in 1767 that he "had an irreconcilable aversion to the Systematical Notion of atonement & satisfaction. A wrathfull god whose anger could only be appeased by the blood of His own Son pour'd out in behalf of Sinners allways appear'd to me next to blasphemous."[1]

Redemption was based on a financial transaction — a slave was ransomed. Atonement was based on law — a criminal act was punished. As opposed to Redemption, Atonement emphasized sacrifice. The roots of Isaiah's story of the servant who atones vicariously for those who mistreated him go back to Abraham's binding of Isaac, whose sacrifice is stopped to substitute a ram for the beloved son.[2] This, together with Exodus 22:28–29 ("the first born of thy sons shalt thou give it me"), and the use of "redemption" in Leviticus as *this* exchanged for *that*, has been interpreted to mean that initially the son was sacrificed. As Jon D. Levenson formulates the origins of Old Testament doctrine, the son was a substitute for the father, as the lamb substituted for the son — "and, in the Christian case, the

confessed son of God will become a substitute for the paschal lamb" of the Exodus Passover (e.g., 1 Cor. 5:7).[3] Saint John, who omits the institution of the Eucharist in his Gospel, places the Passover after the Crucifixion "to make the death of the Lamb of God occur at the same time as the killing of the Passover lamb."[4]

At some point the general problem of evil (death, misfortune) became attached to Adam and his original transgression, and this was the foundation of the "satisfaction theory" of Anselm, the eleventh-century Archbishop of Canterbury. In his *Cur Deus Homo? (Why Did God Become Man?)*, Anselm argued that sinful man, by Adam's Fall, has offended the honor of God and must therefore pay a penalty. But it must be vicarious: Adam committed the sin and all his descendants must suffer for his sin — and it can only be atoned for "satisfactorily" by someone sufficiently elevated to stand in for God as well as for Adam (and humankind) in the transaction. As Anselm formulated the theory, "no one but God *can* make this satisfaction," and "no one *ought* to make it except man," and therefore the penalty must be paid by a "God-Man."[5] The Son's vicarious obedience and punishment satisfied the demands of the *justitia legislativa* and provided an occasion for the Father to show his merciful graciousness toward humans.[6]

Protestant theology, L. W. Grensted writes, laid

> an emphasis upon the sinfulness and helplessness of man which was utterly foreign to the thought of contemporary Roman [Catholic] divines. . . . And this new emphasis naturally brought the doctrine of the Atonement into a new prominence. From henceforth it occupies a more central position than it had ever held for the mediaeval theologians. The overmastering realization of man's utter helplessness naturally turned men's thoughts to the great Fact whereby that helplessness is made good.[7]

The Reformation theologians revised Christ's "satisfaction" into a penalty paid by Christ with his blood to appease the wrath of an avenging God.[8] Anselm's choice between satisfaction and punishment disappeared when satisfaction became equated with punishment, and to such a degree that this view of Atonement came to be called the "penal-substitutionary" theory. The sinfulness and helplessness of humans could be redeemed only by Christ's substitution for them. Penal suffering was the source of "justification" (Grace) for the Protestant reformers, and this was reflected in England in the words of the second of the Thirty-Nine Articles — the official English doctrine: "Who truly suffered, was crucified, and buried, to reconcile His Father to us, and to be a sacrifice, not only for original guilt, but also for all actual sins of men."[9]

The story is beautiful seen through the eyes of faith and belief. The theme is ubiquitous in the hymns of Watts: "I call that legacy my own / Which Jesus did bequeath; / 'Twas purchas'd with a dying groan, / And ratified in death" (Euch. hymn 3). Legal tender slips into sacrifice as Watts writes that the Savior learns that "The price of pardon was his blood": "And with our joy for pardon'd guilt, / Mourn that we pierced the Lord."[10] "Infinite was our guilt, / But he, our Priest atones" (EH 9). " 'Tis Christ that suffer'd in their stead" (EH 14). In hymn 62, Watts has the congregation join with the voices of the angels:

"Worthy the Lamb that died," they cry,
 "To be exalted thus:"
"Worthy the Lamb," our lips reply,
 "For he was slain for us."

In Charles Wesley's words, Christ's was "An offering in the sinner's stead" — "My God, who dies for me, for me!" — "My sins which have thy body torn" (nos. 5, 6).

So Adam commits the sin of disobedience, and both the sin (the capacity for sinning) and its punishment are transmitted to and suffered by all his descendants. To atone for Adam's sin, it is not enough that men and women (all of Adam's descendants) must suffer. True atonement cannot be made to God by man (lowly man, the worm), and yet it was man who committed the Original Sin. Therefore a man-God is the only appropriate agent for Atonement. God must Himself take the form of man and suffer vicariously for him, atone for him.

Milton's Critique

In Patrick Hume's interpretation of *Paradise Lost*, we recall, the Son offers his own blood to satisfy the wrath of the vengeful Father: "*Atonement*, under the Mosaic Law, was an offering brought to appease God's Anger by Sacrifice out of the Herd or the Flocks, which was to be slain by him that offered it. *Lev.* I.v.4, and 5." Thus, Hume concludes, "nothing less than the First-born of the Almighty" can serve as satisfaction for Adam's sin — indeed is *"ordained to be a Propitiation."*[11] Propitiation, appeasement, expiation — these are the words Hume uses to describe the action of book 3, the council in heaven.

Milton's text supports Hume's interpretation. The Father's first plan after his foreknowledge of Adam's fall is condemnation and death; the second is satisfaction by sacrifice, essentially the penal-substitution theory. The Father is speaking of Adam:

> Die hee or Justice must; unless for him
> Some other able and as willing, pay
> The rigid satisfaction, death for death.
> (3.210–13)

Of the Father's call for "rigid satisfaction," Hume comments: "Make full satisfaction, make satisfaction to the utmost. Death for Death: The word *Rigid*, seems to imply a stiffness, an unrelenting satisfaction to be made to the Almighty Justice" (106). The terms are all those of the law.

Satisfaction and revenge comprise the view asserted by God the Father, but Milton adds the voice of the Son, creating a dialogue that supplements justice with mercy. Of fallen man the Father characteristically declares: "to me owe / All his deliv'rance, and to none but me" — "not of will in him but grace in me" (lines 181–82, 174). The Father's speeches are clogged with first person singular pronouns ("I" and "me" versus "him"):

> By me upheld, that he may know how frail
> His fall'n condition is, and to me owe
> All his deliv'rance, and to none but me.
> Some I have chosen of peculiar grace
> Elect above the rest; so is my will:
> The rest shall hear my call, and oft be warn'd.
> (lines 180–85)

The Father's demand, the basis of satisfaction theory ("Die hee or Justice must"), is followed by the question, "where shall we find such love," the answer being in the beloved son, who steps forward to offer his life: so far sacrificial atonement. But the Son replaces the Father's "rigid satisfaction, death for death" with "life for life" — the Son's for man's. And with this the Son enters the space between "Me" and "him," creating the triad of "Me," "Thee," and "him" — substituting "mee for him" and, as conciliation, offering: "Account mee man" and "on mee let thine anger fall." "I for his sake will leave / Thy bosom."[12] The Son freely offers to pay the "rigid satisfaction" and, in the spirit of vicarious Atonement, offers himself as a substitute for man:

> Atonement for himself or offering meet,
> Indebted and undone, hath none to bring:
> Behold mee then, mee for him.
> (3.234–36)

We shall have more to say about this dialogue when we turn to the poetry of Pope in chapter 5. It is enough to note that Hogarth was probably aware of Milton's dichotomy. Around 1725 Hogarth produced two illustrations, for the councils in Hell and in Heaven, books 1 and 3. Milton's contrast between the two councils privileged the latter, but, given our knowledge of Hogarth's views in the 1720s and his method in general, he may have intended a direct parallel — as he did in the two plates of *Before* and *After* (1736) and in plates 11 and 12 of *Industry and Idleness* (1747). The latter show the parallel processions of the Lord Mayor to the Guildhall and the condemned man to Tyburn, suggesting that the differences cancel out.[13]

The Empiricist Critique

As distanced by common sense, empiricism, and skepticism, vicarious Atonement came to sound cruel and dubious. With some irony, in *Leviathan* (1650) Thomas Hobbes described the shading of redemption/ransom into atonement/ sacrifice: "And though this act of our *redemption*, be not always in Scripture called a *sacrifice*, and *oblation*, but sometimes a *price*; yet by *price* we are not to understand any thing, by the value whereof, he could claim right to a pardon for us, from his offended father; but that price which god the Father was pleased in mercy to demand."[14] He turns from the economic to the anthropological model, connecting Christ's sacrifice to the one in Leviticus 16, as "atonement for the sins of all Israel, both priests and others," for whom they sacrificed a young bullock, but for the rest of the people two young goats. "As the sacrifice of the one goat was a sufficient, because an acceptable, price for the ransom of all Israel; so the death of the Messiah, is a sufficient price for the sins of all mankind, because there was no more required." To this Hobbes adds the analogy of "the oblation of Isaac," who was "both the sacrificed goat, and the scape-goat," turning then to the servant of Isaiah 53.[15] The binding of Isaac is the example Hogarth's Harlot hangs on her wall in plate 3 (and Fielding, ten years later, has his pious Parson Adams affirm in words but deny in practice).

Charles Blount's *Great is Diana of the Ephesians: On the Original of Idolatry* (1680), which was in Hogarth's mind when he introduced Nature in the figure of Diana of the Ephesians in *Boys Peeping at Nature*, was one of the basic deist tracts. Blount works characteristically by indirection: he attacks the sacrifices of "Heathenish" religions in order to expose as guilt by association the Christian Atonement.[16] When he recalls Agamemnon, "who offer'd up his only daughter *Iphe-*

genia; and if he could have procured one of the Gods themselves, it is very probable he would have sacrificed him to *Jupiter*" (31), he is obviously referring to another parental sacrifice. He admonishes those who think God "could be no otherwise appeased for the error of the wicked, but by the sufferings of the Innocent" (15).

Hogarth's Latinizing father may have drawn his son's attention to the skeptical Ovid. Near the beginning of his *Fasti*, a work much concerned with sacrifices (of goats and even pigs), Ovid has some fun at the expense of sacrifices offered the gods to appease their anger. The climax is the story of why one sacrifices an ass to Priapus: the god was attracted to a sleeping maiden and was about to insert his prominent sexual organ when an ass, seeing him, brayed in dismay, awakening the maiden and everyone else, making him a laughingstock—and so to appease Priapus asses are sacrificed at his altar ("The cause of the uproar paid with his life, and at Lampsacus this victim still pleases the god").[17] Sacrifice from the classical perspective would have been one way for Hogarth to regard the Atonement. From the colonial perspective, sacrifice was an abomination: the stories from the Americas of human sacrifice on the one hand and cannibalism on the other were easily applied by English Protestants to the Catholic sacrament of the Eucharist.

John Locke's downplaying of the Atonement accompanied his downplaying of Original Sin.[18] In *The Reasonableness of Christianity as Delivered in the Scriptures* (1695), he elided the doctrine of Vicarious Atonement (as well as Transubstantiation and the Trinity), tirelessly demonstrating that the Gospels prove only that Jesus is the Messiah and all that is necessary on the part of the Christian, besides reasonably good behavior, is to believe this. In this limited sense only is Jesus a "Savior."[19] Locke makes no reference to Jesus' words at the Last Supper, and so to the Eucharist and incarnational theory.

Locke begins by looking at "the doctrine of redemption" and what "we lost by Adam" as opposed to "what we are restored to by Christ" according to the evidence of the Scriptures. From "a diligent and unbiased search," he finds that

The two extremes that men run into on this point, either on the one hand shook the foundations of all religion, or on the other made Christianity almost nothing; for while some men would have all Adam's posterity doomed to eternal infinite punishment for the transgression of Adam (whom millions had never heard of, and no one had authorized to transact for him or to be his representative), this seemed to others so little consistent with the justice or goodness of the great and infinite God, that they thought there was no redemption necessary, and consequently that there was

none, rather than to admit of it upon a supposition so derogatory to the honor and attributes of that infinite Being; and so made Jesus Christ nothing but the restorer and preacher of pure natural religion, thereby doing violence to the whole tenor of the New Testament. (1)

Locke's account of the Redemption follows the theory of penal substitution. The crime was Adam's deviation from "the state of perfect obedience, which is called *justice* in the New Testament," whereby he lost eternal life (the "penalty"). Locke finds it hard to believe — and can educe no evidence for the supposition — that some interpret "death" to mean "a state of guilt, wherein not only [Adam], but all his posterity was so involved that every one descended of him deserved endless torment in hellfire." He finds it at odds "with the justice and goodness of God" and "a strange way of understanding a law, which requires the plainest and directest words, that by death should be meant eternal life in misery. Could anyone be supposed [to understand], by a law that says, 'For felony thou shalt die,' not that he should lose his life, but be kept alive in perpetual exquisite torments? And would anyone think himself fairly dealt with, that was so used?" (3). He questions the whole doctrine of "the corruption of human nature in his posterity," which claims that Adam's sin is visited upon all his descendants; for, "as I remember, everyone's sin is charged upon himself only." This sense of vicarious atonement in Adam's descendants obviously includes the equally barbarous sense of Christ's Atonement for Adam's sin.

The third earl of Shaftesbury, in many ways at odds with his teacher, nevertheless is following Locke when he describes the attributes of divinity as "malignity, arbitrariness, partiality or revengefulness." True, says the polite and ironic Shaftesbury, if

a contradiction were affirmed for truth by the Supreme power, they would consequently become true. Thus, if one person were decreed to suffer for another's fault, the sentence would be just and equitable. And, thus, in the same manner, if arbitrarily and without reason some beings were destined to endure perpetual ill and others as constantly to enjoy good, this also would pass under the same denomination. But to say of anything that it is just or unjust on such a foundation as this is to say nothing or to speak without a meaning.[20]

To Shaftesbury even atheism was less corrupting of virtue than emulation of a deity whose will and wrath are beholden to no independent sense of natural justice.

Locke noted, in *The Reasonableness of Christianity*, the strangeness of interpreting Adam's "death" to mean "the corruption of human nature in his posterity." In

law the equivalent of the theological doctrine was the taint of blood, "the instance of corruption of inheritable blood, upon attainder of treason and felony," passed from generation to generation, like Original Sin. Blackstone defines the recovery after "the restoration of king Charles II," including "the complete restitution of English liberty," noting the exception—he adds the "hope that corruption of blood may one day be abolished and forgotten." For the crime of treason (a civil equivalent of the disobedience of the Original Sin), the criminal forfeited all his properties, and by such forfeitures "his posterity must suffer as well as himself." The civil law echoes the Old Testament motto, that the sins of the fathers will be transmitted to the sons; its consequences are entailed on all Adam's descendants. Carrying on the Calvinist mode, Blackstone warns that "nothing can restore or purify the blood when once corrupted . . . but the high and transcendent power of parliament." Once pardoned by the king (the civil equivalent of God), however, the son of the person attainted might inherit, "because the father, being a new man, might transmit new heritable blood." "LASTLY," writes Blackstone, recalling the words of Paul (2 Cor. 17–19), "the *effect* of such pardon by the king, is to make the offender a new man . . . and not so much to restore his former, as to give him a new, credit and capacity."[21]

"And thus law," as Grensted explains the penal-substitutionary theory of Atonement, "came to be regarded as having a certain absolute intrinsic validity, claiming punishment from the offender not on personal grounds, or on grounds of expediency, but simply on grounds of justice. . . . The death of Christ is the legal penalty for sin, and there is no trace of the old alternative, 'either punishment or satisfaction'" (197–99). The Law, which in other ways was demonized by Pauline doctrine, returns to haunt the Calvinist theology of atonement.

A word is called for on the nature of sin. The criterion was obedience, involving duties and rituals owed to God. The Thirty-Nine Articles, seeking the Anglican "middle way," defined Original Sin as a corruption just short of complete depravity:

> Original sin . . . is the fault and corruption of the nature of every man, that naturally is engendered of the offspring of Adam; whereby man is very far gone from original righteousness, and is of his own nature inclined to evil, so that the flesh lusteth always contrary to the spirit; and therefore, in every person born into this world, it deserveth God's wrath and damnation. And this infection of nature doth remain, yea in them that are regenerated. (Art. IX)

Sin is original and ineradicable, a basic commonplace of existence, its consequence eternal damnation unless, in some cases, redeemed by Christ's sacrifice, God's Grace.

Sin is an offense against God (OE *synn*, ME *sinne*). In contradistinction to sin, evil, as a noun (OE), is simply something that brings sorrow or calamity, misfortune — the death, wars, natural disaster, and so on that are the consequences of Adam's Original Sin, the so-called problem of evil. In another sense, as an adjective, an evil person (as opposed to a sinner) violates the duties owed to other humans: a distinction between the OT law and Jesus' teachings of loving thy neighbor as thyself and doing to others as you would they do unto you. These are moral duties, and he who violates them is morally wicked (wicked: causing harm or trouble, disposed to mischief, roguish, knavish).

Trespass is crossing over a border — a violation of (in, during the eighteenth century, descending order) a religious, moral, or social code, an unwarranted infringement; and transgression (Latin *transgressus*): to step beyond or across — go beyond prescribed limits. Thus, the trespass or transgression of the original commandment in Eden is followed by the Ten Commandments handed down to Moses as God's Covenant with the Israelites and the immense body of legislation, from Exodus through Deuteronomy, that set the terms of God's Covenant with Israel. Breaking the first involves disobedience *and* transgression, against both God and man; breaking the second involves only disobedience of rules that set one apart for some degree of *holiness* (chosen people, elect, priesthood).[22]

Crime is the commission of an unlawful act, an act that is forbidden — or the omission of a duty, usually with the implications of civil law, as in the courts of King's Bench or Common Pleas. The important question will be not what is a crime (except to question the limitation of the concept) but what is sin, unholiness, evil, and transgression and what transformations or recoveries they undergo in eighteenth-century England. From the perspective of the clergymen the Harlot sins, of the magistrate she commits a crime, but in fact her error is a transgression — she imitates the fashionable lady, crossing a social boundary, trespassing on forbidden territory, committing a transgression of the sort Boileau associated with the mock-heroic; and of course Hogarth places the Harlot in a mock-heroic situation vis-à-vis the OT, in the allusions and the paintings that hang on her walls.

Substitution: The Harlot Died for Our Sins

The Harlot was not an inappropriate substitute for Christ, who was accused by the Pharisees of consorting with harlots, who excused the woman taken in adultery and befriended Mary Magdalen. Christ himself was usually said to be

"like us in all respects, *apart from sin*,"[23] but by some sects he was thought to share — taking upon himself — human sin as well. In his comment on the Atonement, Luther began with Paul's words, "Christ redeemed us from the curse of the Law, having *become a curse* for us" (Gal. 3:13); that is, Jesus has taken upon Himself the very worst of the human form. This Law has been satisfied, the punishment of Adam substituted for, by the death of Christ:

> He [God] sent His Son into the world, and cast upon Him all the sins of all men, and said to Him: Be Thou Peter that denier, Paul that persecutor, blasphemer, and violent David that adulterer, that sinner who ate the apple in Paradise, that robber upon the cross, in a word be Thou the person of all men, who has wrought the sins of all men: consider Thou therefore how Thou mayest pay and mayest make satisfaction for them. Then cometh the law and saith: I find that sinner taking upon him the sin of all men and I see no sin beside, save in Him, therefore let Him die upon the Cross. And so it attacks Him and slays him. This being done the whole world is cured of all sin and expiation made; therefore also is it free from death and from all ills.[24]

This is a role eminently suited in eighteenth-century England, in the terms of the penal-substitution theory of Atonement, to a whore. What was a whore? — a woman, in the words of *The Ladies Calling* (1673), who is "a kind of monster; a thing diverted and distorted from its proper form."[25] Whores were active givers rather than (the image of respectable women) passive receptacles. While respectable women were advised to remain sexually passive, whores could utilize the powers of the Lucretian Venus "for the sake of" — the pleasure of, the "good" of, the "guilt" of (OE *sacu*) — men.

In 1724 Bernard Mandeville (author of the scandalous *Fable of the Bees* [1714 ff.], which had argued that public virtue required private vice) published *A Modest Defence of Publick Stews*. This treatise argued with heavily pragmatic irony that prostitutes provide men a safe outlet for their sexual desires, prevent cuckoldry within the upper orders, and save women from venereal diseases and husbandly importuning during their frequent pregnancies.[26] Mandeville, however, stops short of the analogy with the Savior, the "spotless lamb": His analogy summons up the "modern Butcher, persecuted with a swarm of Carnivorous Flies," who "very Judiciously cuts off a fragment, already blown, which serves to hang up for a Cure; and thus, by *Sacrificing* a Small Part, already Tainted, and not worth Keeping, he wisely secures the Safety of the Rest" (xi–xii). I have emphasized the word that connects Mandeville's analogy with vicarious Atonement.

Mandeville speaks more directly when he writes that "we may look upon *Whoring* as a Kind of Peccant Humour in the Body-Politick, which, in order to its Discharge, naturally seizes upon such external Members as are most liable to Infection, and at the same time most proper to carry off the Malignity" (57). This "Discharge is promoted by a Licence for *Publick Stews*, which is a Kind of legal Evacuative," which will preserve the national "Constitution."

The public stews will prevent the "sin" of adultery by diverting married men's lust into safe channels. Whoredom, Mandeville notes, though it is "a direct Breach of a *Gospel*-Precept, and is therefore a Sin; but this Sin, barely as such, concerns the *Government* no more than the Eating of Black-puddings, equally prohibited in the same Text [Acts 15:29]" (70). Thus, the distinction that the *Harlot's Progress* makes between sin and morality: Hackabout "sins" but the men who live off of her commit moral crimes.

By introducing the analogies to the scriptural story, Hogarth replaces Mandeville's ironic "already Tainted, and not worth Keeping" with a deeper, more resonant and shocking irony. The back pages of newspapers were covered with remedies for venereal disease. In the late 1720s they began to crowd out respectable advertisements. Judging only by the advertisements, a reader might well conclude that the disease rate had appreciably increased, and this must be taken as part of the commentary of Hogarth's fifth plate, with its physicians and conflicting cures coupled with the image of degeneration and death. It is significant that the Harlot dies of venereal disease—but not, so far as we are shown, any of her clients. The theme was eerily reflected in the death of Mother Needham, the bawd of plate 1, who shortly before the publication of the *Harlot* was pelted to death in the pillory, apparently by (and so dying for) the same men she had supplied with pleasure: "They acted very ungratefully, considering how much she had done to oblige them," one bystander remarked.[27]

In 1728 John Gay's ballad opera, *The Beggar's Opera*, opened, the most popular play of the period, immediately sketched and painted by Hogarth (e.g., see fig. 54). In Mr. Peachum's opening song, he compares himself, the leader of a band of thieves, to the priest, the lawyer, and the statesman (and vice versa). It is only as the play proceeds that we see this as not a simile but, more precisely, a substitution. As the Beggar-playwright concludes:

> Through the whole Piece you may observe such a similitude of Manners in high and
> low Life, that it is difficult to determine whether (in the fashionable Vices) the fine
> Gentlemen imitate the Gentlemen of the Road, or the gentlemen of the Road the

fine Gentlemen. — Had the Play remain'd, as I at first intended, it would have carried a most excellent Moral. 'Twould have shown that the lower Sort of People have their Vices in a degree as well as the Rich: And that they are punish'd for them. (III.xvi)

First, "similitude," then thieves "imitate" the statesman, clergyman, and lawyer, and finally, at the end, they substitute for them on the gallows. Hogarth takes this one step further, showing that they thereby *atone* for the respectable, the "great," the ruling order; with the help of Mandeville, he intersects Gay's similitude and substitution with the Christian Atonement. The hint may have been in *The Beggar's Opera* itself when, in II.iv, Jenny Diver identifies Macheath to the constables by a Judas kiss.

Mr. Peachum and Captain Macheath *substitute* for the wealthy merchants and rapacious gentlemen they imitate and *die* for. Their deaths at the end of a rope are as surrogates for the great, who (perhaps *so that they can*) die in their beds. (Behind the parallel plates 11 and 12 of *Industry and Idleness* [1747] are all the stories of the great dying in bed, the low imitators of the great hanging at Tyburn.)

At the heart of his ballad-opera, Gay naturalizes mock heroic satire (the fish-wife talking like Dido) into actors playing the roles of gentlemen and ladies (Fielding carries this over into his novel *Joseph Andrews* in characters who "affect" the diction of their betters). The same joke, of course, informs the Harlot's situation as she imitates London fashion: she affects the lady, even taking a lady's "lover," and in Bridewell she is beating hemp in a lady's gown.[28] Hogarth, familiar as he was with the London stage, would have remembered the important place affectation played in Restoration comedies. The role of atoner, however, is not the one to which Hackabout aspires; atonement is Hogarth's way of representing in Mandeville's terms her exploitation by the people whose manners she affects.

The Blemished Lamb

The OT laws introduced another sense of transgression. Leviticus chapter 11 distinguishes clean from unclean animals, the latter called "abominations." Uncleanliness is an aspect of unholiness, defined in relation to what is holy, and especially involved with these distinctions were the priests, whose responsibility it was to distinguish the holy from the profane. Thus an important aspect of the unclean or unholy discussed in Leviticus was the blemish: a blemish disqualifies both sacrifice and priest from being efficacious. In Exodus and Leviticus it is

announced that a sacrificial animal, the lamb "shall be without blemish." "But whatsoever hath a blemish, that shall ye not offer: for it shall not be acceptable for you. . . . [I]t shall be perfect to be accepted; there shall be no blemish therein." In short, nothing can be offered unto the Lord that is "blind, or broken, or maimed, or having a wen, or scurvy, or scabbed," "bruised, or crushed, or broken, or cut . . . because their corruption is in them, and blemishes be in them: they shall not be accepted for you" (Exod. 12:5, 29:1; Lev. 1:3, 3:1, 4:3, 22:19–25).

In the NT Christ becomes the sacrificial Lamb. To maintain the correspondence between Jesus and the lamb, which must be intact when sacrificed, John adds the detail that, unlike the others crucified, Jesus' legs were not broken (John 19:36). Peter refers to "the precious blood of Christ, as of a lamb without blemish and without spot," referring to his heavenly origin, his virgin birth (1 Peter 1:19). In the Epistle to the Hebrews, Christ "offered to bear the sins of many": "How much more shall the blood of Christ, who through the eternal Spirit offered himself without spot to God, purge your conscience from dead works to serve the living god?" (Heb. 9:14). Blemish comes to imply original sin and sexual transgression, associated with the "lust of uncleanness" (2 Peter 2:13, 10).

The blemish specified in Exodus designated unsuitable offerings; the blemish specified in Leviticus was intended to define the priesthood. A man with a blemish cannot be a priest: "For whatsoever man he be that hath a blemish, he shall not approach: a blind man, or a lame, or he that hath a flat nose." Such a person "shall not go in unto the veil, nor come nigh unto the altar, because he hath a blemish; that he profane not my sanctuaries: for I the lord do sanctify them" (21:18, 23). As Matthew Henry's commentary explained, "It was very likely that some or other in after-ages that were born to the priesthood would have natural blemishes and deformities: the honour of the priesthood would not secure them from many of those calamities which are common to men." They could be fed if blemished, but "they must not serve at the altar."[29]

The sacrifice, object and officient, must be without blemish — but Jesus, insofar as he has assumed man's sins, *is* a blemish of the Son, even as the Christ, because he is human;[30] the Son in the Incarnation has taken on the human, fallen, blemished body — even more so if we accept the jokes about his mother. A harlot, therefore, could be regarded as the epitome of so-called human sin, especially in the sexual dimension emphasized by the Augustinian strain of Christianity, which was at the heart of Puritanism.

Mary herself was "a virgin, a pure unspotted one," as Matthew Henry put it in his *Commentary* (5:471). In *Harlot* plate 1, compared with Mother Needham's

several beauty patches, Hackabout's face is unblemished; she has one beauty patch in plate 2, presumably indicating the added *allure* of the fashionable patch (Pope's Belinda has on her dresser "Puffs, powders, patches, Bibles, billets doux"). But in plate 3 there are two, and, to confirm that they now conceal lesions, medicine bottles appear near her bed; in plate 4 there are two additional blemishes, small and near the first two as if to suggest the spread of the infection; and in plates 5 and 6 her face is barely visible, swathed in sweating blankets and, finally, enclosed in a coffin. Her blemish begins as an allure beyond ordinary beauty (as Hogarth writes in the *Analysis of Beauty*) but ends as the blemish that in London of the 1730s distinguishes her as the actual from the official, the unblemished sacrificial lamb. Hogarth ends the *Harlot's Progress* by showing his harlot, the blemished lamb, to be a sacrifice or Atonement for the men of London.

Hogarth bestows the priest's blemish ("he that hath a flat nose") on the Harlot's servant woman, whose nose has collapsed since (anticipating the Harlot) she has already suffered from syphilis.[31] This blemished woman is the only person in *A Harlot's Progress* who shows compassion for Hackabout. The clergymen in plates 1 and 6, outwardly without physical blemish but inwardly corrupt and self-serving, shun her. It is surely significant that the blemish is awarded to the one true "priest" who does serve, as it is to the sacrificial lamb.

The Object of Sexual Passion and Devotion

One of the more popular Communion manuals, *A Weeks Preparation Towards a Worthy Receiving of the Lords Supper* (1597), claimed that the sacrament has the effect of "weaning the senses from sin to devotion," that is, substituting a holy for a carnal love: "A little before his passion, he made himself my meat, and my drink, *to enter within me*, for which cause I am to hold his pains and mine own. . . . O that I could *enter into his enflamed heart*, and see the furnace of infinite fire, that burneth therein, and *melt* in those flames . . . issuing forth *full of love*" (emphasis added).[32]

There was a poetic tradition, predominantly Roman Catholic and High Church Anglican, that associated Christ with women, lovers, and the act of seduction itself—a tradition to which Hogarth may have thought it appropriate to join his harlot. In the 1630s–40s Richard Crashaw's ode on "Prayer," echoing Thomas Carew's secular love poem "The Rapture," included "amorous languishments," "dear and divine annihilations," "divine embraces," "soul-peircing glances," and so on. Worshiper and worshiped are in the "positions of ravisher

and ravished, penetrator and penetrated."³³ The result was a congruence of the libertine and devotional lyric (one sense of *parodia sacra*).³⁴

Crashaw became a Roman Catholic, and his excesses would have been regarded by Hogarth as grotesque, a poetry "too feverishly erotic in its address to the Virgin and [St.] Teresa,"³⁵ but he shared with John Donne and sometimes George Herbert a discourse in which the lover with the "power / To rifle and deflour" is urged to "Seize her sweet prey." One recalls Donne's "Take mee to you, imprison mee, for I / Except you enthrall mee, never shall be free, / Nor ever chast, except you ravish mee."³⁶ This type of poetry hovered in the devotional air of the Church of England, echoed in Anglican devotional tracts of the Laudian period that represented the same amorousness. In Christ's attraction "there is love-sickness, and lovely paine in Christs ravishings": "When Christ cannot obtaine and winne the content and good-liking of the sinner to his love, he ravisheth, and with strong hand drawes the sinner to himselfe."³⁷ Even Watts, the Calvinist, employed erotic passion, mediated by the Canticles, to praise the Savior. He refers to Jesus in a hymn as "Infinite Lover! Gracious Lord."³⁸

Anthony Horneck, whose *Happy Ascetick: or, the Best Exercise* was illustrated by Hogarth (6th ed., 1724),³⁹ published *The Passion of our blessed Lord and Saviour Jesus Christ* (1700?): Here the author, drawing on the Canticles, shows himself in the female position, making advances to Christ's beautiful male body: "My Beloved is Fair, having Dove's Eyes, as in the chiefest among ten thousand! Oh that I had my Beloved, I would not let him go, but he should lye all Night betwixt my breasts!"⁴⁰ As a backdrop, both Macheath and the very High Church Sacheverell (on the Harlot's wall in plate 3, next to her holy medal) were also noted for their attractiveness to women. A hundred years later Wordsworth could still write that Sacheverell was "absolved by female eyes / Mingling their glances with grave flatteries / Lavished on Him" (*Ecclesiastical Sonnets*, 3.11).

Behind these metaphors of love and seduction, even rape, was the image of Christ the bridegroom. In the OT this was the story of Jehovah's marriage to the virgin Israel — their rocky marriage ("Thou hast played the harlot with many lovers: Yet return again to me, said the Lord": "Return, thou backsliding Israel, saith the Lord; . . . for I am married unto you" [Jer. 3:1, 12–14]);⁴¹ and in the NT the marriage of Christ and his Church. As M. H. Abrams has pointed out, early commentators interpreted Christ's words on the cross ("*consummatum est*" in the Vulgate, John 19:30) in the sexual sense: "that Christ mounted the cross as a bed on which to consummate the marriage with humanity inaugurated at the Incarnation, in the supreme act of sacrifice which both certified and prefigured His

apocalyptic marriage at the end of time."⁴² Christ was a bridegroom, not a liber-
tine. The imagery of the Book of Canticles served as the type of the believer's
yearning for his Savior. Christ did for believers what bridegrooms did for brides.
He was said by ministers to "impregnate" the believers who longed "for the kisses
of Christ's mouth, not for a single kisse, but for kisse upon kisse." Church services
were the "marriage bed," and "a maid affected with the love of her beloved, is not
satisfied without the enjoyment of the marriage-bed."⁴³ The possession of the
soul by Christ was so physical as to be orgasmic, relying on carnal metaphors to
describe the experience.

 This tradition of sexual passion and devotion was burlesqued in Restoration
comedy, an area with which Hogarth, a devotee of the London stage, was thor-
oughly familiar (as is evident in the examples he cites in his *Analysis of Beauty*
manuscripts). One cannot miss the constant play of wit in similes relating love
and religious devotion. In Etherege's *Man of Mode* (1676), the rake associates
heaven with free sexual play, hell with marriage; doubts and scruples are "in
love . . . no less distracting than in religion" (I.i). Dorimant is regarded by women
as Satan the seducer of Eve — "a devil, but he has something of the angel yet
undefaced in him," Mrs. Loveit says (II.ii).⁴⁴ But the most remarkable example is
Horner in Wycherley's *Country Wife* (1675): Horner, whose name shows his
function, has spread word that he is emasculated in order to secure safe access to
London wives, whose husbands welcome him as a sort of chaperone. Lady Fid-
get's comment associates him with the servant of Isaiah 53, the Savior, and the
Atonement: "But, poor gentleman, could you be so generous, so truly a man of
honour, as for the sakes of us women of honor, to cause yourself to be reported no
man? No man! And to suffer yourself the greatest shame that could fall upon a
man, that none might fall upon us women by your conversation?" (II.i). By the
sacrifice of (the fame of) his manhood, Horner redeems London women from
the penalty of possessive husbands, though for his own pleasure.

 The erotic element of the *Harlot* has long been noted: the first painting Ho-
garth made, whose popularity supposedly led him to make the other five, was the
erotically charged third scene, and one source of the opening scene was Steele's
sentimentally erotic portrait of the young prostitute who stops him in Covent
Garden: "the most agreeable Shape, the finest Neck and Bosom, in a Word, the
whole Person of a Woman exquisitely beautiful. She affected to allure me with a
forced Wantonness in her Look and Air; but I saw it checked with Hunger and
Cold: Her Eyes were wan and eager, her Dress thin and tawdry, her Mien genteel
and childish. This strange Figure gave me much Anguish of Heart."⁴⁵ Steele's

description, mixing sentiment and prurience, would have described the response of spectators to the painting Hogarth first displayed in his shop in 1730.

Mother and Son

Devotional poetry based on the sexual passion for/of Christ also led, among other things, to the association of the Son with his Mother.[46] Precedent for the maternal Christ appears in Herbert's Latin poem "Lucus 34 (To John, leaning on the lord's breast)," which puts the poet in the position of the suckling babe, Christ in the position of its mother — he nourishes with blood as his mother with milk:

> Ah now, glutton, let me suck too!
> You won't really hoard the whole
> Breast for yourself! Do you thieve
> Away from everyone that common well?
> He also shed his blood for me,
> And thus, having rightful
> Access to the breast, I claim the milk
> Mingled with the blood . . .
> (lines 1–7)

Most notoriously, there was Crashaw's Marinesque poem, "Luke 11. Blessed be the paps which Thou has sucked":

> Suppose he had been Tabled at thy Teates,
> Thy hunger feels not what he eates:
> Hee'l have his Teat e're long (a bloody one)
> The Mother then must suck the Son.

The pervasiveness of such imagery in poetry and devotional tracts is testified to in the formulations of modern scholars: "Christ's suffering flesh was 'woman'"; one experiences "a relationship to the body of Jesus which is at once erotic and maternal"; and "To enter into Christ is to return to the womb."[47]

We know Hackabout is a harlot, but one of the details that gives her a positive value is the presence of her son; that is, she does not correspond to the stereotype of the mother guilty of abortion, infanticide, or (like Defoe's Moll Flanders and Roxana) abandonment of her children in infancy. Hackabout *ought* to be, like Moll and Roxana, the epitome of bad motherhood. A good mother, she does not dispose of her child but keeps him. Toni Bowers, discussing Hogarth's portrayal of maternity, has drawn attention to his examples of "maternal failure."[48] But

these are not "failed mothers"; they are good mothers rendered "bad" by society. Hogarth followed Hackabout three years later with the Rake's "wife," Sarah Young, who takes devoted care of her child as well as her faithless husband, and then with the Poet's wife in *The Distressed Poet* (1736, see fig. 52). In *The Distressed Poet* the comic contrast is between poetry and domestic economy, in *The Enraged Musician* (see fig. 53) between composed music and the raucous music of the street, both of which are mediated by a woman associated with the nourishing substance milk; in the first a mother is nursing her child (a cat her kittens), and in the second a pretty young woman is vending milk. Even the "bad mother" of *Gin Lane* (1751), who is feeding her child not milk but gin, is doing so because she has been abandoned (like the Harlot) by the civil authority (epitomized by the remote church spire crowned with the statue of the king).[49]

With these post-Harlot prints Hogarth may be expressing a deeper sense of the people's understanding, as opposed to the priesthood's and the Counter Reformation's, of the salvific story. Henry Adams showed in *Mont-Saint-Michel and Chartres* how the church's doctrine of rewards and punishments, its images of hell and damnation, came to be balanced by the popular images of Mary the Mother. For the people, Adams wrote (meaning medieval Catholics), "Mary was their only hope. She alone represented Love." Indeed,

> Mary concentrated in herself . . . the whole protest against divine law; the whole contempt for human law as its outcome; the whole unutterable fury of human nature beating itself against the walls of its prison-house, and suddenly seized by a hope that in the Virgin man had found a door of escape. She was above law; she took feminine pleasure in turning hell into an ornament; she delighted in trampling on every social distinction in this world and the next.

Adams notes "the convulsive hold which Mary to this day maintains" and argues that it "was due much less to her power of saving soul or body than to her sympathy with people who suffered under law, — divine or human, — justly or unjustly, by accident or design, by decree of God or by guile of Devil." She cared, according to Adams, "not a straw for conventional morality, and she had no notion of letting her friends be punished, to the tenth or any other generation, for the sins of their ancestors or the peccadilloes of Eve."[50] In short, she was felt, deeply and by Protestants as well as Catholics, to be a bulwark against the Law. In any case, Hogarth's Mary was not only a satire on Counter-Reformation Mariolatry but became in the succeeding years a transformation of Mariolatry into a viably sentimental English way of thinking.

We know little about Hogarth's mother: We do know that, after Richard

Hogarth's coffee house failed and he was confined to the Fleet Prison for debt, Anne Hogarth supported him and the children by selling home remedies for children's ailments ("In pity to Infants that cannot tell their Ails," her advertisement read).[51] We also know that in his maturity Hogarth lived in a household dominated by women — his sisters, wife, and his wife's mother — and that the inscription on his portrait of his mother was "His Best Friend"[52] (this vs. the very homosocial life he continued to enjoy in coffee houses and with his well-known circle, which included Fielding, Garrick, Thornton, the Hoadlys, Townley, and others).

By contrast with the mothers, Hogarth's representations of fathers, including that of his own father, shown (*Rake* 7) in the Fleet Prison with a crazy scheme for paying the National Debt, extend from the irresponsible to the tyrannous and destructive, from the Poet, engrossed in his poems while his wife tries to deal with bill collectors, to the old Lord Squander, who destroys his son with a contracted marriage. Unless we except Mr. West in *Industry and Idleness*, there are no good or even well-meaning fathers in Hogarth's works. Fathers both ignore and tyrannize their offspring, while mothers either nurture or are prevented by men from nurturing their children.

The Replacement of God: Deism, Hoadly, and Antinomianism

In *Harlot* 2, in the picture on the wall above the Harlot's head (see fig. 18), the figure of the vengeful God eradicating Uzzah is missing — substituted for by an Anglican bishop. In every representation of a religious painting in his prints, Hogarth elides the figure of God or replaces it by a low, common equivalent — in *The Punishment of Lemuel Gulliver* by Gulliver's bottom. The absence of God, as the immanent source of miracles, implies the primary belief of deists like Woolston in a merely transcendent deity.

Woolston demystified the New Testament miracles, showing an immanent god to be no more than a fabrication of priests. A sociopolitical reformer like Mandeville displaced God to his human surrogates and called them the ruling order, the social manifestation of rewards and punishments. Even the latitudinarian Bishop Hoadly, whom Hogarth cited on other occasions as his ecclesiastical authority, could have served as an authority for the substitutions of the *Harlot*.

In *The Nature of the Kingdom, or Church, of Christ* (1717), at the heart of the Bangorian controversy, Hoadly's "kingdom" of Christ was not of this world. In

this world the ecclesiastics and governors have set up a rival kingdom of men, with their own system of law, rewards, and punishments: "They erect *Tribunals*, and exercise a *Judgment* over the Consciences of Men; and assume to Themselves the Determinations of such Points, as cannot be determined, but by *One* who knows the Hearts [i.e., Christ]; . . . this is so far, the taking *Christ's Kingdom* out of *His* Hands, and placing it in their own"; they have simply replaced or "usurped the authentic legislator's role."[53] So, as Hoadly argues, "the Worship of God" has come to mean the worship of his surrogates — "the Neglect, and the Diminution of the father; and the Worship of other Beings besides, and more than, the *Father*" (7). Hoadly makes clear that against the Law he places the kingdom of Christ, by which he means the teachings of Jesus (as the deists did also).

Hogarth replaces the deity with his surrogate, the bishop who had indicted, convicted, and imprisoned Woolston for blasphemy. The priesthood has, as the deists claimed, appropriated the role of God and metes out his religion of rewards and punishments. God's role has been usurped by the ruling order, whether (in successive plates of the *Harlot*) representatives of the church, law, or medicine. The process of substitution, in short, does not end with the Harlot. Each of the men who prey upon Hackabout is an identifiable portrait of (or, as in the case of the clergyman's letter, an allusion to) a follower of Walpole: his ecclesiastical assistant Bishop Gibson, his magistrate Sir John Gonson, and his notorious follower Colonel Charteris. Gonson prosecuted Opposition satires and used his charges to the Grand Jury of Middlesex to praise Walpole's ministry and to attack Woolston. In 1728 he called for an investigation of "several wicked authors [who], in their pernicious books, dare to *blaspheme that holy name by which we are called* [i.e., Christians], and even in a ludicrous manner to write against the miracles . . . of our . . . Saviour."[54] To Hogarth it would have been doubly appropriate that Gonson (also notorious for his prosecution of prostitutes) should arrest Hackabout, Woolston's deist Virgin Mary. Even Charteris (whose primary association was with Walpole, who in 1730 had secured his pardon after his capital conviction for rape) claimed to have visited Woolston to discuss his *Discourses*.[55]

The Harlot, in this political context, would have reminded readers of Britannia, in the myth of Whig satire a beautiful young woman, the object of the lust of a Stuart monarch and his rakish, libertine courtiers. Opposition satire applied the analogy between the lecher's ruin of a maiden and the prime minister's ruin of the British nation to the reputed womanizer Walpole. In *The Craftsman* she was emblematic of Walpolean England: "A *bribed Corporation* is like a *Woman* debauch'd, and must expect to be turn'd off and left to shift for herself, when the

Corrupter hath serv'd his Turn."[56] Walpole's government was portrayed by the opposition as buying and selling votes: Britannia is therefore "prostituted."[57] Young Hackabout, newly arrived in London, surrounded by Walpolean representatives, begins as "England"; she becomes a victim of—as well as an epitome of—Walpole's "prostituted" England, a place where one can survive only by selling oneself.

For the beloved son the lamb was substituted, and for the lamb a lamb's shank bone on the Seder plate at Passover. In the same way, Charteris and Gonson are Walpolean substitutes or surrogates, serving in the place of another as agent or deputy; they stand in for Walpole as the Harlot does for them. But they are substitutes in the sense not of being sacrificed for him (Walpole saved Charteris from hanging) but of being his representatives. So, if Hogarth represents Walpole by his surrogates (especially Gibson), it is natural that when he deletes God it is to show how his power resides now only in human agents, the priests.

For his Antinomianism Hogarth could have cited Hoadly's *Nature of the Kingdom, or Church, of Christ*, where the Bishop says of the clergy:

> No One of them, any more than Another, hath *Authority*, either to make *New Laws* for *Christ's* Subjects; or to impose a sense upon the *Old* Ones, which is the same thing; or to *Judge*, Censure, or Punish, the Servants of *Another Master*, in matters relating purely to *Conscience*, or *Salvation*. . . . [Christ himself imposed] no Orders for the kind and charitable force of *Penalties*, or *Capital Punishments*, to make Men think and chuse aright; no Calling upon the *secular Arm*, whenever the *Magistrate* should become *Christian*, to inforce his Doctrines, or to back his *Spiritual Authority*. (16, 22–23)

But Hoadly went further, coming close to producing a gloss on the *Harlot*'s demystifying of the Eucharist. Three years after the *Harlot*, he published *A Plain Account of the Nature and End of the Sacrament of the Lord's-Supper* (1735), in which he memorably reduced the Eucharist to a communal supper.[58] Indeed, Hoadly presents the Eucharist as a commemorative dinner, a communion among the faithful, which *requires* Christ's bodily absence and precludes the element of sacrifice:

> The very *Essence* of this *Institution* being *Remembrance* of a past Transaction, and this *Remembrance* necessarily excluding the Corporal *presence* of what is *remember'd*, it follows that, as the only *Sacrifice* and the only *Sacrificer* in the Christian Dispensation are *unremember'd*, and therefore not *present* in the *Lord's Supper*, so the only

Christian *Altar* (the *Cross* upon which Christ suffer'd) being also by consequence to be remember'd, it cannot be present in this *Rite*, because that *presence* would destroy the very Notion of this *Remembrance*.[59]

"The whole Tenor and Form of this Institution," Hoadly concludes, "is in the *Figurative* Way of Speaking" (17). It is possible that Hogarth thought of the Harlot as filling that absence figuratively of the "Promise of Christ's *being in the midst of Us*" (160).[60]

Woolston was convicted of blasphemy for ridiculing church *and* state, which he really did not do, but the fear of blasphemy was that it would rub off from the one onto the other. The text was Exodus 22:28: "Thou shalt not revile the gods, nor curse the ruler of thy people." Joining God and "the rulers of the people" is, however, precisely what Hogarth does in the *Harlot's Progress* by implicating Walpole and equating his divine and secular agents with him. With Hoadly, Hogarth was expressing the belief that church and state should be separate entities.

Typology and Allegory: Mary and Hercules

In *Harlot* 1 Hogarth employs two gestalts, which juxtapose the Christian reference with the classical, the Visitation (Mary Hackabout, Mother Elizabeth Needham, and Colonel Charteris equals Mary, Elizabeth, and Zacharias) with the Choice of Hercules. In the latter the clergyman, Hackabout, and Mother Needham correspond to Virtue, Hercules, and Pleasure.[61] The Choice of Hercules was known by most educated Englishmen from their Latin texts and, more recently, from Shaftesbury's *Notion of a Draft of the Tablature of the Judgment of Hercules* (1713), where it rather than a Christian paradigm was recommended to history painters as the appropriate subject for that supreme genre, and the title page included an engraved example of what Shaftesbury was recommending (fig. 28).[62] The young Hercules (Heroic Virtue) comes to a crossroads, where he is met by two young women: The one upright, pointing, and speaking rational argument is Virtue; the other, languorous, sensuous, and silent, is Pleasure. The first gestures toward the steep hill that leads up to the Palace of Wisdom; the second toward the primrose path that leads to eternal perdition. The Platonist Shaftesbury's Hercules is supposed to choose abstract virtue over sensuality — and, indeed, the sexual intercourse that implicitly follows from an acceptance of Pleasure's embrace (as of the Harlot's).

But Heroic Virtue is a helpless girl from the country, alone in London; Vice is a self-centered clergyman, ignoring the girl, and Virtue is a bawd in the process of seducing her (fig. 29). Unsupported by "Virtue" (whose attention is on his own preferment) and unguarded against "Vice," who is shown assuming the pose of "Virtue" and (as Shaftesbury proposed for Virtue) rationally arguing her case, the allegory is undercut. The other story — of the Visitation, a typological fiction — is preferred, chosen, and pursued through the other five prints.[63]

Hogarth followed Woolston, who "historicized" the New Testament story to demystify and then "allegorize" it. Woolston, following Origin, believed that there *was* no literal, historical meaning, only the allegorical and spiritual (the spiritual level of personification). The story was literally, historically, rationally untrue; therefore it could only be read as allegory — "the mystical and true Meaning," which was invariably for Woolston the Antinomian story of Christ versus Law, Church, and priests. For example, the miracle of the devils Jesus drives out of the Gadarene men into their swine — the second miracle of Jesus discussed by Woolston in his first *Discourse:* Woolston cannot understand how there could be any swine among the Jews — and so it must have been a non-Jewish country, in which case Jesus has deprived the people of their livelihood. So he allegorizes the madmen as Mankind, "possess'd with Devils" because ruled by "diabolical Sins, and subject to the Worship of . . . false Deities, which we translate Devils." Thus the swine are "ministers of the Letter," that is, clergymen who follow the letter of the law and believe in the literal truth of the miracles — "because the *Letter* of the Scripture is mystically call'd *Swines* Food" (see below, p. 286).[64]

Hogarth also believed that the NT story of the Incarnation was not historically true, and he followed Woolston in seeing the true subject (beneath the veil) as Christian love exploited and destroyed by the ecclesiastical and political Law. But he refused to read it as spiritual allegory; he reasserts the historical truth of Charteris, Gonson, and the others, as well as the harlot named Hackabout. In fact, Hogarth named her after a well-known London whore, Kate Hackabout, whose brother Francis was capitally condemned along with Charteris but, unlike Charteris, went to his death.[65] Once again, Hogarth recalls Calvin, defending the figure of sacramental metonymy: "I pass over allegories and parables, lest someone accuse me of seeking a place to hide" (he likes to think of Transubstantiation as "hiding" Christ in the bread).[66]

If Hogarth read both *Grace Abounding* and *Pilgrim's Progress* (as he surely did), he followed the method of the former rather than the latter.[67] In the allegory of *Pilgrim's Progress*, the mental states of the first-person author of *Grace Abounding*

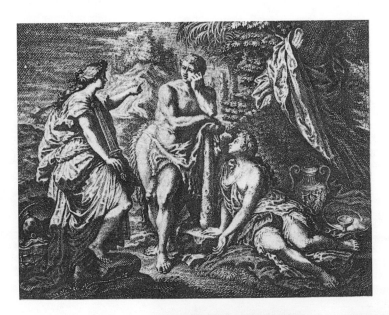

Fig. 28. Paolo de Matteis, *The Judgment of Hercules* (1713), engraving by Simon Gribelin. Reproduced by courtesy of the Trustees of the British Museum.

Fig. 29. Hogarth, *Harlot's Progress,* plate 1 (detail). Reproduced by courtesy of the Trustees of the British Museum.

Fig. 30. Hogarth, *The Cockpit* (1759), etching and
engraving, first state. Reproduced by courtesy of the
Trustees of the British Museum.

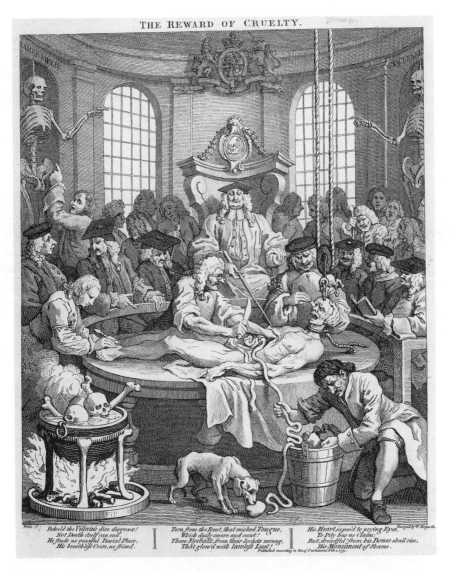

Fig. 31. Hogarth, *The Reward of Cruelty* (1751) (*Stages of Cruelty*, plate 4), etching and engraving, third state. Reproduced by courtesy of the Trustees of the British Museum.

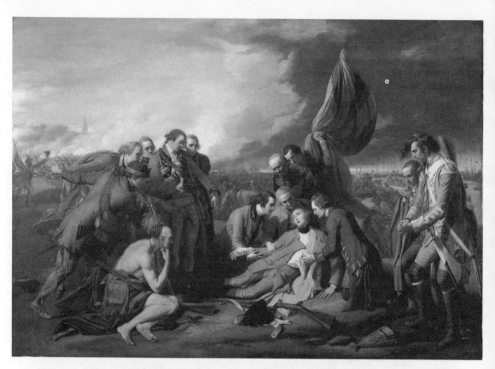

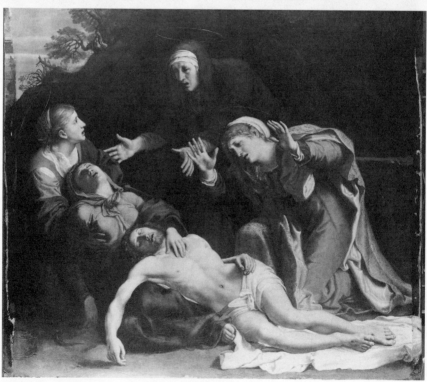

Fig. 32. Benjamin West, *The Death of General Wolfe* (1769), painting. Courtesy of the National Gallery of Canada, Ottawa.

Fig. 33. Annibale Carracci, *Pietà* (1606), painting. London, National Gallery.

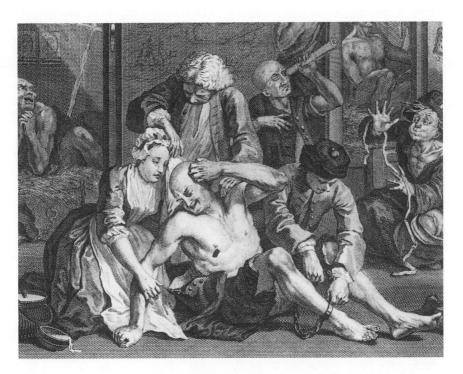

Fig. 34. Hogarth, *A Rake's Progress* (1735), plate 8 (detail), etching and engraving. Reproduced by courtesy of the Trustees of the British Museum.

are materialized in figures of Despair, Ignorance, Hopeful, even Mr. Legality (allegory, according to *Grace Abounding*, is based on "resemblance").[68] The minute concrete particulars of experience in *Grace Abounding* are read as signs — or evidence — of grace, election, and providence — or of damnation. This sort of reading was for Bunyan the opposite of the Anglican Church's "symbolism," its "superstition" of the rituals, vestments, priests, and icons. But with the game of cat — which appears to be much more than a game of cat — he attributes a meaning to it, *making* it an allegory of salvation; as he does with the bells, which are of no significance themselves, but only as he *interprets* them as the source of his sensuous enjoyment of their ringing and so a danger to his own being now and his fate in the hereafter, based on the fear of God's judgment. The same is true of the puddles he approaches in the road, which he makes a sign for whatever is going on in his mind — his thoughts of salvation and his testing of God — and in this case he entertains the possibility that the thought was put into his mind by the devil (as Moll Flanders explains the idea of killing a little girl whose necklace she steals). The significance (relation) of these particulars exists only in the consciousness of the perceiver.[69]

Bunyan in effect allegorizes the details. But when he attempts to define his character, he invokes the typology of precedents or models of good or bad, hypothesizing which he is like or is becoming; models by which he judges his position vis-à-vis salvation and faith. Ideally he is like — typologically related to — Christ (living an *imitatio Christi*), but in fact, he fears, it is Esau, who sold his inheritance for a mess of pottage, and at other times, Judas, Saint Peter, Saint John, and Francis Spira.[70] A historical figure, not an abstraction, is at either end of the typological relationship: Judas and Bunyan, and Judas never becomes Betrayal or Treachery; Bunyan never becomes Christian; and in the *Harlot's Progress* the Harlot, whether M. Hackabout or a generic prostitute, never becomes Pleasure or Vice.

Hogarth's practice of typology is based on the collection of art. The art collector or connoisseur (which includes even the humble Harlot) chooses this picture or object, which therefore characterizes him, expressing his consciousness; possessing it, it possesses him, imposing its meaning — its very ethos — upon him or her. The Harlot hangs portraits of Sacheverell and Macheath on her walls. The figures in the pictures serve as types, Macheath, Sacheverell, and Isaac being saved from Abraham's (read Gonson's) sacrificial knife foreshadowing the Harlot, from her standpoint hopefully. Uzzah and Jonah prefigure the Jew, who is being "stabbed in the back" and casts out the erring Hackabout; the Anglican bishop is

the typological fulfillment of the OT God. In the first three plates, Mary the Mother is the type of Mary Hackabout, but by plate 4, the Flagellation, she has been fitted into the substitutionary framework, taking on the role of Christ the atoner, but she has not herself assumed it as she tries to assume the roles of Macheath and Sacheverell. In the modern world the Christ role has been imposed on her by Charteris, Gonson, Gibson, and their society.

Grace: Choice and Chance

Another problem with the allegory of the choice of Hercules is that the subject should be choice, but choice too is undercut by history. Shaftesbury argued for classical as opposed to Christian iconography and a protagonist, in the act of choosing correctly for virtue, who is male not female. But the reference to Hercules, in the context of a story of crime and punishment, only serves to endow the Harlot with the illusion of choice (a Herculean choice), saying that she makes the wrong choice. In fact, she really has no choice; in the context of the Visitation, Nativity, and Last Supper, she is in a world not of classical choice but of Christian ecclesiastical myth, as shown not only in the NT parodies but also in the impinging forms of priests and bishops, magistrates, and prison warders, mechanisms of church, state, ideology, and power. The point is that this "Hercules," female and vulnerable in London society, has no agency in a Christian world of grace, election, and chance.

Plate 1 and the following five show Protestant choice, providence, and an immanent God disappear into a grim determinism—at best chance. The only choice is between the pill or the drop represented in an allusion to the casting of dice at the foot of the cross. And these scenes recall *The South Sea Scheme* (see fig. 23) and the subject of the notorious burst Bubble (with clergymen casting dice opposite a Flagellation) and *The Lottery*, Hogarth's parody of Raphael's *Dispute on the Blessed Sacrament of the Eucharist*, where the Host is replaced by the lottery wheel, Christian choice by existential chance (fig. 24).

Choice was the paradigmatic Protestant and Old Whig theme, the issue of Whig Liberty supplanting Stuart and papal tyranny. After the Fall, for Adam and Eve: "The World was all before them, where to choose / Thir place of rest, and Providence thir guide" (*Paradise Lost*, 12.646–47). The *Felix Culpa* was fortunate because it gave man choice. It took man out of a pastoral paradise into the real world where moral choice, and therefore good and evil, are possible. But of course moral choice did exist in Eden or Adam would not have fallen. It was not

choice but rather simple obedience that was tested and found wanting: thus at stake was sin and not crime or vice.

Choice was radically ambiguous. In the Miltonic version God the Father gives man free choice but foresees (if he does not predestine, or at least predispose him to) the wrong choice—a knotty theological problem that is worked out only through the mediation of the Son. In the Calvinist system, with a god of incomprehensible love and arbitrary damnation, man has no choice whatever. Whatever he does is marred by sin, bad motives, and natural depravity. Only God's arbitrarily bestowed mercy-Grace, and so only man's Faith, matters. Calvin admits that "Occasionally as the causes of events are concealed, the thought is apt to rise, that human affairs are whirled about by the blind impulse of Fortune, or our carnal nature inclines us to speak as if God were amusing himself by tossing men up and down like balls [*pelottes*]."[71]

Against Original Sin, in the Thirty-Nine Articles, choice and agency carry little weight. Complete dependence on the grace of God is asserted, with only a small loophole for good works:

> We have no power to do good works pleasant and acceptable to God, without the grace of God by Christ preventing us, that we may have a good will, and working with us, when we have that good will. (Art. X)
>
> We are accounted righteous before God, only for the merit of our Lord and Saviour Jesus Christ by faith, and not for our own works or deservings. (Art. XI)
>
> Albeit that Good Works, which are the fruits of Faith, and follow after Justification, cannot put away our sins, and endure the severity of God's Judgement; yet are they pleasant and acceptable to God in Christ, and do spring out necessarily of a true and lively faith; insomuch that by them a lively Faith may be as evidently known as a tree discerned by the fruit. (Art. XII)

From the OT onward, but especially in the Calvinist interpretation of the Pauline Epistles of the NT, God's favor is unrelated to the character of the recipient of grace; the choice is all on God's part, not man's. Favoritism and unpredictability are the characteristics of his choosing, posited on the irrelevance of human worth.

The absence of God in the *Harlot* says, if no more, that Hackabout's choice and her punishment are not a divine (or a poetic) justice but the result of human agency—of the Charterises (who employ the Mother Needhams), the Gonsons, and the clergymen. This imagery reappears in the gambling scene in *A Rake's Progress* (plate 6) and, above all, in *The Cockpit* (1759, fig. 30), another Hogarthian echo of a Last Supper, with the Christ figure now a gambler, replacing Christian

Grace with chance. To transform Holy Communion into a game of chance — a lottery, a cockfight — is perhaps a more imaginative comment than to turn the Savior into a harlot, but the basic premise is the same. The comment is also more plainly on (or can be interpreted as being on) the degenerate times: the Sacrament of Christ's love has been reduced to a lottery, Atonement and Salvation to a cockfight with bets, and Christ the Redeemer to an obsessive gambler. No longer chasing out the money changers from the Temple, Christ draws money from his hat. Religion and politics are still one: This, Hogarth shows, is what has happened to politics as to religion, in the 1750s, reduced to a game of chance.[72]

The Harlot's Last Supper

Isaac Watts's "Eucharistic Hymn" no. 2 describes the Lord's Supper in a way that could have been interpreted by some (especially Protestants attacking Transubstantiation) as a cannibal feast:

> Jesus invites his saints
> To meet around his board
> Here pardon'd rebels sit and hold
> Communion with their Lord.
> For food he gives his flesh,
> He bids us drink his blood;
> Amazing favour! Matchless grace
> Of our descending God!

In no. 5 we read:

> Bless'd be the Lord that gives his flesh
> To nourish dying men;
> And often spreads his table fresh,
> Lest we should faint again.

In no. 8, "Jesus invites his saints / To meet around his [God's] throne, / And we around his board," and so on, hymn after hymn.

It has been said that Watts's hymns were bloodthirsty. Hymn no. 7 of book 1 starts with the Communion "feast," the bread/Body that feeds "hungry, starving souls," and moves on to the Blood as "living streams" that "quench your raging thirst / With springs that never dry," which become "Rivers of love and mercy," "a rich ocean," and again "floods of milk and wine." Although bread is sometimes

invoked, it is primarily the blood that figures in Watts's hymns: the blood that enwraps Christ's body like a robe and the nourishing fountains of his blood that save us. "Mercy, like a mighty stream, / O'er all their sins divinely rolls" (no. 14). And nourishment is supplemented by cleansing:

> Come, and he'll cleanse our spotted souls,
> And wash away our stains
> In the dear fountain that his Son
> Pour'd from his dying veins.
> (no. 9)

The reference is to the blood of his wounds, the wine of his Communion Table.

The Lord's Supper could also be treated with mild subversion, as in Stephen Duck's popular poem, "The Thresher's Labor," which appeared in 1730, just as Hogarth was beginning to paint his six scenes of *A Harlot's Progress*. Duck starts with the classic paradigm of the Virgilian georgic and shows what happens to georgic "labor" in the real world by taking the position (his own, in fact) of the laborer, not the gentleman farmer, but he accomplishes this by conflating the classical *komos*, which celebrates the recovery of all the divisive forces of old and new in a comedy, with its Christian equivalent, the Lord's Supper. The classical analogue (equivalent to Hercules at the Crossroads) in his case is Sisyphus: "Like *Sisyphus*, our Work is never done, / Continually rolls back the restless stone" (lines 280–81). In the real world, the underclass does what its masters order. Indeed, there is no mention of God in Duck's poem, only reference to the master. In this world it is "the Master's Curse" the thresher fears, not God's.

The only way out of the thresher's labor is play and dreams; though, as with Swift's whore Corinna (who "Of Bridewell and the compter dreams, / And feels the lash, and faintly screams"),[73] not even sleep is efficacious: "Nor, when asleep, are we secure from Pain, / We then perform our Labours o'er again" (lines 250–51). The master beguiles the pain of work, once the harvest is done, by serving the communal supper:

> Our Master joyful at the welcome Sight [of the harvest],
> Invites us all to feast with him at Night.
> A Table plentifully spread we find,
> And Jugs of humming beer to cheer the Mind;
> Which he, too generous, pushes on so fast,
> We think no Toils to come, nor mind the past.

But the next Morning soon reveals the Cheat,
When the same Toils we must again repeat:
To the same Barns again must back return,
To labour there for room for next Year's Corn.
(lines 268–76)

Duck's genuinely proletarian georgic, reducing the Roman to the contemporary English countryside, spoke for the laborer but was appreciated by the court (if not by the Opposition, who ridiculed the "thresher Poet"); it also gives some sense of the way Hogarth's *Harlot* could have been read. More significantly, however, the master's feast for the threshers in fact evokes the Communion celebrated by Watts, Charles Wesley, and others. Watts, referring to the "kind memorials of his grace," goes on:

The Lord of life this table spread
With his own flesh and dying blood;
We on the rich provision feed,
And taste the wine, and bless the God.
(no. 6)

In the context of this feast, we are adjoined, "Let sinful sweets be all forgot, / And earth grow less in our esteem," and do not ask for more than the Lord/Master gives. "Carnal provisions can at best / But cheer the heart, or warm the head" (no. 18). In the hymns, as in Duck's poem, "Lord" and "Master" are synonyms, suggesting that for Duck the church is the vehicle for the control of the workers. The master's feast, which cheers the heart and warms the head, beguiles the unhappy threshers.

Ingestion as well as presence-absence was always central to the problem of the Eucharist. Edwin Sandys (distinguishing the "two things, a visible sign and an invisible grace: there is a visible sacramental sign of bread and wine, and there is the thing and matter signified, namely the body and blood of Christ") invoked the Protestant association of the Mass with cannibalism:

Thy teeth shall not do him violence, neither thy stomach contain his glorious body. Thy faith must reach up into heaven. By faith he is seen, by faith he is touched, by faith he is digested. Spiritually by faith we feed upon Christ, when we steadfastly believe that his body was broken and his blood shed for us upon the cross; by which sacrifice, offered once for all, as sufficient for all, our sins were freely remitted, blotted out, and washed away. This is our heavenly bread, our spiritual food.[74]

In this sense there is an implication in plate 6 of the *Harlot's Progress*, in line with English materialist interpretations of the Mass, that Hackabout is—has been—eaten and devoured, "made a meal of," by these cannibalistic Londoners.[75] They certainly—again to conflate Christian and classical imagery, as Hogarth does in plate 1—are all, priest and mercer as well as whores, together, celebrating a *komos* as if at the end of a comedy.

The same is true, even more outrageously, of Tom Nero in the *Stages of Cruelty* (1751). In the third plate an allusion to paintings of Christ taken in the Garden of Gesthemene (the closest analogue is one of the several versions of Van Dyck's painting)[76] begins the turn-around of our attitude toward Nero—from exploiter to himself exploited, an ultimate victim of society. The allusion in plate 3 only prepares for the final biter-bit situation of plate 4 (fig. 31), which is, of course, another parody of the Eucharist, in which Nero's body is now being literally eaten by the dog he tortured in plate 1, officiated over by a figure who is combined doctor, magistrate, and priest. Given the structure of Hogarth's pictures around an altar (as also in *The Cockpit*), the *Reward of Cruelty* can be interpreted as another Eucharistic "sacrifice" with the surgeon/magistrate consecrating the body and the blood. Nero is Christ in the garden and then the sacrificial body—a final reprise of the story of the Harlot.

Jane Shore and Sarah Millwood

In terms of literary sources, M[ary]. Hackabout recalls Nicholas Rowe's popular heroine Jane Shore (*The Tragedy of Jane Shore*, 1714), who was a harlot. Jane, however, was a Mary Magdalen, a harlot who repents and atones for her sins, whereas Hackabout was a humanized and feminized Christ whose death atones (ironically) not for her sins but for *their* sins, the sins of the rakes, clergymen, magistrates, physicians, and prison warders who exploit her. Nevertheless, though there is no suggestion that Jane Shore is a substitute, Rowe attaches Christological imagery to her in verbal echoes that are roughly equivalent to Hogarth's graphic allusions, and there is a sense in which *Jane Shore* is about atonement.[77]

In act V, the husband Jane abandoned to become Edward IV's mistress, returning in disguise, concludes: "Hence with her past offences, / They are aton'd at full." Rowe emphasizes the "three days" of her "Passion," like Christ's. She is betrayed by one who is pledged to "holy friendship" but, at the crucial moment, like Peter, denies her, declaring, "I know thee not" (lines 129–30, 197). The

scene in which Jane walks through the streets of London suffering the derision of the jeering mob "With the greatest Patience" ("silent still she pass'd and unre-pining") evokes the *Via Dolorosa* as well as Hackabout's ordeal in plate 4. Hack-about, of course, does not, like Jane, raise her eyes to heaven to "beg that mercy man denied her here," because she is not a penitent.

The way J. Douglas Canfield puts it is that Jane's "atonement is efficacious because of Christ's: she can achieve *at-onement* with God because, as Rowe's typological patterning suggests, she can participate in Christ's Atonement, which enabled Adam's descendants once again, as Christian doctrine expresses it, to become children of God and heirs of heaven." Rowe's allusions, in other words, suggest "Jane's oneness with Christ" in the sense that his Incarnation made Him one of us.[78]

It is her betrayed husband, Shore-Dumont, however, who, by breaking the law Gloucester has decreed against succoring Jane and therefore knowingly sacrific-ing his own life, takes upon himself Jane's sin and atones for her. When he first reveals his identity to her, he says: "My arms, my heart are open to receive thee, / To bring thee back to thy forsaken home / With tender joy, with fond, forgiving love" (lines 325–27). Jane the sinner expects only the wrath of the OT God:

No, arm thy brow with vengeance, and appear
The minister of heav'n's enquiring justice;
Array thyself all terrible for judgment,
Wrath in thy eyes, and thunder in thy voice;
Pronounce my sentence, and if yet there be
A woe I have not felt, inflict it on me.
(lines 329–34)

Indeed, it was "the merciless, stern law" that condemned her to her *Via Dolorosa*, "doing outrage on her helpless beauty" (I.i.102–3), and she expects no less from her aggrieved husband. But Shore represents instead the mercy of the NT Savior, "come to snatch thee from injustice. / The hand of pow'r no more shall crush thy weakness, / Nor proud oppression grind thy humble soul," meaning the Law, both human and divine (lines 336–38). In the moment of *anagnoreisis* she ex-claims:

Art thou not ris'n by miracle from death?
Thy shroud is fall'n from off thee, and the grave
Was bid to give thee up, that thou might'st come

The messenger of grace and goodness to me,

To seal my peace, and bless me ere I go.

At this point Jane is not herself Christological but, once again, the Magdalen, who first enjoyed the vision of the risen Christ (as Hogarth would show in his Bristol Altarpiece of 1756). As she realizes, "For me — for me! / Oh, must he die for me?" (lines 398–99), and as a Magdalen her words are "Forgive me! — but forgive me!" (line 414).[79]

It is possible that Rowe's play — which Hogarth would certainly have seen on the London stage — gave him the idea of using the Christological imagery of Atonement to show for whom the prostitute really atones in 1730s London. Certainly, Rowe is conveying the same NT revision of the OT law and vengeance that Hogarth makes the centerpiece of *A Harlot's Progress.*

In June 1731, two months after Hogarth announced the subscription for his *Harlot*, George Lillo's *London Merchant; or, The History of George Barnwell* opened at the Theatre-Royal in Drury Lane. Another attempt to modernize and nationalize tragedy and as great a success as the *Harlot*, *The London Merchant* was presumably written during the same period, 1730–31, when Hogarth was painting his "progress" (by the opening of the subscription, all six paintings, if not some of the engravings, would have been on display in his shop). Though laid in Elizabethan times, Lillo's play reflects the same 1730s London, and the aim is similarly to bring tragedy down to contemporary reality, public life to private, and the "superior rank" of the conventional tragic hero to "a humbler dress / Great only in distress." He refers in his dedication to "the novelty of this attempt," and contemporaries agreed, the *Weekly Register* noting the representation of characters "low, and familiar to Life,"[80] while Fielding defended the play against those who dismissed it "because the subject was too low."[81]

The main characters are George Barnwell, a "good apprentice,"[82] and the harlot Sarah Millwood who corrupts him. It is evident, however, at least initially, that it is young Barnwell's capacity for pity that leads him to steal for Millwood. He accepts her story of the lecherous guardian who, having discovered their first act of sexual intercourse, cast her out into the cold. Barnwell literally "redeems [ransoms]" her from the consequences of their "sin" by committing the crime that will lead to his disgrace and death, or to his "atonement" for her sins. He gives his life for her, though not knowingly "atoning" for her sins, which are quite different, but supposedly for *their* (or his own) sin of fornication: "Now you who boast your reason all-sufficient," Barnwell declaims, "suppose yourselves in

my condition and determine for me whether it's right to let her suffer for my faults [i.e., the original fornication] or, by this small addition to my guilt [the stolen money], prevent the ill effects of what is past." "Here"—he gives Millwood the money he has stolen from his master, Mr. Thorowgood—"take this and with it purchase your deliverance. Return to your house and live in peace and safety."[83]

A rough parallel can be drawn between their fornication and that of the Harlot and the young lover, who slips out behind her "guardian's" back in plate 2, the consequence of which is his casting her into the "outer darkness" of plate 3 (Matt. 25:30). But more generally, Lillo has rewritten Hogarth, or Hogarth Lillo.[84] Barnwell for love of Millwood atones for her at the sacrifice of his own virtue and life. That is the story from his perspective, based on his acceptance of Millwood's fiction of her life with her wicked guardian (as if the Harlot told her version of the story to the young man slipping out the door). As Millwood's servant Lucy says, "it is his love" that causes his crime.

But, as he later reveals (or sees it), this is only a rationalization: " 'Tis more than love; it's the fever of the soul and madness of desire. In vain does nature, passion, reason, conscience, all oppose it; the impetuous passion bears down all before it, and drives me on to lust, to theft, and murder," and so he is in fact justly punished for "lust and parricide." In fact, though, the latter is the crime.

The first scene of the play—the Rotarian discussion by the master Thorow-good and the good apprentice Trueman on the virtues, public and private, of the merchant—establishes the context for Barnwell's transgression. It is staying out overnight (secondarily, one of the apprentice's commandments, against fornica-tion), which is disobedience to his master, who was his "father," the figure *in loco parentis* for apprentices. And the conflict set up by Lillo is the old one of the heroic play, between duty/honor and love/passion. It is instructive to see *The London Merchant*, like the *Harlot*, in relation to its more high-flying models: Dryden's Almanzor and Almahide, his Antony and Cleopatra, with their strug-gles between duty and love. Lillo turns these into Barnwell torn between his merchant's law of duty and his passion for Millwood: a translation already re-flected in the burlesque figures of Gay's Macheath and Polly Peachum, who stood in for Dryden's Antony and Cleopatra. As another *Beggar's Opera*, Lillo's play reduces, or rather reclassifies (in his case, elevates as modern and national), chivalric duty into business, the knight into an apprentice—his tragic flaw the apprentice's disobedience. Lust is Barnwell's sin only insofar as it broke one of the rules of the apprentice manuals and insofar as it leads to his second sin, theft from his master—and on to murder of his surrogate father/master, his uncle.

Barnwell's attempt to "redeem" Millwood — on a material level, with money — is contrasted with his failure to redeem her spiritually and with the question of his own redemption. In short, while he sets out to "redeem" Millwood, and for a moment it seems as if this will be his aim, in fact his sin opens up the story of his own redemption, in specifically Christian terms (like Jane's in *Jane Shore*). And since the play is about an apprentice and his master, it reflects Adam's temptation and submission to Eve. "Young, innocent, and bashful" (I.ii), Barnwell is prelapsarian man. The last scenes (including the scene on the scaffold, cut from performance and the early editions) show Barnwell's happy ending, first, in legal and moral terms (the single case of bad conduct punished, the whole spread of his life — or "character" — not only mercifully forgiven but commended, indeed celebrated) and, second, in soteriological terms (saved by God's mercy). And so the end reveals the possibility of forgiveness, contrasted with the case of Millwood, who does not repent. "I find a power within," Barnwell tells Thorowgood as he awaits execution, "that bears my soul above the fears of death, and, spite of conscious shame and guilt, gives me a taste of pleasure more than mortal" (V.ii.75–77).

Thorowgood, who forgives him (as did his uncle before dying), represents the NT God of mercy, and the clergyman he has sent to comfort Barnwell has "removed the doubts I labored under. From thence I've learned the infinite extent of heavenly mercy; that my offences, though great, are not unpardonable; and that 'tis not my interest only, but my duty, to believe and to rejoice in that hope: so shall heaven receive the glory, and future penitents the profit of my example." Barnwell's last words are: "Th'impenitent alone die unforgiven / To sin's like a man, and to forgive like heaven" (V.iii.69, 87–88).

Millwood's role, it seems, is "to punish" him and other men. At this point Lillo has returned to the original lesson of his source, "The Ballad of George Barnwell," which was "Take heed of harlots then, / And their enticing trains."[85] (Millwood's servant Maria — whose name may also be significant — offers, like Sarah Young, to redeem him with her own money.) And when Millwood, apprehended, turns on the men who are arresting her, her speech is one that could have been spoken by Hackabout if she were as eloquent as Millwood. (In her opening sentence Millwood sounds the note of Mr. Peachum in his opening song in *The Beggar's Opera*.)

> Men of all degrees and all professions I have known, yet found no difference but in
> their several capacities. All were alike wicked to the utmost of their power. In pride,

contention, avarice, cruelty, and revenge the reverend priesthood were my unerring guides. . . . Such are your venal magistrates who favor none but such as, by their office, they are sworn to punish. With them, not to be guilty is the worst of crimes and large fees, privately paid, is every needful virtue. (IV.xviii.65)

Mr. Thorowgood responds, for Lillo, that "Your practice has sufficiently discovered your contempt of laws, both human and divine. No wonder, then, that you should hate the officers of both." Despite Thorowgood's denial, Millwood's words ring out as forcefully as Hogarth's images: "Whatever religion is in itself, as practiced by mankind it has caused the evils you say it was designed to cure. War, plague, and famine has not destroyed so many of the human race as this pretended piety has done, and with such barbarous cruelty as if the only way to honor Heaven were to turn the present world into Hell." Thorowgood admits: "Truth is truth, though from an enemy and spoke in malice. You" — he turns, addressing Millwood's own object of abhorrence — "bloody, blind, and superstitious bigots, how will you answer this?" Her position is the Antinomian one, seen from the female perspective:

What are your laws, of which you make your boast, but the fool's wisdom and the coward's valor, the instrument and screen of all your villainies by which you punish in others what you act yourself or would have acted, had you been in their circumstances? The judge who condemns the poor man for being a thief had been a thief himself, had he been poor. Thus, ye go on deceiving and being deceived, harassing, plaguing, and destroying one another, but women are your universal prey. (66)

Lillo makes Thorowgood, though the symbol of "law," a good and forgiving master and not the OT God of Millwood's diatribe. In short, Hogarth's Harlot is divided between Barnwell and Millwood: (1) Barnwell, the moral paragon and martyr whose attempt to "redeem" Millwood is based, however, on her lies and his own (as he admits) lust, and (2) the villainess Millwood, who makes a direct statement of the *Harlot*'s argument that her acts are simply the consequence of church and law. (She suggests that her origins are like those of the Harlot: "I curse your barbarous sex who robbed me of [her "uncommon perfections of mind and body"], ere I knew their worth, then left me, too late, to count their value by their loss.")[86]

On the scaffold Millwood, who denies Barnwell's hypothesis, is the tragic hero. But failing to repent can never really qualify as tragic if the opportunity for salvation exists. The question is: How do we take the interplay of Barnwell and

Millwood *on stage* in the final scene? Is he normative, or are they simply two characters representing different codes, discourses, and histories?[87]

In the final (suppressed) scene, there is, first, the normative voice of Barnwell —speaking obviously for the author—with which, if we believe it, we might expect angels to descend in preparation for his ascent to heaven—and devils for transporting Millwood in the opposite direction. But, second, in the wake of deist methods of reading texts and of Hogarth's *Harlot* itself, it is not difficult to imagine the two characters as speaking, respectively, the discourse of the Anglican Church (associated with the merchant class and the life of the apprentice) and the discourse of the freethinker—an agon without clear resolution. Millwood could but does not become a Penitent Magdalen, in which case she would have at least proved the Barnwell-Thorowgood point that such sinners lose their resolution at the last moment and seek forgiveness.

"I tell thee, youth," she says to Barnwell on the scaffold, "I am by Heaven devoted a dreadful instance of its power to punish"—"heaven" being to her, the Antinomian, the church and constables, religion and law, from the first turned against her, with which there is no inconsistency when she concludes, "Sure 'tis the worst of torments to behold others enjoy that bliss that we must never taste," here and in some suppositious afterlife. Her only wish is an existential one, in no way related to the promise of heaven, "That I could cease to be—or ne'er had been!" The final (moralizing) words are those of Trueman, which support Barnwell's position:

> In vain
> Will bleeding hearts and weeping eyes we show
> A human gen'rous sense of others' woe,
> Unless we mark what drew their ruin on,
> And by avoiding that—prevent our own.
> (Viii.101–5)

In this play the mimesis is at odds with the moral: Either Trueman's instruction undermines Lillo's mimesis, or the mimesis undermines the moral, and Trueman's speech is just another statement of Barnwell's and his master's—the respectable business point of view. But Millwood expresses the Antinomian position in its two aspects: She makes a powerful case against the law and religion (Calvinist predestination, which Barnwell seems to affirm, is to her merely part of the law), but her reaction to her own violation was libertinism, which, however, if we are to believe her words, has a strong component of *ressentiment* and vengeance.

In the Barnwell discourse, her damnation redeems men by its horrible example. In the deist or libertine discourse, there is no way in which her death redeems anyone — though there is no reason to conclude that she is going to be damned any more than Barnwell saved. There are different senses of redemption: Barnwell's false (deluded) redemption of Millwood; his true redemption, as he and his colleagues see it, through God's mercy; and Millwood's refusal to be "redeemed," seeing only damnation ahead *and* accepting it without attempts to repent or seek grace.

Atonement involving as it does the agent's death, in some very general sense Samuel Richardson may have felt that Clarissa's willed death — an action with agency if there ever was one — "atoned for" her terrible family and her seducer Lovelace. But when Belford compares her to a "sweet lamb," it is only in the sense that Lovelace is a wolf who has "singled [her] out from a flock thou hatest."[88] The only atonement is the Harlot's death for the Charterises, Gonsons, and (implicitly) Walpoles.

A sense of atonement was picked up in the nineteenth century in the sentimental deaths of Nancy in *Oliver Twist* and Sydney Carton in *A Tale of Two Cities*. Dickens writes a redemptive novel of a sort that has no parallel in the eighteenth: Oliver is born out of wedlock, the result of his mother's sin, and left in a foundling hospital, subsequently submerged in a life of crime and misery. He does little himself, and the story is of his redemption — that is, his return to his lost family — but it is brought about by the sacrifice (atonement) of Nancy, the prostitute who relives in this Oliver-centered plot the symbolic role of Hogarth's Harlot.

In *A Tale of Two Cities*, the dissolute Sydney Carton takes the place of Charles Darnay, saving him and "redeeming" Lucy and her family. A self-conscious descendant of Hackabout, going to the guillotine in Darnay's place, Carton sees "the evil of this time and of the previous time of which this is the natural birth, gradually making expiation for itself and wearing out." He envisions "the lives for which I lay down my life, peaceful, useful, prosperous and happy," as he understands that "I hold a sanctuary in their hearts, and in the hearts of their descendants, generations hence," and, he concludes famously, "It is a far, far better thing that I do, than I have done."[89] This is on the face of it unlike Hogarth's Harlot, who atones for worse sinners than she. Nancy and Sydney atone for their own sins. But the idea of the respectable contrasted with disreputable people, who are technically not sinners (they do not break the laws) but are evil, is very Dickensian, one of the many lines of influence connecting him to Hogarth.

Efficacious Atonement: West's *Death of General Wolfe*

A case of sacred parody in an eighteenth-century painting that is generally acknowledged by art historians is Benjamin West's *Death of General Wolfe* (1770, fig. 32). West places the dying General Wolfe in the composition of a Pietà or Lamentation (recalling, e.g., Annibale Carracci's *Pietà*, fig. 33).[90] In a very different way from Hogarth's *Harlot*, West suggests — or creates — a parallel between Wolfe's death at the news of his victory in the Battle of Quebec and Christ's body at the foot of the cross. The Union Jack rising diagonally behind and above the dying general punningly invokes the cross. Seen from the perspective of twelve years after the event, the political smoke had cleared and the imperial consequences were apparent, and Wolfe's death has become a Pietà; that is, his death taking place at the moment of imperial victory is a sort of "atonement" in that Wolfe gives his life for England's empire, though what his death is "atoning" for is not clear. The art historian Allen Staley refers to "Wolfe's death for his country as part of the price of a great victory" but adds, misleadingly, "a modern martyrdom," which is considerably less than an Atonement.[91] In West's *General Wolfe* the term *atonement* is politicized and nationalized, stripped of its serious core meaning of death for the sins of others — unless we are to assume that West refers to the sins of the English government or people or the deaths of the soldiers at the Battle of Quebec.

Redemption perhaps rather than Atonement ("part of the price of a great victory")? But Wolfe pays for the victory with his life — on the classical model of self-sacrifice prepared for in West's most recent painting, *The Departure of Regulus* (1769). The Roman general Regulus, who has been sent back to Rome to persuade his countrymen to surrender, feels that he must return and "pay the debt of" his life to the Carthaginians in return for his advice to the Romans to persist in fighting. He atones to the Carthaginians for the lives of the Romans, but, given the classical subject, without having to invoke a Christian icon. The successful reception of *Regulus* was followed by commissions from George III to paint the deaths of Epaminondas and the Chevalier Bayard after their victorious battles.

The subject was history and the result was an orthodox history painting, though it portrayed contemporaries and placed them in a relatively accurate representation of the Plains of Abraham outside Quebec — a heretical procedure

for academic artists even in the 1760s. Most of the figures other than Wolfe were alive and are presumably portraits from life, a group that would have been thought of as a conversation piece, of the sort Hogarth developed in his own way in the *Harlot's Progress*.[92] West's reply to Reynolds's argument, as reported by him to James Galt:

> I began by remarking that the event intended to be commemorated took place on the 13th of September 1758 [in fact 1759] in a region of the world unknown to the Greeks and Romans and at a period of time when no such nation and heroes in their costume any longer existed. The subject I have to represent is the conquest of a great province of America by the British troops. It is a topic that history will proudly record and the same truth that guides the pen of the historian should govern the pencil of the artist.[93]

The painting was a significant landmark for its bold replacement of Roman togas, which universalized, with contemporary clothes, the military attire of the 1750s — a position opposed by Reynolds and the Royal Academy and initially at least by West's patron George III. Echoing his only (well-known) precedent, the Pietà of the dying Rake in Hogarth's *Rake's Progress* 8 (fig. 34), West reversed its effect. Instead of bringing the spiritual down into the local and particular, he raised the temporal into the spiritual. (We can imagine Hogarth noting, with the parallel of cross and Union Jack, that Wolfe was "crucified" on a Saint Andrew's Cross.)

 Unlike the individual scenes of the *Harlot*, where one reads from left to right, in West's painting one's attention is drawn first and primarily to the red, reclining figure of the general — as Reynolds would have said, taken in at a single glance[94] — and then the eye moves through the figures surrounding Wolfe and, following the pointing hands of the figures on the left, back to the scene of victory, perhaps upward to the sky; then, with further attention, beginning in the right with the landing of British troops from the Saint Lawrence and culminating on the far left in victory, carried back from left to right by messengers.

 West's painting, which like Roubiliac's funerary sculptures owes something to Poussin's *Death of Germanicus* (and Wolfe is a sort of recumbent funerary figure), is decidedly distinguished from the *Harlot's Progress* by the unity of expressions surrounding the transfigured body of the general. The responses of Hogarth's figures, as in *Harlot* 6, are diverse and centrifugal, separating one figure from another, certainly not focused on Hackabout's body. West's stratagem is the opposite: He establishes a unity that makes every figure contribute to the single

impression of awe, grief, and exultation focused on Wolfe. West reflects the aesthetic theory of Reynolds, who delivered his first *Discourse* as president of the Royal Academy five years after Hogarth's death. The result was unequivocal celebration of empire, a totalizing procedure that West carried out with an effect quite the opposite of Hogarth's.

Incarnation

Mary's Magnificat

With the doctrine of Incarnation, the emphasis could go either way, toward the idea of God's descent into man, God rendered carnal down to the level of a harlot, or toward the sacralizing of the human, the elevation of man, the proof that, because God took our form, we have value *as humans*. The Calvinist strain of theology leaned toward the Incarnation as the expression of God's condescension. As John Donne wrote: "God cloth'd himself in vile mans flesh, that so / Hee might be weak enough to suffer woe."[1] This was the gist of Watts's hymns, which are all about Christ lowering himself into man's body, never about the value the Incarnation imparts to human beings, who remain for Watts "worms." Eucharistic hymn 2, paraphrasing John 1:1 ff., emphasizes "our descending God":

But lo! he leaves those heav'nly forms,
The Word descends and dwells in clay,
That he may hold converse with worms,
Dress'd in such feeble flesh as they.

"How condescending and how kind . . . pity brought him down." Among "th' amazing deeds / That grace divine performs," one is that "Th' eternal God comes down and bleeds / To nourish dying worms" (nos. 4 and 17).

The other interpretation of Incarnation, as sacralizing of the lowly, was embodied in the Magnificat, Mary's song of praise when, having heard the Annunciation, she compares stories with her cousin Elizabeth and, convinced, exclaims: "My soul doth magnify the Lord, . . . For he hath regarded the low estate of his handmaiden: for, behold, from henceforth all generations shall call me blessed. . . . He hath put down the mighty from their seats, and exalted them of low degree. He hath filled the hungry with good things, and the rich he hath sent empty away" (Luke 1:46–53). The moment when Mary utters the Magnificat was, of course, the moment Hogarth represented in *Harlot* 1, with Mary meeting Elizabeth (Elizabeth Needham) and Zacharias (Colonel Charteris) standing in the doorway.

When Watts imitates the Magnificat (as he does in hymn 60 of book 1, "The Virgin Mary's song"), it is "Our souls [that] shall magnify the Lord," not the Lord who magnifies us, and he draws a heavy line between Mary the Mother and divinity:

> Let ev'ry nation call her bless'd,
> And endless years prolong her fame;
> But God alone must be ador'd:
> Holy and reverend is his name.

As far as Watts will go is to acknowledge that God's condescension has bestowed on man His Grace:

> 'Twas he that cleans'd our foulest sins,
> And wash'd us in his richest blood;
> 'Tis he that makes us priest and kings,
> And brings us rebels near to God.
> (hymn 61)

And, taking a grudging step closer, Watts has his God say, "But I descend to worlds below," and add: "On earth I have a mansion too; / The humble spirit and contrite / Is an abode of my delight" (hymn 87).

In Matthew Henry's commentary on the Magnificat, "the low estate" indicates God's "*condescension* and *compassion* to her [Mary]. . . . that is, he has *looked* upon her *with pity*," for "she was the *least in her father's house*, as if she were under some particular contempt and disgraced among her relations, was unjustly ne-

glected, and the outcast of the family, and God put this honour upon her, to balance abundantly the contempt." While in her Magnificat "Her *soul magnifies* the Lord," the Lord exalts by the Incarnation "those of *low degree*, who despaired of ever advancing themselves, and thought of no other than of *being ever low.*"[2]

If one aspect of the Magnificat was conferring value or sacralizing the ordinary human body, another was raising the low while depressing the high, summed up in the final verse, "He hath filled the hungry with good things; and the rich he hath sent empty away" (Luke 1:53). That God may "elect" some humble person like Mary for his purposes introduces class themes that were picked up by the discourse of radical Protestantism, used to demonstrate, as Clement Hawes has pointed out, that "God's 'regard' for Mary, despite her poverty and gender, represents a triumph for all the lowly of the earth, and a defeat for the rich": "Mary praises God for reversing the hierarchical distribution of attention. . . . It is not only that Mary is elected and 'magnified': more generally, the poor are likewise chosen over the rich, who are to be 'sent empty away.' The Magnificat 'magnifies' not only God, but also the materially and spiritually dispossessed. It is thus a scriptural passage ripe for appropriation by spokesmen for the 'lower' orders."[3]

Hawes cites the Leveller Gerrard Winstanley, who wrote: "the blessing of the Lord is amongst the poore, and the covetous, scoffing, covenant-breaking, thieves and murderers, that croud themselves under the name Magistracie, shall be sent empty away."[4] Thus the notorious case of the Ranter Abiezer Coppe, who, in his tracts called *A Fiery Flying Roll [i.e., of thunder]* (1649 ff.), was uttering a Magnificat when he called for the leveling of "the great ones," the ruling order, and drew attention to the "unspeakable glory" of the basest of mankind, the poor, the thieves, and the whores ("mine own brethren and sisters, flesh of my flesh, and as good as the greatest Lord in England").[5]

The Magnificat is describing what has happened to Mary: God has chosen to possess and raise her — and to lower the great of this world accordingly; as one goes up, the other comes down. The point made by Hogarth's *Harlot* is that the "great" and the miserable are correctly measured in this way, but the artist also, by the allusions to Atonement and Incarnation, elevates all the low figures of the subculture, suggesting a modern truth in the Magnificat.

Christ in Us: James Nayler

The "Incarnation" and "Atonement" of the Quaker James Nayler remained a potent memory, either as admonitory or martyrological figure. In 1716 George

Whitehead, a friend of Nayler, a survivor and leader of the movement, had published *A Collection of Sundry Books, Epistles and Papers, Written by James Nayler, Some of which were never before Printed, With an Impartial Relation of the Most Remarkable Transactions Relating to His Life.* This was, coincidentally, in the last years of Richard Hogarth's life after his release from debtors' prison: yet another person punished beyond his deserts, while such rakes and rapists as Colonel Charteris were pardoned.

In October 1656 Nayler entered Bristol on an ass preceded by followers singing hosannas—repeating Christ's entry into Jerusalem on Palm Sunday. Was it allusion or parody, burlesque or blasphemy? Was it a literal *imitatio Christi?* The judgment of the Puritan Parliament was "horrid blasphemy." According to the most recent analysis of the event, Nayler "enacted [a] symbolic performance."[6] In fact, it was a materialization of the belief that Christ is incarnate in each of us. In the general terms of the Quaker faith, this was not an incarnation but only an extreme case of the belief that each of us can be illuminated by (not the Word of God in the Bible, not a visible church, not an apostolic tradition, but by) an "Inner Light." But Nayler's performance was completed with punishments that could be taken to correspond to Christ's. He was branded with the letter B on his forehead, his tongue was bored through with a red-hot iron, he received five hundred lashes on the bare back, and he was locked up in solitary confinement in Bridewell (where the Harlot would also be locked up). At least the first two of these punishments were symbolic equivalents to the crime of "horrid blasphemy." But John Deacon, a witness, compared the pillorying of Nayler to a tableau vivant of the crucifixion: When his head was put in the pillory,

> came up Martha Symonds, and with her two others, who was said to be Hannah Stranger and Dorcas Erbury; the first seated herself just behind him on the right side, the two latter before him, the one on the right hand, the other on the left, just at his feet, in imitation of Mary Magdalen and Mary the Mother of Jesus, and Mary the mother of Cleophas, John 19.25, thereby to witness their still blasphemous and presumptuous and heretical adoration of him, as Jesus the Christ.

In addition, Nayler was made to repeat the entry into Bristol, this time riding backward on the ass. To some observers this was the exorcism of the Antichrist ("He has fulfilled a scripture, that false Christs should arise, 'to deceive, if it were possible, the very elect' ");[7] to others, it was the appropriate and symbolic completion of the drama Nayler had initiated on the day in October.

Thomas Hobbes wrote in the 1660s that "James Nayler appeared at Bristol,

and would be taken for Jesus Christ. He wore his beard forked, and his hair composed to the likeness of that in the *Volto Santo;* and being questioned, would sometimes answer [as Christ answered Pilate], Thou sayest it."[8] The key words are "taken for Jesus Christ." To David Hume, writing in the 1750s, Nayler was a madman who

> fancied that he himself was *transformed into* Christ, and *was become* the real saviour of the world; and in consequence of *this frenzy* he endeavoured *to imitate* many actions of the Messiah related in the evangelists. As he bore a resemblance to the common pictures of Christ, he allowed his beard to grow in a like form; he raised a person from the dead; he was ministered unto by women; he entered Bristol, mounted on a horse: I suppose, from the difficulty in that place of finding an ass; his disciples spread their garments before him, and cried, "Hosanna to the highest; holy, holy is the Lord God of Sabbaoth." When carried before the magistrate, he would give no other answer to all questions than "thou hast said it" (emphasis added).[9]

Hume concludes with Nayler's punishment: "All these severities he bore with the usual patience," and Leopold Damrosch is led to read the passage (probably accurately) as more about the cruelty of the authorities than about their victim, whom he treats as a poor deluded Quixote who, "sent to Bridewell, confined to hard labour, fed on bread and water, and debarred from all his disciples, male and female," recovered his senses. "His illusion dissipated; and after some time, he was contented to come out an ordinary man, and return to his usual occupations."[10]

Nayler may have been following in William Prynne's footsteps. Prynne's martyrdom, for having spoken ill of the queen, included being branded with the letters "SL" for "seditious Libeller." Prynne and his followers translated the initials as "Stigmata Laudis," which, as one commentator has remarked, "cast Laud as torturer and [Prynne] as Christ-like victim." But the event apparently carried further significance for Nayler.[11]

If the Calvinists believed that man's actions, however tailored to follow the Law, were irretrievably marred by Original Sin, the Quakers believed that Christ's incarnation made it possible for men not merely to hope for their predestined salvation by faith and grace, but rather to become Christ on earth, internalizing Him — thus replacing the punitive legalism of the Old Covenant.

Contrary to deist reason, the Quakers believed that there was no transcendent God but only an immediate one, and by this they meant the full presence of Christ in each of us. Yet the base assumptions, that there was no Trinity and no supreme

Law in a Father-in-Heaven and that divinity resided in the internalization of Jesus (or the teachings of Jesus), were curiously similar. In Nayler's words: "The Father dwells in the light and changes not, and the Son is the light of the world in his own image, by whom he *changes* all things that are out of him, and *overturns* shadows and customs, and *makes the world new*" (emphasis added).[12] There was clearly a revolutionary strain here that was detected by the Parliament that condemned Nayler, and an egalitarian one as well. To speak or preach required no learning, as it did with the professional Puritan "teacher" relying on, and perpetuating with his printed texts, imitation rather than spontaneity. Contemporary descriptions emphasize this Magnificat quality of the Quaker preacher: "It was a glorious day, in which the Lord wonderfully appeared for the bringing down the lofty and high-minded, and exalting that of low degree."[13]

Nayler was asked during his interrogation, "Art thou the only Son of God?" and he replied: "I am the Son of God, but I have many brethren."[14] The Ranters, according to one critic of the sect, "maintain that God is essentially in every creature, and that there is as much of God in one creature, as in another, though he doth not manifest himself so much in one as in another."[15] Here are the words of Richard Coppin, a near-Ranter, imprisoned for his views the year before Nayler's "passion": "God is all in one, and so is in everyone. The same all which is in me, is in thee; the same God which dwells in one, he is in every one."[16] Nayler, carrying the Ranter strain to the early Quakers, claimed "the universal free grace of God to all mankind," believing with Saint Paul that Christ lived within him (Gal. 2:20), that God dwells within each of us. The first aspect is closely related to the Pantheism (cognate with deist belief in a transcendent deity) that sees God in all things, indeed that this is the only form he takes. A. L. Morton, in his history of the Ranters, concludes that the doctrine could lead to "two apparently opposite consequences. It might lead to a mysticism which found God in everyone; equally it might lead to a virtual materialism which in practice dispensed with him altogether," that is, a form of deism.[17]

The Blasphemy Act of 1650 was aimed at the popular sense of Antinomianism — the profession that "the acts of murther, adultery, incest, fornication, uncleanness, sodomy, drunkenness, filthy and lascivious speaking, are not things in themselves shameful, wicked, sinful, impious, abominable and detestable in any person," that they are indeed "in their own nature as holy and righteous as the duties of prayer, preaching, or giving thanks to God."[18] But it also covered another sense of blasphemy, those

persons (not distempered with sickness, or distracted in brain) who shall presume avowedly in words to profess, or shall by writing proceed to affirm and maintain him or her self, or any other mere creature, to be very God, or to be infinite or almighty, or in honor, excellency, majesty and power to be equal and the same with the true God, or that the true God or the Eternal Majesty dwells in the creature and nowhere else, or whosoever shall deny the holiness and righteousness of God.

In 1651, for example, a Ranter, one John Robins, was prosecuted and imprisoned for declaring that he was God the Father and his wife was pregnant with the new Christ.[19] The Fifth Monarchist Anna Trapnel, in *Legacy for Saints* (1654), identified herself with the Virgin Mary.[20]

The Nayler story, though of a time when the Saints ruled England, as it survived in history and myth indicates a kind of Nonconformist belief that helped to redefine the sense of incarnation (as the iconoclasts replaced the Eucharist with an English supper of bread and wine). It also suggests something of the shock that must have remained in 1732 to discover an artist associating the Harlot with, in ascending order, the two Marys and Christ Himself—and in the immediate wake of the Woolston trial and its conclusion with a prosecution for blasphemy followed by what appeared to be a severe punishment. Further, the case against Nayler for blasphemy was based not on words but gestures: Nayler visually impersonated Christ. He therefore set himself up as equal to God (as Milton has Satan do in *Paradise Lost*). The Popean-Scriblerian interpretation of the Harlot would have been that she set herself up and *she* is the blasphemer, the anti-Mary, related to the Antichrist of Revelation (the "AntiChrist of Wit" of *The Dunciad*).

With Nayler, the Harlot could be accused of the "blasphemy" of imitation and role-playing. But, as we have seen, the role is thrust upon her by society. She may also, from a radical Protestant perspective, demonstrate the belief that Christ is manifest in each of us—indwelling in a sense that was not metonymical but "essential" and "personal," a fact as when Nayler entered Bristol.[21] The model of Nayler, a historical figure, the "Christ" who is (again, like Christ, as if he were here in 1656, as in 1732) "crucified," can be detected in the poor whore Hackabout.[22]

Nayler was committed "as a blasphemer and as a man that [believed he] had no sin."[23] He was an Antinomian, not in the popular sense of the libertine "do as you like," but rather in the more general Pauline sense that many radical Noncon-

formists did not believe in sin *as organized religion taught it:* "For until the law sin was in the world: but sin is not imputed when there is no law" (Rom. 5:13).[24] The radical sects carried Calvin and Luther's distrust of the town of Morality to its extreme; in fact, in general their preachings were against the rulers who administer the law (and the Law).[25] Antinomianism was a repudiation of the moral law — not necessarily of the "morality" of Jesus' teachings — and of the civil law. Michael's explanation of the law to Adam in book 12 of *Paradise Lost* follows the Pauline doctrine that law was given men "to evince / Thir natural pravity" (without law, no sin); "Law can discover sin, but not remove" it except by sacrifice of "The blood of Bulls and Goats."[26]

The Law is opposed to "what the Spirit within / Shall on the heart engrave" (12.523–24), and that can be construed as the guide of conscience, Shaftesbury's moral sense. Shaftesbury's was a vision of man blessed with grace of a nonscriptural sort, which in physicopsychological terms is a sixth or moral sense. Man is not born, as Locke believed, a *tabula rasa* or, as the Calvinists believed, marked with original sin. Man's behavior is outside the Law and to some extent autonomous: both senses of the Antinomian paradigm.

If we look in the *Harlot* for a moral system, it consists essentially of criticism of the magistrates, clergy, and ruling orders, whose victim is the Harlot, her own fault the imitation of their values, the values of contemporary fashionable London. Just in from the country, she is essentially innocent, if also "silly" like the goose she brings with her (whose profile rhymes with hers). Here we see the doctrine that equated the moral law with church and state contested by the opposition politics that drew in some of its aspects on the political radicalism of the Ranters and Levellers and the perspective of the oppressed.

The gospel of spiritual Levelling was based on "Universall Love . . . who is putting down the mighty from their seats; and exalting them of low degree" — precisely the message of the Magnificat.[27] I have noted that the deists extracted from the priestcraft of Christian dogma the teachings of Jesus, but Hogarth could also have carried with him from the Nonconformist milieu of his childhood the belief that with the Atonement/Redemption Jesus or his Grace is in all of us, and that this is essentially love:

> Now know that [there] can be no Gospel,
> That must be upheld by a humane Law;
> But it is the Lye in the whole Earth:
> For the Gospel is Love, and then no Law.[28]

The Leveller William Walwyn described himself as "not a preacher of the law, but of the gospell [of love]" and declared that the law was driven out by love — divine love (free grace) and human (from charity to human, sexual love),[29] both antagonists of the Mosaic and the moral law. The doctrine of (specifically) Love versus the Law was transmitted into the eighteenth century by Baptists, Quakers, Behmenists, Philadelphians, and Muggletonians. In the *Harlot* "love," however degraded in the figure of the prostitute, is set up against Gibson, Gonson, the Bridewell warder, even the contesting physicians as representatives of law — and the law that made the Harlot's "love" viable only as prostitution.

If we read the *Harlot* as an attack on the Law, then what value can we find to oppose the Law except the Harlot? In which case, she stands for a cruelly perverted (by the priests and magistrates) version of passion or some form of love — a word that could be applicable in plate 2 where passion (or fashion — "ladies take lovers") has led her to have a "love affair" that produces the Child.

We might then see the other side of the Harlot ("love") in *The Sleeping Congregation* (1736, fig. 35) of a few years later. Here, as the one residue of God in a godless church, the pretty young woman dreaming of matrimony is the alternative to the "worship" that has put the congregation to sleep (all but the reader whose eye is on the girl's bosom). In the 1730s Hogarth progresses from the vented passion of the Harlot to the true love of the Rake's wife, Sarah Young, to the image of "worship" in *The Sleeping Congregation;* and from the lusty actress who plays the virgin goddess of chastity, Diana, in *Strolling Actresses dressing in a Barn* (1738) (like Diana Multimammia, carrying associations with the Blessed Virgin, who was sometimes painted with Diana's crescent moon) to the voluptuous Venus of *Noon* and on to the aesthetic image of Venus in *The Analysis of Beauty,* plate 1 (see figs. 44, 47, and 48).[30]

Nayler was presumably presenting himself as an example of Grace: It is not that he is Christ incarnated but that Christ's Grace is absolute and complete and so transfigures him as he approaches Bristol. Hogarth offers the same choice with his Harlot: Either the Harlot is a case of ironic Atonement/Incarnation, the emphasis being on the parody, or Hogarth sees her as a case of true Grace ("the universal free grace of God to all mankind") — an Antinomian recipient of Christ's Grace and freedom in a London of "morality," legality, of institutions and bondage, or Church and the Law. In Hogarth's case both interpretations apply to the Harlot, but the second comes to be more emphatic in the works of the later 1730s and 1740s.

The ironic typology of Hogarth's Harlot and the Savior is followed by the

direct formal parallel of Sarah Young, Tom Rakewell's faithful wife, with Jesus the healer, in *A Rake's Progress*, plate 4, and *The Pool of Bethesda*, the huge painting Hogarth made for the staircase at Saint Bartholomew's Hospital (see figs. 50 and 51). Not, with the Calvinists, God's condescension to become a worm, but the beauty of the human being is Hogarth's theme, and this comes in a radical Protestant sense from Grace — or in a secular version of it from the "sanctifica-tion" of all things. That is to say, God is not in the Temple or the Law, not in the priest, but — in *Harlot* plate 6 — is revealed to be in the individual sinner, both subject and object of Redemption.

In a sense Hogarth's parody in plate 6 has the same end as Luis Buñuel's in his film *Viridiana* (1961), where Leonardo's *Last Supper* is staffed by Goyesque beg-gars, thieves, and rapists, and the message is: Look, *this* is what has become of Christ's Incarnation; *these* are what the Incarnation and the Redemption have amounted to; *these* are "Christ-in-us." Hogarth's parody includes these wretches but contrasts them with the Christ figure. (Buñuel's "Christ" is, as in Hogarth's *Cockpit*, a blind man — the blind beggar Amalio, as bad as the worst of the "dis-ciples.")

Incarnation in Art

A Harlot's Progress grew out of Hogarth's experiments with conversation pieces — group portraits, likenesses of particular contemporaries gathered in so-cial and psychological interrelations. These were 1720s "modern" versions of the full-length heroic portraits of the "great," the monarch as Zeus or Hercules, the soldier as Mars, and the merchant as Mercury. Sir Peter Lely painted Charles II's mistress, Barbara Villiers, and her illegitimate child as the Madonna and Child; other royal mistresses were painted as the Magdalen and Saint Barbara.[31] In Hogarth's parody of such portraits, or his version of Woolstonian demystifica-tion, the Harlot herself becomes not merely a mock–Virgin Mary but a "human-ation" (a human replacement) of the religious icon. One way of explaining the phenomenon is to invoke Christian typology: she was the modern postfiguration or fulfillment of Mary/Christ. But another is to invoke English Protestant Icono-clasm. The Puritan portrait reflected Cromwell's request to be drawn "warts and all." The related emphasis on naked truth finds an emblem in *Boys Peeping at Nature*. The simplest and most primitively English explanation for Hogarth's art was that he removed idols, images of the "deity," not just degrading and destroy-ing them but transforming them into their ordinary English equivalents.

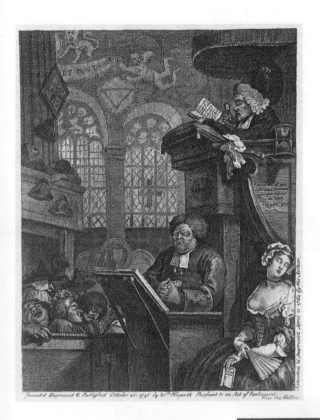

Fig. 35. Hogarth, *The Sleeping Congregation* (1736), etching and engraving, first state. Reproduced by courtesy of the Trustees of the British Museum.

Fig. 36. Hogarth, *Sir Francis Dashwood at His Devotions* (1750s), painting. Private collection.

143

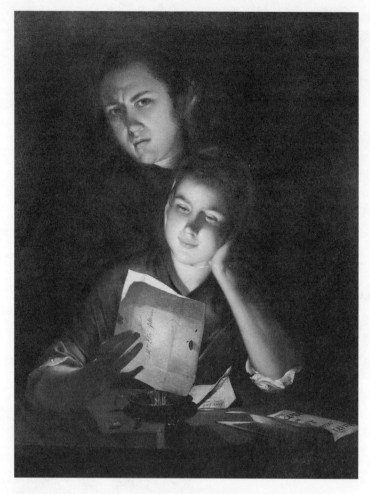

Fig. 37. Joseph Wright of Derby, *A Girl Reading a Letter by Candlelight* (1762–63), painting. Nelthorpe Collection.

Fig. 38. Wright of Derby, *Three Persons Viewing "The Gladiator" by Candlelight* (ca. 1764–65), painting. Private collection, England.

Fig. 39. Wright of Derby, *An Academy by Lamplight* (ca. 1768–69), painting. Yale Center for British Art, Paul Mellon Collection.

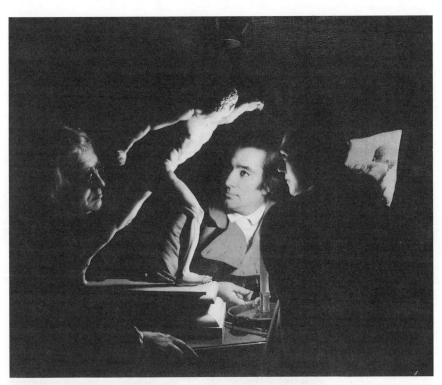

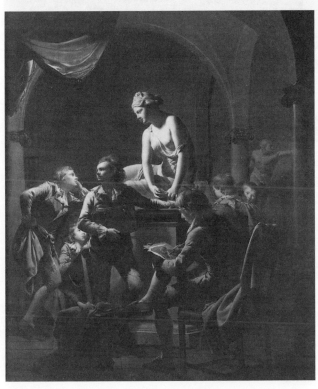

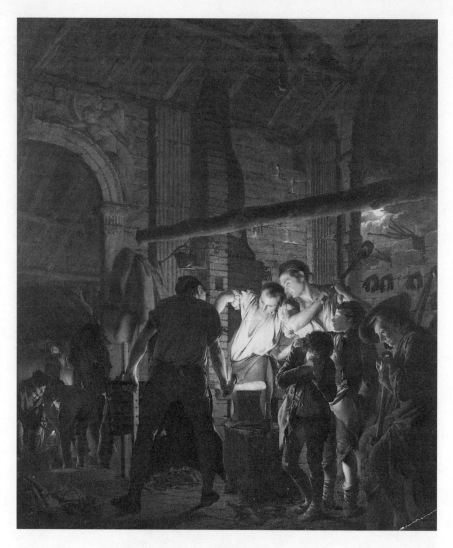

Fig. 40. Wright of Derby, *A Blacksmith's Forge* (1771), painting. Yale Center for British Art, Paul Mellon Collection.

Fig. 41. Thomas Gainsborough, *The Harvest Wagon* (1767), painting (detail). The Barber Institute of Fine Arts, The University of Birmingham.

Fig. 42. Gainsborough, Copy of Peter Paul Rubens's "Descent from the Cross" (1760s), painting. Private collection, presently on loan to the Ashmolean Museum, Oxford.

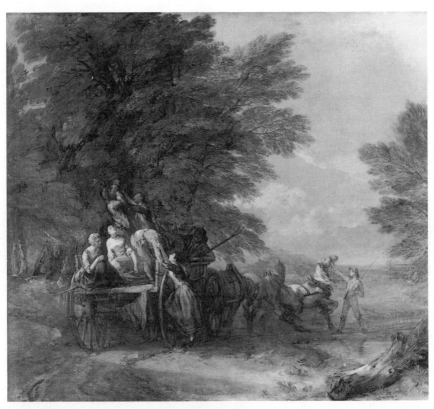

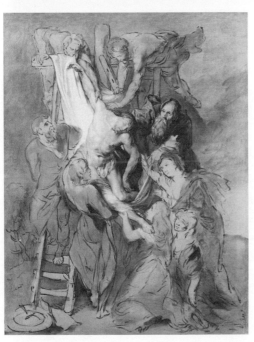

As Calvin would have said, the bread of the Lord's Supper must be not the artful simulation of the wafer, but the common bread itself, "intended solely to feed the stomach," to satisfy physical hunger — as in the case, Hogarth says in plate 6, of the common body of the Harlot. Calvin's view of art was (like Hogarth's) opposed to Catholic visual art with its images of deity and saints. Thus Calvin, while privileging the word against the image (art or music), nevertheless permitted the painting of instructive "histories and events" of the sort Hogarth referred to as "modern moral subjects."[32]

Ann Kibbey draws attention to Calvin's vocabulary of *imagines* that are *vivas* and *iconicas* — which Ford Lewis Battle (the translator of the standard English edition) translates as "symbol," but Thomas Norton, in his translation of 1561, translated more accurately as "lively and natural image."[33] (Kibbey translates as "exact image" — "icon" itself meaning merely representation, likeness, portrait.) By "living images," "live art," Calvin meant the living person as opposed to the dead idol (the bread instead of the wafer).

In Hogarth's works of the 1730s onward, the "living woman" exceeds in beauty the most perfect antique sculpture of Venus. The point is that Hogarth is reflecting Calvin's emphasis on "living" — as in his saying that artists can represent historical events (so long as they are outside a church), but the living sacramental thing or act (i.e., the eating of the bread) is far preferable. And so in iconoclasm the symbol is returned to its "lively and natural image," the wafer to bread, the altar to a table to eat off of.

The absent god of *Harlot* 2 also reflects Calvinist aesthetics that emphatically condemned graphic representations of God: "God's majesty is sullied by an unfitting and absurd fiction, when the incorporeal is made to resemble corporeal matter," and "only those things are to be sculptured or painted which the eyes are capable of seeing":[34] an aesthetics nearly congruent with Hogarth's. This tends to put Hogarth on the side of the Calvinist who sees Christ's body not in the representations of art but in the common hunger-satisfying bread that he blessed with his incarnation and against the deist who, after demystifying the NT miracles, including the Incarnation, instead of remaining with the reality and beauty of common utensils and living people, must allegorize them.

In Roman Catholic art there was the tradition of Caravaggio, which made the biblical story contemporaneous.[35] Caravaggio's effect was the transfiguration of ordinary contemporaries, raising laborers, sharpers, and prostitutes of the everyday fallen world that Christ became man in order to redeem into the dignity and beauty of the scriptural stories. So, as the story went (told by Bellori and Sand-

rart), Caravaggio used the prostitute Lena Aniognetti as his model for the Virgin in his *Death of the Virgin* and *Grooms' Madonna*. The principle was that of the Mass — given central importance in the art of the Counter Reformation — the atonement of God and nature, inanimate and animate nature, which Caravaggio adapted in his painting by revealing in the most intense way the presence of the divine in material flesh.

The *Harlot's Progress* could be regarded as Hogarth's attempt at a demotic, popular, and so unconventional reimagining of the Christian revelation. But Hogarth, of course, ostentatiously rejects the mystery of the Mass along with Caravaggio and his tradition of "dismal dark" paintings. The Puritans were, in fact, not so much against art as against Roman Catholic — Italian, French — art. (The Puritans sold Charles I's art collection because it was largely papist and Italian.) But Dürer was a German Protestant, not an Italian papist, artist. The art thesis becomes somewhat attenuated with the recognition of this fact.[36] Could it be that, by using Dürer's sober, relatively classical forms rather than baroque Italian inventions, Hogarth was tilting his parody toward the positive, incarnational interpretation — away from travesty? The alternative would be to argue for the primacy of the deist interpretation, in which case it would not matter which art model he used; all he would need is something to put the viewer in mind of the NT story. But since art is certainly at issue, we may assume that it was important that Hogarth chose Dürer. North European artists were acceptable to the Puritans, especially the Dutch, because their work (usually portraits or portrait groups) was more sober and was Calvinist, not Italian and papist — thus the North European practice of rendering holy scenes as contemporary events, which must have had an influence on Hogarth's "modern moral subjects."

In *The Lottery* Hogarth's parody of Raphael's *Disputa* is travesty, as it is in *Hudibras meets the Skimmington* (1726), where he parodies Annibale Carracci's *Procession of Bacchus and Ariadne*, an extremely baroque composition: In both, the present situation is being satirized for its degeneration of an ideal. The sacrament of the Eucharist has been reduced to a lottery, and the marriage of Bacchus and Ariadne has become, in Hudibras's England, a squabble between wife and cuckolded husband. The *Harlot* is not travesty in this sense. The effect of the parody is satiric of the church and religion but not of the Harlot. She is a case of social affectation (the mock-heroic) in Fielding's sense of the term: she speaks as if she were Dido, imitates her superiors, in dress and the habit of collecting, but she does not see herself as Christ — as Tom Rakewell does, when in the last plate of the *Rake's Progress* he sprawls in the composition of a Pietà in the manner again of

Carracci (see figs. 33 and 34). She *is* Christ as the bread is an aspect of Christ's incarnation. Typology (this foreshadows that) has become the much stronger term Incarnation (this *has become* that). In this incarnational sense travesty is not a negative term: With Christ's sanctifying fallen man by taking his body, travesty ("to translate it into a delightful, jocose style, so that the savor would be more universal, and everyone, when resting from serious occupation, could take opportune relief")[37] has become a form of celebration — as becomes more clear in the works that followed upon the *Harlot.*

This is in effect what Nayler did, making himself Christ as a sign of the inward Christ in us all: in the flesh, blasphemy, but in graphic images possibly acceptable. Hogarth has conflated the Incarnation and the Redemption/Atonement in the *Harlot* to make different points: with the Incarnation, that the lowest are yet of value; with the Atonement, that the low, in our (hardly redeemed or redeemable) society, atone with their suffering for the great. While discrediting the Atonement, Hogarth accepts the metaphorical implications of Incarnation that instill meaning into the most unromantic details of the contemporary world, into living men and women.

The idea of Incarnation was not acceptable to Shaftesbury because it contradicts Plato's "reluctance to ascribe lasting meaning to the particular physical object as such" — the assumption that "our attention must be directed not towards this material world in which we live" — London in the 1730s — "but towards the 'spiritual' realm of divine Forms of which things in this world are themselves but a pale reflection or imitation." — "It is this same fleshliness, of course, from which Plato advises us it is *necessary* to escape in order to get to grips with truth."[38]

Aesthetics: The "Living Woman"

In the years following 1732, Hogarth replaces the Harlot (the figure of Mary the Mother) with a young actress, a milkmaid, a poet's wife, and finally the Venus of the *Analysis of Beauty* of 1753 and Thalia, the artist's pretty muse in *Hogarth Painting the Comic Muse* of 1759.[39] His move toward aesthetics was, at least in part, a despairing inability to find any positive value, let alone ideal, in political or moral life — or any efficacy in religion — except for the isolated acts of charity that (beginning in 1735 with Sarah Young in *A Rake's Progress*) he associates with a young woman. Thereafter it is precisely and only an aesthetic ideal that survives for him in a world that is bankrupt in terms of religion, politics, and morality.[40]

In the 1750s he theorized this ideal in *The Analysis of Beauty*. In *Harlot* 6 the Host is wittily replaced by the body of the Harlot. Twenty years later *Columbus breaking the Egg*, the subscription ticket for the *Analysis*, is another allusion to a *Last Supper* (see fig. 43). But this time the Harlot's body has been replaced by Columbus's egg, the sign of a New World, in Hogarth's case, of natural beauty. In this case he uses the *Last Supper* to indicate that religion is demystified only to be recovered as natural beauty. To illustrate his point he replaces the Host in the *Last Supper* with two serpentine eels, which form "Lines of Beauty," and two eggs. Eggs appear in theological writings as a *natural* symbol for the Host (while the egg remains the same on the outside, it is being transformed inside into a whole chicken). An example is the ostrich egg suspended above Piero della Francesca's *Sacra Converzatione* in the Brera, Milan.

Hogarth's solution is first, in the *Harlot*, to humanize and then, in the *Analysis*, to aestheticize the Sacrament. For Hogarth it was precisely the fact that the individual has the *mark* of sin (the blemish), and for that very reason is truly human, the "living woman" who, in his aesthetics, is more beautiful than the most perfect antique sculpture of Venus.[41]

Mary Toft, for example, was a living, contemporary Mary, consisting of serpentine lines and a face that Hogarth has in fact beautified beyond that of the real Toft (see fig. 26).[42] The "demystification" or reduction of Mary to Toft involves his preference for the second (the Eucharist as a friendly meal, the altar as a dinner table), precisely because it contains the principle of natural beauty, which was excluded from the straight lines of such religious symbols as the Tetragrammaton and the Latin cross.

The contrast is implicitly between religion (a clerical religion of ridiculous doctrines such as the Eucharist) and Nature, in its deist sense of God, or rather goddess, the Diana Multimammia of *Boys Peeping at Nature*. The woman — the Mary Toft, M. Hackabout, and the women who dominate his works — will be the bridging metaphor for Hogarth between satire and comedy, religion and aesthetics. In the *Analysis* Hogarth transforms the Christian symbol of the Eucharist or the Trinity (or the cross) into versions of his serpentine line (and the serpentine eels on Columbus's plate) and reformulates demystification (or blasphemy) as the pleasure of discovery and the "love of pursuit."

The common factor is wit. Like wit, "Variety," the central descriptive term of Hogarth's aesthetics, has a libertine pedigree. *Varietas* in earlier times designated a negative sense of change or inconstancy, associated with deception, wickedness, and even leprosy. Jeremy Taylor recalled the character of fallen mankind when he

wrote that "We all naturally have great weaknesses, and an imperfect constitution, apt to be weary, loving variety," and Hobbes defined man in terms of his "perpetual and restless" desires and curiosity.[43]

As Loveless said in Colley Cibber's *Love's Last Shift* (1696), "the World to me is a Garden stockt with all sorts of Fruit, where the greatest Pleasure we can take, is in the Variety of Taste," and the Chorus in Sir John Vanbrugh's sequel, *The Relapse*, affirms that "the joys of life and love / Are in variety." Loveless, though claiming to love his wife, "runs after something for variety" (V.ii.). This libertine sense of variety explains the serpent who appears above "VARIETY" and the epigraph alluding to Eve on the title page of *The Analysis*. The context of seduction, sexuality, and the Fall goes some distance beyond the sense of variety in Hogarth's primary source, Addison's category of the Novel, New, and Uncommon in his "Pleasures of the Imagination" essays.

So also the metaphor of the "pleasure [or love] of the chase" or of "pursuit":[44] Horner in Wycherley's *Country Wife* noted that lovers "lose more time, like huntsmen, in starting the game than in running it down," and according to Sir Charles Easy in Cibber's *Careless Husband* (1704, 1.1): "I cannot see why a Man that can ride fifty Miles after a poor Stag, should be asham'd of running twenty in chase of a fine Woman, that, in all Probability, will make him so much the better Sport too." More recently, in Fielding's *Universal Gallant, or the Different Husbands* (1735), Mrs. Raffler says to the rake Mondish: "To your fresh game, sportsman; and I wish you a good chase."[45] But, as the religious poetry of the seventeenth century proved, the homology of aesthetics and erotics joined the libertine chase after the woman and the Christian chase after Christ — after his "beauteous form," his "sweeter BODY," to "ravish" or be "ravish'd."[46]

For Hogarth the ultimate object of beauty in the *Analysis* is the body of a "living woman," and the "pleasure" is in the lover's "pursuit" of her. The angling metaphor, with which Hogarth ends his sixth chapter, recalls the libertine commonplace: "I can play with a Girl as an Angler do's with his Fish; he keeps it at the end of his Line, runs it up the Stream, and down the Stream, till at last, he brings it to hand, tickles the Trout, and so whips it into his Basket."[47]

Hogarth's aesthetics is based on the "pleasure" or indeed "love" of the "pursuit" of lines or forms, but, applied to his prints (as he does by including his two large illustrative plates with his text), this is the pursuit — under the veil of Diana — of meaning. Obscenity was a part of this "pursuit": I might note the Harlot's funeral escutcheon in plate 1, the bawd's escutcheon in 6, Charteris's hand "groping" in his pocket in 1, not to mention the play on "search out your ancient mother" in

the ticket. "Pursuit" presupposes the spectator's openness to explore and remain open to every turn or twist of form or meaning — every ambiguity. In terms of the libertine metaphor, it privileges pursuit over consummation, arguing that the fun in art, as in life and love, is in the wooing. Marriage is so dull, but even sexual consummation — the eye or mind coming to rest — may be less exciting than the pursuit: the extreme case being William Congreve's Vainlove, who loves only the chase, using his alter ego Bellmour to enjoy the prey Vainlove has seduced.[48]

But, as we might expect of the author of the *Harlot*, "It is a pleasing labour of the mind to solve the most difficult problems; . . . with what delight does it follow the well-connected thread of a play, or novel, which ever increases as the plot thickens, and ends most pleas'd, when that is most distinctly unravell'd?"[49] In fact, the "novel" Hogarth refers to is not so much the Richardson or Fielding fiction, with which he associated himself elsewhere, as the amorous "novels" of intrigue they were correcting. An example is Eliza Heywood's *Love in Excess* (1711), in which the reader (largely male) follows the male figures in their seductions, which are intertwined with the theme of informational curiosity (seductions depend on revealing to the quarry the identity of her husband's lover). These novels are direct transmissions of the libertine tradition.[50]

Libertinism: John Wilkes and the Black Mass

After Woolston, the other notorious case of blasphemous libel in the eighteenth century was, forty years later, that of John Wilkes in 1769.[51] Wilkes (influenced by his crony Thomas Potter, appropriately son of the High Church Archbishop of Canterbury) wrote a series of obscene parodies of Pope's *Essay on Man* (an *Essay on Woman*), Pope's *Universal Prayer*, and the Latin hymn *Veni Creator Spiritus*.[52] As David Foxon has commented on the connection between libertinism and liberty: "The revolt against authority first took the form of heresy, then politics, and finally sexual license."[53] In Wilkes's case the stages were simultaneous. He was a close friend of Hogarth's from the early 1750s until they broke over politics in 1762. Hogarth's politics at that point were regarded by Wilkes as insufficiently libertarian or, more specifically, Pittite. (Despite the congruence of their earlier beliefs, Hogarth, who was Serjeant Painter to the King, may have felt that his proper allegiance was to the young George III.)[54]

In the late 1750s both were reputed to be members of Sir Francis Dashwood's Libertine Hell-Fire Club (they called themselves the Medmenham Monks).[55] Whether or not he was actually a member, Hogarth painted the group and some

of their activities, including a portrait of Sir Francis in Franciscan robes worshiping a cross on which lies a beautiful nude woman in the place of Christ (fig. 36). Wilkes seems to have had this painting in mind, though his description is not entirely accurate, in his published account of the brotherhood:

> There was, for many years, in the great room at the King's Arms Tavern, in New Palace Yard, an original picture of Sir Francis Dashwood — presented by himself to the Dilettanti Club. He is in the habit of a Franciscan, upon his knees before the Venus of Medicis, and his gloating eyes fixed, as in a trance, on what the modesty of nature seems most desirous to conceal. The *communion cup* in his hand, which is filled to the brim, tells us the object of his devotion, for it has the words MATRI SANCTORVM in capitals. The *glory*, too, which till then, had only encircled the sacred heads of our Saviour and the Apostles, is made to beam on that favourite spot, and seems even to pierce the hallowed gloom of *maiden thicket*.[56]

Wilkes has displaced the halo and omitted the detail of the Venus's crucifixion; otherwise, this is roughly a description of the painting Hogarth made of Dashwood, which survives in the collection of Lord Boyne, descendant of one of the Monks. Wilkes has a mysterious sentence that seems to allude to Hogarth's aestheticizing of the tetragrammaton on the title page of the *Analysis:* He mentions a temple "in the gardens at West Wycombe, dedicated to ———, the Egyptian Hieroglyphic for the reverend Tristram Shandy's Tetragrammaton, the four favourite ****" (94). The reference is presumably to Sterne's use in *Tristram Shandy* (1759 ff.) of Hogarth's Line of Beauty (his tetragrammaton) and its female equivalent (in plate 1) of Venus.[57] Wilkes adds, defining his own libertine aesthetics: "To this object his Lordship's devotion is undoubtedly *sincere*, though, I believe now, not *fervent*, nor do I take him at present to be often *prostrate*, or, indeed, in any way very regular in his *ejaculations*," and the following sentence makes it clear that Venus is the referent, indeed Hogarth's painting of Sir Francis worshiping Venus. Wilkes gives a fair picture of the libertine ethos that came to be celebrated publicly by his political adherents as "Wilkes and Liberty."

The detail of interest, however, is the beautiful woman who replaces Christ. Wilkes parodied Pope's "Universal Prayer":

> Father of All! in every Age,
> In every Clime ador'd,
> By Saint, by Savage, and by Sage,
> Jehovah, Jove, or Lord!

by turning God the Father into Mother:

Mother of all! in every age,
 In every Clime ador'd,
By Saint, by Savage, and by Sage,
 If modest, or if whored.

Again in his parody of the *Veni Creator* (*The Veni Creator paraphras'd, Or, the Maid's Prayer*), he replaces the divine energy with its bodily, material equivalent, the Trinity with the triune male sexual apparatus. His image of Creation is based on copulation, as hierarchy is based on potency. Both recall Hogarth's replacing Christ with the Mother and his image of Mother Nature (the Venus Multimammia) in *Boys Peeping at Nature*.

In his commentary Wilkes explains that the libations of the Monks were made to "the BONA DEA" — the *magna mater* — and other female versions of deity, especially Venus, who at the entrance to a cave on Dashwood's property was represented in a sculpture "stooping to pull a thorn out of her foot. The statue turned from you, and just over the two nether hills of snow were these lines of Virgil:

Hic locus est, partes ubi se via findit in ambas:
Hac iter Elysium nobis . . ."
(pp. 68–69)

The play is libertine and sexually oriented, locker room jests based on drinking and whoring and sodomy, which supply a libertine basis for Hogarth's blasphemy (and, later on, his aesthetics of the beautiful "living" woman, which were summed up in his *Analysis of Beauty*). Overlapping with the libertine ethos were the deist and Pantheist and Freemason mythology of a female Nature.

From Wilkes's account of the Medmenham brotherhood, it seems to have been a parody of Christ and the twelve Apostles and its chief ceremony was a Black Mass, but he assures us that it was only carried out as "a mock celebration of the more ridiculous rites of the foreign religious orders of the Church of Rome, of the Franciscans in particular, for the gentlemen had taken that title from their founder, Sir Francis Dashwood."[58] It is possible that Hogarth's *Enthusiasm Delineated* (ca. 1759, see fig. 75), as originally conceived, with its satire on Transubstantiation, was a contribution to the group effort. The distrust of Transubstantiation in this context was no more than antipopery, at worst aimed at High Church Anglicans suspected of worshiping the consecrated Host. Instead of attacking popish priests in *The Essay on Woman*, however, Wilkes attacks prelates of the Church of England and Church of Ireland.

The chief difference between the parody in the *Harlot* and the Medmenham

mock ceremonies was that the latter were obviously related to the Black Mass, but then, like the *Essay on Woman*, they were carried out in private — only written up by Wilkes later, partly as exculpation of himself and partly as blame of his political opponents.[59] The discovery of a printed text of the parody poems was what led to Wilkes's prosecution for blasphemy (charged but not convicted).

Hogarth was not, of course, drawing entirely on libertinism; Coppe and his friends thought of themselves as advocates of Pauline liberty, citing Paul's words on the "glorious liberty we have in Christ" and "the glorious liberty of the children of God" (Gal. 5:1, Rom. 8:21). As Hogarth would have been aware, Isaiah 61:1 ("The spirit of the Lord God . . . hath sent me to bind up the broken-hearted, to proclaim liberty to the captives, and the opening of the prison to them that are bound") was the text Jesus preached at Nazareth for which he was expelled from the local synagogue (Luke 4:18, 29).

The example of Wilkes gives some idea of Hogarth's position in the 1730s — the combination in the *Harlot* of blasphemy and heterodoxy with obscenity — "an unusually populist symptom of a Freethinking anticlerical, anti-establishment tradition."[60] Wilkes's background, like Hogarth's, was a Dissenting family; he was educated at Dissenting academies, including a school run by a Presbyterian minister who was put out of the school as an Arian heretic (though Wilkes outwardly conformed in order to run for office).[61] In the 1770s Wilkes, perhaps recalling the mock Eucharist of the Calf's Head Club, told the House of Commons that he thought the anniversary of Charles I's beheading should be celebrated "as a festival, as a day of triumph" — Charles had been "an odious, hypocritical tyrant."[62] The celebration going on around the statue of Charles I at Charing Cross in Hogarth's *Night* (the fourth *Time of the Day*, 1738) could have been read either as a celebration of the Cavalier/Jacobite cause or of the execution; it agrees with Wilkes in denying the traditional fasting and prayer for the royal martyr.

The *Essay on Woman* was called "a most scandalous, obscene, and impious Libel; a gross Profanation of many Parts of the Holy Scriptures; and a most wicked and blasphemous Attempt to ridicule and vilify the Person of our Blessed Saviour."[63] This included blaspheming the doctrine of the Trinity: As Wilkes replied, "I am not the first good Protestant [he cites Archbishop Tillotson] who has amused himself with the egregious nonsense . . . of that strange, perplexed and perplexing mortal . . . Athanasius" — recalling perhaps Hogarth's placement of Athanasius in Bedlam in *Rake* 8.[64]

Not-so-sacred parodies followed in the Wilkesite propaganda of the 1760s,

including a version of the Nicene Creed that replaced the deity with Wilkes ("I believe in Wilkes, the firm patriot, maker of number 45. Who was born for our good. Suffered under arbitrary power. Was banished and imprisoned. He descended into purgatory, and returned . . . ," etc.).[65]

On Wilkes's return from his flight to France to escape the indictment, he was asked by the governor of the port of Calais "how far the liberty of the press extended in England. He replied, 'I cannot tell, but I am trying to know.' " This was Horace Walpole's account; James Harris reported that "he could not say with certainty how far, but that he was now making the experiment."[66] Though referring primarily to *North Briton*, no. 45, the reference included *The Essay on Woman* and recalls the sort of test Hogarth may have been performing with his *Harlot*.

The discourse of libertine wit, which in the hands of the freethinkers is the burlesque of Scripture, is recouped by Hogarth as the discourse of aesthetics, a realm that is outside the laws of conventional (legal, Mosaic) morality. It is by no accident that the aesthetics of both Shaftesbury and Hogarth modify Protestant beliefs along the lines of the Antinomian model, first discrediting the Law and then replacing it with a moral sense, the beautiful, and love in one of its forms from charitable to heterosexual.

The aesthetic formula, we have seen, was the final stage of a process that began with political and religious satire. The relationship between anticlericalism and aesthetics is fairly obvious, as Hogarth's example shows: Belief demystified need not be a merely negative procedure (the usual criticism that the critical deists destroy but cannot rebuild); belief can be reformulated as enjoyment of the beautiful, the object of worship as the object of aesthetic pleasure. But there is a connection as well between politics and aesthetics — at least so far as politics was symbiotic with religion, as it was from Stuart times up to the Hanoverian Succession. The flourishing of the anticlerical wing of the Whig opposition tells us that the congruence of the monarchy with a religious position (Jacobitism with popery; Hanoverianism with Protestantism) had reached a watershed. With the linkage, by way of Hoadly, of the Hanoverian Succession and a liberal, Erastian Protestantism, the ancient politico-religious equation was in fact sundered — or would have appeared so to Hogarth and Amhurst.

The more general association of politics and aesthetics made by recent scholars assumes the internalizing of the former by the latter; the external laws of a police state were rendered more effective as Shaftesbury's moral sense, each sensitive citizen's self-subordination to a moral (rather than overtly a political) imperative.[67] Shaftesbury's politico-aesthetics, however, was not at bottom an

opposition ideology; it presupposed, and indeed supported, the rule of the Whig oligarchy. Amhurst and Hogarth (closer in this respect to the Old Whig Swift) attacked that oligarchy as it was embodied in Walpole and therefore demystified it, in part because it maintained a non-Erastian position on religion, in part because it revealed what was wrong with the politico-aesthetics of Shaftesbury's theory — that the political arm was simply (like Walpole the "pagod") taking on the sacral aura of the religious.

To aestheticize is to recover the subversive or transgressive as well as the "religious" for society, as in Shaftesburian discourse the aesthetic equals the polite. One might argue that, by turning moral condemnation into aesthetics, Hogarth is in fact selling out, becoming the Hogarth of the material culture critics. But Hogarth's libertine aesthetics is itself a reaction to the polite aesthetics of Shaftesbury, and the repudiation of Shaftesbury's facile equation of beauty and virtue with sexual passion is always part of his agenda.

Other elements in the current political scene may explain why after the mid-1730s Hogarth makes no further attacks on the Walpole ministry — or indeed for some while on the church. Times were changing: The Church-Whig (Walpole) alliance was breaking over Gibson's High Churchmanship and his theory of the Anglican hegemony. Walpole and Gibson broke in 1736 over the Quakers' Tithe Bill, and, as J. C. D. Clark puts it, "Hanoverian prelates henceforth occupied a markedly more subordinate political position in relation to the civil power and to Church appointments. The extreme Whig campaigns of the earlier part of the century had not been without results."[68]

Wright of Derby and Gainsborough

The Virgin in Annunciation scenes holds a book on her lap (the Word designating the Word, with whom she is pregnant); Hackabout has before her the Bishop of London's "Pastoral Letter." *Harlot* 3 is something like — though quite a distance from — Vermeer's paintings of a woman reading a letter in the flood of light from a window, on the left: *Woman in Blue Reading a Letter* (Amsterdam, Rijksmuseum) and *Woman Reading a Letter at an Open Window* (Dresden, Gemäldegalerie). These are contemporary Annunciations, or humanations of the Annunciation (the result of his incarnation), in which the natural light replaces the angel and the woman reads the Word (because she is carrying the "Word"). In one of these the woman is actually pregnant.

Joseph Wright of Derby's painting, *A Girl Reading a Letter by Candlelight*

(1762–63, fig. 37), is a simple genre piece that shows a girl's face and the letter she is reading illuminated by a candle.[69] Next to the candle on the table lies the banal detail of a manual of correct letter writing, and the girl's features reveal a discovery that cannot be explained adequately by such manuals — presumably it is a love letter. There is a second figure, a witness present, a worried young man (a rival to the letter writer?) who looks over her shoulder. (In another version the witness is an old man.)

Vermeer's woman was transfigured by the sun coming in through the window that lights her reading. The angel of the Annunciation always appears in a blaze of light, and holy figures in general appear in an unnatural light in religious paintings, supported by the text of the Gospel and Epistles of Saint John. Wright's particular contribution was to combine the English conversation piece with the Caravaggist candlelight tradition: to apply the connotations of Caravaggio's ostensibly sacred paintings to secular subjects. The Caravaggist painters first used one narrow point as the source of light to transfigure a religious subject or, at least, to render it dramatic. At one end of their range, they merely heightened the contrast between the light and the dark in traditional scenes in which a holy figure is the source of light (compare Correggio's *Nativity* [Dresden] and Volmarijn's Caravaggesque *Supper at Emmaus* [Ferens Art Gallery, Hull], in both of which the source of light is the miraculous object).

The painter of "candlelight" pictures per se, however, illuminated some object and the face that meditated on the object by the naturalistic means of an unshaded candle. Honthorst's *Christ before the High Priest* (National Gallery, London) is such a picture, the candle being the single source of light, associated with nothing but itself. It illuminates the important elements, the faces of Christ and the high priest, and no more. Georges de la Tour went so far as to include a candle in his *Nativity:* the objects of meditation, the Christ Child and the Madonna, are illuminated by a candle held by the meditator, whose rapt face is also illuminated. The illumination of the supernatural is not itself supernatural; the point is not the holy radiance but the transfiguration of the meditator as well as of the holy object within the meditation. In one remarkable instance, *Saint Joseph the Carpenter* (Louvre), the object of meditation is Joseph at his carpentry, and the meditator holding the candle, whose face is more radiantly illuminated than Joseph's, is the Christ Child Himself.

Behind Wright's paintings is the tradition of the candle flame as both secular illumination of the sacred and transience — the merely human equivalent of God's candle. It is well to recall that Counter-Reformation paintings like La

Tour's could be taken as either Caravaggesque Nativities and Saint Josephs (i.e., religious scenes seen as genre) or — as the source of light in the candle suggests — these religious subjects demythologized into a mother and child or an old carpenter and his son. In such scenes of archetypes rendered special in their own terms, the transfiguration is man-made and transient, not supernatural.

Wright followed his *Girl Reading a Letter by Candlelight* with two other experiments, this time substituting for the letter, indeed for the girl reading it, an art object. The genre was the conversation piece, which Hogarth had developed in the 1720s, leading directly into his *Harlot's Progress* and *Rake's Progress*. But Wright's conversations follow from Hogarth's aesthetics: In *Three Persons viewing "The Gladiator" by Candlelight* (ca. 1764–65, fig. 38), the candle is set to illuminate the object, the *Borghese Gladiator*, and the faces of the figures around it; these are observers, who meditate on the art object. One observer is sketching the *Gladiator* — representing both another level of response and another kind of reality, which lies between the statue and the observation of it, which in effect makes the canvas itself yet another representation of a representation. There is a further ambiguity, for everything about the statue, from its diagonal lunge to the muscular tension of its limbs, contributes to the sense of motion, while the three viewers, who are real and alive — the "portraits" in a conversation piece — are motionless. The *Gladiator* is in the direct light of the candle, which has the effect of reinforcing the sense of its motion; two of the men are almost totally in shadow, and the third, who holds up his drawing, the copy of a copy (for the statue is a cast of the original in the Villa Borghese), is less intensely illuminated than the statue. What unites artifact and viewers is the arched body of the gladiator, continued in the curves of the men's backs and shoulders and even the undercurve of the leftmost man's arm on the table: they are drawn into a close formal unity that further emphasizes the question of which is the most real, the men, the drawing of the statue, or the statue.

In *An Academy by Lamplight* (ca. 1768–69, fig. 39), the central object is the statue of a beautiful girl, the *Nymph with a Shell*, surrounded by copyists. The source is immediately evident — Hogarth's sculptured Diana Multimammia in *Boys Peeping at Nature*. There one putto simplified and idealized, another looked away and created from his imagination, and a third restrained a faun from lifting and peering at (copying) her ordinarily concealed private parts. In Wright's painting one student has put down his drawing and is merely gazing with rapt attention into her eyes, forgetting the distinction between flesh and stone. Another has finished his drawing and is turning away. Others are still engaged in

making their copies. Our first response as viewers may be: Is she a model or a statue? Is she looking at the boy or he at her? In this picture even the statue is part of a circle of divergent responses of the sort Hogarth and his followers used in their conversation pieces, which includes everything except the one missing element: the real girl called to mind by the artifact.

Much more than in the *Gladiator*, the light gives the statue and the boy closest to her the same yellowish color and texture, recalling the ontological ambiguity of some of the juxtaposed human figures and sculptures in Watteau's *fêtes galantes*. A mutual look between the boy and the sculpture is suggested, if not reinforced, by the way their bodies arch toward each other and by the repetition of this shape in the arch overhead that frames and connects them. None of the other viewers is looking up at the Nymph; all are occupied by other less real imitations of her — on paper or in the mind. The student who has closed his portfolio and is looking off into space at the left, his back turned to the Nymph, is presumably one of those who has her image in his mind. Her head is parallel with his, raising the question of whether she is looking not at the admirer but out of the painting into space, enforcing perhaps the idea that the reality of her beauty is in the mind rather than the flesh — Wright's post-Hogarthian insight into aesthetics and humans who are enamored of ideal being. But, as in many of his paintings, he gives us one small boy who looks straight ahead out of the picture, breaking the circuit of art and life and connecting the pictorial image with the world of the people who are looking at Wright's painting.[70] In the same way, in the *Blacksmith's Forge* and later in the *Air Pump*, he includes a moon, a natural light, contrasted with the human.

With the responder Wright passes into the realm of aesthetic response, appreciation, or perhaps erotic "worship." The composition is a series of concentric circles, at the center of which is an object — art object or scientific (specimen or model) — which is being shown or demonstrated (not being made, e.g., by an artist) *and* being observed by a group, largely laymen. The spectrum of types from young lovers to children to old men is emblematic — a cross section of ages and sexes, arranged in a formal order according perhaps to the Ages of Man. The point is that Wright turns expression (the spectrum of *l'expression des passions* of the art manuals, which we observed most prominently displayed in Leonardo's *Last Supper*) into perception — understanding mixed with awe and other emotions. The result is a painting about aesthetics.

Compared with West's *Death of General Wolfe*, Wright's paintings emphasize the differences, the variety of responses and relationships between subject and

object. The lighting draws the aestheticians together in appreciation as the particularization of the figures pulls them apart. While the statue of the *Gladiator* or *Nymph with a Shell* draws art lovers together, Wright's basic situation is a muted version of Hogarth's, in which people gather around an object and treat it in radically, comically divergent ways, with a leap in sensibility effected, perhaps by a child present or by the eye of a lover that connects with the statue's or by one bystander who catches the viewer's eye and brings with it his own sympathy. Wright's paintings say that the aesthetic or scientific object that draws us together these days lacks the power or the qualities to produce the unity of expressions surrounding the transfigured body of General Wolfe. As Hume, Burke, and Reynolds were to show, the problem of shared response to a beautiful or sublime object was a central issue of taste in the post-Christian world of art.

Between 1771 and 1773 Wright made a series of paintings of blacksmith forges. He replaces the art object with a glowing ingot. He shows man doing something to nature; the transformation of the metal at the center provides its own light, which is reflected on the faces of the men who perform and those who disinterestedly watch — a white light that turns the surroundings red. The setting is the English countryside, stark, rural, and primitive. With *A Blacksmith's Forge* (1771, fig. 40), the relationship to the Nativity is too clear to ignore. Honthorst's Caravaggesque *Adoration of the Shepherds* (Uffizi) comes to mind, but the general idea of a Nativity is evoked by the half-open and ruinous building, the country folk, even the farm animals, and the unearthly glow at the center. (It has recently been shown that Wright used an underpainting of gold leaf on the ingot.) In fact, the ruinous structure in which the shop is lodged is constructed of Romanesque arches, over one of which is an angel carved in high relief. Whether or not Wright intended the building for an ecclesiastic structure (specifically an iconoclasted church), the hovering angel mandates the religious allusion.

In some versions the piece of metal is the child surrogate; in *The Iron Forge* (Earl Mountbatten of Burma), a child in her mother's arms is actually present, and the miracle appears to have been consciously displaced from the human pair to the piece of metal being, under intense heat, transubstantiated. In *The Farrier's Shop* (engraved by W. Pether), the source of light is completely hidden; it might be a white-hot piece of metal, a lantern, or a Holy Child.

To what extent Wright is thinking of something specific like Hume's "On Miracles" and to what extent he is continuing the imagery begun by Hogarth with his Hercules, Mary, and Jesus in contemporary London is uncertain. What is certain is the response to these paintings: of one, for example, that the "face is

transfigured by light as though he were one of Christ's disciples witnessing the Breaking of the Bread."[71] *Something* out of the ordinary is happening, and in the forge paintings the iconography of the Nativity is added to the candlelit aura.

Vermeer's *Woman Pouring Milk* (Amsterdam, Rijksmuseum) shares with his *Woman Reading a Letter* compositions the window at the left and the bare wall, which is like the clean white wall of a Calvinist iconoclasted church. On the table is a basket of bread and a ewer receiving the poured milk. As we have seen, Calvin believed that the body and blood of Christ were literally *in* the plain bread, not somewhere above, symbolized by the Catholics' wafers. But, most interesting, in Vermeer's painting there is no wine; there is milk. Milk is presumably the humble equivalent of wine (what we call the staff of life). The empty mouth of the jar from which the woman is pouring the milk rhymes (concave vs. convex) with her face in its bonnet, and her solidity, that of a butter churn, goes with the pot, basket, bread, and pitcher.[72]

Vermeer's *Woman Pouring Milk* illuminates Hogarth's replacement of Jesus with Mary the Mother (though I do not suggest that Hogarth knew the painting) and his employment in the succeeding prints of mothers: Sarah Young, mother of Rakewell's child, and the wife of the poet, whose cat is nursing its kittens while the milk for the wife's baby is being withheld because her husband cannot pay the bill. Milk is also at issue in *The Enraged Musician* with its central nourishing figure of the milkmaid. In all of these appearances, following the *Harlot*, milk is a substitute for wine and the blood of the Atonement — a more humane sacrament.

This is not allegory and it is not, exactly, typology either, because typology calls for someone in some way singled out — special — who is *like* the person being fulfilled (who is foreshadowed): Here, Vermeer's kitchen maid or letter reader is anyone and so a manifestation of post-Incarnation life, simply blessed by Christ's humanation. Hogarth's harlot Hackabout is both any London prostitute, in which sense he is drawing attention to her humanity, and one being singled out ironically as the protagonist of a postfiguration Atonement.

In the eighteenth century, the Roman Catholic Chardin, possibly a Jansenist, comes close to an iconoclasted Eucharist in one painting, *The White Table Cloth* (Chicago, Art Institute) — a simple dining table holding bread and wine but also one glass overturned and a knife with a wine- or blood-red handle turned toward the viewer and a cut sausage on the plate.[73] Chardin's dead rabbits and pheasants, some in monumental compositions, are redolent of the body and blood and the crucified Christ rather than the bread and wine; these could be symbols of the Incarnation's effect on mundane creatures and diurnal objects, though there is no

evidence that they were taken so. In Catholic countries the Eucharist was most often represented in its heavenly aspect, not its earthly. Counter-Reformation paintings show the Father, Son, and Holy Ghost — or the Supper itself — but never without the divine aspect materialized in paint, however much the illusion of dematerialization is sought.

In 1767 Thomas Gainsborough painted *The Harvest Wagon* (1767), showing a group of harvesters pausing along the roadside on a hot day to imbibe. But the group is based on the figures in Rubens's *Descent from the Cross*, a painting Gainsborough had copied a few years earlier (figs. 41 and 42). He evokes what Hogarth would have understood as the Eucharistic scene: these English country harvesters are striving upward toward the drink of wine from a leather bottle as the figures in the *Descent from the Cross* strove to receive the body and blood of Christ. Gainsborough produces a local, popular, and thoroughly demystified version of the *Descent from the Cross*. The result is contemporary myth: these carousing peasants are participating in some primitive fertility ritual, which is the local country version of the Christian miracle — or, perhaps, of the city atonement of a harlot. At the same time he paints the rustics in the elegant and fluent style of his model, which is his way of appropriating the subject of the Eucharist in a design that plainly utilizes the principle of serpentine lines presented by Hogarth in his *Analysis of Beauty*. I have characterized this elsewhere as "the artist's reclamation of the scene, of the Counter-Reformation iconography, as his own English representation."[74] Gainsborough was an artist who ordinarily removed all overt signs of iconography, classical or Christian, from his paintings, leaving only their traces in nature: mysterious dells that evoke the *genius loci*.[75]

At this point he can sum up the appropriating, localizing, and aestheticizing that Hogarth carried out between his *Harlot* and his *Analysis of Beauty*. In the *Analysis* the common utensils Hogarth cites and illustrates are exact examples of the meaning of Incarnation: the ordinary become special — to correspond to his "living woman," the centered subject, who is preferred to the most beautiful antique Venus. However, we have to take Hogarth's word for it: by schematic and programmatic demonstration, he indicates the importance of the ordinary, but he does not "transfigure" it. In his "modern moral subjects," Hogarth made the point more poignantly in the figures of harlots, milkmaids, and poor wives. Wright and Gainsborough supplement theory with mimesis, iconography with light and darkness, form and color that in their own way dramatize the underlying harmony (the "sacred") of the visible world of things.

Redemption

Milton's Poetic Redemption

In the invocation to book 1, Milton first establishes the parallel between the incarnated Son and the poet:

> . . . till one greater Man
> Restore us, and regain the blissful Seat,
> Sing Heav'nly Muse, that on the secret top
> Of *Oreb*, or of *Sinai*, didst inspire
> That Shepherd, who first taught the chosen Seed,
> . . . I thence
> Invoke thy aid to my advent'rous Song,
> That with no middle flight intends to soar
> Above th' *Aonian* Mount, while it pursues
> Things unattempted yet in Prose or Rhyme.
> (1.4–16)

The Son of God, David the Psalmist (the ancestor of God's incarnation, Jesus), and Milton the poet: *Paradise Lost* was, as well as a "Justification of the Ways of

God to Man," a poetics. Milton carries out both of these themes through the story of the Redemption ("till a greater Man restore us"). The one greater Man who will "Restore us, and regain the blissful Seat," that is, restore mankind to what he lost in Eden, is followed by the "I" who will recount the story in "my advent'rous Song," to do which he connects himself with Moses, "That Shepherd, who first taught the chosen Seed, / In the Beginning how the Heav'n and Earth / Rose out of *Chaos.*" The Son *restores* Adam's descendants, Moses *raises* the chosen people out of chaos, and Milton *soars* above the middle flight to pursue "Things unattempted yet in Prose or Rhyme."

By first taking the dark version of vicarious Atonement — sacrifice and death — and turning it into a victory, and then by replacing sacrifice with resurrection, Milton substitutes an incarnational model for the satisfaction (sacrificial) theory of Atonement. That is to say, he places his emphasis not on atonement but on redemption, and the Redemption in its aspect of Incarnation — the transfer of divine creativity into the human body and the human experience. By Christ's Incarnation, he means the span of Christ's Incarnate life from birth, temptations, miracles, and death to Resurrection and Ascension.[1] And the incarnational emphasis on the divine in the human (that the human experience and imagination is a worthy subject of poetry) opens the door to Milton's associating the "Begotten Son, Divine Similitude" with the poet and the divine Redemption with the poetic redemption. He draws also, of course, upon the old analogy between divine and poetic creation. The "divine analogy" assumed correspondences between human and divine attributes, for example, between God's Creation and the human creative arts, between God and the artist, and so it followed that Milton could infer a correspondence between the Son's redemption of the fallen Creation and the artist as redeemer.[2]

Milton's Son is (in the angels' hymn, 3:384) a "Divine Similitude" of his Father — likeness without equality, and something similar recurs in God's creation of man. In forming man, God declares: "Let us make now Man in our image, Man / In our similitude" (7.519–20), which recalls the angels' description of the Son as "Divine Similitude, / In whose conspicuous count'nance, without cloud / Made visible, th' Almighty Father shines" (7.511; 3.384–86). Adam is originally created, according to the angel Michael, in God's "Divine similitude," with the lowercase *s*, but with the Fall, "Thir Maker's Image . . . then / Forsook them," at which point they have "defac't" "not God's likeness, but thir own" (11.512–22).

The dissociation of the divine similitude in the present (identity to similitude

to simile) is manifest in the discrepancies between great and small, perception and misperception in Milton's epic similes. Milton uses these, first, to explain to human intelligence the divine story and, second, to demonstrate the breakdown of the divine similitude that takes place with the Fall. Milton's poet cannot recreate (redeem) a similitude of the garden, which is an unfallen and irrecoverable operation. He can only offer similes, fallen similitudes made of the materials of the fallen world that by his poetry are redeemed (with a small *r*) on the analogy — and by the historical fact — of the Son's Redemption.

Milton's similitude disintegrates into simile much as Transubstantiation (in Malcolm Ross's interpretation) or the "divine analogy" (in Earl R. Wasserman's interpretation) declined into metaphor, simile, and cliché. As Wasserman notes, "The divine analogy, unlike metaphor, 'is an Actual Similitude and a Real Correspondency in the very Nature of Things.' "[3] Milton is saying that, in this postlapsarian and pre-Apocalyptic (or pre-eschatological) world, having lost the "divine Similitude" of both Adam and Christ, simile is all that is left us, the poor tool of the poet who seeks to assume the role of the Redeemer.

Milton's "observer similes" are about fallen perception, man's misperceiving his surroundings, above and below; they recall the Son's perception (nothing "could his eye not ken," 11.396) and Adam's sight from Pisgah, assisted by the angel Michael's medicaments.[4] "I perceive / Thy mortal sight to fail," Michael says to Adam — "what is to come I will relate" (12.8–12), as opposed to Satan's inventions, lies, disguises, and total difference.[5] Milton's similes stress difference and misapprehension: Satan's shield, to human eyesight even assisted by a telescope, appears to be the moon; Satan's body, which to a human mariner looks like a landspit on which he can safely moor his ship, is in fact like a whale, who will unexpectedly take off, carrying the ship and mariner with him (like Satan, carrying the deluded human to perdition).

These introduce and represent the real world of 1660s England, the common world Locke was to formulate in the epistemology of his *Essay*, which was, for Milton, the time of Antichrist. The similes, postlapsarian certainly, are also post-Redemption. The housebreaker or the astronomer is contemporary with Milton (in the same way that by analogy the Sons of Beliel are now the court of Charles II). The poet himself is blind, physically, humanly blind, an extreme case of the human observer of the similes whose perception is compromised. The similes reflect the poet's own situation — physically blind but inwardly illuminated, as opposed to the "blindness" of the "observers" who await the Last Days.

In unfallen man, to be incarnate was to be born in God's image. Having lost his

"incarnation," man's similitude, reduced to simile, is somehow recovered by the capital "I" Incarnation — the Divine Similitude become man in the Son — by which man is not changed but revalued, his corporeality sacralized by God's taking it on (a different matter from immanence, the indwelling presence of God in the world, in miracles or rewards and punishments). What comes with the capital "I" Incarnation metaphor is a sequence of events — birth, temptations, suffering, death, resurrection, and final judgment, and *this* is perhaps the closest we can come to defining the space Milton lays out and explores in the "observer similes." This area is fallen, postlapsarian but also "redeemed" or waiting for the effects of Redemption, reflected in the artifice of Milton's poetry, which "redeems" to the extent that the simile can do so.

Paradise Lost is about the Son's Incarnation — how it came about and how it works *faute de mieux* on the human level as well as the divine. Adam serves only as the subject of the Fall and of instruction as to the doctrine of Redemption. The Son becomes a second Adam, correcting the first, and so the second, redeemed creation becomes more important, if not more perfect, than the first. And, given the principle of Incarnation, the human protagonist, the poet, recreates Christ's story on the level of the Fall. Milton's alignment is not with Adam but with the Son, whom he invokes as a source of power in the angels' hymn, identifying himself by the first-person pronoun with the angels: "Hail Son of God, Saviour of Men, thy Name / Shall be the copious matter of my Song / Henceforth" (3.412–15).

The loss of the Commonwealth, the fall of the Saints, and the discrediting of the monarchy left only one figure of authority — the poet himself, the surrogate of the Son. The equivalent of eternal life was also available at the hands of the poet, in the immortality of his poem. The Son projects actual immortality, heaven or hell in the afterlife; the poet projects spiritual, which is to say literary, immortality.

We can only valorize the word *redemption*, and think of the poet as *redeeming* fallen man, because the word sounds preferable to *atonement*, lacking as it does the bloody connotations; but it only substitutes a commercial transaction for a sacrificial. Christ's act of redemption follows from his Incarnation, and it is the effect of his Incarnation, as celebrated in the Magnificat, which revalues humans now, at once, in the lengthy interim before the Second Coming. Christ *redeemed* (1) by projecting an eternal afterlife *in place of* the death resulting from Adam's Fall and (2) by condescending to assume, and so sacralize in a new way (by the New Covenant), the human body. The extension of — the bestowal of — incarna-

tion covers the period between Christ's incarnated life and the fulfillment of his promise of everlasting life at his Second Coming. The poet's "redemption" can also include, besides the promise of a sort of immortality, the bestowal or discovery (depending on the poet's perspective) of this aura. So, as we saw in the paintings of Wright, poetic redemption in fact equals a form of incarnation, and in relation to the Son's Redemption, poetic also equals parodic — again, manifest in the need for Milton's similes of misperception.

Addison popularized these assumptions, though in aesthetic rather than poetic terms, in his "Pleasures of the Imagination" essays. When in *Spectator* no. 421 he uses the traditional analogy of the poet's achievement and God's, saying that the poetic imagination "has something in it like Creation," he seems to refer to the "second Creation," the Redemption: "It bestows a kind of Existence, and draws up to the Reader's View, several Objects which are not to be found in Being. It makes Additions to Nature, and gives a greater variety to God's Works" (3:579). Referring to the poetic "embellishments" that "beautifie and adorn" Nature, he implies a specifically secondary sense of creation. In no. 418 he offers his particular evaluation of poetic redemption:

> But because the Mind of Man requires something *more perfect in Matter, than what it finds there, and can never meet with any Sight in Nature* which sufficiently answers its highest Ideas of Pleasantness; or, in other Words, because the Imagination can fancy to it self Things *more Great, Strange, or Beautiful,* than the Eye ever saw, and is still *sensible of some Defect in what it has seen;* on this account it is the part of a Poet to humour the Imagination in its own Notions, by mending and perfecting Nature where he describes a Reality, and by adding greater Beauties than are put together in Nature, where he describes a Fiction. (3:569, emphasis added)

In the twentieth century, Trevor Hart, writing on the artist's sense of the Christian Incarnation, has called it "the voluntary generation of some symbolic supplement to a modification of the actual." Presented with fallen mankind, God does not simply *re*-create, "start over again with a clean slate." Instead, by the Incarnation, "He takes our 'flesh,' together with all its limiting factors and inherent flaws, and through a work of supremely 'inspired' (Spirit-filled) artistry, transfigures it, before handing it back to us in the glorious state which its original maker always intended it to bear."[6] Addison, however, described the artist who, "still sensible of some Defect in what [he] has seen [of the redeemed creation]," makes things "more Great, Strange, and Beautiful, than the Eye ever saw," and so "has the modelling of Nature in his own Hands, and may give her what Charms

he pleases, *provided he does not reform her too much, and run into absurdities*, by endeavouring to excell" (570, emphasis added). This poet may exceed Addison's aesthetic categories (Great, Strange, and Beautiful):

> He is not obliged to attend [Nature] in the slow Advances which she makes from one season to another, or to observe her Conduct, in the successive Production of Plants and Flowers. . . . His Rose-trees, Wood-bines, and Jessamines, may flower together, and his beds be covered at the same time with Lillies, Violets, and Amaranths. . . . If this will not furnish out an agreeable Scene, he can make several new Species of Flowers, with richer Scents and higher Colours, than any that grow in the Gardens of Nature. (569)

He transforms as the scribblers of Pope's *Dunciad* are wont to transform georgic farming into romance fantasy. Milton, needless to say, is classified by Addison as a poet whose "beauties" (greatness, strangeness, and beauty) are adduced from the story of Redemption. At the hands of lesser poets, this is gilding the lily. "Art" in this sense is inherently transgressive of the limits that creation sets and can be interpreted as constituting an offense to the (divine) creativity that it emulates.

Incarnation applies to the here and now, Redemption refers to a remote future time — to a promise and perhaps an illusion. Incarnation can be seen by anyone with the eyes to see: thus the poet and the observer of the simile, and the question of whether the poet, analogous to the Son, bestows or whether he only discovers: Pope and Milton are examples of the first, Hogarth of the second; with the first comes poetics, with the second aesthetics.

Poetics versus Aesthetics: Pope's Belinda

The Whig aesthetics of Shaftesbury, Addison, and Hogarth replaced the worship of the deity with the enjoyment of beauty. Pope, also much concerned with beauty, however broad a base he sought for his satiric and moral works, was a Roman Catholic. The question is: What in the 1700s was a Roman or papist aesthetics? A papist poem might celebrate divine beauty, the beauty of the Virgin or of virginity, as in the devotional poetry of Southwell or Crashaw. A Roman Catholic aesthetics is an apt description of Crashaw's devotional poetry, especially his Eucharistic poems. The effect on the reader is supposed to be devotional, but anyone other than a devotee can only read them as an unintended aesthetics of tears, blood, and wounds — an aesthetics of a morbid, pathological sort. Divine beauty in the founding documents of modern aesthetics, the writings

of Shaftesbury and Addison, is a contradiction in terms. (They would have meant by "divine beauty" the realm of theology, not aesthetics, which is grounded in the world of the senses. Addison defended *both* aesthetics and the concept of "divine beauty.")

Both Shaftesbury and Addison constructed their aesthetic theories out of the tradition of British empiricism, which also theorized the principles of the first earl of Shaftesbury's Whig party. Both were grounded in anti-Tory, anti-Jacobite politics. Shaftesbury's Whig aesthetics-politics shifted the attention from the God, Creator, king, and poet to the aristocrat, the M.P., and the critic-connoisseur. The conception of aesthetics was a Whig idea, based on the model of government in which the creative power of the one monarch was replaced (or at least balanced) by the responses of the many—whether called parliament and people or in reality a small aristocratic elite that wished to outweigh the power of the monarch. In aesthetics the authority of god or priest, of painter or poet, was replaced by that of connoisseurs, "men of taste," patrons, critics, and collectors of the work of art.

A papist aesthetics would therefore be an oxymoron. It would have to be a *non-aesthetics*, the return from an oligarchy to a monarchy. In effect, aesthetics would be replaced by (and returned to) a poetics, focusing on the poet. A papist aesthetics would also have to be Jacobite, a recovery of the Jacobite religion with the Jacobite politics.[7] But this too would seem to be a contradiction in terms. A Jacobite aesthetics would have to offer an alternative to the Shaftesbury aesthetics, which was classical and Platonist and anticlerical, revising it along Christian lines.

Pope's mock-epic, *The Rape of the Lock* (first published 1712), has been identified by Howard Erskine-Hill and others as a coded Jacobite poem: "rape" may allude to William III's seizure of England by the "conqu'ring Force of unresisted Steel," and so on.[8] The aesthetics of Shaftesbury and Addison (the *Characteristicks* in 1711, the "Pleasures of the Imagination" essays in the *Spectator* in 1712) were the immediate context for Pope's poem. Also, adventitiously, was the transition from Stuart to Hanoverian rule in 1714. The revised edition of the *Rape* was completed at the end of 1713 and published in February 1714; George I landed at Greenwich in September. Pope's self-exculpatory *Key to the Lock*, published under the pseudonym of Esdras Barnavelt, appeared in 1715, and the moralizing speech of Clarissa was added in 1717, perhaps to draw attention away from any Jacobite traces.

In this context, *The Rape of the Lock* embodies an aesthetics not of Shaftesbury's

classical Platonic ideal but of the Christian Fall and, as follows, of Redemption. The last we can see as Pope's way to recover from the Whig aesthetics a poetics, returning the attention from the authority of response, criticism, and taste to the authority of the maker, from the many back to the one.[9] Thus a Jacobite aesthetics in *The Rape of the Lock* combines dynastic and religious claims, the twin hopes of restoration and of redemption. And, since the original object was the reconciliation of two Catholic families in marriage, the cult of the virgin is not called for — nor its secular equivalent, the ideal of perfect, unflawed beauty — but rather an aesthetics of the Fall.

The first signs of an aesthetics of the Fall appear in the enlarged 1714 *Rape of the Lock*. The overlap with the 1712 version, and the nucleus of Pope's sense of a religious aesthetics, is discernible in one couplet of the 1712 *Rape*:

On her white breast a sparkling *Cross* she wore,
Which *Jews* might kiss, and Infidels adore.
(1.23–24)

Belinda's cross (which a young Roman Catholic woman might be expected to wear) has lost its religious significance and been aestheticized, that is, beautified. To Pope, the Roman Catholic, this is a secular degeneration of a religious symbol into jewelry.[10] Pope implies that to a Catholic the cross is an object of devotion, to an infidel merely an erotic stimulus.

Contemporaneously, however, from the point of view of the dissenter Daniel Defoe, the cross was an object of papist idolatry.[11] (For example, the Puritan would have none of the cross in baptism for fear it might suggest powers *ex opere operato*.) And Hogarth, writing in his *Analysis of Beauty* forty years later, took up Belinda's cross and improved it by changing the straight into wavy "Lines of Beauty" (fig. 45, Hogarth's fig. 70). The variant crosses appear in plate 2 of his illustrations accompanying the *Analysis* (figs. 44 and 45), and he remarks in the text that the rigid schema of a cross for a man's body (implicitly nailed to the cross, "in distortions of pain") is beautified by serpentine lines. In effect he beautifies, or aestheticizes, the central symbol of Christianity — but a symbol also scorned as an idol by radical Protestants like Defoe. Shaftesbury had led the way when he replaced the Christian deity, a cruel ogre who ruled with a morality of rewards and punishments, with the "divine example" of a perfect Platonic form. Hogarth, on the other hand, justifies his aestheticization of the cross as a humanizing (or correcting) of popish and priestly idolatry *and* of Shaftesbury's Platonist aesthetics as well. "A man," he wrote, "must have a good deal of practice to *mimic*

such very *straight* or round motions, which being incompatible with the *human* form, are therefore *ridiculous*" (emphasis added).[12]

For Pope as well as Hogarth, the issue is not, after all, simply that Belinda devalues the cross into a "sparkling" ornament, a merely social degeneration, but that the cross draws the attention of the male gaze to Belinda's bosom, a synecdoche for the beautiful woman and for a humanist aesthetics in which the end is love, marriage, copulation, and children. For Pope it may be an equivocal good, at best a *felix culpa;* for Hogarth the "living woman" is unambiguously beautiful and (which is the same for him) desirable. In *The Sleeping Congregation* (see fig. 35), he shows the eyes of the one awake congregant on the pretty young woman's bosom, but there is, of course (she being a Protestant), no cross.

One of the questions I raise is how Pope's *Rape* can present an aesthetics that in some ways corresponds to Hogarth's. Hogarth's aesthetics — anticlerical, iconoclastic, empiricist, Whig, and deist — came out of a very different tradition, and yet both end with an aesthetics not of the ideal but of the flaw or blemish. Pope and Hogarth were obviously contraries, one a Roman Catholic and the other a strong anti-Catholic, but they came together in Pope's *Rape.*[13]

One scene introduced by Pope in the 1714 *Rape* is Belinda's toilette, which echoes the scene in book 5 of *Paradise Lost* in which Eve admires her reflection in a pond; Belinda worships herself in the mirror, conflating priestess and idol. Immediately after, returning to the original premise of the poem as parody, a mock-epic wrath of Achilles, she "arms" herself (1.139–44): "Repairs her Smiles, awakens ev'ry Grace" — with cosmetics, not armor; for a card game, not single combat; for a battle of the sexes, not of Greeks and Trojans. The first word, *repair,* with its connotations of carpentering, is balanced on the other side of the caesura by *awakens* (in a *concordia discors*). *Repair* is a reminder of why Belinda has to *arm* herself cosmetically, which however, in the case of a beautiful woman, only *awakens* every grace — "calls forth all the Wonders of her Face; / Sees by Degrees a purer Blush arise." The oxymoron *purer blush,* of course, explains *repair:* she (assisted by her sylphs) wishes to hide the sign of the Fall — the guilt of Eve's sin, which, in Belinda's case, proves to be specifically her consciousness of the "Earthly Lover lurking at her Heart," the knowledge of which will, at the moment of the Baron's attack, disperse her protectors, the sylphs, and render her vulnerable.[14]

This can be (in general *has* been) taken, in moral terms, as the sin of hubris, Eve's desire to be more than human. In aesthetic terms, it is Belinda's conviction that beauty is perfection. Morality deals with right and wrong conduct; aesthetics

with beauty and ugliness. The first—Pope's Christian morality—is precisely what Shaftesbury was reacting against when he created his version of aesthetics: He therefore equates beauty with disinterested virtue (not based on the hope and fear of rewards and punishments). His "divine example," with which he replaces the deity, is perfect harmony. In Pope's poem Belinda's beauty is the issue: before the Fall, perfection; after the Fall, blemish and blush—and, accompanying it, fallen sexuality. As in *Paradise Lost* the Fall is immediately succeeded by both flaw and prurience. It is by privileging this postlapsarian state that Pope produces an aesthetics of the Fall.

The Rape of the Lock opens with Shaftesburian premises: Belinda's perfection, based on her two balanced locks ("two Locks, which graceful hung behind / In equal Curls, and well conspir'd to deck / With shining Ringlets her smooth Iv'ry Neck"), her presence as a substitute sun and deity, her "sparkling Cross" as a beautified crucifix. These transformations are centered on allusions to the Temptation in *Paradise Lost* book 5: Ariel's whisper, "thy own Importance know, / Nor bound thy narrow Views to Things below" (1.35–36), echoes Satan's whispering in Eve's ear: "fair Angelic *Eve*, / . . . be henceforth among the Gods / Thyself a Goddess, not to earth confin'd" (5.74–78).

Earl R. Wasserman, who so far as I know was the first to point out this allusion, saw Ariel's temptation as offering Belinda "a Satanic substitute for Christianity, complete with doctrines of immortality, angelology, psalmody, and cosmology"—including a parody of the Mass at Belinda's dressing table, where she worships herself, as the "sparkling cross" parodies a crucifix.[15] In Wasserman's interpretation, Ariel's retiring after discovering the "Earthly Lover lurking at her Heart" recalls the angelic hosts in *Paradise Lost* who retire, "mute and sad," to heaven after the Fall of Adam and Eve. This is hardly an aesthetic humanization. But Wasserman's description of Belinda's "fall" as from "a religion of unrealistic and anti-social chastity," the narcissistic self-love and arid virginity that the sylphs represent and seek to preserve (and so a "fortunate fall" into a more natural human condition), could also apply to a Christian reaction to Shaftesburian aesthetics, Pope's humanizing of a Platonic symbol.

Wasserman saw the temptation in a context of Christian morality: Belinda is tempted by Ariel and commits the original sin. One way to bypass the vexing question of whether the *Rape* is satire or comedy might be to reinterpret the scene as an aesthetics in which Shaftesbury's ideal, the perfect form, is replaced by the living fallen woman—the Belinda with only one asymmetrical lock. Belinda's pride ("The Nymph exulting fills with shouts the Sky") vaunts her perfection and the retention of that perfection just preceding her Fall.

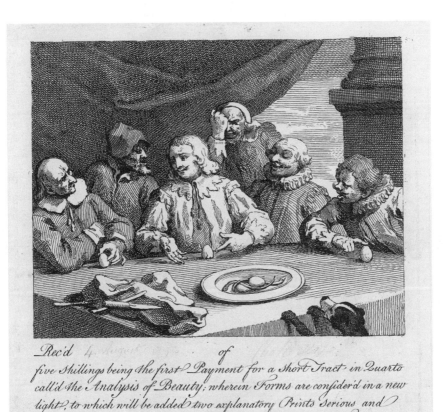

Rec'd _____ of _____
five Shillings being the first Payment for a short Tract in Quarto
call'd the Analysis of Beauty; wherein Forms are consider'd in a new
light, to which will be added two explanatory Prints Serious and
Comical, Engrav'd on large Copper Plates fit to frame for Furniture.

N.B. The Price will be rais'd after the Subscription is over.

W.ᵐ Hogarth

Fig. 43. Hogarth, *Columbus Breaking the Egg* (1752),
etching, first state. Reproduced by courtesy of the
Trustees of the British Museum.

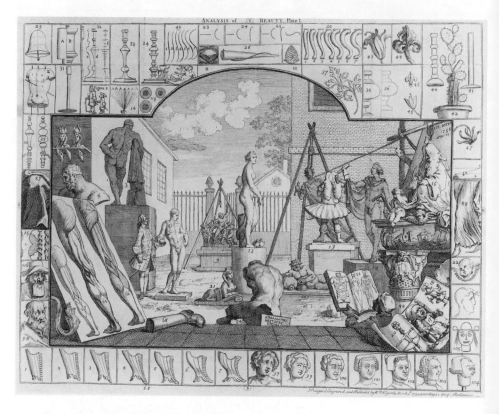

Fig. 44. Hogarth, *The Analysis of Beauty*, plate 1 (1753),
etching and engraving, first state. Reproduced by courtesy
of the Trustees of the British Museum.

176

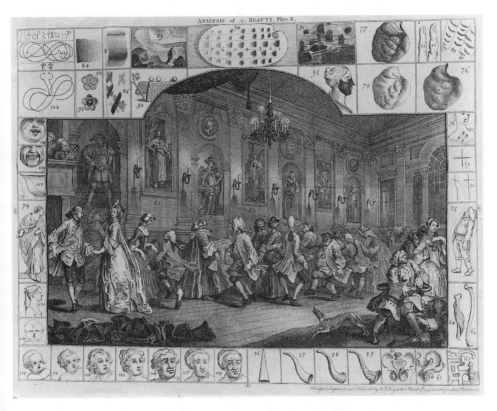

Fig. 45. Hogarth, *The Analysis of Beauty*, plate 2 (1753), etching and engraving, first state. Reproduced by courtesy of the Trustees of the British Museum.

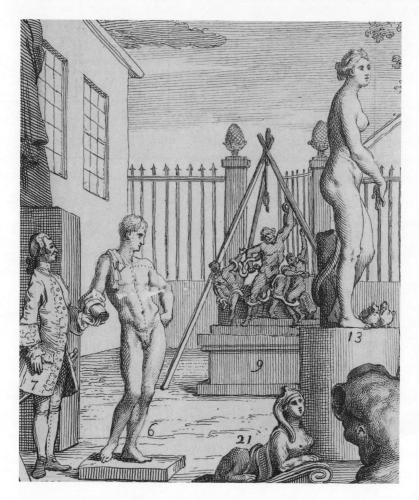

Fig. 46. Hogarth, *The Analysis of Beauty*, plate 1 (detail).

Fig. 47. Hogarth, *The Analysis of Beauty*, plate 1 (detail).

Fig. 48. Hogarth, *The Analysis of Beauty*, plate 1 (detail).

Fig. 49. Hogarth, *The Analysis of Beauty*, plate 2 (detail).

Gendered as female, Belinda the coquette is associated with all the negative aspects of Shaftesbury's whore Pleasure (not the Heroic Virtue of Hercules or the other woman, Virtue) in his *Judgment of Hercules*, which appeared in 1713 between the two versions of the *Rape*.[16] Reading this work,[17] Pope may have seen how his Belinda of 1712 fitted into Shaftesbury's negative pole; Shaftesbury's positive pole would have been the male Achilles implicit in the opening lines of the *Rape*, where it is made clear that this is *not* going to be an epic about heroic (male) virtue. Instead, Pope returns to the religious tradition that Shaftesbury rejected and treats the Eve of *Paradise Lost*, in the 1714 version introducing Ariel, his whispering in Belinda's ear, his temptation, her dream, and finally her admiration of her own image in the pond.

The imagery thereafter shifts back and forth — but Pope, like Milton in *Paradise Lost*, flashes classical only to privilege Christian.[18] He is rejecting the classical as well as the deist, Whig, and misogynist aspects of Shaftesbury. But he is also distancing himself from the negative Whig image of the Cavalier (as castigated, e.g., by Milton) in favor of the gentler version in Cavalier poetry of the Caroline period: the courtly love lyric, specifically of *carpe diem*, and the seduction, temptation, and Fall of *Paradise Lost*.[19] As an aesthetics (a study of response), the *Rape* begins by evoking the "wrath of Achilles," the crudest and most devisive of responses, totally interested and hardly aesthetic in Shaftesbury's sense. Then, with "Sleepless lovers just at twelve awake," Pope introduces the tradition of Petrarchan love poetry.

Belinda, in her negative response to the cutting of her lock, twists *carpe diem* to her own ends: She wishes to be "Like roses that in deserts bloom and die" (4.158; she recalls Waller's "Go, lovely Rose": "hadst thou sprung / In deserts, where no men abide, / Thou must have uncommended died"). She is invoking the rose of the courtly love tradition, emblem of the chaste lady who refuses to yield her "rose" to her ardent lover. But she is responded to by Clarissa, who is the true spokesperson of *carpe diem*. Pope momentarily returns to the *Iliad* with Clarissa's parody of Sarpedon's speech to Glaucus embedded in, and superseded by, her *carpe diem* summation of courtly love, replacing Sarpedon's heroic speech as well as Belinda's with the correct interpretation of "Go, lovely Rose":

To patch, nay ogle, might become a Saint,
Nor could it sure be such a Sin to paint.
But since, alas! frail Beauty must decay,
Curl'd or uncurl'd, since Locks will turn to grey,

Since painted, or not painted, all shall fade,

And she who scorns a Man, must die a Maid.

(5.23–28)

This is Pope's way of recovering or metaphorically "redeeming" a poetry that contemporary Whigs associated with the Jacobite Pretender, looking back to the Civil War and the degenerate Cavaliers, the Restoration Rakes whom Milton associated with Satan and the fallen angels (as plain a sign of Jacobite poetry as the word *rape*). But here the courtly love discourse is contrasted with both the Platonic idealism of Belinda and the heroic virtue of Achilles.

Pope associates the world of *carpe diem* with the Fall (introduced with the parallel of Satan-Eve, Ariel-Belinda) and the Fall with the frail china jars and stained brocade, materialized in Belinda's decline into anger, spleen, and melancholy. With the cutting of her lock, refusing to accept her fallen state, she becomes the spokesperson for Shaftesburian perfection, the perfect prelapsarian unbroken circle (ironically, for the Platonic Shaftesbury, in the figure of a Venus).[20]

We are informed that Belinda's perfection may "hide her Faults, if *Belles* had Faults to hide: / If to her share some Female Errors fall, / Look on her face, and you'll forget 'em all" (2.17–18). These "faults" ask to be related to the flaws and stains referred to by Ariel as signs (tokens, foreshadowings) of her imminent Fall — and so to her harboring an "Earthly Lover" in her heart.

As a self-sufficient object Belinda the coquette embodies the *sine qua non* of aesthetic perception according to Shaftesbury — disinterestedness. She is the replacement of the divine with human disinterestedness: Her eyes, "that must eclipse the Day," "like the Sun, . . . shine on all alike" (1.14, 2.14). As long, that is, as she is under the governance of the sylphs. The "Earthly Lover lurking at her Heart," which disperses the sylphs, has intruded interest. By destroying symmetry, by creating what Belinda and the sylphs regard as a prototypical flaw or blemish, Pope equates interest and flaw, both antithetical to Shaftesbury's assumptions of the beautiful as perfect harmony.

Before this intrusion of interest, however, Belinda recalls Eve, who was tempted to eat the apple not out of hunger but to gain power. Ariel's aim is, in Shaftesbury's terms, to aestheticize Belinda into a (replacement) deity of beauty, yet attaining the deity's power: "Let Spades be Trumps! she said, and Trumps they were" (3.46). Satan's temptation of Eve was based on precisely the interest that Shaftesbury used to distinguish the aesthetic from an ordinary lustful perception of beauty — and when Eve has eaten the apple, and Adam has, they must

don fig leaves, the mythic origin of the cosmetics Belinda uses to obtain "purer blushes," that is, blushes that conceal the desire that produces *impure* blushes. What is revealed, of course, is the interest that Bernard Mandeville would show underlies Shaftesbury's vaunted disinterestedness.[21] But the upshot is the dissipation of the notion that beauty can only be beautiful if regarded with disinterestedness.

Chastity (or coquetry) is the interested retention of disinterestedness. The moment the Baron cuts the lock he replaces the interest of power with the interest of the hunger to possess or be possessed, that is, with the un-Shaftesburian notion of replacing the ideal of chastity with the reality of sense. The "disinterestedness" of Belinda (the aesthetic object) corrected by the interest on the part of the observer (the aesthetic subject) is an exact reversal of Shaftesbury, who defined a disinterested subject as a man without hunger or desire. The apples and oranges hanging on trees *are* edible, says Pope, made to be eaten, and this may not detract from their status as beautiful objects.

The *Rape* ends enumerating the interested human responses to the metamorphosed lock, among other things putting in question a standard (or any standard) of taste. The Baron interprets the lock as a talisman/fetish — the sign of his action but not possession of the ideal woman. The sylphs are "pleas'd" at the apotheosis of their values of unattainable and coquettish beauty. To them the severed lock raised to the skies is no longer (as on Belinda's neck) a blemish but the logo of their idealist aesthetics. The lovers, fornicators, and adulterers, strolling on the Mall and meeting at Rosamonda's Pond, worship this symbol of seduction outside marriage (contrasted with Berenice's lock, the emblem of married love). To the reader the lock may represent a realist aesthetics, the symbol of the Fall, detached now from the perfect face. To the poet Belinda's lock is the one thing that *will* survive the *carpe diem* admonitions of Clarissa — that is, by means of the poet's art. And the final "die" is not, like the earlier ones, a pun on orgasm: it signifies real death, the only compensation for which is Pope's work of art.

As an aesthetics, Addison's "Pleasures of the Imagination" essays (published between the 1712 and 1714 versions of the *Rape*) offered Pope more to emulate than Shaftesbury's neoplatonist *Characteristicks*. While Shaftesbury posited an ideal beauty appreciated by a Whig oligarchy, Addison opened up the Whig ethos to cultivated spectators in general; while Shaftesbury posited only ideal beauty and ugliness, Addison drew from the Ugly other alternatives — the Great and the Novel, Uncommon, or Strange. The latter was a middle area of civil society, in which a wider range of spectators responded to everyday London

events with a supposedly disinterested curiosity and sympathetic laughter; it provided the nucleus of an aesthetics of the living, of contemporary life, which Pope may have chosen as a model. Pope's fallen world finds its aesthetic equivalent in the middle area of Addison's Novel. In *Peri Bathous* (1727), though a poetics and not an aesthetics, Pope follows Addison's aesthetic categories, making an ironic distinction between both the Sublime and the Profound (the sun, moon, and stars and gold, pearls, and precious stones) and "all that lies between these, as Corn, Flowers, Fruits, Animals, and Things for the meer Use of Man." These "are of mean price, and so common as not to be greatly esteem'd by the Curious: It being certain, that any thing, of which we know the true Use, cannot be Invaluable."[22]

Addison presented what Pope could see as both the redemption (false) of fallen nature by the dunces ("to humour the Imagination" being the same as Swift's "play the wag with the senses" in "The Digression on Madness" and what Addison describes immediately following as the poetic ability to "render [nature] the more agreeable" by joining winter and spring flowers, plants from Africa and Nova Zembla) and the redemption (true) by Pope of the fallen duncical writings.

This area, however, Pope Christianizes. Ironically, his way from a Whig to a Roman Catholic (or at least High Anglican) aesthetics is through Milton's *Paradise Lost*, a radical proto-Whig poem. Pope, writing in 1714, carries with him Addison's aestheticized version of *Paradise Lost* in his *Spectator* essays, which replaced the political, moral, and theological content of Milton the regicide with the poem's "beauties." He takes from *Paradise Lost* the Temptation and Fall and, inevitably, he includes the Redemption, which, for Pope as for Milton, has both a divine and a human dimension.

Pope's Christian redeemer is strikingly different from Shaftesbury's "Second *Maker*; a just Promethean under Jove," who is closer to the gnostic image of a demiurge.[23] Shaftesbury's aesthetics is prelapsarian; Pope's fallen, "earthly," and living. And yet for Pope "art" takes on a religious significance it does not have for either Shaftesbury or Addison. From Addison's primary and secondary imaginations onward (though with roots going back to the church fathers) one chief contrast, in fact the contrast that tends to supplant that of right and wrong or good and evil, is nature and art, with the first term privileged.

Pope closes the *Rape of the Lock* by substituting Clarissa's final sense of *die* ("who scorns a man, must die a maid") for the pun (death, *petit mort*) of the battle for the lock:

When, after Millions slain, your self shall die;
When those fair Suns shall set, as set they must,
When all those Tresses shall be laid in Dust;
This Lock, the Muse shall consecrate to Fame,
And mid'st the Stars inscribe *Belinda's* Name.

"*This lock*" is, in the *carpe diem* context of the last lines, Pope's poem, under the aegis of the poetic muse — absorbing aesthetics into poetics. Poetic redemption is the closure Pope gives his poem, his own recovery of the momentary and transient transgression of the Fermor-Petre quarrel in his immortal poem — the recovery of Arabella's lock in his *Lock*. He recovers thereby the authority of the artist from the virtuosi, connoisseurs, and collectors (although Pope, covering all the bases, also studied hard to be one of these), turning an aesthetics back into a poetics, centered not on the Whig oligarchy but on the poet and the monarch (and God, or at least the Son).

If morality deals with right and wrong and aesthetics with the beautiful and the ugly, then politics (as Carl Schmitt has told us) deals with the translation of these into friends and enemies (us and them). The aesthetics of the *Rape of the Lock* (like that of Shaftesbury and Addison) is another politics: it tries to persuade us that a true aesthetics is Christian and religious, not deist and classical, and indeed that it includes (retains or recovers) a poetics in which the Son, who redeems the Fall, sanctions the function of the poet, if not (another intermediary and an analogue) the priest and the Stuart monarch.[24] Insofar as it is Jacobite and a politics, it returns aesthetics from its privileging of the spectator to a poetics focused on the creator as redeemer — here redeemer of Belinda's blemish, in *The Dunciad* of the dreck of poetasters and literary hacks.

Pope has in fact done two things: He has replaced Shaftesbury's deist-Platonic aesthetics with a Christian aesthetics of the Fall and the connoisseurship of the Whig oligarchy with the authority of a poetic, if not a royal, maker and redeemer — a Jacobite version of the poet created by Milton in *Paradise Lost.*

Redemption and Restoration/Recovery: *The Dunciad*

Fifteen years after *The Rape of the Lock*, in the *Epistle to Burlington* (1731), Pope plays with an analogy between the earl of Burlington as architect and himself as poet, emphasizing their common need to "consult the Genius of the Place." From

the gardening of a fallen landscape, he glances upward toward his own poetry. That he implies the congruence of the Christian redemption and the georgic renewal of a war-torn Iron Age, combining the Christian redeemer and the classical georgic farmer, becomes explicit a year later in his *Epistle to Bathurst*. In his character of John Kyrle, the Man of Ross, he confirms the Christian poetics he introduced in the *Rape of the Lock*, supplementing the classical ideal (the golden mean) represented by Bathurst. He cites vicious noblemen, excepting only the fallen and disgraced Oxford and Bathurst (the latter "yet unspoil'd"); for contrast he adduces the humble John Kyrle, who lives a simple but Christological life, redeeming the land (he "divides the weekly bread," etc.) by truly cultivating the genius of the place. The nobles take second place to the Man of Ross, as Shaftesbury did to Pope's aesthetics of the Fall. Kyrle makes his rocky, dry, unpromising countryside into a beautiful, fruitful garden, as Pope himself "redeems" the fallen hackwork of the Dunces with the poetry of his *Dunciad* (1728–43).

The Georgic was a genre that defined recovery or regeneration out of natural disasters, whether storms, plagues, or civil wars. But in *Georgic* IV Virgil is writing not only about the Roman Civil War—the destruction of Aristaeus's beehive—but about Orpheus's loss of his beloved wife: the beehive was destroyed in "atonement" for Aristaeus's sexual pursuit of Eurydice, who fleeing stepped on a poisonous snake, was bitten, and died.

There are three acts of restoration/redemption in the fourth *Georgic*. First, there is the beehive. The bees are a "perfect model state," devoted to their leader (4.4).[25] Among other things, they "take no pleasure in the body's joys, / Nor melt away in love, nor bring to birth / Their young in labor" (4.197–99). The source of its destruction, as of the destruction of Troy, is the love of a woman. When destroyed as a punishment for an attempted rape (sexual passion out of control), the hive is revived—literally reborn—by a combination of religious ritual and practical husbandry (of the poet-farmer who has written the poem): kill an ox and out of the rotting carcass the beehive will regenerate. At the same time, Orpheus the poet compensates for the death of his Eurydice by his mourning song, which continues even after he has been dismembered by the Thracian maenads. And Virgil himself, telling the stories of both Aristaeus and Orpheus, turns the horrors of Roman Civil Wars into poetry. Poetry as a tool of restoration is his subject, as it is Pope's and Milton's.

In his sacred parody in *The Dunciad*, Pope replaces Mary and Jesus with Mother Dulness and her son Theobald/Cibber, the "Antichrist of Wit" (from Revelation). But Pope's model for the action of *The Dunciad* is Virgil's *Aeneid:* as

he tells us in "Martinus Scriblerus of the Poem," "the removal of the imperial seat of Dulness from the City to the polite world; as that of the Aeneid is the Removal of the empire of *Troy* to *Latium.*"²⁶ (He may also, of course, recall the ironic parallel in *Paradise Lost* between Satan's transplanting of his empire to the new world and Aeneas's to Italy.) In the *Aeneid*, as in his *Georgics*, Virgil gives chaos the form of civil war — Aeolus's release of the storm, which destroys Aeneas's ships, delaying his pilgrimage to Italy. Nature overturned is described in the simile of a Roman mob, citizens out of control (political order is regained by the eloquence of one *vir bonus*). Following from the storm simile is the sack of Troy: Out of the Trojan horse climb the Greek soldiers, who kill soldiers and civilians, often in the confusion each other, and Aeneas discovers Helen, the adulterous cause of all this, taking refuge at, of all places, the altar of Vesta, the goddess of home and hearth. It is Aeneas's rage at the sight that prompts him to kill her — only prevented by the arrival of his mother Venus, who reminds him of his duty to reestablish Troy in Italy and found the Roman Empire.

Pope bases *The Dunciad* on this story, in his first book parodying the scene with Venus, now the goddess Dulness, and Aeneas, the despairing scholar Lewis Theobald. But his chaos is no longer Virgil's but Milton's. It is a realm, a geographical area, of uncreation out of which God the Father has created heaven and earth. Satan promises the king Chaos that he will return creation to its former *un*created formlessness. Pope interprets this (as by implication Milton, the bard of *Paradise Lost*, also did), based on the divine analogy of God and poet, as literary, poetic creation. Creation is the subject, chaos the negation; Pope sees the creation of the world embodied (incarnated) in the creation of a literary text, God's and Milton's, though at every point emphasizing that the second is postlapsarian, *in* history (the history of the Civil War, Commonwealth, and Restoration and the world of Virgil's *Georgic* as well). The temptation of Eve, and then of Adam (as in Virgil), is a sexual one, but the world and chaos are both centered on the idea that there is an act of creation, followed by an attempt to return creation to chaos, followed by an incarnational (God-man) redemption.

In the second book of *The Dunciad*, a parody of *Aeneid* 5, the heroes' games, Pope makes the point most brilliantly in the goddess's reward to Curll, who has won the booksellers' race against Lintot, and this is none other than a shaggy blanket, a demotic equivalent of the paintings Aeneas saw (book 1) in the temple of Carthage, which tell the story of the Fall of Troy and include the *lachrymae rerum* passage: The sufferings of the Trojans have been redeemed, insofar as they can be redeemed, by art. The image and the power of pleasurable vision it confers

console for the pain of what it represents. And so Mother Dulness shows Theobald a blanket on which are stitched representations of the defeats of the dunces — Defoe in the pillory (with fictional cropped ears) and Curll's own humiliations, his blanket tossing by the Westminster boys, ending with:

> And oh! (He cry'd) what street, what lane, but knows
> Our purgings, pumpings, blanketings and blows?
> In ev'ry loom our labours shall be seen,
> And the fresh vomit run for ever green!
>
> (2.145–48)

The blanket itself is a travesty of those great paintings in the Carthaginian temple, Curll is a burlesque Aeneas, but the beautiful lines of poetry (the order of the couplets, the assonance and consonance, the "for ever" of the "fresh" green of the vomit) in which these things are represented are the poet's — Pope's — and the process described is the conflation of Miltonic-Christian redemption and Virgilian renewal, as of the empire of Troy, the georgic landscape, and the poet's transforming art. This is what Pope means in the "Advertisement" to *The Dunciad* when he writes that "it is only in this monument that they [the obscure and wretched dunces] must expect to survive, (and here survive they will, as long as the English tongue shall remain such as it was in the reigns of Queen ANNE and King GEORGE)" (5:9).

Milton and Pope both produce a sacred version of the secular redemption projected in Virgil. Virgil's *Georgic* actually conditions Pope's reading of *Paradise Lost*, as it probably did Milton's writing of it — though in *Paradise Lost* the Christian reference discredits and cancels the classical. In *The Dunciad* the classical reference contains the Christian; they are in fact parallel, and the Christian is muted because Pope wishes to conflate georgic renewal and Christian redemption, the poet as farmer and as redeemer, the world of the Stuarts (and Dryden) and of Milton.

In book 1, where the analogy with Aeneas's mission is established, Pope also evokes the Exodus of the Israelites, led by Moses — Theobald "who leads my chosen sons" from Egypt to Promised Lands "that flow with [not of milk and honey but] clenches and with puns."[27] Pope characterizes the literary works of Dulness by harking back to the principles of Leviticus 11: Uncleanliness is focused on the discharges of the body (vaginal discharges, semen) and on death, the idea being that such discharges are a loss, a little death, to the body, but they also breach

boundaries, mixing classes and producing hybrids and impurities, whether of clothing or animal breeding. "Holiness implied separation from the common or the profane. Israel's vocation to holiness thus demanded separation from other nations."[28] The criterion was the same for sacrifices and priests — wholeness and perfection; as we saw above with Hogarth's Harlot, they must be (as Belinda desired to be) without blemish.

For the Israelites the ideal type was defined by their sacrificial victims — the sheep and cattle, whose feet were cleft. In this way, physical perfection, perfect roundness of the hoof, was not the criterion. It was not the ideal of the deist Shaftesbury, geometrical perfection, but the whole, healthy body, without the signs of disease. For Pope, with his Judeo-Christian assumptions, beauty was not perfect regularity but the flawed, unharmonious face of Belinda. What was wrong with the Dunces was not a blemish but, following the Levitical law, the mixed, confused, unclassifiable quality of their work — their defiance of all boundaries, and it is appropriate, given the Levitical source and Pope's Catholic beliefs, that it be redeemed.

In *The Dunciad* the mock warfare of the *Rape of the Lock* (and the real war of *Windsor Forest*) is transformed by the poet into the subject of art — art made specifically out of the georgic material of rotting carcasses, sexual rape, all sorts of "unclean" materials. Pope created, in the vacuum left by the epic, Cavalier love poetry, and the rest, a new kind of poetry, with a new subject, counter to Shaftesburian aesthetics insofar as it returns authority from the critic back to the poet. Pope's poem is *about* the creation of a new poetry, out of the Miltonic epic based on the Christian Redemption, a poetry of renewal-redemption, that is, a redemption of fallen man on the *human* level. It is also a response to Whig aesthetics with a Christian poetics. One objective is to recover poetry from the aestheticians — from the critics. Pope is holding the line, maintaining the religious (and monarchical and poetic) position against the aesthetic.

Redemption, we have seen, is an act of *re*creation: The Son/Christ/Messiah *re*creates, as opposed to God, the Father, and his original, now fallen creation. By a sleight of hand, however, redemption could be seen as the function of the critic or connoisseur in the sense of one who mediates (meddles, interferes) between the created art object and the audience of readers or spectators. So Pope is, among other things, appropriating and securing a particular middle ground from the area of criticism (the work of the Bentleys and Dennises) — a way to recover the position of poet-creator by redefining it against that of critic.[29]

Swift's Anti-aesthetics: The Harlot Celia

The blemish Belinda corrects with her cosmetics into a "purer blush" can be taken as the necessity of art in a fallen or yet-unredeemed world, but the words are still deeply ironic: In Donne's "Holy Sonnet" 4, the woman was told to make herself "red with blushing, as thou art with Sin; / Or wash thee in Christ's blood, which hath this might / That being red, it dyes red souls to white." As Pope must have known, the church fathers felt that the blemish, as a sign of woman's fallen state, should not—could not—be concealed with cosmetics; that the Incarnation, stressing only the weakness in which God chose to enflesh himself, did not raise the body, which in this life does nothing but decay with time and disease. The true blush was the sign of our Fall—the "purer blush" only our attempt to conceal and forget it.

Not long after Pope's *Rape of the Lock* was published, his friend Swift responded with a poem, "The Progress of Beauty" (1719), which focuses on Belinda's "purer blush," draws attention to the poem's aesthetic dimension, and offers a counter- or anti-aesthetics. Swift's Celia is a harlot, who can only try to "teach her cheeks again to blush." That is, she is *beyond* blushing—she is shameless.[30] She uses white lead "to repair / Two brightest, brittlest, earthly things, / A lady's face, and china-ware." The syphilitic Celia is compared to the goddess Diana, who (as the moon) is Swift's equivalent of Belinda's starry lock, shining brightly (seemingly whole) only at night: as if seen by one of Milton's observers. Swift rewrites Belinda's "purer blush," turning makeup into prosthesis—"art no longer can prevail / When the materials all are gone."[31] Celia uses her "beauty" to attract men, not as a coquette but as a harlot, and the "progress" of her toilette is a decline, both physical and moral, from the wholeness of Diana.

An Anglican priest with deep Augustinian roots, Swift travesties Belinda's toilette in order to deny the efficacy of anything that attempts to aestheticize the human condition—that, however ambivalently, trivializes the moral judgment of the Original Sin. Swift assumes the fact that with the Fall comes death—that is, aging and decaying, becoming (with the help of syphilis, or sin) the deteriorating face of Celia or Corinna. We try to defeat the results of Original Sin by deceiving ourselves and others with cosmetics and prosthetics; as opposed to the real Redemption, which offers immortality only in the afterlife.

In the present, before the Resurrection, there is the Holy Spirit, which came down with the Redemption and inhabits us. Paul saw the middle area of life

before redemption as different from prelapsarian days because the spirit of Christ
—the Holy Spirit—is in us, the spirit being something less than God ("God in
us") but more than postlapsarian; the Holy Spirit is distinct from though related
to the risen Jesus. At its most generous, this is the assumption, that after the
coming of Christ transgressors remain among you, "but ye are washed, but ye are
sanctified, but ye are justified in the name of the Lord Jesus, and by the Spirit of
our God" (1 Cor. 6:11). The spirit brings conviction and joy, for we have "re-
ceived the word in much affliction, with joy of the Holy Ghost" (1 Thess. 1:6).

This is the story Swift tells us in the "Stella" poems—and again, of himself, in
"Verses on the Death of Dr. Swift." The body deteriorates—nothing can prevent
this—but the spirit remains. Stella is like (again the simile) a tavern signboard,
now becoming cracked and peeled, but people still give her their trade rather
than the newer inn up the road because of those inner qualities of wit, wisdom,
friendship—or, as in Swift's own case, patriotism.[32]

Swift also rewrites the end of Pope's Canto 4. The *Rape*, after all, began with
the evocation of Achilles' wrath and ended with Belinda's. In "The Progress of
Beauty," Swift transfers Belinda's rage at imperfection from Celia to her lover
Strephon. If he were, like the lover of Ovid's *Remedia Amoris*, to see Celia at her
toilette (too close, without sufficient distance), "Poor Strephon, how would he
blaspheme!" ("Blaspheme" now applies to the woman deified, the false god.) To
this, however, Swift replies with his own version of Clarissa's *carpe diem* speech:
"Poor Celia, but of mortal race, / In vain expects a longer date / To the materials
of her face" (lines 106–8).

In "The Lady's Dressing Room," written a decade or so later, the cosmetic
blush has become the slimy detritus, the waste products, including the feces, of
Celia's body. Strephon does enter her boudoir and opens her close stool: "dis-
gusted [he] slunk away," crying "Oh! Celia, Celia, Celia shits!"[33] And thereafter,
"if unsavoury odours fly, / [he] Conceives a lady standing by" (lines 123–24). His
reaction to Celia is as splenetic and misanthropic as Belinda's to the loss of her
lock. What Strephon and Belinda share is their inability to tolerate a human
flaw—a blemish of the ideal, an acknowledgment of the Fall. His response
echoes, or rather parodies, the overreaction of Belinda (assisted by Thalestris).
For Belinda, however, the flaw is in her own lockless (unsymmetrical) body, and
her anger is directed at the man who, representing reality (or nature), caused it;
for Strephon the flaw is in the idealizing of Chloe or Celia, which means in the
original "arming" of Belinda with cosmetics for her combat with a man.

The epitome in "The Lady's Dressing Room" is her close stool, which is

elaborately decorated but contains her excrement. The close stool is compared by simile, first, to the classical story of Pandora's Box—opening the box, Strephon releases the odors or misfortunes (i.e., consequences of the Fall) and leaves behind the feces or "hope"—and, second, to the Christian (Miltonic) story of Sin's opening for Satan the gate of hell onto Chaos, disorder, and uncreation: "O! may she better learn to keep / 'Those secrets of the hoary deep.' "[34] Sin opens the gate for Satan; she and Satan are the viewers of chaos "dark and deep," and she and Death then construct a bridge by which they can make their way to earth. Strephon has in common with Satan his spiteful quest ("for you to exercise your spite"), and Celia opens the gate of hell but is not strong enough to close it again. It is the realization that women are not goddesses that releases Satan, Sin, and Death into the world.

This is at least partly a reflection of the jaundiced response of Strephon; it is he who interprets Celia's excrement as evil, and it is Swift the poet who celebrates the "gaudy tulips sprung from dung," a realist revision of Belinda's "purer blush." The chief implication of Swift's poem is that, as the sort of clergyman and poet he is, he relies less than Pope on a belief in the efficacy of intervention by priest or poet. Art, sacred or poetic, is no more than carpentry or disguise of the fallen nature that cannot be repaired.

Belinda, looking into her mirror, was both goddess and chief priestess (assisted by a subpriestess who hands the cosmetics), a living symbol of Incarnation. Swift's Celia, though another "goddess," is a harlot, her worshiper her lover, and the role of the poet is changed from redeemer to truth teller. It is quite possible that from Swift's perspective Pope's poet's redemption was not analogous to the work of the Redeemer but rather to the function of the Roman Catholic priest. According to the papist, the priest has the power to make one body and bread, blood and wine, and this, Swift implies, is the delusion of Pope the poet. Pope's irony aside, he would seem to have been taking the analogy with greater comic equilibrium than Milton permitted himself. In Swift's case he is redefining the role of priest to show that Incarnation has no effect whatever on men and women and that Redemption is something that leaves only the true church (the Church of England) to guide us through our moral dilemmas—and the priest then is, besides an exploder of delusion, an instructor in Christian morality (as Swift points out in his sermons).

Swift's critique of the *Rape* raises the questions: Is *The Dunciad* in fact an aesthetics rather than a poetics? Is Pope really writing as a moralist or as an aesthetician? Because Pope's poetry is human in origin and not divine, is it merely

artful? If Swift uses Pope's aesthetics as a way of talking about the moral issues surrounding female beauty, he implies that Pope is liable to plaster over a moral judgment of good-evil with an aesthetic judgment of beauty-ugliness or nature-art. In *The Dunciad* Pope may be thought to assign a moral weight to a merely aesthetic judgment by importing Miltonic allusions to the very conquest of Satan and Sin to which Swift alludes in "The Lady's Dressing Room"—by believing that his poetry can in some sense "redeem" this dross. Swift calls in question Pope's means of expression. Pope's principle would seem to be the darker and more chaotic the subject the greater the decorum of expression. A disciplined disjunction between form and subject, which Pope regards as poetic redemption, Swift sees as merely art employed to quarantine or tame the chaos, avoiding any of the real violence of feeling called for.

Blushes and Blemishes: Belinda and the Harlot

On the subject of the blemish, we might contrast the view of the polite Addison: "I shall endeavour to point out all those imperfections that are the Blemishes, as well as those Virtues which are the Embellishments, of the Sex" (*Spectator* no. 10, 12 Mar. 1711). In no. 57 he criticizes women's desire to speak in public, revealing the political edge on his aesthetics: "As I would fain contribute to make Woman-kind, which is the most beautiful Part of the creation, entirely amiable, and wear out all those little Spots and Blemishes that are apt to rise among the Charms which Nature has poured out upon them, I shall dedicate this Paper to their service. The Spot which I would here endeavour to clear them of, is that Party Rage which of late Years is very much crept into their Conversation" (5 May 1711). Addison wishes to remove the "Spots and Blemishes" that mar women, in particular when they make themselves political subjects. These are Tory women, of whom Addison generously wishes to forgive their blemishes.

In *Trivia*, published two years after the 1714 *Rape*, Gay presented a woman whose "purer blush" was genuine, the result not of lustful thoughts or of cosmetics but of brisk exercise and cold weather: "Her rosie Cheek with distant Visits glow'd, / And Exercise unartful Charms bestow'd" (1.107–8). This was a lady of "old *Britannia's* City"; that is, Gay turns Virgil's georgic, which is about the recovery of the past—a postlapsarian redemption—into a satire, in which the past has *not* been redeemed and the present is merely defined, as it is in Juvenal's satires, as a falling away from an ideal past.[35] Gay sets up an opposition between the fallen world and the redemptive potential of art in which the latter is put in

question as mere artfulness. So far like Swift: But Gay sees art as merely strait-jacketing the endless variety of London life, in effect producing a comic incongruity of art and nature, order and disorder at its extremes.

Although it has not survived, the third painting of Hogarth's *Harlot's Progress* would have shown the Harlot with the same rosy cheeks and creamy skin as Polly Peachum in the *Beggar's Opera* paintings that immediately preceded it. In the 1730s–40s Hogarth presented in his paintings several rosy-cheeked young women of the lower orders. His aesthetics, we have seen, is of the "living woman," and in his chapter in the *Analysis* on coloring he attributes the blush to bashfulness (shyness or diffidence), not shame or lust. Also, recalling *Trivia*, he distinguishes the effects of different weather conditions: "the colouring of park beautys in a winters morning and a summers Evening differ as much as the Trees they walk by"; "The gently glowing warmth brings out the Sweetest colouring, the things are then clear broad and briliant."[36]

Hogarth uses, as epigraph for his *Analysis of Beauty*, the same lines from *Paradise Lost* that inspired Belinda's lock:

So vary'd he [i.e., Satan], and of his tortuous train
Curl'd many a wanton wreath, in sight of Eve,
To lure her eye.
(*Paradise Lost*, 9.516–18)

Hogarth's aesthetics invokes Belinda's hair, which Pope presented as a lure and trap for men, another synecdoche for woman: "Love in these Labyrinths his Slaves detains, / And mighty Hearts are held in slender Chains" (2.23–28); lines that echo Milton's on Eve's "unadorned golden tresses . . . / Dishevelled, and in wanton ringlets waved" — which in turn draw on Virgil's *diffundere ventis*, Venus's hair streaming seductively in the wind.[37]

In the passage, Eve's hair not only attracts Satan but reemerges in his own serpentine movements as he approaches her. The seduction in this case is of Eve, by "his wit and native subtlety" (9.93). Milton could reasonably be interpreted as implying that Satan's wiles are derived from the female line. Her "hairy sprindges" and "wanton ringlets" anticipate his serpentine motions as he approaches and seduces her. After all, his first thought of disobedience was manifested in his daughter-paramour Sin. In the New Testament there is the "woman of the city" who loosens her hair (the sign of a prostitute) and wipes Christ's feet, which she has anointed with oil (Luke 7:36–50), and, of course, there is Mary Magdalen, with her loose, flowing hair.

Hogarth moves Belinda's symmetrical locks from the neck around to the face, removes the balancing lock, and uses the remaining asymmetrical lock to "break" the perfect oval of the lady's face. If Pope suggested that the removal of the lock reveals a bit more of Belinda's "smooth Iv'ry Neck" (twice referred to), Hogarth, by moving the lock around to the face, makes the flaw itself a particular of her beauty; the asymmetry is "more alluring" because it breaks and creates a flaw. It is the lock that breaks the perfect oval of the face: "falling thus across the temples, and by that means breaking the regularity of the oval" of the face, he writes, the "wanton ringlet" produces an almost indecent "allure" (p. 35). This "allure" he associates with Eve, Belinda, and Cleopatra, as well as with his own Harlot. From his point of view, by cutting the symmetrical lock the Baron made Belinda *more* sexually alluring.[38]

Pope and Hogarth join, combining the comic and pathetic, the satire and poignancy of beauty with blemish, wound, or scar. So also the ambiguity of the reader's attitude toward Belinda: lovely but a coquette — and a coquette (or at least her synecdochic lock) turned into an idol. Belinda does, after all, represent the modernity that degrades a religious symbol (a lost ideal) into mere decoration. The temptation of Ariel, to which Belinda succumbs, is to aestheticize — the crucifix, and also the Bible, which she makes merely another billet doux; marriage and sexual intercourse by removing the interest "in things below" — hunger and desire; desire itself by using cosmetics to produce "purer blushes." For Pope, to wear your crucifix to show off your breasts (as, e.g., the young woman in *Sleeping Congregation* does) is transgressive; it can lead to spiritual sterility but also, as a model (Belinda's lock in the sky), to the encouragement of fornication and affairs out of wedlock.

Much of the imagery of the *Analysis* can be traced back to Pope's Belinda: from the Miltonic echoes, the Eve-like associations of "wanton ringlets," the asymmetrical lock, and the aestheticized cross to a reference to Sir Plume (and the round, comic form that Hogarth invokes in his theory of comedy).[39] Yet Pope was a Roman Catholic, if not a Jacobite, and Hogarth was a xenophobic Whig deist. They shared a common skepticism of Shaftesburian aesthetics — the subordination of the artist to critics and connoisseurs, the limiting of beauty to perfect harmony (ultimately in a geometrical, nonhuman form), and the assumption that this sense of beauty equals virtue. Although ideologically opposed, both Pope and Hogarth for most of their careers were in opposition to the government and its state church. Pope the Tory and Hogarth the Old Whig both drew on opposition strategies and imagery (with obvious parallels to Milton's situation and poli-

tics, which was also of opposition). One might say that while they differed in religion, they shared a politics.

The Milton epigraph and the coquette Belinda serve as fulcrum of the two aspects of Hogarth's beautiful woman: on the one hand, the good mother and milkmaid, on the other, the Harlot, Venus, and Sin (of his painting *Satan, Sin, and Death*). Hogarth's aesthetics replaces God and religion with the appreciation of beauty, but it is based on a reaction against both church *and* Shaftesburian aesthetics that replaced priestcraft and Platonic abstraction with the human Jesus, who mingled with harlots and publicans and was executed as a criminal by church and state. The fact that, having passed beyond wife, mother, and milkmaid, he makes his aesthetic object a woman with the "allure" of the harlot, can be attributed to his reaction against Shaftesbury's misogyny: If Shaftesbury implicitly sets up a young man whom his critics inferred was in fact not an object of his vaunted disinterestedness (e.g., the Antinous, accompanied by an effeminate dancing master, in *Analysis* 1), then Hogarth should provide an alluring young woman, a Venus or a Belinda. As this Harlot becomes Venus, and the *Harlot's Progress* turns into *The Analysis of Beauty*, she grows from a parody of Christian redemption to a norm of aesthetic enjoyment, a model of the artist's practice.[40]

Mock Redeemers

In *Columbus breaking the Egg* (fig. 43), when Hogarth again adapts the *Last Supper*, it is not to satirize but to celebrate — Columbus's messianic discovery of a "new world" is analogous to his own "discovery" of the principle of Beauty in a serpentine line. In the story of Columbus's jest at the expense of his detractors, who said *anyone* could have made his discovery (a story attached to Brunelleschi), he challenges them to stand an egg on end. When they cannot, he does so by breaking the egg and standing it on its broken end — showing skeptics how *he* discovered a new world. In the text of the *Analysis*, Hogarth asserts that the perfect oval of a female face is more beautiful broken, for example, by a lock of hair. Here he not only illustrates again this point but connects the break with his principle of "fitness"; the broken egg is like Columbus's discovery of the New World, and the unsymmetrical lock serves to attract the marriageable man.

Hogarth announced the engraving of *Moses brought to Pharaoh's Daughter* (see fig. 58) as ready for subscribers in the same advertisement that announced the subscription to *The Analysis of Beauty*. In the context of the *Analysis* and its subscription ticket, the *Moses* print invites a witty similitude between Columbus,

"discoverer of the new world," and Moses, leader of his people "out of Egypt and into the Promised Land." Those are the two phrases that would have been elicited by Columbus and Moses — verbalizations, so to speak, of those names, as the Jew was "stabbed in the back" and "made a monkey of" in *Harlot* 2. The engraved *Moses* also introduces the symbols of Hogarth's aesthetics (the Line of Beauty inscribed behind the beautiful princess, pyramids in the background) and replaces the nurturing mother with the seductive young woman, who is, in fact, herself consisting of serpentine Lines of Beauty, the central figure of the composition.

Throughout the *Analysis*, text and plates, Hogarth attacks the "laws" of the art treatises and presents tongue-in-cheek images linking himself to the New Testament or New Covenant "Messiah" and his prophecies. Not only in the comic Columbus and the miniature Moses but in the inscription "obit 1753" on the funerary monument of the hanging judge in plate 1, the suggestion is that, with the publication of the *Analysis*, Hogarth has put an end to bad judgment of all sorts, judicial in both the moral and the aesthetic sense — once again, the old Law (see fig. 44).[41]

As poet, Milton's emphasis was on his humility, the discrepancy between his and the Son's efforts; Pope's was only slightly mocking, perhaps compromised by the classical reference of the Virgilian georgic, but essentially intended to raise the status of the poet. Hogarth's is a jest — he notes the similitude of himself as Messiah and does not mean to be taken altogether seriously.

Hogarth's artist is himself far from being either a redeemer or a poet of georgic renewal. After the passage quoted above about the blush, Hogarth turns from "nature" (the natural coloring of the female face) to "art," but by the latter he means not cosmetics but the brush of the artist who tries unsuccessfully to imitate nature. He discusses the "*bloom tints*, or if you please, virgin tints, as the painters call them," and — seeking the utmost "variety, intricacy and simplicity" — he focuses on the female neck and breast: It is the artist now who is "still changing and varying the situations of the tints with one another, also causing their shapes and sizes to differ as much as possible." The artist's aim is to imitate as best he can the "infinite variations in nature from what may be called the most beautiful order and disposition of the colours in flesh, not only in different persons, but in different parts of the same" (90–91).

The object of Hogarth's artist is to recover something, however little, of the beauty of the natural (human, living) female face, neck, and bosom, which "depends on the great principle of varying by all the means of varying, and on the

proper and artful union of that variety" (92)—a process that remains one of a pleasant discovery of the greatest variety within an apparent unity. Hogarth's artist draws the spectator's attention to the variety of the mundane, which includes the ugly and comic as well as beautiful, in what society and religion and Shaftesburian aesthetics try to pass off as a unity. He and Pope primarily disagree on the theology of the Incarnation and Redemption. While Pope's is by Christ and his human surrogate, the poet, producing a poetics, Hogarth's is only by a human, living woman, the center of attention in an aesthetics. The function of Hogarth's artist is discovery (of hidden truths, of analogies, of principles), and his subject is not the artist—who is one pole of an art-nature dichotomy, say of a composer and plebeian noisemakers—but the aesthetic figure who mediates between them.

There were other redeemers in the period, moral and mock redeemers. There were contemporary stories of prostitutes being "redeemed"—as in *The Histories of Some of the Penitents in the Magdalen-House. As Supposed to be Related by Themselves* (1760) and William Dodd's *The Magdalen, or, History of the First Penitent Prostitute Received into that Charitable Asylum* (1799). But the redemption was by the Magdalen House, by religion, and, more specifically, by the prostitute's penitence. She redeems herself, or she atones for her own (not society's) sins. Hogarth gave no indication that the Harlot is redeeming her own sins—because her "sins" are contrasted with the crimes of her associates.

Pamela "redeems" herself, which she certainly does economically and socially if not spiritually, and thereafter, by her "testimony," Mr. B., Lady Davers, and neighboring members of the country gentry. The spiritual and economic senses of the word are equally applicable. So, in *Joseph Andrews* Harriet Hearty literally redeems (ransoms) Mr. Wilson, a genuinely fallen, reprobate man. She sends him the money that permits him to pay his way out of prison—subsequently marrying him and presiding over a new life. Her redemption of Mr. Wilson is different from the atonement of Nancy or Sydney Carton—aside from their sacrificing their lives; for they redeem Oliver and Charles Darnay by atoning for their own sins, not for Oliver's or Darnay's. Harriet is a more efficacious version of Hogarth's Sarah Young in the *Rake's Progress;* the whole of Mr. Wilson's narrative is modeled on the *Rake's Progress* but with a happy ending. Harriet in turn may reflect the more positive redemptive (or, we shall see, mediating) females in Hogarth's prints following the *Rake's Progress.*

Rasselas, like Harriet Hearty, literally redeems his sister's maid Pekuah—

ransoming her from the Arabs. Johnson has Pekuah literally redeemed, but, as if to draw the lexicographer's attention to the pun, he has a general spiritual redemption accompany her physical redemption as everyone's thoughts begin to rise from the "choice of life" (riches, wisdom, etc.) to the afterlife.

Humphry Clinker is, like the Harlot, of the lower orders, his clothes in tatters, an outsider (not one of the Bramble "family," not one of the letter writers), for whom the novel is nevertheless named. He is a Methodist, and Methodism is plainly enthusiastic folly. But Humphry is the Methodist who does convert the appalling ladies of this society (Tabitha, Lady Griskin, as well as the underclass Winifred Jenkins and others) and the most degraded criminals and prisoners. The situation — the figure — is half farcical: The first (mistaken) attempt to save Bramble from the water is farce: Poor Bramble is hauled by Humphry up on the beach before the assembled gaping multitude, but the second attempt saves Bramble's life and initiates the sequence of events that leads to the revelation of Bramble's youthful sin, Humphry's parentage, the reunion of father and son — and the sense in which Humphry has atoned for that sin and redeemed the sinner — significantly for the continuing critique of the Atonement, his father. (Running counterpoint to Humphry's actions is the writing of his love Winifred, whose most notable reference to divine providence is to "the grease of God.")[42]

In an even more general way, we might argue that Dr. Primrose in *The Vicar of Wakefield* redeems, almost atones for (were it not for the theatrically "happy ending"), the prisoners and everyone around him. But Primrose's words are too steadily undercut by his actions and the twists of the plot to make this more than an amusing side issue. One is reminded of the exactly contemporary, the anonymous (but closely connected with the *Vicar*) children's book, *The History of Little Goody Two-Shoes*, published by John Newbery in 1765. The introduction describes a deplorable state, of society and of the individual family and the poor orphan child — the plight of the contemporary poor — and the essential issue that follows is how to deal with it — "the means by which" it can be made tolerable: not, we notice, how to justify or vindicate it, but how to live with it, if not correct it.

Goody Two-Shoes is a child version of the Redeemer, a parody that is a comic and benevolent version of Hogarth's ironic harlot, closer perhaps to his figures of Columbus and the child Moses. Two-Shoes shows how to cope with, compensate for, personal loss of home, family, and brother — for simple poverty. Two-Shoes's father, Mr. Meanwell, "a considerable Farmer in the Parish," falls and is expelled from Eden but not, significantly, through his own sin: suffering "Misfortunes which he met with in Business, and the wicked Persecutions of Sir Timothy

Gripe, and an over-grown Farmer called Graspall, he was effectually ruined" and driven from his farm.

Redemption here means *coping with* the hard realities of life led by the poor; the coping is carried out, however, by literary — or at least philological — means. The vehicle of Two-Shoes's redemption of the children in her parish is not by religion but by the alphabet, by teaching them to arrange the letters into talismanic words: Holding out the letters, "she asked the little Boy next her, what he had for Dinner? Who answered, Bread. (The poor Children in many Places live very hard) well then, says she, set the first letter. He put up the letter B, to which the next [student] added r, and the next e, the next a, the next d, and it stood thus, Bread." Or, another example: "Suppose the Word to be spelt was Plumb Pudding (and who can suppose a better)," when there is the word only without the real plum pudding.[43] The power of words is presented as the only way (acceptable to the ruling order) that the poor can cope with their plight.

The implication, projected in both title page and introduction, is that Two-Shoes is a small, a mock redeemer, who emerges from the fall of her mother and father to save the good and ultimately punish the evil. (She even carries out a Last Judgment on the Gripes and Graspalls.) The book is announced as about a child as hero, moreover with overtones of the Redeemer, but also recalling the Redeemer's "Suffer the little children" or "be as little children" and conflating our usual notions of redeemer and redeemed.

In painting there are, of course, Reynolds's jests — paintings of the child Saint John or of the courtesan Nelly Obrien as a Raphael Madonna holding a lapdog in place of the baby Jesus. These are hardly even mock redeemers: they are merely playful, of a piece with his portrait of young Master Crew in the pose and dress of Holbein's Henry VIII or Sarah Siddons as the Tragic Muse or some lady as a goddess.[44] Perhaps they shared roughly the same space as Hogarth's self-associating with a mock Columbus, a child Moses, and (we shall see) a very short Saint Paul.

Mediation

Redemption and Mediation

In *A Rake's Progress* (1735), plate 4 (fig. 50), Sarah Young, Tom Rakewell's discarded wife, intercedes with the bailiffs who are arresting him, offering her purse with her meager earnings as a seamstress, literally to "redeem" (ransom) him, just as Harriet Hearty did seven years later in Fielding's *Joseph Andrews*. Her pose is remarkably like that of the Christ in Hogarth's serious biblical history, *The Pool of Bethesda*, painted about the same time for the great staircase at Saint Bartholomew's Hospital in Smithfield (fig. 51). Christ heals the sick—Sarah "heals" and in that sense is trying to redeem her husband Rakewell. Beyond the pose, a metaphorical equivalent appears in the oil that overflows the lamplighter's tin, apparently anointing the Rake's head with heavenly grace.[1] Of course, being a woman, Sarah can, like the Harlot, conflate Mary and Christ, intercessor and redeemer. Sarah Young's redemption is as inefficacious as Hackabout's atonement for mankind. This is rather her *mediation* between Rakewell and the bailiffs, the ruined sinner and the forces of the law.

"Christ hath redeemed us from the curse of the law," Paul writes, "Wherefore

then serveth the law? It was added because of transgressions, till the seed should come to whom the promise was made; and it was ordained by angels in the hand of a mediator" (Gal. 3:19). Christ's role is "reconciliation"; "For if, when we were enemies, we were reconciled to God by the death of his Son; much more, being reconciled, we shall be saved by his life" (2 Cor. 5:19; Rom. 5:10). "And for this cause he is the mediator of the new testament, that by means of death, for the redemption of the transgressions that were under the first testament, they which are called might receive the promise of eternal inheritance" (Heb. 9:15). The author of the Epistles to Timothy writes: "For there is one God, and one mediator between god and man, the man Jesus Christ" (1 Tim. 2:5).

As first-born Son, Christ is intercessor and advocate (Rom. 8:29–34; 1 John 2:1). Richard Hooker, in his *Ecclesiastical Polity* (1593–1600), showed the way from the doctrine of satisfaction to mediation:

> Satisfaction is a work which justice requireth to be done for contentment of persons injured: neither is it in the eye of justice a sufficient satisfaction, unless it fully equal the injury for which we satisfy. . . . Now because God was thus to be satisfied, and man not able to make satisfaction in such sort, His unspeakable love and inclination to save mankind from eternal death ordained in our behalf a Mediator, to do that which had been for any other impossible.[2]

And the Service of Holy Communion states in *The Book of Common Prayer*, Christ is "our only Mediator and Advocate."

Writing at mid–seventeenth century, Bishop James Ussher makes the mediation sound immediate and contemporary: Fallen man is "at variance with God, without any means of reconcilement on our part. There cometh in the meantime the Middle-man to take up the matter by assuming unto Himself these two offices. First, He becometh our intercessor, to solicit and make peace for us; secondly, He becometh our advocate, to plead the justice of our cause. He must in this (you see) first seek God's mercy, and then also challenge God's justice, what it can exact."[3] Again, Ussher writes of Christ's "office of mediation," "For as there is *one God*, so is there *one Mediatour betweene God and men, the man Christ Jesus: who gave himself a ransome for all.*"[4] The Son sits now at God's right hand making intercession for us (Rom. 8:34). This is usually taken to mean that his mediation was then and continues now—in the poet John Hey's words, at God's right hand, "With ceaseless intercession there he pleads; / Perfects our wretched sacrifice of pray'r / And frail obedience."[5] Even the Calvinist Watts includes in his hymns references to Christ as furthering "our humble suit" and serving as our

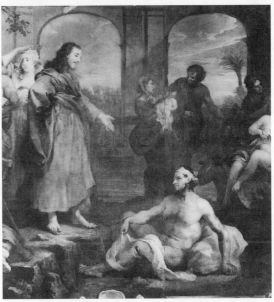

Fig. 50. Hogarth, *A Rake's Progress*, plate 4 (detail) (1735), etching and engraving, first state. Reproduced by courtesy of the Trustees of the British Museum.

Fig. 51. Hogarth, *The Pool of Bethesda* (1737), painting (detail). Reproduced by kind permission of Saint Bartholomew's Hospital.

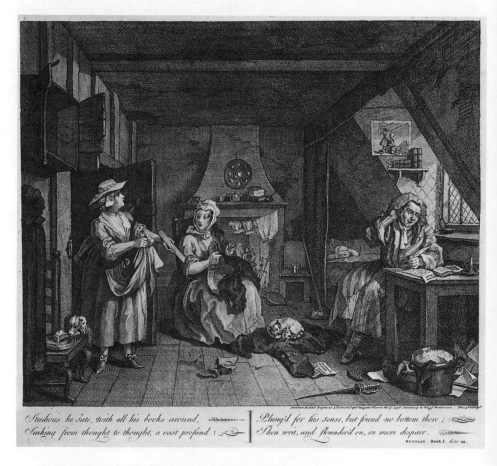

Fig. 52. Hogarth, *The Distressed Poet* (1737), etching
and engraving, second state. Reproduced by courtesy of
the Trustees of the British Museum.

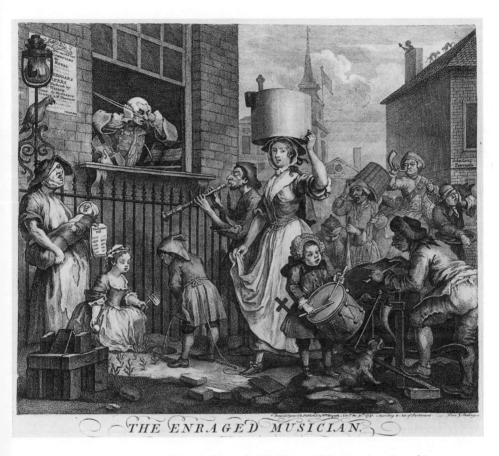

Fig. 53. Hogarth, *The Enraged Musician* (1741), etching and engraving, second state. Reproduced by courtesy of the Trustees of the British Museum.

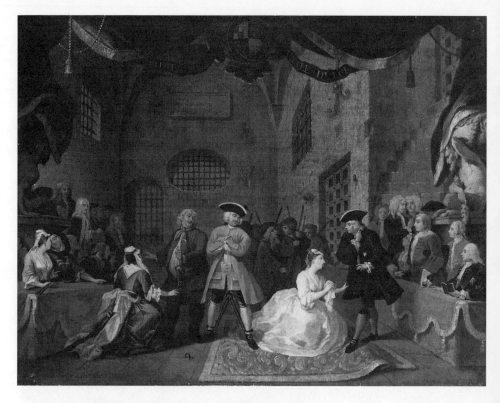

Fig. 54. Hogarth, *The Beggar's Opera* (1728–29), painting.
© Tate, London 2002.

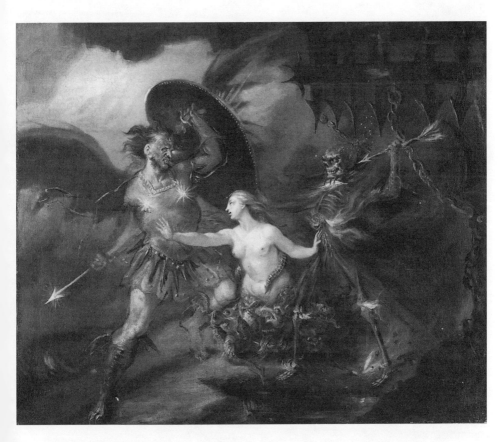

Fig. 55. Hogarth, *Satan, Sin, and Death* (ca. 1736), paint-
ing. © Tate, London 2002.

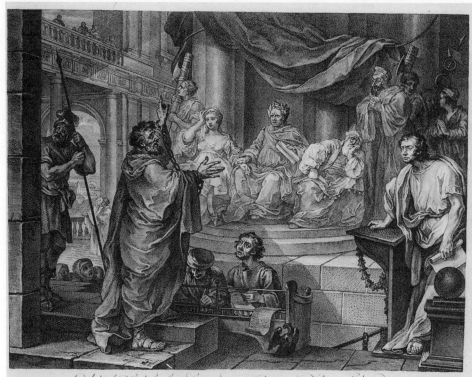

And as he reasoned of righteousness, temperance, and judgment to come, Felix trembled.

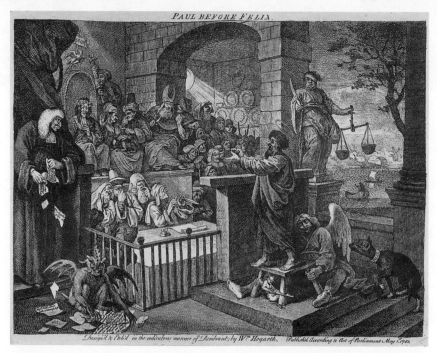

PAUL BEFORE FELIX.

Design'd & Etch'd in the ridiculous manner of Rembrant; by Wm. Hogarth. Publish'd According to Act of Parliament May 1.1751.

Fig. 56. Hogarth, *Paul before Felix* (1752), etching and engraving, first state. Reproduced by courtesy of the Trustees of the British Museum.

Fig. 57. Hogarth, *Paul before Felix Burlesqued* (1752), etching, fourth state. Reproduced by courtesy of the Trustees of the British Museum.

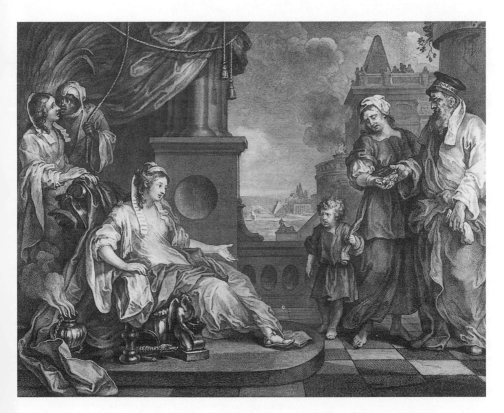

Fig. 58. Hogarth, *Moses Brought to Pharaoh's Daughter* (1752), etching and engraving, first state. Reproduced by courtesy of the Trustees of the British Museum.

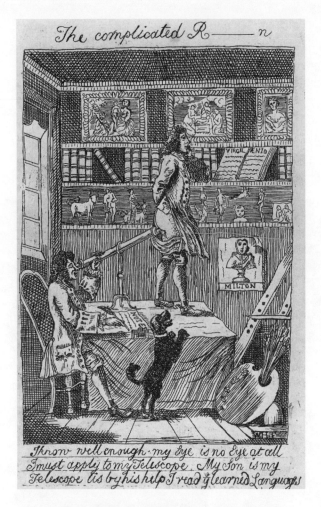

Fig. 59. Hogarth, *The Complicated Richardson*, etching
by W. H. Ireland after a lost drawing by Hogarth (1790s).
Reproduced by courtesy of the Trustees of the British
Museum.

Fig. 60. Hogarth, *The Marriage Contract* (ca. 1733),
painting. Ashmolean Museum, Oxford.

Fig. 61. Hogarth, *The Marriage Contract*, etching by
Jane Ireland (1790s). Reproduced by courtesy of the
Trustees of the British Museum.

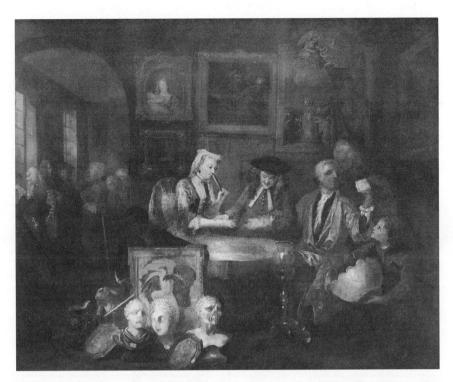

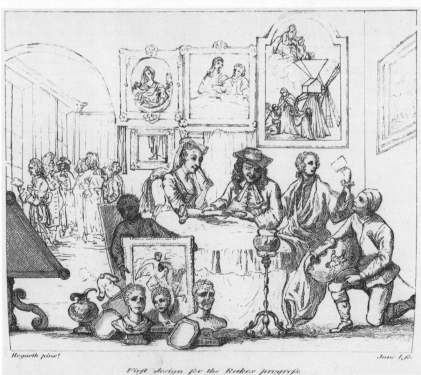

Hogarth pinx! June 1,&c.

First design for the Rakes progress.

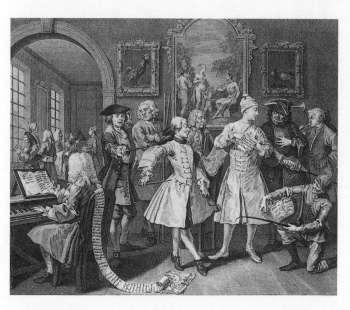

Fig. 62. Hogarth, *A Rake's Progress*, plate 2 (1735), etching and engraving; first state. Reproduced by courtesy of the Trustees of the British Museum.

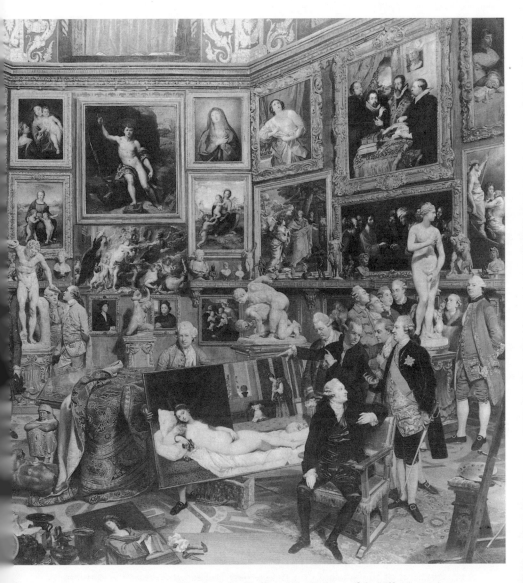

Fig. 63. John Zoffany, *The Tribuna of the Uffizi* (1770s), painting. The Royal Collection © 2002, Her Majesty Queen Elizabeth II.

"advocate on high," referring to the Last Days or our day-to-day life, it is not clear which (perhaps both):

> Before his Father's eye
> Our humble suit he moves;
> The Father lays his thunder by,
> And looks, and smiles, and loves.

(EH 36)

What remains here and now, as we wait? Christ is no longer with us, but he remains as the presence of Christ in the world: "Therefore if any man be in Christ," as Paul wrote, "he is a new creature; old things are passed away; behold, all things are become new. And all things are of God, who hath reconciled us to himself by Jesus Christ, and hath given to us the ministry of reconciliation" (2 Cor. 5:17–19).[6] Though it is not clear whether he means at the Last Day or now, things *are* different since the Incarnation and Redemption. The role of Christ every day is as reconciler—he *has* reconciled us with God, he will serve as our mediator.

Mediation, we shall see, can mean (1) between God and Adam's fallen progeny in the matter of satisfying God's wrath, (2) between God and everyday transactions by men and women in this "isthmus of a middle state," and so, by extension, (3) between God's representatives (church, law, state) or any authority—any absolute such as, in aesthetics, unity—and ordinary common men and women.

Handel's English Sacred Oratorio: The Mediation of Esther

By an odd coincidence Handel's first English oratorio, *Esther*, was given its first public performance within a month of the publication of the *Harlot's Progress*. Hogarth delivered his *Harlot's Progress* to subscribers on 10 April 1732 upon presentation of the subscription ticket, *Boys Peeping at Nature*, his emblematic announcement that this was to be a new history painting based on a return to national roots and depicting contemporary London. On 19 April Handel announced in the *Daily Journal* that on 2 May at the King's Theatre in the Haymarket would be performed "The Sacred Story of ESTHER: An Oratorio in English. Formerly composed by Mr. Handel, and now revised by him, with several Additions, and to be performed by a great Number of the best Voices and Instruments. N.B. There will be no Action on the Stage, but the House will be fitted up in a decent Manner, for the Audience. The Music to be disposed after the Man-

ner of the Coronation Service." Handel's *Esther* was designated as a new form, an oratorio, a sacred drama, sung in English.

Both works were consciously English and introduced popular modes based on theatrical models. Hogarth's *Harlot* was a representation of what appeared to be six scenes excerpted from a play (which within the year had been turned into actual plays and tableaux for the stage); the announcement to Handel's audience that "There will be no Action upon the Stage" recalls the frozen action of a stage performance in Hogarth's scene. *Esther* was (at least in the mind of the spectator) a series of tableaux, performed in a theater, and described by one contemporary as "a mere Consort [concert], no scenary, Dress or Action, so necessary to a *Drama*."[7] Both were performed in contemporary dress.

It has been the generally accepted view that Handel's first English language oratorio was a response to the overwhelming popularity of English ballad operas following the success of Gay's *Beggar's Opera*. The nationalism of Gay's ballad opera is reflected in Handel's oratorio — obliquely, given the fact that Handel was himself a foreigner and chief representative of the Italian opera tradition distrusted by the *Spectator* and replaced by Gay's ballad opera. The English language was substituted for the unintelligible Italian of the operas; indeed, as in the traditional practice of the English stage, attention was focused on the words. Wordbooks were sold to the audience, who were urged to follow them during the performance. (An early complaint of the Handel oratorio was that the English was not comprehensible in the mouths of Italian singers.) What Handel's oratorio rejected, however, was Gay's low subject, merely replacing the classical subjects of Italian opera with the sublimity of the OT.

The Beggar's Opera was also a point of departure for *A Harlot's Progress*, in which Hogarth set out to find an up-to-date equivalent of the subjects painted by the Old Masters. In an early print (*Masquerades and Operas* of 1724), he had carried on the *Spectator* ridicule of Italian operas, but *The Beggar's Opera* showed him how to relate the fashion for opera and its importation of Italian and French music to the collecting of paintings imported from the Continent by English connoisseurs. Following Gay, he replaced the classical with contemporary subjects. With Handel he replaced classical with scriptural, but then he proceeded to replace scriptural with contemporary.

In *Esther*, as Ruth Smith notes, Handel was "celebrating an Old Testament heroine who saves her nation from destruction by foreign oppressors." The story of *Esther* was "one of the 'miraculous' deliverances of the chosen people from persecution" — one that served as a Protestant sermon subject for 5 November,

celebrating the deliverance from the Gunpowder Plot and William III's success-ful landing at Torbay.[8]

The "masque" upon which the oratorio was based, performed privately at Cannons in 1718, was called *Haman and Mordecai. A Masque.* A political inter-pretation was invited. Attributed to Pope, it could be read as a reference to the "persecution" of the Jacobites after the 1715 uprising.[9] In the OT, Ahasuerus remembers Esther's uncle Mordecai's service, which prompts him to reverse the decree against the Jews; in Pope's libretto, he has to be reminded by Esther.[10] The villainous Haman calls upon Ahasuerus to massacre the Jews in his kingdom, and Esther mediates between the king and his chief minister. Mordecai tells her, "Go stand before the king with weeping eye . . . Love will pacify his anger," and Esther sings to the king: "Take, O take my life alone, / And thy chosen people spare," followed by the chorus: "Save us, O Lord! / And blunt the wrathful sword." The First Israelite sings, "Beauty has his fury charm'd, / And all his wrath disarm'd," and the chorus responds: "She is heaven's peculiar care, / Propitious heav'n will hear our prayer."

Pope's Esther was embodied in a masque, by this time a form associated by Pope's circle with Jacobite nostalgia. Thus Haman's threat of disorder and per-secution is recovered by Ahasuerus, who in the Carolean masque would have been played by the king himself, who joins the players of the antimasque to restore order, in this case by means of the intercession of his queen. Pope gives the masque a particularly Roman Catholic twist with the interceding Esther, a type of Mary, emphasized in Counter-Reformation propaganda. Handel, though a "steadfast Protestant," showed interest in the subject: In Italy he composed an early hymn to the Virgin (*Ah! Che troppo inegual!*) and seems to have been attracted to the Marian cult. He may have felt safe substituting OT intercessors — Esther and Deborah, and ultimately, Jephtha's daughter — as figures of mediation.[11]

More to the point, he used women who are nationalist heroines. If Pope's *Esther* made a political statement that was subtly Jacobite and Roman Catholic, in the public performance of 1732 she was "Hanoverianised" by Handel and his librettist, Samuel Humphreys. They added two of the Coronation Anthems Handel had composed for the 1727 coronation of George II, placing one at the end of an added opening scene showing the Jews at prayer, hoping that their position will be ameliorated by Esther's mediation with the king, and the other following her successful intercession. The first of the Coronation Anthems, "Zadok the Priest," begins: "May the king live for ever!" The second anthem, "My Heart is inditing," turns from the king to the queen: "Upon thy right hand

did stand the Queen." The heroine could be interpreted as a figure of Queen Caroline, recognized as a strong influence on her husband.

Handel's *Esther* also conflates the OT story with the NT Redemption. *Esther* is the only book of the Bible in which God is not directly mentioned, but He is invoked regularly in Handel's libretto, and in a crucial passage God and King Ahasuerus are linked: Mordecai has urged Esther, the king's favorite consort, to intercede with him for the lives of the Israelites, condemned to death. "Who goes unsummon'd" to the king, Esther responds, "by the laws shall die." Against law Mordecai urges love, distinguishing king from a deity and associating the former with the NT: "Love will pacify his anger; / Fear is due to God alone." Esther agrees to intercede, singing to her God:

Hear, O God, thy servant's prayer!
Is it blood that must atone,
Take, O take my life alone
And thy chosen people spare.

The "bloody stern decree" of a king whose golden scepter is "Sure sign of grace" evokes an analogy between the situation of the Persian king, the doomed Israelites, and the queen Esther and the wrathful God of Genesis (or *Paradise Lost*), Adam's descendants condemned to death, and the beloved Son who invokes God's Grace to save them. When the king, seeing Esther approach, says, "The law condemns, but love will spare," it is NT love that overrides OT justice and wrath. Further, as the Fourth Israelite comments, drawing on "love" and the feminization of the Savior, it is "Beauty [that] has his fury charm'd / And all his wrath disarm'd." (Of course, as Esther acknowledges later, it was her reminding the king of how Mordecai had previously saved his life that ostensibly leads to his pardon of the Israelites. This is Ahasuerus's reason for overturning his decree, but it only rationalizes his love for Esther.)

Milton's lines on the Son, "in his face / Divine compassion visibly appear'd, / Love without end, and without measure Grace" (3.140–42), equate Grace with love, a quality he makes more evident in the Son than in the Father. The association was accepted by both Antinomians and libertine wits, but, as in the case of Handel's *Esther*, the mediator was gendered female as a more natural vehicle of love. In short, like Hogarth, Handel associates mediation with female beauty and love.

There are, of course, important differences between the work of Handel and that of Hogarth. For one, Hogarth's intention was clear from the outset in his

subscription ticket for the *Harlot;* Handel's *Esther* was the result of a series of coincidences. While *Esther* was immediately popular, and Handel followed its success with *Deborah* (1733) and *Athalia* (1737), he did not realize the importance of the new form he had introduced until the 1740s. He continued putting much of his energy into operas.[12]

His 1718 masque was revived in February 1732 for private performance by the children of his Majesty's Chapel at the Crown and Anchor, at the request of William Huggins (another coincidence).[13] Two months later it was announced in the *Daily Journal* (19 Apr. 1732) by some third party for public performance in York Buildings on the 20th, and in the same issue Handel countered by announcing an *authorized* performance for 2 May. Handel was responding to a pirated public performance of his masque. It was the pirate who first applied the term oratorio: "ORATORIO: or Sacred Drama."

When he hastened to counter the piracy with his own public production, Bishop Gibson intervened and refused "permission for its being represented on that stage."[14] The form of *Esther* was presumably influenced by his objection, based on the Blasphemy Act of 1698, to bringing religious subjects onto the stage. Bishop Gibson regarded it sacrilegious for a scriptural text to be performed by actors and musicians, and therefore Handel presented it without actions, without costumes, with only singers standing on a stage. To distinguish his oratorio from the piracy — and to modify its (Jacobite) politics — he added music, in particular his Coronation Anthems, which also had the effect of reducing the religious focus. In this context (as in Pope's also), the OT story carried associations of a national allegory, which had been used in the seventeenth century by Puritans and adapted by royalists like Dryden — most notably in *Absalom and Achitophel*, where Israel is England, Egypt is France, and David is Charles II.[15] The Puritan tradition of English Protestantism continued to believe the English were the "chosen people" (as the settlers in New England, e.g., fictionalized themselves as Israelites of the Exodus).[16]

There is further significance in the prohibition of an acted version of *Esther.* Performed in a public theater, Handel's oratorio was regarded as "an Entertainment of Musick," and so as "an *Oratorio,* or Religious *Farce,* for [as one contemporary wrote] the deuce take me if I can make any other Construction of the Word, but he has made a very good *Farce* of it."[17] Handel's oratorio combined, another contemporary wrote, "the Solemnity of Church-Musick . . . with the most pleasing Airs of the Stage."[18] If the association of OT texts with stage and

actors was regarded as sacrilegious, one can only imagine how much worse it was to have an oratorio on the New Testament story staged in a theater.

Bishop Gibson was Hogarth's as well as Handel's symbol of censorship. Gibson's punishment of Woolston for the "blasphemy" of his *Discourses of the Miracles* explains his prominence in the *Harlot*. Hogarth's gesture was shocking—blasphemous in its Woolstonian context and quite contrary to Handel's, but it shared with Handel's *Esther* a strongly Protestant (anti-Catholic) and nationalist (anti-Jacobite) belief. Hogarth presents the story of the Life of Christ, ending with the Passion, but played out by recognizable contemporaries in contemporary dress who (like the characters of Gay's *Beggar's Opera*) are *playing* these roles in a stagelike setting. Handel presents the story of Esther sung by performers "in their own Habits" in a *tableau vivant* on the stage of a theater—performers who, like Hogarth's, were notoriously recognizable (some with large followings—Senesino, Strada, and Ann Robinson).

Handel's performance of *Esther*—and ultimately and most significantly of *Messiah*, his one excursion into the NT text—could be regarded similarly. Indeed, the potential shock of Hogarth's six plates can be gauged by the care with which Handel held back on London performances of *Messiah*. Of *Messiah* Philalethes wrote in the *Universal Spectator*, 19 March 1743, that religious matter should not be presented by singers in a playhouse and, on 16 April, that it is indecent "to use the same Place one Week as a *Temple* to perform a *sacred Oratorio* in, and in the next as a Stage, to exhibit the Buffooneries of *Harlequin.*" It was first produced in a theater in the safer ambiance of Dublin; it was performed in London only five times before it caught on in 1750, and then in the context of charity in the chapel of the Foundling Hospital. (It was performed in London three times in 1743 and twice in 1745.) It was, as Paul Henry Lang and others have insisted, not a churchy or a religious work but, given its venue, one celebrating national ideals in contemporary England. It served to incarnate these countrymen and values—or to reaffirm them—as a "chosen people."[19]

There was one other plot latent in Handel's *Esther*. In a performance of *Esther*, the emphasis might easily have shifted from the heroism of Esther to the villainy of the antisemite Haman, Ahasuerus's "first minister." The oratorio could have been interpreted by the opposition as a statement of Haman's false as opposed to Esther's true mediation between monarch and subjects. Haman was one of the analogues for Walpole, as a false steward, in the satire of the Opposition.[20]

There was also the moment of triumph when the tables are turned on Haman

("The Lord our enemy has slain"). Ahasuerus not only pardons the Israelites but hangs Haman on the high gallows he has constructed for the Israelites, and this is celebrated in the triumphant vengeance invoked by the Israelite priests who call upon Jehovah: "Arise, and execute thine ire!"; they urge Him to "pour his vengeance on our foes. / Earth trembles, lofty mountains nod!"

In *Messiah* the Messiah's mediation is briefly invoked, but the emphasis falls on the brutality of his treatment at the hands of the Hamans and, subsequently, on his triumph over them. The story is of his Messiahship—the whole Incarnation, Nativity, suffering and mocking of Christ, followed by his triumph (mockery turned on his oppressors) and resurrection—but Handel's text is almost wholly OT (he even uses the Psalm version of "My God, my God, why hast thou forsaken me," rather than the Gospels) and, though typologically justified, the result is an OT Jesus of wrath and vengeance. Significantly, with the woman the role is mediation, but with the male Messiah it is the wrath and vengeance of the OT god—and associated with the national monarch. The moments Handel chooses (or rather his collaborator Charles Jennens, who compiled the entire libretto before giving it to Handel) are from Second Isaiah's strange story of the servant of God (52:13–53:12) who suffers for the community as a whole:

> He is despised and rejected of men: a man of sorrows and acquainted with grief: and we hid as it were our faces from him; he was despised, and we esteemed him not. Surely he hath borne our griefs, and carried our sorrows: yet we did esteem him stricken, smitten of God, and afflicted. But he was wounded for our transgressions, he was bruised for our iniquities: the chastisement of our peace was upon him; and with his stripes we are healed. (53:3–5)

He is "brought as a lamb to the slaughter"; he is "taken from prison and from judgment, . . . cut out of the land of the living: for the transgression of my people was he stricken." Indeed, "it pleased the LORD to bruise him; he hath put him to grief: when thou shalt make his soul an offering for sin," and he is "numbered with the transgressors; and he bare the sin of many, and made intercession for the transgressors" (53:7–8, 10, 12).

This is the situation of poor Mordecai, threatened to be hanged on high by Haman, who then is himself appropriately sentenced to the same punishment. In *Messiah* it is the moment of Handel's recitative (following Psalm 22:7), which contains the source of Jesus' words on the cross ("My God, my God, why hast thou forsaken me?") and continues with the image of scornful laughter: "All they that see me laugh me to scorn: they shoot out the lip, they shake the head, saying,

He trusted on the Lord that he would deliver him" and the chorus: "He trusted in God that He would deliver Him; let Him deliver Him, if He delight in Him." And this is echoed by his triumphant Resurrection, introduced by the recitative quoting Psalm 2:4 and 9: "He that dwelleth in heaven shall laugh them to scorn; the Lord shall have them in derision," by the air, "Thou shall break them with a rod of iron; Thou shalt dash them in pieces like a potter's vessel," and by the great Hallelujah Chorus.

We recall the laughter of Sarah and all the laughter in the Bible, usually addressed to an impossible act such as Sarah's conception. In Matthew 9:24 the laughter is at one of Jesus' miracles: He says the dead girl will rise, "And they laughed him to scorn" (repeated in Mark 5:40 and Luke 8:53). The triumphant laughter, from the second Psalm, "He that dwelleth in heaven shall laugh them to scorn," is echoed in the laughter of *Paradise Lost* book 12: "Great laughter was in Heaven / And looking down to see the hubbub strange" at the Tower of Babel (12.59–60), essentially at the "affectation" of Fielding's theory of the "ridiculous"; and in Pope's *Essay on Man* at the Titans piling Ossa on Pelion: "Heav'n still with laughter the vain toil surveys, / And buries madmen in the heaps they raise" (4.75–76). Handel's is cruel, malicious human laughter repaid in kind with the triumphant, Hobbesian laughter of the Messiah.

Hogarth and Handel were equivalent artists in the first half of the eighteenth century. What they created was not so different except for the fact that Handel's emphasis on the choruses or anthems tilted his oratorios from the particular (character, actor, aria) toward the general and the celebratory. Hogarth's "modern moral subject," though it originated in the genre of satire, in fact pointed toward a similar celebration, not of national politics (court, ministry), but of contemporary English art.[21] Both created innovative forms that, with their different versions of nationalism, became great popular successes.[22] With the oratorio Handel became what Lang has called the "national English composer" (199), the high equivalent of Hogarth the "national English painter" (who signed himself "Britophil" and "W. Hogarth Anglus").

The most striking difference is that for Handel the OT was an allegory of nationalist England, but for Hogarth it represented priestcraft and the cruel reward-punishment ethos of the Christian God. His Harlot is a negative reflection on the age she of all people has to atone for. In this respect, Hogarth's nationalism supplemented Handel's: While his was based on the need for a national art, strongly local and Protestant (xenophobic, anticlerical, anti-Jacobite), and it celebrated Englishness, it did not celebrate the present state of English

government or society — indeed, it questioned these secular structures as it did sacred, or perhaps insofar as they reflected the sacred.[23]

Hogarth demystified the text, preferring the present to the scriptural past; Handel raised the same local stage drama that Hogarth utilized, and, while he mixed styles, was credited with the sublime style (or Addison's Great). Both were witty and parodic, though Hogarth was incapable of being, like Handel, solemn, stately, grave, and majestic. The open question is whether Hogarth and Handel are the two sides of a coin in the period — comic and witty versus pious, orthodox, and sublime — or in fact analogous responses. Hogarth believes in the value of the human contemporary, the particular individual over the universalizing of the sacred. He believes in the play of human perception and the human imagination, not the divine, especially as handled by priests.

What was Hogarth's attitude toward the Handelian oratorio? He is recorded as asserting that "Handel is a giant in music" — this in the context of a contrast between Handel and his rival Maurice Greene ("only a light Florimel of a composer").[24] This probably applies, like Pope's praise in his 1743 *Dunciad* book 4, to the composer of the oratorios. But three years after the *Harlot* was published, in *A Rake's Progress*, plate 2 (fig. 62), Handel is shown sitting at the keyboard of his harpsichord ("F.H." appears on his score) in his accustomed role of conducting and improvising.[25] In the period of the *Rake's* composition (1733–35), Handel was being attacked by the Prince of Wales's party for his association with the court and even with Walpole; in a *Craftsman* satire of 7 April 1733, Handel was used as another analogue for Walpole — like Wolsey, Falstaff, and Macheath. Hogarth's inscriptions, however, point to the association of Handel with fashionable singers and their fanatical patrons. "F.H."'s score, the "Rape of the Sabines," is a joke on the fact that the singers were castrati; the reference is to Handel's operas.

We know that Hogarth was enough interested in music to belong to the Academy of Ancient Music (along with his friend Huggins). And we have the view of his friend John Lockman, recorded in 1740, that "notwithstanding the wonderful Sublimity of Mr. *Handel*'s Compositions, yet the Place in which Oratorios are commonly performed among us, and some other Circumstances, must necessarily lessen the Solemnity of this Entertainment, to which possibly, the Choice of the Subject of these Dramas may likewise sometimes contribute."[26] The oratorios are regarded as examples of "wonderful Sublimity" compromised by their presentation in a theater. But *Messiah* can, of course, be seen as Handel's idea of a corrective to the sort of work — burlesque, coarse, sentimental — he saw

on the stage and in *The Beggar's Opera*. Whether he would have included Hogarth's works in this category is uncertain.

In *The Enraged Musician* (1741, fig. 53), Hogarth in fact raises the question: what *is* music? And the question is based specifically on the *Beggar's Opera* definition (a poster for a performance dominates the upper left of the picture, balancing the window of the Musician) rather than Handel's. The plebeian music makers may recall Harriet's paeon to London at the end of *The Man of Mode*: "There's music in the worst [street-vendor's] cry in London" (V.ii). But it is the cry (or the song) of the beautiful milkmaid, who mediates between the Handelian composer up in his enclosed space and the plebeian noisemakers on the open street below.

Perhaps also significant is the fact that Hogarth's friend Roubiliac portrayed Handel, in his great full-length sculpture of 1738, in the Hogarthian — and perhaps also Handelian — mode (see fig. 64). Of course, the sculpture draws attention to the fact that its venue was Vauxhall Gardens, a pleasure garden, a secular resort, where Handel's music was played — but also to the wide expanse of what was felt to be Handel's audience. It draws attention to the area of overlap between the works of Handel and Hogarth.

Jephtha's Daughter: Human Sacrifice Mediated

In 1751, Hogarth's friend Thomas Morell produced his libretto for Handel's oratorio *Jephtha*. Morell was an orthodox Church of England priest, author of *Poems on Divine Subjects* (published in 1732, the year of *A Harlot's Progress*), which defended the evidence of miracles and argued that poetry should be used to support the idea of an immanent God.[27] Morell wrote: "Can ye, ye deists, the Apostle hear / With thankless Ear?"[28] In the libretti he furnished for Handel's oratorios, he made a particularly strong statement of God's immanence.[29]

There is no sign that Hogarth and Morell knew each other until they became neighbors in 1749.[30] In the autumn of 1749, Hogarth moved into a house in Chiswick, which was a short walk from Morell's house. Morell was at this time writing the libretto for Handel's *Theodora*, which was completed by January 1751. If Hogarth was until this time only indirectly interested in Handel, the friendship with Morell would have brought Handel closer to the foreground of his consciousness. He must certainly have heard Handel's *Messiah* on one of its performances in the chapel of the Foundling Hospital — most likely one of the two performances in May 1750. In June and July Handel and Morell were putting

together the one-act oratorio on a classical subject, *The Choice of Hercules* (performed on 1 March 1751), and by the summer or autumn Morell was writing *Jephtha*, which was finished by January 1751, when Handel began work on the score.

In the late 1740s Hogarth had painted his *Moses brought to Pharaoh's Daughter* for the Foundling Hospital, and in May 1752, as he announced the subscription for his *Analysis*, he published his engraved version, which introduces his Line of Beauty, equated with the beautiful princess; at about this time Handel was composing the music to Morell's libretto for *Jephtha*. It seems probable that Hogarth was present at the premiere of *Jephtha* at Rich's Covent-Garden Theatre on 26 February 1752, just as he was delivering the prints of *Moses* and *Paul* and announcing the subscription for the *Analysis of Beauty*. At the least, *Jephtha* gave him a Christian context against which to play his aesthetics.

The story was about the sacrifice of Jephtha's daughter (Judges 11:30–40) — a subject consonant with the role of Esther and Deborah in the earlier oratorios, except that the role of Jephtha's daughter called for her sacrificial death. The subject was a popular one — in Bartholomew's Fair, *Jephtha's Rash Vow* was one of the standard farces — but it was also a subject focused on by both orthodox apologists and critical deists. From the latter's point of view, it was another version of Abraham's sacrifice of Isaac (the print the Harlot hung on her wall in plate 3). Although in Jephtha's case it was the father's "rash vow" to the deity rather than a demand of God himself, the evil scriptural deity was implicit.[31]

Back in 1737 John Hoadly, another clerical friend of Hogarth's, who wrote another *Choice of Hercules* with Handel's rival Maurice Greene, wrote the libretto for a *Jephtha* by Greene.[32] We can assume that Hoadly's theology was not unlike that of his father, Bishop Hoadly, whom Hogarth admired and cited as authority for his own religious position. On one occasion John, who enjoyed many lucrative benefices from the influence of his father, wrote to Hogarth: "I am at Alresford [one of those benefices] for a Day or two to sheer my Flock & to feed 'em (money you know is the sinews of War)."[33] Joking or not, he is expressing his father's negative view (as well as Hogarth's) of the clergy. The substitution of a clerical authority for the deity was what Nicholas Amhurst (another admirer of Bishop Hoadly) had accused the Anglican clergy of doing, and Hogarth echoed in his satiric prints of 1726–32. From letters he wrote to Hogarth and David Garrick, it is evident that John Hoadly was a lighthearted companion, delighting in theatricals (most notably, in *Ragandjaw*, a bawdy burlesque of *Julius Caesar* the three concocted in 1743). His father had in fact censored his satirical comedy, *The*

Contrast, after three performances at Lincoln's Inn Fields in 1731. Years later he registered in a letter to Garrick his concern "to break through the prudery of my profession, and the fantastical decency of my (too) exalted station in it, and bring the name of Hoadly again upon the public stage."³⁴

In his *Jephtha* he focuses on the Israelites' idolatry (which leads to their bondage to the Ammonites) and the bad brothers who disown Jephtha and send him away — because his mother was a "harlot"; and so, on the self-righteous pharisaical Israelites who discredit the one good man and are forced to recall him to defeat the Ammonites, that is, to redeem their idolatry (Judges 10:5–18, 11:30–40). Though, seen from one direction, this was another version of Abraham's sacrifice of Isaac, only unreprieved, it was also a type of the New Testament Sacrifice and Atonement of Christ, and in that sense a rewriting (or correcting) of *A Harlot's Progress*. Hoadly shows the Israelites' idolatry and fall and their redemption through the intervention of a blemished man (son of a "harlot") and the sacrifice of his innocent daughter. She is noted to be "his only child" and a virgin. The story is of sin atoned for by a female sacrifice. In this case, as opposed to the Harlot's, a completely innocent woman is doomed by an accident, but it remains another case of the "Virgin" rather than Christ as the atoner, as ironically adumbrated in the *Harlot*, the work of Hoadly's close friend.

The vow that defeats the Ammonites also redeems the Israelites who had fallen into idolatry, and it requires in repayment the sacrifice: "what [when Jephtha 'to his Home return[s]'] first shall meet my Eye, / Of purest Virgin Blood / A Victim worthy God, / Shall to Him devoted die." Given the skeptical thrust of the co-author of *Ragandjaw*, it is hard to imagine what virgin Hoadly's Jephtha thinks he would first meet when he returns home other than his daughter. And when she proves to be the sacrifice, Jephtha laments, suggesting that the Israelites' god is not so different from the Moloch they had been worshiping before their redemption:

Can Heav'n delight in Guiltless Blood? Shall Jephtha
The Judge of *Israel*, like ye Nations round,
Offer his Child, and *Israel*'s God blaspheme
With *Moloch*'s horrid rites? Ah! No. —

This is a *Jephtha* that is not inconsistent with Hogarth's *Harlot*.

In his rewriting of the story (or of Hoadly's *Jephtha*), Morell, a classical scholar, names Jephtha's otherwise nameless daughter Iphis, after Iphigeneia, to recall a similar case of a daughter sacrificed by her father to secure victory in war.

The popularity of Euripides' *Iphigenia* plays in the late seventeenth and eighteenth centuries was in part due to the theme of human sacrifice—an interest going back to the colonialist campaign against human sacrifice of the sort found in the New World, as well as to the deist attacks on Judeo-Christian sacrifice. Two *Iphigenia*'s, one by John Dennis and the other by Abel Boyer, had appeared in December 1699. Boyer's *Achilles; or Iphigenia in Aulis*, based on Racine's version, changed the ending to a happy one that avoided the human sacrifice.[35] In Morell's libretto, Iphis' words focus her role on sacrifice and atonement:

> For joys so vast
> Too little is the price of one poor life—
> But oh! accept it, Heav'n,
> A grateful victim, and thy blessings still
> Pour on my country,
> Friends, and dearest father! (p. 26)

In the following air she contrasts "Happy *they*" with "*I* shall resign" (emphasis added). Hers is in fact an atonement of an only begotten son replaced by an only begotten daughter ("My only daughter!—So dear a child," sings Jephtha, "Doom'd by a father!"). But, consonant with the other Handel oratorios, her sacrifice is for "my country, / Friends, and dearest father."

At this point Morell's Angel appears and tells Jephtha, "thou must dedicate [Iphis] / To God, in pure and virgin state for ever," not offer her as a burnt sacrifice:

> Happy, Iphis, all thy days,
> Pure, angelic, virgin-state.
> Shalt thou live; and ages late
> Crown thee with immortal praise.

Morell commutes her blood sacrifice to perpetual virginity (Iphis must dedicate herself to God). He corrects both Hogarth and Hoadly by finding a happy ending for the female atonement. Or, it could be argued, he Christianizes and, at the same time, modernizes or nationalizes the Old Testament story.[36]

The nationalizing of religion (most obviously in *Messiah*) represented one form of the modern secularizing of religion; another was the aestheticizing of religion carried out by Shaftesbury, Addison, and Hogarth. "Christianizing" in this context means the recovery of the teachings of Jesus from the heavy hand of religious (essentially OT) priestcraft. Morell's solution in *Jephtha* is to soften the

Sacrifice/Atonement, replacing the daughter's role as sacrificial victim with that of mediator. Instead of being sacrificed, Iphis is being preserved as in a "virgin-state" crowned "with immortal praise"—removed from the fatal sacrifice but also from the love of her suitor Hamor (whom Morell had added to the story), who "must for ever mourn / So dear a loss."

In short, Morell Christianizes and Hogarth aestheticizes the OT text—a similar process, based in both cases on love, or rather an interplay of Hamor's and Jephtha's, of Pleasure's and Virtue's. The question is whether Morell's Christianizing is—or could in some sense be regarded by Hogarth as—analogous to the process of aestheticizing. Morell and Hogarth may have been close enough in these years to work out mutually exclusive, and yet complementary, alternatives to the Christian Atonement. Morell could have seen Hogarth's aestheticizing of the Trinity and the cross in his *Analysis of Beauty* as in fact a recovering of them for Christian humanity and away from the priestly obfuscators (or have not noticed because these were primarily evident in the graphic, not the written parts of the book).

"The Mediatorship of the Son of God": Jonathan Richardson

In his commentary on *Paradise Lost*, Patrick Hume based the Incarnation on satisfaction, a penal-substitution theory, God's revenge for man's disobedience, for which only the death of his own Son could atone. In the early 1730s Jonathan Richardson Sr. was reading to his artist friends in Slaughter's Coffeehouse (a group that included Hogarth) from his *Explanatory Notes and Remarks on Milton's Paradise Lost* (publ. 28 Jan. 1734). Richardson's reading was most likely from the first part of his book, his life of Milton. His interpretation of *Paradise Lost* is scattered through the annotations that constitute the remainder of his sizable book. But this garrulous old man (to judge by the leisurely pace of the book) would have laid out what was new in his ideas, and the two most striking insights are the importance of the allegory of Satan, Sin, and Death and the basis of the Son's Incarnation in mediation rather than satisfaction or vicarious atonement— a subject in which the *Harlot* shows Hogarth to have been interested.

The *Explanatory Notes* were primarily important because Richardson not only focuses the action of *Paradise Lost* on the theology of Incarnation/Redemption (as Hume had done) but also changes its emphasis. Richardson raises the issue of mediation at two crucial points in the annotations: the intervention of the Son in book 3 and a second intervention when, in book 6, the Father sends Him to

mediate between the warring forces. On line 389 of book 3, Richardson comments: "Here that Sublime Doctrine of the Christian religion, the Mediatorship of Christ, as an Advocate, and as Uniting Us with God, is Admirably exprest (see also VI.681) a Doctrine Equally Comfortable and Honourable to Human Nature, and Infinitely More So than has been Offer'd by any Invention of Lawgivers, Philosophers or Poets, Ancient or Modern."[37] The "Invention of Lawgivers" presumably refers to the penal theory, which he sees Milton as replacing. At the annotation for line 680 of book 6, Richardson adds emphasis to his interpretation: "The Mediatorship of the Son of God, as it is a Most Sublime and Comfortable Doctrine of the Christian Religion, *Milton* has it Always in View, Often and strongly Inculcates, and Setts it in the Clearest Light, and in a Manner Concise and Noble as Nearly Approaching to the Sublimity of the Subject as is Permitted to Humane Art" (279).

Richardson's interpretation has firm foundation in Milton's text. Milton says in the argument to book 2 that the Son "intercedes" for Adam and Eve, and the Father calls Him "Man's Friend, his Mediator" ("Both Ransom and Redeemer voluntary") and sends Him "to judge" but also to "mitigate their doom," tempering justice with mercy (10.60–61, 71–78).[38] This is the point at which Milton himself, in his *Christian Doctrine*, argues the issue of the Trinity around the term *mediation:*

> Besides it is quite inconceivable that anyone could be a mediator to himself or on his own behalf. According to Gal. iii. 20: *a mediator however is not needed for one person acting alone, but God is one.* How, then, could God be God's mediator? . . . The God to whom we were reconciled, whoever he is, cannot, if he is one God, be the same as the God by whom we were reconciled, since that God is another person. If he is the same, then he is his own mediator between himself and us, and reconciles us to himself by himself; a quite inexplicable state of affairs.[39]

Citing these passages, Leslie Moore has explored Richardson's "mediation" theory to show how he attempts to reconcile theology and aesthetics in *Paradise Lost*. Richardson's terminology mixes Dennis's vocabulary of Sublimity with Addison's various categories of the Great, the Beautiful, and the Novel, New, and Uncommon (and Strange) in his "Pleasures of the Imagination." By focusing on the Mediator, he has fixed his reading somewhere within the middle range of Novel-Strange, which is the area Hogarth then maps out for himself in his aesthetics, a way from the penal-substitution doctrine of the *Harlot* to the principle of aesthetic mediation in the works that followed.

Richardson is also suggesting, as against the satisfaction theory of Atonement, an incarnational version of Redemption—the idea that Redemption does not take place at a specific moment, at the Crucifixion, but through all the events of Christ's Incarnate life and Resurrection and onward to the Last Judgment. The cross makes no sense by itself—only by being related to a life before and after. The service of Holy Communion in *The Book of Common Prayer* emphasizes the Father's wrath ("Provoking most justly thy wrath and indignation against us") but also suggests further benefits from Christ's whole Incarnation, "his blessed passion and precious death, his mighty resurrection and glorious ascension; rendering unto thee most hearty thanks for the innumerable benefits procured unto us by the same."[40]

The Mediation of the "Living Woman"

Richardson's reading and publication of his *Explanatory Notes and Remarks on Milton's "Paradise Lost"* coincided with Hogarth's work on the *Rake's Progress* and his movement from the sacrificial, atoning Harlot to the mediating figure of Sarah Young. Sarah and Rakewell in *Rake* 4 are still presented in the pose of a Redemption, she extending her hand and purse, the bailiffs crowding between them, interposing between redeemer and redeemed. In the prints that followed, beginning in 1736, Hogarth moves her into the formal position of mediation, standing between Rakewell and the bailiffs. And so to Shakespeare's Miranda (between her lover Ferdinand and her angry father, Prospero) in *A Scene from "The Tempest"* and, returning to 1730s London, the wife in *The Distressed Poet* between her bemused husband and the bill collectors and hungry dogs (fig. 52) and the milkmaid of *The Enraged Musician* (fig. 53) between the musician and the noises of the street. Mediation is what was required to transform passive sacrifice (the Harlot's) into active participation, even agency in a new action, in which woman as "redeemer" becomes woman as "mediator." Hogarth's point is that the ugly reality of living here on an unredeemed earth is said to be mediated by the figure of Christ—but it is not Christ's mediation but, nowadays, that of a beautiful young woman.

The form he adopted was already present in his paintings of a scene from Gay's *Beggar's Opera* (fig. 54), which in 1728–29 when he painted them, and through 1732 when he finished the *Harlot*, meant to him the central iconography of Hercules' Choice (see fig. 28). At act III scene ix Macheath tries to "choose" between his two wives, Polly Peachum and Lucy Lockit, singing, "Which way

shall I turn me? — How can I decide? . . . This way, and that way, and which way I will, / What would comfort the one, t'other Wife would take ill." Hogarth combines this pregnant moment with the one immediately following, where attention shifts from Macheath's choice to the two women, who are attempting to mediate between their lover, condemned to hang, and their respective fathers. "Dear, dear Sir," says Polly to Mr. Peachum, "sink the material Evidence, and bring him off at his tryal — *Polly* upon her Knees begs it of you." And Lucy says to Mr. Lockit, the prison warden: "If *Peachum's* Heart is harden'd; sure you, Sir, will have more Compassion on a Daughter."

This second action becomes, in the long run, the more important for Hogarth, who draws from Gay's text the one scene where Shaftesbury's civic-humanist paradigm-for-painters, the Choice of Hercules, is replaced by the sentimental mediation of Polly/Lucy between father and lover (as in *Harlot* 1 it would be replaced by a NT subject, the Visitation). This is why it is from Polly, rather than from the more conventional figure of Jane Shore, that Hogarth developed his Sarah Young, milkmaid, and poet's wife.

The sacred model is Jesus (the Son) mediating between his angry father, the OT God, and fallen, "sinning" men and women. The human, contemporary version is Sarah Young, the wife mediating between Rakewell and his creditors or between her husband the poet and his creditors — with jail and hunger the consequences in both cases — or the milkmaid mediating between the musical taste of a professional musician, a connoisseur of music, and the sounds of plebeian vendors, workmen, and entertainers. The man in the God position, in each case, is in some way deluded into a feeling of superiority, predicating a kind of unrealistic order and, in the case of the musician, venting anger at the plebeian unprofessionals (the "sinners"?).

First, then, the sublime Mediator, the Son, becomes at the hands of the painter of modest conversation pieces the contemporary woman who deals with mundane events and reconciles irreconcilable elements — between order and disorder (the pompous guest and a wrinkled carpet, overturned chair, or disruptive dog or child in Hogarth's conversation pieces), between stasis and energy, unity and variety (and intricacy, curiosity, desire), by which he represents beauty.

There is a question, however: Does she really mediate (i.e., convey a temperate, reformist message)? She fails, like Sarah Young: the dog is making off with the last chop (the cupboard is bare), and the milkmaid's song is not audible over the din. She is a beauty, but a part of her beauty (the "blemish" of it) is her failure. Life, as opposed to beauty, is embodied in the hungry dog and the plebeian

noisemakers whose noise is mostly occupational, or as much for survival as the dog's thievery. Hogarth has produced a parody of mediation, as earlier — with the Harlot — of atonement.

Richardson also turned his attention to Milton's episode of Satan, Sin, and Death in book 2. He sees this strange trio, criticized as a fault of probability by Addison, as in fact the "Allegory which contains the Main of [Milton's] Poem" — a genealogical allegory based on James 1:15 ("Then when Lust hath conceived it bringeth forth Sin, and Sin when it is Finished bringeth forth Death"). When Hogarth painted *Satan, Sin, and Death* (fig. 55) a year or so later, he had the *Beggar's Opera* group in mind, correcting Richardson's reading as allegory by applying Richardson's own theory of mediation. He replaces allegory with an interpersonal relationship, a social scene out of his conversation pieces. Sin mediates between her father Satan and her son/lover Death as if they were guests at a party.

Milton's parody of the mediation of the Son in Satan, Sin, and Death is as well a parody of the Trinity (the Father, Son, and Holy Spirit is replaced by Satan, Death, and Sin), which has the daughter/wife/lover/mother mediating between her father/lover and her son/lover — a scene of adulterous as well as incestuous passion.[41] This is plainly bad in moral terms, and, in aesthetic terms, it would serve as a transition from Hogarth's beautiful to Burke's sublime (in versions modeled on Hogarth's by Blake, Barry, Fuseli, and others).

From the start Hogarth had a precedent for Satan, Sin, and Death in the louche and criminal types of Macheath, Polly, and Mr. Peachum. With Polly, as with Sin, the woman comes to mediate between her father and her suitors, between prison and outlawry (prison warden vs. highwayman). But Macheath and Peachum, like Satan and Death, are held apart and in no very real sense reconciled (Ferdinand and Prospero are eventually reconciled).[42] The effect is a *concordia discors*, a "harmonious confusion," as with the putto and fawn in *Boys Peeping at Nature* (see fig. 17). The middle term, however, is kept separate so that there are *three* distinct elements: as if Nature were in fact *mediating* between (rather than being the object of attention of) the decorous putto and the disrespectful fawn, the one raising and the other holding down her skirt. The two poles by themselves are examples of comic incongruity (a theory Hogarth also broaches in the *Analysis*); this is part of the print's effect — to cause laughter — but with the girl added, it makes a statement about beauty.

In Pope's *Essay on Man* (1734), in this "Isthmus of a Middle State," the principle of order is *concordia discors*. Pope presents it in terms of the poet — his "steer-

ing betwixt the extremes of doctrines seemingly opposite," as he puts it in "The Design," "in passing over terms utterly unintelligible, and in forming a *temperate* yet not *inconsistent*, and a *short* yet not *imperfect* system of Ethics." This is a fiction that is related to the poet's role as redeemer, supported by the formal balance of the couplets exerted by the first-person speaker, who sounds like Horace's poet seeking out a "golden mean" between extremes. But, as Pope admits elsewhere in the *Essay*, it is the deist's Nature, not the poet, whose guiding principle is *concordia discors*, which is in fact a war between opposites based on Heraclitus's theory of strife (*Fragments*, 53: "War is both father of all and king of all"). Regarded as a healthy condition, *concordia discors* has no need of a mediator. God and beast, mind and body, thought and passion are opposed extremes, but they are held in the tension of "well-accorded strife" (2.121):

> The surest Virtues thus from Passions shoot,
> Wild Nature's vigor working at the root. . . .
> Lust, thro' some certain strainers well refin'd,
> Is gentle love, and charms all womankind;
> Envy, to which th'ignoble mind's a slave,
> Is emulation in the learn'd or brave . . .
>
> (2.182–83, 189–92)

Lust in tension with its opposite can produce love, but no mediator is required: this is the process of Nature as first created by God. The poet's role is (as in Pope's opening address to Bolingbroke) more that of a guide through Nature's serpentine labyrinth.

This is the area that Hogarth describes in his aesthetic theory. Initially, the Diana Multimammia of *Boys Peeping at Nature*, Nature in its reproductive component, is the figure the deists substituted for the Judeo-Christian deity — held to be the reality underneath the mysteries promulgated by the clergy. In the Woolstonian context, she evokes the doctrine of natural religion that "Nature is sufficient to direct you" but also fills the vacuum of the *deus absconditus* and so precludes the Redemption and the second creation — which is the story Hogarth hangs as a backdrop to his *Harlot's Progress*. The faun and putto, seeking to expose and to conceal her private parts, indicate the *concordia discors* between extremes that Hogarth is advancing in the *Harlot* — *not*, presumably Horace's "golden mean." This is the empty space of Pope's *Essay* in which Nature operates her "well-accorded strife." Hogarth places in this empty space the beautiful female mediator, who, whatever the degree of her agency (and, we have seen, that

"blemish" includes a sexual component, of coquette or adulteress), is the object of aesthetic interest.

Paul, Drusilla, and Felix

In 1746 Hogarth unveiled a large (120 × 168 inches) painting of *Paul before Felix*, and in 1752, just as he launched the subscription for *The Analysis of Beauty*, he issued engraved copies. *Paul before Felix* was painted for the benchers of Lincoln's Inn, one of the Inns of Court, and this provided the context of the law, the reference being to Paul's lengthy attacks on the Mosaic law, taken up by Luther — and in particular by Antinomians, including the deist Woolston. In *Paul before Felix* Hogarth equates the law (state, Rome) and the Temple, the high priest, and the Sadducees — against the truth teller Paul, whose truth was the crime committed by Felix, the procurator who was himself sitting in judgment of Paul. Note the primary elements: Paul, the falsely accused (by the Jews for opposing the Law, for preaching the Atonement, primarily for opposing circumcision); the judge who is himself guilty — of a sexual offense — and represents the state; and the Jews, priests and Sadducees, and their legal spokesman the lawyer Tertullus.

In the painting and his own engraving of the painting (fig. 52), the magistrate and priest are accompanied by Drusilla, the "harlot." She is a respectable harlot because she is accepted by the procurator Felix, but she is being exposed by Paul. In his engraving Hogarth introduces the joke of Paul's hand, which indicates, by another example of false perspective, the locus of her crime, which was adultery (Drusilla was married to another man).[43] Drusilla looks less surprised than Felix. Her gaze at Paul can be interpreted as (contrasted with Felix's look of surprise, anger, and fear) more one of awe, approval, even attraction. In the context of the romantic triangle created by Felix's hand on her arm and Paul's on her sexual zone, the suggestion is that the Apostle and the Roman procurator are contesting her affection or that she is in some sense mediating between them. Drusilla comes directly from Milton's Sin — in Hogarth's *Satan, Sin, and Death* (fig. 55) — and anticipates the adulterous triangles in both plates of *The Analysis of Beauty*: Hercules, Venus, and Apollo in plate 1; the young wife, old husband, and young lover in plate 2 (see figs. 44–49).

Drusilla and her act of adultery relate the story of Paul to Hogarth's developing aesthetic theory — a step nearer the Venus of the *Analysis*. The beautiful but guilty Drusilla is played off against the figure of the beautiful Pharaoh's Daughter (fig. 58) in the pendant (Moses' adoptive mother who in turn is contrasted in that

plate with the less alluring but true mother of Moses). The two prints were announced as ready for subscribers at the same time that Hogarth first announced the subscription for *The Analysis of Beauty.*[44] The two engravings place Pharaoh's Daughter and Drusilla in roughly parallel positions, though the latter is smaller and in the distance, subordinated to the looming foreground figure of Paul, who is in the same position of prominence as Pharaoh's Daughter — and, though he is standing and she is reclining, both are gesturing with an outstretched hand. If Paul's right hand indicates Drusilla's sex, the other hand points to heaven as if to suggest — in Pauline doctrine — the alternatives of body and spirit or the different forms of love, man's and God's (eros, caritas vs. agape). The hand of Pharaoh's Daughter reaches out an invitation to the child Moses, who, looking uncertain, shrinks toward his real mother.

The point of *Paul before Felix* is, presumably, that here a beautiful woman is a false mediator. Paul is a man — the first dominating and normative male figure in Hogarth's historical works. (Jesus in *The Pool of Bethesda,* I have noted, structurally filled the feminine role of Sarah Young and the other mediating women.) And he is in a position that suggests that he is an alternative, apparently spiritual, to the beautiful Pharaoh's Daughter and in control of the sexual energy of Drusilla. In short, he is a vestige of the Christian story that remains admonitory even in the face of its aestheticization. In the austere, classicizing version of the print, an alternative to his own that Hogarth had engraved by Luke Sullivan, Drusilla is eliminated, as if she were a diversion from the simple moral contrast of Paul and Felix with the two priests on the dais, or spirit and law, NT and OT, as if only for Hogarth and his upcoming *Analysis* was the added element of the beautiful significant and relevant.[45]

Paul, of course, was the man who created the story of Redemption. I doubt if anyone thought of Paul as the only begetter of Incarnation, Redemption, and Atonement or as the antagonist of the Jesus sect in Jerusalem. They did not think that Paul invented the theology that replaced the teachings of Jesus. Paul's formulation in his Epistles was not a "story" — it was either a reality or the doctrine at the heart of their religion that raised to uniqueness the essential truth of the historical man Jesus' ethical teachings. But they did see him, through Luther's eyes, as the father of the Protestant Reformation (Paul vs. Peter, the Pope, and Rome), and as the antagonist of the Jewish Law and the popish religion, of ceremonies and "works" as opposed to faith.

Hogarth plainly saw Paul as significant or he would not have painted him confronting Felix in the climactic episode of Luke's account of his mission in

Acts, moreover in a composition that evokes Raphael's *Paul and Elymas*, one of the tapestry cartoons that were regarded as the apogee of continental history painting.[46] In other words, this was a work that Hogarth was asking to be compared with the Old Masters — as he had in a different, more indirect way in the *Harlot*. It would appear that Paul was Hogarth's hero — and he may have been so as early as his first contact with Thornhill and Thornhill's scenes of Paul's mission painted around the cupola of the dome of Saint Paul's Cathedral. (Paul was the patron saint of London, and according to some sources London and not Rome or Spain was in fact the terminus of Paul's travels, to which he brought his story of the redeeming Christ.)[47] Further, Hogarth chose — the only time he did this — to add to the painting, when he engraved it, a subscription ticket which, as if to recall that first effort of the *Harlot*, burlesqued the serious version (fig. 57). And, to round off the schema, he published these with a pendant engraving based on his Foundling Hospital painting of *Moses*, an OT subject.[48] They are typologically related: Moses between his true and supposititious (false, Egyptian) mother prefigures Paul between the NT and OT God, the spirit and the law.

If the text (as was clear in the many sermons on the subject of Paul and Felix) was justice, divine and civil, the subtext Hogarth presents is love — Felix-Drusilla's eros, adulterous love, versus Paul's caritas (from the famous passage in 1 Corinthians). Given her status, Drusilla represents the dark side of the Harlot. In Hogarth's earlier work the mediator herself has represented love in the sense of being the Rake's or Poet's wife or (another nexus for thoughts of desire, Hogarth's aesthetic motive) the pretty milkmaid, but her mediation has been between extreme alternatives of order and disorder, law and misrule. But with Sin between Satan and Death, and now, inaugurated by the *Paul* and *Moses* plates, in the two *Analysis* plates, Hogarth associates the beautiful mediator with the seductive woman in the middle of an adulterous triangle. The Judeo-Christian or classical version is Drusilla or Venus, and the human, contemporary version is the adulterous woman in *Analysis* plate 2 — paired with the Woman of Samaria, her NT prototype — who holds husband and lover in a kind of *concordia discors* (which was originally the Harlot's situation in plate 2). Adultery is the issue, or presumably sexual release. For aesthetic reasons these are good, though (as *Paul before Felix* shows) the second is plainly immoral: beauty perhaps needs to be outside the moral range — contra Shaftesbury, who equated beauty and virtue, but agreeing (ironically?) with Shaftesbury's principle of disinterestedness, as required for either morality or aesthetics.

And so Drusilla, the adulteress, is the first clear-cut case Hogarth presents, in

the context of the *Analysis,* challenging the Shaftesburian equation of beauty and virtue: Drusilla is beautiful but a sinner — and not just a sinner in the sense of the Harlot and Jesus, "sinners" in the eyes of the priests, but in the eyes of ordinary English citizens. Supplementing Drusilla, he gives us, in the pendant, *Moses brought to Pharaoh's Daughter,* the beautiful woman as the false mother, opposed to the plain woman who is Moses' true mother. And so with these women Hogarth approaches the Venus of plate 1 and the adulterous women of plate 2 of the *Analysis.*

These images express Hogarth's sense of the ambiguity of beauty, its status as (unlike Shaftesbury's Platonic system) existing in the real world, being in fact transgressive as well as healing. And as he approaches *The Analysis of Beauty,* the disruptive aspect replaces the unifying; at the same time he is arguing in the text that the greatest beauty is the greatest variety containable within a unity.

This is not to lose sight of the primary fact that Drusilla is placed in the context of the law: She "mediates" between the judge and the accused, the first guilty and the second innocent — a topos of the unjust magistrate, as Bishop Hoadly noticed in a sermon: "the *Prisoner,* undaunted and unconcerned at his own danger; the *Governour,* terrified and *trembling,* as if his *Prisoner* had been his *Judge;* and were now pronouncing a sentence of Condemnation upon him."[49] Hogarth's use of the legal context points to the route he is taking from the law (as in religion and politics) to aesthetic judgment, which will be summed up in *Analysis* plate 1 in the magistrate's tomb and its inscription indicating the demise of false judgment in art as well as morality (fig. 46). This, the aesthetic dimension, is brought out in the subscription ticket, which announced the engravings by burlesquing the Dutch style of Rembrandt. The subtext in *Paul before Felix* of art and connoisseurship becomes explicit in the subscription ticket.[50]

In the burlesque (fig. 57), Paul is so short he has to stand on a stool to make himself tall enough to be seen: a detail that could be mere burlesque, or it could be Hogarth's memory of the Latin *paulus,* short, or of his own short stature.[51] Drusilla has become a long-nosed crone holding a lapdog (regarded as a male substitute, as in Pope's *Rape*). Felix has beshit himself in terror at Paul's accusations and knowledge of the truth. As if a reprise of Hogarth's desecration of the church in Kent, the story of Paul's speech of moral castigation has been reduced (as, Hogarth suggests, the artist Rembrandt would have reduced it) to excrement. "Burlesque," to judge by the term he applies to the print, means to Hogarth fear reduced to defecation, justice to a blowsy Dutch woman, and Paul to a Dutch burgher. The burlesque is of Rembrandt's religious histories, in particular the

rage in England for his etchings (as recounted in the story of the hoax hatched by Hogarth and Benjamin Wilson),[52] and the angel is certainly a blowsy Rembrandt woman, and Felix himself recalls Rembrandt's dog relieving himself in the foreground of his etching of the Prodigal Son.

In *Paul before Felix* for the first time Hogarth's female mediator is supplemented with a male prophet (Paul himself, as prophet, is balanced by the lawyer, Tertullus). This was just the moment when, as we have noticed, Hogarth is making parodic associations of himself with Columbus and his discovery of the new world, Moses and his leading of the Israelites to the Promised Land. The connection of the artist with Paul is materialized not in the serious religious print, *Paul before Felix*, but in the burlesque, Paul reduced to a very short Dutch burgher. (*Moses*, the pendant, though not a burlesque, slyly reduces the prophet — Michelangelo's sublime Moses — to a child.) Paul is the figure who designates the morally dubious but beautiful woman, the role Hogarth gives in *Analysis* plate 2 to Sancho Panza, who recoils in surprise at the two beauties — or perhaps (given Hogarth's theory of laughter) laughs at the incongruous contrast of their beauty and their immorality in the light of Shaftesburian aesthetics (see fig. 49).

Good and Bad Mediators

If the young woman who mediates is the chief figure of Hogarth's later works, the closest he comes to an ideal in his satire, then the subversion of this ideal is going to be her reverse, the corruption of the figure of mediation. In *The Beggar's Opera*, to begin with, there had been glancing allusions to Walpole, divided between Macheath (who, like Walpole, has more than one "wife" and is condemned [dismissed] and reprieved) and Mr. Peachum (middleman, director, manager, and broker — Walpole the manipulator of Parliament). In his paintings Hogarth centers Macheath, the more glamorous aspect of Walpole, but his pose of "choice" is only a negative version of the good mediation being attempted by his "wives," Polly and Lucy. Walpole was the bad steward, mediating between monarch and the English people. In *Paul before Felix*, we have seen, Hogarth uses the political example but — by way of the subscription ticket — extends adultery and political corruption into aesthetics. With the context of the fashion for Rembrandt etchings, he slips into the form of bad mediation which probably meant most to him: The connoisseur or critic mediates between the artist or the art object and the public — the market or the collector — and his effect is the same as Walpole's on the nation (or Peter Walter's on the landlord, the duke of New-

castle, as well as his tenants, both of whom he cheats).[53] Walpole, of course, was not only the false mediator between king and people but one of the most famous art collectors of his time.

In this sense, Tom Rakewell is a collector — bad in the same way Visto and others in Pope's *Epistle to Burlington* are bad.[54] All the others in *Rake* 2 are the middlemen — dancing masters, fencing masters, musicians, and so on. The art connoisseur is absent as a figure (unless represented by Bridgeman, the landscape architect), but the evidence of his effect on the Rake is the paintings that decorate his house (fig. 62).

If in the *Rake's Progress* Sarah Young is the Christ-like mediator, what of the Rake himself? His story is hardly that of a Rake-as-Christ but rather a moral "progress" or regress (what the *Harlot* was not).[55] He is the sinner who ignores the offer of Grace and proceeds doggedly down the primrose path to destruction. The only obvious allusion to Christ is in plate 8 (see fig. 34), where in this case it is as ironic as the parody in the *Harlot:* He is dying and Sarah is in the pose of Mary in a Pietà; she *is* ministering but he is totally at odds with the role.

In plates 2 and 3, Rakewell tries on different roles but refuses the Christ role.[56] In plate 3, when he breaks the mirror, he invokes the Puritan who (unlike the humanist who sought his own image in the mirror) seeks to eradicate his own image and replace it with Christ's. In 2 Corinthians, "We all with open face beholding, as in a glass, the glory of the Lord, are changed into the same image." But Rakewell chooses instead the face of the worst of the Roman emperors, Nero. (He has cut out the faces of all the other Roman emperors hanging around the walls of the brothel.)[57]

With the mirror and the paintings (after Titian) of the Roman emperors, Hogarth has extended from the *Harlot* the theme of art and its uses. If we want an explanation for Rakewell's *Pietà*, it must be that he now, in Bedlam, *sees himself* as a Christ figure *because* he has set himself up in plate 2 as Rakewell the collector of paintings, which he stupidly imitates. It is a sentimental self-image, an adaptation of an Other to replace and obscure his individuality — or, in religious discourse, the image of Jesus he *should* have been seeking to emulate. Rakewell is a collector for the same reason that he is a "rake" (and that the Jew was a collector and keeper of pretty women and the Harlot of penny prints): He is an "ape" of fashion.

In Hogarth's first thought for plate 2, Rakewell does collect "dead *Christs, Holy Families, Madona's,* and other dismal Dark subjects," but Hogarth replaced these with the paintings of the Choice of Paris and the fighting cocks (figs. 60 and 61). (He may have decided not to pursue the religious parody of the *Harlot.*) The

"dark subjects" he recovered ten years later in Lord Squander's collection of Old Master martyrdoms and murders, OT, Christian, and classical, in *Marriage A-la-mode* 1, which have foreshadowed and determined the "martyrdom" he is inflicting on his offspring.

These collectors reflect the false mediators, the middlemen representing a false aesthetics (for Pope a counterpoetics) that returns the attention from the maker-poet and the writing of poetry, or the painting of pictures, to the critic and connoisseur, in effect the collector whose collection is of foreign, "Old Master" art. In Shaftesburian politics attention was displaced from the monarch to "subjects," in both political and aesthetic senses: from the source of creation and patronage — or a single source — to appreciation, collecting, and the oligarchy of connoisseurs. One consequence was that the quality of the object was determined by the connoisseur, not by the artist, the patron, or the marketplace. The middleman was, for a Protestant Englishman, essentially the figure of the popish priest: In Leviticus 4:35 it is ordered that the priest must place the blood on the altar, acting as mediator between the sinner and the deity. From this derives the false role of the priest when the Son or the Holy Ghost is the true mediator. And with the Levitical laws it was easy to equate the "rules" of the critics involving unity, decorum, and level of styles.

The Connoisseurs' Telescope

The false mediator was, from Hogarth's perspective, the subject of Richardson's most celebrated and influential book, *The Science of a Connoisseur* (1719), a manual for the collector of (largely) foreign art, who goes on a Grand Tour to teach himself, with the assistance of Richardson the Shaftesburian aesthetician, how to buy Old Master paintings and antique sculptures. It was from the perspective of *The Science of a Connoisseur* that Hogarth, at least in part, read Richardson's Milton.

We can return to Hogarth's *Punishment of Lemuel Gulliver* (see fig. 25) of 1726: On the face of it, Hogarth interpreted Gulliver as an image of the honest Englishman — a huge version of Dr. Arbuthnot's John Bull — who stupidly gives up his "liberty" to these pygmy politicians and clergymen. He singles out one of Swift's central themes in the first voyage, Gulliver's crazy assertion of Whiggish liberty at just the moment when he surrenders it to these tiny, pompous, antlike tyrants (themselves Whigs and Hanoverians). But he transfers the punishment from Gulliver's eyes, the crucial organ that designates his "liberty" in Lilliput (his

spectacles were one piece of property he withheld from the Lilliputian confiscation), to his "nether eye," the bottom of his alimentary canal — from perception to (in Gulliver's terms) a shameful, uncleanly evacuation.

The clyster pipe inserted in Gulliver's backside became, a few years later, the telescope in Hogarth's drawing, "The Complicated Richardson" (fig. 59).[58] Early in his *Explanatory Notes and Remarks*, Richardson Sr. acknowledges the role of his son, upon whose travels and knowledge of languages he relied:

> My Son is my Learning, as I am That to Him which He has Not; We make One Man; and Such a Compound Man (what Sort of One Soever He is whom We make) May Probably, produce what no Single Man Can. When therefore I, in my Own Person talk of Things which in my Separate Capacity I am known to be a Stranger to, let Me be Understood as the Complicated *Richardson*. (cxli)

It is hard to imagine Hogarth not reading this and associating Richardson's words with his theory of divine mediation. Richardson Jr., "My Son," is a kind of mediator between his father and the world of the Old Masters, that is, a prototypical connoisseur. And Richardson Sr. even avoids a hint of Arianism by insisting on the "compound Man (what Sort of One Soever He is whom We make)," one who "May Probably produce what No Single Man Can." So he makes himself a parody of the Father, and his son of the Son, ripe for Hogarth's teeming imagination to work upon.

Richardson Sr. goes on, "I know well enough my Naked Eye is as no Eye at all on This Occasion; I then apply to my Telescope: In what depends on the Knowledge of the Learned Languages my Son is my Telescope." The scatalogical "Naked Eye" is obvious enough in the print. The telescope is inserted in the younger Richardson's rectum, directed upward at a row of Old Master paintings, and peered through by his father. A dog is barking to attract the younger Richardson's attention away from Virgil's *Aeneid* and the Old Master paintings to himself. (The dog is one of Hogarth's versions of nature, sometimes his own artistic signature.)[59] The conjunction is significant because Jonathan Jr., following his trip to Italy, published *An Account of the Statues, Bas-reliefs, Drawings and Pictures in Italy, etc.* (1722), which became a Bible for the young Englishman who went abroad, telling him ("Delicious!", "Excellent") what to see and what to buy — usually copies — and instructing him to return to England the champion of foreign art, willing to buy more copies on the London art market. The three paintings, designating their kind of connoisseurship, are a Holy Family, a Nativity, and the portrait of a woman. Jonathan Jr. mediates in a lower bodily way

between the inquiring collector (his father, Jonathan Sr., standing in for all the young men who will consult this book on their Grand Tours) and the art of Italy.

In fact, the telescope recalls (as Richardson would surely have seen if the satire reached his eyes) the telescopes in Milton's similes in *Paradise Lost* of an observer with fallen perception. The telescope is one of the devices man uses in vain to aid his fallen vision. It is easy to see how Milton's observer similes lay the ground-work for a critique of critical perception and connoisseurship, perhaps going back to Paul's image of the mirror in 1 Corinthians 13: Now we see things reflected in the mirror only (as in Plato's cave), but after the Final Days we will (in Plato's version, come out into the light of day and) see "face to face; now I know in part; but then shall I know even as also I am known." So to Galileo (in Milton's simile), looking through his telescope, Satan's shield hanging on his shoulder looks like — Galileo takes it to be — the moon (1.284–91). (In the *Rape of the Lock* Pope has the pseudo-astrologer Partridge "view in cloudless skies, / When next he looks thro' Galileo's eyes" Belinda's lock, misrepresenting it.) The scientist looking for new planets is not aided by the newest contrivances of human inge-nuity — in Geoffrey Hartman's words, the astronomer's "attempt to leave the earth and rise by science above the human world."[60] And in book 5 the angel Raphael flies down from heaven to talk with Adam. His sight is perfect ("no cloud, or, to obstruct his sight, / Star interpos'd, however small he sees"), but from the earth he is by no means so clearly perceived:

> As when by night the Glass
> Of Galileo, less assur'd, observes
> Imagin'd Lands and Regions in the Moon:
> Or Pilot from amidst the *Cyclades*
> *Delos* or *Samos* first appearing kens
> A cloudy spot.
> (5.261–66)

Richardson himself focused on the telescope, comparing the perception of Raphael with that of fallen men: "His Angel Eye saw what We could not have seen by the Help of our Best Telescopes . . . the Angel Saw, but Better, with Greater Certainty, and more Distinctly" (214): thus the telescope through which he at-tempts to see Italian art and the classics. In *The Complicated Richardson* Hogarth picks up Galileo's telescope with its ambivalent associations of perception-aided as mis-perception and applies it directly to the doctrine of connoisseurship. The issue of seeing as opposed to believing and blindly following religious supersti-

tions conflates the notions of connoisseurship and popery (as we saw above, pp. 63–64).

At the other end of the image is *The Punishment of Lemuel Gulliver,*[61] by way of Don Quixote, celebrating the person who sees through someone else's eyes (in Gulliver's case Lilliputian vision, or myopia), or in the words of Isaiah 6:9, "see ye indeed, but perceive not." This is the addressee of *The Analysis of Beauty* whom Hogarth constantly urges to see nature and art through his own eyes, not through the distorting lenses of the connoisseurs.

In sum, with Richardson and Hogarth the critic-connoisseur is a middleman between art and audience (market) who determines the value and vendability of the art object. From Hogarth's point of view, he primarily sees the art of Renaissance Europe, but not what is before his nose in his native England. And so in relation to English art he is primarily Swift's critic, "a Discoverer and Collector of Writers Faults . . . , taken up with the Faults and Blemishes, and Oversights, and Mistakes of other Writers."[62] In practice, Hogarth avoided the power of connoisseurs-patrons by turning to subscription, eliminating the middlemen of the market. (His projected countermodel, outlined in detail in his *Analysis of Beauty*, was of an ever-widening circle, or from an oligarchy to a democratic marketplace.)

Ganymede: Christ and Antinous

Some years ago David Bindman *en passant* dropped the remark that Tom Rakewell's collecting of a painting of *Ganymede* in *The Marriage Contract* (figs. 60 and 61) shows that Hogarth intended to imply that Rakewell is a homosexual.[63] Although the remark was not developed, Bindman may have had a point, at least as to effeminacy. The most prominent figure in *Rake* 2 (fig. 62), which replaced *The Marriage Contract*, is the effeminate dancing master, who is adjacent to the scroll concerning Farinelli ("One God, one Farinelli"), the castrato opera star, and this scroll identifies Rakewell as a connoisseur and patron of opera.[64] Only on a closer examination do we see that Rakewell is the figure farther back under a painting of the *Judgment of Paris*. One reason we might identify Rakewell with the dancing master is that Hogarth has rhymed the forms of the dancing master in plate 2 and Rakewell in plate 1, so that when we look from one to the other we compare the two figures. Hogarth could wish to imply that the dancing master carries one aspect of Rakewell, supported by the connoisseurship that links Farinelli, opera, and paintings. Thus, in his own Judgment of Paris, Rakewell is

suspended between the model of the dancing master and the plainly heterosexual decision he makes in plate 3, where he is in a brothel.

In the foreground of *The Marriage Contract*, below the *Ganymede*, are three antique busts (see fig. 61). The woman's head is inclining, or turning its gaze, toward one man, away from the other, creating the first of Hogarth's romantic triangles. When these juxtapositions reappear in *Rake* 2 (fig. 62), they have become a choice. The New Testament pictures of *The Marriage Contract* have been replaced by the classical Judgment of Paris, with Venus, Minerva, and Juno, framed by two fighting cocks. Cocks serve as signs both of the rake's interest in cock matches and, iconographically, of emulation, in this case (as perhaps in the story of Paris and Venus) of ideal emulation instead of the mere imitation in which he engages. ("Cock" also, of course, as penis, indicates the choice he will make for Venus.)⁶⁵ However strong the homoerotic temptation, Rakewell chooses Venus.

The Ganymede in *The Marriage Contract* is a figure Hogarth associates with castrati when he recovers it in *Marriage A-la-mode*, plate 4, where it hangs above the head of another Farinelli. Given the example of the *Harlot*, which immediately preceded *The Marriage Contract*, we must first note that the picture of Ganymede held in the wings of Jupiter is directly beneath a Madonna and Child with Joseph in the background.⁶⁶ In the myth, Ganymede is "raped," that is carried up to Olympus by Jupiter for his pleasure. In the slang of the period, a Ganymede was "any Boy, loved for carnal abuse, or hired to be used contrary to Nature to commit the detestable sin of *Sodomy.*"⁶⁷ In the Renaissance, however, he was absorbed into the iconography of Christian devotion; the Ganymede carried off by Zeus to Olympus was used as an emblem of Christ ascending to Heaven.⁶⁸

This identification inevitably led to excesses: In Thomas Traherne's "Love" the poet shifts easily from metaphor to metaphor and gender to gender until in the last stanza he offers himself as if Jesus were Zeus: "His Ganymede! His life! His joy! / He comes down to me, or takes me up / . . . I might be His boy" (lines 31–33). Just as easily Jesus was presented as "the true Ganimedes . . . the fairest among the sons of men," therefore related to God as the cupbearer was to Zeus.⁶⁹ The pious William Sherlock could perhaps have been misread when he asked the "devout Soul" "what transports and ravishments of Spirit he feels, when he is upon his knees, when with Saint Paul he is even snatched up into the third Heaven, filled with God, over flowing with praises and divine joys."⁷⁰

In *The Marriage Contract* at the top are the *Madonna and Child* and the baby

Jesus being dropped by his mother into the Eucharist machine, coming out ground into wafers, administered by a priest to his parishioners. At the bottom left, on a diagonal axis with the Eucharist machine, Ganymede is in the clutches of Jupiter's eagle, being carried up to heaven to become his cupbearer and pathic. The parallel is obvious, indicating how we are to judge this "rape": The *Madonna and Child* is a "Before" to the "After" showing the Mother dropping the babe into the Eucharist machine—a fate, Hogarth suggests by his parallels (Christian-classical), similar to that of Ganymede in the hands of Jupiter. Further, Hogarth's having the painting of Ganymede presented by a black slave invokes the common term *slave* (as in *Harlot* 2). Just below the Ganymede are the three busts with the woman turning toward one man, away from the other, in a romantic triangle. In *Analysis* 1, Antinous, the minion of the Emperor Hadrian, while being apparently propositioned by the dancing master, is himself inclining in the direction of the Venus, implying that she may be more attractive to him than the dancing master. The Ganymede in *The Marriage Contract* is in the position of the Antinous, one the object of desire of Jupiter, the other of the dancing master (for which, given *Rake* 2, read *connoisseur*). Hogarth's aesthetic norm is the beautiful woman, married to Vulcan or some other old man, while drawn to—and alluring to—Apollo or some more attractive younger man.[71]

Hogarth, in his aesthetics, was drawing upon what he regarded as a normative assumption (like his assumptions relating to antisemitism): the canonical position of heterosexuality in his culture. He associates with homoeroticism or male-male relationships (or simply effeminacy) the Shaftesburian exaltation of the male at the expense of the female. Shaftesbury projected a Platonic love as the chief principle of aesthetic as opposed to *non*-aesthetic appreciation (as in hunger, power, desire); the rich, powerful, land-owning oligarchy, therefore, alone possessed the disinterestedness necessary for judgment in both government and taste. But, ironically, as Hogarth (as well as Mandeville and others) noticed, connoisseurs and collectors were precisely those who metamorphosed paintings and sculptures from disinterested objects into objects of consumption, rivalry, and self-fashioning in the manner of Rakewell or Lord Squander. Hogarth associates the Shaftesburian aesthetics with the connoisseur—not only of *Characteristics* but in particular of Richardson's *Connoisseur*—and so the idea of a connoisseur as an intermediary between the art object and the common man who should be the enjoyer of art. As in the image of *The Complicated Richardson*, what the telescope is engaged in is sodomitical behavior, which writers such as Swift had earlier associated with critics—as in his double impalement of the "beloved loving Pair," Bentley and Wotton in *The Battle of the Books* (1704). In the Restora-

tion, as in the play *Sodom* (1670s, sometimes attributed to Rochester), buggery had been a metaphor for the subservience and obsequiousness of courtiers.[72]

As James Grantham Turner has noticed, many details in Hogarth's prints emphasize male sexuality.[73] In *Hudibras* plate 1, the frontispiece, there are undeniably two heavy burin strokes on the satyr that designate, for whoever cares to look that closely, an erect penis. And there is, as Turner notes, in the drawing of *Boys Peeping at Nature*, an erect penis added to the putto. It is a clumsy addition (anatomically it does not fit), as if inserted later by a facetious owner of the drawing, but Turner shows that in the print Hogarth has given the drapery that covers this area an agitation that serves as a kind of surrogate. (In *The Sexuality of Christ*, Leo Steinberg has discussed the convention of the floating drapery used to indicate Christ's "manhood.")[74]

The Marriage Contract is paradigmatic and takes us back to *Harlot* 2 and the Jew's collection of paintings—the uniting of connoisseurship and the bad typology of art, as opposed to the good typology in which the "living woman" fulfills the classical form (*figura*, the foreshadowing) of Venus or the Christian form of Mary. The paintings and sculptures—whether in a sculpture yard or a gallery—are random and yet obviously hung by the collector (and arranged by the artist, Hogarth, who represents it). In Hogarth's graphic works the painting or sculpture is never beauty itself (although in the text of the *Analysis* Hogarth sometimes claims that the *Apollo Belvedere* or the *Venus de' Medici* is) but only iconography.

The weight of the paintings (bad typology as precedent and authority) is overwhelming. The father and the son are both crushed under the weight of the paintings the father collects in *Marriage A-la-mode* 1, though they are the father's self-representation: He sees himself as Jupiter Furens and the OT God who overwhelms Pharaoh's army with the Red Sea and has Prometheus nailed to the rock—and so he fulfills the type. His son is therefore Prometheus and, in the Christian register, Saint Sebastian and Saint Lawrence being martyred. The son's young bride is Judith holding Holofernes' (her husband's) head, and her lover-to-be, Lawyer Silvertongue, who will kill Lord Squander's son, is the fulfillment of Cain killing Abel. And the fate of the next generation is prefigured in the *Massacre of the Innocents*.

Zoffany: The Artist and the Connoisseur

A painting that demonstrates the two kinds of mediation—that of the sacred figure and that of the connoisseur—is John Zoffany's *The Tribuna of the Uffizi* (1770s, fig. 63).[75] Zoffany's model was the first plate of Hogarth's *Marriage A-la-*

mode, with its walls covered with the old earl's collection of paintings, scenes of torture, murder, and martyrdom, mixing Christian and pagan myths. He also recalls plate 1 of the *Analysis of Beauty*, a sculpture yard with a few living people interrelated with the copies of the canonical sculptures around them.[76] Zoffany's painting, on a more ambitious scale than Wright's similar conversation pieces centered on art objects, shows little circles of connoisseurs and collectors examining works of art — and, from his point of view, one artist. Zoffany's picture is about art and artists and connoisseurs, one aspect of which is the way they look at sacred pictures or profane, Madonnas or Venuses. The world of art Zoffany presents consists not only of its art objects but of its characteristic denizens: the wealthy patrons like Earl Cowper holding forth, the artistic hangers-on like Thomas Patch, the Grand Tour "companions" like Mr. Stevenson instructing his ward Lord Lewisham, and the artist Zoffany himself.

The central display, as in *Analysis* plate 1, is a Venus, Titian's *Venus of Urbino*, which has been taken off the wall and removed from its frame and is surrounded by eager "art lovers" consisting of Patch, Mr. Gordon, and Sir Horace Mann. (It was a Titian Venus Hogarth evoked in the background of *The Pool of Bethesda*, balancing the caritas of Jesus with the eros of Venus, a combination of beautiful serpentine lines and, by implication given the context of the healing poor, venereal disease.) On the horizontal axis of the composition, Zoffany peers around a *Madonna and Child*, and the *Venus de' Medici* (the Venus Hogarth used in *Analysis*) is being viewed by the earl of Winchelsea, the two Mr. Wilbrahams, and Mr. Watts. In fact, five connoisseurs are contemplating the *Venus de' Medici*'s backside, one (Thomas Wilbraham) with an eyeglass. Only James Bruce of Kinnaird is pointedly looking away. He was in Florence in 1774, having recently returned from the expedition on which he reached the source of the Blue Nile after two years of journeying in Africa. The "joke" is presumably that his thoughts are on the source of the Nile rather than the charms of Venus.

Zoffany's painting shows side-by-side immortal art and mortal, sometimes all too mortal, patrons and artists. Fourteen may be said to be grouped around secular if not sexual art, and eight around the *Madonna*. The composition is anchored firmly on the sculptures of *Cupid and Psyche* at the left and the *Venus de' Medici* at the right, the *Venus of Urbino* at the bottom (just right of) center, and, at the top center a religious subject, Raphael's *Saint John the Baptist*. The *Saint John* is very large, indeed the painting that, with the *Venus of Urbino*, dominates the room, and the vertical axis connects Saint John, the precursor of Christ, and Guercino's *Samian Sibyl*, also prophesying (the sibyls were incorporated into the

Christian tradition as prophets of Christ's coming). The line of Saint John's raised arm leads down through Titian's *Venus of Urbino* and, just below and partly covered by it, an antique sarcophagus — in Christian terms, the empty tomb of the Resurrection. The anchorage of the *Cupid and Psyche* is, moreover, somewhat blurred by the fact that the little group of men beside it are not (as are the similar groups at right and center) regarding it but rather the *Niccolini-Cowper Madonna*, behind which Zoffany himself is seen. A viewer looks first at the *Cupid and Psyche*, and then the eye moves to the *Madonna*. And this whole group is pulled down by the large, prominent figure of the *Arrotino* or *Knife-Grinder*,[77] who looks across the scene like one of those people whose gaze leads the viewer into a Mannerist painting; he is looking specifically at the *Venus of Urbino* and seems to be shocked at what he sees. It is relevant to recall, as Zoffany may have, that Smollett recorded in his *Travels through France and Italy* the story that the knife-grinder is portrayed as he accidentally overhears the conspiracy of Catiline.[78] It may, therefore, be the connoisseurs admiring the *Venus* as well as Titian's painting that prompts his reaction.

Although we can only speculate about the reputations of most of the men portrayed in the *Tribuna*, either public or vis-à-vis Zoffany, it is possible to say a few words about one of the spectators of the *Venus*, who holds onto its upper right corner: Thomas Patch, the connoisseur, copyist, and picture dealer with whom Zoffany had recently quarreled. Zoffany is supposed to have considered painting a black patch on the buttock of one of the *Wrestlers* at which Patch is pointing — a verbal pun in the Hogarthian manner.[79] As it is, he chose Patch as the one man to indicate the central picture of the composition, the *Venus of Urbino*. There was some irony in the fact that the solemn etcher of Masaccio's frescoes in the Church of the Carmine (published in 1770) and of the works of Fra Bartolommeo (1772), who was also a caricaturist of visiting Englishmen in Florence, should be shown handling and displaying the most secular of pictures. The raised finger of his left hand does seem to point at the *Wrestlers*, as if to suggest some parallel between their activity and the reclining Venus: a comment on aesthetic disinterestedness — which recalls Hogarth's use of the effeminate dancing master vis-à-vis the Antinous in *Analysis* plate 1. Patch was known for his homosexuality — the reason, apparently, for his banishment from Rome by the pope. Zoffany has him with his hand on the *Venus of Urbino* but pointing to the equally naked *Wrestlers*. Patch is holding onto the *Venus* but thinking about the *Wrestlers*. As F. J. B. Watson discreetly puts it: "The patch is no longer to be seen and the joke now seems to be a feeble one, though there is reason to suppose that it may have had a

more subtle point for the artist's contemporaries."[80] The joke is still present, patch or no patch.

If Patch, the sodomite, is the middleman (connoisseur, dealer, and copyist), Zoffany is the contrasting artist. In his picture of the world of art, he gives representation to all the important schools of painting, from that of Raphael and the Carracci to that of Caravaggio, but, as Oliver Millar notes in his thorough history of the painting, there is a loud "paean of praise in honour of Raphael" (18). Certainly enough Raphaels are shown and imported into the scene to give us an idea of Zoffany's high regard for the master, but it may also be significant that all but the portrait of Leo X are related to the birth of Christ, and *Leo X* being cut off by the edge of the canvas might indicate, besides the contingency of canvas shape, how grudgingly Zoffany included portraiture (and the portraits that in fact hung in the Tribuna) in his conception of the Raphael oeuvre.[81]

Roughly speaking, a religious subject jostles a pagan and erotic one. The Carracci *Bacchante* was in fact on the wall of the Tribuna where it appears, but Zoffany added beneath it the *Madonna della Sedia* and the *Cupid and Psyche* to make a suggestive trio. Nobody can miss the similarity between the classical Psyche hugging Cupid and Raphael's Madonna hugging the Christ Child or, for that matter, between the Madonna with upturned eyes and the Cleopatra next to her, both by Guido Reni. All of these were inserted and placed by Zoffany in the Tribuna, and he must bear responsibility for the juxtaposition.

According to Henry Angelo, Zoffany tended "to play off his wit against the authority of scripture, and turn the OT into burlesque," but there is also testimony that he was a devout Catholic, at least in his early years.[82] He was given to introducing, "without the permission of the original and often in unflattering guise," acquaintances with whom he had quarreled, including in later years both enemies and members of his family in a *Last Supper*.[83]

Zoffany places himself and Earl Cowper, a special patron of his, looking at a Raphael, the so-called *Niccolini-Cowper Madonna*. We know that Zoffany and the *Madonna* were a late addition: Cowper had originally been shown lecturing on the *Satyr with Cymbals*. One politic reason for the addition might have been that Zoffany had apparently secured the "Niccolini Madonna" for Cowper, who then offered it to George III.[84] But more to the point, he has introduced the artist himself and in peculiar conjunction with not only his patron but another Raphael *Madonna and Child*.

Directly under the *Venus of Urbino* is a sarcophagus, to judge by its size a child's; beneath that, in the foreground, the *Samian Sibyl;* and above it the *Infant*

Hercules Slaying the Serpent (like the sibyl, incorporated into Christian tradition). But of all these details, the child's sarcophagus is the most telling. The sarcophagus in Christian iconography referred to Christ's tomb — but conflates here the Nativity and the Entombment in the manner of Bellini's Madonna and Child paintings, in which the pose is proleptic of a Pietà. Zoffany retains all but one of the *Holy Families* that actually hung on the center wall of the Tribuna (the only wall that comes close to being a copy of the wall as it was), suggesting that this was the wall around which he wished to build his scene, and he adds others — a total of seven, plus a *Charity* that resembles a *Madonna and Child* and a separate *Madonna*. Saint John is indeed surrounded by reminders of his prophecy.[85]

Autobiography at this point intrudes. Zoffany had seduced a fourteen-year-old girl and taken her with him to Italy. They had a child and he married the now fifteen-year-old girl, who, we are told, was both noted for her beauty and "a good mother to her boy, though still so young." A year later, while Zoffany was at work on the *Tribuna*, his son fell down a flight of stairs and, though recovering for a time, "at the end of three weeks he died of abscess at the back of the head."

> Mr Zoffany was not to be comforted, and, as I before observed [continues Mrs. Papendiek], he never wholly got over this terrible calamity. However, he was encouraged to go on with his work in the Gallery, and though this interest, in a measure, distracted him from his own private sorrow, it had an evil effect in another way — for it was at this time that, in order to drown his thoughts, he overworked himself, which brought on the first attack of paralysis, when he lost the use of his limbs, and for some time his senses.

In this context, and the context of the strange self-portraits he painted at the time, Zoffany was a very disturbed man. Both self-portraits, whatever precisely they may mean, share a preoccupation with the subjects of art, love, religion, and, just around the corner so to speak, fatherhood. On the back of one self-portrait, the old Joseph muses over his young wife and miraculous child.[86]

So, for other reasons as well as his relationship with Earl Cowper, the place Zoffany gives himself in the *Tribuna* is appropriate; he is peeking around from behind the Raphael *Madonna and Child*, proudly or self-righteously, guiltily or furtively, rather like the Joseph in his own *Holy Family* on the reverse of his self-portrait. He is decidedly not standing next to the *Venus of Urbino*, which evidently meant something special to him. Thought at the time to represent a Renaissance courtesan, it is one of the most erotic of nudes, and perhaps it was as disturbing and significant to him as it later was to poor, mad George III, who removed

Zoffany's *Tribuna* from the wall while his guards were out of the room and quite possibly at that time "perpetrated the outrages" on the *Venus* to which Millar refers.[87] The eyes of the *Arrotino*, looking up from his work, are frozen on the *Venus;* it also looks as if the Etruscan chimera is roaring at her and Julius Caesar is lying back apparently insensate before her charms. Zoffany is very much concerned to show her powers. We can only speculate on the relation he may have seen between Titian's lovely young woman and the new Mrs. Zoffany or other "self-gratifications."

The *Tribuna* comes close to being a personal document, and it is understandable that, carried away with his subject, Zoffany exceeded his commission. Here the life of the flesh does blatantly mingle with art on the one hand and religion, connected with love of wife and child, on the other. Zoffany has lovingly painted the erotica, putting it in all the emphatic positions, but he takes his own stand behind a *Madonna and Child*, almost as if rehearsing the donning of the Franciscan robe in the second self-portrait.

What the painting proved initially, perhaps to Queen Charlotte who commissioned it, as well as to observers on the sideline like Horace Mann, had to do with the genre itself and the underlying assumption that cabinet pictures were a way of possessing the paintings in other, inaccessible collections. We can project the vision of Queen Charlotte thinking she was possessing the Tribuna gallery, adding these paintings and sculptures to her own collection, when in fact Zoffany himself had possessed it — had made it all his own. This was a fine irony that Zoffany doubtless appreciated as he carried out his commission but that the queen only vaguely sensed in her dissatisfaction with the finished picture.

Zoffany is an artist who, while abandoning the Hogarthian element of narrative, is totally aware of Hogarthian sacred parody and utilizes it to the utmost; if the narrative structure is gone, the complex of meaning remains in the collection of symbols, or rather artifacts as symbols — serving as both themselves and iconographic systems. In *The Tribuna* Zoffany the man identifies himself with a Madonna and Child, but Zoffany the artist is choosing between Christian and pagan art. The public imagery is now expressing a private content. No contemporary mentioned having recognized its meaning, although some showed puzzlement.[88] The picture may have conveyed a sense of disquiet, as was demonstrated by both the immediate reaction of Queen Charlotte and the delayed one, disguised by madness, of King George. The picture conveyed the relationship of humans with different responses to art objects of both a secular and a divine nature, and so a disturbing interplay of these polar values — a typical theme for a conversation

piece, which traditionally (as in Watteau's or Hogarth's) played on the relation of art and nature. Then there was the semiprivate sense, understood by the English colony in Florence, involving the placement of Patch and others, and finally the vexed relationships between Madonnas and Venuses and children's coffins that were meaningful perhaps only to Zoffany's immediate family, or perhaps not even to his wife, or to Zoffany himself, who is representing the whole scene as the artist's atonement for his sins.

Resurrection

Soteriology and Eschatology

The province of poetry was, according to Isaac Watts, "the scenes of religion in their proper figures of majesty, sweetness, and terror!" He singled out "the inimitable love and passion of a dying God; the awful glories of the last tribunal; the grand decisive sentence, from which there is no appeal; and the consequent transports or horrors of the two eternal worlds."[1] Thus, the two subjects of religious belief and concern in the eighteenth century, soteriology and eschatology, concern with one's salvation and (following from it) with the Last Judgment. The eschatological or at least apocalyptic message of the OT prophets, dealing with the disaster of the Babylonian Captivity, served as one basis for the story of Jesus. This (the Gospels as the Good News) was the approaching triumphant End, the Messiah's return to make all new.

Eschatology, seen from the position of the terrified sinner, with the terror of the Last Judgment and the pleasure of everlasting bliss, was the most popular subject of English poetry during the last two-thirds of the century, accompanying

the contra-Popean poetry of Collins and the Whartons and the theories of Longinus, Dennis, and Burke, and so existing in an aesthetics of sublimity. Eschatology led from "graveyard poetry" up to the apocalyptic poetry and fiction that predicted a New Jerusalem here and now in the 1790s. For Dennis, "Enthusiastick Terror" was inspired best of all by "the Wrath and Vengeance of an angry God,"[2] that is, by fear of the Last Judgment rather than the more complex reaction to the mechanics of Atonement and Redemption. Watts dramatized the religious efficacy of the sheer fear of damnation in many of his poems and hymns, in, for example, "To the Memory of the Rev. Mr. Thomas Gouge," where he identifies Christ with the OT God. The text used by the most popular religious poems of the period—those exploiting the aesthetics of the sublime—was, of course, Revelation, and the most popular type was the Last Days poem.

The century opened with two poems of John Pomfret, "The Choice" and "Dies Novissima: or The Last Epiphany." Choice of Hercules poems proliferated (and the topos recurred in the first plate of Hogarth's *Harlot's Progress*), but this remained, as the Hercules topos (and Shaftesbury's use of it) suggests, a secular subject, while the subject of eschatology expressed religious beliefs and fears. Pomfret's poem was followed by Edward Young's popular *A Poem on the Last Day* in 1713, Joseph Trapp's *Thoughts upon the Four Last Things* in 1734, Robert Blair's *The Grave* in 1743, Gray's "Elegy written in a Country Church Yard" about the same time, and, of course, Young's immense *Night Thoughts* in 1742–46. Young's dedication to his *Poem on the Last Day* explains the rationale for such poems:

> There is no Subject more Exalted, and affecting, than this which I have chosen; it's very first Mention Snatches away the Soul to the Borders of Eternity, Surrounds it with Wonders, Opens to it on every hand the most Surprizing scenes of Awe, and astonishment, and Terminates it's view with nothing less than the Fulness of Glory, and the Throne of God.

This prospect, one based on belief and hope, is to be contrasted with Hume's remark "that in matters of religion men take a pleasure in being terrify'd, and that no preachers are so popular, as those who excite the most dismal and gloomy passions." In church as at the theater, fear and terror "give pleasure. In these latter cases the imagination reposes itself indolently on the idea; and the passion, being soften'd by the want of belief in the subject, has no more than the agreeable effect of enlivening the mind, and fixing the attention."[3]

Roubiliac's Funerary Sculptures

The sculptor of resurrections, Louis-François Roubiliac, began his career with a full-length sculpture of Handel (1738) in the Hogarthian mode (fig. 64). The significant fact is that its venue was Vauxhall Gardens, a pleasure garden, a secular resort, where Handel's music was played. Roubiliac, like Handel, was not a native English artist. Born in France in 1704, he received his early training there. He arrived in London in 1730, made only one return trip to the Continent in 1752, and died in London in 1762. He began, like his close friend Hogarth, as a portraitist, a master at catching likenesses. The likeness is particularized, set in the present moment rather than in eternity (not generalized like Rysbrack's or Scheemakers's, often dressed in togas), and yet embodied in that most lasting of media, marble. In this, his first full-length statue, Roubiliac supplements the unedited face with an off-duty body, slouched and dressed in contemporary, informal, disheveled clothing — one might say, in terms of Incarnational theory, the *whole* life, which includes, as well as sins, the diurnal round.

Vauxhall Gardens was a social space created by the entrepreneur Jonathan Tyers for people of the middling to upper orders; within that space Londoners went less to be "polite" (David Solkin's term) than to experience "leisure" (J. H. Plumb's term), that is, to be neither in one's public role, in the way of "business," nor in the privacy of one's chamber reading a novel.[4] But we also know that in 1735 Hogarth had founded the Saint Martin's Lane Academy; his first project was to locate public venues for permanent exhibition of the neglected works of English artists, and one of the first was Vauxhall Gardens. Hogarth is reputed to have given Tyers the idea for how to utilize and decorate his pleasure garden. Like Hogarth in his conversation pieces, Roubiliac was replacing the grand portraits of Van Dyck, Lely, and Kneller — of "gods" and "heroes" — with a figure that was not elevated or affected but casual, relaxed, and defined in terms of the sitter's immediate social milieu.

Roubiliac carried with him from France the reaction against the formal *style Louis XIV,* summed up in Watteau's painting *L'Enseigne de Gersaint,* in which the pompous royal portrait is being packed away and Gersaint's shop — the embodiment of the marketplace — displays rococo images of love and intimacy, whose spectators extend from the aristocratic to (outside, framing the enclosure of the shop itself) a lounging plebe and an unselfconscious canine. This was the ethos of the *fête champêtre,* which had been imported from France by Watteau and his

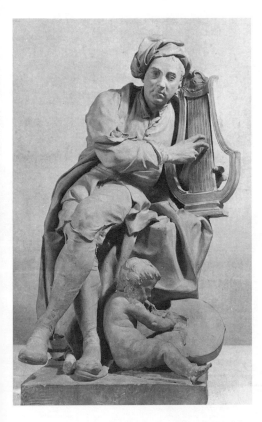

Fig. 64. Louis-François Roubiliac, *Handel* (1738), terra cotta. Fitzwilliam Museum, Cambridge.

Fig. 65. Roubiliac, Handel Monument, Westminster Abbey (1759–62), sculpture. Photograph, The Conway Library, Courtauld Institute of Art.

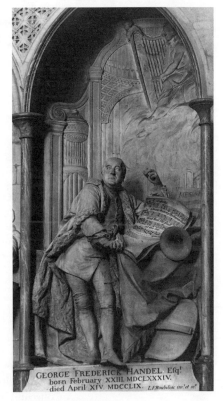

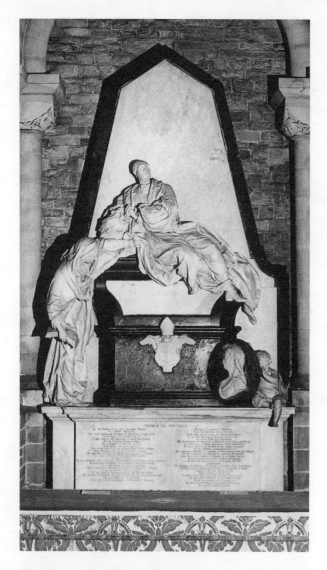

Fig. 66. Roubiliac, Bishop Hough Monument, Worcester
Cathedral (1744–47), sculpture. Photograph, The Conway
Library, Courtauld Institute of Art.

Fig. 67. Roubiliac, *Shakespeare* (1740s) (detail), sculpture.
Reproduced by courtesy of the Trustees of the British
Museum.

Fig. 68. Roubiliac, Myddleton Monument, Wrexham
(1751), sculpture. Photograph, The Conway Library,
Courtauld Institute of Art.

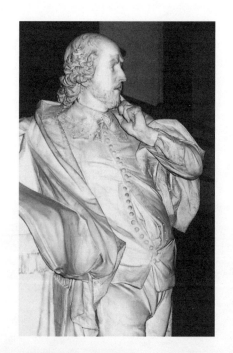

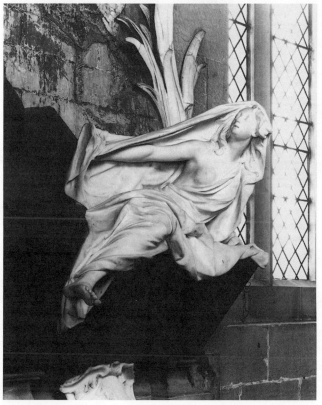

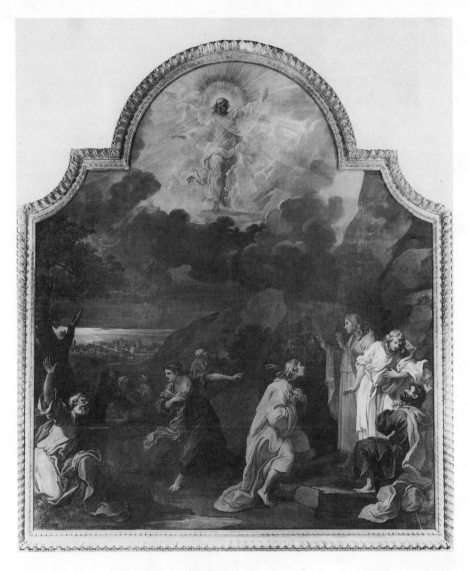

Fig. 69. Hogarth, *The Ascension* (1756), painting, central
panel of altarpiece for Saint Mary Redliffe. Reproduced
by courtesy of the Bristol Art Museum.

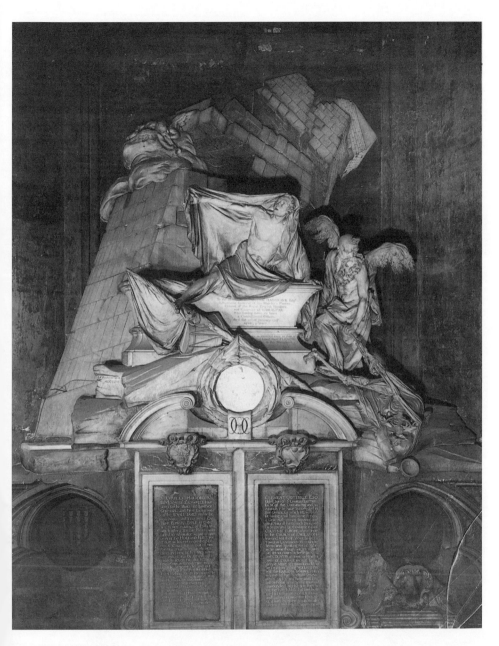

Fig. 70. Roubiliac, Hargrave Monument, Westminster Abbey (1757), sculpture. Photo: Warburg Institute.

Fig. 71. Hogarth, Taylor Monument (1757), two drawings. Yale Center for British Art, Paul Mellon Collection.

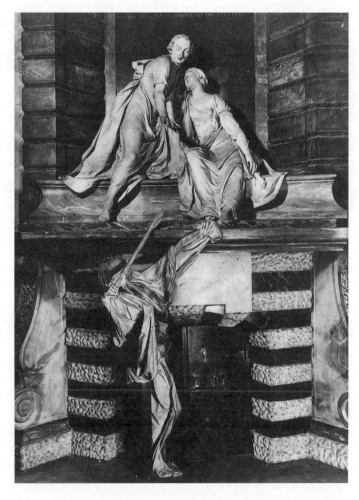

Fig. 72. Roubiliac, Nightingale Monument, Westminster Abbey (1761), sculpture. Photo: Warburg Institute.

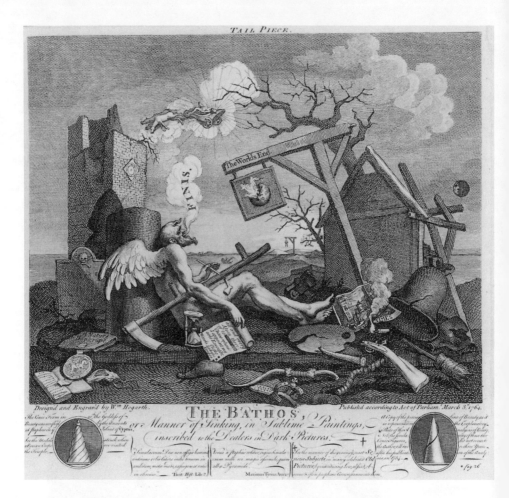

Fig. 73. Hogarth, *Tailpiece* (1764), etching and engraving, first state. Reproduced by courtesy of the Trustees of the British Museum.

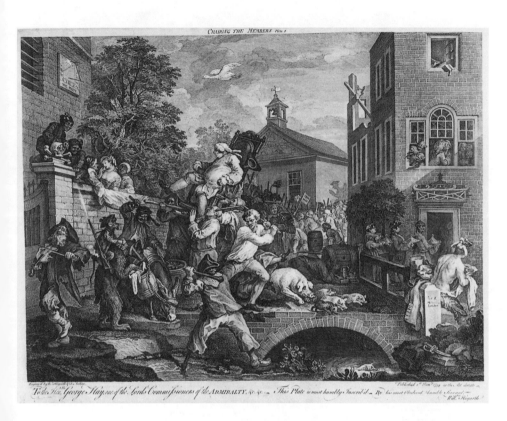

Fig. 74. Hogarth, *Election*, plate 4 (1754–58), etching and engraving. Reproduced by courtesy of the Trustees of the British Museum.

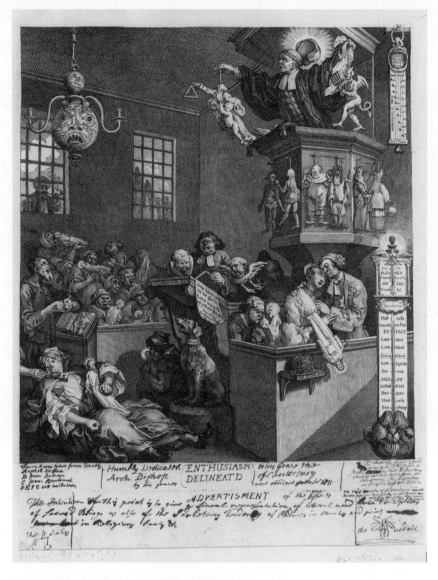

Fig. 75. Hogarth, *Enthusiasm Delineated* (1759?),
etching and engraving with additions in ink. Reproduced
by courtesy of the Trustees of the British Museum.

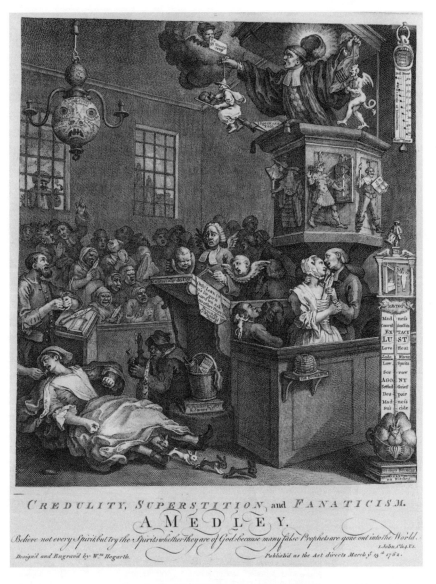

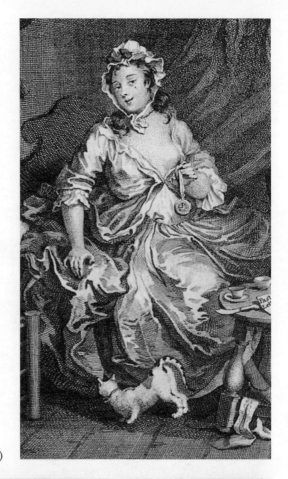

(a)

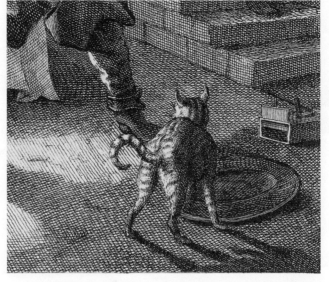

(b)

Fig. 77. (a) Hogarth, *Harlot,* plate 3 (detail).

(b) Hogarth, *Hudibras Beats Sidrophel* (detail); engraving, first state. Reproduced by courtesy of the Trustees of the British Museum.

(c) Hogarth, *Strolling Actresses Dressing in a Barn* (detail), etching and engraving, first state. Reproduced by courtesy of the Trustees of the British Museum.

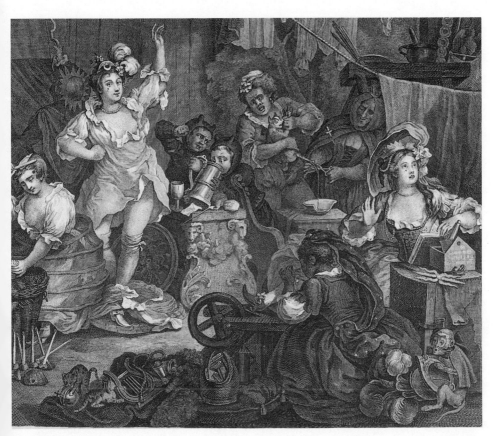

(c)

followers in the 1720s and adapted by Hogarth. While Watteau's *fêtes* (with the exception of *L'Enseigne de Gersaint*) were set in some ahistorical time, Hogarth's conversation pieces were a record of a particular moment as well as a particular place. Roubiliac applied the conversation piece assumptions to sculpture. In the Vauxhall *Handel* he anglicized the French rococo, giving Watteau's delicate elegance body and substance, an impressive monumentality as well as a vulgar particularity. The body bulges within, and sometimes exceeds, the garment, and a leg protrudes, a slipper dangles. Roubiliac's *Handel* restores the scale of the Van Dyck portrait but accompanies an unidealized face with an encapsulated *umwelt* of relaxed pose and attire, a condensation or focusing of the furniture and pictures, relatives, friends, and servants, of the conversation piece.

The *umwelt* of Roubiliac's *Handel* includes Vauxhall Gardens. The composer is shown in the act of musical composition, surrounded by music composed by himself and others, paintings by Francis Hayman and Hogarth (copies of the latter), and an appreciative mixed audience, including all but the lowest orders of society. In his unofficial pose Handel is still the artist; the sculpture defines a sense of the composer and the way he, like the sculptor, ought to go about his art. Roubiliac defines the area of leisurely enjoyment but in a figure of the artist whose music produces the leisure enjoyed by the habitués of Vauxhall who surround him. While Hogarth represents in his "modern moral subjects" a liminal or pregnant moment (or in his "progresses" a series of them), centered on moral choice and immoral action, Roubiliac's moment is centered on music.

This moment corresponded to the virtuous "Step out of Business" defined by Addison in his "Pleasures of the Imagination" (*Spectator,* 1712).[5] In these essays, responding to the demonizing by Hobbes and Locke of the faculty of imagination ("decaying sense"), Addison accepted the discreditable "fictions of the mind" — not denying that they are the source of conflict and error but recovering them as "pleasures" that can be enjoyed. He situated the "pleasures of the imagination" in a middle area between "sense" and "understanding," as a virtuous way to "Step out of Business" without stepping into "Vice or Folly." By representing the virtuous "Step out of Business" in the person of the artist, Roubiliac doubled the sense of a "pleasure of the imagination," or what has come to be called the aesthetic pleasure, an enjoyment that is neither religious nor moral and, in that sense, outside historical time.

Hogarth learned from the Vauxhall *Handel* and two years later produced his painterly equivalent, the full-length and monumental portrait of the plebeian sailor Captain Thomas Coram, who established the Foundling Hospital. The

Coram, however, being a painting, retains the defining furniture of the conversation — table, globe, and charter of his hospital. If we call Roubiliac's *Handel* an aestheticizing of the political portrait, that is, making it about art and leisure, we can see how it could have led Hogarth toward the transition from the "modern moral subject" of the *Harlot's Progress* and *Rake's Progress* to the artist-centered *Distressed Poet* and *Enraged Musician*.

Not portraits, or the Watteau *fête champêtre* or the English conversation piece, however, but "history painting," the depiction of human endeavor at its most heroic, remained the genre for an ambitious artist. This fact was as freely acknowledged by Hogarth and the Saint Martin's Lane artists as by Shaftesbury, Jonathan Richardson, and the connoisseurs. A sculptor practicing in England in this period had relatively little opportunity to "invent," let alone execute, heroic monuments.

Roubiliac, though he may have been baptized a Roman Catholic and certainly worked in the tradition of Roman Catholic Counter-Reformation iconography in his early years in France, lived among the Huguenot French community in London. The Huguenots were Calvinists who shared with their English hosts a hatred of the worship of graven images. What remained for the painter was the execution of portraits and local or contemporary events of an exemplary sort. What remained for the sculptor was the funerary monument, so long as it omitted representations of the deity — in parish churches but, above all, in the two great national repositories, Westminster Abbey and (after Roubiliac's time) Saint Paul's Cathedral. From the sculptor's point of view, these monuments were equivalent to the history paintings that graced other public buildings in London, such as hospitals — Greenwich, Saint Bartholomew's, and the Foundling. Roubiliac's sculptures came to dominate the nave of Westminster Abbey.

To begin with, Roubiliac changed the emblematic and static structure of the funerary monument as he found it (in the work of Cheere, Rysbrack, and Scheemakers) into an implied narrative.[6] The source is certainly Hogarth's "modern moral subjects," every scene of which is both exemplary and narrative, embodying (as Roubiliac does) a pregnant moment. But a more precise parallel is with Hogarth's modern aesthetic subjects that followed these, which replace narrative with relations (*this* contrasted with *that*, *these* polar opposites mediated by *that* young woman).

Malcolm Baker's summary of the temporal effect of Roubiliac's treatment of marble is to the point. He notes the great "animation of the surface itself," which imposes on the spectator both the "wish for verisimilitude" and "a willingness to

look closely": "consciously or not, a viewer who gave this more than simply casual attention would have had to engage with a considerable modification of the conventions of the static monument, and also with the rejection of uniform marble surfaces, with their connotations of permanence, by finishes suggesting the momentary."[7] Whether in an emblematic arrangement or a narrative with an implied *before* (dead, moldering in the grave) and *after* (rising to heaven), the common element is the introduction of time as transience; the development in Roubiliac's sculpture is from a static scene to a moment of transition, like the liminal moment caught in the Vauxhall *Handel*.

We think of Addison's Novel as the aesthetic pleasure of the *Spectator* and spectating, of comedy and the middle area of ordinary experience. But in Addison's essays on *Paradise Lost*, the Novel also figures alongside the Great and Beautiful: the Great is the unformed, the Beautiful the formed, and the Novel or Strange is the unformed in process of being formed. Satan's "transforming himself into different Shapes . . . give[s] an agreeable Surprize to the Reader," and the Novel, in the "Pleasures of the Imagination" essays, "fills the Soul with an agreeable Surprise, gratifies its Curiosity."[8] It is represented in *Paradise Lost*, says Addison, by "the Creation of the World, the several Metamorphoses of the fallen Angels, and the surprising Adventures their Leader meets with in his Search after Paradise."[9] This area — with the elements of surprise, movement, change, and metamorphosis as well as (artistic) creation — is the one shared by Hogarth and Roubiliac and it lends itself to funerary sculpture insofar as it represents these same qualities. This secular moment of liminality fits Roubiliac's generic need in his funerary sculpture to focus on death and resurrection.

Roubiliac's first funerary monument, for Bishop Hough in Worcester Cathedral (1744–47, fig. 66), follows directly from the *Handel*, showing Hough seated athwart his tomb, as casually as Handel but now looking up, his whole body and face expressing a different sort of transition verging on levitation, presumably in the direction of either resurrection or Last Judgment.

Roubiliac's monumental sculpture derived from his portrait busts as Hogarth's "modern moral subjects" did from the "likenesses" of his conversation pieces. In terms of the category *l'expression des passions* (see p. 131), a central doctrine of the painters' manuals, Hogarth's "modern moral subjects" are based on a spectrum of responses to the protagonist, usually discrepant, centrifugal, and expressing disunity — which in *The Analysis of Beauty* he formulates as the principle of variety. Roubiliac follows the same formula, but he models his funerary sculptures on Poussin's painting *The Death of Germanicus*, where the dying is the focus of the

survivors' expressions, unified in versions of grief, in that sense anticipating West's *Death of General Wolfe* of a decade later (see fig. 32). In both cases the responses extend from the figures within the painting or sculpture to the spectators outside, standing in the church aisle, who are implicitly included in the circle of response. Involved in those responses are both the exemplum of the virtuous death and the beauty of the artist's representation — his working of the marble.

Roubiliac's *Handel* defined the artist's subject, as well as the artist himself, as antielevated, antiheroic, and antipolitical. But the point here was not that this is the way things are now, alas — but the Christian one, of the sacramental value of the ordinary. Roubiliac then made the significant transition of subject from artist to bishop, from secular to divine. In Hogarth's case the artist's model became and remained the positive alternative to the painter's conventional heroic subject, whether general, prince, or saint, and led him in theory to an aesthetics, as opposed to a religion or a morality, and in practice to different kinds of transcendence in place of the religious. As Hogarth carried the moment of moral choice, between action and consequence, into a moment of aesthetic apprehension, between unity and variety (or, more generally, art and nature), Roubiliac carried that moral moment directly into the eschatological moment of life becoming death or death becoming eternal life.

Roubiliac frames his career with images of Handel, and in the final monument in Westminster Abbey (1759–62, fig. 65) he shows the composer lifting his gaze from his musical score either to seek inspiration from a harpist angel or to hearken to the angel's call to a better world. This is the same Handel, bulging out of his clothes, of the Vauxhall statue, with pen in hand, but with his head turned upward: harking to the angelic call to the afterlife, instead of (or as well as) the inspiration from a heavenly muse.

Supplementing the ideal of an eternal heaven is the classical vestige of fame — life surviving death in fame, the immortal music, and including the permanence of the marble monument itself. In the Hough monument a female figure (supposedly "expressive of Religion")[10] is attending, mourning and at the same time lifting the bishop's robe to reveal (is it to the spectator or to the judge of the Last Judgment?) the fame of Hough's noble defiance of the tyrant James II forty years earlier. Time past is embodied in the image of the 1680s; time past and present in the mourning woman's memory; time future in the bishop's gesture of awakening, his expectant expression as he looks upward — which, however, is anchored to the present by the additional element, the living mourner who is the spectator standing before the monument.

A woman, by the mid-1740s, has become Roubiliac's primary mourning figure, mediating between the spectators and the statue, the living and the dead, and the dead and their resurrection.[11] In the monument to George Lynn (1758) in the Southwick church, the woman, the mourning widow, simply stares mournfully at the medallion bearing Lynn's profile. In the most elaborate version, the monument to the duke of Montagu (Warkton Church), the figure of Fame has become the deceased's widow standing on the floor, foot turned toward the spectators, those other supplementary mourners. A second woman, a figure of Charity, is caught in the act of hanging the medallion that contains Montagu's profile. The first woman, whose pose implicates the spectator, mourns; the second (Charity, accompanied by three babes) celebrates, drawing attention to the fame of the deceased for charitable acts.[12] The widow's face is a portrait of the living woman, the survivor.

The monument to George Lynn or the duke of Montagu is a religious, eschatological version of Hogarth's *Distressed Poet*. In both, the woman (the wife) mediates, but in the one between artist and world (the "art" of the poet or musician and the variety of nature) and in the other between husband and death (or eternity). Roubiliac, of necessity given his genre, must marginalize his mourning woman, but she remains the source of vitality in his funerary monuments. He makes the point that these are ordinary *living* women — mourning a dead husband. And, by his verism and detail, by overlapping her space with the spectator's, Roubiliac makes his women, though marble, seem to share a reality with the spectator. This figure indicates the difference between Hogarth's aesthetic solution and Roubiliac's religious solution to the problem of fame and the artist. Hogarth's move toward aesthetics was partly a failure to find any positive value, let alone ideal, in contemporary political life — or any efficacy in religion — except for the isolated acts of charity that he associates with a young woman of the type Roubiliac introduces in his monuments beginning with the *Bishop Hough*.

The S-curve was the most obvious element shared by Hogarth and Roubiliac, who brought this aspect of rococo style from France, extending it beyond the simple decorative motifs of his countryman Hubert Gravelot into the governing principle of his sculptures of Handel and Hough. Carried into the smallest flutter of drapery and hint of gesture, it embodies temporality. Extending out into the dangling feet or arms, it also breaks the enclosure of the picture's space (the sense of the marble block), extending the sculptural illusion into the spectator's space — reaching out to make contact, communicate, and implicate the spectator in the

moment (an effect that, in terms of Roubiliac's continental precursors, was related to that of Bernini's Cornaro Chapel). Finally, Roubiliac's S-curves came to define primarily his female figures and their mediation between deceased and spectators.

Roubiliac's use of the S-curve, to the point of parody, would have been a definitive context for Hogarth's formulation of his Line of Beauty and (in the three dimensions of sculpture) Line of Grace, exemplified by the female body and by an epistemology of pursuit or chase through patterns of intricacy, variety, curiosity, and discovery, leading, it is implied, to seduction. For if in Roubiliac's funerary monuments the serpentine lines lead the eye upward, roughly on a diagonal toward heaven, in Hogarth's compositions the serpentine lines not only mingle with other kinds of lines (less graceful, more various, often comic) but also lead the eye around and down into, never upward.

Hogarth could not carry his "modern moral subject" in the direction of Roubiliac's funerary histories, presumably because he did not believe in the immediacy of transcendence in any of its forms except the aesthetic. Their roots were nevertheless entangled, and influence was probably up to a point reciprocal. There is evidence that Roubiliac's base assumptions at least began in as secular a context as Hogarth's. Like Hogarth, he was a member of a Freemason lodge; he had connections with the duke of Montagu and Martin Folkes, both Freemasons and freethinkers, and also with the founding Freemason Theophilus Desaguliers, a Huguenot divine and Newtonian freethinker.[13] Like Hogarth, he elided all Christian imagery from his works (this need only, of course, reflect orthodox Protestant iconoclasm) except, in his funerary monuments, the generic donnée of the resurrection.

His sculpture *Fides Christiana* (ca. 1761), a woman holding a life-sized cross, was commissioned by the nonjuring Jacobite Charles Jennens (best known as a Handel librettist). Before he began his funerary monuments with their grieving women, Roubiliac sculpted a Venus (1738, now lost), contemporary with the Vauxhall *Handel*, for Sir Andrew Fountaine (also a Hogarth patron). And it is tempting to see him adorning his Venus, for a Jacobite patron, with a robe and a cross. Otherwise she points to Hogarth's central figure of beauty in the *Analysis*, plate 1.

The assumption behind Hogarth's aesthetics is the belief in a transcendent god only, with no influence on the immediate present, which therefore is open to free play, including that of the artist. However much Roubiliac's work is bound to the funerary genre and the commissions of patrons, play is the element to which

Malcolm Baker draws our attention when he discerns Roubiliac's "ability as a sculptor to execute a work that requires close attention." Such ability invites on the part of the spectator "a willingness to look closely" — Roubiliac's sculptural version of Hogarth's invitation to the spectator to look closely at, or "read," his scenes.[14]

Hogarth's Resurrections

By the mid-1750s Hogarth was turning his attention to resurrection. Roubiliac had executed his Myddleton monument in 1751 and begun his Hargrave monument in the next year (figs. 68 and 70), and, just at that point, Hogarth was offered the impressive commission for the altarpiece of the church of Saint Mary Redcliffe in Bristol and chose the same subject. The Resurrection brings to a climax the phases of his religious demystification. In the mid-1730s he first attempted conventional religious painting in the huge *Pool of Bethesda* and *Good Samaritan* panels on the stairway of Saint Bartholomew's, a charitable hospital. The text was New Testament, the subject was charity, and its "novelty" or "modernity" was anchored in the inclusion — or supplement — of mimicking dogs, kept mistresses, and anticlerical innuendo.[15] A parody of a Titian Venus (eros) supplemented the figure of Jesus, representing caritas. In the painting *Moses brought to Pharaoh's Daughter* of 1746 (see fig. 58), he illustrated a story in which a nurturing mother is balanced (or replaced) by a beautiful woman, a Mary the Mother by a Mary Magdalen and a Venus, Moses' real mother by a beautiful young woman (notice that he does not give Moses or his mother the stereotypical features of the Jews in the *Harlot* and the *Election* prints). This then was followed by the Magdalen of the Bristol Altarpiece.

Woolston had dealt with the Resurrection, as the climax of his demystifications, and in the 1740s the deist Peter Annet, whose *Miraculous Conception* had ridiculed the Virgin Birth, waged war on the Resurrection. His *Resurrection of Jesus Considered by a Moral Philosopher in answer to The Tryal of The Witnesses* (London, 1744; text, 3d ed., 1744) was written as a response to Bishop Sherlock's defense of Woolston's trial against critics and defenders of free speech (*Tryal of the Witnesses to the Resurrection of Jesus Christ*, 1729) and questioned the textual and historical evidence for the Resurrection, carrying even further the queries and doubts of Woolston's *Discourse* into what are largely quibbles. The response to Annet came in several pamphlets, including Gilbert West's *Observations on the History and Evidence of the Resurrection of Jesus Christ* (1747).[16]

In the side panels of the altarpiece, Hogarth treats the Resurrection in the

manner of Woolston and Annet, as another fraud like the Virgin Birth. He represents the problem of the empty tomb (was it a hoax?). In the central panel, the "Ascension" (fig. 69), however, he diverts attention from the distant, levitating figure of Christ to the chief mourner in the foreground, Mary Magdalen. She was the first to find the tomb empty, to see the risen Jesus, and to carry the news to the disciples. Picking up on the jocular allusion to Columbus and Christ in the subscription ticket, Hogarth combines in the altarpiece the discovery and revelation of the Savior's Resurrection with the discovery of the new principle of art revealed in his *Analysis*.[17]

Mary Magdalen is his central, mediating woman, who is still his muse and subject.[18] She mediates (as she does in John 20:2) between the ascending Savior, a remote figure in the far distance, and the living disciples in the foreground — between the spirit and the flesh, the Lord and his disciples. (In the earlier *Paul before Felix*, Paul's right hand indicated Drusilla's sex, and the other hand pointed up to heaven as if to suggest — in true Pauline doctrine — the alternatives of body and spirit.) Also, of course, the Magdalen recalls his own Harlot and makes the connection between her and the beautiful woman of his aesthetics. His solution to the representation of the Resurrection is a conflation of his Harlot and the Venus who was at the center of his *Analysis of Beauty*. She announces the miracle to the Disciples, which, in the context of the serpentine lines of and around her body, becomes the announcement of Hogarth's Line of Beauty and his aesthetics of variety. In the example of Mary Magdalen's annunciation, he demonstrates once again the relationship between his religious heterodoxy and the essential radicalism of his aesthetics.

Even Hogarth looks toward some form of transcendence: He followed the *Harlot* with inefficacious mediators — the Rake's wife, the Poet's wife — who became more effective with the image of the milkmaid mediating between the composer and the plebeian noisemakers of the street, and then with the beautiful "living women" of *The Analysis of Beauty*. Finally, the Mary Magdalen of his *Resurrection* altarpiece (recapitulating the Harlot) accomplishes a synthesis of the aesthetic and religious, the beautiful and the holy — still, however, noticeably outside the Law, embodied in the skeptical Jewish priests of the side panels, who are sealing the tomb to make sure no "miracle" is perpetrated.

Demotic Imagery of Death and Resurrection

Roubiliac's Hargrave monument (1757, fig. 70) shows the general climbing out of his sarcophagus on the Day of Judgment. In the Nightingale monument

(commissioned 1758, erected 1761, fig. 72), the extreme repoussoir figure of Death, who stands on the pavement of the chapel and connects the spectator with the scene, embodies Roubiliac's personal fiction of temporal change, which is of something emerging (out of the door of a tomb, of *the* tomb of the Nightingales) and being revealed, in the sense that he is exposing himself both by coming out of his hiding place *and* by unveiling his skeletal body — his spinal column — by opening his shroud.

From the beginning Roubiliac had shown irrational shapes emerging from, uncontained by, commonplace objects or coverings (such as clothing), something (a body or a foot) coming out or being unveiled, even in the portraits. Roubiliac's *Shakespeare* (fig. 67), as opposed to Scheemakers's, is bulging out of his coat, half-unbuttoned, as if exposing the interior self or releasing it. The effect is related to Hogarth's utmost variety within a unity (in the image of the cornucopia); for Roubiliac it is the excess of the particular, the body exceeding its garments, the spirit its body, ending in images of resurrection. In the monuments, the drapery is pulled back to reveal the oval portrait medallion or the bas-relief on a pediment, sometimes a whole scene. In the Bishop Hough monument, the woman lifts his robe to disclose the relief of the great public moment of his life that his robe had (out of modesty?) concealed.

With the monument to Mary Myddleton (1751, fig. 68), the detail has materialized in a narrative: her coffin is broken open (by her, at the call of an angel) and she is emerging, one leg out of the coffin over the edge of the parapet. The collapsing obelisk above her corresponds to the broken tomb, but the trumpet and the vegetable stalk growing up next to the broken sarcophagus correspond to her act of resurrection and rebirth. Here the woman is the protagonist, rising up out of her coffin into eternal life. General Hargrave is climbing out of his casket *and* his shroud (see fig. 70). Both Hargrave and Myddleton unveil themselves, with the same gesture of an outstretched right arm, and emerge as from a cocoon. At its strangest, the relief of the Stapleton monument shows the explosion — at the spectator — of the cannon that killed him.

The bursting out of clothes is related to — is a diurnal version of — the sort of resurrection Mikhail Bakhtin has described as central to popular imagery of the "grotesque body." "Contrary to the classic images of the finished, completed man," he writes, the grotesque body is always unfinished, emphasizing apertures and convexities, "growth which exceeds its own limits," an "ever unfinished, ever creating body," an "unfinished and open body (dying, bringing forth and being born)" that compresses into a single image both death and regeneration.[19]

As to the religious subject, popular bodily (carnival) imagery was founded upon debasement and degradation (uncrowning) of the higher order, bringing heaven "downward" and earth "heavenward," which was very similar to (or seemingly overlapping with) the deist demystifications practiced by Hogarth. But always, at least according to Bakhtin, it is a degradation that implies rebirth and regeneration—and is expressed by the laughter of the "carnival spirit" in the populace—versus the high culture ("enlightenment") phenomenon of deism, which apparently applies to Hogarth but not to Roubiliac, who elicits (is generically compelled to elicit) orthodox religious imagery.

Roubiliac, the funerary sculptor, has to make the transition from natural to supernatural. He has to portray the central miracle, but he does so as a redaction of the liveliness of life. There is nothing moribund about Mary Myddleton and General Hargrave—they have more in common with his Vauxhall *Handel* (or Hogarth's *Shrimp Girl*) than with Rysbrack's Newton or even Guelfi's Craggs monument.

The involvement of the Nightingale family with evangelical circles and of Lady Elizabeth Nightingale's sister, the countess of Huntington, with Methodist ideas of communication and persuasion, as well as John Wesley's enthusiasm for the Nightingale monument, supports the argument for a Methodist component. The common term connecting the grotesque body and Methodist rhetoric was *revival* in the present moment. John Wesley repeatedly describes the sequence in his *Journal*: a young woman "cried out aloud, with the utmost vehemence, even as in the agonies of death," but then rose and "burst forth into praise to God"; a young man "was suddenly seized with a violent trembling all over, and . . . sunk down to the ground. But we ceased not calling upon God, till He raised him up full of 'peace and joy in the Holy Ghost.' "[20] The notorious Methodist seizure was attributed to the final effort of Satan to hold onto the sinner, and the ensuing peace to God's victory; death in Satan must precede rebirth in God. This took place *in time*, not at the Day of Judgment, though it is possible to see the resurrections of Myddleton and Hargrave as metaphorical extensions of the Methodist "rebirth." In this sense, Lady Elizabeth Nightingale's imminent seizure might imply, as an exemplum, both death and death-rebirth into Christ.

With this change we can connect Hogarth's move in the later 1740s from the French elegance of *Marriage A-la-mode* to popular imagery, starting with *Industry and Idleness* (1747). Figures of Time and Death begin to appear, emblematically here (plates 4 and 11) and in *Time Smoking a Picture* (1761), naturalistically in *The Reward of Cruelty* (1751, see fig. 31). His turn from an elite to a more democratic

audience also evokes the Methodists and connects his later works with those of Roubiliac. They democratized both the heroic figure and the audience of the work of art—a central issue in the argument of *The Analysis of Beauty*. But the Wesleyan Methodist "claim that the souls of *all* men could be saved, and that it was necessary to promote the idea of the New Birth even among the common people,"[21] was not the same as the argument of Hogarth's *Analysis* or the rhetoric of his popular prints. Hogarth saw the populist, rabble-rousing style of the Methodists' open-air preaching (parallel to Pitt's rabble-rousing political oratory) as tending not to rationality but to superstition.

Hogarth and Roubiliac shared a reaction against the classicizing of the Shaftesbury school of aesthetics and the Rysbrack and Cheere school of sculpture. The figure of Death comes from neither classical nor contemporary Church of England sources but from old English churches; Time, though a classical figure, had been assimilated to popular Christian iconography, part of the native imagery advocated in the 1750s by Hogarth and Bonnell Thornton in their parodies of old English music and signboards — and presumably by Roubiliac also. They held and argued the same position vis-à-vis the academy and the connoisseurs in the early 1760s and at just the time that both began to employ a more popular, more primitive imagery. It could be argued that, for both Roubiliac and Hogarth, "revelation" (ridiculed by the deists) was replaced by the intermediate and more poetic subject of superstition.

The Cock Lane Ghost, to a Methodist, was a voice from the spirit world; to Hogarth it was another hoax, like that of Mary Toft, the Rabbit Woman, which he resuscitated in *Credulity, Superstition, and Fanaticism* (1762, three months after Roubiliac's death [see fig. 76]). The difference is that Roubiliac uses superstition in its original religious context,[22] while Hogarth excludes the religious beliefs and mysteries (whether Roman Catholic or Methodist), extracting from what he regarded as folly the English rural fictions of rabbit women and boys who spew nails, but by way of Addison's aesthetic category, the Strange.

Hogarth himself provided a popular image of resurrection for the tomb of the pugilist George Taylor, who died in June 1757 (fig. 71). Taylor had risen rapidly to fame in the 1740s but was defeated by James Broughton and retired in 1750 to be master of the Fountain Inn in Deptford. He had come out of retirement to fight Tom Faulkener in a savage battle that lasted hours and ended only when Taylor (already blind in one eye) had his remaining eye closed. His death three months later was attributed to the fight. In the surviving drawings Hogarth shows Taylor in two poses fighting Death. In the first he is nearly pinned by

Death, but his left shoulder is still off the ground; his left arm is pushing Death back, his knee is between Death's legs about to give him the "cross-buttocks fall" for which Taylor was famous. In the second drawing—the consequence of the "cross-buttocks" fall—Taylor has successfully pinned Death and is raising his hand in victory, his eyes turned upward.[23] Hogarth joins a precise representation of the wrestler's movements, the apposite metaphor of death-pugilism, and the Roubiliac resurrection, showing Taylor pause and look up at the sound of the last trump. In another drawing of the subject, Hogarth has included a trumpet protruding from clouds above his head.[24]

Hogarth's two scenes for the Taylor monument are immediately consecutive —without any time interval between them—and with an unchanged, living Taylor. The sequence is another *Before* and *After,* a Hogarthian temporality, both taking place in this world and not in eternity; for this reason, as well as Taylor's victory, the angel is unnecessary. It is Taylor defeating death in a pugilistic match that is the focus of attention, not the angel's trump—Taylor has already bested Death when he looks up at the sound. Death succumbs to Taylor's superior skill, precisely rendered; as a *skilled* human, the pugilist is another version of the artist, another offshoot of Roubiliac's Handel and Hogarth's Columbus (in the subscription ticket for the *Analysis*). But Hogarth is certainly aware of the plebeian nature of Taylor's skill—as he was of his own as a mechanic engraver and of Roubiliac's as a stonecutter. Hogarth's one venture into funerary art is the monument to a pugilist, with whom he would have associated himself, especially in the years following the "mauling" he received after publishing the *Analysis,* if for no other reason than that his emblem and mascot was the pug (short for *pugnacious,* closely related to *pugilist*).

He turns to popular imagery of Death but uses it, as in other works of the period he uses the figure of Time, as an opponent of the artist. For example, in *Time Smoking a Picture,* the subscription ticket for an engraving of his painting, *Sigismunda,* Time is shown destroying works of art—which for modern connoisseurs only increases their value. The implication is that *Sigismunda* is *not* one of these paintings darkened, naturally or artificially, by "Time." Perhaps significantly, Roubiliac's Time and Death are always draped (Death in a shroud), Hogarth's naked, as if posing for a life class.

Roubiliac's belief is not only in an afterlife at Judgment Day following a period of death in the tomb but also a resurrection *in the body*—and thus parallel with other kinds of transcendence in his (and Hogarth's) work, such as that of art and the artist. Handel remains Handel and Hargrave remains Hargrave (in fact, a

youthful version of the old general). By contrast, while Hogarth's personal es-
chatology ends bleakly with death, he proposes to survive in his own (the artist's)
monuments, such as the folio of his prints to which his funerary monument, the
Tailpiece (fig. 73), is appended. And this, we must assume, he shared with Rou-
biliac and the subtext of his monuments to the immortality of "fame."

Though both insisted on being "inventors" as well as the mechanic executants
of their works, Roubiliac associated himself with the composing, conceptualizing
Handel.[25] It is reasonable to suppose that in his funerary monuments he felt he
owed less to Hogarth's "modern moral subjects" than to Handel's oratorios. Both
artists make the artist's transcendence central to their work. But while Roubiliac
carries his Handel over into Bishop Hough, Hogarth would never equate a
composer and a bishop as equally "inspired." Hogarth would have undercut
Hough as Roubiliac may undercut the value of heroism in his military monu-
ments in Westminster Abbey.[26]

Roubiliac's monuments presuppose the orthodox position: the man or woman
dies and remains dead in the sarcophagus until the Day of Judgment when he or
she rises pristine — as in youth, not as in death — though it is presented as if it is
happening at the moment we are standing before the sculpture in the church. In
the monuments leading up to the Nightingale, the transition represented is
between death and resurrection; Hargrave has turned away from both Time and
Death and looks up at the angel's last trump; Time and Death fall over each other,
defeated by the last trump.

In the Nightingale monument the transition is between life and death only.[27]
This is a departure in that it recalls Hogarth's Taylor, not only in the personal
combat with Death but also in the absence of any hint of resurrection. Both turn
attention from the resurrection to the agon of death and the human spirit *unaided*
by supernatural paraphernalia; in both, God and the angel of the Last Judgment
are marginalized in favor of the human. It is a popular exemplum, giving Every-
man a chance — another agon but now with a shifted emphasis. But Roubiliac's
conclusion is the opposite of Hogarth's: Death is going to defeat the Night-
ingales, ushering in that long period of mere sleep. Death's attack on Lady Eliz-
abeth is countered only by her husband's defense — and the emphasis has shifted
from the skill of the pugilist to the pathos of the threatened woman.

The Hogarth work that probably influenced the arrangement of the figures
on the Nightingale monument was his painting *Satan, Sin, and Death* of the late
1730s (see fig. 55), which had become newsworthy in 1757 when Edmund Burke
used as examples of terror Milton's descriptions of Satan and Death, contrasting

the sublimity of Milton's words with the comic incongruity of painted represen-
tations (presumably Hogarth's *Satan, Sin, and Death*).[28] The regrouping of Ho-
garth's Satan, Sin, and Death into Death, Mr. Nightingale, and his wife is essen-
tial to Roubiliac's effect. The parallel is clearest as you first enter Saint Michael's
Chapel, with the monument coming up on your right, seeing, from left to right,
Death, Nightingale, and his wife (fig. 72). For Hogarth the woman intervened
between the two women, successfully mediating; Burke had described, indepen-
dently, Death and then Satan, confronting each other but without any mention of
the woman Sin between them. Roubiliac has the male figure try unsuccessfully to
ward off Death's dart directed at his wife.[29]

This scene of terror and grief, love and loss, also evokes the Counter-Refor-
mation model with which Roubiliac grew up and which he must have studied
again on his one visit to the Continent in 1752. Death's dart recalls the arrow of
the angel aimed at the breast of the ecstatic Saint Theresa in Bernini's Cornaro
Chapel, where the erotic and spiritual coexist. In the ambience of Hogarth's
Analysis of Beauty, with its aesthetics centered on Venus, and his paintings of
Sigismunda and *The Lady's Last Stake* in the late 1750s, the erotic element takes on
another, an aesthetic as opposed to religious, significance.

One other detail is relevant. Roubiliac may have begun with the countess of
Huntingdon's account of a dream her husband related to her shortly before his
death: he dreamed that "death in the appearance of a skeleton stood at the bed's
foot, and, after standing a while, untucked the bed-clothes, at the bottom, and
crept up to the top of the bed (under the clothes) and lay between him and his
lady."[30] Bindman connects Roubiliac and Samuel Richardson's *Clarissa* (1747–
48); Roubiliac's Myddleton monument, his first resurrection, of a female, was in
1751. But he misses the point: Richardson's Clarissa, with her "massively sen-
sitized, feminine body,"[31] is responding to potential rape, not to the death of a
beloved husband. Only in the erotically charged Nightingale monument, with its
threatening figure of Death with his dart, does Clarissa's dream of Lovelace and
his dagger come to mind. Clarissa creates her own funerary monument, whose
assumption is a successful resurrection into blessed eternity, but an integral as-
pect of that "monument" is her rape by Lovelace, analogous to the metaphorical
one by Death.

In 1757 Edmund Burke had published *A Philosophical Enquiry into the Origin of
Our Ideas of the Sublime and Beautiful* (1757), which came to be the most influen-
tial aesthetic treatise of the period. Burke replaced Hogarth's aesthetics of plea-
sure, curiosity, and surprise in his *Analysis of Beauty* with an aesthetics of pain,

terror, and death ("the idea of pain, in its highest degree," wrote Burke, "is much stronger than the highest degree of pleasure").[32] By Burke's definition the Roubiliac grouping, as opposed to Hogarth's conversation piece gesture of reconciliation, would have evoked sublime terror: one man tries to exert power over a woman with pain and death as the end. From Roubiliac's point of view, this is a variation, but a very significant one, on his funerary sculptures of women mourning over men or angels announcing their resurrection, and represents a move from the aesthetic assumptions of Hogarth to those of Burke.

In Hogarth's interpretation, the woman who began as a harlot and became a figure of beauty, a comic muse and normative, becomes in the late 1750s a beleaguered woman — the lady of the paintings *The Lady's Last Stake* and *Sigismunda* (both 1758–59), about to lose her honor or her life. It appears that briefly, in the years when Roubiliac was working on the Nightingale monument, Hogarth also tried out the Burkean Sublime in these two monumental paintings (in composition and in funerary subject). They are an interim stage — whether experiment or accommodation — between his own aesthetics and the Burkean, before the genuine signs of reaction against Burke appear in *The Cockpit* and *Enthusiasm Delineated* of 1759, leading into the last prints of the 1760s.[33]

At the end of his life, Hogarth entered a final phase in which he is playing with eschatology, inviting such questions as: Is it Christ or Hogarth's Harlot, or the skilled artist, who is the center of resurrection? His last print, *Tailpiece; or The Bathos* (1764, fig. 73), is a parody of Roubiliac's Hargrave monument (fig. 70) without the hope of resurrection. They share the same imagery and source, arrived at in one case as a positive and the other as a negative. Hogarth's is a reversal of the sense of Roubiliac's monument in that Roubiliac portrayed the collapse of the pyramid (a conventional funerary image, aestheticized by Hogarth in his *Analysis*) as the signal of the last trump that awakens the dead Hargrave and resurrects him. Hogarth's print resists any possibility of resurrection.[34] It portrays the moment of death, not rebirth, the "End" of all things — "FINIS." Myddleton and Hargrave *are* being reborn; Hogarth's Father Time (with the depleted wings of Time in the Hargrave monument) is simply passing away, as the sun is setting, along with everything else of value in the world. The *Tailpiece* can be construed as either Hogarth's statement about art and politics in the 1760s in England or (perhaps and) his deist belief in the absolute closure of death with no hope of an afterlife.[35]

To see the effect of Hogarth's image, we need only recall Wesley's hymn "By faith we find the place above" —

Then let the thundering trumpet sound,
> The latest lightning glare,
The mountains melt, the solid ground
> Dissolve as liquid air;

The huge celestial bodies roll,
> Amidst the general fire,
And shrivel as a parchment-scroll,
> And all in smoke expire?

(stanzas 3–4)

Hogarth has most blatantly turned the page and aestheticized Wesley by directly parodying Burke's description of the sublime as "images of a tower, an archangel, the sun rising through mists or in an eclipse, the ruin of monarchs, and the revolutions of kingdoms" — "a croud of great and confused images" (62).

Roubiliac, in the Nightingale monument, has turned from Christian transcendence to the Burkean Sublime. His woman is transformed from the mediator between life and death/resurrection (in one case the joyous resurrected woman, Mary Myddleton) into the dying Lady Elizabeth Nightingale, whose living husband cannot save her. Bindman reads this scene as a " 'Good Christian' monument," "an *exemplum virtutis*" showing the "mutual devotion" of the "Christian" couple. Or, he suggests, the "monument expresses the vanity of resisting death and, less obviously, offers the comfort that death is not an end but a beginning." Possibly, but there is no indication of this reading in the sculpture itself. Bindman accepts the notion of the sculpture's pathos, but as "a new note of humanity [introduced into] the public space of the Abbey" (143–44). In fact, the Nightingale monument is neither obviously Christian nor moral; as contemporaries remarked, and the Burkean construction suggests, it is concerned with pathos outside a religious structure, and its intention, to terrify and elicit pathos as well as surprise, is aesthetic. Roubiliac and Hogarth shared this process of aestheticizing that at the end bifurcated into the Beautiful for Hogarth, the Sublime for Roubiliac.

Apocalypse: The Conversion of the Jews

Throughout the Pauline Epistles one consistent assumption colors all that Paul says about the law, faith, and grace: that he is living near the End of Days. This assumption is materialized in Revelation, which was written not long after

Paul's death, most likely following the traumatic event of the destruction of the Temple by the Romans. Revelation tells us that the promise of Christ's Redemption will be fulfilled only when Jesus returns, a fierce warrior on a white horse, leading a host of angels against the entrenched power of evil (the Roman Empire, by the Protestants read as Roman Catholicism, by Blake and radicals of the 1790s as the present church and state). But before Christ's Second Coming will first come an Antichrist, the Beast, his Prophet, and the Whore of Babylon. Even now the end has not been reached: Satan is cast into the abyss and chained, but only for a thousand years, during which certain Christians receive special rewards (martyrs, for example) and the world is ruled by Christ and his saints. After this "Millennium," Satan returns with his demons in one last effort to destroy the church, but they are destroyed by fire from heaven. Only now can the Last Judgment take place: the dead are resurrected and judged and either raised to everlasting life in heaven or plunged to eternity in hell. *This* is, finally, the "new heaven and a new earth" John speaks of. At that time, and not before, "there shall be no more death, neither sorrow, nor crying, neither shall there be any more pain" (21:4).

Pope makes it quite clear in *The Dunciad* that he is living in the age of Antichrist (the "Antichrist of Wit," Theobald, Cibber, and the rest). Swift locates his world somewhere between the fact of Redemption and the dreams of its fulfillment. Hogarth's *Tailpiece* is perhaps best described as an image of, or parody of, Apocalypse.

One desideratum for the Second Coming was the conversion of the Jews.[36] Cromwell's followers had urged him to admit Jews to England because that would advance the time of the Second Coming. The Jews believed that *after* the coming of the Messiah the Christians would be converted (i.e., all peoples would accept the sovereignty of [the Jewish] God).

Twenty years after the *Harlot's Progress*, four years after *The March to Finchley*, at about the time he was working on the Bristol altarpiece, in his four *Election* prints (published 1754–58), Hogarth replaced resurrection with apocalypse. He gave prominent place to the repeal of the so-called Jew Bill of 1753, which provided "That Persons professing the Jewish Religion may, upon Application for that Purpose, be naturalized by Parliament, without receiving the Sacrament of the Lord's Supper." This required a modest residency of three years, and the measure easily passed Parliament and became law, with George II's approval in mid-1753. The Tory forces, however, looking for an issue, caused such a furor that the Whig government, anticipating a general election, repealed the Jew Bill

in December. A great deal of antisemitism was unleashed. Arthur Murphy, for example, a close friend of both Hogarth and Fielding, in his *Gray's Inn Journal* (14 July 1753), predicted that children would be circumcised and a nonjuring clergyman would be whipped for speaking disrespectfully of the coming of the Messiah.

Celebrating the General Election of 1754, Hogarth's *Election* plate 1 shows a vastly extended Last Supper, apostles and Christ turned into electors and candidates, the sacrificial figure now the mayor who has eaten too much and is succumbing to apoplexy. Through the window is a banner carrying the profile of a Jew and a slogan attacking the Jew Bill. Plate 2 shows a candidate using a Jewish peddler's wares to bribe a pair of young women, and a grenadier wearing the star of David as insignia on his cap, instead of guarding against electoral bribery, is preoccupied with the inn mistress's shekels. The issue emerges as central in the fourth plate (fig. 74), which shows a Jewish fiddler leading the triumphal procession of the victorious candidate. Hogarth implies the Judaizing of England, precisely what the opponents of the Jew Bill prophesied. The *Election* prints introduce the idea of the Eschaton — the conversion not of the Jews, as prophesied, but of the Christians.

The victorious candidate carried aloft evokes — or rather parodies — the Beast and the Whore of Babylon of Revelation. As parody, it recalls the mock-heroic satire of Dryden and Pope: In *MacFlecknoe* Shadwell (Christ to Flecknoe's John the Baptist) was an Antichrist, and in Pope's *Dunciad* Theobald-Cibber was the Antichrist of Wit. The climax of Pope's first dialogue of his *Epilogue to the Satires* (1737) had Vice as the Whore of Babylon take the place of Virtue in her chariot, with Virtue in Vice's place following at the tale of the cart, whipped like a whore, and in the position of the defeated slave in a Roman Triumph. Pope's allusion was to the recent marriage of Mary Skerritt by Sir Robert Walpole, whose wife had finally died: Vice recognized, nominally taking the place reserved for Virtue, is the ultimate corruption (perhaps recalled in the figure of Felix's Drusilla).

Most interesting, however, is the fact that in this scene Hogarth offers a reprise of the painting on the wall of *Harlot* plate 2 that showed King David's triumphal procession with the Ark of the Covenant (see fig. 18). In *Election* 4, Hogarth seems to be saying, the parvenu, "aping" Jew of *Harlot* 2 has succeeded and the Jews have taken over English society. No longer "made a monkey of" by the Harlot and her boyfriend, the duped Uzzah has become the triumphant King David, though his harp is reduced to a fiddle. The Jewish fiddler and his motley followers (the "mob") bear the successful candidate as if he were the Ark of the Covenant — and are about to drop him as they did the Ark but with no Uzzah in

the vicinity to save him.[37] Michal is the young woman above who is fainting at the fall the elected member is about to take — or perhaps at the fiddler whose cavorting is as offensive to her as David's.

The popular parallel between England and the Israelites as the chosen people had in the 1740s–50s become extremely prominent in the oratorios of Handel, and in *Election* 4 it is as if Hogarth is saying: Now we have indeed become Israelites. One of the prints attacking the Jew Bill was called *A Prospect of the New Jerusalem*. In 1756, two years before publishing *Election* plate 4, Hogarth made two *Invasion* prints, in one of which the French *have* invaded England accompanied by priests and the Inquisition. Now, in the depths of the Seven Years' War, it is the French abroad, the Jews at home.

The Jews in the *Election* are, however, *un*assimilated Jews — in fact, the peddlers who wandered the countryside (Hogarth represents the Oxfordshire election), not the clean-shaven London Jew of *Harlot* plate 2. They are "picturesque" figures, formally as well as thematically adding to the variety and disorder of the election. If the Harlot's assimilated Jew led the victorious candidate's procession, there would have been less comic incongruity (the "improper, or *incompatible* excesses" that, when they meet, "always excite laughter," described in *The Analysis of Beauty*).[38] Indeed, it is difficult to determine the tone, whether it is fear of the possibility of a Jewish takeover or amusement at the fantasies of the Tories, even after the Jew Bill was repealed.[39] In plate 1 an effigy of a Jew marked "No Jews" is joined by a sign inscribed "Marry and Multiply in Spite of the Devil," opposing the "Marriage Act" of 1753, and another with "Give us our Eleven Days," complaining about the change in the calendar that took effect in 1752 when eleven days in September were dropped. Was Hogarth, as was apparently the case with many of the politicians and perhaps even the propagandists, simply entertained by the jokes about Saint Paul's Cathedral being turned into a synagogue and English children circumcised?

Dashing away from the triumphal procession are the Gadarene swine into whose bodies the legion of devils (presumably out of the bodies of this mob) have been driven by Christ. Here, as with the triumph of the Beast, Hogarth is "correcting" Revelation: "Fallen, fallen is Babylon the Great! She has become a dwelling for demons, a haunt for every unclean spirit [i.e., in the Gadarene swine], for every foul and loathsome bird [perhaps the goose, flying overhead, who warned the Romans of the barbarians' approach]" (Rev. 18:2).[40] Or the swine are simply driven out because they are unclean beasts to the Jews.[41] If so, it is natural that with the triumph of the Jews the porkers should be purged: "be-

hold, the whole herd of swine ran violently down a steep place into the sea, and perished in the waters" (Matt. 8:32). Perhaps the swine only comment on the serving of pork and ham at the Tory dinners and the singing of an adaptation of "The Roast Beef of Old England": "Sing oh! the Roast Pork of Old England, / Oh! the Old English Roast Pork."[42]

Although the potential circumcision of all English males was one of the red flags of the agitation against the Jew Bill, Hogarth includes no reference to it in his *Election* prints. In *Paul before Felix* (see fig. 56), Hogarth made the Jewish priests plainly racial stereotypes. He associates them with organized religion and religion with the Law, implicitly against the Christian ethics of Jesus and Paul. To Paul and his followers, the Law meant circumcision and the requirements of the dietary laws. And the Jews want to put him to death because of his preaching against circumcision and for admitting Gentiles into the Jesus sect — for, in effect, creating the religion of Christianity. In the burlesque (see fig. 57), one rabbi holds a circumcision knife with which he obviously wants to attack Paul. (Hogarth would have recalled the role of circumcision in the Jews' attack on Paul in Acts, during his last visit to Jerusalem when he was mobbed and sent to Caesarea to plead before the Roman procurator.) Five years later, Hogarth's tone has darkened. There is little humor in *Enthusiasm Delineated* (ca. 1759, fig. 75) and (its published form) *Credulity, Superstition, and Fanaticism* (1762, fig. 76), where he again shows the circumcision knife.[43] Here the Jew, who has an open book with an illustration of Abraham's sacrifice of Isaac, represents blood sacrifice, harsh judgment, possibly even the antisemite's crazy extension of circumcision into castration.

Hogarth's strongest image of the Jew corresponds to his most radical statement against religious belief, and this corresponds to the final stage of his engagement with aesthetics, a subject of increasing importance and, after the mixed response to his *Analysis of Beauty*, sensitivity. The images being eaten by the congregation are of Christ in the Eucharist (or at least in popish Transubstantiation). The figure of the Jew at the left is emblematic: In the context of the Eucharist Christs being devoured by the devoted Christians, the Jew has an open book with an illustration of the sacrifice of Isaac (as the Harlot has on her wall in *Harlot* 3), the type of the Father's sacrifice of the Son. Once again Hogarth has absorbed the Jew into the bloody-mindedness of Christianity, or at least its enthusiast versions.

Between the *Election* and *Enthusiasm Delineated*, Burke published his *Philosophical Enquiry*. Burke had cited the Old Testament for his examples of the sublime,

and corresponding to the popularity of Burke's sublime was the upturn of interest in the poetry of the OT, praised in the lectures of Robert Lowth and others. Hogarth associated Burke's threatening new aesthetics with developments in politics following the General Election of 1754 and the *Election* prints and easily assimilated it to the Old Master paintings and their Old Testament punishments, indeed to their foreignness and their Jewish collectors.[44] We could argue that Hogarth picks up the Jew from the 1753 General Election and plates 1 and 2 of the *Election*, revises plate 4 (which was not published until 1758), and *then* undertakes *Enthusiasm Delineated* (ca. 1759), in which the Eucharist has been literalized and the Jew is the emblem of sacrificial atonement.

All of this is summed up in *Enthusiasm Delineated* with the Jew, the priest, and God the Father parodied from Old Master paintings. The pleasure thermometer, topped by the triangle of the Trinity (which Hogarth had used on the title page of his *Analysis,* where he replaced the Tetragrammaton with his Line of Beauty), descends from "Pleased" to "Angry," "Revelation," and so down to "Madness" and "Ecstasy."[45] Horace Walpole thought it one of Hogarth's "most capital works," "a mixture of *humourous* and *sublime* satire, that not only surpassed all his other performances, but which would alone immortalize his unequalled talents." It is a dark, threatening, and frightening scene, and the Old Testament Jew is as demonized as the essentials of Christianity.[46]

In the published state, *Credulity, Superstition, and Fanaticism* (April 1762) (fig. 76), Hogarth has bowdlerized the print: the Jew has placed a knife inscribed "Bloody" on the book, which now shows only the altar with a flame that indicates a burnt offering; he has replaced Moses, as well as Saints Peter and Paul and other biblical figures, with famous ghosts (Caesar, Buckingham); and the shocking Christ image being eucharistically devoured is disguised, replaced by the Cock Lane Ghost, the ghost of the young woman, Miss Fanny, supposedly murdered and returned from the grave to accuse her murderer, who had been made the center of a superstitious cult.[47] This has incidentally permitted Hogarth to return to his idea, going all the way back to the *Harlot's Progress*, of the female substitute for Christ. The ecstatic Saint Catherine from a Counter-Reformation painting in the lower left corner of *Enthusiasm Delineated* has also been replaced with a reprise of Mary Toft (a "mother") and her rabbits from Hogarth's Nativity scene, *Cunicularii*—yet another superstitious "fraud."

Smart

The *Magnificat* and *Jubilate Agno*

The Harlot's Cat

In the third plate of *A Harlot's Progress*, there is a cat cavorting at the feet of the
Harlot, who is sitting on her bed dangling a watch she has just stolen from a
customer (fig. 77a). It is not difficult to associate the Harlot and her cat in terms
of gender. At least one commentator, consulting Jacob Cats's emblem books, has
read the cat as "cat in heat" and whore.[1] But prostitutes were ordinarily portrayed
as accompanied by dogs — men-substitutes, surrogates for their customers; the
cat refers to the woman herself, presumably because a cat in heat will mate with
more than one male and attracts males from far and near. The Harlot's cat has a
collar around her neck (she is "kept"), is sniffing under the Harlot's skirt, and has
her tail raised in the air, her vulva prominently displayed. But is she sniffing the
odor of recent sex? Is her provocative pose intended to represent the in-heat
position? Is it an invitation to be mounted?[2]

Yet another story is projected from the figure of the cat: that the cat is in fact
drawing our attention to the hiding place of James Dalton, whose recent pres-
ence in the room is indicated by his wig box atop the Harlot's bed and his wig
hanging on the bed curtain, as if he has not had time to don it before slipping into

hiding. Alexander Gourlay wonders why otherwise Gonson would "bring his whole army with him to bust Moll in what is obviously not a whorehouse but a private room."[3] He refers to Gonson's obsessive raids on brothels. This subnarrative is one possibility Hogarth leaves open, but the main point, I should have thought, is the disproportion of Gonson and his "army" to the one harlot, as harmless as the kitten. For Hogarth seems to suggest that she is simply playing, being "kittenish," and in that sense reflecting the merely "playful" — innocent, aesthetic, unmoral — element in her theft of the watch, as opposed to the unplayful real world of the magistrate who is about to arrest her. The natural, instinctual kitten is therefore contrasted with the Harlot's affectation, imitation, and desire to be what she is not, embodied in the aesthetics of her dress, tea service, and "art" collection.

In *Harlot* 3 the cat serves as part of an image sequence: cat, harlot, witch's hat, and broomstick, signifying *witchcraft* as well as *masquerades* (where whores met clients). There was also a medieval legend of a cat who was born at the same time as the Christ Child, illustrated by Leonardo in his projected *Madonna of the Cat*.[4]

In the broadest sense, cats are solitary and self-sufficient creatures, more often than not regarded warily and superstitiously. "The familiars of Witches do most ordinarily appear in the shape of cats, which is an argument that this beast is dangerous in soule and body." This idea, written in 1607 during one of the periods of witch scares (by Edward Topsell in his *Historie of Foure-footed Beasts*), persisted in popular wisdom.[5] Hogarth's earliest cat, in *Hudibras Beats Sidrophel* (1726, fig. 77b), appears in a scene of necromancy in which the cat is responding to Hudibras much as her master the astrologer Sidrophel does, alarm conveyed in her very expressive back — a different back from the one in *Harlot* 3, now arched to indicate defense of her territory. The cat and Sidrophel are related by their responses and also by circular shapes, one held by Sidrophel, the other behind the cat (which anticipate the "glory" shape behind the Harlot's coffin, made by her hat).

The occult, the most common association with cats, reappears in *Strolling Actresses Dressing in a Barn* of 1738 (again the cat's female gender is evident — this is an all-female acting troupe), and blood is being drawn from the cat's tail (fig. 77c). Folk wisdom claimed that, "to recover from a bad fall, you sucked the blood out of a freshly amputated tail of a tomcat." But the ritual is being conducted here by a *play* witch in a theatrical performance. The cat's angry expression denotes, as well as pain, her displeasure at being forced into this unnatural role. Recalling the Harlot and her cat, she serves as an emblem of the inappropriateness of the roles

assigned to all the other actresses in the scene, beginning with the fleshly young woman assigned the role of Diana, the goddess of chastity. Cat-as-occult-creature is being imposed upon the poor cat as the role of Diana is upon the lusty young woman. Hogarth is saying that witchcraft is no less "theatrical" than the operatic illusions of classical mythology or of more orthodox religious sects: for the "witch" holds the cat over a table, adjacent to an altar, drawing blood into a bowl, therefore, in the context of ritual sacrifice. The cat and demonic "cat" remain separate not only as actor and role, seen from backstage, but as participating in a performance of Transubstantiation — only incarnate in the same sense that Christ is in heaven, and the bread is on the table.

At the bottom of *Strolling Actresses* are two more felines. These are, however, kittens, and they are playing with a royal orb and a harp, making part of a *vanitas* emblem that includes a monkey relieving himself in a hero's helmet. The orb is a substitute ball — cats play with balls, as in a conversation piece, *The Family Party* (Yale Center for British Art).[6] The other kitten has its paws around the harp, mimicking the pose of a bard. Here the connotation of the adjectives "kittenish" and "play" are clearly intended, as well as "natural" (vs. playacting), a meaning that connects these kittens with the cat of *Harlot* 3 and the Harlot herself with the nature goddess, Diana Multimammia, who announces her in the subscription ticket, and all of these with the aesthetics of play, love, and pursuit formulated by Hogarth over the next decade.

Five years after the *Harlot's Progress*, however, the cat in *The Distressed Poet* (see fig. 52) is a mother feeding her kittens, parallel to the Poet's wife and her baby — representing the mother's protective function, her domestic centrality in the garret of a poet who is himself irresponsibly writing a poem "On Riches." This cat has what appears to be an intensely worried look on her face, parallel to the wife's concern for her offspring amid the chaos of the poet's lifestyle, which includes both the milkmaid who demands payment for her bill and the dog — the cat's natural enemy — who enters with the milkmaid, a threat not only to the family's last chop but to her own kittens.

Given the cat's reputation for solitary self-sufficiency, it is significant that Hogarth chooses to show one cat as a mother, at that time when she is momentarily domestic, and oppose her to a solitary, marauding dog. At the same time, she suggests a parallel with the cat in *Harlot* 3, as the dog does with the threatening law officers, who are also denizens of a more brutal world intruding on this one: the Harlot as mother, whom Hogarth substitutes for her son (the Harlot, by the next plate, is herself pregnant and in plates 5 and 6 accompanied by her son).

Hogarth uses animals in general as an aspect of "nature" in contrast to the art or artifice employed in various ways by the Londoners "above" them in the biological and social scales. Throughout his engraved works he divides the scene horizontally into an upper area, where pictures of divine subjects (images of fashion to be emulated by the foolish) hang, and a lower one, in which dogs, cats, and monkeys expose the instincts concealed by such painted illusions.[7] The cat, we can conclude, is not simply another parody of Atonement and Incarnation, like the Harlot, which is the analogy upward into the world of art. The cat represents another aspect of Hackabout, the original pilgrim of the title, "A Harlot's Progress." The cat is the animal aspect of her—as the dog, when he appears, usually is Hogarth himself.

A dog is Hogarth's alter ego in his most famous self-portrait (London, National Gallery). A dog is used repeatedly by Hogarth to reflect the feelings of men (the hanging head of the dog in *Evening* reflects his dejected master, not his domineering mistress). He is always the irreverent joker, testing the family order with a gesture toward disorder, questioning appearances, and lifting a leg on what he finds suspect, but always with a straight face (unlike the violent, expressive cat). The cat has always a more lively—indeed, manic—face, a stronger and more open expression, whether of aggression, anger, alarm, or apprehension.

From Hogarth's images it appears that cats were not ordinarily pets in London households. They must still have carried some of the sense of danger (or bad luck) they had in the times of witchcraft scares. They generally wandered the streets, scavenging for food, and suffered the consequences of such a life—as in *Noon*, in *The Four Times of the Day* (1738), the cat lies dead in a gutter with bricks and other stones nearby that someone has thrown at her. The cats on the rooftops in *The March to Finchley* and *The Enraged Musician* are also strays. (In *Finchley*, three cats appear on the roof of a brothel, one with its rear end toward us, recalling the pose of the Harlot's cat, as the "shop sign" of a "cat house.")

Domestic cats are in the household less as a friend than as a mouser or ratcatcher. Society utilizes the cat's natural killer instinct. Even the cat in *Strolling Actresses* was presumably kept in the barn to rid it of mice before being appropriated by the troupe for an unaccustomed role in their play. A rat but no cat appeared in *The Punishment of Lemuel Gulliver* (see fig. 25); there, where the rat was carrying off human babies, a cat was the obvious desideratum. The cat of the miserly Old Rakewell (*Rake's Progress* 1) was certainly not kept as a pet. But this emaciated creature—with a face wonderfully expressive of both hunger and rage, with her paws up on a chest filled with gold plate, which in the Rakewell household has come to take the place of food—also serves as emblem of the avarice of

her master, who has repaired his "holy" shoe by cutting a "soul" out of the "Holey" Bible.

In *Harlot* 3, where there is no dog to complement the cat, we have to ask how this cat can be associated with both Harlot (as whore) and police (as ratcatcher). The answer is in the subscription ticket, *Boys Peeping at Nature*, where the female Nature is being exposed — her skirt lifted for a peek at her most natural parts — by a boy satyr. In *Harlot* 3 the cat takes on the satyr's function (formerly in Hogarth's work a combination of natural sexuality and satyr-satire), to "sniff out" the Truth under the Harlot's skirt *and* to seize her as a "criminal," because both are aspects of the Hobbesian state of nature (without the dimensions of morality and social order that are always present in the actions of Hogarth's dog). The sniffing out of the smell of recent sexual activity, of the mouse, and of the offender against society are all part of the truth of nature, and the cat's act is analogous to both the satyr's and the clergyman's in plate 6 as he reaches under a whore's skirt for another sort of truth.

Smart's Magnifi-cat

Geoffrey Hartman has drawn attention to this pun (among many others, including those on purring) in Christopher Smart's *Jubilate Agno*, written in a London madhouse between 1759 and 1762 (unpublished until 1939).[8] While Hartman is being playful like his namesake the cat, and Smart's allusions to the Magnificat ("*For I pray the Lord Jesus to translate my* MAGNIFICAT *into verse and represent it,*" B43) precede by many lines the praise of Jeoffry, this cat is the chief among the innumerable creatures "magnified" in *Jubilate*, the only one dealt with at length and in detail, and Smart's own ("I am possessed of a cat, surpassing in beauty, from whom I take occasion to bless Almighty God" — "my cat Jeoffry," B68, 695). Cats, and in particular Jeoffry, dominate and bring to a climax fragment B. Jeoffry is gendered male; otherwise the qualities enumerated resemble those Hogarth attached to his cat and to his aesthetics in the *Analysis* of kittenish play.

In the A fragment Smart compares the cat with the dog:

Let Tobias bless Charity with his Dog, who is faithful, vigilant, and a friend in poverty.
Let Anna bless God with the Cat, who is worthy to be presented before the throne
 of grace, when he has trampled upon the idol in his prank.
(A56–57)

To elucidate Smart's extremely compact and allusive lines: Tobias, the son of Tobit, on his journey to heal his father's blindness was accompanied by a dog;

charity was the chief virtue of Tobit and led to his persecution at the hands of the Assyrian king Sennacharib. Smart's dog is thus faithful and vigilant, to which is added "a friend in poverty," which applies to Tobit after his misfortunes rather than to Tobias returning successfully with the cure for his father's blindness. Smart further defines the dog by contrast with "the Wolf, which is a dog without a master" (A76).

Both dog and cat are domesticated creatures. But the dog's role is simple compared to the cat's. Anna blesses God with the cat: Anna (Hanna), the wife of Tobit, mother of Tobias, was an example of the good wife and mother. But another Anna (characteristically, Smart's references are polyvalent, or typological) was the prophetess who attended the presentation of Jesus at the temple and recognized Him as the Messiah: she "spake of him to all them that looked for redemption in Jerusalem" (Luke 2:36–38). Cats were temple creatures, here associated with grace ("the throne of grace") and iconoclasm ("trampled upon the idol"). By a sleight of hand, Smart substitutes the cat for Jesus in the temple: it is "the Cat, who is worthy to be presented before the throne of grace." And the way the cat tramples the idol is "in his prank" (see below).

Fragment B ends, or climaxes, with "consideration" of Smart's cat Jeoffry: "For I will consider my Cat Jeoffry." *Consider* means to examine or look at attentively; to ponder or study; to take into consideration or give thought to with a view to placing, accepting or rejecting, or considering him fit or unfit; to regard him highly, to esteem him — as what is usually regarded as a low creature within the context of the Magnificat, to *magnify* him. In the final sense, Smart "considers" Jeoffry by situating his daily life within the Christian code (as he fits the dog into obedience to a master). We have noted the cat's association with the occult, which was drawn upon by Hogarth and perhaps carried from *Hudibras Beating Sidrophel* into *Harlot* 3. Smart simply redefines the occult (witchcraft and the cat as the devil's servant) as Christian observance:

> For he is the servant of the Living God duly and daily serving him.
> For at the first glance of the glory of God in the East he worships in his way.
> For is this done by wreathing his body seven times round with elegant quickness.
> For then he leaps up to catch the musk, which is the blessing of God upon his
> prayer.
> For he rolls upon prank to work it in.
> (B695–99)

Jeoffry progresses through a day beginning with sunrise (but "East" also recalls the star in the east that notified the Wise Men of the Nativity), measuring

his feline movements according to the holy number seven, the number of letters, seals, trumpets, vials, and visions in Revelation. He "roles upon prank": A favorite word of Smart's, *prank* is, according to Johnson's *Dictionary*, "A frolick; a wild flight; a ludicrous trick; a mischievous act. A word of levity." "Grace," in the context of "prank," is not only the dispensation of Christ at the Redemption but a feline jest as well. The word conflates worship and aesthetic transformation (or substitution) and, of course, wit.

Then Jeoffry "considers himself" — to do so performing ten functions ("ten degrees"), essentially primping, the natural, observed actions of a cat but set in the number of the OT Commandments:

> For first he looks upon his fore-paws to see if they are clean.
>
> For secondly he kicks up behind to clear away there.
>
> For thirdly he works it upon stretch with the fore paws extended.
>
> For fourthly he sharpens his paws by wood.
>
> For fifthly he washes himself.
>
> (B703–7)

That is: Thou shalt peruse thyself, stretch thyself, prepare for combat, be clean, and so on, rolling, fleaing himself, rubbing himself against a post, performing all the humble but ritual acts of an ordinary cat — the Law of Ten adjusted to the natural feline motions.

Jeoffry prepares for his service, first by cleaning his forepaws ("Cleanliness is next to godliness"). Jeoffry is "the cleanest" (though technically one of the Levitical abominations), dexterous, and quick. Recall how Hogarth utilized for "sacrifice" people like the Harlot who are blemished and therefore unfit to be either sacrifice or priest. Jeoffry, like so many of the animals enumerated by Smart, is unclean because he walks on paws rather than cloven hooves and does not chew his cud: "whatsoever goeth upon his paws, among all manner of beasts that go on all four, those are unclean unto you" (Lev. 11:27), and "creeping things" (11:29) are singled out ("But all other flying creeping things, which have four feet, shall be an abomination unto you" [11:23]).

The catalogue of creatures, planets, nationalities, flowers, letters of the alphabet, musical instruments, and colors ends with the bull, which serves as transition to the cat Jeoffry:

> For Fire is under Bull.
>
> For I will consider my cat Jeoffry.
>
> (B694–95)

By juxtaposing bull and cat, Smart contrasts the OT manner of serving God — to atone for sins through blood sacrifices — with the new, Christian way of serving God ("the servant of the Living God duly and daily serving him"), and by the agency, not to say energy, of the cat versus the passivity of the bull.

The preparation for service ends with Jeoffry looking up "for his instructions," and: "For Tenthly he goes in quest of food" (B711–12), with its vaguely Eucharistic overtones. (Communion is one of Smart's chief concerns in the *Jubilate* — for which, see below, p. 323.) The *source* of "food," however, leads to his essential felineness. "For having consider'd God and himself he will consider his neighbor": Jeoffry echoes Jesus' advice to love God, himself, and his neighbor (Matt. 27:37–40) — in his case, first another cat (whom he kisses, echoing St. Paul in Romans, Corinthians, and Thessalonians) and then (Love thy enemies) his natural prey, a mouse.

This leads Smart to recapitulate the story of the Redemption: from the Fall and Original Sin, Jeoffrey, like Adam's other descendants, has inherited the serpent's hiss, which "in goodness he suppresses." Instead, "he purrs in thankfulness, when god tells him he's a good Cat" (B726). "God is his Saviour" — he is "of the Lord's poor" (Matt. 5:3), and "the divine spirit comes about his body to sustain it." Through his own electricity — his spiritual substance (he partakes of the Pentecost [Acts 2:1–4]) — the glory of God can be perceived in the glow that radiates from his fur. In short, this cat loves his God and his neighbor — replacing the Levitical sense of obeying laws, paying tithes, or serving on a vestry; by this, Smart indicates that he is redeemed, in the sense of living under the New rather than the Old Covenant. The story of Moses leading the Israelites out of Egypt (one type of the Redemption, as the Passover was of the Eucharist) includes the detail that cats were so revered by the Egyptians that the Israelites had to smuggle them out in bags. Then, in the NT, the cat's natural independence, aloofness to the outside world, and vanity are "redeemed," turned to God's purpose, and he "worships in his way."

The religious dimension, moreover, is qualified — or redefined — by an aesthetic one. The cat is more interested in the pursuit than in the catch: "For when he takes his prey he plays with it to give it chance. / For one mouse in seven escapes by his dallying" (B715–16). Again the number seven. That he plays (dallies) with the mouse, letting one in seven escape, suggests on the one hand the Sabbath day of rest and on the other the sense of play that accompanies dance and prank. He is enjoying what Hogarth called "the pleasure of pursuit." Jeoffry himself is "surpassing in beauty" (B68), and earlier Smart equates with beauty the

Hebrew letter *lamed*, which resembles Hogarth's Line of Beauty (B548). The characteristics of Jeoffry are curiosity, pursuit, discovery, intricacy, and variety. Specifically, "God has blessed him in the variety of his movements" (B763) — he clambers rather than flies, his motions are graceful, he dances to music, swims for life, and creeps. Jeoffry's motions — connected with "prank" — are the aesthetic motions of the Hogarthian dance but returned to a sense of religious ritual, joined to the *imitatio Christi* of his daily observances: Jeoffry is working God's grace into himself and thus receiving "the blessing of God upon his prayer."

Beauty and play are supplemented, as in Hogarth's *Analysis,* by utility. Jeoffry worships, considers God and his neighbor, engages in play, and then, at night, carries out the cat's basic job of protecting the house from predators. When night arrives, his "day's work is done" and "his business more properly begins," that is, the practical "business" of a mouser as opposed to religious and aesthetic ritual. Called a "cherub" (noted for its capacity for seeing God), Jeoffry keeps "watch in the night against the adversary," the devil. Smart is remembering 1 Peter 5:8: "Be sober, be vigilant; because your adversary the devil, as a roaring lion, walketh about, seeking whom he may devour."

> For he counteracts the Devil, who is death, by brisking about the life
> For in his morning orisons he loves the sun and the sun loves him.
> For he is of the tribe of Tiger.
> (B720–22)

Here, in three lines, Jeoffry wards off the devil "by brisking about the life," being vivid, energetic, and agile in the present, the here and now, and rises from the "jeopardy" of cat to the triumph of tiger (glancing toward Revelation).

Smart's Magnificat is defined by an aesthetics of waggery and prank, related to the Hogarthian aesthetics of *variety* (one of Smart's favorite honorifics): the play of the greatest variety of lines within an apparent unity, interweaving piety/praise and beauty, first alluded to early in fragment A with the hare, "whose mazes are determined for the health of the body and to parry the adversary," and the ape, "who is the maker of variety and pleasantry" (A22–23). The sea-bear is celebrated because it "is full of sagacity and prank" (B192) — and the scolopendra because, having rid himself of the fisherman's hook "by voiding his intrails," he will then ascend the stream "and afterwards prank itself into ten thousand agreeable forms" (B210). Indeed, this mixture of beauty and utility is the case not only with the animals — all the animals of Noah's Ark — but with Smart's own work, the *Jubilate* itself, which defies the Augustan decorum of boundaries and genre,

or rather seeks, within the open boundaries of a Psalm of praise, the greatest diversity.

The Magnificat sacralizes all, even the lowest creatures, implicit in the Magnifi-cat pun, for Jeoffry "is of the Lord's poor" — "Poor Jeoffry! Poor Jeoffry! The rat has bit thy throat" (B740). "Tongues" (the power of language, which involves the innumerable puns and other witty word play the poet utilizes for "naming") is extended to the creatures themselves — "every Creature" is called upon to "magnify his name together"; that is, to engage in a Magnificat, which in the animal encyclopedia of fragment B, in its climactic order, becomes a Magnifi-cat.

The "ritual praise" carried out by Jeoffry himself, as Marcus Walsh notes, shows that "every creature worships God simply by being itself."[9] But Smart picks out the animal that is closest to himself, having most in common with himself. Jeoffry is Smart's only friend; he refers to having "neither money nor *human* friends" (B283, emphasis added).[10] Smart, locked in the madhouse, is also among the lowest. Jeoffry and Smart are both, in the beautiful motions of their praise, redeemed creatures, substitutions (as Harlot and her cat, Smart and Jeoffry), and incarnations within a Magnificat.

Jeoffry "worships in his way": Hogarth was said, as both praise and limitation vis-à-vis the Old Masters, to be a master artist "in his way" — merely as a painter of drolls or morality, not as a history painter of the Raphael or Rubens sort. Applied to Smart, the words refer to his peculiar way of worshiping (in the streets, naked) — and so also to that of Jeoffry the humble cat, whose aesthetic proceeds within the order of Christian worship.

Mary Midnight

Let Jubal rejoice with Caecilia, the woman and the slow-worm praise the name of the Lord.

For I pray the Lord Jesus to translate my MAGNIFICAT *into verse and represent it.*

(B43–44)

Jubal, the first musician, father of harpists, rejoices with Caecilia, the slow-worm but also Saint Caecilia, patron saint of church music. The slow-worm conflates the serpent who tempted Eve and was defeated by Jesus ("The seed of the woman hath bruised the serpents head," B98) with the low, earth-hugging worm, "man the worm," who is elevated by the Magnificat.

"*My* Magnificat" recalls Mary Midnight, Smart's earlier persona in his journal, *The Midwife, or The Old Woman's Magazine* (1751–53). A Mother Midnight was defined in the *New Canting Dictionary* as "a Midwife (often a bawd)." Mary — the bawd and midwife and now, in the madhouse world, a second Mary the Mother — utters the Magnificat. Smart's own Christian name, Christopher or Christ-bearer, brings together Mary's womb and his utilization of women speakers in his journalism. Mary Midnight is described in *The Midwife* as both midwife and mother: "From the Nature of my Character and Office, I apprehend it is imag-ined, that my general Care and Regard are employed in watching over and superintending the various and daily Productions of our fertile, multifarious Parent, the *Community*." And she refers to her "*maternal* Concerns for the Good of this Kingdom."[11] Her "maternal" "Care and Regard" is focused precisely upon "the various and daily" works of London life, primarily literary. The terms ap-plied to Jeoffry and the Magnificat were already in place in the persona of Mary Midnight, who wrote of love, marriage, and the family.

Smart identifies himself with Mary and Cecilia, child-bearing woman and female bard (later with another mother, Hannah, B458, C149) — specifically sources of creation, or linked creations. The personal application of "My" is pursued in the following lines that connect the Magnificat (which juxtaposes high and low) with Cambridge and himself (his own short stature). He, like Mary, is magnifying, blessing, glorifying God, but he makes clear that God by his Incar-nation has elevated him (short, mad, deserted, a hack writer) and all the creatures, including those designated by the OT as unclean. In short, the magnifying of the Magnificat is of the low by the low.

The moment when Mary utters the Magnificat was, of course, the moment Hogarth represented in *Harlot* plate 1, with Mary meeting Elizabeth (Needham) and Zacharias in the doorway (Luke 1:68–79).[12] I see no reason to suppose that Smart did not know these plates and the *Analysis of Beauty*, given in the 1750s his apparent friendship with Hogarth, their common friends of those years (Thorn-ton, Coleman, Murphy, Fielding), and Hogarth's later subscription to his *Psalms of David* (though Hogarth died before they were published). Smart published "A Description of Mr. Hogarth's original Painting, from whence was copied his curious Plate of the March to Finchley" in *The Midwife* (unsigned), and Smart's other, Oxford journal, *The Student*, ran a witty account of the print in January 1750/1.[13]

At one point in *The Midwife*, Mary Midnight recreates Hogarth's Harlot — or rather offers her interpretation of the Harlot's progress.[14] Walking at night

through the streets of London, accompanied by a link boy, she observes "Knavery, Bribery, Cruelty and Extortion, in the Habit of substantial honest Citizens," while naked on bulks and at shop doors she sees

> poor Orphans, young helpless Girls, that have been debauch'd and ruin'd by the Sons, and 'Prentices of the honest Citizens, and after that turn'd out by their generous and compassionate Masters. Or perchance, they are brought to this wretched State, by some of the righteous Lads of the *Temple*, and Inns of Court. However that may be, it need not affect us Boy. Lay still my Heart; Women are not of the Human Species, so down with them, down with them. Boy if ever thou livest to be a Man (as in all probability thou wilt, if the Halter don't catch thee soon) do thou, whenever any poor Creatures tumble down, kick them about, 'tis the way of the World Boy, and all must conform to Custom (1:7).

These "honest Citizens," "generous and compassionate Masters," and "righteous" law students are, in Mary's ironic discourse, equivalents of the respectable clergymen, magistrates, physicians, and gentlemen (Charteris, Gonson, Gibson) who represent "the way of the World" in the *Harlot's Progress* (elsewhere in the *Midwife* Smart refers to "the great Folks," and she follows up with an appendix of "Maxims selected from the Wits of all Nations" on ministers of state, clergy, lawyers, and physicians).[15] In both cases we have a Magnificat that sacralizes the lowest creatures *and* raises (as God feeds) the dispossessed while denigrating (sending away empty handed) the rich.

Mary Midnight, as if recalling Lillo's Millwood, follows the attack on "the great Folks" with the story of a girl from the country very like M[ary]. Hackabout.[16] In this case her cousin does meet her when she reaches London — but to no avail, for the girl is nevertheless seduced by a gentleman who rode with her in the coach, who woos her and has a Fleet Marriage performed, and having impregnated her departs, leaving her penniless, ill, and with the reputation of "an infamous Creature" (1:22–27).

Mary Midnight assumes the role of Hogarth, the ironic reporter of London life, but Smart, as prisoner and inmate of a madhouse, associates himself as well with Mary herself, the young harlot. In *Jubilate* he describes the response of the "great Folks" to himself, for example, when he prays in public: "the officers of the peace are at variance with me, and the watchman smites me with his staff" (B89–90). The reference recalls the treatment the Harlot received in plate 4 and so back to the type of Christ's flagellation. Smart, from both positions, is saying, more positively than Hogarth, that with the Redemption the high ones are (or

will be) laid low and the low—such as Mary and Elizabeth or Smart himself, in his madhouse, the lowest place in this fallen world, or the even lower creature, Jeoffry the cat—will be exalted.

The context for "poor Jeoffry" reaches back to Mary Midnight's Oratory, which opened on 30 December 1751 (almost a year after Hogarth published his *Stages of Cruelty*, with its depiction of the torture of dogs and cats). This included a "Cat Organ" made up "of Cats of different Sizes, included in Boxes, whose Voices express every Note in the Gamut, which is extorted from the imprison'd Animals, by placing their Tails in Grooves, which are properly squeez'd by the Impression of the Organist's Fingers on the Keys. . . . it is also very well known that the best Voices are improved by castration, I therefore never have less than eight Geldings in my treble Clift." This organ has a double row of keys:

[T]he Upper Row on which I play *Piano*, or softly, consists of Cats, both of a lesser Size, and whose Tails we squeez'd by a much less Degree of Pressure. . . . But the Lower Row, on which I play *Forte*, or loudly, contains an harmonious Society of banging Grimalkins; and whose Tails are severely prick'd by Brass-Pins, inserted in the End of the Key for that Purpose. . . . I have underneath my Instrument a Treddle, like that of a Spinning-Wheel, which I work with my Foot: this Treddle activates a certain Number of Forceps or Pinchers, which open and shut at my Pleasure, upon the Noses and Chins of all the Cats. For, tho' the *Cat-Organ*, when accurately in Tune, is incomparably melodious, yet it may be so managed, as to utter Shrieks very little inferior to the Cries of the Infernals themselves.—Happy that Instrument, where Terror and Transport, Ornament and Utility are so exquisitely blended. (1:98–102)

We need to understand why Mary Midnight, whom Smart associates a few years later with his own voice in the *Jubilate*, should behave sadistically toward a cat, a creature with which Smart also associates himself. The answer is because he is both—Mary and his cat Jeoffry, agent and patient.

Hogarth, we recall, opposes the dog (his figure for himself) to the cat as the feminine other—the object on whom his aesthetics is focused. For Smart the cat is male, a substitute or analogue for himself and, therefore, for Mary Midnight as well—the low-life bawd and midwife. The Magnificat elevates Midnight along with cats, as it does Smart's own dubious life—the dissipation, drinking, and whoring, the hack writing, which included *The Midwife*.[17] All of this, both acts of the agent and suffering of the patient, is "redeemed" by Christ, and this Redemption is the subject of Smart's song of his present condition, in a contemporary and

personal Magnificat. Smart, a prisoner in a madhouse, abandoned by his family, with small creatures, especially the maligned, superstition-ridden cat, his only companion, celebrates these (like the cats of the *katzenmusik* of Mother Midnight) with a song also forced by pain.

Smart, of course, extends the Magnificat far beyond Hogarth's Virgin Mary and a prostitute to Mary and a carp, Joseph and a crocodile, Moses and a lizard, Cornelius and a swine, Boaz and a rat, Job and a worm, Alexander and a sea urchin. As Clement Hawes notes, the Magnificat's juxtapositions can have a leveling effect that recalls the discourse of the revolutionary seventeenth century;[18] also, in its primary function, by the act of Incarnation, in a celebration of Redemption, Mary Midnight / Smart "redeems" the carp, crocodile, and worm, and, above all, Jeoffry the cat and Smart the madman.

Hogarth and Smart invoke the Magnificat to show that as artists they wish to serve as witness to the fact of the Incarnation, which "exalted them [these people] of low degree," and so to celebrate whores and cats, a poor mad man, and all the fishes in the sea, with or without fins (clean or unclean). The connection between Magnificat and Incarnation lies in the yoking of incongruities: God and man, spirit and flesh, Christ's body and blood and bread and wine, divinity and a cat, men and animals, and in Smart's hands the result is uniquely both comic and profoundly reverent.

Smart's *Jubilate* has to be seen in the context of the great comic art of the first half of the century, not of the lugubrious funerary poetry of Young, Blair, and Harvey. His cheerful poetry asks to be read either as Scriblerian wit or — as contemporaries would have — as lunacy. Beginning with his early georgic poem, *The Hop Garden,* the basis of Smart's poetics is the mock forms of the Augustans and *The Dunciad* or Gay's *Trivia.* The Magnificat rendered mock-heroic, he shows, is the biblical model for the mock-heroic satire practiced by Swift, Pope, and Gay; the reversal of high and low becomes the play of one against the other for satiric or merely comic purposes. Beginning in B with the juxtaposition of OT name and the present Christopher Smart — and of course the animals and ultimately Jeoffry the cat — are all mock-heroic (and so comic) as well as reflections of the Magnificat (devotional). Indeed, if Hartman is correct, Magnifi-cat is precisely the point at which the mock-heroic mode and the Magnificat join.[19]

David the Psalmist

In the poem, itself an act of "waggery" and "prank," Smart reflects on how his "waggery" is scorned: "For I shou'd have avail'd myself of waggery," he writes,

"had not malice been multitudinous" (B17). Smart's "waggery" was to pray in public. As he describes it himself: "For I blessed God in St James's Park till I routed all the company" (B89), and as Samuel Johnson recalled: "He insisted on people praying with him, and I'd as lief pray with Kit Smart as any one else."[20] The "waggery" includes his ability to "speak the truth from my heart" (B92), and even worse: "For to worship naked in the Rain is the bravest thing for the refreshing and purifying the body" (B384). But, Smart tells us, "the officers of the peace are at variance with me, and the watchman smites me with his staff" (B89–90). He makes a fool of himself, relating himself to the water fowl that brays like an ass "because he makes the best musick in his power" (however asslike) and even Mucius Scaevola, because he did his best though with only one hand (B19).

Smart's immediately relevant persona in the Magnificat was the Mary of *Mrs. Midnight's Journal*, but the figure with whom he primarily associated himself in his Psalm-like undertaking was David, whom Milton had also invoked as a poet connecting him with the Son. Typology could be personal. Sinners were urged by devotional writers to find parallels between their own and the life of Christ. Donne singled out David: "*David* was not onely a cleare Prophet of Christ himselfe, but a Prophet of every particular Christian: He foretels what I, what any shall doe, and suffer, and say."[21]

Except for the poem on God's omniscience, all Smart's Seatonian Prize poems open with an invocation to David and indicate Smart's association of himself with the Psalmist, who also praised the divine attributes as revealed in nature, not merely as abstract qualities; he served, moreover, as an OT type of Christ the Redeemer (also his ancestor) in that, taking on our common sin, he was scorned.[22]

Smart's self-association with David focuses on the years in the madhouse, in the *Jubilate* and the *Psalms of David* and *The Song to David* — the first his plain, personal identification, the second the work by which he hoped to rejuvenate the Church of England, and the last his masterpiece of formal order, the very opposite of the mix of diary and liturgical form, particular and general, personal and universal in the *Jubilate*.

Smart also associated himself with Orpheus, another poet who met a sad end through his wife and the scorn of the Maenads (celebrated also by Pope, who associated himself with Orpheus in the final version of *The Dunciad*). But Orpheus was only another eighteenth-century double for David, as Smart notes in the opening lines of his "On the Goodness of the Supreme Being": "Orpheus, for so the Gentiles call'd thy name, / Israel's sweet Psalmist, who alone couldst wake / Th'inanimate to motion" (*Poetical Works [PW]*, 4:305, lines 1–3).[23]

David enters in the first lines of fragment A with the evocation of his Psalms

and the references to the Ark of Salvation which conflate the arks of David and Noah with the messianic mission of Christ. In A41 Smart introduces David's fight with the bear, his victory over the Philistines, and the power of his harp (associated with the victories England enjoyed over France in 1758):

> Let David bless with the Bear — The beginning of victory to the lord — to the Lord
> the perfection of excellence — Hallelujah from the heart of God, and from the
> hand of the artist inimitable, and from the echo of the heavenly harp in
> sweetness magnifical and mighty.

This includes the celebration of David as Psalmist, and so the association with himself and the "magnifical." In the following verses David is surrounded by his son Solomon, another associate named Romamti-ezer, the prophets Samuel and Nathan. "Let Nathan with the Badger bless God for his retired fame, and privacy inaccessible to slander" (45). Nathan, who condemned David's primary sin, the adultery with Bathsheba and the death of her husband Uriah, opens the door to the association of David's slanders and transgressions with Smart's own troubles (his "jeopardy"), which have led to his confinement in the madhouse.

Smart's *Song to David*, which he apparently began in the madhouse, was both defensive and topical, written in the context of contemporary attacks on David as cruel, vindictive, lascivious, and hypocritical. The deist Peter Annet had disparaged David among his other personal attacks on biblical figures (see above, p. 274). In response to Samuel Chandler's funeral sermon for George II celebrating him as a modern King David (1760), he had published *A View of the Life of King David*, in which he drew attention to David's immoralities — and again in *The History of the Man after God's Own Heart* (1761).[24] Smart's self-association with David included the bad with the good — an identification that was apparently made by contemporaries as well. In a letter, which appears to have been addressed to Smart after his breakdown, he is lectured about the Grace bestowed by Christ on sinners like him: "*David's* sins were aggravated by every condemning circumstance, yet he found mercy; there is the same mercy for you."[25]

David, here and in the *Song to David*, was not only the Psalmist (in particular of Psalm 100, the "Jubilate") but also the David of the great moment when he brings the Ark of the Covenant (the tabernacle that bears the tablets of the Ten Commandments and the dwelling place of God Himself) into Jerusalem, singing and dancing before it. It is an impressive occasion: David "played before the Lord on all manner of instruments made of fine wood, even on harps, and on psalteries and on timbrels, and on cornets, and on cymbals" (2 Sam. 6:5). But the moment of the Ark's triumphant entry into Jerusalem is fraught with a strange mix of the exalted

and degraded: First, David, like Jeoffry the cat (and like Smart the poet-poetaster), is dexterous and quick, a mixture of gravity and waggery, full of "prank," *and* he enjoys the favor of God. This is the Davidean aesthetics as Smart interpreted it, embodied in David's "leaping and dancing" before the Ark.

The preferred form of art in *The Midwife* was dancing. Speaking "from the Rostrum," that is, of her Oratory, Mary Midnight delivered "A Dissertation on Dancing," which concludes: " — as when I see a Man of a sour, ill-natured, saturnine Disposition, I judge with *Shakespeare*, that he has not Musick in his Soul. — So on the other Hand, when I see a clumsy, awkward, rustic, unmannerly lout, I am confident he has not learn'd to dance."[26] This was affirmed by Hogarth in the climactic pages of his *Analysis* and by Smart in *Jubilate*.

But David in his "enthusiasm" (a word that could include, as Hawes shows, radical evangelical activity), dancing and singing, exposes himself and earns the scorn of his wife Michal. He is wearing only an ephod, which, when he whirls about, exposes his genitals. She sees him "leaping and dancing before the Lord; and she despised him in her heart" (6:16), addressing him with heavy irony: "How glorious [or honored] was the king of Israel to-day, who uncovered himself to-day in the eyes of the handmaids of his servants, as one of the vain fellows shamelessly uncovereth himself!" (6:20). David's reply, "And I will yet be more vile than thus, and will be base in mine own sight: and of the maidservants which thou hast spoken of, of them shall I be had in honor," could be Smart's. In Robert Alter's commentary, "David flings back Michal's sarcastic 'how honored,' suggesting that, unlike Michal, the simple slavegirls will understand that his gyrations before the ark are an act of reverence and will honor him for it."[27]

If David's "waggery" consisted of "leaping and dancing," wearing a garment that exposed him, Smart's was the need to "worship naked in the Rain." Smart's "waggery" referred, as well as to a Hogarthian aesthetics, to his earlier hack writings and the *Jubilate* itself. Like David's dance, these very songs of praise have earned him scorn. David is an exalted but flawed figure, comically juxtaposed in *Jubilate* with the small and dubious figure of Smart. The significance to Smart was that his wife and relatives had confined him to a madhouse because, like David, he prayed loudly and publicly, on the streets of London.

David's behavior was seen in a positive light by the radical Protestants like Abiezer Coppe, who, himself a witness to the Antinomian topos of nakedness, boasted that David was "confounding, plaguing, tormenting nice, demure Michal by skipping, leaping, dancing, like one of the fools."[28] In *The Song to David*, Smart describes David bringing in the Ark "With dances and with songs" and offers an idealized image of David's wife Michal's response:

When up to heav'n his thoughts he pil'd,
From fervent lips fair Michal smil'd,
 As blush to blush she stood;
And chose herself the queen, and gave
Her utmost from her heart, "so brave,
 And plays his hymns so good."
(Stanza 29, *PW* 2:134)

In the *Jubilate* Michal is less favorably introduced at B61, associated with her scorning of David, and the suggestion is that Smart was also scorned by *his* wife, who has taken the children and departed for Ireland (in Smart's case she is a Moabite, or Roman Catholic, wife [B56]):

> For Bukki rejoice with the Buzzard, who is clever, with the reputation of a silly fellow.
> For silly fellow! Silly fellow! Is against me and belongeth neither to me nor my family.
> Let Michal rejoice with Leucrocuta who is a mixture of beauty and magnanimity.
> For he that scorneth the scorner hath condescended to my low estate.

Michal (vs. the magnanimous Leucrocuta) recalls the earlier references to David, and the lines following, as Karina Williamson notes, contain names that come "from the house of David: his wives (B61, 70, 98, 102–5), sons (67–85), other kin, officers, servants, etc."[29]

David's transgressive behavior to Smart is "leaping and dancing," but what Michal complains of is that David "uncovereth himself" — the act being committed on Mother Nature in *Boys Peeping at Nature*, of which Jane Thornhill may well have complained.[30] The story of David's singing and the Ark was such a significant moment for Hogarth that in *Harlot* 2 he suggested the parallel with himself (David and Saul, Hogarth and Thornhill) and recalled it in the final, apocalyptic print of his *Election* series, published in 1758, the year before Smart undertook *Jubilate Agno* (above, p. 285). One wonders if Smart's association of himself and his wife with David and Michal was only coincidental.

Both *Magnificat* and *Jubilate Agno*

In fragment B Smart calls his *Jubilate Agno* his "Magnificat." In the first lines of fragment A, however, he also introduced the *Agnus Dei*, the Lamb of God, which embodies proleptically its slaughter and sacrifice, therefore the Atone-

ment/Redemption. He conflates the "Jubilate Deo" of the 100th Psalm with the "Agnus Dei," producing a "Jubilate Agno," as he inscribed it on the first page of the manuscript, but from the start he is also thinking of the Magnificat:[31]

> Rejoice in God, O ye Tongues; give the glory to the Lord, and the Lamb.
>
> Nations, and languages, and every Creature, in which is the breath of Life.
>
> Let man and beast appear before him, and magnify his name together.
>
> (A1–3)

The first line distinguishes God the Father from the Lord Jesus Christ who was the sacrificial Lamb, and the third line calls upon "man and beast" to "magnify his name together." The poem is a litany of rejoicing and praise, not of God's creation but of his aspect as the Lamb, therefore of Incarnation and the second, redeemed creation.

The opening of fragment A continues, with the typically compressed allusiveness of the *Jubilate:*

> Let Noah and his company approach the throne of Grace, and do homage to the
> Ark of their Salvation.
>
> Let Abraham present a Ram, and worship the God of his Redemption.
>
> (A4–5)

Noah, the survivor of the second Fall of man, is connected in the first line with the Grace Jesus offered for man's salvation, embodied in the "Ark of their Salvation," which connects the Arks of both Noah and David with the "Grace" and "Salvation" of Jesus (conflated again in A16, "the Ark of the Testimony"). The sacrificial Lamb is prefigured by Abraham's binding of Isaac, the substitution in the sacrifice of the ram for the beloved son, the type of Jesus' "Redemption" of man with his own (the Lamb's) sacrifice. In the lines following, the OT Isaac, Jacob, and Esau are paired with references to the Redemption ("the hope of his pilgrimage," "the good Shepherd of Israel," and "the blessing of God his father"), and so on to "blessing" (i.e., thanking) "the Lord his people and his creatures for a reward eternal" (the salvation that follows on the Redemption).[32]

Smart could have been remembering hymns like Watts's no. 62, which concludes:

> The whole creation join in one,
> To bless the sacred name
> Of him that sits upon the throne,
> And to adore the Lamb.

In another hymn, however, Watts made a point closer to Smart's: "Wisdom belongs to Jesus too, / Though he was charged with madness here. . . . Blessings for ever on the Lamb / Who bore the curse for wretched men."[33]

More pertinent, in bringing together the Incarnation and the Redemption/Atonement, Smart sets going a theme not too different from Hogarth's in his *Harlot's Progress*. Hogarth used the Incarnation to argue that the lowest of society are of as much value as the "great" (in aesthetic and in political terms) and used the Atonement to argue that the lowest, in our unredeemable society, atone with their suffering for the sins of the great. Smart's argument is that all living creatures are, as established by the Incarnation, inestimable proof of God's immensity, omniscience, power, and goodness. But the time of Redemption is promise only, indefinitely postponed, as we continue to live in a madhouse in a world at war with a church that is definitely (Smart implies) short of redemption. So there is the individual, social and incarnate, and there is the unredeemed milieu, consisting of "the great Folks" (or redeemed only in the sense that there is a hope of heaven and happiness lying somewhere ahead).

Between Resurrection and Redemption

The New Testament texts were interpreted to say that at the moment of his Resurrection Jesus' act of Redemption secured the forgiveness of sins (Rom. 3:24, Eph. 1:7, Col. 1:14, Titus 2:14, Heb. 9:11–15) but the Redemption of the body awaits his return — and the Last Judgment (Luke 21:28, Rom. 8:23, Eph. 1:14, 4:30). In Matthew 24:3–13 Jesus warns of the interim period:

> many shall come in my name, saying, I am Christ; and shall deceive many. . . . Then shall they deliver you up to be afflicted, and shall kill you: and ye shall be hated of all nations for my name's sake. And then shall many be offended, and shall betray one another, and shall hate one another. And many false prophets shall rise, and shall deceive many. And because iniquity shall abound, the love of many shall wax cold. But he that shall endure unto the end, the same shall be saved.

In *Paradise Lost* Milton has the Father explain: "*Then* Heav'n and Earth renew'd shall be made pure. . . . Till *then* the Curse pronounc't on both [heaven and earth] proceeds" (10.638–40, emphasis added), when, as Milton says, echoing Revelation's assurance that in the last days heaven will be both on earth and in heaven,

> Whether in Heav'n or Earth, . . . then the Earth
> Shall all be Paradise, far happier place

Than this of *Eden*, and far happier days.

(12.463–65)

God promises Adam that he and his progeny will become more "Godlike" and will be "Improv'd by tract of time" (5.498), which can mean either by the presence of the Son and his actions and teachings now or simply at the Last Judgment.[34] The condition where "God shall be All in All" (3.341) is not, however, here and now but purely eschatological.

One can be grateful for the demise of paganism and the rise of the Christian religion. But many—from Milton to Hogarth to Blake—did not concur. As Milton saw it, Christ brought men Christianity—his teachings—but also (depending on the perspective) the good or evil of the sacraments (baptism, marriage, confession, as well as the Eucharist). The angel Raphael explains to Adam that after the ministry of the apostles came the Church:

> But in thir [the apostles'] room, as they forewarn,
> Wolves shall succeed for teachers, grievous Wolves,
> Who all the sacred mysteries of Heav'n
> To thir own vile advantages shall turn
> Of lucre and ambition, and the truth
> With superstitions and traditions taint,
> Left only in those written Records pure [the NT]
> (12.507–13)

Milton recalls Jesus' warning to his disciples that they would be "as lambs in the midst of wolves" (Matt. 10:16, Luke 10:3). In fact, the Redemption will occur, the promise fulfilled, only after centuries of continuing suffering and death, which include the corruption of the Christian religion itself (as Milton noted in *Lycidas* as well as *Paradise Lost*), and spent in the grave before the Second Coming and all the struggles leading up to the Last Judgment.

But with the end not imminent, life has to be led in the Roman world—as in Restoration England or Walpole's England. Life continues much as before. In the case of Milton, the clear historical fact is the Restoration of the Stuarts and the corruption of the church: the peculiar situation of the blind Homer or the blind Samson in a world (however blessed) controlled by the Philistines. How to reconcile this historical situation with Paul's idea of the presence of Christ in the world?

In *Paradise Lost* the post-Eden exists all too manifestly. Eden itself is defined as a "middle space," "mid Heaven" where angel or God and man meet. Thus the

middleness (in Pope's words, "this middle state") of their refuge in the fallen world and their constant efforts to recover and rebuild it as a demi-Eden — as by analogy the poet attempts also. The poet with Urania's aid re-creates the Garden but only as a fallen, blind artist in the city of London. One of Smart's earliest poems was a georgic, *The Hop Garden*, and the reconstructive aspect remains in the *Jubilate*'s project for reforming the Church of England.

The theology of the *Jubilate* emerges from the more conventional religious poems Smart wrote before and after. A continuum connects Smart's Seatonian Prize poems of praise of God's attributes with the praise of Jeoffry the cat (though Jeoffry is *offered* in praise of the Redeemer), whose attributes are comic analogues to those in the Seatonian poems. The Seatonian poems first established Smart's reputation as a serious, high-culture religious poet, quite distinct from the career of journalist he was also pursuing in *The Midwife*, *The Student*, and the mock-epic *Hilliad*. The set subjects for the Seatonian poems were the attributes of God — eternity, immensity, omniscience, omnipotence, and goodness, which cover the issues of creation, innocence, and transcendence. However, the year the subject was God's justice Smart did not submit a poem, avoiding the problems of evil and vicarious Atonement. In *Eternity* (1750) he skipped from the Creation to the Eschaton, making only a passing reference to "the two prime Pillars of the Universe, / Creation and Redemption" (lines 54–55). Only in *Power* (1754) did he seriously attempt the transition:

> tis man's redemption
> That crowns thy glory, and thy pow'r confirms,
> Confirms the great, th' uncontroverted claim

— that is, to supremacy (lines 110–12; 4:277). But the form Redemption takes is conventional and deferred — peace on earth, victory over death and hell, and everlasting life as a pastoral idyll.

Another Seatonian prize poem, "The Redemption" (1763), by John Hey, a fellow of Sidney Sussex College, Cambridge, attempts to justify or vindicate the Redemption. Hey's poem is mediocre but interesting — partly because it is so orthodox, mapping out the difficult territory between the Incarnation/Redemption and the Last Judgment. To explain the problem — and the supposed benefits — of the Redemption, he returns to the paradox of the Incarnation: God, in "form of Man," though "spotless, bears th'infirmities of guilt, / And tho' disguis'd, impair'd, disfigur'd, clog'd, / Displays it [the form of man] in it's genuine purity" (lines 240–41). But this takes place in a world where Christ experiences

"Mis'ry at ev'ry glance! . . . O Treachery! Ingratitude! Blind Scorn!" "Blest innocence!" he exclaims, "How dost thou groan beneath those dreadful pangs / Which Guilt that only caus'd, shou'd only feel!" (lines 249–54). What seems to concern Hey is the fact that though Christ, after *his* misery, "from the cold grave / Triumphant rises, / From this gross earth, and claim[s] a purer air: / At the right hand of Majesty on high / To sit, with never-fading glory crown'd" (lines 285–94), he nevertheless leaves unanswered the question of what happens to the men whose form he temporarily assumed and whom he "redeemed." True, this "great, stupendous sacrifice" has "avail[ed] to draw the pois'nous sting of Death" at the Last Judgment. But what purpose in the meantime does it serve?[35]

It took Smart's *Hymn to the Supreme Being on Recovery from a dangerous Fit of Illness* (1756) to prepare the way for the problematics of his *Jubilate*. Smart's illness and emotional crisis—alcoholism, probably syphilis, and certainly fear of damnation for the sins of his past life and for "those rakish values reflected in his earlier writings"—came in the spring of 1756 accompanied by a conversion experience.[36] Smart's theological position was Church of England but with a strong evangelical strain that let itself be known when, after his conversion, he took to praying in the streets of London. He considers his experience, however, one not of conversion but of "Redemption and Forgiveness." He speaks of the hope that "he's Christ's own case— / O all-sufficient Lamb!" (lines 40–41). As a conversion experience, this is similar to Robinson Crusoe's illness and "vision," characterized by the passivity of the man—and the agency of Christ. Smart's imagery is of redemption, renewal, and restoration ("exil'd reason takes her seat again," line 46), with his wife and family still around him (in *Jubilate* they have deserted him). As if filling in the absent poem about God's justice, while praising the Father ("the Supreme Being"), "Whose power's uncircumscrib'd," he turns to the Son:

> But yet whose justice ne'er could be withstood,
> Except thro' him—thro' him, who stands alone,
> Of worth, of weight allow'd for all Mankind t'atone!
>
>
>
> My feeble feet refus'd my body's weight,
> Nor wou'd my eyes admit the glorious light,
> My nerves convuls'd shook fearful of their fate,
> My mind lay open to the powers of night.
> He pitying did a second birth bestow

A birth of joy — not like the first of tears and woe.

(lines 58–60, 67–72; 4:321–22)

Thus in *Jubilate* it is the sun (son) of God that makes beautiful creation — the dock or hemlock or the song of the linnet.

In Smart's *Hymns and Spiritual Songs,* published after his release from confinement (1765), the "Crucifixion of our Blessed Lord" recalls not the Redemption but the miracles and the ungrateful mob that crucified Jesus, taken to be the final evidence of Original Sin (conflating the cross and the Tree of Knowledge) that his Redemption will forgive in some interval of his Father's wrathful justice:

Lay not this horror to our charge,
 But as we fast and weep,
Pour out the streams of love profuse,
Let all the pow'rs of mercy loose,
 While wrath and vengeance sleep.

(lines 98–102; 2:51)

It is in the hymn of "The Ascension of our Lord Jesus Christ" that he treats the Redemption and offers a gloss on *Jubilate.*

For *not a particle of space*
 Where'er his glory beam'd,
With *all* the modes of site and place,
But were the better for his grace,
 And up *to higher lot* redeem'd.

(lines 11–15; 2:60, emphasis added)

The significance of attaching Redemption to the Ascension rather than to the Crucifixion or the Last Supper may be to emphasize the triumph of the whole incarnate life and not merely the death. But the hymn ends with two stanzas that fill in the remainder of the grim *Jubilate* story:

The song [of these redemptions] can never be pursu'd
 When Infinite's the theme —
For all to crown, and to conclude,
He bore and bless'd ingratitude,
 And insult in its worst extreme.

(lines 56–60; 2:61)

The redeeming figure is persecuted on Earth by the very creatures he is redeeming (he "bore and bless'd ingratitude"). Only then, with the crucifixion (the act of Redemption), "having then such deeds atchiev'd / As never man before," does he ascend to heaven "To reign with God for evermore" — "[f]rom scorn and cruelty repriev'd," that is, by God the Father who sentenced him to incarnation and crucifixion. He is, after all, leaving the redeemed creatures still full of "scorn and cruelty." Their "natures" have not yet but only prospectively "recurred / To what they were in Eden's field." The cruel and evil "great Folks" (Mary Midnight's phrase) remain somewhere opposite the poor and low who were sacralized by Incarnation. Smart is therefore ambivalent toward the era of Redemption: He celebrates its effects on all creation but remains himself locked in a madhouse (as Christ was whipped and crucified), but even he, the lowest of creatures, is sacralized by Christ's intervention — the result of the Incarnation if not of the Redemption.[37]

A question raised by Smart's combining *Magnificat* and *Agnus Dei* is whether he is talking about the Incarnation only — which is really just what the Magnificat celebrates. The Magnificat is the form Smart gives his hymn on "The Nativity of our Lord and Saviour Jesus Christ" (no. 32): He evokes the "stupendous stranger," "MOST HOLY," "so mean and lowly," "O the magnitude of meekness!" — and concludes:

> God all-bounteous, all-creative,
>> Whom no ills from good dissuade,
> Is incarnate, and a native
>> Of the very world he made.
> (lines 32–36; 2:89)

He means "made" *then*, before assuming human form. As Marcus Walsh and Karina Williamson note, the last two lines are based on John 1:10, in the context of Incarnation: "He was in the world, and the world was made by him" — which elides Christ's agency once in that world and his redemption of it. It is the Incarnation that sacralizes creation at the moment of the Nativity. *Jubilate* thus celebrates God's Incarnation — by which the true value of all (fallen) creation was established.

And yet, while primarily about the Incarnation, as the title "Nativity of our Lord and Saviour" reminds us, the poet's instruction is: "Shew me where my *Saviour* lies." The question Smart raises in *Jubilate* is: When *is* a creature re-

deemed (as opposed to honored by Christ's Incarnation as man)? Is there any appreciable difference in the interim between Incarnation and Last Judgment, given the reception the Savior himself received on earth — and our empirical evidence of current history? This is the scene Smart presents — the glory of creatures sacralized by the Incarnation but the sad state of the same awaiting the results of Redemption. According to Milton in his "On the Morning of Christ's Nativity," on which Smart based his "Nativity of our Lord and Saviour," paganism and the classical gods dwindle and the religion of Christianity (the "blind mouths" of its priests) comes to fill the space — but, as he notes in "Lycidas," this is not necessarily a good thing or a good time.

Redemption of the Unclean

Smart reconciles the Old Testament and the New by way of the Redemption — as he also did in his translations of the Psalms, for example, his version of Psalm 137: "O daughter of Babylon, who art to be destroyed happy shall he be, that rewardeth thee as thou hast served us. Happy shall he be, that taketh and dasheth thy little ones against the stones" (137:8–9). Smart's revision redeems the Psalm for the New Testament:

> Renown'd the man! That shall reward
> And serve thee as thou'st serv'd the Lord,
> Thou shalt thy turn deplore;
> There's desolation too for thee,
> Thou daughter of calamity,
> And Babylon no more!
> But he is greatest and the best,
> Who spares his enemies profest,
> And Christian mildness owns;
> Who gives his captives back their lives,
> Their helpless infants, weeping wives,
> And for his sin atones.
> (lines 43–54; 3:355–56)

Smart modifies the ending, substituting Christ's Atonement for the wrath of the OT God. (Watts, who was also thought of as one who Christianized the Psalms, simply omitted Psalm 137 from his translation.)

One way the Redemption applies is in the treatment of the unclean creatures

of the OT. Both grace and prank apply to the abundant list of animals, clean and unclean (camel, snail, and swine), a redemption that Jesus' coming performed on those unfortunate beasts rendered "abominations" by Leviticus. In the line, "Let Shemaiah bless God with the Caterpillar — the minister of vengeance is the harbinger of mercy," the "minister of vengeance" and "harbinger of mercy" indicate the moment of transition between Old and New Covenants, confirmed by the allusion to the centurian Cornelius, associated in Acts with Peter's vision of God's cleansing of "all manner of fourfooted beasts of the earth, and wild beasts, and creeping things, and fowls of the air" (Acts 10:12).[38] Cornelius "*purifyeth* all things *for the poor,*" that is, for the lowly who, in the Incarnation and in Mary's Magnificat, are raised up.

The transgression, uncleanliness, and lowness of the Levitical laws is what Smart, writing in a madhouse, proclaims as the "redeemed" in *Jubilate.* He notes the very wide scope covered by the term *unclean* in all the elements, of air, sea, and land.[39] Smart is saying that in his Magnificat he is revealing the sacredness of even this waste matter that partakes of Christ's Incarnation — of the very worms to which man is compared. *Jubilate Agno* is another *Dunciad,* which ironically but orphically redeemed the waste matter of British culture. Smart is offering up the detritus Pope exhumed — the lowest, least promising subject of poetry — to worship the Redeemer, in the context of Incarnation and Redemption. But Smart redeems the whole range of Levitical abominations as well as the narrower subject of *The Dunciad.*[40] And in Smart's case there is added a pervasive pity that extends to all such hack work, including the very journeyman work he produced himself between his Seatonian odes and the hymns and psalms, as it must have seemed from the Popean perspective, which was one of Smart's perspectives.

Thus the focus on the most humble creatures — not only cats and dogs but mice, fleas, toads, and gnats — and Smart himself. This is partly the result of the milieu in which he was writing, George Potter's private madhouse at Bethnal Green. Some of the mad are named, and all are contemporary, living creatures, as against the biblical names addressed with God's name.

The structure of Smart's *Let-For* responses is roughly this: Let [an OT figure] rejoice with [an animal, plant, etc.] *in order to* bless Jesus in [some respect]. For I [or some contemporary] have been raised or magnified by Him [Jesus] — or through Him reflect the magnification of God's creation. Jesus is being praised for magnifying us by his Incarnation.[41] *Let,* I believe, operates in its sense of "give opportunity to or permit" rather than the imperative, the deity's "Let there be light."[42] In other words, the poet (the Psalmist) Smart sees himself not in the God

position but in a position of praise, magnification of the magnifier, and so one of the hopefully redeemed:

> Let Elizur *rejoice* [vs. *bless* in A] *with* the Partridge, *who is* a prisoner of state and is
> proud of his keepers.
> For *I* [Smart, like the partridge in *his* prison] am not without authority in *my*
> jeopardy, which I derive inevitably from *the glory of the name of the Lord.*
> (B1, my emphases)

Elizur and Shadeur were both (son and father) followers of Moses through the Wilderness. In the present context Smart uses them as types of himself, in the "For" lines, in the madhouse writing his *Jubilate*, working his way out into the Promised Land. The second half of the first *Let* line has the partridge in its cage, referring to Ecclesiastes 11:30, where the caged partridge is compared to "the heart of the proud," and so in the madhouse context, Smart is "proud of his keepers." "I," Smart, in the *For* line is therefore "not without authority in my jeopardy, which I derive inevitably from the glory of the name of the Lord," that is, Jesus, the Savior, *his* keeper.[43]

The OT name appears in A to balance the creature (partridge).[44] That "jeopardy" refers to Smart's own imprisonment in the madhouse is confirmed by B560, which refers to "the Fifth year of my jeopardy June the 17th N.S. 1760."[45] In general, the contrast is between OT and NT, Elizur and the Lord (the Lamb, Christ), with Smart himself (and the partridge) in the middle, between wrath or justice and mercy. The *Let* line is general and OT, the *For* line is personal, local, and English. The *For* line adds the present, contemporary scene, often directly personal, transient, and fallen, redeemed by the reference to the Savior/Lamb, but also public and newsworthy — a microcosm of jeopardy and uncertainty in the public context of England and the Seven Years' War. Smart conflates the public with the private, which is his own confinement, his own domestic situation (confined by his wife and family, who took his daughters away to Ireland, perhaps bringing them up as papists). All are concentrated in B4–8, where he calls on God to "send good Angels to the allies of England!" (I am skipping the *Let* lines):

> For I bless the PRINCE of PEACE and pray that all the guns may be nail'd up, save
> such as are for the rejoicing days.
> For I have abstained from the blood of the grape and that even at the Lord's table.
> For I have glorified God in *Greek* and *Latin,* the consecrated languages spoken by
> the Lord on earth.

For I meditate the peace of Europe amongst family bickerings and domestic jars.

For the HOST is in the WEST — the Lord make us thankful unto salvation.

The "PRINCE of PEACE" refers both to Smart's hope for an end to the Seven Years' War and to the Son/Lamb, while "nail'd" refers to the preceding line about Jael, who drove a nail through the enemy general Sisera's head, an allusion that applies both to his hope that "all the guns may be nail'd up" and to his own inimical wife. "Host" connects the family supper with the "Lord's table," the host of the army fighting in the American zone of the war with the "consecrated" host associated with the more general Prince of Peace and "salvation."

Smart has "glorified God in *Greek* and *Latin*, the consecrated languages," and he has embedded (or embodied) the Greek and Latin in the experiential moment — the daily journal he is keeping. Smart's original claim to fame was for his brilliance at Latin composition — the reason for his association with Pope, who felt his work would be more permanent translated into Latin. The Seatonian Prize poems, however, were required, in the terms of Thomas Seaton's bequest, to "be always in English."[46] The use of forms of liturgy to frame himself, his marriage, the war with France, and particular people and events quite literally joins the sacred and the vernacular in order to recover, redeem, and regenerate it (though he usually retains the Latin names of Linnaeus for his animals). The *Jubilate* is a genuine *parodia sacra* in that Smart takes the Latin *Jubilate Agno*, *Magnificat*, and *Benedicite* and Englishes them — retaining the biblical cadences while inserting demotic language and national, personal, and local references.

In the 1750s, when he married and was therefore no longer entitled to a Cambridge fellowship (when he had annually won the Seatonian Prize for a poem praising an aspect of God), Smart settled in London and into writing whatever earned him money. Now, "living in London among a new set unable to appreciate Latin verse," he became himself part of the demotic and bore a peculiarly personal relationship to the parody.[47] He transformed the ephemera of London hack writing into his own English couplets, yet he felt that his English carried less permanence than a translation into an enduring language, Latin — and so he introduces the demotic into which he has fallen in the fleshpots and markets of London. This work, which with Pope he would have regarded as hack work, opened up for him a comic potential that both contradicted and supplemented his "serious" poems and in a particularly Scriblerian way, a way that led him in *Jubilate* to thank God for Gay, Pope, and Swift (B84).

The Cornu-copia

Allusions to the horns of the cuckold appear associated not only with David and Michal but with Smart and his wife, property, and inheritance, erupting in the word *wittol*, the contended cuckold (B46, 48, 52, 58).[48] The references conflate sexual and poetic virility (loins/lines of poetry) at B80, and at B115, following "humiliation upon humiliation" (B112): "Let Michal rejoice with the Horned Beetle who will strike a man in the face. / For they throw my horns in my face and reptiles make themselves wings against me." Then follows a passage on Joseph and Mary, another married couple: Joseph is associated with the turbot — its size, its fate as food (in a verse written on the eve of 8 September, the Nativity of the Virgin Mary):

> Let Joseph rejoice with the Turbot, whose capture makes the poor fisher-man sing.
> *For the poor gentleman is the first object of the Lord's charity and he is the most pitied who*
> *hath lost the most.*
> Let Mary rejoice with the Maid — blessed be the name of the immaculate
> CONCEPTION.
> *For I am in twelve* HARDSHIPS, *but he that was born of a virgin shall deliver me out of all.*
> (B138)

The "poor gentleman" is Joseph of the cuckold jokes, and "the Lord's charity" is the gift of Jesus by Joseph's virgin wife Mary, and so Joseph is "the most pitied who hath lost the most." "Maid" is a pun on the fish, a young skate, and the Virgin Mary and the immaculate conception, as well as the "maiden" or "virgin" of Isaiah 7:14. The last line conflates Hercules' labor applied to Smart with the Virgin Birth and Christ who "shall deliver [redeem] me out of all" these hardships (labors), and the following verses pursue the idea of Christ's Redemption. As a structuring device, the list of apostles is followed by Joseph's genealogy from Luke (3:23 ff.).

Smart's association of himself with both Mary (Mary Midnight, Mary the Mother) and Joseph is by way of the horn, which points the way to both the sign of a cuckold and, in fragment C, the horn of triumph, plenty, and jubilation. In the Benedicite, we read: "Blessed be the Lord God of Israel; for he hath visited and redeemed his people. And hath raised up an horn of salvation for us in the house of his servant David" (Luke 1:68–69). The play is on the double sense of horns, as insult and humiliation and as power, victory, glory.[49] In the horn Smart

found the profound ambiguity of weakness and power (what Hawes refers to as "horns of potency and plenty with the horns of a cuckold"),[50] defeat and victory, and so of the Crucifixion itself (the mocking of Christ, the triumphal return) and Smart's own situation in the madhouse but writing his praise of the Lamb in his *Jubilate*.

In fragment C, Smart transvalues the horn. "I prophecy that we shall have our horns again. . . . For in the day of David Man as yet had a glorious horn upon his forehead" (C118 ff.). The reference is both to David and Michal and to the age of giants preceding and, he hopes, to follow, when horns will have a positive sense. The horn was, above all, the musical instrument announcing the Jubilee and, for Smart, the new world or salvation (C152)—which becomes the horn of plenty, the cornucopia (C153). The celebration of the horn brings together Moses (his horn, or ray of light), the Tabernacle (holding the Covenant of the Law), the ambiguity of the Second Covenant, and Joseph's cuckold's horns that are also signs of the Incarnation and so salvation and abundance.[51]

To accomplish the Redemption, Christ *gave up* his horn—his symbol of power (the "brightness" of Moses, phallic supremacy) when he became man, emptying himself of godhead; his fall was embodied most personally and closely in his human "father," Joseph, the proverbial cuckold.[52]

For our Blessed Saviour had not his horn upon the face of the earth.
For this was in meekness and condescension to the infirmities of human nature at
 that time.
For at his second coming his horn will be exalted in glory.
For his horn is the horn of Salvation.
(C147–49, only the *for* lines)

The last reference is to Psalms 18:2 and 2 Samuel 22:3. So Christ gives up his horn "on the face of the earth"—in "condescension [that favorite word of Watts's Eucharist hymns] to the infirmities of human nature," but Smart announces the recovery of his horn. "For Christ Jesus has exalted my voice to his own glory. / For he has answered me in the air as with a horn from Heaven to the ears of many people," that is, the ram's horn, the musical instrument, that is blown to announce the Jubilee (introduced with the title of his poem).[53]

The horn of *Jubilate* comes five or six years after Hogarth published his *Analysis*. In Hogarth's text there is simply the cornucopia, which Hogarth uses as an example of the greatest variety of forms within a whole that both contains and does not quite contain them (the discovery of the utmost variety within apparent

unity; the enclosure of the greatest number of parts within a whole). This is the figure that contains the most serpentine lines of beauty and grace, the object that best represents the principle of plenitude[54] — what Smart refers to as the "innumerable": "For nature is more various than observation tho' observers be innumerable" (B53). But in plate 2 (see fig. 45), where Hogarth pictorially elaborates with "prank" the rather dry theory of his text, he shows the elderly cuckolded husband (his wife receiving a letter from her young lover) and in the margin, below and to the left of the husband, he adds a series of horns from ram's horn to cornucopia (p. 12; Hogarth's figs. 56–59; our fig. 49). For Hogarth and Smart the horns began with antlers, but the single horn signifies as both lack and power, as Smart makes emphatically clear. The series at the bottom of plate 2 progresses from a simple cone to various forms of horn elaborated until the last seems transformed into a pelvis, which is directly below the cuckolded husband and his wife (his figs. 60–61); although it is not clear whether male or female, it obviously refers to what is going on above.

In plate 1 the cone appears in figure 26, turned on its side and encircled by the Line of Beauty. On its back, so to speak, this is the pure, abstract form that is fleshed out directly beneath in the vertical figure of Venus (see figs. 47 and 48). And in plate 2, above the series of figures, from cone to horn to cornucopia to pelvis, is a live woman — not, in Hogarth's terms within his text, a sculpture but a living woman. And, of course, more complex than the cornucopia is the human form, where the serpentine lines pervade the interior of the body as well as appearing on its surface — and it is in the human, preferably female, body that he finds "the utmost beauty of proportion."[55] This beautiful woman is in process of cuckolding her husband (thus the horns), demonstrating the relationship (outlined on the title page of the *Analysis*) between beauty and, not (as Shaftesbury had argued) virtue, but seduction and adultery, reflecting Hogarth's libertine genealogy of the "pleasure of pursuit" and the "love of the chase." On the title page, we have seen, the Tetragrammaton was replaced by the Line of Beauty *as* a serpent, under an epigraph from *Paradise Lost* describing the serpent's seduction of Eve.[56]

I think it likely that, given their shared discourse of aesthetics, Hogarth may be the missing link in the association between cuckold horns (beginning with Hogarth's *Skimmington* of 1726 and the wallpaper design in *Harlot* 2) and the ideal form of the cornucopia — as well, of course, as the strain of the Magnificat that runs through both the *Analysis* and *Jubilate* in its idealizing of the low, common utensil and the "living" woman.

The cornucopia as a generative symbol is, of course, a female principle — and Hogarth in plate 1 parallels the upright Venus with the recumbent Venus abstracted into the form of a cone twisted around with a Line of Grace — the beginnings of the horns in plate 2 — as well as with the flowers, fruit, and other figures that surround his plates.[57] The Ark is another womb like Mary's — a second, new womb for the post-Flood renewal of humankind.[58] Of course, the horn is both the male generative organ (the horn has become a plow in C156) and, as a cornucopia, the female womb overflowing with abundance. As opposed to Hogarth's unambiguous woman, Smart's is a male-gendered figure that wears the disguise of the woman (and so Smart with his male cat vs. Hogarth's female cat) and thus projects the ambivalence of Smart's cornucopia.

Smart has added his conflation of the poet-singers Orpheus and David to the female voices of Hannah and Mary (B458, 43), the biblical mothers who combine song and fertility, poetic creativity and the female womb.[59] These women create what is in some way a second reality, different even from the celebrations of Orpheus for his loss of Eurydice. Smart, associating himself with Mary, is not the creator per se (God) but a *bearer* of the Redeemer (of the Redemption). As he puts it, "For I bless the Lord JESUS for his very seed, which is in my body" (B144). More than its mere celebrator, he carries the seed of redemption (of the church, of Christ's religion) within his poetry: and so another reason for his association with David, who, unlike Orpheus, is another singer of praise of God who also bears within him the seed (on the female side) of Jesus *and* Mary.[60]

In *Analysis* plate 2 (see fig. 49), in the margin, directly to the right of the trio of elderly husband, beautiful young wife, and her lover (passing her a note), is the diagrammatic figure of Sancho Panza illustrating the curve of surprise — (1) in the Coypel illustration from which Hogarth has copied him, at Don Quixote's attack on the puppet show, mistaking its illusion for reality (he wishes to save the princess); (2) inside the representation, at the transgressive behavior of the beautiful woman; and (3) in the opposite margin, at the diagrammatic figure that balances him, the Woman of Samaria (from Annibale Carracci's painting in the Brera, Milan), who illustrates in Hogarth's text Lines of Beauty embodied in a woman's body, but also the lady whom Jesus exposed as an adulteress (his figs. 74 and 75; our figs. 45 and 49).[61]

Hogarth's illustration is constructed spatially in a way very similar to the allusions we have noted in Smart's *Jubilate*. Both employ polyvalent figures that operate spatially rather than serially. This is natural enough in Hogarth's graphic form, but in the *Jubilate* Smart, despite the gestures at the encyclopedic and

alphabetical orders, shows little interest in consecutive or diachronic reading. As in a Hogarth scene (a sculpture yard, a country dance), there is also much else going on out of which the reader extrapolates certain threads, following one and subordinating others. Within the structure of the alphabet, the list of animals, colors, musical instruments, and plants, there are divergent strands to be picked up — based on the same curiosity, pursuit, and discovery. So also the polysemous quality: Mary Hackabout is a modern Hercules, Mary the Mother, and the Savior, as the Ark is a reference to Moses, David, and Christ. Indeed, much as one does in a "modern moral subject," one discovers and elucidates the doctrine of his aesthetics in the illustrations, rather than in the words, of the *Analysis*, where Hogarth's expression and exposition are obviously less subtle and completely rendered. As the passages I have cited in the *Jubilate* show, Smart uses the vocabulary of Hogarth's aesthetics — and, though in an ostensibly linear progression, its synchronic (spatial) practice as well.

But if Hogarth has produced an aesthetics based on the emptying, bringing down to contemporary life, or iconoclasting of religious symbols (as in the case of the Tetragrammaton on his title page), Smart has recovered Hogarth's aesthetics (and, so far as I can see, no one else's) for religion. As with Hogarth, this is not the Sublime but the Novel — diurnal and of our time, embedded in history and autobiography, with particular names, dates, and personal references, all summed up in a particular cat, Smart's own, named Jeoffry. The cornucopia and the liturgical encyclopedia celebrate not original but redeemed Creation, not the Creator but, in every case, the Redeemer and fallen creation redeemed in history. This is the plenitude Smart so notably celebrates and himself incarnates in the Popean sense by recreating and representing, giving "presence" to, the most corporeal creatures — in particular Jeoffry, whose play is placed within a structure of Christian worship (the Ten Commandments, Revelation's Seven, Jesus' command to love thy neighbor, the admonition to preserve the Sabbath, and so on). Beauty, as the serpentine line, as variety, play, prank, pursuit, and discovery, is recovered in the context of Christianity.

While Smart blesses "the Lord Jesus for the memory of GAY, POPE, and SWIFT," he adds, as if reclaiming the mock heroic for the Magnificat, "For all good words are from GOD, and all others are cant." The capitals make the four names seem parallel; and, as if applying the recovered, sanctified mock-heroic as Magnificat to himself: "For I am enobled by my ascent and the Lord haith raised me above my Peers" (B84–86). These lines are followed shortly by his account of the consequences of his praying in Saint James's Park.

This is a "new" poetry Smart is writing — a "NEW SONG" (B390) and new way

of writing (D84, quoting Virgil). As critics have said, he is a "creator by introducing something new," certainly "poetic innovation,"[62] but Smart's stated aim is to rejuvenate the Church of England ("For by the grace of God I am the Reviver of ADORATION amongst ENGLISH-MEN," B332), specifically the bread on the Eucharist altar.

> Let Nicanor rejoice with the Skeat — Blessed be the name of the lord Jesus in fish
> and in the Shewbread, which ought to be continually on the altar, now more
> than ever, and the want of it is the Abomination of Desolation spoken of by
> Daniel.
>
> (B205)

The Shewbread refers to the Eucharist and Smart's "High Church feeling about the decline of Eucharistic observance,"[63] but the fish and honeycomb referred to in B221 ("Blessed be the name of him which eat the fish and honey comb"), 243 ("Broild fish & honeycomb may be taken for the sacrament"), and 236 ("Fish and honeycomb are blessed to eat after a recovery") was the food of the *resurrected* Christ (Luke 24:42).[64]

> For NEW BREAD is the most wholesome especially if it be leaven'd with honey.
> For a NEW SONG also is best, if it be to the glory of God; & taken with the food like
> the psalms.
>
> (B389–90)

Smart the poet is attempting to redeem the vernacular, the Church of England service, by making it demotic, perhaps an equivalent of his praying naked in the streets. But it is important to notice that Smart uses the word *altar* and imagery of sacrifice, as opposed to the Hoadlian model of communion. Even Joab, David's general, killed "at the altar praying for his posterity," is made a type of Christ's sacrifice (Joab, "whose death was the type of our Saviour's") (B433–34).

Fragment C, the strangest of Smart's fragments, moves into apocalypse. Smart seems to prophesy a triumphalism looking back to Nayler's God-in-us and forward to Blake's New Jerusalem. The verses are briefer, simpler:

> Let Ramah rejoice with Cochineal [both insect and dye].
> *For H is a spirit and therefore he is God.*
> (C1)

Now the contemporary place is filled by a letter of the alphabet, and Smart plays on the pun of *aspirit* and *a spirit;* the divine clause in this case says that the letter H, an aspirit, is a spirit, therefore the deity.

> Let Gaba rejoice with the prickly Pear, which the Cochineal feeds on.
> *For I is person and therefore he is God.*
> (C2)

Again, the letter of the alphabet, but now the pun is on the letter *I* and the first person singular pronoun, Smart the poet. He — the human — is divine. And so in the following lines, the king, love, music, novelty (N for the aesthetic of novelty, based on variety, Smart's own) — all of these are divine, and the result of Redemption seems to be that we are all God but in a particular sense in which aesthetics and religions have come together as neatly as the Magnificat and the Jubilate Agno.

Fragment C progresses from the redeemed to the triumphal fulfillment of the Redemption on this earth, prophesied by David/Smart but still based on Mary's Magnificat, embodied in the deeply ambivalent image of the horn. The Welsh and the leek prompt the cry, "David for ever!" (C18, meaning St. David, the patron of Wales), and the alphabet is followed by numbers, and before long Smart begins to prophesy. Now the OT David becomes Orpheus, another "cunning player on the harp" (C53), though still with a troubling relationship with his wife — and singing out of this troubling experience. The orphic prophecy is a generalizing of Smart's condition and of the assumptions of the earlier fragments:

> Let Aziza rejoice with the Day lily.
> *For I prophecy that the praise of God will be in every man's mouth in the Publick streets.*
> Let Zabbai rejoice with Buckshorn Plaintain Coronopus.
> *For I prophecy that there will be Publick worship in the cross ways and fields.*
> (C62–63)

This passage reprises B89–90, about Smart's worshiping in Saint James's Park. Everyone now will be praying in the streets and naked in the rain (C113), even dancing: "For I prophecy in the favour of dancing which in mutual benevolence is for the glory of God" (C94). This is utopia, paradise on earth, the New Jerusalem, which Smart sums up as the Age of Horn. If Smart is playing with a theory of Immanence — the cat is a sign of grace, of Christ's Redemption — it becomes in fragment C an expression of Christ's Incarnation in each of us. The relationship is what he constantly stresses — the poet, the creature, the blessing, and God.

Jubilate is concerned with the beauty of the unclean, beauty discovered and conferred by, as he saw it, Christian worship. Smart joins aesthetics and religious devotion — or attempts to rejoin, for he is celebrating impossible jointures, made possible only by Christ's Redemption, such as the performances of Jeoffry the cat

and David the psalmist. These are comic as the juxtaposition of incongruities — a cat and a Christian, the Psalmist who celebrates the Ark and makes a fool of himself, both proto-Christ and sinner-poet. Insofar as *Jubilate* succeeds, Smart makes salvation beautiful and beauty salvific — universal, of *all* creatures, eliminating the OT distinctions between clean and unclean, as well as the aesthetic distinctions between beautiful and ugly.

So the discourse of Redemption persists in *Jubilate*, often as lower-case redemption — and it is in this pun that the play originates between religion and aesthetics, and we see how, after replacing religion, aesthetics (Hogarthian aesthetics, Popean poetics) is reclaimed by Smart for religion. The redemption of the fallen creates an aesthetic object, as the Redemption of the fallen creates (recreates) a saved person, and if we can mark a swing from religion to aesthetics, we can also mark one back from aesthetics, reclaimed or sacralized, to religion.

Mediation — aesthetic mediation, which was Hogarth's point of rest — does not figure in the imagination of Smart, despite his concern with the middle area between redemption and resurrection where mediation usually operates. Smart does not see himself as a mediator, nor is he concerned with figures who, within the middle area, serve as mediators (Jeoffry a mediator?). However much he relies on Hogarthian principles of aesthetic appreciation, he is concerned with poetic redemption, as if in the manner of Pope. But, of course, Smart *praises*, only offering to redeem in the restricted sense of his desire to bring about reforms in the Church of England. Praise in *Jubilate* cannot redeem but only, in the manner of David the Psalmist, celebrate the glory of God's transactions with believers, in Smart's case Christ's Redemption of *all* things. He celebrates rather than (as with Milton and Pope) reenacting the Redemption. Insofar as he redeems it is his recovery of aesthetics for religion — an aesthetics that had been extracted or stolen from religion by Shaftesbury, Addison, and Hogarth. But it is specifically the Hogarthian aesthetics — the aesthetics Hogarth had recovered from religious worship, doctrine, and belief — that he re-invests with religious belief.

Blake

The Harlot and the Lamb

"The Youthful Harlot's Curse"

Blake is the obvious end of a study of "sacred parody." Parody was his starting point in the unpublished "An Island in the Moon" and in his earliest published works. In *Songs of Innocence*, he parodies children's verses, especially Isaac Watts's *Divine and Moral Songs for Children*. In *The Marriage of Heaven and Hell*, he starts with a parody of the forms and assumptions of Swedenborg's *Heaven and Hell*, turning the Swedenborgian theology on its head, and reverses the values of Jacob and Esau, the Israelites and the Ebonites. In the works beginning with *The Book of Urizen*, he writes, as he promised in the *Marriage of Heaven and Hell*, a "Bible of Hell," the angel's Scriptures retold by the devil and painted to recall illuminated manuscripts of the Bible. In *The Book of Urizen* and *The Book of Los*, he rewrites Genesis, and in *Ahania* the remainder of the Pentateuch.

In "The Everlasting Gospel," the summation of his "Bible of Hell," drafted late in life, Blake points out that Jesus gave no "Lessons of Chastity," and he adds: "The morning blushd fiery red / Mary was found in adulterous bed":[1]

> Earth groand beneath & Heaven above
> Trembled at discovery of Love

Jesus was sitting in Moses Chair
They brought the trembling Woman There
Moses commands she be stoned to death
What was the sound of Jesus breath[?]
(E512)

The reference is to Jesus' defense of the woman who is accused of adultery. In another draft, Blake asks:

Was Jesus Born of a Virgin Pure
With narrow Soul & looks demure[?]
If he intended to take on Sin
The Mother should an Harlot been[.]
Just such a one as Magdalen
With seven devils in her Pen
(E794)

Blake conflates the two Marys, Virgin and Magdalen, with the woman taken in adultery and sets them against the Mosaic law. His use of "harlot," like Hogarth's, draws attention to the two senses of the word, OT and NT: those who worship a false god, an alternative to their husband Jehovah (Deut. 31:15), and the kind of person Jesus associated with — not priests but harlots and publicans ("the Publicans & Harlots he / Selected for his Company" [E512]); and raises the impious suggestion of subculture skeptics that his own mother, supposedly a virgin, was no better than she should be.

In the expanded allegory of *Jerusalem* (1804), in Blake's retelling of Matthew 6:14, Mary says to Joseph:

 If thou put me away from thee
Dost thou not murder me? Joseph spoke in anger & fury. should I
Marry a Harlot & an adulteress? Mary answerd, Art thou more pure
Than thy Maker who forgiveth Sins & calls again Her that is Lost
Tho she hates. he calls her again in love. I love my dear Joseph
But he driveth me away from his presence, yet I hear the voice of God
In the voice of my Husband, tho he is angry for a moment, he will not
Utterly cast me away. if I were pure, never could I taste the sweets
Of the Forgive[ne]ss of Sins! If I were holy! I never could behold the tears
Of love of him who loves me in the midst of his anger in furnace of fire.
(plate 61, E209)

The story of the Virgin Mary hoax entered Blake's work fairly late—late enough to have been inspired by his friend Thomas Paine's *Age of Reason* of 1794.[2] Paine retold the joke in the safer ambience of the French Revolution, when it reflected the jokes about young parvenus cuckolding King Louis XVI with Queen Marie Antoinette. Discussing belief, probably drawing on such works as the *Traité des Trois Imposteurs*, Paine opens with the story:

> When also I am told that a woman called the virgin Mary, said, or gave out, that she was with child without any cohabitation with a man, and that her bethrothed husband, Joseph, said that an angel told him so, I have a right to believe them or not; such a circumstance required a much stronger evidence than their bare word for it; but we have not even this—for neither Joseph nor Mary wrote any such matter themselves; it is only reported by others that *they said so*—it is hearsay upon hearsay, and I do not choose to rest my belief upon such evidence.

In the deist manner, Paine connects the story—that Jesus was the Son of God—with the Ovidian stories of Jupiter cohabiting with human females and producing demigods: "It is curious to observe how the theory of what is called the Christian Church sprung out of the tail of the heathen mythology. A direct incorporation took place in the first instance, by making the reputed founder to be celestially begotten." He adds, indicating one motive behind Hogarth's subscription ticket for his *Harlot*, *Boys Peeping at Nature*, that "the statue of Mary succeeded the statue of Diana of Ephesus," the iconographic Nature (53). In the retelling in part 2 of *The Age of Reason* (1795), the story has become the jest: "Were any girl that is now with child to say, and even to swear it, that she was gotten with child by a ghost, and that an angel told her so, would she be believed? Certainly she would not."[3]

Blake recovers the Joseph joke as belief, with the authority of Luther behind him: In order to redeem mankind, Jesus took on humanity in its totality, including sin (see p. 97). The passage in "The Eternal Gospel" continues:

> Or what was it which he took on
> That he might bring Salvation[?]
> A Body subject to be Tempted
> From neither pain or grief Exempted
> Or such a body as might not feel
> The passions that with Sinners deal[.]
> (E794)

Meanwhile, chapter 3 of *Jerusalem* continues with Joseph's forgiveness of Mary, thereby signaling Blake's repudiation of both Redemption and Atonement in the orthodox sense:

Saying, Doth Jehovah Forgive a Debt only on condition that it shall
Be Payed? Doth he Forgive Pollution only on condition of Purity[?]
That Debt is not Forgiven! That Pollution is not Forgiven[!]
(61.17–19, E209)

For, "If you Forgive one another, so shall Jehovah Forgive You: / That He Himself may Dwell among you" (61.25–26, E210). And this assertion of Christ-in-us is followed by Mary's Magnificat: "Then Mary burst forth into a Song!"

In Blake's poems the harlot Mary is a natural woman, "innocently gay & thoughtless," as Blake writes in *The Last Judgment* (1810), living "in the midst of a corrupt Age" and therefore to be forgiven (E549). To demonstrate the basic principle of the forgiveness of sins, the true end of Redemption, Blake associates the two Marys (and the woman taken in adultery) with the principle of sexual freedom. The sexual is an urge that "can never be defiled."[4] Blake is reversing the Augustinian doctrine that Adam's sin was transmitted through the act of sexual intercourse and so only through the intervention of the Savior could it be corrected.[5] It is necessary that Jesus inherit sin, and by sin Blake means such natural behavior as sexual intercourse, drinking, cursing, and not going to church, which in *The Marriage of Heaven and Hell* (1790) he presented as "diabolic." "Sinning" is Blake's irony in that "sins" are only the natural violations of the OT law; natural behavior is *called* diabolic by the self-styled angels of the Christian religion, the same distinction that Hogarth made in the *Harlot's Progress* between sin and morality. Hackabout "sinned," but the men who debauched her committed moral crimes. Like Hogarth's Mary Hackabout, Blake's Mary is an ironic conflation of harlot and Savior, mother and son.

Mary's "sin" was not concupiscence but only the concealing of her transgression from Joseph, committing adultery in secret like the Sick Rose of *Songs of Experience* (1794). The Virgin/harlot Mary, symbol of natural sexuality, betrays Joseph because we all have to "sin" in order to be forgiven: she takes upon herself the convention of mankind's sinning nature.[6] In short, she is made an adulteress (1) in order to ensure the Son of earthly sin and (2) to thereby permit Joseph's forgiveness, but (3) she is, in effect, only a sinner because the Mosaic law ("the moral Virtues," E792, 793) calls her one.

Jesus is the greatest transgressor because he breaks every law of the Deca-

logue, as Blake enumerates in "The Everlasting Gospel": "He mockd the sabbath & he mockd / The Sabbaths God & he unlockd / The Evil spirits from their Shrines / And turnd Fishermen to Divines" (E794). These are the "moral values" that appropriate Jesus' doctrine of forgiveness:

> The Moral Virtues in Great fear
> Formed the Cross & Nails & Spear
> And the Accuser standing by
> Cried out Crucify Crucify
> (E793)

And in *For the Sexes* (ca. 1816), following the crucifixion, with its "Mutual Forgiveness of each Vice,"

> Jehovahs Finger Wrote the Law
> Then wept! Then rose in zeal & Awe
> And the Dead Corpse from Sinais heat
> Buried beneath his Mercy Seat
> O Christians Christians! Tell me Why
> You rear it on your Altars high[?]
> (E256)

Mutual forgiveness is the message of the Redemption ("the gates of Paradise" or eternal life), which defeats "the Accuser" Satan's "chief design," the corruption of God's creation.

Jesus breaks all the Ten Commandments, but his crucifixion, which is intended to indicate forgiveness of sins, is appropriated by the church and assimilated to the Commandments: revenge and punishment, sacrifice and the Eucharist. Atonement is, or rather historically was, for Blake the institutionalizing of Redemption — of Jesus' crucifixion, his suffering and forgiveness. Blake shows the OT God's Law (given to Moses on Mt. Sinai), which required sacrifice and atonement, recovered and worshiped ("on your Altars high") by "religion," the Christian church. Sacrifice and ritual slaughter exist today in contemporary London, "Between South Molton Street & Stratford Place: Calvary's foot / Where the Victims were preparing for Sacrifice their Cherubim"[7] — that is, on army parade grounds, in the prisons, and on the Tyburn scaffold.

Blake states the case most clearly in *The Marriage of Heaven and Hell*: "Know that after Christ's death, he became Jehovah," that is, the NT was recovered by the OT (plate 6); this is glossed by plate 11, where the "ancient Poets" (Christ's

human incarnation) are said to have "animated all sensible objects with Gods or Geniuses" (of the sort Blake will soon begin to create in his visionary works), mental deities grounded in "the genius of each city & country" (in theory at least the Hackabouts of Hogarth's works, the harlots of Blake's *Songs*). The process ended when "a system was formed, which some took advantage of, & enslav'd the vulgar by attempting to realize or abstract the mental deities from their objects: thus began Priesthood"; and "Thus men forgot that All deities reside in the human breast" — that is, the poetic genius potentially in the breast of every man.

Mary, Rahab, and Tirzah

In *Songs of Experience* "the youthful Harlots Curse" is the symbol of innocence oppressed, curbed, and perverted by the church that denied sexual freedom, appearing in its most intense and concentrated form in "London" and in lines such as those in "Auguries of Innocence": "Prisons are built with stones of Law, Brothels with bricks of Religion" and "The Harlots cry from Street to Street / Shall weave Old Englands winding Sheet." The youthful harlot is only the climactic figure in the triad of youth oppressed that includes chimneysweep and soldier.

Blake's ideal of free love, or "lovely copulation" (in some ways reflecting a libertine ethos, in others an Antinomian), is embodied in its contradiction, the symbol of experience, a harlot. A harlot, both innocent and experienced, is youth, love, and divine energy (God-in-us) but confined in the girl (a Hackabout) who must give herself to whoever pays for her, whose love is locked in the chains of religion, morality, and law.

Hogarth's youthful harlot ironically atoned for the sins of Englishmen — though in a passive Atonement: By the biblical juxtapositions Hogarth showed it to be a mock atonement. Blake's youthful harlot curses — blasts with syphilis and whatever the opposite is of atonement — her offspring and the men who employ her. Yet Blake's view of the harlot is not as a sinner. The curse (in the secondary sense of "plague") has been put on her and so passed down from men to her body to other men and their offspring. It was infused into her by the men who have had her. And her role was imposed on her not, as Mandeville and Hogarth suggested, by a society that maintains virtue by vice but specifically by the Christian religion that needs sexual sin to justify its primary doctrine of Atonement.

In Blake's prophetic book *Europe* (1794), the church's law is "that Woman's love is Sin" (E61). Religion represses sexual desire (the rendering of sex as sin).

"The Sick Rose," "The Garden of Love," and other poems of *Experience* established sexual repression as the particular form of religious oppression, and the *Visions of the Daughters of Albion* (1793) placed in this context the virgin Oothoon, the emanation (female lover) of Theotormon and the spokesperson for the validity of sex: she is raped by her master Bromion (as Ann Bond was by Colonel Charteris)[8] and therefore repudiated by her puritanic lover. When Bromion rapes her he labels her "harlot" — "behold this harlot here on Bromion's bed" (E45). The historical context, overlapping with the French Revolution, is the slave trade: Oothoon appears, on the naturalistic level of the narrative, to be a slave, Theotormon an Oroonoco figure, and Bromion the slave ship master who imposes his droit de seigneur on his cargo.

Blake gives two aspects to this woman, naming them Rahab and Tirzah.[9] Rahab, the Jericho harlot who sheltered the Israelite spies in return for the preservation of her house, was also the betrayer of her city. She is the aspect of Hogarth's Harlot as seductress, alluring (as the single lock of hair is "too alluring" to be strictly decent), the "False Feminine Counterpart Lovely of Delusive Beauty" (E363). She is the transgressive aspect of Mary — when she conceals her adultery (Hogarth's Venus). The Virgin Mary, Blake presumes, is a force of sexual desire (one form of liberty) and does commit adultery but only because she follows the direction of the Holy Ghost within her (its energy, associated in this case with sexual desire), who in Blake's terms is the human imagination.[10] But with time and institutionalization, Rahab will become the Whore of Babylon, the church, the system of moral virtue, the persecutor of Jerusalem, and the crucifier of Jesus.

Tirzah was the capital of Israel, the fallen country of the lost Ten Tribes, as opposed to Jerusalem, the capital of Judea and the city that subsequently fell but eventually recovered its dispersed people. If Rahab is the harlot aspect of woman, Tirzah is the mother, a more complex version of Hogarth's Nature because she may revert, in her case, from nurture to child sacrifice; she is Natural Religion, the figure with whom the deists replaced the OT God — but then so is Rahab in her other aspect, for Rahab is seductress, mother of Tirzah the prude. And as mother, Tirzah finds it her motherly duty to bind the infant Orc and crucify the transgressive Jesus. Mary, though Rahab's most illustrious descendant, is in a sense only another Rahab and will in time become Rahab's daughter, Tirzah. She appears as Tirzah in "To Tirzah," the lyric added at the end of *Songs of Experience:*

Whate'er is Born of Mortal Birth,
Must be consumed with the Earth
Go rise from Generation free;

Then what have I to do with thee?

(E30)

These were Christ's words to his mother at Cana, declaring his independence of her — evidence that Jesus and not Mary is for Blake the significant figure (as for Hogarth Paul came to stand against Drusilla and Venus). For Blake, Mary herself is only a brief phase of Jesus' Incarnation, and eventually Blake shows both Rahab and Tirzah joining forces to crucify him.

So Mary is only one aspect of the Blakean human psyche — which, as in "The Mental Traveler," can grow (and age) from "Virgin bright" to "woman old," from seductress to mother, from love to possession using on her child the same nails, thorns, and other implements of crucifixion (references to Prometheus as well as Christ).[11] These personifications (Rahab and Tirzah, as also Orc and Urizen) are what Blake calls eternals, both in the psyche of man and in the historical process. The figures are interchangeable, and so, typologically speaking, pre- and postfiguration. Mary is the harlot and the mother as they shift in their different forms from liberating to protecting to confining and destroying. She is the figure who, greatly dilated, finally appears as Jerusalem (the old Jerusalem, not yet the new), forced to become "a wandering harlot in the streets," prostituted by the Beast and the Whore of Babylon:

> Jerusalem replied. I am an outcast: Albion is dead!
> I am left to the trampling foot & the spurning heel!
> A Harlot I am calld. I am sold from street to street!
> I am defaced with blows & with the dirt of the Prison!
> (E210)

A foundational metaphor for Hogarth's play with harlotry and sexuality in *A Harlot's Progress* was the image of Christ the bridegroom.[12] The whole story of Christ's redeeming marriage comes into play with Blake: the old Jerusalem rendered a harlot and redeemed in marriage as the new Jerusalem. The redemption of man is figured in the Redeemer's marrying his bride, which is associated with God in Isaiah and with Christ in the Last Days of Revelation when the New Jerusalem replaces the Whore of Babylon and the reunification of the sundered Albion — or of any human psyche.[13] In Revelation, the book that dominates Blake's fiction, the "apocalypse" or the vision of a new, better world that replaces the old one (either an earthly or a heavenly paradise) joined the fiction of the redeeming marriage.

In Revelation the Whore of Babylon, the figure of the Roman Empire, "did

corrupt the earth with her fornication" (19:2); "the kings of the earth . . . have committed fornication and lived deliciously with her" (18:9); Babylon ("she") has fallen "because she made all nations drink of the wine of the wrath of her fornication" (14:8). Is *fornicate* good or bad — as opposed to "Lovely copulation"? In terms of his usual "contraries," Blake has a good harlot and a bad, copulating and fornicating, Mary (Virgin and Magdalen) and Rahab, who become in Revelation the good Mary with her Child and the Whore of Babylon.[14]

A similar transvaluation took place when Hogarth followed his good mediators, the Poet's wife and the milkmaid of *The Enraged Musician*, with the adulterous Drusilla, the false mediator between Paul and her lover Felix. In *Industry and Idleness* (1747), Hogarth had parodied Proverbs, adapting the two women, Wisdom and the Harlot, and the wise man and the man who leaves the path of righteousness for the dark paths. He accompanied his plates with inscriptions from Proverbs — ostensibly proverbial wisdom applied to the divergent paths of the industrious and idle apprentices. In these inscriptions he identifies Wisdom, the bride of God, with the master's daughter whom the industrious apprentice, Francis Goodchild, courts and marries, which leaves the harlot to be associated with the prostitute Tom Idle takes up with and who betrays him. And yet, typically, while Goodchild and Idle are ostensibly equivalent to the two men of Proverbs chapter 2, the proverbs that accompany Goodchild's story identify him with the prudent legalist. Hogarth has reversed the values attached to the two apprentices in a way that looks back to his turning the harlot of Deuteronomy 31:15 (who whores after idols) into (or "redeeming" her as) the harlot of the NT, transvaluing her precisely as Christ did.[15] And in this Hogarth looks forward to Blake's transvaluing of the angel and devil in *The Marriage of Heaven and Hell*, which begins with the reversal of Jacob and Esau, like Hogarth's Goodchild and Idle, the prudent legalist and the defrauded other (the Israelites and the Edomites). In a positive sense, *Industry and Idleness* was a continuation of Hogarth's demonstration of female mediation: the daughter, Wisdom (like Hogarth's own wife, Jane), mediates between the industrious apprentice and his master (Hogarth and Sir James Thornhill). But Hogarth has divided himself, in this case, between the two apprentices, the idle one as well as the industrious, as Blake would divide his psyche into opposing principles in his visionary works.

The Human Form Divine

Blake's *Songs of Innocence* (1789) starts as *Jubilate Agno* did, with the subjects of poetry and praise. Up both sides of the "Introduction" to *Songs of Innocence*, Blake

renders the Tree of Jesse, Christ's genealogy, often found in illuminated manuscripts and church windows, announcing the theme of Redemption in the birth of Jesus. A piper meets a child who asks him to pipe a song about "a Lamb" (capitalized), which causes the "Child" (also capitalized) to weep; then to sing a song, which makes the child this time weep with joy ("he wept with joy to hear"); finally to write the song in a book — taking a hollow reed, making (cutting) a pen out of it, and staining clear water to make ink. In this song the child asks the piper to celebrate the lamb in increasingly logocentric terms. By contrast, in the song called "The Lamb" the subject is not the lamb's celebration/recreation by a poet but the creation of the Lamb — by Him who "calls himself a Lamb" and "became a little child" (now lowercase). "The Lamb" makes clear that the lamb was made by the Lamb of God, Christ:

> For he calls himself a Lamb;
> He is meek & he is mild
> He became a little Child;
> I a child & thou a lamb,
> We are called by his name.

The final repeated refrain, "Little Lamb God bless thee," functions like one of Smart's "Let" lines. This is how "God" blesses the lamb, by calling Himself (making Himself) one, by becoming the Lamb of Redemption. This is, of course, as in *Jubilate*, "the Lamb of God who takes away the sin of the world" (John 1:29, 36). As in *There is No Natural Religion* (1788), "Therefore God *becomes* as we are, that we may be as he is" (my emphasis): that is, the reference is to the Redemption and Christ, who *only* takes a human body at that point in time. Thus, when the child orders the piper, "sit thee down and write," and the poet "stain'd the water clear," the clear water is prelapsarian and must be stained in order to record on the page the Redemption/redemption of the fallen world.

The conjunction of child, lamb, weeping, and joy stands for the equation of child-Lamb-God and the tears/joy of the Redemption. The only distinction is the capitalization of the Lamb of God. This lamb as usual carries, with the constant reiteration of weeping (and the stain in the clear water), the OT association of impending sacrifice and so the Redemption. In "A Cradle Song" the nurse sings:

> Sweet babe in thy face,
> Holy image I can trace.
> Sweet babe once like thee,
> Thy maker lay and wept for me.

The child's face is the image of both the Savior *and* the saved: this is why the child's mother weeps as she smiles. Again, the Mother Mary and the Child anticipate the *Pietà*. Whenever the mother appears she alludes to Mary, whether in text or in illustration. In "Infant Joy," while the design is not an Annunciation, it does represent a Madonna and Child with a worshiping angel (posing in a tumescent flower balanced by a detumescent one below). This is the holy birth, but it is also a holy birth in the sense that all births are holy.

"The Divine Image" introduces the term "the human form divine," which sums up the similitude of God and man (and poet): "For Mercy Pity Peace and Love" (the line is repeated) first "Is God our father dear" and then "Is Man his child and care."

> For Mercy has a human heart
> Pity, a human face:
> And Love, the human form divine,
> And Peace, the human dress.

Blake's refrain in *Songs of Innocence, The Marriage of Heaven and Hell,* and throughout the 1790s is "All deities reside in the human breast," "God only Acts & Is, in existing beings or Men," and "every thing that lives is Holy." Again, Blake remarks that "those who envy or calumniate great men hate God, for there is no other God." Or, as Crabb Robinson reported (December 1825): "On my asking in what light he viewed the great question concerning the Divinity of Jesus Christ, he said: *'He is the only God.'* But then he added — 'And so am I and so are you.'"[16] Note, however, that Incarnation or Redemption (Blake never uses the word Incarnation) means that by becoming man God made us God.

By God Blake means Jesus Christ, the Lamb and Child. In the text of "The Divine Image," only man and divinity are equated, but the design shows Jesus as the form taken by divinity, and the figure of Jesus is raising a man *and* a woman, suggesting that one of the divine attributes is natural sexuality, in the words of the poem, "virtues of delight." (In "The Shepherd" the lamb and the ewe can refer either to mother and child or to lovers: "the ewes tender reply" is both maternal and sexual.) The "Divine" is not God the Father, who makes his appearance in the equivalent poem in *Songs of Experience* (1794), "The Human Abstract," as the gray-bearded rocklike figure who, revised in the frontispiece to *Urizen,* is shown holding the two tablets of the Law.

Blake's "human form divine" echoes the words of the Ranters "that God is essentially in every creature, and that there is as much of God in one creature, as

in another, though he doth not manifest himself so much in one as in another."[17] With the Ranters' rhetoric (as preserved in Aliezer Coppe's *Fiery Flying Roll* and other prophetic books), Blake shares his basic assumption that God exists in man and, indeed, has no independent existence.

Thomas Edwards described an Antinomian preacher in London who sounds very like the little boy of *Experience:* "on a Fast Day [he] said it was better for Christians to be drinking in a Ale-house, or to be in a whorehouse, than to be keeping fasts legally." Eating and drinking are life-giving ways of breaking the dead Law. The little boy sings: "Dear Mother, dear Mother, the Church is Cold, / But the Ale-house is healthy and friendly and warm" — a sentiment both Hogarth and Wilkes would have shared with the boy. We might recall Blake and his wife naked in their garden ("Come in! it's only Adam and Eve you know") and his belief, reiterated in prose and poetry, that the naked human form was the supreme symbol of the divine in man and the liberation of the spirit; also recall that Abiezer Coppe was accustomed "to preach stark naked many blasphemies and unheard of villanies in the daytime," as Antony à Wood tells us, "and in the night he drunk and lye with a wench that had also been his hearer stark naked."[18] According to Ranter doctrine clothing represented a loss of innocence, the curse of the Fall, and a return to nakedness represented the lifting of the curse and the moral law.

This body of doctrine has been called the "Everlasting Gospel" and derives from the writings of such diverse sorts as Thomas Munzer and the Anabaptists, Jacob Boehme, Henry Nicholas and the Familists and the Seekers, and especially that short-lived sect the Ranters. What most of these shared was Antinomianism, an extreme form of Paul's attack on Jewish law, by which its opponents often meant mere libertinism (all is permitted). Whether Antinomianism implies Grace or Incarnation, Christians were *freed by grace* from the need to obey the OT law; obedience per se was to be rejected as legalistic; or, if holiness flowed from the inner working of the Holy Spirit, this was the result of an Incarnation that left Christ-in-us.

Blake's antisemitism follows from his Antinomianism. He could be putting a gloss on Hogarth's *Election* 4 when, in *The Marriage of Heaven and Hell,* he explains (through the OT prophet Ezekiel) why "all nations would at last be subject to the jews": "for all nations believe the jews code and worship the jews god, and what greater subjection can be[?]" (E38). By which Blake means the Levitical law and the OT God of wrath — that Antinomian assumption which is also one way of understanding the satire of Hogarth's *Harlot.*

In *Experience*, the question in *Innocence* of "who made" the lamb is replaced by the question of "who made" the tiger. If the lamb was made by Christ, the merciful agent of redemption, the tiger was made by a god of wrath, associated with the punishment of the fallen angels for their rebellion, with Zeus's punishment of Prometheus for giving humans fire and of Icarus (or Phaeton) for the pride that led him to approach the sun. Mercy, love, and pity are the values of the lamb, not of the tiger. "The Lamb" and "The Tiger" contrast the worlds of Innocence and Experience.

But, given the diction of *Innocence*, they show that Blake is not talking about pre- and postlapsarian but redeemed and postredeemed worlds. In the latter the tiger becomes a Satanic rebel figure — in the context of the 1790s and the French Revolution — who lost the war against the creator of the tiger as Jesus lost the war against the Mosaic law; all are cases of God punishing a rebellious "son." (At first God and Satan are conflated in the ambiguous "he," as are the tiger and its maker, but then distinguished as God and the fallen angels.) The story of the Incarnation and Redemption are here but also the identity of human and divine — and, implicit, the Atonement-sacrifice as well. But which came first? Was the tiger redeemed by (or turned into) the lamb? The tiger already apparently (in some of the versions of the illustration) is becoming the lamb or vice versa?[19] The Lamb becomes a tiger in Revelation. God and the Lamb (Christ) are seated together on the throne, and it is announced that "the Lamb shall overcome" the whore, beast, dragon, and their followers (they will suffer "the wrath of the lamb" [Rev. 7:10, 17:14, 6:16]).

The Ranters of the 1650s believed that the Redemption meant that Christ is now among us, not back in heaven at God's side or suppressed by the church — or that, following the Redemption, we are now approaching the Second Coming because we are obviously in the time of Antichrist, which is destined (according to Revelation) to precede it. This was the rhetoric used by the Ranters, reported by Thomas Edwards in his attack on the Ranters, *Gangraena* (1646). The leaders of the English revolution in the 1650s believed they had "great works to do, the planting of a new heaven and a new earth among us, and great works have great enemies."[20] In the 1790s Burke drew on antidissenter satires, and Paine drew on Burke's images for his anti-Burke and pro-revolutionary arguments. In the case of Blake, we have a poet who turns back to the dissenter tradition itself and its millenarianism.

When he refers to the human form divine or Christ-in-us, Blake is therefore thinking not so much of the Incarnation as of John's vision in Revelation: "Be-

hold, the tabernacle of God is with men, and he [God] will dwell with them, and they shall be his people, and God himself shall be with them, and be their God" (Rev. 21:2–3). In this sense God is in us — if we are at the stage of Apocalypse when the New Jerusalem has come down to us to fulfill the promise of the Redemption. As Burke recognized as well as Blake, if God dwells not merely in the elect but in all men, all are going to be equally entitled to vote, to rule, to read God's intentions, to preach (including women), and to either overthrow the government or wait for God in the near future to do so.[21]

Blake puts himself in the world of Antichrist and the Whore and the Beast — the time in which Paul and John of Patmos thought themselves to live. His poet, like Milton's, is in London, an apocalyptic city, Pandemonium or a fallen Jerusalem. In the *Song* "London" the word *mark* designates something to take note of. On faces, a mark is a sign, trace, of a brand, seal, or label (the Mark of Cain) — a stigma, stain, or scar. Though connected with "chartered" and its political connotations,[22] "mark" carries primarily biblical-prophetic connotations, specifically the authority of Revelation: "And he causeth all, both small and great, rich and poor, free and bond, to receive a mark in their right hand, or in their foreheads: And that no man might buy or sell, save he that had the mark, or the name of the beast, or the number of his name" (13.16–17). The third angel says "with a loud voice, If any man worship the beast and his image, and received his mark in his forehead, or in his hand, the same shall drink of the wine of the wrath of God" — first this and then that.

Related to the "youthful harlot," a "mark" was "a noisome and grievous sore upon them which had the mark of the beast, and upon them which worshipped his image" (Rev. 16:2; 15:6, 8). Like "chartered" (both granted liberties *and* hired for exclusive use), which also applies to the harlot, the mark of the beast is on those who buy and sell human values — marketable goods like the harlot, soldier, and chimneysweep, and it is a mark that reaches to those who are bought and sold as well, with echoes of the "mark of Cain." These marks, parodies of the marks referred to in Ezekiel 9:4, which set off the virtuous from the evil, indicate the followers of the Beast and Whore. The radicals of the seventeenth century and of the 1790s associated the Beast and his followers with the rich and powerful.

For Smart there ought to be a reformation of the church, for Blake its total renunciation and — following the chiliasts — the attempt to establish the Redemption (the New Jerusalem) here and now. Blake's *Experience* is not the gray area of Redemption-before-Resurrection depicted and celebrated by Smart but the time of Apocalypse: Antichrist is here, and where is Christ? "London" and

the other *Songs* introduce in an incredibly compressed and indirect way, and "A Song of Liberty" in *The Marriage of Heaven and Hell* begins to adumbrate, the allegory of Blake's prophetic books. If Smart represented the time between Redemption and its fulfillment (our present time), Blake represents the time of Antichrist — of Rome, the destruction of the Temple, and anticipation of the imminent Second Coming.

It is during this time that, as in *Innocence*, the angels (the priests) beguile the children for their sad lives with stories of a happy afterlife. The angel in "The Chimney Sweeper" "told Tom if he'd be a good boy, / He'd have God for his father & never want joy," and this makes Tom "happy & warm." So long as he does his "duty" he "need not fear harm." The three operative words are "weep," "smile," and "beguile." In "A Cradle Song" the infant is "beguiled" by an angel through the darkness of the night — "beguile" being to entertain, charm, and divert but also to delude by guile or craft, to mislead. (One recalls Stephen Duck's master's feast, which cheers the heart and warms the head, beguiling the unhappy threshers as it does the little chimneysweeps and young harlots of London, or Uncle Toby's sense of "beguiled," the hobbyhorse that keeps one anesthetized to the pain of one's wound.) So, too, in "Night" the angels guard the sleeping child-lamb, but if the tigers "rush dreadful" upon the prey, "The angels most heedful, / Receive each mild spirit, / New worlds to inherit." The tiger or lion's "wrath" "Is driven away, / For our immortal day" — that is, the angel's promise of an eternity in the afterlife.

The easy solution to the problem of the long interim between Redemption and Resurrection — that of the church and religion — was the myth of a glorious immortality *after* death in a world modeled on the lost Eden ("the sufferings of this present time are not worthy to be compared with the glory which shall be revealed in us"). The message of Dr. Primrose's sermon to the prisoners in *The Vicar of Wakefield*, based the lure of religion on pleasure and self-interest (religious belief makes one happy), repeated the orthodoxy of the latitudinarian Archbishop Tillotson: "Two things make any course of life easy; present pleasure and the assurance of a future reward. Religion gives part of its reward in hand, the present comfort and satisfaction of having done our duty; and for the rest it offers us the best security that heaven can give. Now these two must needs make our duty very easy; a considerable reward in hand, and not only the hopes but the assurance of a far greater recompense hereafter."[23] The latitudinarians and the deists, in fact, shared a belief in the pragmatic function of religion and the need to reassure the weak, who internalize both the Atonement and the promise of joy in the afterlife. This is what Blake meant by "*mind*-forged manacles."

Blake and Milton

Blake's fiction has its origin in the doctrines of Incarnation and Atonement, and specifically as they were dramatized in *Paradise Lost*. Blake's "human form divine" is a personal, Antinomian extension of Milton's description of man as created in the "Image of God / Express," answering his "great Idea" (7.527–28, 557). Blake's equation of God and man, manifested in the human imagination, is his version of the relationship of Son and poet in the poetry of Milton.

Milton began with the problem of the Trinity, the difference of a single syllable separating the Athanasian dogma that says father and Son are of the same substance from the Arian heresy that says they are of like substance. Thus, referring to the Son as "Divine Similitude," Milton contrasted the Father and Son as strict justice and mercy. Blake's reading of *Paradise Lost* was not too different from Pope's, but Pope had elided the negative aspects of the Father by focusing on the Son. Blake's reading is closer to William Empson's. In the Father's first appearance, as Empson put it, "we get the stage-villain's hiss of 'Die he or Justice must.' God is much at his worst here, . . . [in order] to make the offer of the Son produce a dramatic change."[24] Milton sets up a dramatic dialogue in which the satisfaction theory of the Father is corrected by the revisionary theory put forth by the Son. The satisfaction theory posits a divided godhead, as is quite clear in book 3, where the Father's "Die hee or Justice must," expressing the OT Law (and the legal imagery continues), is distinguished from, contrasted with, the Son's expression of love and mercy: "Father, thy word is past, man shall find grace" (3.227).

The ancient case for dualism was based on the question of how a good God could make his creation suffer so; therefore one must posit a *good* and a *bad* god. Milton splits the godhead into Father and Son and then supplements the Son with himself, the divinely inspired poet; Blake not only splits Father and Son but makes them opposite principles, the one OT law and "religion," the other the NT Jesus — at first ironically called Satan because the source of the obvious dualism begins in the rebel Satan withdrawing from God the Creator, the devils from the angels of *Marriage of Heaven and Hell*. But the dualism of Father/Son also permitted Blake, rewriting Milton, to conflate aspects of Satan (his energy, seductiveness, rebelliousness) with Jesus, by way of Jesus' interest in harlots and publicans.

Jesus and fiery Orc share, with the Satan of *Marriage of Heaven and Hell*, uncontrolled and "transgressive" energies: "Jesus was all virtue, and acted from

impulse, not from rules" (E42), while the youthful "fiery Orc" speaks in terms of love and liberty, but Orc embodies revolution, Jesus forgiveness and peace (which are to the angels equally "sins").[25] Yet they end in the same way, crucified and becoming what their act of Redemption/redemption had attempted to correct, in one case by being appropriated by and in the other by aging into the very God they have rebelled against.

The boy Orc first appears in *America* (1793), Blake's allegory of the American Revolution, produced at the height of the French Revolution: "The fiery joy that Urizen perverted to ten commands" (E53). He is chained by Urizen, a stand-in for Albion's Angel (George III), but breaks his chains and rapes his keeper's daughter (the "Shadowy Female," as Blake calls her) and escapes: Orc embodies the energy of rebellion against constraint (tyrannic power as well as reason [Urizen, Your-reason], law, and order); he is a personification and his act an allegory of the American Revolution — war and not, as with Christ, peace.

A year later in *Songs of Experience* — in the much more compressed, lyric form — Blake presents the little boys, the small Orcs. In *Experience* he has added fathers and mothers (as in the second "Chimneysweeper" poem): the "God & his Priest & King / Who make a heaven of our misery." "Heaven" is the name the angels give to hell, designating the eternal life they promise in recompense for the miseries of this existence, which equals the prison, chapel, grave (the cold church vs. the warm alehouse). Now the children complain and rebel against their fathers — break out of their swaddling bands and denounce the father surrogates the priests, who "bind with briars, my joys and desires." Or they repress their rebellion and merely sulk ("Infant Sorrow"). Love is now repressed — by God, priest, and king, or sometimes, as in "The Sick Rose" and "The Angel," the children are martyred or succumb to the paternal power. The birth of Christ in *Songs of Innocence*, the implied story of Redemption and Atonement, is followed in *Experience* by the child as a rebel, bursting out — becoming the young man of *America*, but now with the "sin" he took on him with his humanation.[26]

Jesus first appears (after *Innocence*) in *Europe*, which takes up where *America* left off. The Shadowy Female prophesies that the peace to come following Orc's revolution will begin with a Nativity: "And who shall bind the infinite with an eternal band? / To compass it with swaddling bands? / And who shall cherish it / With milk and honey?" She sees it "smile" like the child in *Innocence*, and she tells how (adapting Milton's "Morning of Christ's Nativity") "the deep of winter came; / What time the sacred child, / Descended thro' the orient gates of the eternal day." But, she explains, the Redemption will be followed by the establish-

ment of the church, which will replace the freedom of the Redemption (related here as a corrective to Orc's violent response to tyranny) with bondage, based on the indefinitely deferred promise of eternal life: "That an Eternal life awaits the worms of sixty winters / In an allegorical abode where existence hath ever come." In the meantime, "Forbid all Joy, & from her childhood shall the little female / Spread nets in every secret path" (E60–61).

In *Urizen* (1794) Orc and Jesus are conflated, as are Urizen and the OT God who chains Orc to a mountain top and, around and enclosing him, weaves "the net of religion." Finally, in 1795 in *The Book of Ahania*, a figure named Fuzon momentarily takes on the role of Orc, now in the Chronos myth, castrating his father Urizen, an act that has the effect of dividing Urizen from his emanation (his female aspect) Ahania, and evokes something like the Oedipal situation. Urizen responds by impaling Fuzon and hanging his "dead corse" on a tree.

The rebellions of Orc and Fuzon against Urizen ask to be read as an interpretation either of *Paradise Lost* book 3, in which the Son speaks for man against the Father and his death/sacrifice is to save mankind, or, alternatively, of *Paradise Lost* books 1 and 2 (and 9), in which Satan rebels against God and is cast down — conflated with Prometheus's fate (chained to a mountain top). Fuzon is more plainly Satan — producing Ahania-Sin; crushed with the rock of the Ten Commandments and "crucified" on a tree. In Blake's "Bible of Hell," it is the son who disobeys — rebels against — the father and is nailed to a tree, only to age into the image of the father.

Blake focuses on the crucifixion as the universal salvific act, an act of forgiveness — which the priests appropriate as an act of vengeful sacrifice. He fits the crucifixion into his Orc cycle as the moment of transition when the old order crucifies the revolutionary enemy and appropriates him to its theology of rewards and punishments. A father (any father, or paternal principle) binds the son, the son rebels and overthrows the father, and then grows/ages into the father, producing his own son, whom he binds and who then rebels against him, and so on. In Blake's system they not only do battle, they alternate and change (cyclically) into each other, becoming aspects of one figure, producing something approaching a more sophisticated monotheism, based perhaps on the synthesis Milton worked out between the Father and Son in book 3. Orc originates as a Satanic version of Jesus — or vice versa as Satan becomes the voice of organized Christianity — and ages into the institutionalized form of Urizen and the church: first the Ten Commandments and the OT law, then Orc, and then again Urizen perverting Orc's (or his own) energy to the Ten Commandments.[27]

There is also, despite his denials, the deist Blake, presenting the human form divine as a kind of subjectivism, saying, "There is really no God but Man" — meaning, *in* man, in his mind, invented by man: the divine presence and idea are internalized — created by the (divine) imagination of man, and the "God" or religion is externalized by man in "mind forged manacles." Blake's Incarnation is gnostic in that spirit (the "human form divine") is imprisoned in body, whether "body" is understood as externals like religion and law or internals like reason. (In that sense he anticipates in an allegorical form *The Prelude*, in which Wordsworth replaced Milton's cosmos with the human mind.)[28]

He does not create a new religion. The organized worship of a god — the institutionalized system of religious attitudes, beliefs, and practices — was associated by Blake with law and morality and was anathema. Nor does he create a theology, that is, a systematic account of god and his relation to our world (vs. both a theodicy, which defends his goodness and omnipotence in view of the existence of evil, and a "theology" in the sense of a rational interpretation of religious faith, practice, and experience). Theology, for Blake rather a theomachy, melts into a polytheist mythology, the relation of legends dealing with the struggles of various gods, demigods, and heroes — in his case largely invented stories, to some extent based on gnostic interpretations of the Christian story.

Blake's product is something like a psychology, a systematic account of the human mind and behavior, and an aesthetics, an account of these figures as constituting the formal beauty of the world and its subsequent disintegration and reintegration. Milton's dualism Blake renders an agon, turning theology into psychology: His Son does not simply supplement the Father (justice with mercy) but engages in a struggle — and one psychologically rather than theologically rendered. The plot, implicit in the *Songs* and spun out at great length in the prophetic books, is essentially one of rebellion, fall, redemption, and restoration in the 1660s sense — or gnostic good and evil becoming energy and stasis, open and closed, free and bound, expansion and contraction. Blake is writing not so much a cosmology as a spiritual pilgrimage, not as a narrative but as a psychomachy in which the mind's wholeness is broken down into contraries, warring factions, and entropy, which fragmentation he attempts to reassemble into a new unity (poetic at least, hopefully political).

Blake and Hogarth

The terms of Blake's fiction — open and closed, free and bound, expansion and contraction — were shared by psychology and aesthetics. One recalls Hogarth's

contrasts in his engravings of closed, claustrophobic and open spaces, the ordered and the disordered, and in general unity and variety. Blake's version of Hogarth's aesthetics does not need Hogarth himself, since Blake shared what was probably Hogarth's Antinomianism sources, including the libertine aspect of Aliezer Coppe and the Ranters ("Prisons are built with stones of Law, Brothels with bricks of Religion" [E36]). For both Blake and Hogarth, *religion* was a demonized term, which raised the question "why has it led the human race into deeper depravity and fouler wickedness than no religion at all"[29] — one of the questions probed by Paul in Romans, contra the Jews. It was, in this sense, "religion" that Hogarth was desecrating when he relieved himself on the church porch. The *Harlot* was, whatever its deist sources, deeply Antinomian along the lines set out by Paul in Romans, drawing on as many of the strains of radical Protestantism as Blake.

And so with the Antinomians they produced a version of Christ-in-us: If you believe Paul, the important consequence of the Redemption is that, unlike the distant and wrathful God of the Jews, Christ is in one sense or another present and with us — or *in* us. This was what Paul meant by predicating "life in Christ" here and now, whatever we think about the timing of a resurrection and everlasting life. Christ-in-us is ironically embodied in the Harlot, though she is corrupted by society into imitating its "laws" of fashion, but it is reflected in the mediating figure who followed her, an expression of Pauline caritas (1 Cor. 13), love or, as translated by the King James Bible, charity, the latter word more apposite in the social scene of midcentury London, in Hogarth's association with its charitable institutions. The significant fact is that Hogarth associated the Pauline idea of charity with beauty and aesthetics by using the figure of a beautiful young woman.

Blake would not have disagreed with Hogarth's deletion of God: the real God is not imminent on the walls of churches. This god has been appropriated by royalty, episcopacy, and law — but exists in each member of the congregation. In fact, he would agree that it is most particularly in the serpentine young woman in *The Sleeping Congregation* (see fig. 35), whose breasts are the object of worship by the clergyman (the one awake person). Blake's "lovely copulation" is close to the Hogarthian sense of the desirable "living woman," and Blake's energy, "eternal delight," is the source of (the active aspect of) variety; energy produces variety, and both are the enemy of laws, codes, and stasis.[30] "Exuberance is Beauty" could be the tag of a Hogarth emblem, but when Blake (or his Satan) utters the words he means that beauty *is* Christ-in-man. Hogarth's aesthetics is another, secular way of saying "everything that lives is holy" or "The nakedness of woman is the

work of God" (Hogarth would say, the *nakedness* of woman is *beauty*). The rest of the congregation are the equivalents of the chimneysweep Tom and the other "beguiled" sleepers.

More than a rewriting of *A Harlot's Progress*, however, "London" rewrites *The Enraged Musician* (see fig. 53): the beautiful disorder of noises becomes the pity and horror of the chimneysweep (who appears in Hogarth's print as part of the noise) and the soldier (Hogarth's little drummer boy is "playing" soldier), and the mediating figure of Hogarth's singing milkmaid becomes the cursing harlot, both young women central or climactic, one comic and a beauty, the other what Blake would have called her spectre. The particulars that in Hogarth's *Enraged Musician* represent a mediation between different kinds of order by a female figure of beauty (human and natural) in "London" are understood by the Bard as symbols of oppression; as if to say: Hogarth was sentimental and too hopeful, whereas this is the mark of the beast. Tom and the rest are in "mind forged manacles." It is the youthful harlot who stands out from the chimneysweep and soldier because she curses, in the double sense we have seen: she is a prophet and she is a version of the Whore of Babylon/London, placing her curse, another form of the "mark," on London, which (as in the verses of Revelation about buying and selling) includes herself. Mandeville's ironic blessing of the harlot (for her service to respectable society) is just reversed and has become her curse of disease.

In the margin of his copy of Lavater's aphorisms, Blake marked the aphorism on beauty: "piety is nothing but the love of beauty," reclaiming beauty from aesthetics to theology; to which Lavater added his definition of beauty out of Hogarth's *Analysis:* "Beauty we call the MOST VARIED ONE, the MOST UNITED VARIETY. Could there be a man who should harmoniously unite each variety of knowledge and of powers — were he not the most beautiful? Were he not your god?" In the margin Blake added, "this is our Lord" (E581), substantiating his "human form divine."[31]

As it was for Hogarth, the Incarnation is clearly of central importance to Blake. He sees Christ-in-us; his chief concern is to make the natural man into the spiritual man — or to "redeem" the natural man as the spiritual, and his model for this is Christ's Incarnation, in which the Word became flesh.[32] Believing in Christ-in-us ("God is Man & Exists in us & we in him" [E654]), that Christ persists in human beings in a sort of continuing Incarnation, he locates this spirit in the imagination: Christ is the Poetic Genius.[33] Christ assumes the human body as thought assumes the material form of sounds or language, words or images on

a page. In short, where the skeptical Hogarth used the Incarnation as a sacred metaphor to suggest the secular importance, significance, and meaningfulness of the ordinary English man or woman, as the subject of the artist, Blake uses his apparent belief in Christ's Incarnation to raise man to a perception of the infinite.

There are two different, Blake felt contradictory, senses of incarnation: one true, the other false. One is typological: Christ *becomes* A, through X, Y, and Z; the other is this incarnation appropriated by the law, the priests, and the church as "religion." The latter is, for Blake, a degeneration of typology into allegory. For example, referring to the Christian promise of eternal joy in the afterlife, he writes "That an Eternal life awaits the worms of sixty winters / In an allegorical abode where existence hath ever come" (E60). And, of the Catholics: "The Pope supposes Nature & the Virgin Mary to be the same allegorical personages, but the Protestant considers Nature as incapable of bearing a child."[34] Allegory turns a complex historical particular into an abstraction — uses the particular to illustrate an abstraction. In the words of his *Vision of the Last Judgment*, "Fable or allegory are a totally distinct & inferior kind of Poetry." But then he adds: "Vision or Imagination is a representation of what Eternally Exists. Really & Unchangeably. . . . The Hebrew Bible & the Gospel of Jesus are not Allegory but Eternal Vision or Imagination of All that Exists" (E544).

Blake's typology is based on the principle of recurrence and circularity. In the *Descriptive Catalogue* (1809), he explains Chaucer's pilgrims in relation to classical and divine types: "The Franklin is one who keeps open table, who is the genius of eating and drinking, the Bacchus; as the Doctor of physic is the Esculapius, the Host is the Silenus, the Squire is the Apollo, the Miller is the Hercules, &c. Chaucer's characters are a description of the eternal Principles that exist in all ages" (E527).

This sounds strangely like Fielding's lawyer, a character in *Joseph Andrews*, who "is not only alive, but hath been so these 4000 Years, and I hope G—will indulge his Life as many yet to come." Fielding says he describes "not Men, but Manners; not an Individual, but a Species."[35] But Blake's "eternal Principles" are the abstractions that Hogarth, Fielding, and Smart deny — and that Blake himself denies in his allegorical plot of Urizen-Orc-Urizen. Part of what Blake is saying is what Hogarth was saying: that the Canterbury pilgrims can be seen as modern, everyday recurrences of Rahab and Hercules, which is to say that the Word exists only in human forms, not in the abstractions of the Mosaic law. Leslie Tannenbaum has formulated his practice: "For, like biblical types, Blake's figures are historical realities or at least fictions intended to be considered as historical

realities. They all point to other fictions or historical realities rather than intel-
lectual abstractions, and they all have a prefigurative or postfigurative content.
They are all freely combined with biblical figures, pagan figures, figures from
natural history, and figures from yesterday's news."[36] Blake shows that the Can-
terbury pilgrims "become separated from their divine origin," but specifically "as
they are appropriated by those who would promote empire and tyranny," by
church and state. And, in Tannenbaum's summary of Blake's argument, "At this
point they degenerate into allegory, as their human significance is obscured by
the abstractions that are attached to them" by church and state. They have fallen
into the hands of the priests, become signs detached from what they signify — and
so the objects of idolatry (attachment to the sign at the expense of what it sig-
nifies). And now, Tannenbaum writes: "When the types become thus encrusted
by orthodoxy or become part of state policy, it is the visionary artist's task to
liberate or redeem the types by embodying them in a new art object; and by
liberating or redeeming the type, the artist redeems man as well" (108).

Blake, in this respect like Pope, sees the artist's role as metaphorically redemp-
tive. Blake uses these redeemed types as "vision" or prophecy, that is, in order "to
bring the past and the predicted future to bear upon a situation located in the
present" (117). But Blake's terms *vision* and *imagination* have to be taken on faith
to designate types rather than, in fact, fables and allegories of his own.

The process described is ostensibly much the same with Chaucer in medieval
England, Hogarth in the 1730s, Fielding in the 1740s, Smart in the 1750s, and
Blake in the 1790s. Blake's Canterbury pilgrims are recurring figures that point to
both classical and Christian types — the pilgrims to the Greek gods as well as the
OT Cherubim that are identified in the NT with Christ, as Hogarth's Harlot is a
modern recurrence of both Hercules and Mary/Christ. While Hogarth chose
the Christian over the classical precedent (Hercules disappears with plate 1),
Blake stresses the continuity between classical and Christian — all are one. And
while Hogarth then chooses the London whore of the 1730s over the religious
doctrine, Blake retains the equivalence at the level of abstraction.

In fact, by making the Franklin a Bacchus "who is the genius of eating and
drinking," Blake allegorizes Chaucer's particularized characters. Hackabout, the
London whore of 1732, replaced the Christian "allegory" of Mary/Jesus in the
NT. Because it was a religious topos, Hackabout, as a human being, *exceeded* it —
as Fielding defined Joseph Andrews in terms of the allegories of the OT Joseph
and the epic Achilles or Hector, both of whom he exceeds because he is an
English youth of the 1740s located in London and on the road to Booby Hall.

Smart defined — or "considered" — his cat Jeoffry in terms of the OT names, covenant, and laws he now, in a 1750s London madhouse, abundantly exceeds. In Jeoffry's case he exceeds because he has been redeemed in the NT sense — and Smart defines himself similarly in terms of the OT David.

In *The Marriage of Heaven and Hell*, Blake relates the French Revolution to the prophecy of Isaiah 63, but to substantiate the historicity as well as universality of the latter, not to distinguish it as more from less real; it is more real in a Platonic sense, less in terms of particulars of time and place. In Blake's mode Urizen is the OT God of the Ten Commandments as well as Nebuchadnezzar and other bad OT kings; in the American Revolution, he is England's king, and in the French Revolution, he is initially the *ancien régime*, then the principle of reason (Your-reason), the Girondin phase. But in Blake's fiction Urizen and the reason of the Girondins never become the particular Condorcet.[37] The closest he comes is in the likenesses (to George III, to Burke) he introduces in his illustrations. The OT God is not recovered by a living contemporary. He, himself the epitome of allegory, is overthrown by another allegorical figure, Orc or Fuzon, type of the Jacobin-Robespierre, who is himself overthrown again by Urizen as Thermador (not the particular man Napoleon).

It seems significant that the particular likenesses are only in the pictures, not in the text — taking us back to Hogarth and the problem of verbal versus graphic censorship. The pictures serve to particularize the allegory — make the figures seem to be people. Once into the prophetic books, however, people Blake particularizes only at the level of Michelangelesque abstraction. There is little resemblance between Hogarth's lumpy, contemporary, rather Watteauesque figures and Blake's "giants" or "eternals."[38]

The matter is clarified by a remark of the Reverend John Trusler. Trusler had bowdlerized Hogarth's engravings in his work of 1768, *Hogarth Moralized*, and produced such other edifying works as *Luxury not Political Evil* (1780?) and *The Way to be Rich and Respectable* (7th ed., 1796). But he stood on the Hogarth side of the temporal divide when he returned the allegorical figure of "Malevolence" Blake had drawn for him with the comment that "It accords not with his Intentions which are to Reject all Fancy from his Work": "*Your Fancy* from what I have seen of it," he wrote Blake, ". . . seems to be in the other world or the World of Spirits, which accords not with my Intentions, which whilst living in This World Wish to follow the Nature of it." Blake's response was that he smiled "at the difference between the doctrines of Dr Trusler & those of Christ."

In practice, what Blake's figures, embodying the Human Form Divine (even if

in a figure of malevolence), meant was the imitation of "Michael Angelo[,] Rafael & the Antique & of the best living models. . . . I know," he wrote Trusler, "that This World is a World of Imagination & Vision[.] I see Every thing I paint in This World, but Every body does not see alike. To the Eyes of a Miser a Guinea is more beautiful than the Sun & a bag worn with the use of Money has more beautiful proportions than a Vine filled with Grapes."[39] This is the other side of the skeptical Hogarth image — as well as of the deeply complex image projected by Smart.

But Blake's example takes us from the prophetic books back to the *Songs:* the guinea and the sun, the money bag and the bunch of grapes are symbols against which Blake's allegorical figures are as abstract and un-Hogarthian as Willilam Collins's Fear and Mercy. The allegorical figures of the prophetic books must be set beside the concrete (here and now as well as apocalyptic) figures of the harlot, the soldier, and the chimneysweep.

Hogarth's tools were burin, etching needle, and acid; he fulfilled the vocabulary of satire by cutting and burning into the copper the lineaments of his figures. Blake's method is to burn away with the acid the material (the dross or waste) of the copperplate, letting emerge his images of spiritual essences. He dramatizes the revelation of vision and truth out of recalcitrant matter, in the emergent lines, words, and images that physically arise — as he described in "Printing house in Hell" in *The Marriage of Heaven and Hell:* When the devil writes "with corroding fires," it is his way of "clearing away the rubbish from a cave's mouth" and "hollowing the cave" to reveal the lines, "melting the metals [of the copperplates] into living fluids" (plates 6 and 7). This waste is precisely the material world Hogarth celebrated in the *Analysis,* Smart in the *Jubilate.*

There are, in fact, three categories applicable. The first is real humans, living chimneysweeps and harlots in 1790s London, though unnamed. In Hogarth's case, there was the Harlot, named Hackabout, a partly allegorical name like Badman or Despair, but existing on a level with historical men recognized as Charteris, Gonson, Gibson, and Walpole (recognized as perhaps George III and Burke were in Blake's *America* and *Europe*). Second, there were historical realities such as the phenomena of Thermador, Brumaire, and Napoleonic tyranny in the 1790s. Finally, there were abstract ideas such as Atonement and Redemption, Justice and Natural Law, into which the first two categories were transformed by church and state. From this Hogarth recovered Mary/Christ in a contemporary harlot named Hackabout, in the contemporary yet unredeemed world.

How do we accommodate Blake's allegory to his hatred of abstraction — the prime mental sin in the simplification of "One command, one joy, one desire"

and the Ten Commandments? As Michael Ferber notes, "What abstract concepts and laws do, clearly enough, is conceal or obliterate the unique character of each individual and draw attention to the contradiction between the assertion of minute particularity and the abstract terms (like 'Minute Particulars' [*J(erusalem)* 91.28]) by which the assertion is made."[40] If we distinguish concepts from laws, Blake might say that the abstraction of law (the Ten Commandments) can be expressed only through abstractions such as the figure of Urizen. But what of Los or Orc?

William Collins's personifications, according to his editor, Laetitia Barbauld, were "endeavours to embody the fleeting forms of mind"[41] — a formulation that would apply to Blake, though his names are less clearly personifications (not Fear or Mercy but Urizon and Los). These (like Gray's in "Ode on a Distant Prospect of Eton College") are Blake's different aspects of godhead — or, rather, of the human mind.

Insofar as Urizen, Orc, & Co. are "personifications," they are covered by a term Blake privileges — in incarnational terms, the communication of the Word (God) in human form.[42] Wasserman's summation of the importance of personification for the eighteenth century was based on this sense of incarnation: "It presents a universal in the corporeal substance by which alone it has existence for man and can be comprehended by him."[43] He quoted John Ogilvie's description of personification in the 1770s as a way to vivify (bring to life, make vivid or, of course, *re*vivify) the immaterial and abstract (not real people): abstractions are "coloured, impersonated, and presented vividly to the eye, [which] forms the highest and most conspicuous characters on which her [Imagination's] creative energy is exerted."[44] As Ogilvie suggests, personification was taken to be a way of enlivening the immaterial (such as the deity), not of sanctifying the material, and so *the reverse of incarnation*, it seeks to make God knowable to man. The allegorical personification is explained, enlightened, by the human body, but it does not, certainly in practice, also restore its dignity — it only uses the flesh to convey its message. Personification, the mode of Collins and the post-Pope generation of poets, and Blake's in his first book, *Poetical Sketches* of 1783, attempted to restore energeia to abstractions.

Blake recovers the mystery and intensity by conflating London in the 1790s and the Book of Revelation, compressing two senses of a word that could be distinguished as *then* and *now*, as spirit and body — a sort of reconstituted Transubstantiation, if it were not closer to Calvin's sacramental metonymy. Calvin says, "I pass over allegories and parables, lest someone accuse me of seeking a place to hide" — and Blake says exactly the same thing in his "Last Judgment." He

thinks he is writing metonymy (or typology) and that this sort of "sacramental realism" is historically appropriated by the church as allegory and fable. The trouble is that by the time he is writing his prophetic books (after 1795) he is in fact writing allegories and fables himself.

The *Songs*, however, are historical events in this world, not in the world of the "tree filled with angels, bright angelic wings bespangling every bough like stars" Blake saw while walking on Peckham Rye by Dulwich Hill in approximately 1767.[45] Like Milton's observer similes, they combine the visionary and the local (Satan and the whale) with Milton's sense of the observer's (the angel's) delusion as well. The angels are actually with the children, as they were with the young Blake, but they are also part of the contemporary world as religious or priestly fable or allegory imposed on them. This distinction is lost in the later poetry, or rather it is translated into fable and allegory.

Blake seems to believe along the line of Hogarth and Smart — and he certainly comes as they do by way of satire as well as radical dissent — but he has not been able (or willing) to shed the poetic baggage of the Collins generation or the Macpherson (Ossian) idea of epic, and so returns sharp satire and the polysemous intensity of the *Songs* to something that glimmers here and there in the old way but is in the long run another scripture calling for the demystification of a Hogarth or a younger Blake.

The line joining Hogarth's *Harlot* and Blake's "London" is the axis on which this book has pivoted. The story Blake told was as radical a parody of the Bible as Hogarth's, but distanced and made safe, first, by the imagery of apocalypse rather than everyday and, second, on the one hand by the extreme compression of the *Songs* and on the other by the impenetrable and fatiguing allegory of the prophetic books — safe even during the dangerous years of the war with France. Blake made no effort to publish "The Everlasting Gospel," the most explicitly "blasphemous" of his poems — the one in which he is most explicit about Mary and Joseph and "Christ the sinner."[46]

"Vision," in Johnson's third definition (following mere *seeing*), is "A supernatural appearance; a spectre; a phantom" — a spiritual manifestation, god's hand at work as in the Cock Lane Ghost calling for justice. His fourth definition: "A dream; something shown in a dream. . . . A dream is supposed natural, a vision miraculous; but they are confounded," Johnson adds. "Visionary" was what contemporaries referred to when they thought Blake was mad (a "mad Wordsworth," we "suppose him to be mad," etc.),[47] and such judgments probably kept him from prosecution or persecution until the height of the war with France.

At bottom, the blasphemy Blake and Hogarth shared was the dissociation of sin from evil; they questioned the religious assumption that moral evil (sin, disobedience of God's Ten Commandments) produces natural evil (suffering, punishment). Hogarth anticipated and Blake fulfilled Rousseau's thesis that evil is socially, not theologically, grounded (in his *Second Discourse on Inequality* and *Emile*, of 1755 and 1762, respectively) — though it was not, in Rousseau's case, the fault of a crafty priesthood but man's own once he became a part of society.[48] Rousseau agreed with Augustine that natural evil is always a punishment for moral evil, but he corrected Augustine, replacing Grace and penance with education/knowledge, showing that the situation *can* be changed. This is where Rousseau mediates between the positions of Hogarth the satirist and Blake the prophet. Hogarth and Blake, with sacred parody, do what Rousseau lays out discursively. The dualism of sin-evil corresponds to the "dismal sacred word and cheerful folk word" of sacred parody (see above, p. xv).

In the *Harlot*, from the religious perspective, Hackabout is a sinner and in the 1730s would have been understood as such by high and low church English men and women, but from a broader social perspective — the perspective of Hogarth's images — the series is about a social evil: It attacks the society in terms of which the Harlot is a relatively innocent victim. Her only transgression is social, aspiring to be what she is not (a fine lady). Seen from the retrospect of Rousseau and the 1760s, the Harlot was good when she arrived in London and is corrupted by London fashion/society — in the specific sense that she is punished for what society regards as "sin" by a society that is itself (partly for this reason) "evil." (Rousseau developed the philosophical sense of "God created man in His own image," identifying the self with God, showing how God's presence is realized in the being he created.) Blake's myth says the same thing in broader, more explicit terms: Religion itself sanctions social evils focused on the figure of the Harlot because she embodies the outmoded, anachronistic concept of sin, which deflects the attention of the pious from the real social evils that made her a harlot. Evil is historical and thus, possibly changeable — as Rousseau and Blake, if not Hogarth, would have agreed (though Blake, writing post-Revolution, less optimistically).

The dissociation of sin and evil was not, however, limited to subversive works like Hogarth's and Blake's. In an unquestionably pious work fifteen years after the *Harlot*, Richardson's *Clarissa*, the basic situation involves theological evil: Lovelace is a Satan figure who, when he cannot seduce Eve, rapes her — indeed, does not make her sin but commits an act of evil upon her, both in the sense of Satan's seduction and in the literal sense of suffering (primarily Clarissa's but ultimately his own as well). But there is another story in *Clarissa*, that of Clarissa's family,

and this, from the theological perspective — which is that of Clarissa herself — involves the sin of disobedience to the father (the surrogate of God). Richardson's audience, and one must presume Richardson himself, cannot have read the moral that way: The father himself, insofar as he is imposing on his daughter dreadful rich husbands, is evil — as evil, in terms of the consequences of his actions, as Lovelace. However complicit Clarissa's actions can be found (a secret love of Lovelace), her disobedience of her father can no longer be judged solely in religious terms. This is what *Clarissa*, for all its differences, has in common with Hogarth's and Blake's harlots.

A century after the *Harlot*, in America, Nathaniel Hawthorne wrote *The Scarlet Letter*. The letter is worn as a sign that Hester Prynn has committed the sin of adultery. But the evil was the seduction of her by the very clergyman who imposes the punishment on her, embodied in the pain she suffers and in his feelings of guilt.

Notes

The following are short titles for the frequently cited works on Hogarth:

Analysis	William Hogarth, *The Analysis of Beauty*, ed. Ronald Paulson (New Haven: Yale Univ. Press, 1997).
Autobiographical Notes	Hogarth, "Autobiographical Notes," in *The Analysis of Beauty*, ed. Joseph Burke (Oxford, England: Clarendon Press, 1955).
Beautiful, Novel, and Strange	Paulson, *The Beautiful, Novel, and Strange: Aesthetics and Heterodoxy* (Baltimore: Johns Hopkins Univ. Press, 1996).
Breaking and Remaking	Paulson, *Breaking and Remaking: Aesthetic Practice in England, 1700–1820* (New Brunswick, N.J.: Rutgers Univ. Press, 1989).
Drawings	A. P. Oppé, *The Drawings of William Hogarth* (London: Phaidon Press, 1948).
Emblem and Expression	Paulson, *Emblem and Expression* (London: Thames & Hudson; Cambridge: Harvard Univ. Press, 1975).
Genuine Works	John Nichols and George Steevens, *The Genuine Works of William Hogarth* (1708–10).
Graphic Illustrations	Samuel Ireland, *Graphic Illustrations of Hogarth*, 2 vols. (1794, 1799).
HGW	Paulson, *Hogarth's Graphic Works* (1st ed., New Haven: Yale Univ. Press, 1965; 2d ed., 1970; 3d rev. ed., London: Print Room, 1989). Unless otherwise noted, reference will be to the 3d edition.
HLAT	Paulson, *Hogarth: His Life, Art, and Times*, 2 vols. (New Haven: Yale Univ. Press, 1971).
Hogarth	Paulson, *Hogarth*, 3 vols. (New Brunswick: Rutgers Univ. Press, 1991–93).
Hogarth Illustrated	John Ireland, *Hogarth Illustrated*, 3 vols. (1791, 1798).
Hogarth, Walpole, and Commercial Britain	David Dabydeen, *Hogarth, Walpole, and Commercial Britain* (London: Hansib, 1987).
Hogarth's Paintings	R. B. Beckett, *Hogarth's Paintings* (London: Routledge, 1949).

Preface

1. Mikhail Bakhtin, *The Dialogic Imagination*, trans. Caryl Emerson and Michael Holquist (Austin: Univ. of Texas Press, 1981), 74–77; see Francesco Novati, *Parodia sacra nelle letterature moderne* (Turin, 1889). Another, quite different usage is the one described by Louis Martz: converting the profane to sacred use, as in love poetry into religious poetry ("to convert these devices to the service of religion") — in England a tradition from Southwell through Donne and Herbert to Vaughan (Martz, *The Poetry of Meditation* [New Haven: Yale Univ. Press, 1954], 186, 184–93).

2. Paul Lehmann, *Die Parodie im Mittelalter* (Munich: Drei Masken Verlag, 1922; 2d ed., 1963), 124; trans. Joseph A. Dane, *Parody: Critical Concepts versus Literary Practices, Aristophanes to Sterne* (Norman: Univ. of Oklahoma Press, 1988), 175.

3. John Locke, *Essay Concerning Human Understanding*, ed. A. C. Fraser (New York: Dover, 1959), 4.15.3, 2:365; 4.18.2, 2:415.

4. Pierre Proudhon, *Système des contradictions économiques* (1846), ed. Roger Picard (Paris: Les Presses Universitaires, 1923), 1:55–56.

5. James Martineau to Elizabeth Peabody, 9 Dec. 1876, *The Life and Letters of James Martineau*, ed. James Drummond and C. B. Upton (New York: Dodd, Mead, 1902), 2:86–87. I am indebted for this and the following citations to Boyd Hilton, *The Age of Atonement: The Influence of Evangelicalism on Social and Economic Thought, 1795–1865* (Oxford, England: Clarendon Press, 1988), 5.

6. Vernon F. Storr, *The Development of English Theology in the Nineteenth Century, 1800–1860* (London: Longmans, Green, 1913), 73.

7. David Newsome, *Two Classes of Men: Platonism and English Romantic Thought* (London: J. Murray, 1972), 80.

8. See Ernest Lee Tuveson, *The Imagination as a Means of Grace: Locke and the Aesthetics of Romanticism* (Berkeley and Los Angeles: Univ. of California Press, 1960), 135.

9. J. G. A. Pocock, "Post-Puritan England and the Problem of the Enlightenment," in *Culture and Politics: From Puritanism to the Enlightenment*, ed. Perez Zagorin (Berkeley and Los Angeles: Univ. of California Press, 1980), 91–111; and "Clergy and Commerce: The Conservative Enlightenment in England," in *L'Età dei lumi: Studi storici sul settecento europeo in onore de Franco Venturi*, ed. R. Ajello (Naples, 1985), 524–62. As to the currency of the word *Enlightenment*, which we apply anachronistically for convenience, see J. C. D. Clark, *English Society, 1660–1832* (Cambridge: Cambridge Univ. Press, 2000), 9–10.

10. Knud Haakonssen, "Enlightened Dissent: An Introduction," in *Enlightenment and Religion: Rational Dissent in Eighteenth-Century Britain*, ed. Haakonssen (New York: Cambridge Univ. Press, 1996), 3.

11. Pocock, "Conservative Enlightenment," 97–98.

12. J. G. A. Pocock, *Barbarism and Religion*, vol. 1: *The Enlightenments of Edward Gibbon, 1737–1764* (New York: Cambridge Univ. Press, 1999), 7.

13. Haakonssen, "Enlightened Dissent," 2.

14. Pocock's is, in fact, a historian's way of describing the distinction literary historians long held, perhaps most persuasively presented in Paul Fussell's *The Rhetorical World of Augustan Humanism: Ethics and Imagery from Swift to Burke* (Oxford, England: Clarendon Press, 1965), which includes in its conservative tradition Swift, Pope, Johnson, Burke, Gibbon, and Reynolds. The difference is that Fussell would not have thought of these writers as representatives of the Enlightenment but rather as its enemies.

15. David Bindman, *Hogarth and His Times* (London: British Museum, 1997), 63n. 147. American literary historians and German art historians have been more receptive to my identification of the *Harlot* parodies. I first pointed out the parallels in 1971 in *HLAT*, 1:270–71, again in 1975 in *Emblem and Expression*, in 1991 in *Hogarth*, vol. 1, and most recently in *Beautiful, Novel, and Strange* (1996).

16. Jeremy Howard, "Hogarth, Amigoni and 'The Rake's Levee,'" *Apollo* 146 (1997): 36. See Frederick Antal, "Hogarth's Borrowings," *Art Bulletin* 29 (1947): 36–47, later incorporated into *Hogarth and His Place in European Art* (London: Routledge, 1962).

17. Hogarth's "Britophil" essay, *St. James's Evening Post*, 7–9 June 1737; reprinted, *London Magazine* 6 (July 1737): 385–86, and Paulson, *HLAT*, app. F.

18. Introduction, *HGW*, and *HLAT.*

19. Edgar Wind, "'Borrowed Attitudes' in Reynolds and Hogarth," *Journal of the Warburg Institute* 2 (1938): 183–85; reprinted in Wind, *Hume and the Heroic Portrait: Studies in Eighteenth-Century Imagery* (Oxford, England: Clarendon Press, 1986), 69–73.

20. Michael Leddy, "Limits of Allusion," *British Journal of Aesthetics* 32 (1992): 111–12; cited, in a discussion of Christopher Smart's use of allusion, by Marcus Walsh, "'Community of Mind': Christopher Smart and the Poetics of Allusion," in *Christopher Smart and the Enlightenment*, ed. Clement Hawes (New York: St. Martin's Press, 1999), 29–30. Cf. also Gérard Genette, *Palimpsests: Literature in the Second Degree*, trans. Channa Newman and Claude Doubinsky (Lincoln: Univ. of Nebraska Press, 1997), 2.

21. John Wilkes's latest biographer, a distinguished historian, refers to Hogarth (in the one page he devotes to the Hogarth-Wilkes relationship) as a "cartoonist" (Peter D. G. Thomas, *John Wilkes, a Friend of Liberty* [Oxford, England: Clarendon Press, 1996], 22).

22. See Bernd Krysmanski, "Hogarths 'A Rake's Progress' als 'Anti-Passion' of Christ," pt. 2, *Lichtenberg-Jahrbuch* 1999 (Saarbrücker Druckerei und Verlag, 2000): 131–33; citing Jan Bialostocki, "'Alt' und 'neu' in der Kunstgeschichte," *Jahrbuch der Hamburger Kunstsammlungen*, 20 (1975): 10. See also Alexander Goulay, "On Allusion, Narrative, and Annunciation in Hogarth's *A Harlot's Progress*," forthcoming in *1650–1850: Ideas, Aesthetics and Inquiries of the Early Modern Era.*

23. In *Popular and Polite Art in the Age of Hogarth and Fielding* (Notre Dame, Ind.: Univ. of Notre Dame Press, 1979) and again in *Hogarth*, vol. 2 (in the chapter on industry and idleness), I showed how the lower orders — in particular, apprentices and masters who had been apprentices — would have read Hogarth's prints and come up with a reading very similar to that of his elite, educated audience.

24. E. P. Thompson, *Witness against the Beast: William Blake and the Moral Law* (New York: New Press, 1993); Clement Hawes, *Mania and Literary Style: The Rhetoric of Enthusiasm from the Ranters to Christopher Smart* (New York: Cambridge Univ. Press, 1996).

25. Ronald Paulson, *Representations of Revolution (1789–1820)* (New Haven: Yale Univ. Press, 1983).

26. *Breaking and Remaking*, pt. 1, chap. 2, and pt. 2, chap. 1.

27. Ronald Paulson, *Don Quixote in England: The Aesthetics of Laughter* (Baltimore: Johns Hopkins Univ. Press, 1998).

CHAPTER ONE: Introduction

1. My opinion, although I am aware that neither Partridge nor the other dictionaries of slang agree with me. Robert Graves thought that *bloody* was derived from By Our Lady

(*Lars Porsena or The Future of Swearing and Improper Language* [London: Kegan Paul, 1927], 29, 42–43). On the use of *Jesus Christ* as opposed to *God* as an expletive, see p. 13.

2. Or at least St. Paul was the first to transmit the story. It is possible that he may have received, within four or five years of Jesus' death, the outlines of the story from the Apostles in Jerusalem, who had already interpreted Christ's life "according to the scripture," and passed them on in his epistles. See Robin Fox Lane, *The Unauthorized Version: Truth and Fiction in the Bible* (New York: Knopf, 1992), 120–21; cf. A. N. Wilson, *Paul: The Mind of the Apostle* (New York: Norton, 1997), passim.

3. A. N. Wilson also draws attention to Paul's home, Tarsus, as a center of Mithraic worship: the story of Hercules' descent into the underworld to bring back Alcestis, a divine (son of Zeus) savior who redeems and restores life, and the drinking of the blood of sacrificial bulls or its symbolic equivalent in wine (*Paul*, 25–27).

4. Mark 10:45, Matt. 20:28, Luke 21:28; see also 1 Tim. 2:6. See *Eerdmans Dictionary of the Bible*, ed. David Noel Freedman, Allen C. Myers, and Astrid B. Beck (Grand Rapids, Mich.: Eerdmans, 2000).

5. In Leviticus 16:10–11 two goats are sacrificed, one that is killed outright and a second, called the *scapegoat*: "But the goat, on which the lot fell to be the scapegoat, shall be presented alive before the lord, to make an atonement with him, and to let him go for a scapegoat into the wilderness."

6. *The Book of Common Prayer and Administration of the Sacraments and Other Rites and Ceremonies of the Church* (Greenwich, Conn.: Seabury Press, 1953), 78, 84.

7. The image of the shepherd is associated in the OT with God, with his kings, and in particular with David and the prophecy that God's shepherd would come from David's line and would suffer on behalf of his sheep. In the NT Jesus calls himself the "good shepherd" who "lays down his life for his sheep" (John 10:1–29), perhaps based on Zech. 13:7. His mission is "to the lost sheep of Israel" (Matt. 10:6, 15:24).

8. Nothing of this appeared in Genesis, where Adam's sin merely introduces toil and childbirth, not death, into man's life. St. Augustine argued from Romans 5:12–18 that Original Sin had been transmitted by Adam to each of his descendants. But his text for Romans was Latin and mistranslated Paul's Greek "death passed upon all men, because [in that] all sinned" as: "death passed upon all men because of Adam, [in whom] all sinned." As Robin Fox Lane puts it, "Original sin was read unnecessarily into Genesis and was then forced on to Paul by a wrong translation of his writings" (Fox Lane, *The Unauthorized Version*, 25).

9. Leslie Tannenbaum, writing in the context of Blake: *Biblical Tradition in Blake's Early Prophecies: The Great Code of Art* (Princeton: Princeton Univ. Press, 1982), 103–4, 102. For the best account of typology, see Paul Korshin, *Typologies in England, 1650–1820* (Princeton: Princeton Univ. Press, 1982).

10. Tannenbaum, *Biblical Tradition in Blake's Early Prophecies*, 103–4.

11. In the mid–eighteenth century William Warburton published a multivolume argument to prove that the doctrine of a future state is what distinguished Christianity from Judaism, NT from OT. See *The Divine Legation of Moses* (1738), in particular pt. 2, bks. 5 and 6.

12. Literal translation: "[Jesus Christ] Who, being in the form of God, thought it not robbery to be equal with God [did not cling to his equality with God]: But made himself of no reputation [emptied himself], and took upon him the form of a servant, and was made in the likeness of men [assumed the condition of a slave and became as men are]: And being

found in fashion as a man, he humbled himself, and became obedient unto death, even the death of the cross" (Phil. 2:6–8).

13. See Leo Steinberg, *The Sexuality of Christ in Renaissance Art and in Modern Oblivion*, rev. ed. (Chicago: Univ. of Chicago Press, 1996).

14. See also 1 Cor. 10:16–17.

15. See Horton Davies, *Worship and Theology in England* (Princeton: Princeton Univ. Press, 1975), 2:311. For ecclesiastical background, see C. W. Dugmore, *Eucharistic Doctrine in England from Hooker to Waterland* (London: Society for Promoting Christian Knowledge, 1942), esp. chap. 6.

16. On the controversy, see Davies, *Worship and Theology in England*, 1:76–123.

17. Charles Wesley, "Eucharistic Hymns," in John and Charles Wesley, *Selected Writings and Hymns*, ed. Frank Whaling (Mahwah, N.J.: Paulist Press, 1981), 12, 1.

18. John Jewel, *A Reply to Mr. Harding's Answer*, in *Works of John Jewel, Bishop of Salisbury*, ed. J. Ayre (Cambridge: Parker Society, 1845–59), 1:449, 2:1, 121.

19. Malcolm M. Ross, *Poetry and Dogma: The Transfiguration of Eucharistic Symbols in Seventeenth Century English Poetry* (New Brunswick, N.J.: Rutgers Univ. Press, 1954), 61. See Eliot's essay, "The Metaphysical Poets" (1921), and his British Academy lecture on Milton (1947) and Frank Kermode, " 'Dissociation of Sensibility': Modern Symbolist Readings of Literary History," in *Romantic Image* (London: Routledge, 1957; ARK paperbacks, 1986), 138–61.

20. William Haller, *The Rise of Puritanism* (New York: Columbia Univ. Press, 1938); Perry Miller, among others, *The New England Mind: The Seventeenth Century* (Cambridge: Harvard Univ. Press, 1956).

21. Frank Kermode, in Robert Alter and Frank Kermode, *The Literary Guide to the Bible* (Cambridge: Harvard Univ. Press, 1987), 143.

22. Kermode's phrase, in Alter and Kermode, *Literary Guide to the Bible*, 144.

23. John, in his Gospel, omits the Last Supper and, making another typological move, relates the "Communion" of the multitude fed by Christ with loaves and fishes to the Israelites fed by Moses with manna: "Our fathers did eat manna in the desert; as it is written, He gave them bread from heaven to eat. Then Jesus said unto them, Verily, verily, I say unto you, Moses gave you not that bread from heaven; but my Father giveth you the true bread from heaven. For the bread of God is he which cometh down from heaven, and giveth life unto the world" (6:31–33). In this passage Jesus asserts that "I am the bread of life; he that cometh to me shall never hunger; and he that believeth on me shall never thirst" — and we are back at the Lord's Supper. "I am that bread of life," he says, but then, implicating the Passion, adds that "He that eateth my flesh, and drinketh my blood, dwelleth in me, and I in him" (6:48, 56).

24. Calvin, *Institutes of the Christian Religion*, ed. John T. McNeill, trans. Ford Lewis Battles, 2 vols., Library of Christian Classics, vols. 20 and 21 (Philadelphia: Westminster Press, 1960), 1385.

25. Ann Kibbey, *The Interpretation of Material Shapes in Puritanism: A Study of Rhetoric, Prejudice, and Violence* (New York: Cambridge Univ. Press, 1986), 56, 55.

26. J. A. I. Champion, *The Pillars of Priestcraft Shaken: The Church of England and Its Enemies, 1660–1730* (New York: Cambridge Univ. Press, 1992), 7.

27. See Raymond D. Tumbleson, *Catholicism in the English Protestant Imagination: Nationalism, Religion, and Literature, 1660–1745* (New York: Cambridge Univ. Press, 1998), chap. 4. I am indebted to Tumbleson's thorough account of the subject for the quotations following.

28. Richard Baxter, *Fair-Warning: or, XXV Reasons against Toleration and Indulgence of Popery* (London, 1663), 14, 17.

29. Thomas Pope Blount, *Essays on Several Occasions* (1691), 52; Champion, *The Pillars of Priestcraft Shaken*, 9.

30. See Davies, *Worship and Theology in England*, 1:266, 275.

31. Ibid., 2:27; John Pocklington, *Altare Christianum or the Dead Vicars Plea* (1637), 141.

32. *The Works of the Most Reverend Father in God, William Laud, D.D., Sometime Lord Archbishop of Canterbury*, ed. W. Scott and J. Bliss (Oxford, England: John Henry Parker, 1847–60), 6:57.

33. Kibbey, *Material Shapes in Puritanism*, 48; citing Keith Thomas, *Religion and the Decline of Magic* (New York: Scribner's, 1971), 75. See Ernest B. Gilman, *Iconoclasm and Poetry in the English Reformation* (Chicago: Univ. of Chicago Press, 1986), and Kibbey, *Material Shapes in Puritanism*, chap. 3. Iconoclasm is also discussed in *Breaking and Remaking*, pt. 1.

34. *Visitation Articles and Injunctions*, ed. W. H. Frere and W. M. Kennedy (1910), 2:126.

35. See Philip Harth, *Pen for a Party: Dryden's Tory Propaganda* (Princeton: Princeton Univ. Press, 1993), 11.

36. See Kibbey, *Material Shapes in Puritanism*, 48.

37. Already under way before the turn of the century. A print of the club in action in the 1720s was long attributed to Hogarth (erroneously): See *HGW*, no. 281.

38. See *Matthew Henry's Commentary on the Whole Bible* (Peabody, Mass.: Hendrickson, 1991), 1:430. Henry concludes, "Christ can and hath redeemed the inheritance, which we by sin had forfeited and alienated, and made a new settlement of it upon all that by faith become allied to him."

39. Writing of Dryden's "To His Sacred Majesty," which compares Charles to David and Augustus, to Noah and Julius Caesar, James D. Garrison notes, "The Biblical allusions are clustered at the beginning of the poem, giving way in the end to the Roman" (*Dryden and the Tradition of Panegyric* [Berkeley and Los Angeles: Univ. of California Press, 1975], 167). I am indebted to Garrison's subtle analysis of the panegyrics welcoming Charles II's restoration.

40. The title of the book itself is *Astrea Redux. A Poem on the Happy Restoration & Return of His Sacred Majesty Charles the Second* (1660), lines 50–52, 275, 316–23; in *The Works of John Dryden*, ed. Edward Niles Hooker, H. T. Swedenberg Jr., etc., California ed. (Berkeley and Los Angeles: Univ. of California Press, 1961), 1:23, 29–31.

41. Dryden, *Annus Mirabilis*, stanzas 167, 266, 283, 264–65, 276, 283 (California ed., 1:85, 98–99, 101–2).

42. Alan Roper points out that in its first half, the English-Dutch war, *Annus Mirabilis* is primarily a series of epic similes (*Dryden's Poetic Kingdoms* [London: Routledge, 1961], 15–34, 74–86).

43. George Cheyne, *An Essay on Regimen* [London, 1740], 228; see Earl R. Wasserman, "Nature Moralized: The Divine Analogy in the Eighteenth Century," *ELH* 20 (1953): 39–76; and cf. Korshin, *Typologies in England*, 18–19.

44. *Annus Mirabilis*, stanzas 293–95 (California ed., 1:103). T. S. Eliot noted the importance of the *Georgics* for the Christian world as the Benedictine fusion of work and prayer ("Vergil and the Christian World," *On Poetry and Poets* (New York: Farrar, Straus,

1957), but there is no sign that the Christian commentators of Virgil picked up on the analogy of regeneration, recovery, restoration, and redemption.

45. Aside from the recovery of the Homeric conventions of games, visit to the underworld, etc., there is the recovery of the story of Aeolus's bag of winds, the hero's sad contemplation of the paintings of the Trojan War, and the final battle between the hero and his antagonist (Aeneas and Turnus fulfill the function of Odysseus's long-delayed combat with Alcinous). The plot itself reverses the battles and travels of the *Iliad* and *Odyssey*, revaluing the exuberant Homeric battle into an unfortunate necessity.

46. See Steven N. Zwicker, *The Art of Disguise: Politics and Language in Dryden's Poetry* (Princeton: Princeton Univ. Press, 1984). The Rome-England parallel is most clearly expressed by Dryden in his "Dedication of the Aeneis" and his translation.

47. Dryden's is a libertine retelling of *Paradise Lost*, in the ethos though not the manner of his then friend the earl of Rochester. He is interested in the love and foreplay of Adam and Eve, the seduction, the Fall, and Hobbes's State of Nature — but not in the redemption that corrects the Fall. Likewise, in *Absalom and Achitophel* the king reasserts his control, but there is no "redemption" as there was in *Annus Mirabilis*. Dryden treats the subject of redemption briefly in *The Hind and the Panther* (1687), II.499–514.

48. Dryden, "Discourse concerning the Original and Progress of Satire" (1693), in *Works*, California ed., 4 (Berkeley and Los Angeles: Univ. of California Press, 1974), 15.

49. John Dennis, *The Grounds of Criticism in Poetry* (1704), in *The Critical Works of John Dennis*, ed. Edward Niles Hooker (Baltimore: Johns Hopkins Press, 1939), 1:369.

50. "Plaisanterie poëtique qui consiste à tourner quelques ouvrages serieux en burlesque." I am indebted in the following paragraphs to Joseph A. Dane, *Parody: Critical Concepts versus Literary Practices, Aristophanes to Sterne* (Norman: Univ. of Oklahoma Press, 1988), 121–34. My examples are cited by him.

51. "qu'on y a introduit trop de license, tant dans le sujet que dans les vers, & trop de ridicules plaisanteries."

52. *Dictionnaire de l'Académie françoise* (1694 and 1776 eds.); cited by Dane, *Parody*, 124–25. Johnson's definition in his *Dictionary*, citing the French *travesti*, is "Dressed so as to be made ridiculous; burlesqued."

53. "Pareva a mio guidizio che si facesse torto a poeme così eminente di non tradurlo in dilettevole stile giocoso, affinche il gusto fosse più univeersale e potesse ciascuna, nell'ora di respirare dalle gravi occupazioni, prendere opportuno sollevamento" (cited by Dane, *Parody*, 132).

54. "Defense of the Epilogue," in *The Works of John Dryden*, California ed., 11:204.

55. Boileau, *Le Lutrin*, "Au lecteur," in *Oeuvres* (1702), 1006. He calls his *Lutrin* a "burlesque" since, unlike a parody, it does not have a particular poetic source, only epic in general. Following Boileau, Dryden wrote (discussing Varronian satire) that the parodist "quoted the Verses of *Homer* and the Tragick Poets, and turn'd their serious meaning into something that was Ridiculous" ("Discourse concerning . . . Satire," in *Works*, 4:47).

56. Boileau, *L'Art poétique*, lines 79–84.

57. Dane, *Parody*, 139.

58. Joseph Mazzeo, "New Wine in Old Battles: Reflections on Historicity and the Problem of Allegory," in his *Varieties of Interpretation* (Notre Dame, Ind.: Univ. of Notre Dame Press, 1978), 64–65.

59. Shaftesbury, grandson of the founder of the Whig party, "made [in Michael Ferber's words] God into a constitutional or even titular monarch, stripping him of all at-

tributes but the power to found the state and reign in name over it" — a philosophy applied by Whigs to the government of the state. See Michael Ferber, *The Social Vision of William Blake* (Princeton: Princeton Univ. Press, 1985), 106.

60. See *Beautiful, Novel, and Strange*, chap. 3.

61. I have treated the novel elsewhere, arguing that deism created a novel-reader that interpreted novels (or at least more sophisticated readers) in a way that made a religious reading — one of religious belief (e.g., in providence) — no longer possible. See *Beautiful, Novel, and Strange*, 129–30.

CHAPTER TWO: Blasphemy and Belief

1. Hogarth, *Autobiographical Notes*, 216. Parts of this chapter appeared, in a different form, in "Some Thoughts on Hogarth's Jew: Issues in Current Hogarth Scholarship," in *Hogarth: Representing Nature's Machines*, ed. David Bindman et al. (Manchester, England: Manchester Univ. Press, 2001), 236–80.

2. Charteris and Gonson were identified by George Vertue as soon as the prints were displayed in Hogarth's window. Contemporaries also knew the stories of how Charteris seduced such girls from the country by having a bawd hire them into service when they arrived in London (see *Hogarth*, 1:248).

3. The Harlot is identified in plate 1 on her trunk as "M.H." and in plate 3 on a piece of paper as "M. Hackabout." See *HGW*, nos. 120–26.

4. James Hall, *Dictionary of Subjects & Symbols in Art* (New York: Icon, 1974), 268.

5. This is Leo Steinberg's argument about Leonardo's *Last Supper*: see *Leonardo's Incessant "Last Supper"* (New York: Zone Books, 2001), 23, 252.

6. Addison, *Spectator*, no. 315. See Michael Murrin, *The Veil of Allegory* (Chicago: Univ. of Chicago Press, 1969).

7. Richard Steele, *Conscious Lovers* (1722), V.iii. See *HLAT*, 1:261, and *Hogarth*, 1:278–79.

8. A. N. Wilson, *Paul: The Mind of the Apostle* (New York: Norton, 1997), 183; Clinton E. Arnold, *Ephesians, Power, and Magic: The Concept of Power in Ephesians in Light of Its Historical Setting* (New York: Cambridge Univ. Press, 1989).

9. In plate 1 Mother Needham is chucking Hackabout's chin — the chin-chucking gesture Leo Steinberg notices in so many scenes involving the Christ Child. Needham is treating Hackabout as if in a conflation of Visitation and Nativity (Steinberg, *The Sexuality of Christ* [Chicago: Univ. of Chicago Press, 1983], 6–8).

10. See Hogarth's *Analysis of Beauty* (1753) and below, chap. 4.

11. While the images are most easily traced to the Dürer prints, they are found in numerous paintings and prints of the fifteenth to seventeenth centuries, especially north European.

12. William Blackstone, *Commentaries on the Laws of England*, IV.4.iv–v, 4 (1769): 59–60.

13. See Leonard W. Levy, *Blasphemy: Verbal Offense against the Sacred, from Moses to Salman Rushdie* (New York: Knopf, 1993). A more recent study, from the French perspective, is Alain Cabantous, *Blasphemy: Impious Speech in the West from the Seventeenth to the Nineteenth Century*, trans. Eric Rauth (New York: Columbia Univ. Press, 2002).

14. G. D. Nokes, *A History of the Crime of Blasphemy* (London: Sweet 7 Maxwell, 1928), 42.

15. *The Diary of Samuel Pepys*, ed. Robert Latham and William Matthews (London, 1970), 4:209–10; also Levy, *Blasphemy*, 213–15.

16. Matthew Hale cited by Levy, *Blasphemy*, 221n. 35.

17. See Nokes, *Crime of Blasphemy*, 46–49. "Taylor's case became the leading authority for the proposition that the common law had jurisdiction over the expression of unorthodox religious opinion" (49).

18. *State Trials*, 13:917–20, 923–27; quotation from Michael Hunter, " 'Aikenhead the atheist': The Context and Consequences of Articulate Irreligion in the Late Seventeenth Century," in *Atheism from the Reformation to the Enlightenment*, ed. Michael Hunter and David Wootton (Oxford, England: Clarendon Press, 1992), 225–26 (221–54).

19. Levy, *Blasphemy*, 232–35.

20. "An Act for the More Effectual Suppressing of Blasphemy and Profaneness," 1697, 9 Will. 3, c. 35. See Donald Thomas, *A Long Time Burning: The History of Literary Censorship in England* (London: Routledge, 1969), 67, 69.

21. Levy, *Blasphemy*, 237.

22. It may be enough to note the failure of Archbishop William Wake's blasphemy bill of 1720 in Lords by a two-to-one majority (only five prelates voted for it). Ibid., 299–301.

23. Nokes, *Crime of Blasphemy*, 77; for Woolston, 75–78. Thomas Emlyn was prosecuted in 1703 for his *Humble Inquiry into the Scripture Account of Jesus Christ* (sentenced to two years in prison) and Edward Elwell in 1724 for *A True Testimony for God and His Sacred Law*, but no case had the influence of the Woolston case.

24. Thomas Woolston, *First Discourse on the Miracles of our Saviour*, 5th ed. (1728), 19–20.

25. T.S. 11.577, 21 May 1728; William H. Trapnell, *Thomas Woolston: Madman and Deist?* (Bristol: Thoemmes Press, 1994), 61.

26. Trapnell, *Thomas Woolston*, 62.

27. Laurence Hanson has traced the practice back to Charles I's Star Chamber: "The influence of Star Chamber practice is evident most of all in the dominant part played by the judges in trials for libel. It was left solely with them to determine whether a publication was libelous or not. Theirs was the right to decide on the irony or sincerity of any libel" (Hanson, *Government and the Press, 1695–1763* [London: Oxford Univ. Press, 1963], 19).

28. *Genuine Works*, 2:101; *HGW*, no. 122. Giles King was a pupil of George Vertue (whose diary furnishes us with most of the intimate knowledge of Hogarth's activities in these years), and King's copies of the *Harlot* were sold from Vertue's house. See Timothy Clayton, *The English Print, 1688–1802* (New Haven: Yale Univ. Press, 1997), 83, 294n. 39.

29. In 1714 the Lower House of Convocation voted to prosecute Clarke's *The Scripture-Doctrine of the Trinity* (1712), but proceedings were blocked by the Upper House. See J. P. Ferguson, *Dr. Samuel Clarke: An Eighteenth-Century Heretic* (Kineton: Round Wood Press, 1976), 83–97.

30. For the parallel between Uzzah and Woolston in the picture and the Jew in the scene below — by way of the "stab in the back" — see p. 66.

31. See *State Trials*, vol. 15 (1710), for which my thanks to Roger Lund.

32. *Sir John Gonson's Five Charges to Several Grand Juries*, 3d ed. (London, 1737), 37; cited in *Hogarth, Walpole, and Commercial Britain*, 113.

33. *The Oxford Almanac of 1712, Explain'd* (1712), 4, 5. The reference is to the *Last Supper* in St. Mary's Whitechapel; see p. 60.

34. Sigmund Freud, *The Interpretation of Dreams*, in *Standard Edition of the Complete*

Psychological Works of Sigmund Freud, trans. James Strachey (London: Hogarth Press, 1966), 4:277–78.

35. See in particular Sandby's print, *The Author Run Mad* (*Analysis,* 23 and fig. 43).

36. *A Harlot's Progress,* as an image in the popular consciousness of the 1730s, was paradigmatic for works of the following decades by Richardson, Cleland, Fielding, and Sterne. Sterne has at least one episode in *Tristram Shandy* that plays on the Mary-Joseph joke of virgin birth (see *Beautiful, Novel, and Strange,* 166–67, 173–75).

37. See Paulson, *The Life of Henry Fielding* (Oxford, England: Blackwell, 2000), 89–91.

38. Fielding, *Works,* Henley ed., 9:306–15.

39. See Peter Lewis, "Fielding's *The Covent-Garden Tragedy* and Philips' *The Distrest Mother,*" *Durham Univ. Journal* 37 (1976): 33–46.

40. *Grub-Street Journal,* 13 July 1732; cited in Martin C. and Ruthe Battestin, *Henry Fielding, A Life* (London: Routledge, 1989), 135.

41. Corbyn Morris, *An Essay towards Fixing the true Standards of Wit, Humour, Raillery, Satire, and Ridicule* (1744).

42. Jeremy Collier, *A Short View of the Immorality, and Profaneness of the English Stage* (London, 1698), 12–13.

43. Raymond Tumbleson's words, in *Catholicism in the English Protestant Imagination* (Cambridge: Cambridge Univ. Press, 1998), 137. See Elkanah Settle, *A Defense of Dramatick Poetry: Being a Review of Mr. Collier's View of the Immorality and Profaneness of the Stage* (London, 1698) and *A Farther Defense* . . . (London, 1698).

44. Settle, *Farther Defense,* 64–65.

45. Philip Stubbes, *Anatomie of Abuses* (1583), 2:86; William Prynne, *Histriomastix* (1632), 491; Jonathan Dollimore, *Radical Tragedy* (Durham: Duke Univ. Press, 1993), 22.

46. Hogarth, *Analysis of Beauty,* ed. Burke, 209, 211.

47. In *Noon* of *The Four Times of the Day* (1738), *The March to Finchley* (1750), *Harlot* 1, and *Hudibras and the Skimmington* (*HGW,* nos. 147, 184, 121, 88).

48. The Jesuit Robert Parsons claimed that in Sir Walter Ralegh's "school of Atheists" "both Moses and our Savior, the Old and the New Testament, are jested at" (quoted in Ernest A. Strathmann, *Sir Walter Ralegh* [New York: Columbia Univ. Press, 1951], 25; see Stephen Greenblatt, "Invisible Bullets: Renaissance Authority and Its Subversion, Henry IV and Henry V," in Jonathan Dollimore and Alan Sinfield, ed., *Political Shakespeare: New Essays in Cultural Materialism* [Ithaca: Cornell Univ. Press, 1985], 18–47). In the sixteenth century there was the man who laughed at the idea of Queen Elizabeth as the *Virgin Queen* — and lost his ears.

49. The story, referred to in Origin's attack on the late-second-century pagan Celsus (*Against Celsus* 1.1), appears most notoriously in the anonymous *Traité des Trois Imposteurs* [i.e., Moses, Jesus, and Mohammad] (1719; 1775 ed., 53). For the story of Panthera, see, e.g., Thomas Woolston, *The Moderator between an Infidel and an Apostate* (1725), 66–67.

50. Charles Blount, *Great is Diana of the Ephesians: On the Original of Idolatry* (1680), 24.

51. Peter Annet, *The Miraculous Conception: or, The Divinity of Christ* (n.d.; reprint, London: R. Carlile, 1819), 12; cited in James A. Herrick, *The Radical Rhetoric of the English Deists: The Discourse of Skepticism, 1680–1750* (Columbia: Univ. of South Carolina Press, 1997), 133. Herrick dates the *Miraculous Conception* 1744.

52. Fielding, Preface to *Joseph Andrews* (1742).

53. Mikhail Bakhtin, *The Dialogic Imagination,* trans. Caryl Emerson and Michael Holquist (Austin: Univ. of Texas Press, 1981), 76–77. I proposed the subculture possibility in

Notes to Pages 57–60 365

Popular and Polite Art in the Age of Hogarth and Fielding (Notre Dame, Ind.: Notre Dame Univ., 1979), but I based my argument not on Bakhtin (whose *Dialogic Imagination* I had not yet read) but on E. P. Thompson's more historically grounded essays on eighteenth-century English popular culture.

54. *Hogarth's Peregrination*, ed. Charles Mitchell (Oxford: Clarendon Press, 1952), 7.

55. See Henry Sacheverell, *The Political Union: A Discourse Showing the Dependence of Government on Religion* (1702), 50–51; cited in J. P. Kenyon, *Revolution Principles: The Politics of Party, 1689–1720* (New York: Cambridge Univ. Press, 1977), 93.

56. Cited in Battestin, *Henry Fielding*, 135.

57. This was a song used more than once by Fielding in his farces. Fielding's context in *The Grub-Street Opera*, III.iii., air 45, is that the English have "been taught to dress our meat by nations [the French] that have no meat to dress."

58. Linda Colley has made the provocative suggestion that these are "nuns." That the women, while the crosses they wear show they are pious Catholics, are only fishmongers is indubitable, not only from observation (one has a crate of fish on her back) but from Hogarth's own account of the scene (*Autobiographical Notes*, 227–28; Linda Colley, *Britons: Forging the Nation, 1707–1837* [New Haven, 1992], 33).

59. Hogarth may have intended a further witty allusion in the epigraph to *Boys Peeping at Nature*, "Antiquam exquirite matrem": Dryden had used it as an epigraph for his apology for Catholicism, *The Hind and the Panther* (1687), where it meant: Seek out your original mother, the Church of Rome.

60. On the cult of martyrdom, see *Marriage A-la-mode* 1, where Hogarth mixes Christian and pagan martyrdoms and murders, e.g., St. Sebastian and Prometheus. His point, among others, is the deist one — the parallels between Christian and pagan stories.

61. The copy (1684, the first collected ed.), with Hogarth's signature in pencil on the verso of the title page, was sold by Maggs Bros. Ltd., cat. no. 937 (*Association Books*, 1971), no. 63. I am grateful to DeAnn DeLuna for the reference.

62. See Rachel Weil, *Political Passions: Gender, the Family, and Political Argument in England, 1680–1714* (Manchester, England: Manchester Univ. Press, 1999), 94–95. I am indebted to Catherine Molineux for drawing this to my attention.

63. Kent had also cost Sir James Thornhill an important royal commission that should have been his as Serjeant Painter (*Hogarth*, 1:84–88).

64. *HGW*, no. 63; see Eirwen E. C. Nicholson, "The St. Clement Danes Altarpiece and the Iconography of post-Revolution England," in *Samuel Johnson in Historical Context*, ed. J. C. D. Clark and Howard Erskine-Hill (Hampshire, England: Palgrave Publishers, 2002), 55–76, which fills in details from the parish registers and the contemporary journals. Nicholson presents rather dubious evidence for Burlington's Jacobitism and reproduces an almost illegible photograph of the since-destroyed painting and Jakob Frey's portrait of Clementina (his illustrations 1 and 3). This article contains useful archival research but, like other scholars in the Clark circle, Nicholson pushes the Jacobite business too far.

65. See G. V. Bennett, *White Kennett, 1660–1728, Bishop of Peterborough: A Study in the Political and Ecclesiastical History of the Early Eighteenth Century* (London: Church Historical Society, 1947), 251.

66. *A LETTER from a Parishioner of St. Clement Danes, To the Right Reverend Father in God, EDMUND, Lord Bishop of London, Occasion'd by His Lordship's causing the picture, over the Altar, to be teken down. With some Oservations on the Use and Abuse of Church Paintings in*

General, and of that Picture in Particular (Sept. 1725). Nicholson, "The St. Clement Danes Altarpiece," 55–76. Nicholson believes the pamphlet is by Hogarth; I doubt this, although in some respects it expresses his views.

67. In one of the articles celebrating Hogarth's tercentenary, an art historian identified a source for the Eucharist machine in north European antipapist penny prints and concluded, again recalling Antal (this time, *Hogarth's Place in European Art* of 1962), that it "reminds us once again of the breadth of the artist's background" but with no recognition of the political and historical context or of Hogarth's own anticlericalism, no notice of the parallel in his "Britophil" essay to "Ship Loads of dead *Christs, Holy Families, Madona's*, and other dismal Dark subjects" (a Madonna also hangs on the wall), and no reference to the context of *Harlot* 6 and its parody Eucharist. See Christopher Woodward, "Hogarth's *Marriage Contract*," in *A Rake's Progress from Hogarth to Hockney* (London, Soane Museum catalogue, 1997), 14.

68. Francis Haskell dates the introduction of the term *Old Master* to the late eighteenth century (*The Ephemeral Museum: Old Master Paintings and the Rise of the Art Exhibition* [New Haven: Yale Univ. Press, 2000], 3–4).

69. John Trenchard and Thomas Gordon, *Cato's Letters: Essays on Liberty, Civil and Religious, and Other Important Subjects* (London, 1720–24; reprint, New York: Da Capo Press, 1971), 3:118.

70. I have pointed out how Hogarth plays with the issue of how many breasts an artist should represent on the Diana Multimammia (*Hogarth*, 1:275).

71. Bernd Krysmanski, "Hogarths 'A Rake's Progress' als 'Anti-Passion' of Christ," pt. 2, *Lichtenberg-Jahrbuch* 1999 (Saarbrücker Druckerei und Verlag, 2000). The object, therefore, is to ridicule the connoissseur. Recognition will demonstrate their need to revise their standards, and if they do not recognize the borrowings, their inability to recognize the models forces them to recognize Hogarth's superiority.

72. Leo Steinberg, *Leonardo's Incessant "Last Supper"*; cf. David Rosand's review, *New Republic*, 10 Sept. 2001, 42.

73. See, e.g., Edwin Jones, *The English Nation: The Great Myth* (Gloucestershire: Thrupp, 1998).

74. Giovanni Paolo Lomazzo, *Trattato dell'arte della pittura* (1584), and Cardinal Federico Borromeo, *Musaeum* (1625); cited in Andrew Butterfield, *New York Review of Books*, 18 July 2002, 14.

75. In the case of *The Last Supper*, however, the figure of John bending his head toward Jesus resembles the figure of the prostitute who leans over Hackabout's body (in reverse, of course, given Hogarth's habitual failure to correct for reversal in engraving).

76. *Genuine Works*, 1:43–44. Hogarth's politics at this point were apparently independent of, if not at odds with, Thornhill's, although the commission of the Walpole Salver in 1727–28 could have been through Thornhill's good graces as a Walpole supporter. We know that in 1729 Thornhill angrily repudiated Hogarth when he eloped with his daughter Jane, but in 1730 he collaborated with his son-in-law on a group portrait of M.P.s that included Walpole. All of this may be taken as further evidence of Amhurst's influence on Hogarth's politics (see below) but also of Hogarth's relative indifference to the political, as opposed to the religious, aspect of his satire.

77. The source was George Vertue's diary; see *Hogarth*, 1:237–38.

78. For the identification of the painting with an Ecce Homo scene, see Dora Panofsky, "Gilles or Pierrot?" *Gazette des Beaux-Arts* 162 (1952): 319–40. The engraving, by

Bernard Baron (who later did work for Hogarth), was published in Mar. 1733 (announced, *Mercure de france*, Mar. 1733, 554), but Hogarth could have seen it in progress since Baron was by this time working in London.

79. Charles Leslie, *The Case Stated*, 4th ed. (1714), 144–45, 207; cited in Nicholson, "The St. Clement Danes Altarpiece," 64–65.

80. Hogarth, rejected passages from the *Analysis*, 116; *Autobiographical Notes*, 209, 210, 209.

81. See *Hogarth*, vol. 1, chap. 1.

82. There were also, however, many William Hoggarts or Hoggards in Westmoreland. The chief Hoggart or Hoggard Christian names were William, Lancelot, and Richard.

83. J. G. A. Pocock, "The Varieties of Whiggism from Exclusion to Reform," in *Virtue, Commerce, and History: Essays on Political Thought and History, Chiefly in the Eighteenth Century* (Cambridge: Cambridge Univ. Press, 1985), 219.

84. Sacheverell, *The Political Union*, 50–51; cited in Kenyon, *Revolution Principles*, 93. In the terms of party politics, we should note that Richard Hogarth's Latin letter to Robert Harley ("Optimo Mecoenas") in the summer of 1710 was just at the outset of Harley's ministry and of his Tory phase—before his ministry, under the influence of the October Club, he sought to prohibit the practice of occasional conformity and close dissenting academies. Richard, in short, would have known Harley as an Old Whig, of dissenter stock. (See *Hogarth*, 1:26, 28–30.)

85. This is, I believe, the purpose of the obviously Roman Catholic holy medal. I do not think it labels her a Catholic, as Paul Monod does (and as I suggested in *Beautiful, Novel, and Strange*, 29; Monod, "Painters and Party Politics in England, 1714–1760," *Eighteenth-Century Studies* 26 [1993]: 390).

86. This is a story we have only on the word of Adam Walker, a contemporary who is also the source for Richard Hogarth's origin in Westmoreland (*Genuine Works*, 3:315–17; Walker's account first appeared as a footnote in Nichols's *Biographical Anecdotes* of 1781). If this story is true, Richard has to have arrived in London not in 1688 but in 1686 (when Gibson is recorded as metriculating at Queen's College, Oxford), unless, of course, the trip was between Gibson's terms at Oxford. For Gibson, see Norman Sykes, *Edmund Gibson* (Oxford, England: Clarendon Press, 1926). In one case Gibson may seem to have been an ally of Hogarth's: Gibson removed William Kent's painting of St. Cecilia from over the altar of St. Clement's Church, an act Hogarth celebrated in a burlesque of Kent's painting (Oct. 1725) (*HGW*, no. 63).

87. Despite the Toleration Act of 1689, which permitted Protestant Dissenters to worship, the restrictions remained on Nonconformist teaching, and teachers were prosecuted for teaching without a license; thus Richard Hogarth supported himself with the proprietorship of a coffee house. See David L. Wykes, "The Dissenting Academy and Rational Dissent," in *Enlightenment and Religion: Rational Dissent in Eighteenth-Century Britain*, ed. Knud Haakonssen (New York: Cambridge Univ. Press, 1996), 102.

88. Full title: *Codex Juris Ecclesiae Anglicanae; or the Statutes, Constitutions, Canons, Rubrics and Articles of the Church of England digested under their proper heads, with a Commentry Historical and Juridical.*

89. J. H. Plumb, *Sir Robert Walpole: The King's Minister* (London: Cresset Press, 1960), 95. See *Harlot's Progress*, plates 1 and 3 (in *HGW*, nos. 121, 123; *Hogarth*, 1:2, 249, 253, 288–90, 389, 328–29). For Gibson, see J. C. D. Clark, *English Society, 1688–1832: Ideology, Social Structure, and Political Practice during the Ancien Regime* (Cambridge: Cambridge

Univ. Press, 1985), 277–315. Clark points out an example of Gibson's politics: He followed the Ministry, voting in Lords against a bill to suppress atheism, profaneness, and blasphemy (332).

90. Hogarth may have recalled commonplaces of anticlerical wit from the Restoration: "There sits a chambermaid upon a hassock / Whom th' chaplain oft instructs without his cassock." In Vanbrugh's *The Relapse* (1697) the chaplain, Bull, is told, "Thou art always for doing something in private with Nurse."

91. See *HLAT*, app. B.

92. Hogarth preserved the Bible (British Library), lightly crossing out the Gibbons genealogy and adding the Hogarth family genealogy beginning with Richard and extending to his own marriage to Jane Thornhill and the deaths of his father, mother, and father-in-law.

93. *Post-Man*, 8–11 Jan. 1703/4.

94. J. A. I. Champion, *The Pillars of Priestcraft Shaken: The Church of England and Its Enemies, 1660–1730* (Cambridge: Cambridge Univ. Press, 1992), 7.

95. Gerrard Winstanley, *The Law of Freedom* (1652), in *Works* (Ithaca: Cornell Univ. Press, 1941), 470, 523.

96. See *HGW*, nos. 43, 53, 56. *The South Sea Scheme* has been traditionally dated ca. 1721 on the basis of its referent, the South Sea Bubble, and its style, but the first known publication was with *The Lottery* in 1724 (*Hogarth*, 1:72–73).

97. In the terms of past-present, the past in *MacFlecknoe* is the memory of Augustus and Virgil, and so the present of Flecknoe and Shadwell is a degeneration, but, in the 1670s, it is only a subculture within a classical culture and not yet dominant. *MacFlecknoe* is not yet Juvenalian but rather a mock-heroic satire on the ridiculous pretensions of the poetasters and their political analogues, the out-of-place Whigs.

98. My text is *Gulliver's Travels*, ed. Herbert Davis (Oxford, England: Basil Blackwell, 1959). This section was originally delivered at a symposium, "Jonathan Swift, 1667–1745," at Yale University in Sept. 1995 and was published, in a fuller form, as "Putting Out the Fire in Her Imperial Majesty's Apartment: Anticlericalism, Opposition Politics, and Aesthetics," in *ELH* 63 (1996): 79–107.

99. *A Key, being Observations and Explanatory Notes, upon the Travels of Lemuel Gulliver*, a pamphlet which connected Walpole and George Townshend with Flimnap and Reldressal, also announced on the 5th, was published by Edmund Curll, who had published most of Amhurst's earlier works. The *Craftsman* itself does not mention *Gulliver's Travels* until no. 14 (16–20 Jan. 1726/7) and then only as an example in an ironic history of ridicule in England.

100. The author of the pamphlet *The Devil to Pay at St. James's*, published a few months later (June 1727) at the time of the fracas involving the opera divas Cuzzoni and Bordoni at the Royal Academy of Music, may recall *The Punishment of Lemuel Gulliver*. It calls on Hogarth to illustrate other scenes in *Gulliver*.

101. Earlier Hogarth had adapted the clothes worship of chap. 1 of Swift's *Tale* in *Royalty, Episcopacy, and Law* (1725) — and later he drew upon the *Tale* and *Mechanical Operation of the Spirit* in *Enthusiasm Delineated* and *Credulity, Superstition, and Fanaticism* (1759–62). For that matter, he reinterpreted Swift's "Baucis and Philemon" in *The Sleeping Congregation* (1736) and *The Battle of the Books* in his *Battle of the Pictures* (1745). The one point of explicit contact was Faulkner's letter to Hogarth of 15 Nov. 1740: "I have often the Favour of drinking your Health with Dr. Swift, who is a great Admirer of yours, . . . and

desired me to thank you for your kind Present, and to accept of his Service" (British Library, Add MS. 27995, 4). In this letter Faulkner ordered fifty sets of the *Distressed Poet, Enraged Musician*, and the projected companion "on Painting" for his shop. This corrects *Hogarth*, 2:394n. 57.

102. The fact that the book and frontispiece were first announced in Mar. 1722/3, however, could suggest that they knew each other earlier. See *HGW*, no. 100.

103. William Law, *A Second Letter to the Bishop of Bangor* (London, 1717), 67; cited in Clark, *English Society*, 327.

104. Quoted by Clark, *English Society*, 352, who adds that "it was not Lockeian contractarianism but Hoadleian ecclesiology which provoked the most bitter domestic ideological conflict of the century."

105. Tumbleson, *Catholicism in the English Protestant Imagination*, 164–66 and 244n. 41. The title of Hoadly's 1716 tract made the point: *Preservation against the Principles and Practices of the Non-jurors, both in Church and State, an Appeal to the Conscience and Common-sense of the Christian Laity* (versus the clergy).

106. The shared veneration of Hoadly raises another question about the Hogarth-Amhurst relationship. There is no indication of Hogarth's personal contact with the Hoadlys, the bishop and his two sons, until the 1730s (perhaps through Sarah Curtis Hoadly, the bishop's first wife, a portrait painter). It is possible that he first met the bishop through his great admirer Amhurst. See *Hogarth*, 2:166.

107. Kenyon, *Revolution Principles*, 116. Hoadly, according to Leslie Stephen, was "the best-hated clergyman of the century amongst his own order" (Stephen, *History of English Thought in the Eighteenth Century* [London, 1876; reprint, New York: Harcourt, 1962], 2:129). Hoadly was hardly "a clergyman in good standing" (David Bindman's words, arguing for Hogarth's orthodoxy, in *Hogarth and His Times* [London: British Museum, 1997], 51) except with the civil authorities, who rewarded him for his argument for the separation of church from state with ever higher preferments. J. C. D. Clark expresses his own High Church bias when he refers to Hoadly's "infamous sermon" *The Nature of the Kingdom or Church of Christ* (1717), which started the Bangorian controversy (Clark, *English Society*, 334).

108. The only other portrait was his own engraving of his painting of Martin Folkes, a freethinker of the same mold as Amhurst. In at least one case, he used the Hoadly engraving as frontispiece of the folio, in place of his own portrait (now in the Richard Greenberg Collection, New York), presumably for someone in Hoadly's see.

109. See Champion, *The Pillars of Priestcraft Shaken*, 170–222.

110. Clark, *English Society*, 350–51.

111. Ibid., 352–53.

112. *Protestant Popery: or, the Convocation* of 1718 (a year before the expulsion) is addressed to and presented as a defense of Hoadly (with his portrait by Gerard Vandergucht as frontispiece). Amhurst's pose is Hoadlian Protestant versus Oxford Roman Catholic. *Protestant Popery* was followed by *The Protestant Session, a Poem* (1719), this time addressed to Stanhope, the chief minister. The poem celebrates Stanhope and George I, as well as, once again, Hoadly, as Protestant heroes who banish popery and superstition from England. What intervened between 1719 and the inauguration of *The Craftsman* in 1726 were the South Sea Bubble, the disgrace and death of Stanhope, and the rise to power of Walpole and with him Bishop Gibson. The chief event, however, was personal.

113. My citations are from Amhurst, *Poems on Several Occasions* (1720), 3d ed., 1724.

Another volume, also called *Poems on Several Occasions*, also published in 1720, and also with the Hoadly frontispiece, signed "By a Student of Oxford," is a collection of Amhurst's Bangorian poems (with their original title pages) ending with an ironic prose attack on William Law, Hoadly's most skillful responder, with a separate title page signed "By a Free-Thinker at Oxford" and at the end signed "Philalethes Oxoniensis."

114. Settling into the life of a hack writer in London, in 1721 Amhurst published the fifty *Terrae-Filius* essays (every Wednesday and Saturday from 11 Jan. to 6 July), satires on all aspects of Oxford but focused, in nos. 14–18, on the subject of his expulsion. For the collected edition (published in June 1726), Hogarth furnished a frontispiece showing a grim clergyman within what appears to be an ecclesiastical court tearing in two a copy of *Terrae-Filius*, while poor Amhurst, prevented from ascending the lectern, is being stripped of his wig and robe by clerics. The location is probably the Sheldonian Theatre. Hogarth may identify himself with the *Terrae-Filius* as he had identified himself two years earlier with Apuleius and Charles Gildon (the latter another deist) in his frontispiece for Gildon's *Metamorphoses* (1724; see *HGW*, no. 43).

115. Amhurst and Hogarth have focused on these issues in the graphic image of *The Punishment of Lemuel Gulliver*. My text is *The Craftsman*, 1st collected ed. (2nd ed., 1727), which runs from no. 1, 5 Dec., to no. 9, 2 Jan. 1726/7. No. 13 (13–16 Jan.), in its original publication, announced publication of the first nine numbers (and separately no. 11, on the East India Co.).

116. *British Museum Catalogue of Satiric Prints*, no. 2327; repro. Paul Langford, *The English Satirical Print, 1600–1832: Walpole and the Robinocracy* (Cambridge, England: Chadwyck-Healey, 1986), no. 48. George II's rump was the namesake of the Rump-Steak Club; the club was formed in 1734 to commemorate the king's turning his "Royal Rump" on courtiers who had gone into opposition.

117. The purge also implies a parody of the purifying sense in the liturgy of water (Mark 9:41, John 4:10, Rev. 22:17). Gulliver's water bowl in the foreground makes a sort of baptismal font into which one of the Lilliputian children has fallen.

118. If Amhurst is the author of *The Twickenham Hotch-Potch*, signed by Caleb D'Anvers, a spinoff of *The Beggar's Opera* that spells out its anti-Walpole satire, he is certainly not friendly toward the Scriblerians, whom he calls "an impertinent *Scotch*-Quack, a Profligate *Irish*-Dean, the Lacquey of a Superannuated Dutchess, and a little virulent Papist" (vi). *The Twickenham Hotch-Potch* (a copy in Yale's Beinecke Library) was published by J. Roberts, whereas most *Craftsman* offshoots signed Caleb D'Anvers were published by the *Craftsman* publisher, Francklin. Internal evidence, however, leads me to think Amhurst the author. The evidence of advertising is inconclusive. Amhurst repeatedly advertised Lewis Theobald's attack on Pope, *Shakespeare Restored*, in 1727; on the other hand, he thrice advertised the Swift-Pope *Miscellanies* (nos. 50, 51, 52).

119. On the diversity of opposition writing and outlook, see Christine Gerrard, *The Patriot Opposition to Walpole: Politics, Poetry, and National Myth, 1725–1742* (Oxford, England: Clarendon Press, 1994), 16–17.

120. As one example among many, Robert Howard's *History of Religion* (1694), which found equivalents of pagan worship in Catholicism (pagan Hades, Catholic Purgatory, demonology, and worship of saints), passed for an attack on the Roman Church, but his sense of "priestcraft" extended to the Church of England, and he drew on Charles Blount's deist *Great is Diana of the Ephesians* (1680). Howard, *History of Religion*, 52, 28–29; cited in Champion, *The Pillars of Priestcraft Shaken*, 138.

121. See *HGW*, no. 106.

122. The parody of an Adoration of the Magi in *Cunicularii*, which I noticed in "Putting Out the Fire," was (unknown to me) first recognized by Dennis Todd, who took it to be a Christmas joke, given the publication date of the print, and merely ornamental (Todd, *Imagining Monsters: Miscreations of the Self in Eighteenth-Century England* [Chicago: Univ. of Chicago Press, 1995], 99).

123. The title, "Wise Men of Godlimen," conflates the stories of the Wise Men of the Nativity and the Wise Men of Gotham, the subject of many jocular stories, some about cuckolding, the point being the Gothamites' stupidity and gullibility.

124. I am grateful to Anne Barbeau Gardiner for this counterargument (in a letter to me), which resulted from discussion at the conference referred to in note 98, above.

125. Woolston, *First Discourse*, 35.

126. Woolston, *Moderator*, 66–67, 62–64. See Trapnell, *Thomas Woolston*, to whom I am grateful for the details of biography and publication history.

127. The breakdown followed the reception of his first controversial publication in 1705; see Trapnell, *Thomas Woolston*, 36–37, citing William Whiston and others.

128. Woolston's lawyer, Humphrey Birch, argued that Woolston did not mean "to bring our religion into contempt, but to put [it] on a better footing" (*Account of the Trial of Thomas Woolston, B.D., An* (1729), 3.

129. Roger Lund, "Irony as Subversion: Thomas Woolston and the Crime of Wit," in *The Margins of Orthodoxy: Heterodox Writing and Cultural Response, 1660–1750*, ed. Lund (Cambridge: Cambridge Univ. Press, 1995), 170–94.

130. Woolston, *First Discourse*, 32.

131. Anthony Collins, *Discourse of the Grounds and Reasons of the Christian Religion* (1724), 41–42, 53.

132. The first *Discourse* was dated and announced early in 1727; Hogarth's *Cunicularii* was published at the end of December. On the other hand, "woman in the straw" was proverbial for a woman in childbirth (as in Farquhar's *Recruiting Officer*, 1.1, "Wench in the Straw," line 129, and "Woman in the Straw," line 272). Eric Partridge *(Dictionary of Slang)* speculates that the words may have derived from cattle calving in the hay, but they could as easily derive from the stable manger of the Nativity; in any case, Hogarth's "Lady" draws attention to the "Our Lady" aspect and the stable-manger scene (and the Mariolatry of Counter-Reformation popish propaganda).

133. British Museum, Dept. of Prints and Drawings, B 1670d 1733 C.IV (S.U.B.2)P.

134. Trapnell, *Thomas Woolston*, 68–72.

135. See above, n. 77.

136. Voltaire was one witness; see Trapnell, *Thomas Woolston*, 57–58. Bishop King, writing to Swift's housekeeper, Mrs. Whiteway, on 6 Mar. 1739, thought Swift had confused Woolston with William Wollaston, who *had* been patronized by Queen Caroline, though not with a pension (*Correspondence*, ed. Harold Williams [Oxford, England: Clarendon Press, 1965], 5:140). There was also, of course, a strong negative reaction to Woolston, who was insulted and attacked more than once while living within the Rules of the King's Bench Prison. See *The Life of Mr Woolston, with An impartial Account of his Writings* (London, 1733), 26–27.

137. Jonathan Jones, "Liberty Vindicated," attached to Woolston's *Defence*, pt. 1, accuses Gibson (12), but there were also accounts in the newspapers that connected the prosecution with Gibson (see Trapnell, *Thomas Woolston*, 56 and nn. 153–54).

138. Edmund Gibson, *The Bishop of London's Pastoral Letter to the People of his Diocese* (London, 1728), 8, 22. The pamphlet ran through six editions in two years.

139. Thomas Paine, *Age of Reason*, ed. Philip S. Foner (Secaucus, N.J.: Carol Publishing, 1998), 42.

140. Gibson, *Bishop of London's Pastoral Letter*, 4, 8, 32–35.

141. J. D. C. Clark regards the deists as a small but influential group of intellectuals: Charles Blount, John Toland, Anthony Collins, and Matthew Tindal. Clark refers to "the abstruse and 'advanced' opinions of the heterodox elite" (e.g., on three consecutive pages in *English Society*, 321–23): Deism derived its beliefs "from the evidence of nature rather than from specific disclosures to mankind in revelation," by which he means the Scriptures (324–25).

142. R. K. Webb, "The Emerging of Radical Dissent," in Haakonssen, *Enlightenment and Religion*, 26–27.

143. Collins, *A Discourse of Free Thinking* (1713), 44.

144. Collins, *Grounds and Reasons*, v, vi.

145. Herrick, *Radical Rhetoric*, 107; see chap. 5 in general.

146. Herbert Randolph, *Legal Punishments Consider'd. A Sermon Preached at the Assizes held at Rochester before the Honourable Mr. Justice Denton, On Wed. March the 12th, 1728/9* (London, 1729), dedication. Herrick cites these and other proponents of censorship and prosecution.

147. William Tilly, *A Preservative Against the growing Infidelity and Apostacy of the Present Age* (London, 1729); Richard Smalbroke, *Sermon Preached to the Societies for Reformation of Manners on Wednesday, January 10, 1727* (London, 1728), 16.

148. Jonathan Jones, "Liberty Vindicated," 13.

149. Matthew Tindal, *An Addess to the Inhabitants of the Two Great Cities of London and Westminster in Relation to a Pastoral Letter, Said to be Written by the Bishop of London* (London, 1729), A2.

150. C.U.A.Add. 2961, p. 1 (cited in Trapnell, *Thomas Woolston*, 67–68).

151. This sort of encoding is discussed by David Berman, "Deism, Immortality, and the Art of Theological Lying," in J. A. Leo Lemay, ed., *Deism, Masonry, and the Enlightenment: Essays Honouring Alfred Owen Aldridge* (Newark, N.J.: Rutgers Univ. Press, 1987), 61–78. On Hogarth and Freemasonry and on Freemasonry's use of the exoteric-esoteric division, see *Hogarth*, 2:55–60.

152. David Solkin, "The Excessive Jew in *A Harlot's Progress*," in Bindman, *Hogarth: Representing Nature's Machines*, 219–35. Solkin originally offered this argument in a lecture delivered at the Paul Mellon Centre for Studies in British Art in London, 11 Nov. 1997. My reply was published following his essay, "Some Thoughts on Hogarth's Jew: Issues in Current Hogarth Scholarship," in *Hogarth: Representing Nature's Machines*, 236–63. For the context of *philo*semitism, see Howard Weinbrot's useful chapter, "Jews and Jesus: This Israel, This England," in *Britannia's Issue: The Rise of British Literature from Dryden to Ossian* (New York: Cambridge Univ. Press, 1995), 405–45.

153. I made this point in 1971 (*HLAT*, 1:256). In the nineteenth century, the operation of *peri'ah* (following the *milah* executed with the knife), which was traditionally done manually with the *mohel*'s thumbnail, was supplemented with a scissors. See *Jewish Encyclopedia* and *Encyclopedia Judaica*; also, David L. Gollaher, *Circumcision: A History of the World's Most Controversial Surgery* (New York: Basic Books, 2000).

154. See above, n. 47. For a survey of Hogarth's iconography of scissors throughout his

work, see Aaron Santesso, "William Hogarth and the Tradition of Sexual Scissors," *Studies in English Literature* 19 (1999): 499–521.

155. Jenny Uglow, *Hogarth: A Life and a World* (London: Faber, 1997), 187.

156. Indeed, Gibson's particular attack on this *Discourse* and Woolston's rabbi may be connected with his own antisemitism, as evidenced in *The Deliverance and Murmurings of the Israelites and these Nations* (1716).

157. The fact is that Judaism and the OT were central to Collins's *Discourse of the Grounds and Reasons of the Christian Religion*, whose argument was that *because* Christianity is founded on Judaism, the NT on the Old, "then is Christianity false." Collins's attack is chiefly on typology. The "Sacrifice" of the *Harlot*, plate 6, for example, is foreshadowed typologically, as Collins would have said, in the print of "Abraham's Sacrifice of Isaac" on the Harlot's wall in plate 3.

158. Woolston's persona of the rabbi was not only a convenient cover or mask, it also reflected a primary source for the sort of arguments Woolston used against the NT. See Richard H. Popkin, "Jewish Anti-Christian Arguments as a Source of Irreligion from the Seventeenth to the Early Nineteenth Century," in Hunter and Wootton, *Atheism from Reformation to Enlightenment*, 157–81 (esp. p. 178).

159. Ruth Smith, *Handel's Oratorios and Eighteenth-Century Thought* (New York: Cambridge Univ. Press, 1995), 154–56, citing Thomas Morgan's *The Moral Philosopher* (1737–40).

160. On the Jewish origins of Christianity, argued by Henry Stubbe, John Toland, and others, see Champion, *The Pillars of Priestcraft Shaken*, 123–32.

161. The black boy functions as either the Jew's (another "possession" like Hackabout) or Hackabout's: a fashionable young lady "hath always two necessary Implements about her, a *blackamoor,* and a little *Dog,* for without these, she would be neither *Fair,* nor *Sweet*" (*The Character of a Town Misse* [1675], 7; see also J. Jean Hecht, *Continental and Colonial Servants in Eighteenth-Century England* [Northampton, Mass.: Smith College, 1954], 36).

162. In another Fielding imitation of the *Harlot, Miss Lucy in Town* (1735), Lucy is instructed that "a fine lady may kiss any man but her husband" — that is, like Hackabout in plate 2, she takes a beau. Lucy, like Hackabout, is "a girl just arrived out of the country" wishing to learn "all that a fine lady ought to be." She unwittingly takes lodging in Mrs. Midnight's brothel, attends masquerades, and is bought by both Lord Bawble and Mr. Zorobabel; the latter, recalling the Jew of *Harlot* plate 2, tells her that if she will "kiss" him he will "make you the first of ladies" and "furnish a house for you in any part of the town" (Fielding, *Works,* Henley ed., 12:43, 37, 48). The difference is that Fielding dramatizes their meeting; Hogarth illustrates the consequences of his making her his trophy.

163. See Jonathan Freedman, *The Temple of Culture: Assimilation and Anti-Semitism in Literary Anglo-America* (New York: Oxford Univ. Press, 2000).

164. See Kalman P. Bland, *The Artless Jew: Medieval and Modern Affirmations and Denials of the Visual* (Princeton: Princeton Univ. Press, 2000).

165. Michal does not appear in any of the Bible illustrations for the story, all of which, like Hogarth's, show both David leading the Ark and Uzzah — usually already fallen. I am indebted to Alexander Gourlay, who has canvassed the Bible illustrations.

166. *Matthew Henry's Commentary on the Whole Bible* (Peabody, Mass.: Hendrickson, 1991), 2:368.

167. There was even a Jonathan (John Thornhill), who was Hogarth's friend as he was Saul's. Of Jane Hogarth we know that after Hogarth's death she employed the Rev. John

Trusler to moralize his prints. And one of our few glimpses of Jane Hogarth is attending St. Nicholas Church, Chiswick — something we never hear of Hogarth doing.

CHAPTER THREE: Atonement

1. Rev. Jacob Duché to Thomas Paine, 18 Dec. 1767, quoted in Désirée Hirst, *Hidden Riches: Traditional Symbolism from the Renaissance to Blake* (New York: Barnes & Noble, 1964), 11.

2. The first-born son is to be sacrificed as the father's most precious possession but can be redeemed by the substitution of an animal, as in Exodus: "the firstling of an ass thou shalt redeem with a lamb. . . . All the firstborn of thy sons thou shalt redeem" (Exod. 34:20; cf. 13:13, 22:29).

3. Jon D. Levenson, *The Death and Resurrection of the Beloved Son: The Transformation of Child Sacrifice in Judaism and Christianity* (New Haven: Yale Univ. Press, 1993), 27 — which became in the Christian tradition "Jesus' identity as sacrificial victim, the son handed over to death by his loving father or the lamb who takes away the sins of the world" (x).

4. Frank Kermode, in Robert Alter and Kermode, *The Literary Guide to the Bible* (Cambridge: Harvard Univ. Press, 1987), 460.

5. Eugene R. Fairweather, ed. and trans., *A Scholastic Miscellany: Anselm to Ockham* (New York: Macmillan, 1970), 151, 105. See L. W. Grensted, *A Short History of the Doctrine of the Atonement* (Manchester, England: Longmans, Green, 1920), chap. 6; also George Hendry, *The Gospel of the Incarnation* (Philadelphia: Westminster Press, 1958), 117 ff. For Milton, see C. A. Patrides, "Milton and the Protestant Theory of the Atonement," *PMLA* 54 (1959): 7–13; and *Milton and the Christian Tradition* (New York: Oxford Univ. Press, 1966), 130–42. Throughout these pages I am grateful to Leslie Moore, whose doctoral dissertation first drew my attention to these issues in *Paradise Lost* (*Milton's Poetics of Redemption: Incarnation and Simile in "Paradise Lost" and "Paradise Regained,"* Yale Univ., 1981, chap. 1). On Anselm, see also Richard Southern, *Saint Anselm: A Portrait in a Landscape* (New York: Cambridge Univ. Press, 1990).

6. Patrides, "Milton and the Protestant Theory," 9; Grensted, *Doctrine of the Atonement*, 198–99, 222–23.

7. Grensted, *Doctrine of the Atonement*, 197.

8. Ibid., 204–5 and chaps. 9 and 10 passim.

9. *The Thirty-Nine Articles and the Constitutions and Canons, of the Church of England* (London, 1724).

10. Watts, "Eucharistic Hymns," no. 4, in *The Psalms and Hymns of Isaac Watts* (Moran, Pa.: Soli deo Gloria Publications, 1997), noted hereafter as EH.

11. Patrick Hume, *Annotations of Milton's Paradise Lost*, 107, attached to *Paradise Lost*, 6th ed. (1695). See Moore, *Milton's Poetics of Redemption*, 137.

12. On the me-thee-him triad, see Moore, *Milton's Poetics of Redemption*, 49–51, and Joseph Summers, *The Muse's Method* (Cambridge: Harvard Univ. Press, 1970), 179–80.

13. Hogarth's illustration for book 3 shows Father and Son in conversation atop a cloud of angel-heads, of the sort he satirized around the same time in *Kent's Altarpiece* (see fig. 20).

14. Thomas Hobbes, *Leviathan*, 3.38 (1650, ed. Michael Oakshott, Oxford, England: Basil Blackwell, 1960), 304.

15. Ibid., 3.41, 316–17.

16. Charles Blount, *Great is Diana of the Ephesians: On the Original of Idolatry* (1680), 1–2. See David Berman, "Disclaimers as Offence Mechanisms in Charles Blount and John Toland," in *Atheism from the Reformation to the Enlightenment*, ed. Michael Hunter and David Wootton (Oxford, England: Clarendon Press, 1992), 260–62. I pointed out Hogarth's use of Blount's *Great is Diana of the Ephesians* in *Hogarth*, 1:292.

17. Ovid, *Fasti*, book 1, lines 439–40; trans. Betty Rose Nagle, *Ovid's Fasti* (Bloomington: Indiana Univ. Press, 1995), 48.

18. See W. M. Spellman, *John Locke and the Problem of Depravity* (Oxford, England: Clarendon Press, 1988), esp. 103, 135–37.

19. John Locke, *The Reasonableness of Christianity as Delivered in the Scriptures* (1695, ed. George W. Ewing, Washington, D.C.: Regnery, 1965), 81. The wide circulation of this work, in J. C. D. Clark's words, "meant that Locke's later significance was primarily in the realm of religion" and not the politics of the *Two Treatises* (Clark, *English Society, 1660–1832* [Cambridge: Cambridge Univ. Press, 2000], 328). See Victor Nuovo, ed., *John Locke and Christianity: Contemporary Responses to "The Reasonableness of Christianity"* (Bristol: Thoemmes Press, 1997), and Richard Ashcraft, "Anticlericalism and Authority in Lockean Political Thought," in *The Margins of Orthodoxy: Heterodox Writing and Cultural Response, 1660–1750*, ed. Roger Lund (Cambridge: Cambridge Univ. Press, 1995), 73–96.

20. Shaftesbury, *Characteristics of Men, Manners, Opinions, Times*, ed. Lawrence E. Klein (New York: Cambridge Univ. Press, 1999), 181.

21. Blackstone, IV.33.v and VI.4:431, 433; IV.4:373–81; IV.31.4:395. The subject is discussed by Joan Dayan, *Held in the Body of the State*, forthcoming, Princeton Univ. Press.

22. The Ten Commandments, though opening with and stressing duty to God, also include commandments against murder, adultery, and stealing — anti-social crimes.

23. Declaration of the Council of Chalcedon, quoted in Leo Steinberg, *The Sexuality of Christ in Renaissance Art and in Modern Oblivion*, rev. ed. (Chicago: Univ. of Chicago Press, 1996), 17, emphasis added.

24. Luther, *Commentary on Galations* (1535), cited and translated by Grensted, *Doctrine of the Atonement*, 199.

25. *The Ladies' Calling* (1673), 14.

26. See Bernard Mandeville, *A Modest Defence of Publick Stews* (1724), xi–xii; *Hogarth*, 1:254–55. A connection between whore and hackney coach was made by Mandeville in the *Modest Defence*, 73–74, reflected in the *Harlot* in the name "Hackabout."

27. *Grub-street Journal*, 6 May 1731, citing *Daily Journal, Post Boy*, and other papers for 1 and 4 May. On 8 May *Mother Needham's Lamentation* was published *(Daily Journal)*.

28. We have noticed that Hackabout, imitating the ladies, takes a lover: as in Steele's *Conscious Lovers*, where the servant Tom imitates "the men of pleasure," which means that "We are false lovers [and] ruin damsels"; and much the same is true of his female equivalent, Phyllis. In *The Beggar's Opera*, because ladies of quality are "never without the Cholic," the whore Jenny Diver suffers from the cholic (II.iv).

29. *Matthew Henry's Commentary on the Whole Bible* (1706; Peabody, Mass.: Hendrickson, 1991), 1:416–17.

30. Cf. Steinberg, *The Sexuality of Christ*.

31. I discussed this in *Don Quixote in England: The Aesthetics of Laughter* (Baltimore: Johns Hopkins Univ. Press, 1998), chap. 4, especially concerning Maritornes' flat nose; the discussion of beauty patches was subsequently elaborated by Peter Wagner in "Spotting the Symptoms: Hogarthian Bodies as Sites of Semantic Ambiguity," in *The Other Hogarth:*

Aesthetics of Difference, ed. Bernadette Fort and Angela Rosenthal (Princeton: Princeton Univ. Press, 2001), 102–19.

32. "G.B.," *A Weeks Preparation Towards a Worthy Receiving of the Lords Supper* (London, 1679), 38, 79–80.

33. Richard Rambuss, *Closet Devotions* (Durham: Duke Univ. Press, 1998), 39, 73.

34. See above, Introduction, n. 1.

35. Mark Schorer, *William Blake: The Politics of Vision* (New York: Henry Holt, 1946), 95.

36. George Herbert, "Prayer," lines 114–15, 107; Donne, "Holy Sonnets," XIV, lines 12–14.

37. Samuel Rutherford, *Christ Dying and Drawing Sinners to Himselfe* (1647); "ravishings" are also present in Alexander Grosse's *Sweet and Soule-Perswading Inducements Leading Unto Christ* (1632); cited in Rambuss, *Closet Devotions*, 73.

38. Watts, hymns vii, xvi, xxi, xxx, liv, ix, c.

39. *HGW*, no. 52.

40. Anthony Horneck, *The Passion of our blessed Lord and Saviour Jesus Christ, or, Cryes of the Son of God* (London, 1700?), 2. For Horneck, see Madeleine Forell Marshall and Janet Todd, *English Congregational Hymns in the Eighteenth Century* (Lexington: Univ. Press of Kentucky, 1982), 25.

41. Isaiah cries: "How is the faithful city become an harlot!" (1:21); but now, he prophesies, "the Lord hath comforted his people, he hath redeemed Jerusalem. . . . For thy Maker is thine husband . . . and thy Redeemer the Holy One of Israel" (52:9, 54:5).

42. See M. H. Abrams, *Natural Supernaturalism: Tradition and Revolution in Romantic Literature* (New York: Norton, 1971), 45, 42–45.

43. John Cotton, *A Brief Exposition . . . Upon the Whole Book of Canticles* (London, 1655), 4, 66. See Edmund Morgan, "Those Sexy Puritans," *New York Review of Books*, 27 June 2002, 15–16, and Richard Godbeer, *Sexual Revolution in Early America* (Baltimore: Johns Hopkins Univ. Press, 2002).

44. Harriet is fond of Dorimant's song in which he associates himself with Satan by way of the wolf-entering-the-sheepfold simile used by Milton to describe Satan's entry into the Garden of Eden (4.183; *Man of Mode*, III.ii).

45. *Spectator*, no. 266 (4 Jan. 1711/12). George Vertue first recorded the fact that the third scene was what attracted (presumably prurient) attention to Hogarth's *Harlot;* I noted this in *HLAT* and *Hogarth;* more recently, James Grantham Turner has carried the notion to an extreme ("'A Wanton Kind of Chace': Display as Procurement in *A Harlot's Progress* and Its Reception," in Fort and Rosenthal, *The Other Hogarth*, 38–61).

46. For "the possibility of a feminized Christ" and "the mystery of Christ's descent into vulnerable flesh as an adoption of tacitly feminine traits" in the poetry of Herbert and others, see Michael Schoenfeldt, *Prayer and Power: George Herbert and Renaissance Courtship* (Chicago: Univ. of Chicago Press, 1991), 249. For "Jesus as mother," see Schoenfeldt, citing Herbert's Latin lyric (350). I owe these citations to Rambuss's valuable study.

47. See E. Pearlman, "George Herbert's God," *English Literary Renaissance* 13 (1983): 107; Carolyn Bynum, *Holy Feast and Holy Fast: The Religious Significance of Food to Medieval Women* (Berkeley and Los Angeles: Univ. of California Press, 1987), 261; Schoenfeldt, *Prayer and Power*, 250; and Leah Marcus, *Childhood and Despair: A Theme and Variations in Seventeenth-Century Literature* (Pittsburgh: Univ. of Pittsburgh Press, 1978), 148.

48. Toni Bowers defines "virtuous" motherhood in this period as "mothers who sub-

mitted to the developing code of domestic womanhood, abdicating both public inter-course and autonomous subjectivity" (*The Politics of Motherhood: British Writing and Cul-ture, 1680–1760* [New York: Cambridge Univ. Press, 1996], 98). On bad mothers, see 95–96; on Defoe, 97–101 ff.; on the monstrous mothers of the Tory satirists and their exces-sive reproduction, see 124.

49. Hogarth, however, never leaves things quite so clear-cut. The Harlot's son has unkempt hair, lice, a ragged sleeve, drooping stocking, and other signs of a neglected child and a careless mother. These are, however, evident at the stage of the Harlot's death; we do not see him earlier. No mother suffering the mercury cure for syphilis is going to be able to pay her child great attention.

50. Henry Adams, *Mont-Saint-Michel and Chartres* (1905, 1912; reprint, Boston: Houghton Mifflin, 1937), 252, 276–77.

51. See *Hogarth*, 1:26.

52. R. B. Beckett, *Hogarth's Paintings*, no. 75.

53. Hoadly, *The Nature of the Kingdom, or Church, of Christ* (London, 1717), 14; M. A. Stewart, "Rational Dissent in Early 18th-Century Ireland," in *Enlightenment and Religion: Rational Dissent in Eighteenth-Century Britain*, ed. Knud Haakonssen (New York: Cam-bridge Univ. Press, 1996), 52.

54. *The Presentment of the Grand Jury for the County of Middlesex to His Majesty's Court of King's Bench* (1728), p. 4; cited in William H. Trapnell, *Thomas Woolston: Madman and Deist?* (Bristol: Thoemmes Press, 1994), 60; for the Opposition satires, see *Political State of Great Britain*, ed. Abel Boyer, 35 (1728): 462–63.

55. See E. Beresford Chancellor, *The Lives of the Rakes* (New York: Brentano's, 1925), 119–20; *Some Authentic Memoirs of the Life of Colonel Ch . . . s, Rape-Master General of Great Britain* (1730), 45; *Scotch Gallantry Display'd, or the Life and Adventures of the unpararalleled Col. Fr . . . nc . . . s Ch . . . rt . . . s impartially related* (1730).

56. *Craftsman*, 10 Jan. 1730; cited in *Hogarth, Walpole, and Commercial Britain*, 95.

57. Cf. Toni Bowers, writing on the amorous tales of Behn, Haywood, and Manley: "The 'sexual' and the 'political' don't merely *overlap* in Augustan seduction writing; they *conflate*, forcing us to recognize not two categories but one. In many of the most widely-read amatory tales, virtually every steamy interaction 'counts' as political" ("Seduction Narratives and Tory Experience in Augustan England," in *The Eighteenth Century* 40 [1999]: 129).

58. In *Joseph Andrews*, when Barnabas and the bookseller cry him down, Parson Adams responds by citing the authority of Bishop Hoadly's *Plain Account*, "a Book written (if I may venture on the Expression) with the Pen of an Angel"—a work that has survived the enmity and attacks of the clergy (one of which was to be found in Shamela's library). Barnabas responds by calling Adams a Woolstonian deist, a Hobbesian materialist, a Muslim, and the Devil himself (1.17).

59. Hoadly, *A Plain Account of the Nature and End of the Sacrament of the Lord's Supper* (1735, 2d ed., 1735), 54.

60. One of the responses to Hoadly's Zwinglianism in his *Plain Account* was an anony-mous tract that argued against his idea of Christ's absence with the idea of the substitution of Him by a representative—as a seal represents the thing itself: "Nothing is more com-mon than to call the representations of things by the names of the things themselves which they represent. If then the bread and wine are representatives of the seal of the new covenant, what forbids that they should be termed the seal?" It is in this sense that

Charteris, Gibson, Gonson, and the others represent — are representatives of — Walpole, and in that sense substitutes. *Representation* seems to be the more precise term. (*Remarks on a Book lately published entitled A Plain Account of the Nature and End of the Sacrament of the Lord's Supper* [1735], 33; quoted in Darwell Stone, *A History of the Doctrine of the Holy Eucharist* [London: Longmans, Green, 1909], 2:491.)

61. The other place where Hogarth most prominently uses the Choice of Hercules as duty vs. pleasure is *The March to Finchley*, where the grenadier is drawn by a bawd toward the brothel and by a pretty young girl toward the sign of Adam and Eve, family, and duty.

62. Apropos the question of the evidence of contemporary references, in contemporary readings of Shaftesbury's *Characteristics*, we find many reactions (mostly hostile) to his *Sensis Communis*, numerous complaints about his apparent deism, but surprisingly little commentary on his aesthetic theories. Shaftesbury's most recent critic, Lawrence Klein, sees Shaftesbury in political or social terms and pays little attention to his aesthetics. But Hogarth in prints (*The Lottery, Harlot* 1, all the way to *The March to Finchley*) makes clear that he was aware of Shaftesbury's *Judgement of Hercules*. The aesthetic theory was transmitted by Francis Hutcheson in his *Inquiry concerning Beauty, Order, Harmony, and Design* (1725) and Jonathan Richardson in his *Science of a Connoisseur* (1719), in philosophical and popular terms. And there is the negative evidence of Hogarth's *Analysis of Beauty*, text and plates, whose assumptions are anti Shaftesbury's aesthetic principles.

63. Although Hercules clearly does not fit the Harlot's situation, he had been absorbed into Christian typology as a "suffering, martyred Christ, the subduer of symbolic evil, the performer of seven miraculous tasks" (Korshin, *Typologies in England*, 81; Jean Seznec, *The Survival of the Pagan Gods* [Princeton Univ. Press, 1953], 11, 154–55). Shaftesbury was "correcting" this tradition by returning Hercules to his classical and allegorical origins.

64. Woolston, *Discourses*, 1:32–34, 36–37.

65. *Hogarth*, 1:244–46, 251.

66. Calvin, *Institutes of the Christian Religion*, ed. John T. McNeill, trans. Ford Lewis Battles, 2 vols., Library of Christian Classics, vols. 20 and 21 (Philadelphia: Westminster Press, 1960), 1385.

67. I said, in *Hogarth* 1:10–11, that Hogarth learned from *Pilgrim's Progress*, from Interpreter's House with its "pictures" on the walls and its "pictured" images. But that was allegory, and Hogarth, who specifically avoids the allegorizing proposed by Woolston and other deists, also avoids Bunyan's. He does, however, follow the Puritan's reading of significance into the minutest detail — a procedure that in a way sacralized those details, which carry a heavy load of meaning/significance, as indeed did, in the same way, the bread and wine on the table of the Lord's Supper.

68. Bunyan, *Grace Abounding to the Chief of Sinners*, ed. Roger Sharruck (Oxford, England: Clarendon Press, 1962), 19–20.

69. Ibid., 9, 10, 19–20.

70. Ibid., 25, 44–45, 47–48, 49.

71. Calvin, *Institutes*, 1.17.1.

72. Hogarth may have known Pierre Bayle's notorious analogy between God, who gives Adam free will to sin, and the mother, who lets her daughter go out into the world and, of her own free will, lose her virginity. Where, he asks, is Hackabout's mother and father — and her "lofing cosin" who was to meet her — let alone the clergyman? (Bayle, *Historical and Critical Dictionary*, ed. Richard Popkin [Indianapolis: Bobbs-Merrill, 1965], 177–81).

73. Swift, "Description of a Young Nymph Going to Bed."

74. Sandys, *The Sermons of Edwin Sandys, D.D.*, ed. John Ayre (Cambridge: Parker Society, 1841–42), 1:88–89.

75. Swift had envisaged the satiric metaphor of cannibalism in *The Modest Proposal* (1728), suggesting that Ireland was being devoured by England.

76. Versions are in the Prado and the art museums of Bristol and Minneapolis.

77. For a good discussion of the Christological imagery in *Jane Shore*, see J. Douglas Canfield, *Nicholas Rowe and Christian Tragedy* (Gainesville: Univ. of Florida Press, 1977), 154–65.

78. Ibid., 162.

79. Hastings is another atoner in a play obsessed with atonement—one who dies for his own sin (he is a "lawless libertine") and for that of his lover Alicia (whose sin is jealousy). In the final scene with Alicia, who has unwittingly betrayed him as well as Jane, he asks what he could have done "so beyond the reach of pardon, / That nothing but my life can make atonement," and before going to execution he forgives her.

80. "Some remarks on the Play of George Barnwell . . . ," *Weekly Register*, 21 Aug. 1731; reprinted by John Loftis, ed., *Essays on the Theatre from Eighteenth Century Periodicals* (Los Angeles: Univ. of California Press, 1960), 33.

81. According to the account of Thomas Davies, editor of Lillo's *Works* (1775), 1:xv–xvii. In 1736 Fielding produced Lillo's next play, *Fatal Curiosity*.

82. Eighteen years later Hogarth rewrote *The London Merchant* in *Industry and Idleness*, making Trueman and Barnwell into Francis Goodchild and Tom Idle (in one drawing he names him Barnwell). For his subversion of Lillo's moral, see *Hogarth*, 2:307–9.

83. *London Merchant*, II.xi, ed. William McBurney (Lincoln: Univ. of Nebraska Press, 1965), 38.

84. I have discussed elsewhere the rewriting of the *Harlot* by Richardson in *Pamela* (a positive revision) and John Cleland in *Fanny Hill* (an aesthetic: see *Beautiful, Novel, and Strange*, 136–42).

85. Reprinted in McBurney, *London Merchant*, 86. In the ballad, "redemption" of Millwood is not a motive, only the greed of both Millwood and Barnwell.

86. Laura Brown has noted Lillo's problem, "that of motivating a workable tragic plot with a static, flawless and supremely pathetic central figure." His solution is "ingenious inconsistency": Barnwell is a thief and murderer, but the fault is with the evil temptress ("sorceress") who seduces him, who serves as "a negative advocate for the values represented in the action": her speech, Brown notes, "extends the source of evil to which our exemplary hero succumbs from the wiles of a single angry woman to the inequities of a whole society. We learn that Millwood is the product of a pervasive institutional corruption, in the courts, the government, and the church. She convincingly attributes her crimes to her poverty and to her situation in an unjust world." These words could apply equally well to Hogarth's Harlot. Thus Barnwell's fall, as Brown sees it, is the inevitable consequence of the kind of social corruption specifically opposed to the progressive and reformist bourgeoisie. (Laura Brown, *English Dramatic Form, 1660–1760* [New Haven: Yale Univ. Press, 1981], 159.)

87. This is essentially Hogarth's approach in *Industry and Idleness*, where Idle's stigmatic name, his plebeian ugliness, his placement in the dark part of the workshop—the three strikes he has against him at the outset—are played against Goodchild's good looks and charm; the latter takes the form of pleasing his master and courting the master's daughter.

88. *Clarissa* (1st ed., 1747–48), ed. Angus Ross (Harmondsworth: Penguin, 1985), 559.

89. *Works of Charles Dickens*, ed. Andrew Lang (New York: Scribner's, 1899), 21:436–37. In Rossetti's painting, *Found*, the girl arrived in London from the country is emblematized by the adjacent lamb bound for the slaughter, but there is no sign that she is atoning for anybody. *Found* was begun ca. 1854 and never completed (Delaware Art Museum; a finished drawing is in the BM). On the subject of typology in nineteenth-century English art, see George P. Landow, *William Holman Hunt and Typological Symbolism* (New Haven: Yale Univ. Press, 1979).

90. Another example among many is Van Dyck's *Lamentation* in the Alte Pinakothek, Munich.

91. Allen Staley, *The Paintings of Benjamin West* (New Haven: Yale Univ. Press, 1986), 57.

92. "It is not primarily a group portrait, but its interest to the public was certainly enhanced by recognizable likenesses of contemporary figures in the great event" (ibid., 59–60).

93. James Galt, *The Life of Benjamin West* (London, 1820), 48. Staley notes: "In the actual monument to Wolfe in Westminster Abbey by Joseph Wilton, probably begun before West's painting but completed after, the dying hero is nude, but his attendants wear contemporary military uniform" (Staley, *The Paintings of Benjamin West*, 156n. 65).

94. Reynolds view was: "What is done by Painting, must be done at one blow"; see *Discourses of Art*, ed. R. R. Wark (New Haven: Yale Univ. Press, 1975), 146.

CHAPTER FOUR: Incarnation

1. John Donne, "Holy Sonnets," XI, lines 13–14; again, XV, lines 13–14.

2. *Matthew Henry's Commentary on the Whole Bible* (Peabody, Mass.: Hendrickson, 1991), 5:475.

3. Clement Hawes, *Mania and Literary Style: The Rhetoric of Enthusiasm from the Ranters to Christopher Smart* (New York: Cambridge Univ. Press, 1996), 41–42.

4. Gerrard Winstanley, *Fire in the Bush*, in *The Works of Gerrard Winstanley*, ed. George H. Sabine (Ithaca: Cornell Univ. Press, 1941), 474.

5. Aliezer Coppe, *A Fiery Flying Roll* (1649 ff.), 1:6–8, 2:2–4, 13–15, 19; see Leonard W. Levy, *Blasphemy: Verbal Offense against the Sacred, from Moses to Salman Rushdie* (New York: Knopf, 1993), 138–41.

6. Leopold Damrosch, *The Sorrows of the Quaker Jesus: James Nayler and the Puritan Crackdown on the Free Spirit* (Cambridge: Harvard Univ. Press, 1996), 2; I am indebted to Damrosch's perceptive study.

7. William Goffe, in *Diary of Thomas Burton, Esq.*, ed. John Towill Rutt (New York: Johnson Reprint, 1974), 1:52, quoting Matthew 24:23–24.

8. Thomas Hobbes, *Behemoth, or, The Long Parliament* (completed 1668, publ. 1679), ed. Ferdinand Tonnies (2nd ed., London: Frank Cass, 1969), 187.

9. David Hume, *The History of England*, vol. 3 (1757) (Indianapolis: Liberty Classics, 1983, followed the 1778 ed.), 6:145–46.

10. Damrosch, *Sorrows of the Quaker Jesus*, 3–4.

11. John R. Knott, *Discourses of Martyrdom in English Literature, 1563–1694* (New York: Cambridge Univ. Press, 1993), 142–43.

12. James Nayler, *What the Possession of the Living Faith Is* (1659), in *A Collection of Sundry Books* (1676), 459.

13. Report of the Kelk Monthly Meeting, in Hugh Barbour and Arthur O. Roberts, eds., *Early Quaker Writings, 1650–1700* (Grand Rapids, Mich.: Eerdmans, 1973), 58.

14. Transcript, in Deacon, *The Grand Impostor Examined: Or, the Life, Tryal, and Examination of James Nayler* (1656), 11.

15. John Holland, reporting the beliefs of the Ranters, *The Smoke of the Bottomless Pit* (1657), cited in A. L. Morton, *The World of the Ranters in the English Revolution* (London: Lawrence & Wishart, 1970), 73; E. P. Thompson, *Witness against the Beast: William Blake and the Moral Law* (New York: New Press, 1993), 26.

16. Richard Coppin, *Divine Teachings* (1653), cited in Christopher Hill, *The World Turned Upside Down* (Harmondsworth: Penguin, 1975), 220.

17. Morton, *The World of the Ranters*, 74.

18. *Acts and Ordinances of the Interregnum, 1642–60*, ed. Charles Harding Firth and R. S. Rait (London: H.M. Stationery Office, 1911), 2:410.

19. See J. F. McGregor, "Seekers and Ranters," in *Radical Religion in the English Revolution*, ed. J. F. McGregor and B. Reay (London: Oxford Univ. Press, 1984), 133; Alexander Gordon, *The Origin of the Muggletonians* (1869), 16–17, and *DNB*, "Robins"; Thompson, *Witness against the Beast*, 28.

20. Diane Purkiss, "Producing the Voice, Consuming the Body: Women Prophets of the Seventeenth Century," in *Women, Writing, History, 1640–1740*, ed. Isobel Grundy and Sue Wiseman (Athens: Univ. of Georgia Press, 1992), 156.

21. See Damrosch, *Sorrows of the Quaker Jesus*, 73.

22. Deacon, *An Exact History of the Life of James Nayler* (1657), 35–37; Damrosch, *Sorrows of the Quaker Jesus*, 223–24.

23. Damrosch, *Sorrows of the Quaker Jesus*, 102.

24. "God had made all things good," Lawrence Clarkson wrote in 1660, "so nothing evil but as man judged it; for I apprehend there was no such thing as theft, cheat, or lie, but as man made it so" (Clarkson, *The Lost Sheep Found* [1660], 27).

25. The Jewish context of Christ's entry into Jerusalem certainly includes, as it may have for Hogarth's Harlot, the words of John 19:7, which were quoted against Nayler: "The Jews answered him [Pilate], We have a law, and by our law he ought to die, because he made himself the Son of God." (John Deacon, *The Grand Imposter EXAMINED: Or, The Life, Tryal, and Examination of JAMES NAYLER . . .* [1656], 7.)

26. See *Paradise Lost*, 12.285–306.

27. Cited in Thompson, *Witness against the Beast*, 24.

28. Thomas Tany, *Theauraujohn His Theousori Apokolipikal* (1651), cited in Thompson, *Witness against the Beast*, 30.

29. William Walwyn, *Just Defence* (1649), 8; see Morton, *The World of the Ranters*, 146–47.

30. Hogarth's ending his sequence of women with Venus is not surprising: Besides Ovid, Hogarth would have known through his father Lucretius's *De Rerum Natura*, the great predecessor and inspiration for Ovid's *Metamorphoses*. Lucretius's poem opens with an invocation of Venus, the source of all nature to whom man turns (for pleasure and for procreation) when human life is "weighted down / By grim Religion looming from the skies, / Horribly threatening mortal men." (Humphries trans., *The Way Things Are* [Bloomington: Indiana Univ. Press, 1969].)

31. Copies are in the National Portrait Gallery, London, and the collection of the duke of Grafton. See David Piper, *The English Face* (London: National Portrait Gallery, 1957), 130.

32. Ann Kibbey, *The Interpretation of Material Shapes in Puritanism: A Study of Rhetoric, Prejudice, and Violence* (New York: Cambridge Univ. Press, 1986), 44–46, citing Calvin, *Institutes of the Christian Religion*, ed. John T. McNeill, trans. Ford Lewis Battles, 2 vols., Library of Christian Classics, vols. 20 and 21 (Philadelphia: Westminster Press, 1960), 112.

33. Thomas Norton "emphasized the *figura* of common bread as a stylistic mandate for the human living icon" (Kibbey, *Material Shapes in Puritanism*, 49, also 45).

34. Ibid., 101, 112.

35. I offered this explanation in *HLAT*, 1:277–79.

36. In the *Analysis* Hogarth showed his dislike of Dürer's drawing manuals, based on mathematical proportions (*Analysis*, 5, etc.). But there is no way in which Dürer cannot have served as a model for Hogarth the engraver.

37. See above, chap. 1, n. 43.

38. Trevor Hart, "Through the Arts: Hearing, Seeing and Touching the Truth," in *Beholding the Glory: Incarnation through the Arts*, ed. Jeremy Begbie (London: Darton, Longman, & Todd, 2000), 9, 6, 7.

39. *HGW*, no. 204.

40. I use the word *aesthetics*, though it was first used by Alexander Baumgarten in his *Meditationes Philosophicae* of 1735 and further developed in his *Aesthetica* of 1750. Derived from the Greek *aisthetikos*, it means simply *perception* and has nothing per se to do with art or beauty; Baumgarten applies the word to poetics and discourse. See Baumgarten, *Meditationes (Reflections on Poetry)*, trans. Karl Aschenbrenner and William B. Holther (Berkeley and Los Angeles: Univ. of California Press, 1954), 78. As a context for the following pages, see *Beautiful, Novel, and Strange*.

41. *Analysis*, 59.

42. Cf. the pudgy body and round, unprepossessing face of Toft in John Laguerre's portrait, engraved in mezzotint by John Faber, *Mary Tofts of Godelman the pretended Rabbit Breeder* (announced 21 Jan. 1726/7, *Mist's Weekly Journal*, BM Sat. 1783).

43. Jeremy Taylor, *Unum Necessarium*, in *The Whole Works of the Right Reverend Jeremy Taylor*, ed. R. Heber (London, 1822), 8:262; Hobbes, *Leviathan* (1651), ed. Michael Oakeshott (Oxford, England: Blackwell, 1960), 64, 68.

44. See *Analysis*, chap. 5.

45. Fielding, *Universal Gallant, or the Different Husbands* (1735), 5.1. The metaphor appears in Fielding's earliest play, *Love in Several Masques* (1728), 1.1.

46. John Donne, Holy Sonnets, 13, 14; Crashaw, "Office of the Holy Cross," "Compline"; and Richard Rambuss, *Closet Devotions* (Durham: Duke Univ. Press, 1998), 140n. 5.

47. *Beaux Stratagem*, 1707, 3.2.

48. *The Old Batchellour*, 1690. Or does Hogarth's "pursuit" go beyond seduction *and* enjoyment to love and marriage (and motherhood)? Another couple descended from Vainlove and Bellmour were Archer and Aimwell in George Farquhar's *Beaux Stratagem* (1707): While Archer draws the line at "discretion" (seduction), he notes that Aimwell, who says of Dorinda, "I love her to distraction," goes over that line (4.2.7–9).

49. *Analysis*, 33.

50. I am indebted to a paper delivered by Scott Black at the 2001 Annual Meeting of the American Society for Eighteenth-Century Studies (ASECS).

51. Prior to Wilkes, Jacob Ilive was tried and convicted for his reply to an antideist tract by Bishop Sherlock in 1753 (thrice pilloried and sentenced to a year in prison); for Peter Annet's case in 1762, see below, p. 397n. 47.

52. It used to be thought that Potter wrote the *Essay on Woman*. In fact, Potter wrote Wilkes on 27 Oct. 1754, "I have read your parody for the ninety-ninth time, and have laughed as heartily as I did at the first. . . . In my conscience I think you exceed yourself" (BL, add. MSS 30867, f. 103). He may have added touches between then and the printing of the poem ca. 1763. In the meantime the manuscript presumably was circulated among the Medmenham friends. (See Peter D. G. Thomas, *John Wilkes, a Friend of Liberty* [Oxford, England: Clarendon Press, 1996], 4 and n. 23.)

53. David Foxon, *Libertine Literature in England, 1660–1745* (New Hyde Park, N.Y.: University Books, 1965), 50. Arthur H. Cash has recently produced a scholarly text of the book, *An Essay on Woman by John Wilkes and Thomas Potter* (New York: AMS Press, 2000), with a useful introduction.

54. See below, p. 397n. 47.

55. See Donald McCormick, *Hell-Fire Club: The Story of the Amorous Knights of Wycombe* (London: Jarrolds, 1958), and Horace Bleackley, *Life of John Wilkes* (London: John Lane, 1917), 48–51.

56. This, perhaps official, account comes from Wilkes's notes to Churchill's *The Candidate*, to the lines beginning "Whilst Womanhood, in habit of a nun, / At Medmenham lies, by backward monks undone" (line 695) — which go on to refer to "Libations" "from a common cup" "to the Goddess without Eyes." Printed in *Letters between Various Persons and John Wilkes, Esq.* (1769), 1:42–48, and in the *New Foundling Hospital for Wit* (1784), 3:104–07; quoted in *An Essay on Woman and Other Pieces Printed at the Private Press in Great George-Street, Westminster, in 1763, and now Reproduced in Facsimile from a Copy believed to be unique . . .* (London, 1871), 94–95.

57. See *Hogarth*, 3:277–80, 282–84.

58. John Wilkes, *An Essay on Woman*, 67–68.

59. Again by Charles Johnston in *Chrysal* (1759 ff.).

60. J. C. D. Clark, *English Society, 1660–1832* (Cambridge: Cambridge Univ. Press, 2000), 368.

61. Bleackley, *Life of John Wilkes*, 8–9, 54–55, 259–60.

62. 26 Jan. 1775, John Almon, *Parliamentary Registers*, 1:116; cited in Peter D. G. Thomas, *John Wilkes*, 177.

63. *Lords Journals*, 30:415.

64. Wilkes quoted in Bleackley, *Life of John Wilkes*, 438.

65. *Britannia's Intercession for the Deliverance of John Wilkes, Esq. From Persecution and Banishment. To which is added A Political Sermon* (London, [1768]), sig. Cr; cited in J. C. D. Clark, *English Society*, 367.

66. Horace Walpole, *Letters*, ed. Paget Toynbee (Oxford, England: Clarendon Press, 1903–5), 5:315; James Harris, Malmesbury MSS, photocopies, B. 56–57; cited in Thomas, *John Wilkes*, 233n. 61.

67. See, e.g., Howard Caygill, *The Art of Judgement* (Oxford, England: Blackwell, 1989); Terry Eagleton, *The Ideology of the Aesthetic* (Oxford, England: Blackwell, 1990); and Peter de Bolla, *The Discourse of the Sublime: History, Aesthetics, and the Subject* (Oxford, England: Blackwell, 1989).

68. Clark, *English Society*, 354–55.

69. The following pages are drawn from my chapter on Wright of Derby in *Emblem and Expression*.

70. Hogarth did the same with children and with dogs in his conversation pieces. See *Hogarth*, 1:224–25.

71. Benedict Nicolson remarked on *The Alchemist* (Derby) in *Joseph Wright of Derby* (London: Paul Mellon Centre, 1968), 52.

72. Vermeer converted to Catholicism in 1653 when he married a well-to-do Catholic. The paintings are post-1658. So we must suppose that they consciously or unconsciously carry on, or came out of, Vermeer's Protestant upbringing. They are simply not Catholic paintings. The Netherlands was, of course, known for toleration.

73. I am indebted to Thomas Crow's paper on Chardin at ASECS, Apr. 2001.

74. See *Beautiful, Novel, and Strange*, 239. On Gainsborough's use of Hogarth's aesthetics, see *Emblem and Expression*, 204–231; *Analysis*, xlix.

75. There are one or two exceptions, e.g., *Diana and Actaeon* (Royal Collection), discussed in *Emblem and Expression*, 224–25.

CHAPTER FIVE: Redemption

1. For the Incarnation theory, see chap. 1, n. 6.

2. See, e.g., Joshua Sylvester's translation of Du Bartas's *Divine Works* (1605, 1641, etc.), I.i.23, 49–52, 169–183; I.vii.11–18; in *The Complete Works of Joshua Sylvester*, ed. Alexander Grosart (Edinburgh, 1880). For analogy, see chap. 1, n. 42.

3. Wasserman, "Nature Moralized: The Divine Analogy in the Eighteenth Century," *ELH* 20 (1953): 55; citing Peter Browne, *Things Divine and Supernatural Conceived by Analogy* (London, 1733), 3. The divine analogy served for Wasserman as another case of a dissociation of sensibility, which he uses as a transition from eighteenth-century ways of thinking to Romanticism (more fully developed in *The Subtler Language*).

4. The term is Geoffrey Hartman's, in "Milton's Counterplot," *ELH* 25 (1958): 1–12, reprinted in Hartman, *A Critic's Journey, 1958–1998* (New Haven: Yale Univ. Press, 1999), 109–19. Leslie Moore's interpretation, to which I am indebted, is quite different. This "true 'middle' — a place with room for the bird who sings darkling, a substitute for lost Eden," as Moore puts it, "This alternative middle realm has been present from the early lines of the poem: it is the ambiguous region of darkness, expectation, obscurity and terror of the 'observer simile,' where figures such as the Plowman, Mariner, and Laborer try to interpret their fallen environment" (Moore, "Milton's Poetics of Redemption: Incarnation and Simile in 'Paradise Lost' and 'Paradise Regained'" [Ph.D. diss., Yale Univ., 1981], 91–92 and chap. 2).

5. Milton's model is presumably the passage in the *Aeneid* where Aeneas sees Dido in the underworld: he "recognized her / dim shape among the shadows (just as one / who either sees or thinks he sees among / the cloud banks, when the month is young, the moon / rising)" (6.595–99). Allen Mandelbaum (trans.), *The Aeneid of Virgil* (New York: Bantom, 1961).

6. Trevor Hart, "Through the Arts: Hearing, Seeing and Touching the Truth," in *Beholding the Glory: Incarnation through the Arts*, ed. Jeremy Begbie (London: Darton, Longman, & Todd, 2000), 5.

7. Theoretically, of course, a Jacobite could, like Bolingbroke, be also a deist.

8. Howard Erskine-Hill, "Alexander Pope: The Political Poet in His Time," *ECS* 15 (1981–82): 130–31; more recently, *Poetry of Opposition and Revolution: Dryden to Wordsworth* (Oxford, England: Clarendon Press, 1996), chaps. 3 and 4; also, Murray G. H. Pittock, *Poetry and Jacobite Politics in Eighteenth-Century Britain and Ireland* (New York: Cambridge Univ. Press, 1994), 107–19, esp. 112–13. These pages originally appeared, in a somewhat

different form, as "*The Rape of the Lock:* A Jacobite Aesthetics?" (presented at a conference on Jacobitism at the Univ. of Pennsylvania, 1997) and as "Pope's *Rape of the Lock:* A Jacobite Aesthetics?" in *Acts of Narrative*, ed. Carol Jacobs and Henry Sussman (Stanford: Stanford Univ. Press, 2003), 130–45.

9. Pope's *Essay on Criticism* (1711), written just before the *Rape*, was, of course, addressed to critics and not poets; it dealt with judgment and only indirectly, from the perspective of the critic, with poetic creation. Nevertheless, Pope's satire fell on the bad critics and their false judgments, not on the Homers and Virgils they criticize and attempt to supercede. The good critic turns out to be the satirist and judge of morals, not the aesthetician (lines 526 ff.).

10. The infidels and Jews who worship the "sparkling Necklace" in the *Rape* were anticipated by the critics in the *Essay on Criticism:* "tuneful fools" who "admire . . . but to please their Ear, / Not mend their Minds; as some to *Church* repair, / Not for the *Doctrine*, but the *Musick* there" (lines 340–43).

11. As Daniel Defoe wrote in his *Review* (1704): "For a Protestant to wear a cross about her Neck is a Ridiculous, Scandalous piece of Vanity; . . . to wear that which in all Countries is the Badge and Signal of a *Roman* Catholick, and which for that Reason has been left off by all the Protestant Ladies in the World, is a tacit owning themselves in the Wrong, and is Scandalous to Protestants." (Defoe, *Review*, 18 July 1704, ed. Arthur Secord, 9 vols. [New York: Columbia Univ. Press, 1938], 1:171.)

12. *Analysis*, 66, 102, 106.

13. Coincidentally, there is a small illustration of the *Rape* that is probably by Hogarth. It shows Sir Plume, dispatched by Belinda, demanding her stolen lock of the Baron. In the manuscript of the *Analysis*, writing about comic incongruity, Hogarth notes that "the effect [of round lines] is rather ridiculous than ugly. Sr. Plumes Empty look discrib'd in the rape of the Lock would not be so strong without the Idea of its roundness" (quoting 4.125–26, "With round unthinking face . . ."). See *HGW*, no. 244. I am inclined now to think it Hogarth's work — date uncertain.

14. Cf. *Paradise Lost* 9.886–87, when Eve reports to Adam that she has eaten the apple: "Thus *Eve* with Count'nance blithe her story told; / But in her Cheek distemper flushing glow'd"; vs. her prelapsarian greeting of the angel Raphael, "No thought infirm / Alter'd her cheek."

15. See Earl R. Wasserman, "The Limits of Allusion in *The Rape of the Lock*," *JEGP* 65 (1966): 425–44. The quotations are from 433 and 431.

16. *The Judgement of Hercules* (see p. 109) was Shaftesbury's attempt to impose on the painter a subject and ethos by the connoisseur who dictates the program and commissions the painting (as Shaftesbury did with Paolo de Mattheis, who executed the painting that he used as frontispiece). In one of his only overt references to Shaftesbury, Pope laughs at Theocles' "vision" in the *Moralists* (*Dunciad*, 4.448).

17. Perhaps in the company of his friend the painter, Charles Jarvis, who would certainly have read it. Pope's views on painting, as opposed to aesthetics, were conventional — Palladian, Burlingtonian, and Richardsonian (connoisseurship).

18. Pope's rejection of heroic virtue is also Miltonic as well as Christian. Milton's Satan embodies an outmoded attachment to a belief in chivalry (Stuart Cavalier values): the "long and tedious havoc fabl'd Knights / In Battles feign'd," which Milton opposes to "the better fortitude / Of Patience and Heroic Martyrdom / Unsung" (*Paradise Lost* 9.30–37).

19. Paul Monod notes in Jacobite poetry the mixture of the "libertine popularism of

386 *Notes to Pages 182–194*

the Cavalier poets and the stern religiosity of High Church divines" (*Jacobitism and the English People, 1688–1788* [New York: Cambridge Univ. Press, 1989], 66).

20. An extreme example of the Shaftesbury-Belinda position can be seen in Rochester's early Cavalier poems, e.g., in his *"In Obitum Serenissimae Mariae Principis Arausionensis"* (1661): "Once even a minor blemish sullies her delicate face, perhaps a woman may escape, a goddess cannot. A being whose body matches her soul, she who is all loveliness, how can she survive her own beauty" (*Rochester's Poems*, ed. Frank Ellis [Harmondsworth: Penguin, 1994], 3). For the general Belinda situation, see Rochester's "Song" ("While on those lovely looks I gaze"), which opposes the woman's "art of *charming*" to his own "of *loving*"), or "Advice," lines 39–40, 47–50. The alternative is Fair Cloris (in the pigsty, masturbating) who is both "innocent and pleased," while Belinda ends innocent and *dis*pleased.

21. See Bernard Mandeville, *Fable of the Bees* (1724 ed.).

22. Pope, *Peri Bathous*, chap. 4, in *The Prose Works of Alexander Pope*, ed. Rosemary Cowler (Hamden, Conn.: Archon Press, 1986), 2:191. Hogarth's aesthetics begins with a chapter on "Fitness," and throughout he emphasizes the fact that beauty without fitness is mere ornament. A functional dung basket is more beautiful than a gilt shield that does not withstand a sword or spear. Fitness represents the human function.

23. "Soliloquy or Advice to an Author," in *Characteristics*, ed. J. M. Robertson (New York: Dutton, 1900), 1:136.

24. On Pope's "masque," *Haman and Mordecai*, see p. 216.

25. *Virgil's Georgics*, trans. S. Palmer Bovie (Chicago: Univ. of Chicago Press, 1956).

26. *The Dunciad*, in *Twickenham Pope*, ed. James Sutherland (New Haven: Yale Univ. Press, 1943), 5:51.

27. But the analogy is immediately reclaimed for the *Aeneid*: " 'Till each fam'd Theatre my *empire* own, / 'Till Albion, as Hibernia, bless my *throne!*" (1.251–54, my emphasis).

28. *Eerdmans Dictionary of the Bible*, ed. David Noel Freedman, Allen C. Myers, and Astrid B. Beck (Grand Rapids, Mich.: Eerdmans, 2000), 263.

29. It might be argued that, in book 4, where he in effect "sacrifices" himself to the victorious forces of Dulness with his "Dunciad," Pope goes beyond the poetic redemption/recovery of the old *Dunciad* to a poetic atonement.

30. Cf. "To Stella, Visiting Me," line 23: "Nor is Complexion Honour's Place"; "Cadenus and Vanessa," line 171: "They blush because they understand."

31. The parallels are many: Celia's hair is the first to show the signs of decay — the dye runs down "from her tresses on her front." Like Belinda, she adores her own image; when made up, she is "the wonder of her sex; / Say, which among the heavenly powers / Could cause such marvellous effects?" (lines 54–56); even Partridge is invoked, and Galileo is replaced by Flamsteed.

32. See Paulson, "Swift, Stella, and Permanence," *ELH* 27 (1960), 298–314.

33. Here Swift is remembering Ovid's recommendation for avoiding falling in love: "Go take a look some time when she's smearing her face with cosmetics" (*The Remedies for Love*, trans. Rolfe Humphries [Bloomington: Indiana Univ. Press, 1958], 191–92).

34. *Paradise Lost* 2.883–91.

35. Cf. Garth's *Claremont* (1715), on the time when "Of *Spanish* Red unheard was then the Name; / For Cheeks were only taught to blush by Shame." For further context, see Ruth Bernard Yeazell, *Fictions of Modesty: Women and Courtship in the English Novel* (Chicago: Univ. of Chicago Press, 1991), 65–77.

36. *Analysis*, 89, and, among the *Analysis* MSS., 133.

37. *Paradise Lost*, 4.347–50; *Aeneid* 1.319.

38. That the Apollo Belvedere, he also notes, "has been hitherto thought so unaccountably *excellent* in its general appearance, hath been owing to what hath seem'd a *blemish* in a part of it" (*Analysis*, 101).

39. When Ariel·sees "an Earthly Lover lurking at [Belinda's] Heart," he is "reclin'd" "on the Nosegay in her Breast" (3.141–44). Hogarth writes of the nosegay: "Observe the well-composed nosegay how it loses all its distinctness when it dies; each leaf and flower then shrivels and loses its distinct shape; and the firm colours fade into a kind of sameness: so that the whole gradually becomes a confused heap" (p. 43). For Hogarth the memory of *The Rape of the Lock* provides the nosegay with the associations of Belinda's breast and what is lurking within her heart. He goes a step further than Pope, noting what will happen when *(carpe diem)* the nosegay decays and dies — the flowers, beautiful as long as distinct, will wither into ugly undifferentiation, recalling the "go, lovely rose" theme of the *Rape*.

40. Hogarth's sense of "harlot" is closer to that in Swift's "Beautiful Young Nymph Going to Bed" ("Of Bridwell and the compter dreams, / And feels the lash, and faintly screams") than to "The Progress of Beauty."

41. Note also the Woman of Samaria in plate 2, Hogarth's fig. 74: According to the biblical commentators, in his exposure of her, Christ's intention was double — to "bring her to the sense of her sin" as an adulteress and "also to an acknowledgment of him as the Messiah" (or "to receive the glad tidings of a Saviour, which he was about to publish to her") (Poole, *A Commentary on the Holy Bible by Matthew* [Peabody, Mass.: Hendrickson, n.d.], 3:297).

42. See Melvyn New, "'The Grease of God': The Form of 18th-Century English Fiction," *PMLA* 91 (1976), 235–43.

43. *The History of Little Goody Two-Shoes* (1765, Garland Press ed., 1977), 3, 27. For a fuller account, see *Beautiful, Novel, and Strange*, 184–97.

44. See *Emblem and Expression*, 88–90.

CHAPTER SIX: Mediation

1. See *HGW*, no. 135, where I use the word *repent*.

2. Richard Hooker, *Ecclesiastical Polity* (1593–1600), 6.5.2, ed. John Keble (Oxford, England, 1866), 3:69.

3. James Ussher, *Sermons*, ed. C. R. Elrington (1864), 23:286.

4. James Ussher, *Immanuel, or, The Mystery of the Incarnation of the Son of God* (London, 1645), 8.

5. John Hey, "The Redemption" (1763), lines 300–302.

6. "Christ shall be magnified in my body, whether it be by life, or by death. For to me to live is Christ, and to die is gain. But if I live in the flesh, this is the fruit of my labor: yet what I shall choose I wot not. For I am in a strait betwixt two, having a desire to depart, and to be with Christ; which is far better: Nevertheless to abide in the flesh is more needful for you" (Phil. 1:20–24).

7. Cited in Ruth Smith, (New York: Cambridge Univ. Press, 1995), 43. I am indebted to Smith's thorough examination of the contexts of Handel's libretti. I have also found useful on the historical background of the musical traditions Paul Henry Lang's *George Frideric Handel* (New York: Norton, 1966).

8. Smith, *Handel's Oratorios*, 7, 277.

9. Pope's masque can also be read as a reference to Racine's *Esther*, performed before James II and Mary of Modena in France — as Smith describes it, "an allegorical takeover" by Pope, who revised Racine's play so that "Esther's stature as heroine is enhanced, the Jews' salvation being more entirely her achievement." Pope is identified as author of the original "masque": "As it was compos'd originally for the most noble James Duke of Chandos, the Words by Mr. Pope, and the Musick by Mr. Handel." (Pope, *Haman and Mordecai*, in *Minor Poems*, Twickenham Pope, ed. John Butt [New Haven: Yale Univ. Press, 1954], 6:427–32.)

10. Smith, *Handel's Oratorios*, 280; see 277 ff.

11. See Lang, *George Frideric Handel*, 103–4.

12. Despite the success of *Esther*, Handel immediately returned to opera. As Lang puts it: "Handel neither recognized the significance of the warm reception of the English works nor was he inclined to give up opera for anything else" (ibid., 240–41; also 289–90).

13. Hogarth's close friend William Huggins wrote, with William Defesch, the unsuccessful oratorio *Judith* (Feb. 1733). In the premiere of *Judith*, John Ireland reports, despite the "musical mania" of the audience, "when the *Jewish heroine* had made her theatrical *debut*, and so effectually smote *Holofernes*,

— As to sever,
His head from his great trunk for ever, and for ever,

the audience compelled her to make her exit" (*Hogarth Illustrated*, 2:295–96). Hogarth designed a frontispiece for his friend when the libretto was published, but he had already expressed his opinion in *A Chorus of Singers* (Dec. 1732, *HGW*, no. 127). The singers, very contemporary in attire and expression, are performing "JUDITH: an ORATORIO: or SACRED DRAMA by . . . ," singing: ". . . *world shall bow to ye Assyrian Throne.*" The effect is plainly mock-heroic, a small reflection of the large *Beggar's Opera* paintings, and also, just possibly, recalling the rhetoric of the Coronation Anthems in *Esther*. Hogarth was enough interested in music to belong to the Academy of Ancient Music (along with his friend Huggins).

14. Charles Burney, *An Account of the Musical Performances . . . in Commemoration of Handel* (London, 1785), 22, 100–101. See Donald Burrows, *Handel* (New York: Schirmer Books, 1994), 165–70. As dean of the Chapel Royal, Gibson was responsible for the children, and, as Burrows writes, "his reluctance to allow his charges to act on the London stage is understandable on administrative grounds" (167).

15. On the English use of the OT as "national history," see Lang, *George Frideric Handel*, 362, 384–90.

16. I think this is a stronger motive for Handel and his librettists than the one Smith notes. According to Smith, we must see the OT stories and the Handel-Morell oratorios in the context of the deism debates — Handel's clergyman librettists would have used their texts as defenses of Christianity against skepticism, especially (in the wake of Collins's attack) of the OT (Smith, *Handel's Oratorios*, chap. 6). By the late 1740s and early 1750s, however, despite the publication of Bolingbroke's *Letters*, this view would seem to have been diluted by discussions of the OT as sublime poetry. For Smith on "British Israel," see pt. 2 and esp. pp. 213–32.

17. *See and Seem Blind* (1732), 14–16; quoted in Burrows, *Handel*, 170.

18. Newburgh Hamilton, preface to *Samson*, cited in Smith, *Handel's Oratorios*, 22.

19. See Lang, *George Frideric Handel*, 334–35.

20. For Haman-Walpole, see Bertrand A. Goldgar, *Walpole and the Wits: The Relation of*

Politics and Literature, 1720–1742 (Lincoln: Univ. of Nebraska Press, 1976), 215–16. For this and other interpretations, see Smith, *Handel's Oratorios,* 280–84.

21. On the "entirely new" nature of the Handel oratorio, see Lang, *George Frideric Handel,* 366–67.

22. See Smith, *Handel's Oratorios,* 22.

23. See Lang, *George Frideric Handel,* 199 ff.

24. *Genuine Works,* 1:237. Presumably an allusion to "false Florimel," *Faerie Queene,* III.viii. Hogarth was with Cheselden, so sometime before 1752, when Cheselden died. One wonders if this dates from his acquaintance with Thomas Morell, though it need not. Hogarth could have been acquainted with Handel from the Vauxhall period (ca. 1735) or, later, the Foundling period (1740 ff.). Hogarth was a great joiner; Handel was not. Thus they did not overlap in any of Hogarth's many clubs and in the Foundling only after 1750.

25. As Lang notes, this "constitut[ed] a drawing card that almost equaled the works [operas] themselves" (Lang, *George Frideric Handel,* 119, 243–44; later the organ, 245, 251–52).

26. John Lockman, introduction to John Christopher Smith Jr.'s libretto of *Rosalinda* (1740). If, as Lang argues, the true equivalent sought by Handel was Greek tragedy, the distinction between Great and Novel or New remains (Lang, *George Frideric Handel,* 377–83).

27. Full title: *Poems on Divine Subjects, Original, and Translated from the Latin of Marcus Hieronymus Vida, Bishop of Alba (and M. A. Flaminius).* The Yale MSS., in the Osborn Collection.

28. Morell, *The Christian's Epinikion* (1743), cited in Smith, *Handel's Oratorios,* 141.

29. In *Judas Maccabaeus* in 1747: "Nor add *the second Cause,* . . . / It is the Lord, who for this *Israel* fought, / And this our wonderful Salvation wrought" (quoted in Smith, *Handel's Oratorios,* 147). Smith points out that, while the OT oratorios "try to have it both ways, giving a rational explanation (or 'second cause') while claiming divine intervention," Morell makes a particularly intransigent statement of God's immanence (146–48).

30. Thus, Morell's orthodoxy is not evidence for Hogarth's at the time he made *A Harlot's Progress* (if ever), as Bindman would like to think (*Hogarth and His Times* [London: British Museum, 1997], 51).

31. Smith, whose reading is political, sees a reference to George II's treatment of the Prince of Wales in the casting out of Jephtha (Smith, *Handel's Oratorios,* 338–45).

32. Greene, at first a close friend of Handel's, had turned against him. He had exploited the popularity of *Esther* later in 1732 with his *Song of Deborah and Barak,* which was then quickly followed by Handel's own *Deborah.* For Hogarth's and Huggins's association with the Academy of Ancient Music (a group to which Handel did not belong), and with Greene, see *Hogarth,* 1:61–64. This suggests both Hogarth's interest in music and the probability of affinity with the taste of Huggins and Hoadly.

33. Hoadly to Hogarth, BL Add. MS. 27995, f. 23.

34. John Hoadly to David Garrick, 21 July 1765, in Garrick, *Letters of David Garrick,* ed. David M. Little and George M. Kahrl (Cambridge: Harvard Univ. Press, 1963), 1:191. Again, in another letter to an unknown correspondent, he refers to the difficulty of "break[ing] through the prudery of my profession and (in my situation in the church) produc[ing] a play upon the stage" (quoted in *Biographia Dramatica* [1812], 1:351). In the verses he wrote for Hogarth's *Rake's Progress* (publ. 1735), he imposed on Hogarth's complex images a simple, orthodox moralizing.

35. Dennis's *Iphigenia* was based on Euripides' *Iphigenia in Taurica*. See Robert D. Hume, *The Development of English Drama in the Late Seventeenth Century* (Oxford: Clarendon Press, 1976), 219, 454.

36. Burrows, *Handel*, 356, citing Dean, *Handel's Dramatic Oratorios*, 592. Burrows adds that, in fact, Morell was recovering the story of Abraham and Isaac: True, but this was precisely the story the Christian and deist critics of Judaism cited against the OT. It is simpler, and more accurate, to say that Morell Christianizes. Smith (*Handel's Oratorios*, 144) cites the discussion of the OT God's allowing the sacrifice in *Gentleman's Magazine*, April 1734, 615.

37. Richardson, *Explanatory Notes and Remarks on Milton's "Paradise Lost"* (1734), 118.

38. Ibid., 12.240–44.

39. *The Christian Doctrine*, trans. John Carey, in *Complete Prose Works of John Milton*, ed. Maurice Kelley (New Haven: Yale Univ. Press, 1973), 3:218. Richardson also, incidentally, justifies the "blemishes" he finds on Milton, man and poet: "Whatever Spots, or Blemishes appear about his Judgment in certain Points, let the Charitable Eye look beyond Those on his Immaculate Integrity" (Richardson, *Explanatory Notes*, cvi).

40. *The Book of Common Prayer*, 81.

41. Cf. my erroneous conflation of Trinity and mediation in *Beautiful, Novel, and Strange*, 35–43. Hogarth does not emphasize the parody of the Trinity (as earlier illustrators had done by placing Satan, Sin, and Death in a line). He does use the graphic image of the Trinity, the triangle, turning it upside down in *Sleeping Congregation* and employing it for aesthetic purposes in the *Analysis* (where he replaces the four-lettered unutterable name of the Jewish God with his Line of Beauty). Elsewhere, breaking up the Trinity, he reduces the Paraclete to a crow in *Gate of Calais* (added in the painting, supposedly to conceal a tear in the canvas), a goose in *Election* 4 (fig. 74), and, somewhat more positively, a dove of peace in *Times*, plate 2.

42. The analogy Hogarth would have had in mind with *A Scene from "The Tempest"* was between Miranda, Ferdinand, and Prospero and his wife Jane, himself, and her father Sir James Thornhill, in a painting executed not long after Thornhill's death (*Hogarth*, 2:105–7).

43. Around the same time he was making his satire on false perspective, which served as frontispiece to his friend Joshua Kirby's *Dr. Brook Taylor's Method of Perspective made easy* (1754). See *HGW*, no. 232.

44. *Covent-Garden Journal*, 24 Mar. 1751/2.

45. *HGW*, no. 192/1.

46. Raphael's Cartoons were in the royal collection and accessible to artists; they were known in many engravings and painted copies. Thornhill spent his last years painting one set of copies.

47. In *Marriage A-la-Mode* 2, Paul appears in one of the pictures of saints on the wall.

48. We have had some indication of Hogarth's idea of Jesus. The picture of Jesus in *The Pool of Bethesda* (see fig. 51) is of Jesus the healer and teacher. Implicit in *The Pool of Bethesda*, however, was another element: the priests who, offstage, persecute Jesus for working miracles on the Sabbath ("And therefore did the Jews persecute Jesus, and sought to slay him," John 5:16). The pendant painting, *The Good Samaritan*, underlined this subtext with the story of the Samaritan who saves a wounded man who has been ignored by the Jewish priests, seen disappearing over the hill: his bloodiness from their perspective makes him unclean. Insofar as Hogarth conceived of Jesus as opposing (and opposed by) the OT law,

it was through the eyes of Paul, and it seems probable that he saw Paul as promulgating the same teachings (and healings).

49. Hoadly, "St. Paul's Discourse to Felix, Preached before the king, Feb. 15, 1729/30," in Hoadly's *Works* of 1773 (3:735–42).

50. In the recent past Paul had been in the news. Lord Lyttelton's ambitious *Observations on the Conversion and Apostleship of St. Paul* appeared in 1747, and around this time Peter Annet, a deist following in Woolston's footsteps, published his attack on Paul in his *History and Character of St. Paul, Examined* (London, n.d.). Attacking Paul in order to put in question the religion he was prominent in founding, Annet charges him with, among other things, madness—Paul "acted with as much Madness against the Priests as he had acted for them." One wonders if Hogarth's *Paul before Felix Burlesqued* reflects Annet's "burlesque" of Paul. See Peter Annet, *History and Character of St. Paul, Examined: in a Letter to Theophlus, a Christian friend . . . in a Letter to Gilbert West, Esq.* (London, n.d.), 6. According to Herrick, he also published a response to Lord Lyttelton's pro-Paul tract *Observations on the Conversion and Apostleship of St. Paul* (1747).

51. Hogarth may have known the apocryphal *Acts of Paul*, in which Paul is described as "a man of little stature, thin-haired upon the head, crooked in the legs, of good state of body, with eyebrows joining, and nose somewhat hooked." (*The Apocryphal New Testament*, trans. M. R. James [Oxford, England: Clarendon Press, 1924], 273.)

52. *Hogarth*, vol. 2.

53. For Walpole as "steward," see Howard Erskine-Hill, *The Social Milieu of Alexander Pope: Lives, Example, and the Poetic Response* (New Haven: Yale Univ. Press, 1975), chap. 8.

54. Pope's *Epistle to Burlington* opens with a picture of bad mediation, though the focus is on the consumer rather than the middleman whose example Virro or Sir Visto follows in collecting his objects of consumption—his drawings, his fine wife, and finer whore—the trophies he gathers, human and material. The middleman is the person who shows him what to acquire, who actually is able to use it for his own purposes (whether it's the appreciation of a drawing or of the body of a woman), and who will get it when it passes out of Virro's hands. Pope's critique of connoisseurship in his *Epistle to Burlington* draws on another locus in *Paradise Lost*—Eve, Adam, and the "taste" of the apple: "What brought Sir Visto's ill got wealth to waste? / Some Daemon whisper'd, 'Visto! Have a Taste'" (lines 15–16)—taste of the apple, acquire "taste" and be a true connoisseur.

55. Applying my reading of the *Harlot*, Bernd Krysmanski interprets the *Rake's Progress* as an anti-Passion: plate 1, the erection of the cross; 2, the Flagellation; 3, washing of the feet and Last Supper; 4, the Resurrection and a *Noli me tangere* as well as casting of dice for Christ's robe (the boys in the foreground); 5, the marriage of the Virgin Mary; 6, the Transfiguration (replacing the Ascension); 7, Christ's imprisonment, the Harrowing of Hell, and a Temptation of St. Anthony; and 8, a Pietà. Obviously these bits and pieces are at best a jumble of echoes of Old Master paintings. The Pietà in plate 8 is, of course, well known; plate 6 could be Christ in the Garden of Gethsemene ("Lord Pass the cup"). The others seem to me fanciful. See Bernd Krysmanski, "Hogarth's *A Rake's Progress:* An 'Anti-Passion' in Disguise," in *1650–1850: Ideas, Aesthetics, and Inquiries in the Early Modern Era* (1996), 4:2–19; reprinted as "Hogarths 'A Rake's Progress' als 'Anti-Passion' of Christ," pt. 1, in *Lichtenberg-Jahrbuch 1998* (Saarbrücker Druckerei & Verlag, 1999), 204–42; pt. 2, *Lichtenberg-Jahrbuch 1999* (2000), 113–60.

56. The suggestion of a "Christ in the Garden of Gethsemene" in plate 6 might be a *trying on* of that role by Tom Nero.

57. See Sacvan Berkovitz, *The Puritan Origins of the American Self* (New Haven: Yale Univ. Press, 1975), chap. 1.

58. The drawing, which Horace Walpole describes, survives only as an etched copy, possibly based on Walpole's description rather than the original. I reproduce the copy that was bowdlerized by Samuel Ireland for his *Graphic Illustrations:* he has shortened the telescope so that it does not touch Richardson Jr. For the story, attributed to Joseph Highmore, see *Graphic Illustrations*, 1:117–20; *HGW*, 1970 ed., 1:314.

59. Hogarth may also recall Milton's simile on the landing of Satan on Earth: "a spot like which perhaps / Astronomer in the Sun's lucent Orb / Through his glaz'd Optic Tube yet never saw" (3.588–90), glossed by Richardson, "Telescope, or Perspective Glass," in *Explanatory Notes* (129).

60. Geoffrey Hartman, *A Critic's Journey, 1958–1998* (New Haven: Yale Univ. Press, 1999), 113.

61. This connection was pointed out to me by Claude Rawson.

62. *Tale of a Tub*, 2d ed., ed. Guthkelch and Smith (Oxford, England: Clarendon Press, 1958), 95.

63. David Bindman, *Hogarth* (London: Thames & Hudson, 1981), 62; repeated by Woodward in the Soane Museum catalogue of the *Rake's Progress* exhibition. The following is excerpted from my review of *The Other Hogarth*, ed. Fort and Rosenthal, in *Albion* 34 (2002): 492–95.

64. Richard Meyer has drawn our attention to the relationship between plates 1 and 2 ("Nature Revers'd: Satire and Sexual Difference in Hogarth's London," paper delivered at the Hogarth symposium at Columbia Univ., 7 Nov. 1998; publ. in *The Other Hogarth: Aesthetics of Difference*, ed. Bernadette Fort and Angela Rosenthal (Princeton: Princeton Univ. Press, 2001), 142–61.

65. See Partridge, *Shakespeare's Bawdy* (New York: Dutton, 1968), 80.

66. The middle picture is not identifiable, but it could be (if there were more women) a Lot and His Daughters of the sort Hogarth later used in *Marriage A-la-mode* 4.

67. Thomas Blount, *Glossographia: Or a Dictionary Interpreting the Hard Words of Whatever Language, Now Used in our Refined English Tongue* (1670), 596.

68. See, e.g., Giles Fletcher, *Christ's Victory and Triumph* of 1610, line 117.

69. Alexander Ross, *Mystagogus Poeticus, or the Muses Interpreted* (London, 1647), ed. John R. Glenn (New York: Garland Press, 1987), 335. I am indebted to Richard Rambuss, *Closet Devotions* (Durham: Duke Univ. Press, 1998), 54–56; also James M. Saslow, *Ganymede in the Renaissance: Homosexuality in Art and Society* (New Haven: Yale Univ. Press, 1986), and Leonard Barkin, *Transuming Ganymede and the Erotics of Humanism* (Stanford: Stanford Univ. Press, 1991), 26. One additional example: Dryden associates Charles I, whose martyrdom was "The Nation's Sin," with Ganymede: "Heaven would no longer trust its Pledge; but thus / Recall'd it; rapt its *Ganymede* from us" ("Hastings," lines 51–52).

70. William Sherlock, *A Practical Discourse concerning Death* (London, 1689), 41. In *Marriage A-la-mode* the Ganymede is one of a series of paintings that show the classical gods' Ovidian rapes of mortals, together with the painting of Lot being seduced by his daughters.

71. As I have shown in *Rowlandson: A New Interpretation* (London: Studio Vista, 1970), this grouping was picked up and used almost ad nauseam by Rowlandson as an aesthetic paradigm: a beautiful young woman, a handsome young man, and an old, ugly husband (sometimes father).

72. I think we must assume, qualifying George Haggerty's argument in *Men in Love*, that anal penetration was generally regarded as the sign of the sodomite. Haggerty cites the one notorious case, of 1726, when several men were apprehended in a Molly House and indicted for "the heinous and detestable Sin of Sodomy, not to be named among Christians," and there was no mention of penetration. Haggerty thinks that cross-dressing and kissing were sufficient for a capital conviction — that the really threatening transgression was violating class boundaries, doing what upper-class gentlemen did; and that "marriage" (the men would withdraw into a private room and be "married") referred only to kissing and fondling. I cannot imagine risking the gallows for less than a total sexual experience. (George E. Haggerty, *Men in Love: Masculinity and Sexuality in the Eighteenth Century* [New York: Columbia Univ. Press, 1999], 55.)

73. I have also noted the erotic element in the third, originating scene (*Hogarth*, 1:238), a point that James Turner would make the sole explanation for the five scenes that followed (Turner, " 'A Wanton Kind of Chace': Display as Procurement in *A Harlot's Progress* and Its Reception," in Fort and Rosenthal, *The Other Hogarth*, 38–61).

74. In the case of *Boys Peeping at Nature*, Turner has indicated an intriguing ambiguity: Is the putto, with the implied erection, who seems to be preventing the satyr from uncovering Nature's vagina, in fact not covering but *un*covering it? There are other examples of exposed penises Turner does not adduce — on the royal lion in *The Sleeping Congregation* and, simulated by tails, on the lion and unicorn in *Masquerade Ticket* (not to mention the boy's in the painting of the outdoor version of *Before*). Whether Turner can legitimately make analogies between these penises and Hogarth's burin — and therefore make Hogarth out to be a "prostitute" — is less clear.

75. This section draws upon my *Emblem and Expression*, 138–58. My argument there draws upon the research in Oliver Millar's *Zoffany and His Tribuna* (London: Paul Mellon Centre, 1966), which offers most of the facts available concerning the picture (though strangely omitting the biographical).

76. Horace Walpole called Zoffany "the Hogarth of Dutch painting, but," he added, referring to *The Tribuna*, "no more than Hogarth, can [he] shine out of his own way." See Walpole to Sir Horace Mann, 17 Apr. 1775, in *Walpole's Correspondence*, Yale Edition (New Haven: Yale Univ. Press, 1967), 24:92–93.

77. See William L. Pressly, "Genius Unveiled: The Self-Portraits of Johan Zoffany," *Art Bulletin* 69 (1987): 88–101. Pressly's evidence confirms, and in some places augments, my chapter on Zoffany in *Emblem and Expression*.

78. Tobias Smollett, *Travels through France and Italy* (Dublin, 1766), 2:76–77.

79. *Literary Gazette*, 15 July 1826, the source given as Zoffany himself. See Victoria Manners and G. C. Williamson, *John Zoffany, RA* (London: John Lane, 1920), 63, citing without giving a source except "a writer of this period" and presumably referring to the *Literary Gazette*.

80. F. J. B. Watson, "Thomas Patch (1725–1782)," *Walpole Society* 28 (1940): 29; cf. Manners and Williamson, *John Zoffany*, 100.

81. The Raphael *Madonna della Sedia*, *Leo X*, and *St. John* were by this time in the Pitti Palace, but earlier they had been part of the Uffizi collection (Millar, *Zoffany and His Tribuna*, 18).

82. Henry Angelo, *Reminiscences*, quoted in Manners and Williamson, *John Zoffany*, 12 and 15.

83. Manners and Williamson, *John Zoffany*, 100; for the *Last Supper* painted in Calcutta, see 100–102, and for the same subject and treatment when he returned home, 118–19.

84. Millar speculates (*Zoffany and His Tribuna*, 28) that perhaps the whole passage was painted in for George III's benefit, since Cowper badly wanted the Order of the Garter, which he thought he might buy with the Niccolini-Cowper Madonna.

85. In the Pitti self-portrait Zoffany shows Houdon's *écorché* apparently anointing him, and Pressly notes that it was originally a study for a commissioned St. John the Baptist, thus "attributing to Zoffany Christ-like qualities."

86. This is the self-portrait in Parma. For a detailed account of the self-portraits, see *Emblem and Expression*, 138–47, and Pressly, "Genius Unveiled."

87. Millar, *Zoffany and His Tribuna*, 33.

88. E.g., Mann; see above, n. 59.

CHAPTER SEVEN: Resurrection

1. Isaac Watts, *Horae Lyricae* (1709), preface.

2. John Dennis, *Grounds of Criticism in Poetry*, in *Critical Works*, ed E. N. Hooker (Baltimore: Johns Hopkins Univ. Press, 1939), 1:361–62, 183.

3. Hume, *Treatise of Human Nature*, 3.1.9, ed. P. H. Nidditch (Oxford, England: Clarendon Press, 1978), 115.

4. See David Solkin, *Painting for Money: The Visual Arts and the Public Sphere in Eighteenth-Century England* (New Haven: Yale Univ. Press, 1993), chap. 4, for his account of Vauxhall; J. H. Plumb, *The Pursuit of Happiness: A View of Life in Georgian England* (New Haven: Yale Center for British Art, 1977).

5. *Spectator* no. 411, in *The Spectator*, ed. Donald F. Bond (Oxford, England: Clarendon Press, 1965), 3:539.

6. David Bindman draws attention to Roubiliac's "heightening of the narrative," his "reworking of monumental conventions so that they became far more strongly narrative in nature," and his facilitating "the reading of the narrative by detailed, highly finished carving" (David Bindman and Malcolm Baker, *Roubiliac* [New Haven: Yale Univ. Press, 1995], 216, 230, 244, 263). To illustrate the "literary" in Roubiliac's monuments, Bindman relies heavily on the "graveyard school" — Blair, Young, and Harvey; the only paintings he cites are the sub-Hogarthian pair, from a few years later, painted by Francis Hayman for Tyers, the *Death of the Good* and *Bad Man* (surviving in engravings).

7. Malcolm Baker, in Bindman and Baker, *Roubiliac*, 256.

8. *Spectator* no. 321, 3:172; no. 412, 3:541.

9. *Spectator* no. 417, 3:566.

10. Bindman and Baker, *Roubiliac*, cat. no. 1.

11. For some earlier thoughts on Roubiliac's funerary monuments and his mourning women, in the context of an aesthetics of mourning, see *Breaking and Remaking*, 230–45. The present chapter is a revision of "Roubiliac and Hogarth: Representations of Temporality and Eternity," in *Eighteenth Century Life* 20 (1996): 104–26.

12. In the adjacent duchess's monument, the putto on the floor, with one knee on the bottom step of the monument and the other on the floor, holds a spindle and directs it toward the spectator. Here, in a monument to a woman, the three women mourners assume the roles of the three Fates. For contemporary identifications of the imagery, see Bindman and Baker, *Roubiliac*, cat. nos. 5 and 8.

13. That the Freemasons excluded John Toland from membership was not an indication (as Bindman thinks — *Hogarth* [London: Thames & Hudson, 1981], 67n.) that they

excluded freethinkers, only that they did not want Toland's unsavory reputation to draw attention to their heterodoxy. The evidence Bindman adduces in fact points to the lodge as a haven of heterodoxy — e.g., Folkes, whose "infinite prejudice to Religion" is noted, was not only portrayed by Roubiliac; he was another of the few whose engraved portraits Hogarth included in his folios of his prints with Bishop Hoadly's and his own. John Lockman, identified by Bindman as a translator of Voltaire, was yet another name connected with Hogarth as well as Roubiliac.

14. Baker, in Bindman and Baker, *Roubiliac*, 221.

15. Hogarth's precedents included Veronese's Last Supper paintings; the earliest engraved copy of Leonardo's *Last Supper* added a dog to the composition.

16. Also *The Resurrection Reconsidered* (1744) and *The Resurrection Defenders Stripped of all Defense* (1745).

17. Cf. Blake's expression of the same feeling when he has Jerusalem say, "but I, thy Magdalen, behold thy Spiritual Risen Body" (*Jerusalem*, 62.14).

18. Both deism and Protestant iconoclasm would justify Hogarth's distancing the figure of Christ to a remote icon and focusing on the human figures of the Magdalen and the Apostles in the foreground. But he could also have invoked the authority of his graphic model, Raphael's *Transfiguration* (Vatican, Rome), which was notable for the disjunction of the scene of Christ above and the cure of the epileptic boy below.

19. Mikhail Bakhtin, *Rabelais and His World*, trans. Helene Iswolsky (Cambridge: MIT Press, 1968), 25–27, see esp. chaps. 5 and 6.

20. See Rupert E. Davies, *Methodism* (Harmondsworth: Penguin, 1963), 69–71.

21. Bindman, in Bindman and Baker, *Roubiliac*, 32.

22. Roubiliac, it would appear, goes back as well to the Counter-Reformation art of his native France. Bindman believes that he brought back the figure of Death from his trip to the Continent in 1752 (105–6) but, we have seen, Hogarth had already introduced the figure into his own work in the late 1740s.

23. George Taylor died in June 1757, age 43 (*London Evening Post*, 18–21 June). For the pugilistic details, see Pierce Egan, *Boxiana; or Sketches of Ancient and Modern Pugilism* (complete ed., n.d. [1829]), 1:30, 65–67.

24. One version, pen over chalk, is in the Mellon Collection (reproduced, fig. 71); the other, red chalk, in the D. L. T. Oppé Collection, has a continuous decorative border along the top (with the trumpet protruding from clouds in the second), which suggests that they were intended to be seen side by side. See *Drawings*, cat. no. 79.

25. "Invention" for a sculptor meant planning as well as executing the whole sculpture, proclaiming himself an artist rather than a "mechanic" statuary (as Shaftesbury or Richardson would have called him) — a response parallel to the painter's need to produce his own painting before having it engraved, reproduced, and distributed to a wider audience. Both Roubiliac and Hogarth insisted on their role as "inventor" — Roubiliac of the whole monument, Hogarth of the painting from which the engraving (always signed "invenit." as well as "sculpsit") was copied.

26. There are three funerary monuments by Roubiliac situated parallel on the wall of the south aisle of Westminster Abbey — to Field Marshal Wade, to General Fleming, and to General Hargrave. Bindman, examining the evidence, speculates: "The 'Good Christian' typology of Hargrave's monument may have been intended to allude to his charity in leaving his estate to his friend [the friend who used some of the money to commission the monument]; or, more cynically, it might have been a clever way of deflecting the ridicule

that would surely have greeted an heroic portrayal of Hargrave," who was "a professional soldier of unsavoury reputation" (Bindman, in Bindman and Baker, *Roubiliac,* 157–62). Turning to the other two soldiers, Bindman guesses that the combination of Valor and Prudence on General Fleming's monument could be read "in a cynical spirit to imply that Fleming's career was as conspicuous for prudence as for valour" and, returning to Field Marshal Wade, that the struggle of Fame with Time could apply specifically to the fact that he and his friends felt he had ended his days under a cloud of failure. Bindman's speculations are unified by the title of his chapter, "Equivocal Heroism"; he also refers to Roubiliac's "discomfort with the heroic conventions of the military monument" (172). If so, this would be another connection with Hogarth, whose *March to Finchley* projected a similar sentiment.

27. Bindman would like to conflate the Nightingale scene with a resurrection, reading a mingling of grief and hope on Mr. Nightingale's face.

28. Similarly, Burke admired the Nightingale monument but felt that "the image of Death would be much better represented with an extinguished torch than with a dart." A year after Roubiliac's death, on whose authority it is not clear, the invention of the Nightingale monument was attributed to James Harvey, author of *Meditations among the Tombs,* in the *Royal Magazine* 9 (1763): 115 and ill. 172. One reason may be merely the fact that Hervey refers in the *Meditations* to Death's "fatal Javelin, which has drank the Blood of Monarchs, and finds its Way to the Hearts of all the Sons of Adam" (cited in Bindman and Baker, *Roubiliac,* 372n. 33). But we also find in Blair's *Grave* such lines as "Death's shafts fly thick."

29. Bindman mentions Hogarth's painting but gets his account skewed. In accounting for Roubiliac's knowledge of Hogarth's painting, he remarks that it was "well-known from Rowlandson's etching of it" (89). Rowlandson's etching did not appear until 1792 (one by Townley appeared in 1767). Roubiliac would have had easy access to the painting itself in Hogarth's house. "In the end," Bindman concludes, "such source-hunting is beside the point." On the contrary, the regrouping of Hogarth's Satan, Sin, and Death into Death, Mr. Nightingale, and his wife is essential to Roubiliac's effect.

30. Cited in Bindman and Baker, *Roubiliac,* 326.

31. Bindman, in ibid., 33; he is quoting John Mullan, *Sentiment and Sociability: The Language of Feeling in the Eighteenth Century* (Oxford, England: Clarendon Press, 1988), 74.

32. Edmund Burke, *Philosophical Enquiry into the Origin of Our Ideas of the Sublime and Beautiful,* ed. J. T. Boulton (London: Routledge, 1958), 64.

33. I have argued that Dante's *Inferno,* translated by Hogarth's friend William Huggins and shown him, influenced Hogarth in these works of the late 1750s. Huggins had asked him to make illustrations for his translation. The fact that Dante's *Divine Comedy* was traditionally cited by Protestant reformers as the text of a Catholic attacking papal corruption may also have interested him (*Hogarth,* 3:245–47).

34. Bindman notices this, remarking that the *Tailpiece* is a funerary monument "in which the soul fails to ascend to the opening heavens" (Bindman and Baker, *Roubiliac,* 95). In the case of the Hargrave monument, the intact pyramid of the adjacent Chardin monument, recently erected, pointed up its own disintegrating pyramid, emblem of the collapse at the Day of Judgment and resurrection into eternity.

35. See Toland, that "men perish entirely at death without any future restoration or renovation of things" (*Christianity Not Mysterious,* cited in Bindman and Baker, *Roubiliac,* 26).

36. See Augustine, *De Civitate Dei* 20, describing Doomsday: "At or in connection

with that judgment the following events shall come to pass, as we have learned: Elias [Elijah] the Tishbite shall come; the Jews shall believe; Antichrist shall persecute; Christ shall judge; the dead shall rise; and good and the wicked shall be separated; the world shall be burned and renewed." See Eugen Weber, *Apocalypses: Prophecies, Cults, and Millennial Beliefs through the Ages* (Cambridge: Harvard Univ. Press, 1999), 129–30.

37. In *The Jacobite's Journal* Fielding compared the Jacobites to "the headstrong Temper and wilful Blindness of the *Jews*" (no. 25, 21 May 1748).

38. *Analysis*, 37.

39. Hogarth's friends Bonnell Thornton in *The Connoisseur,* Arthur Murphy in *The Gray's Inn Journal,* and James Ralph in *The Protector* all wrote against the Jew Bill and satirized it. Ralph's attacks in particular were antisemitic. See Thomas W. Perry, *Public Opinion, Propaganda, and Politics in Eighteenth-Century England: A Study of the Jew Bill of 1753* (Cambridge: Harvard Univ. Press, 1962), 108.

40. The Gadarene swine had also become a topos of sublimity since Anthony Blackwall's response: "the attentive reader has all that glorious scene of wonder and astonishment full in his eye and mind. . . . Who is not shocked with horror and trembling at the first appearance of the raging Demonic . . . ?" (Anthony Blackwall, *The Sacred Classics Defended and Illustrated* [1725], 250–54.)

41. Matthew Poole's commentary explained that "The devils knew Christ to be the Son of God, though the Jews would not believe it" (*A commentary on the Holy Bible* [Peabody, Mass., n.d.], 3:36). Benjamin Atkinson, one of the many who responded to Woolston's interpretation of the Gadarene swine in his *Discourses,* replied that Jesus probably punished the Jews "for their covetousness in keeping herds of swine," i.e., when it is against their law (*A Vindication of the Literal Sense of . . . Three Miracles of Christ* [1729], 55).

42. For a fictional account of such a dinner, see *The Connoisseur,* 2 Apr. 1754; *Gentleman's Magazine,* 23 (1753): 384.

43. William Romaine, whose Calvinist vision of the world hangs above the Jew's head, wrote a pamphlet attacking the Jew Bill in 1753 and was at this time an ardent follower of Whitefield. He was nevertheless (Hogarth's point) an ordained Church of England clergyman.

44. See *Hogarth,* vol. 3, chap. 9.

45. For an exhaustive analysis of this print, see Bernd W. Krysmanski, *Hogarth's Enthusiasm Delineated: Nachahmung als Kritik am Kennertum* (Hildesheim, Zurich: Georg Olms, 1996).

46. Walpole, *Anecdotes of Painting,* 4 (1771): 145; *Memoirs of the Reign of King George III* (1845), 1:97.

47. The mood of the court, under the scrutiny of the new, young, and pious monarch, George III, may have influenced Hogarth. In the Michaelmas Term (Sept.) of 1762, Peter Annet was tried and convicted of blasphemy (like Woolston, before King's Bench). Though a man of sixty-nine, he was condemned to stand thrice in the pillory and spend a year in Bridewell. The offending text was his journal *The Free Inquirer,* which was published between 17 Oct. and 12 Dec. 1761, and in particular his ridicule of Moses. The fuss at court would have had some effect upon Hogarth, who was now Serjeant Painter to the king. His revision of *Enthusiasm Delineated* was published in April 1762.

CHAPTER EIGHT: Smart

1. P. J. de Voogd, *Henry Fielding and William Hogarth: The Correspondence of the Arts* (Amsterdam: Rodopi, 1981), 26. J. Ireland associated the kitten with "the wantonness of

the young one" (*Hogarth Illustrated* [1791], 1:12). For general background, see Robert Darnton, *The Great Cat Massacre* (New York: Basic Books, 1984), 95. He also comments on the cat and sex: "*Le chat, la chatte, le minet* mean the same thing in French slang as 'pussy' does in English, and they have served as obscenity for centuries." He adds that "cats connoted fertility and female sexuality everywhere. Girls were commonly said to be 'in love like a cat'; and if they became pregnant, they had 'let the cat go to the cheese.' " Ibid., 94; on cats and witchcraft and occult powers, see 92–94. For yet more, see Tammie Maria Causey, "The Folklore Surrounding Cats," *Louisiana Folklore Miscellany* 5, no. 4 (1984): 40–48. "Cats were sometimes regarded as creatures of the devil" (Emmanuel le Roy Ladurie, *Montaillou*, trans. Barbara Bray [Harmondsworth: Penguin, 1978], 290). An extended version of this section appeared as "Hogarth's Cat" in *Raritan* 12 (1993): 1–25.

2. Artists often showed a cat beneath the tree from which Eve plucks the apple; see James Grantham Turner, *One Flesh: Paradisal Marriage and Sexual Relations in the Age of Milton* (Oxford, England: Clarendon Press, 1987), 43–49, 301–4, citing prints by Dürer and Rembrandt. Like the cat in Hogarth's most famous cat picture, *The Graham Children* (London, National Gallery), she is about to pounce.

3. Debra Tayler, "Fatal Missteps: Death in Hogarth's Engravings," *1650–1850: Ideas, Aesthetics and Inquiries of the Early Modern Era* 7 (2002): 166; originally drawn to my attention by Alexander Gourlay.

4. See *Leonardo da Vinci, Master Draughtsman*, ed. Carmen C. Bambach (New York: Metropolitan Museum, 2003), 144, cat. nos. 18–19, figs. 71, 72.

5. Edward Topsell, *Historie of Foure-footed Beasts* (1607); quoted in Muriel Beadle, *The Cat: History, Biology, and Behavior* (New York: Simon & Schuster, 1977), 83.

6. The cat is in the center foreground, self-absorbed and playing with a ball of yarn (in its self-absorption it has overturned young miss's sewing basket, making the female association); the dog, by contrast, is on his young master's lap ingratiating himself.

7. The cat in *The Graham Children* simply represents the cat's killer (like its maternal) instinct as a natural force, one that initiates the Graham children into the real world.

8. Geoffrey H. Hartman, "Christopher Smart's 'Magnificat': Toward a Theory of Representation," in *The Fate of Reading and Other Essays* (Chicago: Univ. of Chicago Press, 1975), 74–98; my text is Karina Williamson and Marcus Walsh, eds., *The Poetical Works of Christopher Smart* (Oxford, England: Clarendon Press, 1980–96), vol. 1 (vol. 1 is edited by Williamson alone).

9. Marcus Walsh, *Christopher Smart: The Religious Poetry* (Manchester, England: Carcanet, 1988), 11.

10. See Arthur Sherbo, *Christopher Smart: Scholar of the University* (Ann Arbor: Michigan State Univ. Press, 1967), 130.

11. *The Midwife, or the Old Woman's Magazine*, 3 vols. (London, 1751–53), 1:225.

12. Lance Bertelsen argues for the Benedicite instead of the Magnificat ("Journalism, Carnival, and *Jubilate Agno*," *ELH* 59 [1992]: 369). Karina Williamson also believes *Jubilate* "resembles the Benedicite more closely than the Magnificat" (Williamson, *Poetical Works of Christopher Smart*, 1:xxv). Clement Hawes sides with the Magnificat because of its leveling action (*Mania and Literary Style: The Rhetoric of Enthusiasm from the Ranters to Christopher Smart* [New York: Cambridge Univ. Press, 1996], 42 ff.). The Benedicite, spoken by Elizabeth's husband Zacharias, continues Mary's particular theme: "O all ye Works of the Lord, bless ye the Lord: praise him and magnify him for ever. Blessed be the Lord God of Israel; for he hath visited and redeemed his people. And hath raised up an

horn of salvation for us in the house of his servant David" (Luke 1:68–69). It is the reciprocal action of both Magnificat and Benedicite that Smart imitates (notice that only the "for" clauses appear here, in A), and the Benedicite specifies "redeemed his people" and (significant for Smart) the "horn of salvation" (see p. 318). But it is more particularly Mary's voice that Smart imitates.

13. Translated from Rouquet's French commentary, *Description du Tableau de Mr. Hogarth, qui représente la Marche des gardes à leur rendez-vous de-Finchley, dans leur Route en Écosse* (1750) (*Midwife*, 1:182–85), and *The Student, or, The Oxford and Cambridge Monthly Miscellany* (Oxford, England, 1751), 2:162–68.

14. Or, possibly, reading Hogarth's source, Steele's *Spectator* no. 266 (see p. 103).

15. *Midwife*, 1:12.

16. Mary Midnight's was by no means the only rewriting of the story of Hogarth's Harlot — others included Cleland's *Fanny Hill* and even (with a happy ending) Richardson's *Pamela* (see *Beautiful, Novel, and Strange*, chaps. 5 and 6).

17. Bertelsen has described Mary Midnight, as she was regarded by the other writers engaged in the paper war of 1751–52 (pro and contra Smart), as functioning "not so much as a character with a voice, but more as a kind of pervasive referent, almost an atmosphere, redolent of all the madcap, transformative, irreverent subjects and goings-on that characterize Grub Street journalism." Bertelson, " 'Neutral Nonsense, neither True nor false,' " in Hawes, *Mania and Literary Style*, 141.

18. Clement Hawes, "The Utopian Public Sphere," in *Christopher Smart and the Enlightenment*, ed. Hawes (New York: St. Martin's Press, 1999), 202.

19. This was suggested by W. K. Wimsatt Jr. in "The Augustan Mode in English Poetry," in *Hateful Contraries* (Lexington: Univ. Press of Kentucky, 1966), 158–62.

20. Boswell, *Life of Johnson*, ed. G. B. Hill and L. P. Powell (Oxford, England: Clarendon Press, 1934), 1:397.

21. Donne, Sermon on Psalm 63:7, in *Sermons*, ed. George K. Potter and Evelyn Simpson (Berkeley and Los Angeles: Univ. of California Press, 1953–63), 7:41.

22. See Guest, *A Form of Sound Words: The Religious Poetry of Christopher Smart* (Oxford, England: Clarendon Press, 1989), 106.

23. On the eighteenth-century identification of David and Orpheus, see Raymond-Jean Frontain and Jan Wojcik, *The David Myth in Western Literature* (West Lafayette, Ind.: Purdue Univ. Press, 1980). On Smart's drawing for himself upon the personal sufferings of David and Job, see Thomas Keymer, "Presenting Jeopardy: Language, Authority and the Voice of Smart in *Jubilate Agno*," in *Presenting Poetry: Composition, Publication, Reception*, ed. Howard Erskine-Hill and Richard A. McCabe (New York: Cambridge Univ. Press, 1995), 97–116.

24. *A View of the Life of King David* was published under the pseudonym of W. Stilton, Horologist. Besides the anonymous *History of the Man after God's Own Heart*, there was a flurry of such attacks. See Guest, *A Form of Sound Words*, 252.

25. Letter, *Christians Magazine*, Sept. 1762, 413–16; in the extremely useful *Annotated Letters of Christopher Smart*, ed. Betty Rizzo and Robert Mahony (Carbondale: Southern Illinois Univ. Press, 1991).

26. *Midwife*, 1:92.

27. Robert Alter, *The David Story: A Translation with Commentary on 1 and 2 Samuel* (New York: Norton, 1999), 230n.

28. Abiezer Coppe, cited in Hawes, *Mania and Literary Style*, 122.

29. Williamson, *Poetical Works of Christopher Smart*, 1:22; to which we can add Hushai, B101.

30. David's dance and its reward from Michal were anticipated by the unseemly act of Uzzah: The oxen trip and the Ark is about to fall but is saved by the intervention of Uzzah: "And the anger of the Lord was kindled against Uzzah, and God smote him there for his error; and there he died by the ark of God" (2 Sam. 6:7). This is an act that angers David, a stronger version of Michal's scorning David for his unseemly actions.

31. See Williamson, *Poetical Works of Christopher Smart*, 1:xxv.

32. The promise of "eternal reward" leads into further allusions to sacrifice and the strange word (which goes back to *Magna Carta*) amerce, here (A12) and A89 and C143, in each case indicating our punishment for the Original Sin — our sacrifice. In its active, to amerce is to fine arbitrarily or according to one's own estimate — to punish by an arbitrary fine. It also means, in its passive sense, a gift in recompense, a present, a favor, or, in other words, grace.

33. Watts, no. 63.

34. Again, see the similar passage (*Paradise Lost* 7.157–61) that refers to the Eschaton, where "merit" means grace.

35. Hey offers many answers: At God's right hand, Christ continues to mediate: "With ceaseless intercession there he pleads; / Perfects our wretched sacrifice of pray'r / And frail obedience" (lines 300–302). Another aspect of the Redemption is that our works can reduce the guilt of our sins and give us a reasonable hope during our waiting period. Christ's merit "gives our tears / The wond'rous efficacy to blot out / The stains of Guilt, indelible before [the Redemption]" (lines 304–6). But Hey's questioning *adversarius* intrudes to ask:

> But sure in Eden's grove God was the guide
> Of wand'ring Man; and shall th' anointed Son
> Only in part restore the charter lost
> By disobedient choice of our first Sire?
> (lines 310–13)

And Hey's answer is that the Son has given us — what we did not have in Eden — the liberty and knowledge to choose between good and evil; He has left behind him for us his example and teachings, which were not available before (lines 317–18). But the world he has left us in is still (or therefore, given our choices) one in which we are "doom'd to walk the wild, perplexing paths / Of constant Trial and Uncertainty" (lines 324–25) — both dangerous and exhilarating: "Such is the wond'rous story of our Race" (line 326). The interim — of evils, liberty, and choice between good and evil, not to mention the doubts as to whether one is saved or damned — leads Hey to fall back on the mode of Pope's *Essay on Man* (which he recalls with his emphasis on happy hopes): "Presumptuous reptile! It is thine to know / What it is thine to practice," he mockingly exclaims, pointing with Pope to the "boasted monuments of human pride" (lines 396, 407).

36. Rizzo and Mahoney, *Annotated Letters of Christopher Smart*, 56–67 and app. A.

37. One essay in *The Student* of 1750 (I believe by Smart) is "On the Humiliation and Suffering of our Blessed Saviour" (celebrating Good Friday). It is addressed to men who are too polite to hear or read sermons and freethinkers who are uninterested in the Savior: "But to an honest, unprejudiced, and humble mind," the author asks, "How must his contemplative soul be lost in the abyss of wonder as well as sorrow, when, with a steady

faith, he beholds the pungent agonies of his blessed redeemer? No less a person than the eternal son of God, did infinite wisdom think sufficient to execute the important work of man's redemption": "this sovereign Lord of universal nature led as a lamb to the slaughter, and as a sheep before his shearers," who "earned his bread by the sweat of his brow," is "despised by his friends and relatives, who envied his superior wisdom" (he "taught the will of God in a plain, easy, and familiar way"); "And though He thus went about doing good, he received in return perpetual insults and affronts. At last one of his own disciples betrays him, and all the rest forsake him."

All of these thoughts lead the author, as if already projecting the *Jubilate Agno*, to "cry out with the Psalmist [David], *I will magnify thee, O God, my King; and I will praise thy name for ever and ever. Every day will I give thanks unto thee, and praise thy name for ever and ever*" (1:137–39). This image of Christ the Redeemer was at hand when Smart found himself in what, given his experience of 1756, he saw to be a Christological role (he and Jeoffry living an *imitatio Christi*). He puts himself in the position of the mocked Christ: "For the Lord is my ROCK and I am the bearer of his CROSS" (B94).

38. In Acts, close on the heels of Paul's vision on the way to Damascus, Peter has a vision of all the animals of the earth, including the beasts forbidden in the OT. Peter "became very hungry, and would have eaten," and he falls into a trance: "And saw the heaven opened, and a certain vessel descending unto him, as it had been a great sheet knit at the four corners, and let down to the earth; Wherein were all manner of four-footed beasts of the earth, and wild beasts, and creeping things, and fowls of the air." A voice tells him, "kill, and eat," to which Peter replies, "Not so, Lord; for I have never eaten any thing that is common or unclean." "And the voice spoke unto him again the second time, What God hath cleansed, that call not thou common." The lesson Peter draws is that "God hath showed me that I should not call any man common or unclean" (Acts 10:10–15, 28).

39. Hawes sees this in terms of the Magnificat as leveling; I see it as also mixing in the Levitical sense. What he sees as "a revisionary expansion of the biblical covenant to include all of creation," I see as also the affirming of the new Christian Covenant and Christ's Redemption of the OT (Hawes, "The Utopian Public Sphere," in *Christopher Smart and the Enlightenment*, 202).

40. Hawes, whose important book draws attention to the origins of this strain in the enthusiastic writings of the seventeenth century, takes this to mean that Smart claims to be "a private channel of grace, bypassing all priestly offices" (*Mania and Literary Style*, 132). Bertelsen has drawn attention to the subculture imagery, evident in Smart's hack writing as he turned from the Latin scholarship of Cambridge to the market of London. Bertelsen, who refers to Smart's "excessive clowning and role-playing," often involving cross-dressing in his various journalistic incarnations, also notes the connection with popular crowd rituals. He sees Mary Midnight as Smart in drag, "replicat[ing] the costume of actual eighteenth-century rioters, dressed in women's clothes, with high-crowned hats and blackened faces, who beat down the fences of the great, broke expensive windows, and threatened elite lives in the defence of what they felt to be the traditional rights of the underclass." See Bertelsen, "Journalism, Carnival, and *Jubilate Agno*," 361, quoting from E. P. Thompson, *Whigs and Hunters: The Origin of the Black Act* (New York: Pantheon, 1975), 256–57.

41. In fragment A the form is: "Let Iddo [an OT name] *bless* [or *praise* the Lord Jesus] *with* the moth [some animal] — the writings of man perish as the Garment [transient,

earthly], but the Book of God [the heavenly, eternal] endureth for ever" (A68). Sometimes the second clause is replaced by a "who is" explanatory clause: "Let Azarias bless with the Reindeer, who runneth upon the waters, and wadeth thro the land in snow" (A78).

42. Hawes's argument, *Mania and Literary Style*, 175.

43. If there were "Let" lines complementing the "For" lines in the Jeoffry passage, they would presumably leave Jeoffry the substitute for "I."

44. In B, Karina Williamson notes, in the *For* verses, Smart "takes on the mantle of an OT prophet, in captivity, like Ezekiel, looking forward, like Isaiah, in time of war [the Seven-Years War] to peace and salvation through Christ" (Williamson, *Poetical Works of Christopher Smart*, 1:12).

45. The "I" is occasionally replaced by a "he," as in B12–14: the reference is to the Savior in 12 and 14, in 13 to "the merciful man [who] is merciful to his beast, and to the trees that give them shelter"; again, B39 refers to the Savior.

46. "A Clause of Mr *Seaton's* Will," prefacing Smart's *On the Eternity of the Supreme Being* (1750).

47. The quotation is from Rizzo and Mahony, *Annotated Letters of Christopher Smart*, 5.

48. See Smart's poem, "Apollo and Daphne," where he plays upon cuckold horns (*Poetical Works*, 4:176).

49. In the OT: "His glory is like the firstling of his bullock, and his horns are like the horns of unicorns; with them he shall push the people together to the ends of the earth" (Deut. 33:17); the Horn of Salvation — the king's saving power, 2 Sam. 22:3: "[God] is my shield, and the horn of my salvation, my high tower, and my refuge, my saviour" (again, Ps. 18:2, "my horn of salvation"). Daniel's fourth beast, with ten horns (Dan. 7:8), was repeated in Revelation (Rev. 13:1) but, combining the horns with Christ-the-Lamb: there "stood a Lamb as it had been slain, having seven horns and seven eyes, which are the seven Spirits of God sent forth into all the earth" (Rev. 5:6).

50. Hawes, *Mania and Literary Style*, 186.

51. For its triumphal prophetic associations, Smart is also drawing for his age of Horn upon Homer/Virgil's Gate of Horn, the portal of true dreams (vs. the Gate of Ivory).

52. Cf. Hawes, *Mania and Literary Style*, 192.

53. See Malcolm Chase, "From Millennium to Anniversary: The Concept of Jubilee in Late Eighteenth- and Nineteenth-Century England," *Past and Present* 129 (1990): 132–47; Hawes, *Mania and Literary Style*, 193–94.

54. *Analysis*, 50–52. The connection between the cornucopia and satire was made by Dryden in his "Discourse concerning the Original and Progress of Satire" (1692), where he emblematized Roman *satura* as a satyr carrying a cornucopia, signifying "Full, and abundant: and full also of Variety"; *satura lanx*, he added, is a filled platter called "satire because of its variety" (California Dryden [Berkeley and Los Angeles: Univ. of California Press, 1961–2000], 4:37, 39).

55. *Analysis*, 53, 61. For Smart's cornucopia, see also Alan Liu, "Christopher Smart's 'Uncomunicated Letters': Translation and the Ethics of Literary History," *boundary* 2, 14 (1985–86): 121, and Kenneth Fraser Easton, "Bad Habits: Cross-dressing and the Regulation of Gender in Eighteenth-Century British Literature and Society" (Ph.D. diss., Princeton Univ., 1990), 267.

56. Smart's essay "On Beauty" (*Student*, no. 5, 31 May 1750) questions the Shaftesburian equation of beauty and virtue in terms reminiscent of the *Analysis*: "An handsome *Courtizan* is a very mean and contemptible creature: the beauty of her face, instead of

excusing her folly adds to the deformity of her character" (*Student*, 1:161–62). The aesthetic categories Smart invokes are modesty, good sense, good nature, and good breeding.

57. But note that Hogarth's illustrated cornucopia is empty. Inside, the eye imagines more "serpentine lines, as in their twistings their concavities and convexities are alternately offer'd to its view" (*Analysis*, 52). There is no sign that he means a filled, overflowing cornucopia — he seems to be interested only in its interior "concavities and convexities." Hogarth may have recalled Isaac Fawkes's most famous trick, the "Egg-Bag trick," in which an apparently empty bag, turned inside out, became a cornucopia overflowing with eggs, silver, gold, and live hens. See Henry Dean, *The Whole Art of Legerdemain: or Hocus Pocus in Perfection* (London, 1763), 26–27.

58. See Hartman, "Christopher Smart's 'Magnificat,' " 96.

59. I am indebted to Easton's argument here, " 'Mary's Key' and the Poet's Conception," in Hawes, *Christopher Smart and the Enlightenment*, 168–71.

60. The metaphor of birth, of course, recalls *The Dunciad*'s monstrous new births vs. the analogy of poetry and birth that was generally rejected by Augustan writers. See also Terry Castle, "Lab'ring Bards: Birth *Topoi* and English Poetics, 1660–1820," *Journal of English and Germanic Philology* 78 (1979): 193–208.

61. See *Analysis*, 154–55.

62. Guest, *A Form of Sound Words*, and Easton, " 'Mary's Key,' " 166–70.

63. Williamson, *Poetical Works of Christopher Smart*, 1:46, citing Samuel Hardy's *Scripture-Account of the Nature and Ends of the Holy Eucharist* (1784), 353.

64. This may suggest, as Harriet Guest has noted, "that the sacrament of the resurrection should replace the sacrament of the crucifixion and death of Christ" (*A Form of Sound Words*, 138).

CHAPTER NINE: Blake

1. My text is David Erdman, *The Poetry and Prose of William Blake* (Garden City, N.J.: Doubleday, 1965), cited in the text as E. When citing one of the prophetic books, I also include the plate and line reference.

2. *Jerusalem* plate 61, on Joseph and Mary, was inserted quite late (1820s).

3. Thomas Paine, *Age of Reason*, ed. Philip S. Foner (Secaucus, N.J.: Carol Publishing, 1998), 52, 160.

4. See *Marriage of Heaven and Hell* 9 and *America* 8.13.

5. Augustine, *City of God*, 2:53–55.

6. In S. Foster Damon's words, "Mary is one of the Transgressors, and therefore the appropriate mother of the greatest Transgressor of all, who also forgave an adulteress" (Damon, *A Blake Dictionary: The Ideas and Symbols of William Blake* [New York: Dutton, 1971], 264).

7. *Milton*, 4.21–22, 97, E97.

8. Ann Bond was Hogarth's model for Mary Hackabout in *Harlot* 1 (see *Hogarth*, 1:242–43). Bromion's lust and rape recall the Hogarthian (or rather *Craftsman*) equation of Colonel Charteris with Walpole, the state, and the "moral" law — as well as the clergyman, magistrate, and prison warder (more explicit in *America* in the caricature of George III).

9. See Leslie Tannenbaum, "The Bride and the Harlot," *Biblical Tradition in Blake's Early Prophecies: The Great Code of Art* (Princeton: Princeton Univ. Press, 1982), chap. 6; Michael Ferber, *The Social Vision of William Blake* (Princeton: Princeton Univ. Press,

1985), chap. 4; and Susan Fox, "The Female as Metaphor in William Blake's Poetry," in *Essential Articles for the Study of William Blake, 1970–1984,* ed. Nelson Hilton (Hamden, Conn.: Archon Books, 1986), 75–90.

10. In this sense, Thel (*Book of Thel,* 1789) is her contrary, retreating back into the vale of Har, rather as Pope's Belinda recoiled from the Baron's advances.

11. Hazard Adams writes, "It is perfectly consistent to see the agony of the cross as similar to earlier turns of the wheel of human sacrifice: thus the blending of the stigmata with the idea of the cutting out of the babe's heart. Under the aegis of a nature goddess, then, Jesus becomes a part of the pattern of ancient seasonal rituals in a never ending cycle" (*William Blake: A Reading of the Shorter Poems* [Seattle: Univ. of Washington Press, 1963], 89).

12. See Florence Sandler, "The Iconoclastic Enterprise: Blake's Critique of 'Milton's Religion,'" in Hilton, *Essential Articles,* 42.

13. Quoting M. H. Abrams, *Natural Supernaturalism: Tradition and Revolution in Romantic Literature* (New York: Norton, 1971), 45.

14. But even the good Mary of Revelation chapter 12 was to Blake the mother of the child who was to rule all nations with a rod of iron. As early as 2:20 the Whore appears as "that woman Jezebel, which calleth herself a prophetess, [who is permitted] to teach and to seduce my servants to commit fornication, and to eat things sacrificed unto idols"; this as opposed to "the marriage of the Lamb [which] is come, and his wife [the true church] hath made herself ready" (19:7). John sees the "new Jerusalem, coming down from God out of heaven, prepared as a bride adorned for her husband" (21:2–3).

15. The main difference is that Tom Idle's harlot, unlike Mary Hackabout, is ugly and deceitful. For an analysis of *Industry and Idleness* along these lines, see *Hogarth,* 2:289–322.

16. G. E. Bentley, *Blake Records* (Oxford, England: Clarendon Press, 1969), 310.

17. Jacob Buthumley, *The Light and Dark sides of God, Or a plain and brief Discourse of The Light side (God, Heaven and Earth) The dark side (Devill, Sin, and Hell)* (1650).

18. Cited in E. P. Thompson, *Witness against the Beast: William Blake and the Moral Law* (New York: New Press, 1993), 10.

19. The question of the tiger and its image may be glossed by the fact that the French revolutionary "tiger" was, like Lyca's lion and tiger, feared to excess by critics of the Revolution; Blake could be suggesting that we qualify and reduce the image in our imagination to something closer to reality. See Ronald Paulson, *Representations of Revolution (1789–1820)* (New Haven: Yale Univ. Press, 1983), 88–110.

20. Stephen Marshall, 1641, quoted in Michael Walser, *The Revolution of the Saints* (Cambridge: Harvard Univ. Press, 1965), xiv.

21. Mark Schorer calls Blake's belief "the major piece of social wisdom of his day ('All deities reside in the human breast')" (Mark Schorer, *William Blake: The Politics of Vision* [New York: Henry Holt, 1946], 21).

22. See Thompson, *Witness against the Beast:* The reference is to the "chartered rights" or "liberties" of Englishmen that were part of the rhetoric of Whig ideology, offering exclusive privileges and implying for Paine and Blake exclusion and limitation; these liberties contain within themselves a denial of the same liberties to other, non-Whig oligarchs.

23. Tillotson, sermon 6, *Sermons,* ed. R. Barker (1695–1704), 1:173. See Norman Sykes, *Church and State in England in the Eighteenth Century* (New York: Cambridge Univ. Press, 1934), 258–62.

24. William Empson, *Milton's God*, rev. ed. (London: Chatto & Windus, 1965), 120.

25. At one point Blake remarks that Christ "was wrong in suffering himself to be crucified. He should not have attacked the government; he had no business with such matters" (Bentley, *Blake Records*, 311).

26. I do not accept Zachary Leader's reading that the children are merely no longer innocent; that they are denizens of experience and so subtly implicated; that what has happened in "The Garden of Love" is partly the speaker's own responsibility, and in "The Vagabond" one alternative is as bad as the other (Zachary Leader, *Reading Blake's Songs* [London: Routledge-Kegan Paul, 1981], 174–76). In the last I presume Blake intended to recall, with the cold church and warm alehouse, Jesus with the publicans and harlots.

27. One source for the cyclic movement was OT Judaism, which contained, after all, a revolutionary myth of oppression under the Egyptians, the Babylonians, and so on, in each case preceded by a sin or falling away, followed by liberation through the covenant with the Lord, but this then was followed by another falling away — or by the recourse to kings — from which the myth of Christian revolution was necessary to free men. So the Redemption itself returns cyclically ("slouching toward Bethlehem to be born") followed by its institutionalization and then eventually another revolution-redemption that will again be betrayed.

28. The cycle was already posited by Blake in his earliest attempt at an epic, *Tiriel* (1789?), where tyrant and slave, father and child, were correlative terms. The tyrannical father enslaves his sons until they rebel and cast him out and become tyrants themselves. Tiriel is a conflation of old, deranged kings from King Lear to the temporarily insane George III. But the poem's emphasis falls on the natural cycle that perpetually connects tyranny and slavery, which is as beyond man's power to stop as the rising and setting of the sun. "In a mirtle shade," a poem of the time of *Songs of Experience* but not used (E460), shows an Orc rebelling and realizing it was only youth that made him do so, and now he has become a Urizen. The development of the French Revolution only made Blake transform this progression into a narrative, most fully described in the manuscript poem *Vala* or the *Four Zoas*. As is well known, Blake's own progress was from belief in the Revolution to disillusionment and the abandonment of the public solution after 1795 to the subsequent attempt to internalize the message in *Jerusalem*.

29. A. N. Wilson, *Paul: The Mind of the Apostle* (New York: Norton, 1997), 194.

30. So far as I am aware, Blake's only surviving references to Hogarth have to do with Cook's re-engraving of his plates, which Blake criticizes for having removed all the character of Hogarth's originals (E496). His elaborate and painstaking engraving of Hogarth's *Beggar's Opera* shows only that he accepted a lucrative commission from Boydell. His disapproval of Reynolds may have been a silent nod toward Hogarth.

31. Lavater obviously knew Hogarth's *Analysis;* he used copies of Hogarth's faces to illustrate his physiognomy.

32. In what follows I have found very useful Tannenbaum's argument *(Biblical Tradition in Blake's Early Prophecies)*, esp. chap. 4.

33. Blake follows Augustine in believing that "it is only through the Incarnation that both language and the human body acquire any universal and eternal significance" (ibid., 76).

34. On Cellini, E659.

35. Fielding, *Joseph Andrews*, 3.1.

36. Tannenbaum, *Biblical Tradition in Blake's Early Prophecies*, 117.

37. W. J. T. Mitchell, "Visible Language: Blake's Wond'rous art of Writing," in *Romanticism and Contemporary Criticism*, ed. Morris Eaves and Michael Fischer (Ithaca: Cornell Univ. Press, 1986), 58–59. For the subject of Blake's graphic-verbal play, which I neglect in this chapter, see Mitchell, *Blake's Composite Art: A Study of the Illuminated Poetry* (Princeton: Princeton Univ. Press, 1978).

38. See E39, E145.

39. See Bentley, *Blake Records*, 182.

40. Ferber, *Social Vision of William Blake*, 99, 100. See *Urizen* 3.6–7.

41. *The Poetical Works of Mr. William Collins*, ed. Laetitia Barbauld (1797), vii.

42. Tannenbaum, *Biblical Tradition in Blake's Early Prophecies*, 74–75.

43. Earl R. Wasserman, "The Inherent Values of Eighteenth-Century Personification," *PMLA* 65 (1950): 450.

44. John Ogilvie, *Observations on Composition* (1774); cited in ibid., 442.

45. Alexander Gilchrist, *The Life of William Blake* (1863), ed. W. Graham Robertson (London: John Lane, 1907), 7.

46. As Mark Schorer wrote of the *Songs* vs. the hermetic prophetic books, with the anti-Jacobin days, "Blake went underground with [the other radicals] and his poetry in a very real way went underground with him" (*William Blake*, 17).

47. See Bentley, *Blake Records*, 132 ff.

48. See Susan Neiman, *Evil in Modern Thought: An Alternative History of Philosophy* (Princeton: Princeton Univ. Press, 2002), a book into which the present study might fit as an endnote.

Index